ART

Artists
Subjects and Stories
Glossary
Prices
Art on the Internet
Quotations

ART
A Field Guide

Robert Cumming

Alfred A. Knopf, New York, 2001

THIS IS A BORZOI BOOK PUBLISHED BY ALFRED A KNOPF

Text copyright © 2001 Robert Cumming
Art on the Internet, text copyright © 2001 John-Paul Stonard

www.aaknopf.com

Knopf, Borzoi Books, and the colophon are registered trademarks of Random House, Inc.

Library of Congress Cataloging-in-Publication Data

Cumming, Robert, 1943–
A.R.T a no-nonsense guide to art and artists
p. cm.
ISBN 0-375-41312-X
1. Art--Handbooks, manuals, etc. I. Title.
N31 .C86 2001
700--dc21
2001033823

First American Edition

Published simultaneously in the UK by Everyman Publishers Plc, London
under the title **A.R.T a no-nonsense guide to art and artists.**

Editor: Clémence Jacquinet
Editorial consultant: Peter Leek
Copy-editor: Susannah Wight
Designed and colour separated by Anikst Design
Printed and bound in Singapore by CS Graphics Pte Ltd

CONTENTS

ACKNOWLEDGEMENTS

This book has evolved over many years of looking at works of art, often on my own, but preferably in the company of others. The eye is the sovereign of the senses, and to share looking is one of life's great pleasures – it increases with age and is not confined to works of art.

It is not possible to name all those who have helped me to see with greater clarity and engage more fully with works of art. Not least are many former students and colleagues at Christie's, but I would like to single out the following, some of whom may be surprised to find themselves mentioned: Joe Darracacott, Arthur Grimwade, Anne Heseltine, Carole Hodgson, Diana Johnson, Sandra Joys, Gabrielle Keiller, Erika Langmuir, Norbert Lynton, Umberto Morra, Eduardo Paolozzi, Pietro Raffo, Bridget Riley, Duncan Robinson, Mo and Lynn Rothman, Irving Sandler, Eric Shanes, Virginia Spate, Mercedes Stoutzker, the Symington family, Simon Wilson; and my mother and grandmother who sowed the first seeds.

I would like to thank Duncan Hislop of the Art Sales Index who gave generous help with the art prices, Jenny Page of the Bridgeman Art Library who helped with the illustrations, and John-Paul Stonard who wrote the chapter on Art and the Internet. Special thanks go to Reagan Upshaw who helped me with the entries on American artists and who taught me much about them; also, and particularly, to George Deem and Ronald Vance on whose doorstep in Cortona, Italy, this book was effectively conceived, one summer evening, over 25 years ago, and who have been godparents to it ever since.

I have written several books and know the necessity for a first-class editor. However no author ever had a better editor than Clémence Jacquinet who is a true professional and a genuine pleasure to work with. She and the designer Misha Anikst have really entered into the spirit of the project and made it a far better and more beautiful book than I dared hope.

Above all I must thank my family – my wife Carolyn who has contributed more to this book than anyone else, and my daughters Hester and Phoebe. I am immensely fortunate to be able to share all my looking, writing, artistic involvements and travel with Carolyn, just as she share hers with me. Writing books is absurdly time consuming, and they have always shown great patience and forbearance, and have always been a great encouragement.

INTRODUCTION

My first job in the art world was at the Tate Gallery, as a new member of a small team whose task was to stand in front of the works on display and explain them to the public. I soon learned that four questions were asked over and over again:

1) What should I look for? What are the key features in a Picasso, Rembrandt, Raphael, Turner?
2) What is going on? What is the story? Who is Hercules? What is the Nativity? Who is that girl with a broken wheel? Who is the man abducting the woman who looks like a tree? Does that big red square mean anything?
3) What is its value? Am I looking at £10? £10,000? £1 million? £10 million?
4) Is it any good or, in front of a pile of bricks or an unmade bed, am I being taken for a ride?

I also found that most of my audience seemed to enjoy getting involved in an informed discussion or exchange of opinions about a particular work of art, or about specific issues (sometimes provocative or controversial ones) and about what they saw, thought and felt.

In this book, I have tried to capture that sort of involvement and to address the four basic questions. Also, I have been part of the art world long enough to know that when those of us who work in it are 'off duty' (looking at art purely for pleasure, uninhibited by the need to maintain professional credibility) we often voice quite different – and sometimes much more interesting – opinions than when we are 'on duty'.

The present-day art world is a huge industry of museums, teaching institutions, commercial operations and official bodies, all with reputations and postures to maintain. They are often desperate to convince us of the credibility of their official messages. I understand the pressures that impel these institutions to maintain a party line, but in the face of all that vested self-interest there is a need for a no-nonsense alternative voice.

I hope this book will prove to be a friendly companion, an entertaining and practical aid for looking at art. If it fulfils its aims, it will:
- Jog your memory about things you once knew but may have forgotten.
- Provide an answer to some of the most frequently asked questions.
- Provoke you, make you query your own opinions, cause you to stop, think and, I hope, smile too.

- Encourage you to believe what you see, rather than what you are told.
- Make you go back to a painting or sculpture and see aspects of it you had not perceived before.
- And, not least, increase the pleasure you feel when looking at a work of art.

ARTISTS

In the book's first section you will find characteristics and features to serve as a guideline when looking at works by a particular artist. My observations are entirely personal, but I have tried to pick out qualities that anyone with a pair of eyes can see, and have pleasure searching for, throughout an artist's whole work. Most of the entries were written, at least in note form, while looking at the works of art. In fact, nearly eveything I have written in this book is what I would say if we were standing in front of a work of art. In such a situation it is, I think, better to say too little rather than too much, so as to allow those who are with me to make their own discoveries and connections.

The activities of observing, interacting, questioning and puzzling, and a desire to share them, are at the centre of our relationship with any work of art. So I have set down what I see, together with some of the ideas, thoughts and feelings that then occur to me. For my own part, I look at works of art to have my eyes opened, my imagination stretched, horizons broadened, life enhanced and confidence fortified.

The artists are listed alphabetically, and divided into the following categories:

AG All-Time Greats (Michelangelo, Picasso, etc.)

OM Old Masters (lesser greats from the early Renaissance to the end of the 19th century)

MM Modern Masters (key figures from the end of the 19th century onwards)

NH National Heroes (British and American artists frequently found in UK and US public galleries, but in many cases seldom exhibited in other parts of the world)

CS Contemporary Stars (the living artists who are most widely seen and talked about today).

This book is an ongoing project and I am conscious that sculptors, especially prior to the 1920s, are at the moment underrepresented. Thus Michelangelo is treated almost solely as a painter, and Bernini (sorry, Bernini, your works are wonderful!) is not included at all. This is not because I have a prejudice against sculptors; in the event of an expanded edition, I intend to devote a whole

section to them, but time was limited and I had to draw a line somewhere. One of the features of 20th-century art has been the blurring of the traditional boundaries between painting and sculpture. Consequently, I have included most of the significant modern and contemporary artists, regardless of the media they work in.

SUBJECTS AND STORIES

Much of Western art has been stimulated by a knowledge of the Bible and the great stories of Greek and Roman mythology. These writings were often the cause of passionate inspiration and belief, at times lifting artists to their moments of greatest creation. There is also an extensive visual vocabulary of codes and symbols that artists have used. These were all once very familiar to any educated individual; now they are often forgotten, or never learned.

Unravelling the stories and the codes is one of the chief pleasures of looking at works of art. I have included the main stories and pertinent information about gods and goddesses, saints, heroes, symbols, etc. No one can remember all of them, and too often they are presented in a way that is overcomplicated or tediously dry. I hope this section will be useful as a quick 'informer' and aide-mémoire. There are extensive cross-references throughout the section – so you can follow your own route, depending on whether you find yourself in familiar or uncharted territory.

GLOSSARY

I have given deliberately short answers to technical questions and terms that are part of the everyday language of talking about works of art. My guiding principle has been to give the bare, factual minimum – the one or two basic points to hang on to – but there are two exceptions to this: 1) where we have included an illustration, it seemed necessary to say more so as to integrate the image with the relevant entry; and 2) when the entry obviously addresses an issue that requires some elaboration and discussion– for example, I have included the current buzzwords and jargon and they cannot be explained in one sentence.

Too often works of art are surrounded by an overload of abstruse information and explanations. Visitors to galleries sometimes spend too much time reading and interpreting the officially presented words, instead of looking at and enjoying the art on display.

FURTHER READING

I have not written a dictionary of artists, symbols and terms – and also I have tried not to write 'art history', because the art that I connect with lives in the present, no matter when it was made. To treat such art primarily as history runs the risk of treating it as if it were dead.

The world is awash with art dictionaries, art encyclopaedias and histories of art. You will soon discover which ones appeal to you most and which are the most useful. I am fortunate enough to have a good art library, but the reference sources that I use most frequently are:

- *The Yale Dictionary of Art and Artists*
- *The Oxford Companion to Art*
- James Hall's *Dictionary of Subjects and Symbols in Art*
- Encyclopaedia Britannica (the classic 1911 book edition and the current edition on CD-ROM)
- The Art Sales Index (on CD-ROM)
- The on-line *Grove Dictionary of Art*
- www.askjeeves.com

I am deeply indebted to all of them.

FEEDBACK

I have recently set up my own website (www.robertcumming.net) and would be delighted to have your feedback about any topic relating to art, or any aspect of this book, as part of the mutual seeing and sharing that is central to enjoying works of art.

A BRIEF EXPLANATION OF PRICES

I have included prices because what people pay for works of art is fascinating, both in absolute terms and comparatively. Some works are worth every penny of the vast sums paid for them; some are ridiculously overpriced; and some wonderful works of art are almost given away simply because they are out of fashion or overlooked.

All prices are 'hammer' prices, which is the value called out at auction, and at which the item is 'knocked down' to the bidder. The actual price paid by the successful bidder will be increased by the addition of a premium charged by the auction house (its amount can vary betweeen auction houses), and possibly local taxes. The £/$ exchange rate is that prevailing at the date of the sale.

The symbol ⓐⓥ introduces the number of works by a particular artist sold at public auction between 1 January 1999 and 31 December 2000, together with the lowest and highest prices achieved by these works in that same period (some artists will have achieved new record prices since then). Paintings, works on paper (including original prints usually issued with the artist's supervision and bearing a signature), and sculpture (comprising 3-D works), are included. The aim is to give a snapshot of the current art market, and it seemed sensible to take a two-year span. The press inevitably reports the highest prices, so it is refreshing to find how (relatively) cheaply you can acquire something (albeit modest) from the hand of a major artist, even today. If there is no entry, it means that nothing was sold at public auction in that period. Works by many of the old masters rarely come onto the market, because few survive and because most are now in public collections.

The symbol ⚲ introduces the highest prices paid at public auction prior to 31 December 2000. Factors such as inflation have not been allowed for. The art market hit a peak in 1989/90, and it is interesting to note how many of the record prices achieved then have not been exceeded since. If inflation is taken into account, the 1989/90 prices need to be increased by approximately 50 per cent. Also, prices are partly dependent on the quality of what comes onto the market – and, as mentioned above, in the case of many old masters this may not be significant, because most, or all of their major works, are now in public collections.

ART SALES INDEX

The information on prices has been provided by the Art Sales Index Ltd, who can be contacted at 194 Thorpe Lea Road, Egham, Surrey TW20 8HA, UK. Founded in 1968, ASI records the price, provenance and other details of works of fine art sold at auctions all around the world. It is available in book form, as a CD-ROM and now on the Internet (www.art-sales-index.com). Details from over 3,000 catalogues are received each year and stored on a database which now exceeds 2.4 million entries, stretching back to the early 1950s.

SYMBOLS USED IN THIS BOOK

SECTION 1: ARTISTS

◉ What to look for

🔎 Details to pay attention to

🏛 Where the main collections are

Ⓐ Average prices

⚒ Record prices

SECTION 2: SUBJECTS AND STORIES

☛ References to other words found in Section 2

SECTION 3: GLOSSARY

◪ References to artists found in Section 1

ARTISTS

1. Jacques-Laurent Agasse, *Miss Casenove on a Grey Hunter*
2. Josef Albers, *Homage to the Square: Joy,* 1964
3. Sir Lawrence Alma-Tadema, *The Tepidarium,* 1881

ABBATE Niccolo dell' OM
c.1512–71 Italian

Italian-born decorator of palaces and portrait painter. Had a refined, elaborate, mannered and artificial style playing with fantasy landscapes and themes of love. Settled in France in 1552 to work for the royal court. Was a key link figure between Correggio and Parmigianino (who influenced him), and the French classical landscape painters, such as Claude and Poussin (whom he influenced).

🏛 Bologna: Palazzo Pozzi
🔨 £80,000/$134,400 in 1998, *Portrait of a young man wearing a plumed hat* (oil p.)

AERTSEN Pieter OM
c.1508–75 Dutch

Painter of altarpieces and large-scale peasant subjects. Monumental genre and still-life scenes (such as a butcher's shop) that have a religious subject hiding in the background. Good at modelling with light in the Italian manner. Likes movement. A Brueghel without the humour and moral observation; a Rubens without the panache and power.

🅐🅥 (4) £17,000/$24,480 – £33,742/$55,000
🔨 £186,495/$317,042 in 1998, *Parable of Royal Wedding* (oil p.)

AGASSE Jacques-Laurent OM
1767–1849 Swiss

Swiss born, Paris trained (by J. L. David, and as a vet), worked in England. Known for faithfully observed, meticulously executed paintings of animals and their owners or keepers (especially horses and wild animals). At his best a truly great painter, but he had a small output and died poor and unknown. Animals were not considered a serious art subject (and still aren't, even today).

🅐🅥 (9) £700/$1,100 – £102,000/$164,000
🔨 £3.5m/$5.81m in 1988, *Two Leopards playing in the Exeter Change Menagerie* (oil p., 1808)

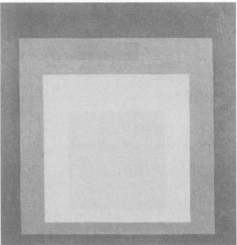

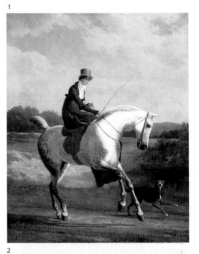

ALBERS Josef MM
1888–1976 German/American

One of the great artist-educators of the Modern Movement. Pillar of the Bauhaus from 1923 to 1933. Emigrated to the USA in 1933.

◗ Highly original work that combines investigations into perception with a simple beauty. Best known for his 'Homage to the Square' series in which he experiments with nests of squares that explore values of light and degrees of temperature in contrasting colours and hues. He uses the square because it is the most static of geometric forms, able to accentuate the colour relationship, and it is without movement. He was also an accomplished photographer and designer in stained glass.

🔍 'Homage to the Square' sounds boring, but is visually fascinating because Albers understood that you can never predict scientifically what colour is going to do, and how it constantly catches you unaware and delights you.'Homage to the Square' is the ultimate proof of this, but you need to get involved and experiment (by half closing your eyes, for instance) to enjoy and appreciate what is going on.

🏛 Essen (Germany): Albers Museum, Bottrop Collection
Ⓐ (43) £743/$1,063 – £67,901/$110,000
✦ £367,143/$600,000 in 1996, *Despite Mist*, study for 'Homage to the Square' (oil p., 1967)

ALECHINSKY Pierre MM
1927– French

Painter and printmaker – creates decorative, joyful, abstract paintings, notable for their spontaneity, lightness of touch and glowing translucent colour. Often uses the formula of a central panel surrounded by a complementary border of small calligraphic images. Pleasure-giving work that is mercifully free from introspection or pretension to profound meaning.

Ⓐ (91) £1,074/$1,734 – £140,000/$226,800
✦ £270,000/$440,100 in 1990, *Épave* (oil p., 1959)

ALLAN David NH
1744–96 British

The Scottish Hogarth, deeply influenced by a visit to Rome. Wanted to be remembered as a history painter (*de rigueur* at the time, but not his forte); was a successful portrait painter and established the tradition of Scottish genre paintings with anecdotal illustrations of Scottish life and history.

Ⓐ (1) £4,500/$7,380
✦ £62,000/$109,120 in 1992, *Portrait of three boys wearing Windsor uniform* (oil p.)

ALMA-TADEMA Sir Lawrence NH
1836–1912 British

Dutch born, naturalised British. Highly successful with the Victorian business classes for whom he produced fashionable, meticulously painted, erotic but safe fantasy images of the leisured classes of Greece and Rome – usually the women in private with their clothes off. Dedicated archaeologist. Used photographs and own site drawings.

Ⓐ (7) £3,067/$5,000 – £358,025/$580,000
✦ £1,562,500/$2.5m in 1995, *The Finding of Moses* (oil p.)

3

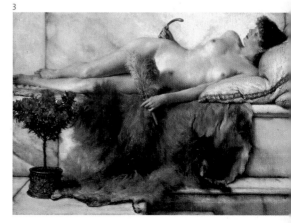

1

ALTDORFER Albrecht OM
c.1480–1538 German

Mainly a painter of altarpieces. Their most notable features are strange visionary landscapes with eerie light effects, in which wild nature is in control, with man taking second place. Small output. Gave up painting to go into local government.

🏹 £4,255/$7,021 in 1998, *Jahel and Sisera* (woodcut, c.1513)

ALYS Francis CS
1959– Belgian

Painter, and conceptual and performance artist. Active principally in Mexico City, where he sets up elaborate projects that are said to catalogue the (banal or surreal?) urban experience. Some involve other people, such as advertisement painters. On one occasion he dragged through the city a small magnetic dog that attracted metal debris.

🔵 (2) £4,375/$7,000 – £31,250/$50,000
🏹 £31,250/$50,000 in 1999, *Entr'acte, NYC Series* (oil p.)

ANDRÉ Carl CS
1935– American

One of the first exponents of Minimal art. His work reflects his boyhood in a Massachusetts shipyard town and his early job on the Pennsylvania railroad – surrounded by metal plates, girders, railway lines, industry, quarries. One of the few artists to be indicted for murder.

🌑 Notorious for the *Pile of Bricks,* which hit the headlines in the 1970s (the Tate Gallery and André were ridiculed in the popular press). His most successful work is typically of simple industrially-made components (such as bricks or metal plates), which are arranged in mathematical order; also chunky, rough-cut wood constructions made from pre-cut units. In the 1970s genuinely challenged the gallery-goer to question what is and what is supposed to be art. Now an old timer.

🔵 (19) £1,481/$2,400 – £243,243/$360,000
🏹 £243,243/$360,000 in 2000, *Aluminium-magnesium alloy square* (sculpture, 1969)

ANDREWS Michael NH
1928–95 British

Sensitive work that reflects his inner personality. Large-scale paintings of places and people he knew well and felt deeply about. Delicate, unassertive technique (spray-painted acrylic). Shy, reclusive personality, painstakingly slow worker (hence few works), totally absorbed by his subjects and activity. English sensibility to light and nature.

🏹 £12,000/$23,520 in 1990, *Head of Man* (oil p.)

ANGELICO Fra AG
c.1387–55 Italian

Florentine, Dominican friar whose work combines old-fashioned (Gothic) and progressive (Renaissance) ideas.

● His paintings interpret the Christian message with directness, enthusiastically telling the story of God's goodness. They are delightfully happy, attractive and holy, and have great innocent purity – as if he saw no evil in the world (perhaps he didn't).

🔍 There is disarming and childlike innocence in the detail: youthful, happy faces with peaches-and-cream complexions and pink cheeks; everyone is busy doing something. Angelico takes evident pleasure in colours (especially pink and blue) and things that he has observed closely, such as flowers. Uses old-fashioned gold embellishments and modern perspective with equal enthusiasm; his soft draperies have highly detailed borders.

🏛 Florence: Convent of San Marco (fresco series)

ANTONELLO DA MESSINA AG
c.1430–79 Italian

From Messina, Sicily. Made a key visit to Venice in 1475–6. One of the pioneers of oil painting in Italy.

● Combined Italian interests (sculptural modelling, rational space and man-the-measure-of-all-things characterisation) with northern obsessions (minute detail and unadorned reality). Had a marvellous ability to observe and paint light, and created wonderful portraits and faces, which seem to live and breathe, showing bones under the skin and an intelligence behind the eyes – which look and answer back. Sense that he shines both an intellectual and a physical spotlight on his subjects.

🔍 Wonderful ability to recreate the appearance and feel of the skin – differentiating between lips, a stubbly or shaven chin, a hairless cheek – eyebrows, hair, the liquid surface of an eye (can only be done with oil paint and requires supreme technical mastery). Oil-paint equation: learns technique from northern artists in Naples and hands it on to clever Venetians, such as Bellini. Probably used a magnifying glass– and it is worth using one when looking at his paintings.

ANTONI Janine CS
1964– Jamaican/American

Bizarre narcissist works that are about (and the product of?) stereotypical female obsessions – beauty, cleanliness, appearances, love, guilt. Thus licking huge blocks of chocolate or soap into self-portraits; using her long, died hair like a paint brush; weaving a blanket with the same computer patterns as her dreams.

🔨 (6) £616/$900 – £121,622/$180,000
🔨 £121,622/$180,000 in 2000, *Gnaw, 600 pounds chocolate, 600 pounds lard phenylethylamin in cabinet* (sculpture, 1992)

2

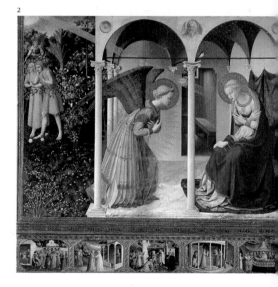

APPEL Karel CS
1921– Dutch

Important postwar artist. Founder member of CoBrA. Recognisable for thickly painted, brightly coloured Expressionist paintings, which attempt to capture the spontaneity of children's painting, but also benefit from adult sophistication/organisation and aesthetic sensibility, together with an ability to create on a large scale.

Ⓜ (194) £459/$679 – £175,000/$281,750
⚒ £350,000/$535,500 in 1995, *Femmes, enfants, animaux* (oil p., 1951)

ARCIMBOLDO Giuseppe OM
1527–93 Italian

Best known for fantastical faces and bodies made up of vegetables, trees, fruits, fish and the like – he had the type of artistic curiosity produced in times of cultural and political upheaval (as much a feature of the late 20th century as of the late 16th century). Worked mostly in Prague for Rudolf II, who was addicted to alchemy and astrology.

Ⓜ (1) £797,546/$1.3m
⚒ £797,546/$1.3m in 2000, *Reversible anthropomorphic portrait of a man composed of fruit* (oil p. 1580)

ARELLANO Juan de OM
1614–76 Spanish

Pre-eminent Spanish flower painter of the 17th century. Created detailed, skilful works, often executed and designed as pairs. Shows bouquets in baskets, on rough stone plinths or in vases of crystal or metal, with a careful balancing of red, white, blue and yellow. His later work is more loosely painted, with full-blown flowers and curling leaves.

Ⓜ (5) £14,319/$22,480 – £550,000/$891,000

⚒ £653,595/$1m in 1993, *Still life of mixed flowers* (oil p.)

ARMAN Armand Fernandez MM
1928–98 French

Stimulating and witty manipulator of objects. More visual than conceptual. Avid collector since childhood; father a furniture and knick-knack dealer; grand-mother an obsessive accumulator of junk.

◓ His work is transformed through accumulations, combustions, cut-ups. Obsessive interest in manufactured objects (such as keys, car parts, machines, dolls or paint tubes). Their repetitive accumulation, and luxurious and bizarre presentation out of context (for instance Perspex boxes, resin beds and wall mounts), endow them with a kind of poetry. Cut-up musical instruments or charred furniture simultaneously shock and cause reappraisal of the true function of objects.

Ⓜ (290) £403/$605 – £45,226/$71,457
⚒ £151,515/$250,000 in 1998, *Counterpoint for cellos* (sculpture, 1984)

ARP Jean (Hans) MM
1886–1966 German

Poet, painter, sculptor. Experimenter, best remembered for wood reliefs, cardboard cutouts, torn paper collages and (after 1931) stone sculptures. His early work is modest in scale and appearance. Arp liked simplicity, biomorphic shapes and chance. Took natural forms and sought to perfect their shape and inner spirit. Founder of Dada and Surrealism.

Ⓜ (79) £297/$427 – £463,576/$700,000
⚒ £532,444/$900,000 in 1990, *Torse végétal* (sculpture)

1. Giuseppe Arcimboldo, *Whimsical Portrait*
2. Karel Appel, *Child III*, 1951
3. Arman, *Office Fetish*, 1985
4. Juan de Arellano, *Pair of still lifes of flowers*

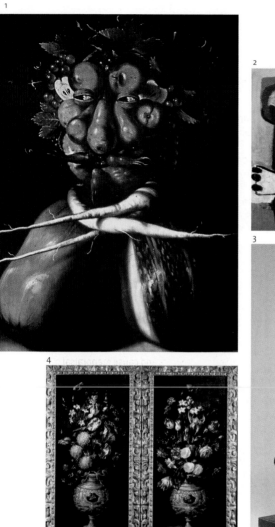

AUDUBON John James NH
1785–1851 American

Bastard son of a Haiti slave trader.
Paranoid braggart. Creator of one of the
greatest books of natural history of all
time, *The Birds of America* (4 volumes,
435 species). Stunning combination of
artistic mastery (composition and detail),
empirical realism (he shot birds, wired
them into lifelike poses, then drew them)
and sensitivity to nature's cruel drama.

- Ⓐⱽ (6) £1,840/$3,000 –
 £16,867/$28,000
- 🔨 £141,975/$230,000 in 1987,
 Pair of boat-tailed grackles (w/c)

1. Hendrick Avercamp, *Skaters on a frozen river*
2. Frank Auerbach, *Head of Gerda Boehm*
3. Francis Bacon, *Lying Figure*, 1969
4. John James Audubon, *Whooping Crane, from 'Birds of America'*

1
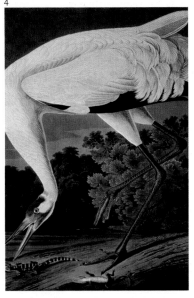

2

4

3
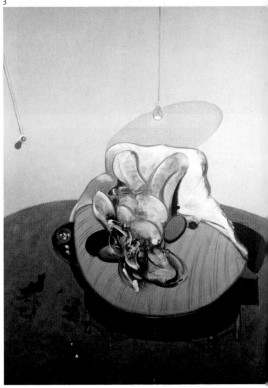

AUERBACH Frank CS
1931– British

German born, British by adoption. Small-scale paintings in which the paint can be as thick as the crust of a loaf, the result of constant revisions piled on one another. Images mostly of central, urban London, but also nudes. His work is an almost defiant declaration that although the art of painting may be considered by some to be out of fashion, it will certainly never die.

Ⓐ (20) £400/$576 –
£170,000/$268,600

🔨 £357,143/$600,000 in 1990,
*Mornington Crescent with the statue
of Sickert's father-in-law* (oil p.)

AVERCAMP Hendrick OM
1585–1634 Dutch

Mute painter from Kampen, in Holland. Specialised in atmospheric, popular, winter scenes, usually with a landscape setting, bare trees, a pink castle and a throng having a happy time on the ice and snow. Often uses high horizons. Warm-coloured buildings that intensify the coldness of sky and snow; the thin painting of figures gives them vitality and movement.

Ⓐ (1) £104,396/$149,286
➴ £700,000/$1.26m in 1990, *Skaters, Kolf players and other townsfolk on frozen floodwaters at Campen* (oil p.)

AVERY Milton NH
1885–1965 American

Self-taught, inspired by Matisse, but cosier and less intellectual. Simple, flowing lines; rich harmonies of colour; abstraction from nature. Also the proof of what the love of a good woman can do: aged 40 or so, he married an artist 20 years his junior, who pushed him to drop his old Impressionist ways. Many fine, expressive etchings.

Ⓐ (40) £1,227/$2,000 – £375,000/$600,000
➴ £375,000/$600,00 in 1999, *Figure with bouquet* (oil p., 1944)

BACON Francis MM
1909–92 British

One of the most significant figurative painters of the postwar period. Largely self-taught. A loner, personally and artistically. His long-term significance has yet to be assessed and will depend on whether he is followed, or if he proves to be a dead end.

❂ Shows genuine originality in his imagery, and the way he constructs it and handles paint. His central (only?) image is of an isolated figure, usually male, often naked, under stress, in bare, brightly lit or coloured space. Said by Bacon (and others) to indicate the condition of postwar Europe and modern human isolation. Beautifully crafted, controlled drawing and line, tense, emotional colour. Creative interplay between what he intends and what happens accidentally.

🔎 Like many contemporary artists he has suffered from unhelpful excess of praise, such as 'He's as good as Goya or Van Gogh.' He's not, because he has, in truth, only one image and one emotion, which he repeats with variation (thus he is more like Boucher). Late developer – nothing of sustained significance until his late 30s, then 20 years or so of very powerful work; after about 1971 (aged 61 and following the death of his lover George Dwyer) he declined into repetitive formula.

Ⓐ (28) £1,176/$1,918 – £4,225,352/$6m
➴ £4,225,352/$6m in 2000, *Portrait of George Dwyer Talking* (oil p. 1966)

BAILEY William CS
1930– American

Paints meticulous still lifes of crockery and eggs laid out on a tabletop to be viewed at eye level. Uses soft, white light, precise shadows, flawless surfaces, subtle tones. Highly refined (and contrived?) sensibility that owes more to European art than American. Has spent summers in Italy, at Monterchi, and was consequently much influenced by Piero della Francesca.

➴ £49,689/$80,000 in 1997, *Still Life, Villa Aurelia* (oil p., 1983)

BALDUNG GRIEN Hans OM
c.1484–1545 German

Painter and engraver from Strasbourg. May have trained with Dürer. Especially

gifted at visionary themes, which incorporate the elemental and super-natural and sometimes the gruesome and macabre. His early subjects tend to be religious; his later work is secular. Good draughtsmanship; intense colour. He also produced very high-quality woodcuts with strong chiaroscuro.

- ● (2) £1,988/$3,200 – £2,265/$3,398
- ⚒ £4,734/$8,000 in 1997, *Group of seven wild horses* (print/woodcut, 1534)

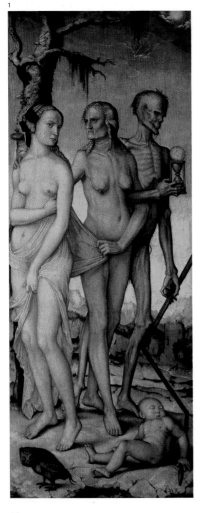

1

BALKA Miroslav CS
1958– Polish

Figurative and conceptual sculptor. The constants are planned human scale and dimensions, use of own personal objects and (mercifully unneurotic) autobiography (Polish roots, Catholicism, fall of Communism). Understated, human, emotionally wide-ranging, grown-up, genuine and convincing – good.

- ● (1) £8,500/$12,835
- ⚒ £8,500/$12,835 in 2000, *Untitled* (sculpture)

BALLA Giacomo MM
1871–1958 Italian

Leading Italian Futurist who had a brief, important, innovative, key period from 1912 to 1916. Interested in sensations: speed, flight, movement and light, which he represented by fragmentation and colour – progressing from Divisionism via Cubism to clean-cut Abstraction. Declined after 1916 into decorative figuration. Also produced theatre designs and sound poems.

- ● (46) £472/$675– £420,000/$663,600
- ⚒ £2,366,864/$4.4m in 1990, *La Scala degli Addii – Salutando* (oil p.)

BALTHUS (Balthasar Klossowski de Rola) CS
1908–2001 French

Self-taught and precocious, with Polish antecedents; well connected intellectually (Bonnard and Rilke were family friends). Reclusive. Consciously worked against the modern grain – ideologically opposed to abstract art, determined to establish the importance of craftsmanship; bypassed modern masters to connect to old masters such as Piero della Francesca.

- ◑ Painted landscapes and portraits; best known for images of adolescent

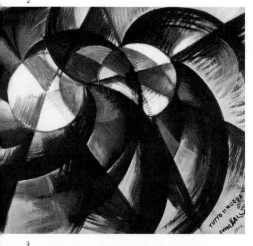

BARNEY Matthew CS
1967– American

Former medical student well known for creating events of interlinked film performances, installations, videos and art books with a common narrative or theme. Attracted by the repellent – strange, nightmarish forms made from horrible synthetic materials, slime made from Vaseline, mutants padded with cushions, bizarrely made-up models, etc.

🌀 The underlying message is not yet clear: is he trying to provoke so as to make a meaningful comment or critique of Western consumer society? Or, even if he is, is he merely pandering to that society's inherent voyeurism and narcissism – its love of looking at itself even (especially?) when it is particularly distorted, repellent or violent?

Ⓐ (10) £14,907/$24,000 – £216,049/$350,000
🔨 £216,049/$350,000 in 1999, *Cremaster 4* (sculpture, 1994/5)

BAROCCI Federico OM
1526–1612 Italian

Urbino based painter of sentimental religious pictures, who suffered from terrible ill health. Sugar-plum colours and soft forms (he was one of the first artists to use pastels), sweetly-faced Madonnas and well-handled crowds. His work lacks bite, like a cheap, sweet wine – all fruit and sugar, without acidity.

🏛 Urbino (Italy)
Ⓐ (9) £2,800/$4,424 – £1,463,415/$2.4m
🔨 £1,463,415/2.4m in 1999, *Madonna del popolo* (drawing)

BARRY James NH
1741–1806 British

Highly gifted Irish-born painter who became a professor at the Royal Academy.

young girls, sleeping or lost in moments of private thoughts; static (but not frozen) moments in time. His work probes the area between innocence and perversity, reality and dream. Slow, careful workmanship. Affirmation of time-honoured virtues such as precise draughtsmanship, oil paint, observation from life, conscious creation of beauty, muted tones, delicate colour, light, harmony and the primacy of the human figure.

Ⓐ (32) £697/$1,114 – £1,854,305/$2.8m
🔨 £1,854,305/$2.8m in 2000, *Nu aux bras levés* (oil p. 1851)

1

2

3

❂ Large-scale elaborate altarpieces of throned Madonnas with the Christ child that show the main characteristics of the High Renaissance style – monumental, solemn, balanced, with dignified compositions and figures. Bartolommeo replaced the intensely observed detail of the early Renaissance with generalisations (especially in faces and drapery) and idealisation.

🔎 Look for well-fed people with a tendency to chubby cheeks, double chins and a self-satisfied look. Landscapes that look prosperous and well farmed. Warm colour and light.

Aimed for the top: large-scale history painting on the scale of Raphael's Vatican frescoes. Was so paranoid and pretentious as a person that he ruined his opportunities and died lonely and unloved.

🜨 (1) £22,791/$33,503 –
↗ £207,792/$320,000 in 1996, *The Crucifixion* (oil p.)

🔨 £10,000/$18,000 in 1990, *Venus Anadyomene* (oil p.)

BASELITZ Georg cs
1938– German

Creator of big, lively, colourful, energetically painted, not very original paintings (neither in technique nor subject), in which bodies are often portrayed upside down. Acclaimed in official art circles. Also makes large-scale crudely hewn, sculptures out of wood.

BARTOLOMMEO Fra Baccio della Porta AG
c.1474–1517 Italian

Major Florentine painter who influenced the change in style between the early and High Renaissance.

◗ Baselitz claims (perhaps honestly?) that his works have no particular meaning, although this does not deter the art establishment from endowing them with deep significance and cheerfully paying enormous prices for them. Notice the direction of the paint drips – at least they prove the figures were painted upside down and that he hasn't just up-ended his canvases.

🅐 (43) £709/$1,149 – £260,000/$429,000

➹ £558,659/$1m in 1991, *Ludwig Richter auf dem Weg zur Arbeit* (oil p., 1965)

BASQUIAT Jean-Michel MM
1960–88 American

Young, black, middle-class New Yorker, who died of a drug overdose aged 28. Frenzied and prolific self-taught artist whose work powerfully reflects the obsessions and conflicts of his city and his decade (1980s).

◗ His large-scale work has the appearance, content and crudity of graffiti on buildings (he began his career by secretly and illegally painting on public buildings). Their sheer energy, size, number and consistency indicate an intelligence seeking release or crying for help. Shocking, controversial, ugly, drug-crazed they may be – boring and dismissable they are not.

🔎 Words, images and collaged materials reflect the street life in which he grew up and lived notably: racism, money (the art market took him up and his works sold for high prices), exploitation of people and resources, Third World cultures, comics, TV and films, rap music, break-dancing, junk food, black heroes, urban ghettos and sex.

🅐 (152) £1,690/$2,687 – £880,282/$1.3m

➹ £1,807,229/$3m in 1998, *Self-Portrait* (oil p., 1982)

BASSANO Jacopo OM
c.1517–92 Italian

Best-known member of the prominent Venetian da Ponte family, who lived at Bassano (where the liqueur grappa is made).

◗ Painter of standard religious subjects, chosen for their power and drama. Note how he interpreted them to make the best of his interest in stocky peasants, animals, stormy mountain landscapes and spectacular lighting.

🔎 Note how Bassano packs great drama into small spaces – which is why everyone seems to be in such a hurry, and either moving into the picture space or trying to get out of it. Beautifully painted muscular hands and arms; striking light effects; marvellous, urgent handling of paint, which reflects the drama of the scene as if Bassano were part of it.

🅐 (6) £3,823/$6,078 – £115,000/$186,300

➹ £1,294,964/$2,020,144 in 1994, *Deux chiens se reposant près d'un tronc d'arbre* (oil p.)

BATONI Pompeo Girolamo OM
1708–87 Italian

Highly successful portrait painter, especially of English visitors to Italy on the Grand Tour. Polished and finely painted work, careful attention to detail (lace, stitches in clothing), with beautiful results. Established a formula that favoured stock poses with smart clothes, ruins in the background and dogs at the feet – or both. Knew exactly what his snobby clientele wanted and provided it.

🅐 (12) £1,159/$1,900 – £128,378/$202,500

➹ £420,000/$625,800 in 1993, *Portrait of Sir Charles Watson* (oil p., 1775)

Painting is a very difficult thing. It absorbs the whole man, body and soul.
MAX BECKMANN

BAUMEISTER Willi MM
1889–1955 German

Good, early Modernist painter but, like many such, was always caught on the horns of unresolved dilemmas. To pursue abstraction or figuration? The scientific progress and its ideal new world, or the inner spirit, pre-history, primitive and unknown? Thus his art covers too many styles and lacks firm direction. Popular success in 1950s/1960s. Now neglected.

Ⓐ (53) £329/$526 –
£200,000/$330,000
↗ £440,000/$655,600 in 1993,
Monuti, Diskus III – mit Schwarzwald (oil p., 1954)

BAUMGARTEN Lothar CS
1943– German

From East Berlin. Uses photography and film to address concerns such as green and environmental issues and the instability of cultural values. Has lived with Amazon Rainforest Indians and uses his knowledge of their social behaviour to confront our own.

↗ £9,317/$15,000 in 1997,
Hyazinth ara (oil p., 1985)

BEARDEN Romare NH
1914–88 African/American

Born in Harlem. Intellectual parents. Along with Jacob Lawrence, one of the most important African-American artists of the 20th century. Lived in Pittsburgh as a young man. His primary subject is the black experience in the USA (as a social narrative, not as propaganda). Developed the range and scale of collage. Sophisticated synthesis of black culture and European Modernism.

Ⓓ Made figures or faces from small photographic elements, which he then enlarged and recut; then he combined

these with cut, coloured papers and paint. This creates a buzzing vitality through the oddity of the imagery, changes in scale, sudden breaks and repetitions – a kind of visual equivalent to jazz or blues. His artistic legacy comes from Grosz (with whom he studied); Matisse (*papier découpé*); Ernst and Heartfield (photomontage).

Ⓐ (20) £1,829/$3,000 –
£46,584/$75,000
↗ £48,193/$80,000 in 1998,
Jazz musicians (works on paper)

BEARDSLEY Aubrey NH
1872–98 British

Self-taught, tubercular, workaholic, master of the sinuous, sensual, erotic (sometimes pornographic) black-and-white drawing and print. Brilliant Art Nouveau illustrator. Highly original and gifted, capturing the essence of *fin de siècle* decadence. Had a boring private life – his eroticism was all in his mind.

↗ £38,000/$65,740 in 1990,
La femme incomprise (drawing)

BEAUX Cecilia NH
1855–1942 American

Daughter of French immigrants, raised in genteel poverty in Philadelphia. Beaux started by painting porcelain and later perfected the grand manner of oil-painting in Paris. Developed a successful version of Sargent's fluid, flattering portrait style and is rightly regarded as one of the best portrait painters of her day. Won many prizes and was much sought after by the rich and famous.

Ⓐ (1) £1,481/$2,400
↗ £208,861/$330,000 in 1992,
Portrait of Alice Davison (oil p.)

BECKMANN Max MM
1884–1950 German

One of the great painters of the 20th century. Generally overlooked because never one of the Modernist 'gang', and difficult even now for officialdom to pigeonhole. To sustain such Expressionist intensity and quality is a rare (unique?) achievement.

☻ Beautiful, expressive, sombre paintings with rich colours and strong drawing. Many portraits, self-portraits and allegories full of symbolism. Beckmann's works are very much of their time, but do not belong to any 'school' or 'ism'. Their underlying theme is the human condition and concern for the triumph of the human spirit.

🔎 Beckmann's use of black (one of the most difficult pigments) is stunning and worthy of Manet; his understanding of the human condition is worthy of Rembrandt. His work charts a central vein of the spiritual anguish of 20th-century Europe. Born into the gifted, optimistic generation of the 1880s, he experienced the horrors of World War 1 and the collapse of civilised values in Germany in the 1920s and 1930s. Chose voluntary self-exile from his homeland in 1937. Took refuge in the USA from 1947.

🏛 New York: MoMA
🅰 (166) £920/$1,500 – £1.2m/$1,728,000
🔨 £2,172,130/$3,757,787 in 1990, *Der Wels* (oil p., 1929)

BEECHEY Sir William NH
1753–1839 British

The bog-standard, competent, safe, rather boring, portrait painter of his generation. A low-key interlude between the excitements of Reynolds and Lawrence.

🅰 (12) £750/$1,223 – £200,000/$320,000
🔨 £200,000/$320,000 in 1999, *Portrait of Archdeacon Strachey and his family* (oil p.)

BEECROFT Vanessa CS
1969– Italian

Arranges performances and exhibitions of girls who are often wearing only shoes and underwear, and who, although lively and moving, look identical and characterless, like mannequins in a shop window. She photographs or videos these events as documentation. Said to be exploring the silent imagination of the models and viewers, as well as the insidious power of the media.

🅰 (31) £1,761/$2,500 – $54,054/$80,000
🔨 £54,054/$80,000 in 2000, *VB 34* (photographs, 1998)

BELL Vanessa NH
1879–1961 British

Sister of Virginia Woolf. To her credit, helped introduce Matisse and French modern art to England. To her discredit (like all her fellow Bloomsbury set), a howling social and intellectual snob with an impossibly high opinion of her own talents. Pre-1920, colourful abstract and semi-abstract work made her a local heroine. Internationally very minor.

1
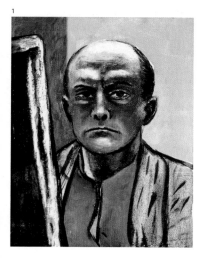

⏣ (14) £619/$898 – £62,000/$87,420
🔨 £85,000/$140,250 in 1997,
The Model (oil p., 1913)

BELLINI Gentile OM
c.1429–1507 Italian

Giovanni's brother. Much respected in his own lifetime. Noted especially for panoramic views of his native Venice, peopled with crowds and processions; thus established a subject and tradition that reached its apogee in Canaletto.

🔨 £25,000/$40,750 in 1991,
Virgin and Child with Saint Peter and female martyred saint (oil p., 1491)

BELLINI Giovanni AG
c.1430–1516 Italian

One of the supreme masters of the early Renaissance and the Father of Venetian painting. The best known of a distinguished family of painters. Among the first to exploit oil-painting technique in Venice.

◑ Known for his altarpieces, portraits and, above all, the depiction of light – beautifully and carefully observed, lovingly and accurately recorded, and always warm. His work sings of the harmonious relationship that should exist between man, nature and God. The profound mood and spirituality of his religious pictures result from his belief in God's presence in light and nature.

🔎 His figures respond to light and often turn their faces and bodies towards it, in order to enjoy its physical and spiritual benefits. Is he the first painter who really looked at clouds and studied their structure and formation? Notice his love of detail in rocks, leaves, architecture and rich materials such as silks. Note how his style becomes softer as he gets older (a natural trait in most humans?). No outlines, just gradations of tone.

🏛 Venice: Accademia and various churches
⏣ (2) £11,500/$18,630 – £380,000/$573,800
🔨 £750,000/$1,237,500 in 1996
Madonna and Child with male donor, landscape beyond (oil p.)

BELLINI Jacopo OM
c.1400–70 Italian

Giovanni's father. Not much is known about him. Very little of his work survives other than sketchbooks. Progressive – was interested in latest artistic developments such as perspective, landscape and architecture.

🏛 Paris: Musée du Louvre
London: British Museum
(sketchbooks)
🔨 £40,718/$67,185 in 1998,
Santa Lucia (oil p.)

BELLOTTO Bernardo AG
1720–80 Italian

Nephew of Canaletto, from whom he learned his trade. Left Italy in 1747 because of family problems and never returned.

◑ Painted views of northern European towns, which were commissioned by the old-fashioned aristocratic patrons who ruled them and who employed him on a salary as court painter (Dresden, Vienna, Warsaw).

🔎 His impressive, large-scale works are distinguishable from Canaletto's by their different subject matter and cooler, blue-green, silvery palette (he painted on darkly primed canvases). Less imaginative use of space (used only a standard single-viewpoint perspective), but better response to trees and vegetation. Good anecdotal detail, but figure painting cruder than Canaletto's.

⏣ (17) £2,291/$3,665 – £1,343,750/$2.15m

1. George Wesley Bellows, *Pennsylvania Station Excavation*, 1909
2. Giovanni Bellini, *Madonna and Child Enthroned between Saints* (San Giobbe Altarpiece, c.1487)
3. Bernardo Bellotto, *The Marketplace at Pirna*, c.1764
4. Gentile Bellini, *Procession in the St Mark's Square*, 1496

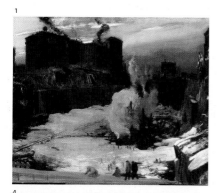

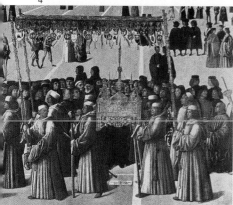

🔨 £3.1m/$5,642,000 in 1991,
Fortress of Königstein (oil p.)

🅐🅥 (49) £1,779/$2,900 –
£15,625,000/$25m
🔨 £15,625,000/$25m in 1999,
Polo crowd (oil p., 1910)

BELLOWS George Wesley NH
1882–1925 American

Leading member of the Ashcan School
whose best period was pre-1913, when
he tackled tough, gritty subjects, such
as construction sites (Penn Station),
New York slum dwellers, boxing matches
– full of depictions of raw energy. Later
became weaker – too self-conscious and
affected by theories about symmetry
and the Golden Section.

BENTON Thomas Hart NH
1889–1975 American

The High Priest of American Regionalism.
Came from a national, political family
and was a cantankerous, homophobic,
anti-Modern and energetic self-publicist.
Determined producer of subjects that
proclaim the authentic virtues of the
Midwest, non-urban American life –

bulging, restless figures in heaving swirling spaces. Used vulgar colours. Very popular. Influenced Jackson Pollock.

🏛 Jefferson City (Missouri, USA), for murals in Capitol Building
Ⓐ (43) £1,840/$3,000 – £506,520/$810,000
🔨 £506,520/$810,000 in 1999, *Roasting Ears* (oil p., 1938)

BERNARD Émile MM
1868–1941 French

Close friend of Gauguin, Van Gogh and Cézanne. Painted his own competent versions of Gauguin's style (clear outline; solid, flat colour). Good, but not as good as he thought (although he did influence the Nabis). Most important now for his writings – especially his interviews with Cézanne – and as the editor of Van Gogh's letters. In the 1920s he gave up painting and retired to Venice to write.

Ⓐ (68) £276/$395 – £142,857/$230,000
🔨 £272,727/$450,000 in 1998, *Madeleine au bois d'amour* (oil p.,1892)

BEUYS Joseph MM
1921–86 German

One of the stars of the 1980s, highly regarded by intellectuals and lionised by ambitious curators and dealers. A serious, gentle, mystic and charismatic figure who sought to comment on his own times, and was also (paradoxically) a victim of them.

🌑 To establish a connection with these so-called works of art you have to establish a rapport with the whole Beuys phenomenon – the man, his appearance, his lifestyle, his biography, his beliefs. Thus the lumps of fat, fur or felt that you find in the museum showcases are like fragments of a total work; or, put another way, they are like the traces that a wild animal makes to establish its presence or the extent of its territory.

🔎 Only by accepting the Beuys phenomenon can you begin to 'see' the claims made for references to the energy of the world, harmony with nature, the dilemmas of modern Germany, Beuys' early childhood experiences and so on. If you don't want to or can't cross this threshold, don't worry – it may all be self-deception anyway. The phenomenon is an unexpected alliance of the artist's ego with museum or commercial interests, looking for instant history, and a public that thrives on the unhappiness of others.

🏛 Darmstadt (Germany)
Ⓐ (107) £248/$404 – £100,334/$160,535
🔨 £270,000/$413,100 in 1994, *Stapelkopf Siegel* (1952)

BEVAN Robert Polhill NH
1865–1925 British

Interesting and underrated painter who studied in Paris in the 1890s and met Gauguin at Pont-Aven, in Brittany. Painted traditional subjects, with successful, if limited, individual

2

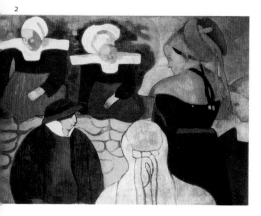

Modernist style – stiff, angular, simplified, with luminous colours. Rather better than the contemporaneous Bloomsbury set (Bell, Fry and Grant).

🅰 (9) £480/$773 – £20,000/$30,000
🔨 £95,000/$173,850 in 1992, *Horse Dealers at the Barbican* (oil p.)

BEVAN Tony CS
1951– British

Creates intense works, sometimes portraits, that are intended to reveal or explore extreme psychological tensions, desolation and alienation. Note heavily-worked techniques in acrylic or charcoal, intense colours, and obsession with open mouths. Maybe too insistent and shrill to be truly communicative and effective.

🅰 (6) £267/$385 – £48,000/$76,320
🔨 £48,000/$76,320 in 2000, *Horizon* (oil p. 1997)

BICKERTON Ashley CS
1959– Jamaican/Indonesian

Wide variety of works, many with a common visual denominator of the products, images and brand labels of today's urban society. The underlying

message seems to be that our technological world is doomed to self-destruction and that nature, perverted by man's ingenuity and irresponsibility, will take revenge and condemn mankind to extinction.

🅰 (1) £8,075/$13,000
🔨 £44,379/$75,000 in 1991, *Abstract painting for people 4 – bad* (sculpture)

BIERSTADT Albert NH
1830–1902 German/American

German born, Massachusetts raised. Painted large-scale landscapes of American West during era of early railroads, with low viewpoints, convincing but fanciful compositions, good anecdotal detail, and crisp use of light and shade. Did for the American West what Canaletto did for Venice. Also worked in Switzerland and Bermuda. Brilliant oil sketches.

🏛 New York: Metropolitan Museum of Art
🅰 (50) £318/$500 – £609,375/$975,000
🔨 £1,518,987/$2.4m in 1989, *Platte River, Nebraska* (oil p. 1863)

BINGHAM George Caleb NH
1811–79 American

Born in Virginia, brought up in Missouri, the first significant painter from the Midwest. Had decade of brilliant talent, 1845–55, painting scenes of the American frontier and 'jolly flatboatmen'. Contrived simple compositions bathed in golden light. As formal as Poussin and as proudly documentary of his new Republic as any 17th-century Dutch master.

🔨 £109,380/$175,000 in 1982, *Generals on horseback to capture Camp Jackson* (oil p.)

BLAKE Peter CS
1932– British

One of the founders of British Pop art
in the 1960s. Finely crafted work that
is rather fey and increasingly has more
to do with a nostalgic and often witty
longing for a world that was the stuff of
schoolboy dreams – comics, badges, pop
and film stars, girls and wrestlers, corner
shops – rather than anything modern.
A Peter Pan figure.

⊛ (14) £400/$564 – £77,000/$115,500
⚒ £77,000/$115,500 in 2000, *Little
 Lady Luck* (oil p./collage, 1965)

BLAKE William AG
1757–1827 British

Genuine visionary Romantic – truly
inspired and driven by inner voices and
sights, many of which are difficult to
understand. Unruly son of non-conformist
Christian parents. Impoverished.
Neglected in his lifetime.

☽ Had an extraordinary originality

in imagery, technique and symbolism.
Created mostly small(ish) works on
paper, watercolours and drawings,
and a combination of these with print
techniques (engraving). Blake's imagery
and symbolism are highly personal but
at heart is the wish to express his dislike
of all forms of oppression. Championed
creativity over reason; love over repression;
individuality over state conformity.
Believed in the liberating power of the
human spirit.

🔎 One of the few truly gifted in
both poetry (he wrote 'Jerusalem') and
visual creativity. Look for idealised human
figures with spiritual expressions and a
fascination with fire and hair, which are
similarly stylised. He loved Gothic art,
especially illuminated manuscripts –
note how he borrows freely from their
inspiration when combining words and
imagery together. Uses biblical sources,
especially from the Old Testament. Also
inspired by Dante.

🏛 London: Tate Britain; British Museum
 Boston (USA): Museum of Fine Arts
⊛ (4) £2,532/$4,000 –
 £23,000/$36,800
⚒ £195,000/$327,600 in 1998,
 The Larger Blake-Varley Sketchbook
 (drawing)

1

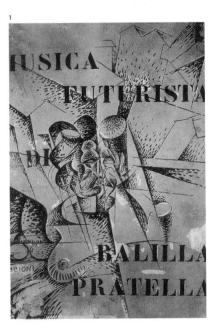

2

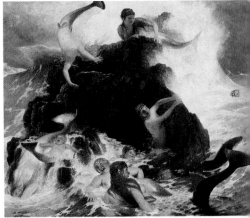

BOCCIONI Umberto MM
1882–1916 Italian

Leading Futurist painter and sculptor who embraced the verve of modern life and enjoyed conflict. Joined a World War 1 bicycle brigade, but died falling from a horse, at the age of 34.

◑ Pioneering work in subject and style. Interested in highly charged modern subjects, such as dynamic collective experience (crowds and riots); movement and speed; memories and states of mind shown as continuous time; emotions and experiences beyond the incidental trivia of time and place. Innovate in adopting French Cubist interlocking planes and fragmentation, then adding colour as a means of representing his ambitious subjects.

◉ His work is always on a small scale and not always successful – his ambitions (especially in terms of subject) often outran his technical abilities and the means at his disposal. (Such is often the fate of the true visionary.) Ditto for his sculptures, of which only four remain. He is to later artists what Bleriot's flying machine is to jet aircraft.

◍ (2) £2,833/$4,051 – £68,504/$110,291
➶ £766,284/$1.38m in 1988, *Romanza di una cucitrice* (oil p., 1908)

BÖCKLIN Arnold OM
1827–1901 German

Leading German Symbolist painter. Swiss born, Düsseldorf trained, but most influenced by Italian art (especially Raphael). Meticulous craftsman of classical, mythological figures in intense moody landscapes, that are intended to trigger dream-like reveries. Very much the languid *fin de siècle* fashion, but now seems cloying and artificial.

🏛 Basel (Switzerland): Kunstmuseum
◍ (2) £16,871/$23,788 – £91,633/$137,450

➶ £110,000/$168,300 in 1993, *Kentaurenkampf* (oil p.)

BOETTI Alighiero MM
1940–94 Italian

Leading member of Arte Povera. Created bits and pieces (such as assemblages, embroideries, drawings) that scratch away at attempting to make sense of a 'fragmented but all embracing world' (so what's new?). Naïve systems, which the viewer is supposed to decode. Fashionable, not trivial, but ultimately insignificant. Untrained (it shows).

◑ He is a useful reminder that the ideas, appearance and agenda of the young, 'cutting-edge' art of the 1990s have been in play for a good 30 years.

◍ (50) £577/$929 – £130,000/$215,800
➶ £130,000/$215,800 in 1999, *La mapa del mondo* (1972)

BOL Ferdinand OM
1616–80 Dutch

Pupil of Rembrandt. Worked very much in the master's style, to whom his works have often been attributed (Rembrandt being more prestigious and much more valuable). Liked the formula of sitters posing by an open window. Did allegories and history paintings for public buildings. Dark early style that becomes lighter after c.1640.

◍ (5) £7,692/$11,385 – £26,163/$39,487
➶ £122,699/$200,000 in 1998, *Portrait of young woman holding leather fan* (oil p., 1641)

BOLDINI Giovanni OM
1842–1931 Italian

Prolific, long-lived, hugely successful and talented friend of the rich and the

famous (as well as Sargent and Degas). Settled in Paris in 1871. Best known for flashy *fin de siècle* portraits with finely painted, mask-like faces, contrasting with dynamic, elongated poses and loosely painted surroundings. Also noted for landscapes, small, frothy 18th-century costume pieces, and etchings.

🅐🅥 (50) £300/$1477 – £210,124/$340,401

🏹 £891,720/$1.4m in 1995, *Portrait of Marchesa Luisa Casati* (oil p., 1908)

BOLTANSKI Christian CS
1944– French

Produces disturbing installations that are gloomy, dimly lit, labyrinthine and claustrophobic. Collects items such as photographs, old clothes and personal relics to address his central thesis of lost childhood, death, anonymity, the Holocaust. Attempts to create a visual requiem for all innocent victims. Familiar war subject matter, to which he brings a new twist.

🅐🅥 (8) £6,647/$10,768 – £84,507/$120,000

🏹 £103,093/$175,258 in 1990, *Les Saynètes comiques: le baiser caché* (works on paper)

BOMBERG David NH
1890–1957 British

Son of Polish Jewish immigrants. Briefly on the cutting edge of the avant-garde (c.1914) when he pioneered Cubism and Vorticism in Britain. Then changed style and churned out rather gloomy, thickly painted, minor Expressionist subjects.

🅐🅥 (39) £900/$1,485 – £85,000/$136,000

🏹 £145,000/$240,700 in 1998, *San Miguel, Toledo, Afternoon* (oil p., 1929)

BONINGTON Richard Parkes NH
1802–28 British

The English Delacroix, with whom he worked closely. Died (suitably for a Romantic) of consumption, aged 26. Lovely, small-scale, fresh, open, luminous oils and watercolours of picturesque places (Normandy, Venice, Paris), and costume history pieces, all done with consummate skill and ease. Works to savour and enjoy. A genius and a sad, early loss.

🅐🅥 (12) £800/$1,280 – £13,000/$18,590

🏹 £88,000/$148,720 in 1997, *Shipping off Genoa* (w/c)

BONNARD Pierre AG
1867–1947 French

One of the great masters of colour. If Matisse is the king of colour, Bonnard is the queen. Though less intellectual than Matisse, he shared his view that art should be a celebration of life and a source of visual joy.

☀ Painted the places, rooms and people that he knew most intimately, notably his neurotic, bath-obsessed wife, Marthe. Most of their life was spent living simply in the South of France. Early work is progressive, later work is deeply personal and stands outside the mainstream. Lovely, free drawings that are masterpieces of observation. The paintings were done in his studio from memory and from black-and-white notes and sketches – all that glowing colour came out of his head.

🔎 Stand well back and see how he creates thrilling spaces (rich, textured foregrounds and hazy distances). Walk forward and see how glorious colour harmonies take over (blues, violets, greens, with glowing pinks and oranges). When really close, let the detail of flickering brushwork and subtle colour weavings fill your eye. Immerse yourself

1. **David Bomberg**, *Study for The Mud Bath*
2. **Pierre Bonnard**, *Nude by the Bath Tub*, 1931
3. **Hieronymus Bosch**, *The Last Judgement* (altarpiece), detail of the dagger

1

2
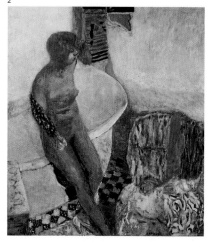

3
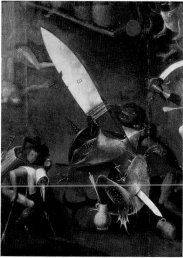

❧ Best known for his complex, moralising works, of which the central theme is the sinful depravity of man, human folly, deadly sin (notably lust), the seductive temptations of the flesh and the almost inevitable fate of eternal damnation (salvation is possible but only with the greatest difficulty). Like hellfire sermons, they are a complete contrast to the Renaissance view of man controlling a rational world. Also produced more conventional religious works.

🔎 His works show bewildering detail and unique imagery of part-animal, part-human, part-fantasy creatures; visions of depraved activity and torture. Not drug induced but illustrations of ideas and images in wide circulation at the time. Brilliant rapid technique and luminous colour: flecked highlights and chalk underdrawing. Was influenced by ornate manuscript illumination. Acute, intricate intensity reflects his belief that he was depicting certainty and reality, not fantasy.

🏛 Madrid: Museo del Prado
Ⓐⓥ (1) £4,934/$7,895
🔨 £4,934/$7,895 in 1999, *The bellows-maker* (drawing)

and let go of strict reality, as with music or poetry. His work becomes brighter with increasing age (unusual).

Ⓐⓥ (152) £366/$519 – £2,582,781/$3.9m
🔨 £3,736,264/$6.8m in 1988, *Après le repas* (oil p.)

BOSCH Hieronymus AG
c.1450–1516 Netherlandish

Last and perhaps greatest of the mediaeval painters. Much admired in his lifetime, especially by ardent Catholics such as Philip II of Spain, who initiated the Inquisition.

If Botticelli were alive today he'd be working for Vogue.
PETER USTINOV

BOTERO Fernando CS
1932– Colombian

Creator of immediately recognisable paintings and sculptures, which are wholly out of the mainstream of 'serious' contemporary art. Tubby, cheerful, overinflated (literally and metaphorically) figures, meticulously painted in bright colours, through which he ridicules the pomposities of life, art and officialdom. A real breath of fresh air.

- ⓐ (47) £2,160/$3,500 – £280,000/$420,000
- ⚡ £927,152/$1.4m in 1992, *La Casa de las Gemelas Arias* (oil p.)

BOTH Jan OM
c.1618–52 Dutch

Dutch landscape painter who studied in Rome and introduced the Italianate Arcadian landscape, à la Claude, to Holland. More detailed and literal than Claude, and usually without the references to classical mythology.

- ⓐ (3) £31,034/$45,000 – £1.3m/$1.96m
- ⚡ £1.3m/$1.96m in 2000, *Italianate evening with a muleteer and goatherds on a wooded path* (oil p.)

BOTTICELLI Alessandro di Mariano Filipepi (Sandro) AG
1445–1510 Italian

Major Florentine Renaissance artist, at a key moment, who emphasised ornament and sentiment rather than scientific observation and realism.

- ◕ Painter of deeply felt religious pictures and pioneering large-scale mythologies. Note the way he portrays the human figure (on its own, in relationship to others, or in crowd scenes) – always with great dignity, strange and distant, with dream-like unreality and distortions. One of the great draughtsmen of all time.

His later work is odd and retrogressive because he retreated into the past, unable to cope with Florence's turbulent descent into social and political turmoil.

- ρ His subjects have wonderful bone structure – especially in their cheeks and noses, long and refined hands, wrists, feet and ankles – and beautifully manicured nails; they have fine and crisply drawn outlines like tense wires. Notice his fascination with pattern – in elaborate materials, hair and crowds, which he turns into designs of shape or colour, or both. He found ideas like scientific perspective of no interest; instead, he cleverly combined old Gothic decorative styles with new, classical and humanist ideals.

- 🏛 Florence: the Uffizi
- ⓐ (1) £586,207/$850,000
- ⚡ £750,000/$1.2m in 1982, *Portrait of Giovanni de Pierfrancesco de' Medici* (oil p.)

BOUCHER François AG
1703–70 French

One of the key artists of the sumptuous, profligate, overindulgent *ancien régime* of Louis XV, and a favourite of Madame de Pompadour. Epitomises the full-blown Rococo style.

- ◕ Creator of lavish images of and for a world of narcissistic, self-indulgent, material luxury, namely the French royal court of the mid-18th century (that does not stop them being wonderful paintings). At his most magnificent with his depictions of the classical gods, who (according to Boucher) enjoyed a similar lifestyle; also heavily sentimental pastoral and genre scenes. In addition, Boucher designed for the royal tapestry works and porcelain factories.

- ρ Notice the acres of soft, pink flesh set among frothy and false vegetation; lavish silks, satins and lace in the portraits – all

1

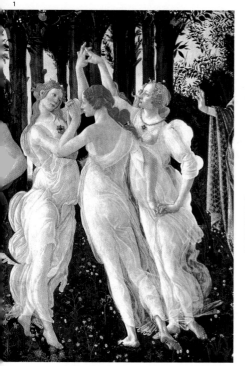

2

painted with great technical skill and caressing sensuality; a brilliant marriage between what his patrons wanted (the subject matter) and style and technique – one of the hallmarks of great painting.

🏛 Paris: Musée du Louvre
London: Wallace Collection
Stockholm: National Museum
Ⓐ (44) £604/$887 – £600,000/$906,000
🔨 £1.24m/$2,237,094 in 1988, *Les amusements de la campagne. La musique pastorale* (oil p., 1743)

BOUDIN Eugène OM
1824–98 French

Best known for charming small-scale beach scenes of holiday-makers on the Normandy coast (Trouville), dressed up in their crinolines and bonnets on cloudy, breezy days. Had a sketchy style and was an exponent of plein-air spontaneity, a forerunner of the Impressionists (very influential on young Monet). Also painted scenes of Venice, Holland and France. If you can't sense the breeze, it's probably not a Boudin.

Ⓐ (146) £331/$532 – £416,667/$675,000
🔨 £891,720/$1.4m in 1989, *Venise, vue prise de San Giorgio* (oil p.1895)

BOUGUEREAU William-Adolphe OM
1825–1905 French

The archetypal conservative pillar of the French academic system in its final years, refusing to abandon the language and manners of a by-now debased classical tradition.

◑ Delighted his public with big-scale theme paintings and a dazzlingly accomplished technique. However, his work now looks curiously stilted and unconvincing – a dinosaur of art history. His lofty rhetorical subject matter (for example, nude Venuses) invites us to suspend disbelief in reality, but his style, which apes the reality of photography, contradicts or denies the invitation. Art that inspires to be this great requires

a convincing unity between subject and style.

🔎 Smooth, hairless, firm flesh and rosy nipples, which anticipate (inspire?) the air-brushed girlie pin-ups of World War 2 or *Playboy* magazine. His paintings of everyday peasant life are more convincing than his grander works, because they do not aim so high (so cannot fall so low) and do not demand suspension of disbelief to the same degree.

🔵 (22) £1,194/$1,934 –£2,105,263/$3.2m
↗ £2,105,263/$3.2m in 2000, *La charité* (oil p., 1878)

BOURGEOIS Louise CS
1911– French/American

Current heroine of feminism, but unknown until she was in her 60s. Daughter of an emotionally dysfunctional family, she works out the consequent trauma through her art.

🌑 Wide variety of work and materials – sculpture, constructions, installations; images of bodily experiences such as pregnancy, birth, breast feeding; images of the house. She plays on notions of desire, attraction, repulsion and male–female relationships. References to her mother's activities of sewing and tapestry. She's not trying to illustrate anything but to recreate the way she feels: anxiety, loneliness, defencelessness, vulnerability, aggression, sex and death.

🔎 Her womanising father installed a young mistress in the family home who was hated by her mother; Louise was caught in the middle. Like many from Van Gogh onwards she has turned to artistic activity to relieve her pain and find a role. Is she among those who have the ability to communicate to someone with completely different experiences? Or is she among those whose very insistence and (neurotic) predictability eventually kills the emotion or message?

🔵 (18) £1,975/$3,200 – £58,642/$95,000
↗ £178,571/$300,000 in 1997, *Untitled* (sculpture, 1953)

BOUTS Dieric (or Dirk) OM
c.1415–78 Netherlandish

Possibly a pupil of Rogier van der Weyden. Very little known about him and few attributable works. Altarpieces, narrative scenes and portraits. Solemn, restrained paintings with beautifully observed detail and painstaking craftsmanship. Note the lovely landscape details of rocky backgrounds and shimmering light.

↗ £64,220/$107,890 in 1996, *Madonna and Child* (panel)

BOYLE Mark (and family) CS
1934– British

Scottish-born highly original creators of large-scale 3-D slices of apparent

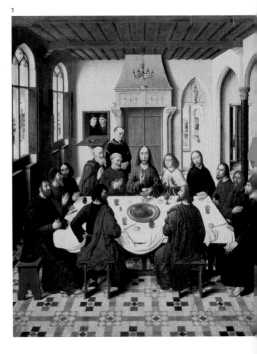

reality, such as a road surface 2 metres (6 feet) square that looks like the actual thing, complete with yellow lines, but is not. Technique a closely guarded secret. Quirky, tough work that is strangely compelling and moving.

➤ £15,000/$24,450 in 1997, *Broken path study with smashed concrete and gas plate* (sculpture)

BRAMLEY Frank NH
1857–1915 British

Competent painter of well-executed scenes of English West Country life in which some local drama (news of death at sea for instance) occurs. Especially good observer and recorder of light from several sources simultaneously. Member of the Newlyn School.

🅐🅥 (9) £491/$800 – £8,500/$13,770
➤ £367,550/$555,000 in 1996, *Delicious Solitude* (oil p., 1909)

BRANCUSI Constantin MM
1876–1957 Romanian/French

Seminal figure in 20th-century art, with a profound influence on sculpture and design. Born into a Romanian peasant family. Settled in Paris in 1904. Student of Rodin. Remained indifferent to honour and fame.

🌙 His work shows tireless refinement and a search for purity. Constant re-working of selected themes – children, Danaïdes, human heads, birds, modular columns. Interested in abstract ideals such as the purity of primordial (simple) forms, but never an abstract artist – a reference to a recognisable nature is always present. Emphasis on the inherent qualities of materials ('truth to materials'). Touches something very basic in the human psyche. As soothing as the sound of the waves of the sea.

🔍 Endless pleasure can be derived from the contemplation of pure line, simplicity of form (such as an egg shape), light reflecting off surfaces, materials unadorned and unadulterated – take your time with Brancusi. Notice the bases that are an integral part of the whole work. His studio became a work of art in its own right because of the way he grouped his work in it to bring out comparisons and reflections of light.

🏛 Paris: Centre Pompidou (with a recreation of his studio)
🅐🅥 (7) £4,088/$6,500 – £679,012/$1.1m
➤ £4,733,728/$8m in 1990, *La négresse blonde* (sculpture)

BRANGWYN Sir Frank William NH
1867–1956 British

An odd mix: born in Bruges of Welsh parents, later apprentice of William Morris. The result is a rather un-English style of painting, full of bravado; rich colours and thick, swirling paint; grandiose subjects; overstatement and easy, seductive skills. Mostly self-taught. Completely out of fashion. Underrated.

🅐🅥 (49) £320/$451 – £30,000/$42,300
➤ £30,000/$42,300 in 2000, *St Ives* (oil p., 1889)

BRAQUE Georges AG
1882–1963 French

One of the most innovative and majestic painters of the 20th century. Built on the example of Cézanne and the 18th century to lift decorative painting (especially still life) to new heights.

🌙 One of the key early leaders of the avant-garde. Produced important Fauve paintings in 1905–14, then invented Cubism with Picasso. Later work concentrates on still life, the human figure and studio interiors. Be totally at ease to enjoy the way he freely develops

the language of Cubism, and his instinct for colour, texture and paint. This is work that delights the eye, in the way romantic music delights the ear, and touches the heart rather than the intellect.

🔍 Cubist innovations included the use of letters, *papier collés*, sand mixed with paint and trompe-l'oeil wood graining. Braque used rich, earthy colours and images built up layer by layer. His works show a wonderful sense of controlled freedom as he moves images and details around to create lyrical harmonies of colour, line and shape (he loved music and you can sense it going through his head as he paints). Late work famous for the bird image as a simple symbol of human spiritual aspiration.

Ⓐ (164) £1,382/$2,212 – £1,958,042/$2.8m
🔨 £6m/$8.84m in 1986,
Femme lisant (oil p.)

BRATBY John NH
1928–92 British

Painter and novelist who in the 1950s briefly and successfully epitomised acceptable 'modern art' for the conservative middle classes. Created brightly coloured, thickly painted, bold images and portraits with a frisson of daring and ugliness, but their underlying context is more suburban respectability than kitchen-sink squalor. Once a celebrity, he is now almost forgotten.

Ⓐ (53) £300/$426 – £6,000/$9,480
🔨 £7,000/$10,920 in 1994,
Window with cornflakes and view of church (oil p.)

BRETT John NH
1830–1902 British

Devotee of Ruskin, emulator of Holman Hunt, resulting in early intensely detailed, high-coloured landscapes that are a *tour de force* of precise observation

and technique. Painting trips to Italy and the Alps (as approved by Ruskin). Commercially more successful with later works (especially panoramic views of the ocean), but they are flabby by comparison with his earlier work.

Ⓐ (15) £520/$770 – £15,000/$24,000
🔨 £1.2m/$1,848,000 in 1989,
Val d'Aosta (oil p., 1858)

BRIL Paul OM
1554–1626 Flemish

Landscape painter who lived in Rome, and was much influenced by Elsheimer. Small landscapes observed from nature, sometimes done on copper. Characteristically uses prominent diagonals, and recession, created through planes of light and dark.

Ⓐ (7) £692/$1,094 – £196,319/$320,000
🔨 £54,878/$90,000 in 1999,
Extensive landscape with stag hunt (oil on copper)

BRONZINO Agnolo AG
1503–72 Italian

Best known for his aloof and icy portraits. Court painter to the Grand Duke of Tuscany. Humble background.

🌙 Painted portraits of brittle artificiality – he lived in an age when artifice and striking poses reigned supreme. He sums it up with rare beauty: note the body language of the poses and faces which communicate such arrogance, contempt or insolence; and the equally arrogant ease of his technique, with its superb facility, deliberately complex and artificial compositions and intense, insolent colours.

🔍 Look for flesh that seems to be made of porcelain (as smooth as the people he portrays). Notice the elongated faces and bodies and eyes that can often seem

1. Paul Bril, *Christ Healing the Possessed of Gerasa*, 1608
2. Agnolo Bronzino, *Portrait of Eleanor of Toledo and her Son, Giovanni de Medici*, c.1544–5
3. Pieter Bruegel (the Elder), *Hunters in the Snow – February*, 1565

vacant, like those of a child's doll. Look also for more rarely seen allegories and religious works with intricate designs, involving many figures whose poses are deliberately stolen from Michelangelo.

🏛 Florence: the Uffizi; Palazzo Vecchio
🔨 £265,000/$410,750 in 1996, *The Meeting of Joseph and Jacob in Egypt* (drawing)

BROODTHAERS Marcel MM
1924–76 Belgian

Unsuccessful poet turned untrained artist (in 1964) who created bizarre objects and installations or exhibitions of objects and real works of art. His aim? To investigate issues such as: the meaning of art; the definition of art; art institutions and power structures; the art market and aesthetics – and in doing so to challenge received opinion.

Subtle, humorous, influential, successful.

🅰 (9) £358/$577 – £225,352/$320,000
🔨 £360,000/$687,600 in 1992, *Armoire blanche et table blanche* (sculpture)

BROWN Cecily CS
1969– British

Currently 'hot' in New York. Produces large-scale canvases of heavily worked thick paint. Their intensity, energy, bridging of abstraction and figuration, parallels with de Kooning and Bacon, and writhing genitalia that might just be porn rather than art, make for plenty of easy conversation on the art critics' and cocktail-party circuits.

🅰 (4) £1,613/$2,420 – £52,817/$75,000
🔨 £52,817/$75,000 in 2000, *Kiss me Cupid* (oil p. 1999)

BROWN Ford Madox NH
1821–93 British

Trained in France and close follower of the Pre-Raphaelites. Highly detailed work – landscapes painted in the open air and figurative works containing social commentaries on contemporary life, which reached out to intellectual political activists. Too idiosyncratic to be successful in his own day.

- (3) £450/$720 – £42,000/$63,420
- £140,000/$219,800 in 1995, *The Last of England* (oil p., 1852)

BRUCE Patrick Henry NH
1881–1937 American

Member of an old Virginia family, and an early American Modernist who visited Paris in 1904 and was influenced by Matisse, Steins and Delaunay. Good semi-abstract still lifes with spare, geometric shapes, primary colours, hot pinks and thick paint like icing on a cake. Unrecognised. Could not sell his work, gave up painting, destroyed his works and sold antiques; later committed suicide.

- (1) £769,231/$1.1m
- £769,231/$1.1m in 2000, *Still Life* (oil p., c.1919)

BRUEGEL Pieter (the elder) AG
c.1525–69 Flemish

Nicknamed 'Peasant' Bruegel – because of the subject matter of his paintings, not his character. Leading Flemish artist of his day whose subjects reflected contemporary religious and social issues. Paved the way for Dutch masters of the 17th century. Spelled his name 'Brueghel' until 1559, then dropped the 'h'.

- Brilliant works and accurately observed commentaries on the appearance and behaviour of the ordinary people of his day – like a first-rate stage play or TV soap opera. They are powerful because, as well as enjoying the existence and minutiae of his day and age, we can recognise ourselves – especially when he illustrates human follies, greed and misdemeanours. Like all great artists, he speaks simultaneously about the personal and the universal.

- Bruegel's bird's-eye views place us outside his world (we look down god-like, distanced and superior); then, by the fineness and charm of detail, he draws us into it – we are simultaneously in his world and apart from it. Clear outlines and detail lead the eye through each picture. Early work (from Antwerp) is busy and anecdotal; later work (from Brussels) is simpler and more consciously and artistically composed and organised. Saw the Alps in 1552–3 on his way to Italy.

- Vienna: Kunsthistorisches Museum
- £780,000/1,282,400 in 1989, *Landscape with Christ appearing to his disciples at the Sea of Galilee* (oil p., 1553)

BRUEGHEL Jan OM
1568–1625 Flemish

Second son of 'Peasant' Breugel, nicknamed 'Velvet' Breughel (retaining the 'h' in his name). Flower paintings, landscapes and allegories with rich, velvety textures, very finely painted. He sometimes worked with Rubens.

- Munich: Alte Pinakothek
- (13) £932/$1,500 – £1.04m/$1.7m
- £1,107,785/$1.85m in 1990, *Wooded landscape with covered wagons and cattle on road* (oil p., 1610)

BRUEGHEL Pieter (the younger) OM
1564–1638 Flemish

Elder son of 'Peasant' Bruegel. Made copies and imitations of his father's work. Later did fashionable hellfire

1. Alberto Burri, *Hunchback*
2. Pieter Brueghel (the Younger), *The Egg Dance*
3. Jan Brueghel (the Elder), *Vase of Flowers*, c.1607–8
4. Sir Edward Coley Burne-Jones, *The Godhead Fires*, 1868–70

1

2

4 3

scenes, which gave him the nickname
'Hell' Brueghel (he also retained the 'h' in
his name).

🄰 (24) £43,592/$69,311 –
£1,955,714/$3,129,142
🔨 £1,955,714/$3,129,142 in 1999,
Feast with theatre and procession
(oil p., 1604)

BURDEN Chris CS
1946– American

Extreme exponent of physically
provocative body art – for example, he
shut himself in a left-luggage locker for
five days; had himself shot in the arm by a
friend. Also creator of installations which
are intellectually provocative. Only
photographic records survive. Naked

exhibitionism, or a serious questioning
of society's moral and political values
(such as all those shootings on TV)?

🄰 (3) £7,042/$10,000 –
£20,270/$30,000
🔨 £20,270/$30,000 in 2000,
747 bed piece (sculpture, 1974)

BURNE-JONES Sir Edward Coley NH
1833–98 British

Quiet, retiring, otherworldly painter,
with a streak of calculating shrewdness.
Famous and successful after 1877.

🌑 His paintings reflect his character
and one aspect of the age he lived in.
His early mediaeval and mythological
subjects are heavily laden with mysticism
and symbolism that look back to a
'golden' age, chosen to fulfil a wish to
escape from modern urban and industrial
reality; yet the large-scale, precise style,
fascination with materials and realistic
details are very worldly, showing a
personal (and typically Victorian) duality.

🔍 Highly developed sense of 2-D
design (due to his closeness to William
Morris, who encouraged him to become
an artist instead of following a career in
the Church) and a technique that shows
a love of meticulous craftsmanship

1

(due to his closeness to Ruskin). Was also influenced by early Renaissance art (such as Botticelli). Produced very successful designs for tapestry and stained glass; and illustrations for texts of mediaeval and classical legends.

Ⓐ (32) £400/$600 – £240,000/$362,400
✗ £700,000/$1,092,000 in 1989, *Nativity* (oil p.)

BURRA Edward NH
1905–76 British

Eccentric, slightly dotty painter who found a Modernist and Surrealist niche. Best known for large watercolours of vaguely threatening scenes of urban activity. Had a liking for sailors in tight-fitting uniforms in bars. Well travelled (France, Mexico, Harlem).

Ⓐ (11) £4,000/$5,760 – £55,000/$82,500
✗ £180,000/$329,400 in 1992, *War in the Sun* (w/c)

BURRI Alberto MM
1915–95 Italian

Doctor-turned-artist who had some success in the 1950s with original work (for the time), using sacking and other non-arty materials, to produce serious looking collages. (Some connection with doctors bandaging patients and using splints? Commentary on the state of postwar Europe?)

Ⓐ (17) £1,972/$2,836 – £230,000/$381,800
✗ £1.68m/$2.62m in 1989, *Umbria Vera* (1952)

CABANEL Alexander OM
1823–89 French

One of the pillars of the establishment of late 19th-century Paris. Conventional, fashionable, much sought after. Painted nudes, allegories, portraits. Now seen in true light – academic painting at its worst and most flatulent. Weak technique; sickly, garish colours; banal subjects. A warning that much-praised contemporary art can be dire (then and now).

Ⓐ (7) £750/$1,103 – £220,000/$347,600
✗ £275,862/$400,000 in 1993, *Cléopâtre essayant des poisons sur des condamnés à mort* (oil p.)

CADELL Francis Campbell Boileau NH
1883–1937 British

One of the four Scottish Colourists (with Fergusson, Hunter and Peploe), trained in Paris and Munich. Chose Impressionist-type subjects – landscapes, interiors and portraits. Loose structures; vibrant, bright colours; easy, relaxed brushwork. Particularly successful with views of the Scottish island of Iona. Brought Mediterranean light to Scotland (in the same way that Cuyp brought Italian light to 17th-century Holland).

Ⓐ (19) £1,700/$2,785 – £56,000/$81,760

⚒ £160,000/$270,400 in 1990,
Interior – Eagle Mirror (oil p.)

CAILLEBOTTE Gustave MM
1848–94 French

Second-rank painter who knew what
talent was (he was one of the first
collectors of great Impressionist
paintings), and who occasionally showed
some in his own work.

❥ Typical Impressionist subject matter
and technique (very similar to Monet and
Manet). Scenes of everyday contemporary
Paris, especially street scenes with
exaggerated, plunging perspectives.
Always interesting work but essentially
derivative, and hampered by being too
anecdotal – it could often be one of those
illustrations for a 19th-century novel that
visualise a specific phrase or sentence
in the text.

🔎 Recognisable pink-green-blue-
purple palette, which is often too strident
and overdoes the purple. Cropped
compositions influenced by photography.

⊕ (9) £41,926/$60,704 –
£8,609,273/$13m
⚒ £8,609,273/$13m in 2000,
*L'homme au balcon, boulevard
Haussmann* (oil p., 1880)

CALDER Alexander MM
1898–1976 American

The man who gave the world the mobile,
thus making it a better and happier place.
Child of a sculptor father and painter
mother. Trained as an engineer and
industrial draughtsman, and cartoonist.

❥ Enjoy the movement and *joie de vivre*
in his mobiles (from mid-1930s) – those
famous, delicately balanced constructions
of wire and discs painted in primary
colours or black. Tiny or large scale, they
are marvels of endless variety. Stabiles are

steel constructions firmly planted on the
ground and immobile but their swooping
shapes suggest movement. Early work
includes wire figures and a circus of tiny
figures, which he could animate, like a
child playing with a toy.

🔎 Let the child in you come alive and
forget worldly cares. Animate the mobiles
into life (a breath of wind is usually
enough); walk around and through the
large stabiles to explore their life.
Deceptive simplicity and soothing
unpredictability are among the life-
enhancing qualities of Calder's works. If
you must speak art jargon, talk about
drawing in space, negative space, spatial
relationships, form and colour. Wonderful,
energy-filled gouaches.

🏛 New York: Whitney Museum (the
video of him playing with his circus
is its best-loved exhibit)
⊕ (177) £470/$757 – £2,676,056/$3.8m
⚒ £2,676,056/$3.8m in 2000,
Stegosaurus (sculpture, 1972)

CALLCOTT Sir Augustus Wall NH
1779–1844 British

Solid establishment figure who produced
competent landscapes and seascapes
inspired by the Dutch masters. In his day
some thought he was as good as Turner
(a reminder of how difficult it is to make
a contemporary judgement on art that
will stand the test of time, and how the
art establishment usually overrates its
own groupies).

⊕ (6) £420/$613 – £3,200/$5,184
⚒ £14,000/$20,860 in 1993, *Dead Calm,
Boats off Cowes Castle* (oil p.)

CALLE Sophie CS
1953– French

Makes gallery displays with photographs
and texts. Acts as a recorder and
chronicler of society – spying on strangers,

photographing them, recording what they say, involving them in her own deliberate role play. Fascinated by the interplay of public and private, fiction and reality, exhibitionism and secrecy. Works through well thought-out strategies. Good.

🔊 (2) £4,054/$6,000 – £5,743/$8,500
🔨 £5,743/$8,500 in 2000, *Les aveugles no. 15* (sculpture, 1986)

CAMERON Sir David Young NH
1865–1945 British

One of the Glasgow Boys (who included Guthrie, Henry, Lavery and Melville). Talented landscape painter whose work became increasingly brightly coloured. Superbly gifted producer of etchings, at a time when such a talent was rated very highly, both commercially and aesthetically (the print market collapsed in 1929 after the Wall Street Crash). Influenced by Whistler and compared to Rembrandt.

🔊 (29) £460/$745 – £6,400/$10,240
🔨 £16,000/$26,650 in 1990, *Ypres* (oil p.)

CAMPIN Robert (Master of Flemalle) AG
c.1378–1444 Netherlandish

Shadowy figure whose identity is difficult to pin down. Attributions are rare and speculative. One of the founders of the Netherlandish School.

◑ His devotional altarpieces and portraits are painted with the concentrated intensity that you get in a diminishing mirror (do visual intensity and detail equal spiritual intensity and commitment?). Virgin and Christ child are shown as down-to-earth people in everyday settings – not idealised, but presented in a way that creates a fascinating three-way tension between realism, symbolism and distortion, which Campin manipulates with the greatest subtlety.

🔍 Notice his acute powers of observation, especially in the way things (such as window shutters) are made, how light catches a corner, how drapery falls, or flames look. Uses light to isolate objects. The odd perspective is worked out experimentally, not scientifically. Use a magnifying glass to examine the extraordinarily fine detail; don't forget to look out of his windows at what is happening in the street. Objects and details usually contain or imply much complex symbolism.

CANALETTO Giovanni Antonio AG
1697–1768 Italian

The most famous Venetian view painter. Instantly recognisable. Much loved and collected by English Grand Tourists. Also painted views of England.

◑ His early views of Venice (1720s and 1730s) are the best, being surprisingly subtle and poetic (later works tend to become mechanical and dull). Stunning use of perspective and composition (he may have used a camera obscura). Views are not of reality, but cunning fictions. One of the few painters who has been able truly to capture not just the light and feel of Venice, but also the pageantry and history of a once great empire in its dying years.

🔍 See the way he enlivens perspective with crisp, accurate architectural details and opens up a scene by using several different viewpoints in one work. Shows clever use of light and shade: judicious balance of both with razor-sharp shadows and an exciting, unexpected fall of light on a wall. Delightful, original, anecdotal (figure) details and first-hand observation; sense of something (unseen) happening around the corner. Also produced exciting, fluent drawings and sketches.

🏛 London: Royal Collection; National Gallery. Dresden (Germany): Gemäldegalerie.

⚫ (45) £1,711/$2,595 – £7m/$10.3m

➹ £9.2m/$16m 1992 *The Old Horse Guards, London, from St James's Park, with Figures Parading* (oil p.)

CARAVAGGIO Michelangelo Merisi da AG
1571–1610 Italian

The only major artist with a serious criminal record (hooliganism and murder). Died of malarial fever at the age of 37. Contemporary of Shakespeare (1564–1616). Immensely influential.

🕭 Displayed a complete disregard for accepted proprieties and rules. Lived in a state of hyperexcitement and as in life, so in art. Sensational subjects: .severed heads; martyrdom; young men suggesting decadence and corruption (his tastes were heterosexual – his girlfriend was a prostitute); biblical subjects of dramatic moments of revelation. Brilliant technique; vivid theatrical lighting (chiaroscuro); masterly foreshortening.

𝒫 Notice the way he manipulates drama and makes the onlooker an accomplice (a criminal mind at work?). Beautiful still-life details, sometimes containing symbolic meaning (look

for fruit with wormholes). Caused and can still cause deep offence by use of peasant models (too realistic – true art requires idealisation, Christ and saints should not be shown as lower-class mortals). Brilliant modelling of flesh (look closely to see the range of subtle rainbow colours used).

1

3

2

1

2

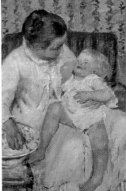

3

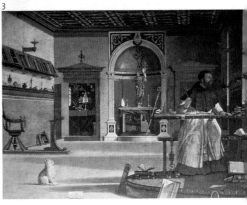

🏛 Rome

Ⓐ (4) £1,526/$2,426 – £5,000/$7,850

🔨 £140,000/$257,600 in 1988,
An allegorical female figure (oil p.)

CARO Sir Anthony CS
1924– British

Prominent, usually proclaimed (how correctly?) as the leading contemporary British sculptor. Studied engineering at Cambridge (which shows) and worked with Henry Moore (which doesn't show).

🐚 Creator of sculpture constructed out of heavy metal, which is usually welded together, recycling the elements of the engineering and construction industries (plates, beams, propellers). Emphasis on structure, space, horizontals, verticals and constructions hugging the ground or tabletop like a well-organised scrap. Displays truth to industrial materials.

His early work (1960s) is brightly painted; later work is undecorated other than with carefully controlled rust.

🔍 Under the modern outer garment is a deeply traditional soul. Solid, honest, plain-speaking, down-to-earth (literally), no-frills work that emphasises basic values (space, construction, materials), but can be didactic and schoolmasterish, suggesting the deep-seated, sometimes stubborn, values of middle England (and none the worse for that). Not for those who seek an art that will release flights of fantasy or poetic imagination.

Ⓐ (18) £1,350/$2,200 –
£40,373/$65,000

🔨 £46,686/$77,500 in 1987,
Back cover flat (sculpture)

CARPACCIO Vittore OM
active 1490–1523 Italian

Notable Venetian storyteller with an eye for homely, factual detail, crowds and processions. Set his religious and mythological stories within images of his own familiar Venice and thus chronicled his own times. Not a pioneer, but a forerunner of later domestic genre painters and recorders of the Venetian scene, such as Canaletto.

🏛 Venice: Scuola di San Giorgio; Accademia (Scenes from *The Life of St Ursula*)
Ⓜ (2) £36,000/$54,360 – £153,374/$250,000
➚ £200,000/$360,000 in 1990, *Sacra Conversazione* (drawing)

CARRACCI Annibale AG
1560–1609 Italian

Born in Bologna, lived in Rome from 1595. Most talented member of a brilliant trio (with brother Agostino and cousin Ludovico). Revived Italian art from the doldrums that followed Michelangelo. Victim of change of fashion from c.1850. Neglected in the 20th century.

☞ The arguments for his greatness are that he is as good as Raphael (brilliant draughtsmanship, observation of nude, harmonious compositions); as good as Michelangelo (anatomical knowledge, heroic idealisation – his frescoes in the Farnese Palace are on a par with Michelangelo's in the Sistine Chapel); and as good as Titian (richness of colour). He was also very original: he invented caricature and his early genre scenes and ideal landscapes are full of fresh observation. Had a pivotal influence on Rubens and Poussin.

🔍 The arguments against his greatness are that he was too eclectic – merely a plagiarist with no originality, the whole less than the individual parts.

Look who his followers were – the awful Bolognese School. But, look for a large number of wonderful drawings, full of humour and personal touches. He had a strong belief in drawing and observing from life as an answer to sterile academicism – to the point of establishing a school to teach it – a belief shared in a different way by Impressionists, especially Cézanne.

🏛 Rome: Farnese Gallery
Windsor Castle (England): Royal Collection (for drawings)
Ⓜ (5) £2,400/$3,912 – £185,000/$299,700
➚ £1,342,282/$2m in 1994, *Boy Drinking* (oil p.)

CARRIERA Rosalba Giovanna OM
1675–1758 Italian

Known for her highly successful portraits in pastels, which cleverly combine graciousness and delicacy with spontaneity, plus a judicious realism that neatly negotiates the fine divide between honesty and flattery. She was much sought after by the rich and fashion-conscious as she took her artistic skills round the capital cities of Europe.

Ⓜ (11) £600/$978 – £20,859/$34,000
➚ £64,417/$105,000 in 1998, *Female personification of summer* (works on paper)

CASSATT Mary MM
1844–1926 American

Daughter of wealthy Pittsburgh family, settled in Paris. Mixed with avant-garde and helped American collectors spend their loot (very Henry James). Friend of Degas, she also helped the Impressionists. Produced attractive works with a strong sense of design, courageous colour and cropped angled viewpoints that capture personal, meaningful moments of the well-to-do. Spottable influences from Degas, Japanese prints and Ingres.

● (36) £447/$747 – £1,888,112/$2.7m
✈ £2,450,331/$3.7m in 1996,
In the Box (oil p.)

CASTAGNO Andrea del OM
c.1423–57 Italian

Shadowy but highly successful
and innovative early Florentine
with commanding mastery of linear
perspective (worked with Uccello) and
the portrayal of the human figure (knew
about Masaccio). Painter of conventional
portraits and religious subjects, which
can appear rather wooden to present-day
eyes. Died of the plague.

🏛 Florence: Refectory of Sant'Apollonia;
(frescoes); Duomo

CATENA Vincenzo OM
c.1480–1531 Italian

Reputable second-rank Venetian. Good
middle-of-the-road painting – uninspired
figures and composition, but well-observed
light and attractive, warm colours. Every-
thing looks swept meticulously clean –
because cleanliness is next to godliness?

✈ £117,834/$185,000 in 1995, *Madonna
and Child, with two angels musicians
and landscape beyond* (oil p.)

CAULFIELD Patrick CS
1936 – British

Pioneering Pop artist. Very recognisable,
with a 1960s style using mass media
images and spare, simple shapes. His
colours are bright and flat with a strong
black outline. Somehow he has got stuck
and has never moved on.

● (2) £1,600/$2,272 – £9,000/$14,400
✈ £32,000/$52,160 in 1997,
Lunchtime (oil p., 1985)

CÉSAR (César Baldaccini) MM
1921–98 French

Celebrated for constructions and
compressions in metal, often with unusual
material, such as car parts. Very visual,
human, witty, active work. Liked animal
skeletons, bones, structure, surfaces like
bats' wings. His work in paper and plastic
lacks strength and tension (as if the
material bored him?) and can be kitsch.
Disturbing self-portraits.

● (195) £275/$407 – £315,126/$513,655
✈ £315,126/$513,655 in 1999,
L'homme de la liberté (sculpture)

CÉZANNE Paul AG
1839–1906 French

The Mother and Father of Modern art.
Solitary, pioneering, difficult, workaholic .
Thought that his life and work were
failures.

☯ His works have multilayered
significance: central to him are the same
(traditional) subjects painted over and
over again in a constant attempt to record
accurately what he sees, to express what
he feels and to produce an aesthetically
satisfying picture. Not easy, as these goals
are constantly changing and are often in
conflict, but he achieves it in the works of
1885–1901. Cézanne's paintings have an
extraordinary power, as though you were
seeing with his own eyes.

🔍 Examine the marks that he makes –
small, precise, beautiful, every one in its
place for a reason. He only makes marks
when he has seen and felt something;
they create the illusion of an object,
or space, but also remind you that a
painting is not an illusion but a physical
representation on a canvas. He also
weaves the marks together to produce
a harmony of colour and design. Every
picture surface trembles with the thrill
and anxiety of his intense seeing, feeling
and making.

1

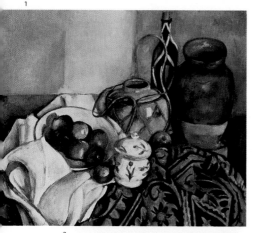

and loyalty was to his early cultural roots. Hugely successful and popular.

◑ His unique and personal marriage of subjects, themes and quirky, personal style perpetuate an enduring air of child-like innocence and wonder; poetic, dream-like images of his early life in Russia (Vitebsk) and happy married love life; love of the Bible (New Testament symbolism, such as the Crucifixion, as well as Old Testament stories); combination of Russian folk art with French Cubist fragmentation and Expressionist colour. Settled in France in 1914.

3

2

🏛 Philadelphia (USA): Barnes Foundation. Paris: Musée d'Orsay.
📈 (50) £3,056/$4,951 – £33,950,616/$55m
🔨 £33,950,616/$55m in 1999, *Rideau, cruchon et compotier* (oil p., c.1893–4)

CHAGALL Marc MM
1887–1985 British

Major master of the 1880s generation of artistic pioneers and giants. Russian-born Hasidic Jew whose ultimate inspiration

🔎 Was very prolific – paintings, prints, ceramics, stained glass, murals – which inevitably lead to uneven quality. Best paintings generally early and pre-1950; worst work is sugary, sentimental and slight (but has never lost its popularity). Major stained-glass projects after 1950. Do the odd floating heads and bodies and his combination of simultaneous events in one picture reflect his own strange, peripatetic life and consequent cultural eclecticism?

🏛 New York: MoMA; Lincoln Centre Paris: Centre Pompidou; Paris Opera Jerusalem: Hebrew University
📈 (723) £408/$669 – £4,658,385/$7.5m
🔨 £7,988,166/$13.5m in 1990, *Anniversaire* (oil p.)

CHAMBERLAIN John CS
1927– American

Famous for sculptures (free-standing and wall reliefs) made from crushed car parts. They are not arbitrarily made, but carefully planned and prepared for aesthetic effect (look for inclusion of chrome parts). Don't look for a social comment on a car-obsessed consumer society – his later work uses non-car materials such as aluminium foil, polyurethane foam and paper bags.

- Ⓐ (19) £2,676/$4,334 –
 £59,006/$95,000
- 🔨 £206,250/$330,000 in 1995,
 Coconino (sculpture, 1969)

CHAMPAIGNE Philippe de OM
1602–74 French

Born in Brussels; arrived in Paris in 1621. Brilliant, successful painter of portraits and religious pictures at the court of Louis XIII (favoured by Cardinal Richelieu). Unique, memorable style, which combines over-the-top Baroque grandeur with severe, crisp, detailed, colourful, authoritarian austerity – it should not be possible, but he showed it could be done.

- Ⓐ (2) £108,108/$160,000 –
 £147,239/$240,000
- 🔨 £147,239/$240,000 in 2000,
 Adam and Eve Lamenting the Death of Abel (oil p.)

CHAPMAN Jake and Dinos CS
1962 – and 1966 – British

Creators of life-size resin and fibreglass figures, usually of pubertal or pre-pubertal children. In part rendered with startling realism, in part distorted by grotesque, obscene and impossible sexual organs; also mutilated anatomies, which recreate realistically the imagery of Goya's *Disasters of War*.

🌑 The Chapman brothers admit that their purpose is totally cynical – to create an aesthetic of indifference, insensitivity, with no cultural value. In other words they are not artists but self-confessed pornographers (and should be seen as such). Any human activity that merely becomes an end in itself, rather than a means to achieving something greater, is flawed. Shock has always been a legitimate artistic weapon, but shock for its own sake alone is worthless.

- Ⓐ (10) £2,136/$3,139 – £16,901/$24,000
- 🔨 £17,000/$28,220 in 1998, *Iconic hallucination box* (sculpture)

CHARDIN Jean-Baptiste-Siméon AG
1669–1779 French

Quiet, modest, diligent artist, widowed early with two children. Exemplified in paint the best qualities of the Age of Reason.

🌑 Painted exquisite small-scale still lifes and genre scenes that display harmony of order, sober colour, pleasure in simple things and relationships. Loving observation of light and handling of paint. The subjects and style reflect Chardin's own modest, open personality and his love of craftsmanship.

🔎 The surfaces and textures of the still lifes are so believable that your fingers want to touch them – you feel you know exactly what everything is and where it is in space. The genre scenes crystallise moments of simple and restful intimacy, such as childish pleasures, experience instructing youth, the dignity of domestic labour, etc. Simple, easy-to-understand symbolism.

- 🏛 Paris: Musée du Louvre
- Ⓐ (6) £392/$565 – £540,541/$800,000
- 🔨 £1.306,818/$2.3m in 1989,
 Fish, vegetables, pots and cruets on a table (oil p., 1769)

CHASE William Merritt NH
1849–1916 American

From prosperous Indiana background.
Successful, gregarious, witty, flashy
dresser, cultivated in the European
manner (friend of Whistler). Developed
two distinct styles, both direct and
spontaneous: his early works are dark,
heavy, elegant portraits (style learned
in Munich); after 1890s they become
light-filled French-Impressionist-style
scenes of Long Island (Shinnecock).

Ⓐ (17) £4,938/$8,000 – £937,500/$1.5m
🔨 £2,307,693/$3.6m in 1993,
Peonies (work on paper, c.1897)

CHICAGO Judy CS
1939– American

Best known for the collaborative venture
(400 participants directed by Chicago)
Dinner Party (1973–9) – a room-size
installation of a triangular table, and
elaborate named place settings for 39 key
historic and mythological females (with

plates in form of vaginas or butterflies).
Her activities are a celebration of
sisterhood but they are more popular
with the public than with feminists.

🔨 £1,250/$2,000 in 1996,
Study for reincarnation triptych
(work on paper, 1973)

CHILLIDA Eduardo CS
1924– Spanish

Basque artist, notable for abstract
constructions, mainly in forged or
welded iron that combine several Spanish
influences: modern, such as Picasso, and
traditional, such as old-farm implements.
These sculptures are sometimes
monumental but always graceful – often
without a base, so they touch the ground
with a dancer's lightness. Many have
interlocking and embracing themes.

Ⓐ (28) £1,204/$1,926 –
£360,000/$583,200
🔨 £360,000/$583,200 in 1999,
Tolerance (sculpture, 1986)

1

CHIRICO Giorgio de MM
1888–1978 Italian

Originator of metaphysical painting.
Melancholic curmudgeon with a brief
period of true greatness, around 1910–20.
Haunting paintings of deserted Italianate
squares with exaggerated perspectives,
irrational shadows, trains, clocks,
oversized objects, and a sense of latent
menace and ungraspable meaning. Much
influenced by Nietzsche. Late work is weak.

- (136) £456/$729 – £699,301/$1m
- £3.1m/$4.8m in 1989, *Evangelical
 Still Life* (oil p., 1916)

**CHRISTO Christo Jaracheff and Jeanne
Claude** CS
both 1935– Bulgarian/American

Husband and wife partnership. Nomadic
artists who travel the world to create
highly original, memorable projects.

- They wrap objects. They started
with small items and moved on to very
large ones, e.g. wrapping the Pont Neuf in
Paris and the Reichstag in Berlin, in thin,
fragile materials, which both suggest and
conceal the thing wrapped. Also creators
of landscape projects such as an 80-km
(50-mile)-long curtain (literally) running
across open countryside. The big projects
are deliberately temporary, so one only
has a limited opportunity of seeing them.

- Their underlying purpose isn't
social but aesthetic – the transformation
of the well-known into the unfamiliar or
disquieting. The realisation of the big
projects requires large finance: there are
drawings and collages of the proposals
for these projects which they sell to raise
money. It also necessarily involves the
local community and officialdom
(planning regulations and local interest
groups, for instance), which is part of
their strategy: that their art touches and
involves everyone in the creative process
and provokes debate for and against it.

- (100) £453/$657 – £198,758/$320,000
- £198,758/$320,000 in 1999, *Yellow
 Store Front* (sculpture, 1965)

CHRISTUS Petrus AG
active 1444–72/3 Flemish

Major painter from Bruges, follower
of Van Eyck and influenced by Van der
Weyden. Underrated.

- His intimate, small-scale religious
works and portraits are organised
carefully and painted with meticulous
detail. Note especially his interest in space
and light: likes deep space and places
figures in the corners of rooms to suggest
both space and intimacy. He was the first
northern painter to understand and use
Italian single-point perspective.

- Robes have elaborate, crisp
drapery, with folds arranged decoratively,
often flipped back to show a lining or
undergarment in contrasting colour,
sometimes brightly outlined. Note how
Christus uses brownish rather than pink
flesh tones and favours red and green
colour schemes. He organised broad
areas of tone and filled in on top with
meticulous detail, which makes cleaning
and restoration especially risky.

- £120,000/$182,400 in 1995,
 The Virgin and Child (oil p., 1449)

CHURCH Frederic Edwin NH
1826–1900 American

The greatest American landscape
painter. Combined detailed observation
of nature with the heroic, sublime vision
of Romantics such as Turner. God-fearing
and patriotic (and it shows).

- His large-scale, stunning vistas or
panoramas of North and South America
have natural phenomena (Niagara Falls),
mountains and dramatic light (blood-red
sunsets) to the fore. Uses high view-

points, which give a birdlike feeling of being free to go anywhere, and combines this with the quasi-scientific observation of microscopic details – indicating his deep spiritual belief in the morality of Nature and presence of God in the largest and the smallest feature.

🔎 Note the thrilling shafts of light falling on the landscape; exquisite painting of distant mountains and waterfalls; and sharp, bright colours (used new, heavy, metal pigments). At his peak in the 1860s, he had a long, slow decline (bad rheumatism in his hands).

🏛 New York: Metropolitan Museum of Art. Hudson (New York State): Olana State Historic Site
🅰 (6) £21,605/$35,000 – £2,687,500/$4.3m
🏹 £4,746,836/$7.5m in 1989, *Home by the Lake, Scene in the Catskill Mountains* (oil p., 1852)

CIMA DA CONEGLIANO OM
c.1459–c.1517 Italian

Successful but minor Venetian, content to follow the lead set by others. 'The poor man's Bellini' – similar use of light, but harder and less subtle. Best on a small scale, when his crispness comes to the fore. Good light; satisfying blue mountains; intense surprised faces; general air of busyness; slightly comical, frozen poses (as when a photographer says 'hold it').

🏛 London: National Gallery
🏹 £49,677/$84,948 in 1992, *Madonna and Child in Landscape* (oil p.)

CIMABUE (Cenni di Peppi) OM
c.1240–1302 Italian

Florentine contemporary of Dante. Traditionally said to be Giotto's teacher – i.e. it is claimed that he initiated the move from the static 'old' and 'unreal' Byzantine style to the 'modern' and 'realistic' style,

with more credible 3-D space, human form and emotion. As only one work (*Christ Enthroned with the Virgin and St John*, in Pisa) can be proved to be by him, it remains pure, but not entirely useless, speculation.

🏛 Pisa (Italy): cathedral apse (mosaic)

1

2

compositions and colours to produce a serene, luminous, calm and harmonious atmosphere – although somewhere in the airless heat there is usually a refreshing breeze: look for the rustle in the tree tops, the unfurling of a flag, the sails of a boat in the far distance, or birds gliding on a current of air.

🏛 London: National Gallery
Paris: Musée du Louvre

🅐🅥 (16) £619/$898 – £1.2m/$1.86m

🏹 £1.2m/$1.86m in 1999, *Evening landscape with Mercury and Battus* (oil p.)

CLAUSEN Sir George NH
1852–1944 British

Son of Danish parents. Trained in London and Paris. Painter of landscapes and rural scenes, who managed to combine bits of old-fashioned, Academy-approved style with bits of progressive Impressionism. He pleased his audience then and pleases it now by never offending.

🅐🅥 (18) £420/$601 – £240,000/$343,200

🏹 £355,828/$580,000 in 1997, *Evening Song* (oil p., 1893)

CLEMENTE Francesco CS
1952– Italian/American

Born in Naples, lives in New York. Painter in tempera and watercolour, and one of the most respected members of the current art establishment. Prolific, multi-faceted, multinational – multi-everything. The epitome of official contemporary artistic acceptability.

🌑 Creates both large-scale works (declamatory, designed for public museum spaces) and smaller ones. Likes exploring dual themes that are the meat of political correctness such as the relationship between past and present, human and animal, Europe and

CLAUDE Gellée (Claude Lorrain; also Claude Lorraine) AG
1600–82 French

Originator of the pastoral or picturesque landscape. Immensely influential and popular, especially in the 18th and early 19th centuries. Worked in and around Rome.

🌑 Claude's landscapes and seascapes are enjoyable on two levels: as exquisite depictions in their own right and as a poetic setting for the staging of mythological or religious scenes. Notice how he moves your eye from side to side across the picture in measured steps via well-placed figures, buildings or paths *(coulisse)*, and at the same time takes you from warm foreground to cool, minutely detailed distance (aerial perspective).

🔎 Magical painter of light – the first artist to paint the sun itself. Uses a formula of well-proven balanced

America, man and woman, East and West. Uses a wide variety of impeccable source material (Italian Renaissance, Indian art). Technically very sound and intellectually complex, with much symbolism to unravel.

🔎 With such correct, self-assured, firmly controlled agendas, technique and subject matter, it is difficult to find fault. But why are the faces, eyes and imagery in general so sad and lonely? Any art that takes itself so deadly seriously risks becoming passionless – does he never laugh at or enjoy human absurdity? Why the obsession with genitalia? Seems like joyless self-obsession: subjects are often sexual but not erotic. And it is the sort of art that public institutions want.

🏛 Bilbao: Guggenheim Museum
🔨 (41) £2,069/$3,000 – £173,913/$280,000
🔨 £193,750/$310,000 in 1994, *The Celtic Bestiary* (work on paper, 1984)

CLOSE Chuck cs
1940– American

Produces huge portraits of himself and his intimate friends, always from the neck up. Works from photographs, which are squared up and the final images created tiny square by tiny square, according to a complex, time-consuming and mechanical procedure. Uses colour after 1971. The end result is compelling, but is it because of the face or the frankly mind-boggling technique?

🔨 (7) £2,593/$4,200 – £683,320/$1.1m
🔨 £683,230/$1.1m in 1999, *Cindy II* (oil p., 1988)

COHEN Bernard cs
1933– British

Abstract painter whose overriding interest is a somewhat limited and introverted concern with the process of painting and what paint does.

🔨 (1) £3,200/$5,184
🔨 £3,600/$5,760 in 1997, *Red One* (oil p., 1965)

COHEN Harold cs
1928– British

Bernard's brother. Currently interested in drawings made by computers that have been programmed to produce work that looks freehand.

🔨 £556/$900 in 1998, *Contemporary Still Life of Two pears and a Pitcher* (oil p., 1953)

COLDSTREAM Sir William NH
1908–87 British

Painter and arts administrator. Polite, well-crafted work, predominantly of nudes and urban landscapes, in which observation, measurement, balance, caution and compromise predominate (all the qualities demanded of a sound administrator). Key figure in reform of art school teaching in England in the 1960s.

🔨 £2,500/$4,625 in 1991, *Falmouth* (oil p. 1978)

COLE Thomas NH
1801–48 American

British born (Bolton, Lancashire), but family emigrated to USA in 1818. Major figure in American art – founder of the Hudson River School and the tradition of the grand landscape. Romantic, conservative, melancholic, often at odds with a world given to fast-changing materialism.

◐ His early Hudson River landscapes (done in the 1820s) interpret the American rural scene through the European conventions of the picturesque and sublime. His later work gets larger in scale and overlaid with literary and

moralising ideas, which he also expresses in verse and diaries. Combines landscape with biblical and historical themes, which to modern eyes can go completely over the top in the manner of bad operas or Hollywood spectaculars.

🔍 The reason for the earlier works is a genuine response to the beauties of relatively virgin US nature unsullied by too much tourism, development or artistic interpretation (unlike Europe). The reason for the later work is his fear of the clash between this nature and an aggressive material culture, which he feared would gobble it up. Two allegorical series 'The Course of Empire' and 'The Voyage of Life' predict the rise and fall of American culture.

🅐 (1) £4,777/$7,500
🔨 £617,284/$1m in 1997, *View of Boston* (oil p.)

COLLINS Cecil NH
1908–89 British

Deep thinker with mystic inclinations. Influenced by Surrealism (1930s), Far Eastern art and philosophy (1940s). Fundamentally a loner. His concern with visionary experience, spiritual quest and the place of creative man in the mechanised and dehumanised modern world is expressed through iconic images such as The Fool, The Angel, The Soul (anima = wife, Elizabeth).

🅐 (12) £380/$600– £17,000/$28,050
🔨 £17,000/$28,050 in 1999, *Shepherd Fool* (w/c, 1945)

COLQUHOUN Robert NH
1914–62 British

Glasgow born. Lived with and was inseparable from Robert MacBryde when active gay relationships were against the law. Very British. Parochial, but sincerely felt vision of existential angst by one whose sexuality forced him to be an outsider to 'normal' society. Much influenced by Picasso's work.

🅐 (3) £360/$594 – £14,500/$21,170
🔨 £14,000/$21,560 in 2000, *Performer* (oil p., 1947)

CONSTABLE John AG
1776–1837 British

One of the great landscape painters who pioneered a new type of plein-air painting based on the direct observation of nature. He believed that nature, with its dewy freshness, sunlight, trees, shadows, streams, and so on, was full of moral and spiritual goodness. Devoted family man.

🌙 Limited subject matter: he only painted the places he knew best. Seems to know every square inch of ground and all the local day-to-day activity. Note how the light in the sky and the fall of light on the landscape are directly connected (not so in Dutch landscapes). The sketches (not for public display) have a direct spontaneity, absent from the more laboured, finished paintings (especially the 'six-footers') with which he hoped to make his reputation.

🔍 How does he get that sense of dewy freshness? Look at the way he juxtaposes different greens (full of subtle colour variation) and introduces small accents of red (the complementary colour) to enliven them. Note, also, the layering of clouds to create perspective recession; the figures, sometimes almost hidden in the landscape. Late work is much more emotional, darker, more thickly painted.

🏛 London: National Gallery; Victoria & Albert Museum; Tate Britain
🅐 (6) £3,000/$4,800 – £640,000/$915,200
🔨 £9.8m/$19,306,000 in 1990, *The Lock* (oil p.)

1

2

3

he would be dubbed a pacifist and Tory hanger-on.

🔍 Note how he adapted to the grand-manner style of portrait painting (more decorative, pompous and frothy) after his visit to Italy. It did his portraiture no good, but he achieved great success in London with huge-scale modern-history paintings (heroic actual events presented as though they were moral tales from Ancient History). Late, melancholic decline as he went out of fashion and felt exiled (he never returned to the USA).

🅐🅥 (1) £181,818 – $260,000
🔨 £181,818/$260,000 in 2000, *Mrs Elizabeth Coffin Amory* (oil p.)

COPLEY John Singleton NH
1738–1815 American

The greatest American painter of the colonial period. Self-taught. Slow, earnest, timid, indecisive as a person but assured, talented and pioneering as a painter. Son of poor Irish immigrants, he married well (the daughter of a rich Tory merchant).

🌑 Had two separate and successful careers and styles. Pre-1774, in Boston, he established himself as the leading portrait painter. Decisive, high-quality, sober works, which show his own and his sitters' liking for empirical realism. Precise (perhaps overhard) line, clear detail and enumeration of material objects, severe light and dark contrasts. In 1774 he left Boston, disliking politics, fearful that

CORINTH Lovis MM
1858–1925 German

Rarely seen outside Germany. Major figure who tried to reinvent the tradition of the old masters in a modern idiom. Ambitious, gifted, Prussian.

🌑 In his traditional style he painted established subjects (portraits, still lifes, mythologies), using an earth palette and

influenced by old masters, especially
Rembrandt and Hals. In his modern style
he painted frank, direct interpretations.
Free and expressive paint-handling –
he used painting as a personal and
emotional release. After a stroke in 1911,
his work became increasingly loose,
reflecting his physical handicap,
awareness of death, isolation (he disliked
Modernism) and melancholy at the
defeat of the German Empire in 1918.

🔎 Impressively versatile, he produced
stunning, small late watercolours and
prints, which were easier to handle after
his stroke and show thrilling emotional
and technical invention. His plein-air
landscapes (especially those around
his house at Walchensee, Bavaria) hover
between Impressionism and Expressionism
and were a great commercial success in
Berlin. Compositions in late works often
lean curiously to the left. Painted series of
self-portraits every year on his birthday
(after 1887).

🅰️ (49) £304/$487 – £260,000/$374,400
🔨 £330,000/$524,700 in 1994, *Eisbahn
im Berliner Tiergarten* (oil p., 1909)

CORNELL Joseph NH
1903–c.1972 American

Creator of strange, small-scale
imaginative boxes. Though often pigeon-
holed as Surrealist, they are poetic reveries
rather than Freudian dream worlds. Lived
lonely, reclusive life in Flushing, New York,
with his mother and crippled brother.
Scoured junk shops for bits and pieces,
which he filed away meticulously.
Passionate about ballet, opera, music
and film.

🌙 Many of the reveries are about
travel that he never undertook (maps and
images of Paris, for instance) or film stars
he never met. Often tinkered for years
with images and contents of individual
boxes. The glass fronts of the boxes
symbolically separate the real world

from the dream. No sexual imagery –
he disapproved of Surrealism's dark,
'unhealthy' aspects.

🅰️ (24) £4,688/$7,500 –
£92,593/$150,000
🔨 £290,323/$450,000 in 1989,
Grand Hotel Pharmacy (sculpture)

COROT Jean-Baptiste-Camille AG
1796–1875 French

Major landscape painter of the
19th century. A bridge between
the English landscape tradition and
French Impressionism. Kind, gentle and
unusually unegocentric for an artist.

🌙 His late, best-known, paintings
(post-1860) – silvery-green, soft-focus,
lyrical landscapes – are based on
remembered emotions ('souvenirs')
and sketches from nature. But notice, too,
the earlier, artificial, more conventional
(academic and sometimes ludicrous)
landscapes; also enchanting figure
paintings. He has been much copied and
faked. There are said to be more 'genuine'
Corots in the USA than all the pictures
he painted in his lifetime.

🔎 Unquestionably at his best with
his small plein-air, on-the-spot sketches
(called *pochades*). Shows wonderful
observation of light and clouds in the sky
and empirical exploration of space; note
the way he tightens the soft focus with
sharp dark accents of paint.

🅰️ (86) £306/$441 – £895,062/$1.45m
🔨 £2,755,905/$3.5m in 1984,
*La femme à la grande toque
et à la mandoline* (oil p.)

CORREGGIO Antonio Allegri AG
c.1494–1534 Italian

Once hugely revered and popular
(especially in 17th and 18th centuries),
and consequently very influential.

1. Jean-Baptiste-Camille Corot, *Recollections of Mortefontaine*, 1864
2. Antonio Allegri Correggio , *Venus with Mercury and Cupid ('The School of Love')*, c.1525
3. Pietro da Cortona, *Allegory of the Arts* (ceiling painting)

Now no longer well known: his virtues are completely out of fashion. Most important works are in Parma, northern Italy (visit essential).

◉ His works are full of genuine charm, intimacy and tender emotion, and occasional sentimentality. Chose subjects from mythology and the Bible and had a lyrical and sensitive style; everything (though immensely accomplished and not unambitious) is gentle – light, colour, foreshortening. Compositions are

complex but satisfying, with easy-to-read subjects displaying pleasing anatomy and relationships, youthful faces and sweet smiles. Invented the idea of light radiating from the Christ child.

🔎 The in-situ decorations in Parma are forerunners of the over-the-top illusionistic decorations in Baroque Rome 100 years later (the link from one to the other was Lanfranco). See how he turns the ceiling into an illusionistic sky and then makes exciting things happen in it (Mantegna did this first and Correggio followed him.) The charming, sentimental side derives from Leonardo and influenced French Rococo. Liked wistful faces and idealised profiles. Many fine drawings.

🏛 Parma (churches; public buildings). London: British Museum (drawings)

💰 (3) £1,624/$2,566 – £75,284/$121,960
🔨 £92,179/$165,000 in 1992, *Study of two apostles* (drawing)

CORTONA Pietro Berrettini da OM
1596–1669 Italian

Virtuoso architect, decorator and painter, much sought after by Catholic grandees in Italy and France. Known as key creator of Roman High Baroque and for large-scale extreme, illusionistic paintings

where ceilings open up into a bold, dramatic, rich theatre of space, colour, human activity, architecture, learned allusion and spiritual uplift.

🏛 Rome: Palazzo Barberini; Santa Bibiana

⊛ (6) £1,686/$10,000 – £150,000/$232,500

✈ £240,000/$391,200 in 1991, *Wooded river landscape with cascades and men dragging net* (drawing)

COSWAY Richard NH
1742–1821 British

Best remembered as the outstanding miniaturist of the 18th century. Look for long, aquiline noses with very noticeable nostrils and shadows under the nose. A few unsuccessful large-scale oils. Married Maria Hadfield (1759–1838), a successful Irish/Italian painter, miniaturist and illustrator. Friend of the Prince of Wales.

⊛ (26) £300/$471 – £16,000/$23,680

✈ £30,000/$49,500 in 1998, *Group portrait of the children of Edmund Boyle, 7th Earl of Cork* (oil p.)

COTES Francis NH
1726–70 British

Contemporary with and follower of Reynolds, but without the variety of observation and character – more interested in fashion and clothes. Best work often in pastel.

⊛ (5) £2,500/$3,750 – £4,500/$6,795

✈ £650,000/$1,079,000 in 1996, *The Young Cricketer, Lewis Cage, with Cricket Bat* (oil p., 1768)

COTMAN John Sell NH
1782–1842 British

Leading member of the Norwich School. Beautiful work that is pure watercolour,

not coloured drawing. Distinctive style – well ordered, sombre, flat colour, translucent washes, minimum shadow, and shape defined by the firm edges of the wash, not a drawn outline.

⊛ (23) £300/$468 – £24,000/$34,220

✈ £19,000/£32,110 in 1997, *Bolton Abbey* (w/c)

COURBET Gustave AG
1819–77 French

Radical scourge of corrupt Second Empire France and the tedious old-fashioned traditions of the French Academy. The major exponent of 19th-century realism.

🌑 Chose large-scale subjects (such as life, death, destiny, the ocean, the forest) and often produced physically large

paintings. Brilliant, gutsy technique with thick, physical paint. Portrayed toughness and realism – real people carrying out unglamorous, everyday activities. Had an intimate knowledge of all the activities, people and places he painted and valued down-to-earth, provincial life more highly than fashionable Parisian glamour.

🔍 His work can range from the most brilliantly inspired and executed to sloppy, uninspired and bad painting. Note the very unusual rich green, especially in his landscapes – it is not artistic licence: in his beloved homeland (Ornans, near Besançon) the copper in the soil turns the vegetation that colour. The area is worth a visit for its stunning beauty, but also to see what it was that inspired him and how 'real' his realism is. Note his prominent red signature – what a big ego!

🏛 Paris: Musée d'Orsay. Montpellier (France): Musée Fabre
🅰 (41) £1,897/$3,036 – £1,324,503/$2m
🏹 £1,666,667/$2.7m in 1998, *Portrait de Jo, la belle Irlandaise* (oil p., 1865)

COX David NH
1783–1859 British

Well travelled (France, Flanders, Wales); lived in Hereford, London, Birmingham. Produced talented, small-scale, freely executed oils and watercolours that capture the spontaneity of rapidly shifting light and breezes, experienced in the open air. One of the few painters to make one feel wind and rain (the French Impressionists rarely, if ever, attempted it).

🏛 Birmingham (UK): City Art Gallery
🅰 (96) £300/$501 – £36,000/$57,600
🏹 £98,000/$158,760 in 1997, *Crossing Lancaster Sands* (w/c, 1839)

COZENS Alexander NH
1717–86 Russian/British

Russian born, Rome educated. Watercolour landscapes and etchings. Fascinated by systems and famous for his method of using accidental blots on a piece of paper as a visual inspiration out of which an idea, such as a landscape, might develop (still worth trying, as the Surrealists realised).

🅰 (1) £1200/$1,920
🏹 £390,000/$631,800 in 1997, *After Rain* (oil p.)

COZENS John Robert NH
1752–97 British

Alexander's melancholic son. Well travelled (Alps, Italy, Naples). Wonderful early watercolours, prefiguring those of Turner, in which he shows how a landscape can be a vehicle for emotion and mood when made with imagination and inventive techniques. Luminous skies full of atmosphere, space and light.

🅰 (2) £7,500/$12,000–£24,000/$36,000
🏹 £178,000/$318,620 in 1991, *Lake Albano, Castel Gandolfo, sunset* (w/c)

CRAGG Tony CS
1949– British

Maker of energetic, large-scale objects from industrial materials that are reminiscent of other natural or man-made objects. By causing a visual double-take they pose the questions: why do things look like that? Why are they made like that? He stimulates a reappraisal of our visual world and what we accept or dismiss as ugly, beautiful, interesting or boring.

🅰 (9) £7,000/$10,080 – £40,000/$57,600
🏹 £53,073/$95,000 in 1992, *Three Cast Bottles* (sculpture)

CRANACH Lucas (the elder) OM
1472–1553 German

A leading figure of the German Renaissance. Worked for the Electors of Saxony in Wittenberg, although his style remained essentially provincial rather than international (Italian). Large, active studio. Staunch Protestant.

◑ Painted impressive and solid court portraits, being especially good at old men's faces. Most notable for the strange, unique and capricious pictures of female mythological subjects, which have a compelling power and character. These women are curiously reminiscent of the brittle, present-day high-fashion posed and posing models who strut along the catwalk. Both wear outrageous designer creations, and have hard little faces and faraway looks. He makes us adopt the role of voyeur.

𝒫 Note the sloping shoulders; small, round breasts; feet turned out; long arms and legs; one leg twisted over another; prominent navels; crazy hats and clothes; rings on fingers; feathers; jewelled collars; rocky landscapes and armour. Hard, glassy eyes, sometimes with strange highlights; manipulative hands; greedy, calculating facial expressions.

🏛 Vienna: Kunsthistorisches Museum
🅐 (18) £2,833/$4,109 – £1,605,976/$2,328,665
↗ £4.4m/$7,920,000 in 1990, *Portraits of Kurfurst Herzog Johann von Sachsen and of his son* (oil p., 1509)

CREDI Lorenzo di OM
c.1458–1537 Italian

Minor Florentine who had a similar style to the early works of his fellow pupil, Leonardo da Vinci. Altarpieces and portraits. Technically competent but lifeless. Used an unpleasant high-key palette with orange/gingery tone. Flesh and draperies have the same squashy

appearance, and he shows odd upturned thumbs and toes.

🅐 (1) £182,927/$300,000
↗ £705,128/$1.1m in 1995, *Saint Quirinus of Neuss* (oil p.)

CRIVELLI Carlo OM
active 1457–93 Italian

Middle-rank Venetian with a self-conscious, old-fashioned style.

◑ Crivelli's works show an extraordinary and obsessive attention to detail, which virtually overwhelms everything else. His strange, hard, dry, linear style makes the figures look real but unreal (a bit like biological specimens); similarly with the architecture, his buildings look like painted stage sets rather than the real thing.

𝒫 Note the lined faces with bags under the eyes and bulging veins on hands and feet. The real yet unreal-looking fruit and garlands (which have complicated symbolic meanings) resemble marzipan cake decorations.

🏛 London: National Gallery
Milan: Pinacoteca di Brera
🅐 (2) £41,379/$60,000 – £103,448/$150,000
↗ £500,000/$840,000 in 1988, *Madonna and Child* (oil p.)

CROME John NH
1768–1821 British

'Old Crome' (to distinguish him from his eponymous son) was the principal founder of the Norwich School. Painter (oils and watercolours), printmaker, collector and dealer, and teacher. His romantic landscapes were much influenced by 17th-century Dutch masters. His works – local landscapes, buildings and riverscapes – show fresh perception, strong design, and clear, warm

colour and light. They have an 'unfinished' appearance. Popular and much copied. High-quality etchings.

🅐 (3) £900/$1,305 – £4,000/$6,400
🗡 £26,000/$40,650 in 1999, *View of Rouen* (oil p.)

CURRY John Steuart N H
1897–1946 American

American regionalist painter from Kansas, specialising in scenes of prairie life with farms, fairs, tornadoes and riverside baptisms. His uncertain style is more akin to illustration than art, but it now carries status by virtue of the authority bestowed by nostalgia.

🅐 (6) £741/$1,200 – £30,247/$49,000
🗡 £90,625/$145,000 in 1995, *My Mother and Father* (oil p., 1929)

CUYP Aelbert AG
1620–91 Dutch

Son of a painter who married a wealthy widow in 1658 and thereafter neglected his art for local politics. Much loved and collected in England. Never set foot in Italy.

🌓 Produced some of the most beautiful landscapes and riverscapes ever painted. Using Italianate, golden light (which he never actually saw – it came entirely from Italian paintings) he transformed his native Holland (especially Dordrecht) into a fantasy dream world, which epitomises the start or end of a perfect day. Had qualities attractive to the patrician classes who commissioned and collected his work: order, stillness, clarity, security, everything and everyone in their own appointed place, harmony with nature, a sense of proprietorship and timelessness.

🔎 The light floods in from the left, casting long, soft shadows (surprising how few definite shadows there are). Note how the golden light catches just the edges of plants, clouds or animals, with highlights laid on in thick, impastoed paint. Uses a warm palette of earthy golds and browns contrasted with cool, silvery skies and foliage. Nice ambiguities and easily overlooked details, such as birds in flight; is it morning or evening?

🏛 London: National Gallery
🅐 (3) £14,423/$21,779 – £1,793,103/$2.6m
🗡 £3.8m/$5,852,000 in 1994, *Orpheus Charming the Animals* (oil p.)

65

DADD Richard NH
1817–86 British

'Mad Dadd' murdered his father in 1843 and was locked up, but his doctors encouraged him to go on painting. Has recently become famous through his meticulous and obsessively detailed paintings of fairy subjects made in the 1850s.

- Ⓐ (2) £3,000/$4,800 – £4,000/$6,480
- ⚒ £1.5m/$2,775,000 in 1992, *Contradiction, Oberon and Titania* (oil p., 1854)

DADDI Bernardo OM
c.1290–c.1349 Italian

Younger contemporary of Giotto. Blended Giotto's tough realism with the sweetly lyrical qualities of Sienese artists (such as Lorenzetti). Look for smiling Madonnas, cute children, flowers and draperies. Creator of popular, easy-to-look-at, small-scale portable altarpieces. Then, as now, art that is kind to the eye and mind tends to have a wide following.

- Ⓐ (1) £20,000/$32,000
- ⚒ £320,000/$617,600 in 1990, *St Catherine of Alexandria* (oil p.)

DAHL Michael NH
1659–1743 Swedish/British

Born in Sweden, settled in London 1689. Produced competent portraits of aristocracy, royalty and the literati. Languorous, elegant style, but poor characterisation. Good on draperies; used diffused, silvery tones and short brushstrokes. Kneller's principal competitor. Dahl was prolific and successful. His earlier works are best.

- Ⓐ (6) £2,400/$3,936 – £17,000/$24,310
- ⚒ £26,000/$43,680 in 1998, *Portrait of gentleman and lady, usually identified as Sir Bulstrode Whitelock and his wife* (oil p.)

DALÍ Salvador MM
1904–89 Spanish

Flamboyant self-publicist, and one of the most popular painters of the 20th century. Made a brief but major contribution to Surrealism.

🌙 An artist of astonishing technical precocity and virtuosity. He mastered almost any style (see early work), finally choosing one based on the detailed, 'realistic', 17th-century Dutch masters – instantly popular and recognisable as 'very skilful' (the optical illusions are breathtaking). Ultimately just a flashy showman with a big ego and a ong moustache – like a singer who churns out popular opera arias in a spectacular way, but devoid of any real expression, meaning, or freshness.

🔍 There is one exception to the above. Look for the works of 1928–33, which are great and profound. Briefly, as a true pioneer of the Surrealist movement, Dalí created works to explore his 'paranoia-critical method'. Using Freudian ideas about dreams and madness, he produced obsessional images in which detailed reality is suddenly transformed into different, intricate and disturbing pictures. Technically and imaginatively brilliant. He ought to have persisted with it.

🏛 Figueras (Spain): Salvador Dalí Museum. St Petersburg (Florida, USA): Salvador Dalí Museum
🅰 (248) £414/$675 – £2.6m/$3.77m
🔨 £2.6m/$3.77m in 2000, *Ma femme nue regardant son propre corps devenir marches* (oil p., 1945)

DANBY Francis NH
1793–1861 British

Irish-born landscape painter who never settled to a consistent theme or style. Look for grandiose, literary, biblical and apocalyptic subjects, often over the top; detailed, picturesque works of nature, with children as a prominent feature; late romantic, serene but solemn, sunset landscapes. He was plagued by marital and financial problems.

🅰 (8) £1,500/$2,400 – £20,000/$32,000
🔨 £92,000/$135,240 in 1994, *View of Villeneuve on Lake Geneva* (oil p., 1836)

DAUMIER Honoré AG
1808–79 French

Called the 'greatest 19th-century caricaturist', but is much more because he reveals universal truths about the human condition. His subjects are French men and women living in a corrupt, greedy, bourgeois regime (French Second Empire), but the message is timeless.

🌙 His compelling images observe the absurdities and obsessions of husbands, wives, lawyers, politicians, artists, actors, theatre-goers, collectors etc. Had a prolific output: prints (he was a pioneer of lithography), especially , watercolours, sketches; some oil paintings after 1860 (he was never comfortable with the scale and technique – at his best with a smaller and more spontaneous scale and medium). Never judgemental or unkind, even though his work was censored. Went semi-blind in 1870.

🔍 Notice his captivating facial expressions, body language, hands – all speaking volumes (you cannot leave a Daumier exhibition without reappraising everyone you see there, or on the way home). His use of light, shade and atmosphere is as good as Rembrandt's. Works have a probing, lively line (you sense the excitement in his hand as he works). He produced miraculous small clay-model caricatures of politicians. Ignored the rich and famous, and was never successful commercially. Makes the everyday sublime and moving.

🅐 (53) £358/$573 – £362,942/$587,966

🔨 £1.5m/$2,235,000 in 1993, *Le fardeau – la blanchisseuse* (oil p.)

DAVID Gerrit (or Gerard) AG
1484–1523 Netherlandish

Last great Netherlandish painter in the tradition of Van Eyck's and Van der Weyden's meticulous realism. Worked in Bruges and Antwerp.

🌑 Painter of altarpieces and portraits. He loved exact details of objects and faces. Had a conscious awareness and acknowledgement of the Netherlandish tradition in which he was placed (and that was coming to an end). Fascinated with landscape and townscape, placing figures naturally and at ease within them – his landscapes are especially fine. Spaces are open and relaxed, not crowded, which gives a feeling of calm, poise, and harmony with nature and God.

🔎 Notice how the Italian influence on his work increases progressively and inexorably, but never takes over completely; moves from love of particular detail to more generalised storytelling. Note the individualism of each tree with detailed leaves. His characters have modest, solemn, but seemingly expressionless, faces. Splendid, subtle, rich colours, harmoniously woven together. His paintings remind us that fine craftsmanship and skill are God-given talents, and that he worshipped God by exercising his.

🔨 £100,000/$152,000 in 1995, *The Lamentation* (oil p.)

DAVID Jacques-Louis AG
1748–1825 French

Passionate, volatile character – an artistic Napoleon (dictatorial, austere, inflexible). Deeply involved in politics of French Revolution and Napoleonic Empire.

Died in exile in Brussels. Founder of French neoclassical painting, but was an arts administrator as well as a creative genius.

🌑 If you want authority in art – this is it. He applies the precision of the painter of miniatures on a massive scale. Stern moral and artistic rules: behind the storytelling and theatre is the ideological commitment to art as a public and political statement in the service of the state. Body language and facial expressions are used as drama. No place for ambiguity: what you see and feel are as precise and as clear as can be.

🔎 Observe his attention to detail, especially in hands, feet, tassles, armour and stones. His flesh is as smooth as porcelain, with never a hair in sight. His portraits of victors of the French Revolution have direct, busybody eyes. Even shadows and light seem to have been disciplined and regimented. Love of antiquity and archaeological accuracy of detail (Roman noses everywhere). You have to experience the sheer physical size of the big set pieces at first hand.

🏛 Paris: Musée du Louvre

🅐 (12) £1,036/$1,481 – £207,317/$340,000

🔨 £3.4m/$5,542,000 in 1997, *Portrait de Suzanne le Peletier de Saint-Fargeau* (oil p., 1804)

DAVIE Alan CS
1920– British

Unusual but well-regarded painter, working today in a totally individual manner. Talented athlete and jazz musician. Prolific.

🌑 Magic. His work is all about trying to express the inexpressible and how to reach the primal and mystical forces of humankind (the sort of experience that the hippy generation sought). He invites you to enter this magical world. If you

1

2

🔨 £53,797/$85,000 in 1989, *Oh to be a serpent that I may love you longer* (oil p., 1962)

DAVIES Arthur Bowen NH
1862–1928 American

America's leading Symbolist, much influenced by Puvis de Chavannes and Böcklin, hence dreamy landscapes, muted nuanced colours, nymphs, unicorns, sea. Sociable and mild, he loved hidden secrets and meanings, both in art and life. Ran two happy family households simultaneously for 25 years, each completely unaware of the other.

🅰️ (26) £340/$500 – £34,375/$55,000
🔨 £37,037/$60,000 in 1997, *Avatar* (oil p.)

DAVIS Stuart NH
1894–1964 American

Leading American Cubist. From 1924 developed striking and individual abstract paintings and collages, notable for their bright colours and jazzy rhythms. Fascinated by urban scenes and advertising posters. Initially trained in the world of advertising (and it shows to his advantage).

🅰️ (11) £1,166/$1,900 – £59,441/$85,000
🔨 £1.3m/$2.2m in 1997, *Odol* (oil p., 1924)

DEACON Richard CS
1949– British

Creates sculptures out of industrial materials, such as steel, laminated wood and linoleum. Likes to reveal methods of construction (for example, rivets), as he sees himself as much a craftsman or fabricator as an 'artist'. Titles of works are important – he is interested in the way we use language as a means of recognising, shaping and interacting with the world.

cannot accept the possibility of magic, or are unwilling to travel with him, his work will remain meaningless and appear no more than a design for a cover to a handbook on Indian mysticism.

🔎 He needs a large scale to express fully the magnitude of his endeavours . Early work is thickly painted in an Abstract Expressionist style. Since the 1960s he has worked in a figurative style, full of signs and symbols that are highly reminiscent of Indian art and decoration.

🅰️ (33) £420/$674 – £18,000/$27,180

Ⓐ (2) £9,459/$14,000 – £21,622/$32,000

🔨 £25,000/$39,500 in 1995, *Other Men's Eyes No. 2* (sculpture, 1986)

DEEM George CS
1932– American

New York-based painter well known for his 'School of' paintings. Takes elements from well-known works by famous artists, such as Vermeer, and paints them in a schoolroom setting – which is itself borrowed from a painting by Winslow Homer. Witty, perceptive, inventive. Uses subtle brushwork, which reproduces the techniques of the old masters. Makes you look and think twice.

🔨 £2,193/$3,750 in 1998, *School of Winslow Homer* (oil p., 1983)

DEGAS Edgar AG
1834–1917 French

One of the greatest draughtsmen of all time. Successfully bridged the gap between the old master tradition and modernity. Shy, haughty, conservative and single.

🌙 Each picture shows a self-contained and self-absorbed world, whatever the topic. Even when the subjects of his portraits make eye contact, they give nothing away. Ballet and race scenes are a means of exploring complex space and movement. His technique, his extraordinary capacity for drawing, and his attention to detail are equally self-absorbed – one of those rare, perfect unions between subject matter and means of expression.

🔎 Degas was fascinated by meticulous but innovative craftsmanship, and experimented in many media: pastel, prints and sculpture. Also was interested in photography – he borrowed and used the cut-off effect brilliantly. Worked and reworked the same subject or theme to achieve ever greater understanding and perfection. Notice how often he uses the receding diagonal as the main armature for his compositions. Had astonishing colour sensitivity, even when old and nearly blind.

🏛 Paris: Musée d'Orsay. New York: Metropolitan Museum of Art

Ⓐ (134) £1,515/$2,439 – £16m/$25,280,000

🔨 £16m/$25,280,000 in 1999, *Danseuse au repos* (works on paper, 1879)

DELACROIX Eugène AG
1798–1863 French

Small in stature but big in spirit – the fashionable, fiery hero of French Romanticism. Supposedly the illegitimate son of Talleyrand. Was willing to shock with strong subject matter and vigorous style, and often did.

🌙 Chose big, romantic subjects where the linking theme is heightened emotion, especially through sexuality, struggle and death. Inspired by literature (Dante, Byron), current politics, historical events, wild animals, North Africa (visited in 1832). Before the 1830s produced set-piece works for the official Salon (now mostly in the Louvre). Had complex working methods, which produced much preliminary work, often sketches: these are what you will most often see outside Paris.

🔎 Note how he uses colour as the main means of expression: colour and the play of light keep the eye always on the move, without a specific point of focus or climax. Loves rich materials and textures, lush reds and intense, coppery greens. His later work exploits colour theory and uses complementary colours and the colour wheel. After 1833 his major works are set-piece official commissions (for the Bourbon Palace, for instance), which can only be seen in situ. His *Journal* is essential reading.

1. Eugène Delacroix, *The Death of Sardanapalus*, 1827
2. Richard Deacon, *Kiss and Tell*, 1989
3. Edgar Degas, *The Rehearsal*, c.1877

🏛 Paris: Musée du Louvre; Palais
Bourbon; Palais du Jardin du
Luxembourg; Church of St Sulpice;
Musée Delacroix

⊕ (73) £297/$427 – £153,698/$245,917

🔨 £4.65m/$7,765,500 in 1998,
Choc de cavaliers arabes (oil p.)

DELAUNAY Robert MM
1885–1941 French

One of the pioneers of Modern art who
sought new types of subject matter and
made an early breakthrough to abstract
painting. Much supported by Russian-
born wife, Sonia, who produced equally
talented art in a similar style, and was also
a noted theatre and textile designer.

◑ His early work takes modern
themes such as cities, the Eiffel Tower,
manned flight and football. Delaunay
used colour in a free and highly inventive
way, most famously in his discs, which are
abstract, lyrical, full of light and pleasure,
and intended to celebrate the emotional
and joyful impact of pure colour. He
believed that colour alone could be
the main subject of serious painting.

🔎 If you can see his work set out chronologically, note how he works slowly, step by step, towards his abstract painting. In these abstract works let the colours fill your eye and enjoy the visual impact: it is like listening to Romantic music. You can work at analysing the colour combinations but, don't let that activity overwhelm the total impression or sensation.

🅐🅥 (14) £2,469/$4,000 – £2,781,457/$4.2m
🏹 £2,655,367/$4.7m in 1991, *Premier disque* (oil p.)

DELVAUX Paul ᴍᴍ
1897–1994 Belgian

Loner who created a limited and repetitive *oeuvre* of finely detailed, vaguely erotic and symbolic, night-time dreamland images around themes of naked women, semi-deserted railway stations or landscapes, and classic buildings. Admired by, but never allied with, true Surrealists. Influenced by Magritte and the De Chirico exhibition of 1926. Deceptively unprofound.

🅐🅥 (131) £273/$444 – £2.9m/$4,698,000
🏹 £2.9m/$4,698,000 in 1999, *Le miroir* (oil p., 1936)

DEMUTH Charles NH
1883–1935 American

Leading Precisionist of the 1920s and 1930s who produced small-scale views of industrial architecture (factories, water towers and silos), carefully painted with a front-on view and emphasis on simplified geometry. Note his subtle colours and acute observation of light and shade, and the total absence of human presence.

🅐🅥 (14) £938/$1,500 – £244,755/$350,000
🏹 £474,684/$750,000 in 1992, *Welcome to our city* (oil p., 1921)

DENIS Maurice ᴍᴍ
1870–1943 French

Leading Symbolist who led the reaction against Impressionism. Driven by theory, not what the eye sees. Founder member of Nabis.

🌑 His works demonstrate his art theory: no realistic representation, insignificant subject matter; small-scale

1

2

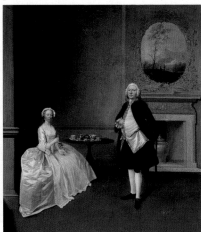

easel painting is king. The result is paintings with a deliberately flat, decorative, stylised or Art Nouveau appearance; strange colours; trivial, everyday subjects. As effective (more so?) with his stage and costume design and book illustrations. Committed Catholic who applied his art to the service of church decoration.

- ⓐ (65) £503/$759 – £322,129/$467,087
- ⚒ £322,129/$467,087 in 2000, *Les communiantes, la promenade au jardin* (oil p.)

DENNY Robyn CS
1930– British

Large, abstract, geometric works based on human scale and proportion. Uses flat, sober colours, vertical, symmetrical, upright compositions. His underlying theme is moral: the virtues of self-discipline, obligation and sobriety.

- ⓐ (6) £450/$707 – £1,100/$1,804
- ⚒ £1,600/$2,640 in 1997, *A day 3* (oil p., 1968)

DERAIN André MM
1880–1954 French

Best remembered as Matisse's main partner in creating Fauvist paintings in the South of France, in the early 20th century. One of the first to take an interest in African sculpture.

- ☽ His early works were extremely influential in the development of the use of colour in Modern art. Stayed (mostly) with traditional landscape themes, with an important series of views of London (River Thames) painted in 1906. Then he unwisely abandoned colour and concentrated on form. His later work is mediocre and currently overrated.

- 𝒫 Early work is notable for attractive paint handling, open brushwork, and strong, confident compositions. He makes subtle use of colour, exploiting colour harmonies as well as colour contrasts, and placing half-tones and full tones together. Intensifies local colours, but never gets away from them (unlike Matisse). Thus skies are always blue, leaves green (Matisse's skies can be yellow, green… anything).

- ⓐ (104) £324/$518 – £111,801/$180,000
- ⚒ £5.6m/$8.79m in 1989, *Bateaux dans le port, Collioure* (oil p.)

DEVIS Arthur NH
1711–87 British

Small-scale family conversation pieces with doll-like figures (he used dolls as models), neatly dressed and arranged in their houses and parks. Successful with the newly emerging middle classes. Gives us a charming and authoritative insight into 18th-century society.

- ⓐ (7) £2,000/$3,240 – £55,000/$78,650
- ⚒ £95,000/$143,450 in 1992, *Portrait of gentleman standing by tree, Belvoir Castle beyond* (oil p., 1763)

DEWING Thomas Wilmer NH
1851–1938 American

Painter of accomplished works depicting elegant, stately, distant women in tastefully furnished interiors or wandering in lush, dreamy landscapes. They are often large in scale and were turned into Japanese-style screens. Also produced studies for the above, pastels and silverpoints. Good example of Aestheticism – a pot-pourri of Pre-Raphaelites, Whistler and Japan. Note the frames.

- ⓐ (3) £15,541/$23,000 – £189,189/$280,000
- ⚒ £189,189/$280,000 in 2000, *Woman in black, portrait of Maria Oakey Dewing* (oil p., 2887)

DIBBETS Jan CS
1941– Dutch

Photographer (black-and-white and colour) and installation maker.

☻ His photos are to be admired for their rigorous and meticulous qualities – formal and dry – and their limited experiments with perspective and space, rather than their inventiveness or revelation. Also produces installations that are strong sociological or political observations and critiques of capitalism, especially of the museum and art world's links to big business.

☻ His photo experiments are said to be part of a traditional Dutch interest in perspective and order that goes back to Saenredam via Mondrian. Maybe, but Dibbets does not have their feel for the poetry of space and light.

Ⓐ (4) £1,800/$2,718 – £20,270/$30,000
⚒ £37,500/$60,000 in 1995, *Octogon II* (collage, 1982)

DIEBENKORN Richard MM
1922–93 American

An American West Coast Matisse (much taken with Matisse). Talented, influential, very visual, but lacked the master's range and tough-minded certainty.

☻ His early abstracts (abstraction from nature) of 1948–56 are reactions to specific places (colour, topography, light). Vigorous figurative work from 1956, with bold, simple designs, glowing colour and juicy paint. Return to abstraction with the 'Ocean Park' series (from 1966); these works are large scale, translucent, investigative and statuesque. It is important to see pieces by natural light – hard, artificial light kills subtleties. Don't rush: let the eye bask and play.

🔎 His most confident work is figurative. His abstracts are always oddly tentative – justified as sensitive, responsive, and so on, but somehow he could never reach that final distillation of sensation that so distinguishes Matisse. His early abstract work can be repetitive and unstructured, and can kill colour (perhaps the reason he moved on to figuration?). Stunning response to light (as good as Hopper's). Lovely small-scale works (cigar-box lids 1976–9) and late works (still small, as a heart disease prevented him from working large scale).

Ⓐ (35) £1,840/$3,000 – £761,589/$1.15m
⚒ £2,181,818/$3.6m in 1998, *Horizon – Ocean View* (oil p., 1959)

DILLER Burgoyne NH
1906–65 American

One of the most important American abstract artists. Produced 3-D abstract painted reliefs and geometric paintings. Simple shapes, primary colours on white or black, and understated brushwork. Much influenced by Mondrian and the Dutch De Stijl movement, both in appearance and in his aspiration for social and spiritual reformation.

Ⓐ (4) £2,917/$4,200 – £3,704/$6,000
⚒ £61,290/$95,000 in 1995, *First Theme 1959–60* (oil p.)

DINE Jim CS
1935– American

Pioneer of Pop art. Makes constructions with a strong biographical element in which tools (childhood memories of grandfather's hardware store), paint, palettes (artist's studio) and domestic objects are prominent. His work is full of wit and simple poetry, released by sensitive juxtaposition of objects, colour and stencilled labels.

Ⓐ (63) £532/$850 – £98,765/$160,000
⚒ £379,747/$600,000 in 1996, *Hearts* (oil p., acrylic on 57 canvases, 1969)

DIX Otto MM
1891–1969 German

Mocking, bitter observer and recorder of German society during World War 1 and the 1920s and 1930s as its moral and social values collapsed. Fascinated by ugliness – reflected in a powerful distortion of realistic observation with intense line, detail and acid colour, expressed in portraits of friends and powerful engravings. Anti-Nazi, but had no personal political agenda. Recognised only after 1955.

- (177) £667/$1,067 – £3.3m/$5,445,000
- £3.3m/$5,445,000m in 1999, *Portrait of the lawyer Dr Fritz Glaser* (oil p.,1921)

1

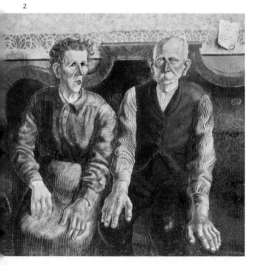

2

DOBSON William NH
c.1610–46 British

Brief career as a painter to the doomed court of Charles I at Oxford. Only 50 known paintings: nothing known pre-1642. Robust, direct style. Half-length portraits: red-faced, earthy, conservative male subjects with classical allusions and visual references, which emphasise the sitter's learning or bravery (or both).

- £92,000/$161,920 in 1992, *Portrait of Sir Thomas Cricheley* (oil p.)

DOIG Peter CS
1959– British

British born and trained, but childhood and adolescence in Canada. Effective, no-nonsense paintings with a high degree of personal content, such as his love of skiing or pop concerts. Openly works from photographs and films. Has an able, relaxed technique that suits his subjects. Uses sharp colours. Good design and atmosphere. Post-Impressionism brought up to date.

- (8) £5,634/$8,000 – £98,592/$153,900
- £98,592/$153,900 in 1999, *Lunker* (oil p., 1995)

DOLCI Carlo OM
1616–86 Italian

Florentine who was prolific and famous in his own day, but is now totally out of fashion and ignored. A very slow worker (it could take him a week to paint a foot), he understandably worked on a small(ish) scale. Noted for portraits and religious, storytelling pictures of pious intensity (he was saintly, even as a child). Technically competent, with bold colours and graceful figures – but derivative, not original.

- (3) £1,290/$1,935 – £48,276/$70,000

£420,000/$693,000 in 1997, *Christ in the House of the Pharisee* (oil p.)

DOMENICHINO (Domenico Zampieri) OM
1581–1641 Italian

Bologna born, worked in Rome and Naples. Small in stature (Domenichino means 'little Dominic'). Look for idealisation that is influenced by Raphael and antiquity (unlike his contemporary Caravaggio). Harmonious classical landscapes with mythological themes. Figures with expressive gestures that symbolise emotion but do not embody expression.

- ⏣ (3) £2,800/$4,088 – £1,840,491/$3m
- ➤ £1,840,491/$3m in 2000, *Rebuke of Adam and Eve* (oil p.)

DONGEN Kees van MM
1877–1968 French

Dutch born but considered an honorary Frenchman (settled in Paris in 1897). Best remembered for the work he produced from 1905 to 1913: genuinely original, boldly painted works, in saturated vibrant colours, which made him one of the leading Fauve painters and placed him almost on a par with Matisse. Later work is lively, but repetitive and unimaginative.

- ⏣ (134) £745/$1,200 – £1.25m/$1,887,500
- ➤ £2m/$3.32m in 1997, *Femme au grand chapeau* (oil p., 1906)

DOSSI Dosso OM
c.1479–1542 Italian

Somewhat obscure Venetian painter in the mould of Titian and Giorgione – moody, poetic, sensuous, using rich light and colour. He painted myths, allegories, portraits, lush landscapes and frothy trees. Had a liking for animals. Few works remain, most of which are badly damaged. It is fashionable to say he is wonderful – he ought to be, but he is somehow ungainly and gauche.

- ⏣ (1) £900,000/$1,395,000
- ➤ £2.1m/$3,255,000 in 1989, *Allegory of fortune* (oil p.)

DOU Gerrit (or Gerard) OM
1613–75 Dutch

Remembered as Rembrandt's first pupil (age 15). Small-scale works with fine detail, high, glassy finish, brilliant colours, focused light and shade (he trained initially as an engraver and glass painter). A conjurer's world, dedicated to self-conscious illusion, obsession with showmanship, skilful special effects and hidden symbolism.

- ⏣ (2) £42,587/$66,861 – £208,589/$340,000
- ➤ £208,589/$340,000 in 2000, *Old Hermit* (oil p.)

DOVE Arthur Garfield NH
1880–1946 American

Shy, reclusive farmer manqué, keen sailor. First American artist to paint an abstract picture (1907–9). Produced small-scale lyrical work, derived from a true love of land and seascape, full of natural shapes, rhythms and essences of nature; also witty collages and assemblages. Unappreciated in his lifetime.

- ⏣ (6) £5,793/$9,500 – £312,500/$500,000
- ➤ £393,939/$650,000 in 1997, *Long Island* (oil p.)

DUBUFFET Jean MM
1901–85 French

Painter, sculptor, printmaker, collector and writer. Son of a wine merchant. Turned full-time artist in 1945 after an early life of

sculpture. Sought intensity, not beauty. Promoted Art Brut and tapped into the unschooled creativity of children and psychotics.

➲ Raised naïvety to the highest level of sophistication and knew exactly what he was doing – one of the few occasions

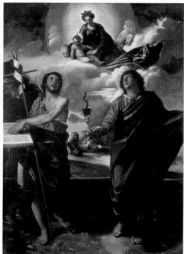

trade, military service, divorce and dilettantism. Developed a challenging and consciously anti-aesthetic, anti-art establishment style – but ended up as the art establishment's favourite example of radical chic.

➲ His art went through a succession of cycles. In each case he had a thought-out agenda and different experiments with materials, which he then promoted via exhibitions: 1942–50 portraits and graffiti; early 1950s obese nudes in smeary oil paint; late 1950s 'Earth' themes and sand-gravel textures; 1960s black outlined 'jigsaw' style and polystyrene

where this 'game' works. The trouble with most *faux naïf* work is that you have no idea (unless told) whether the work is to be admired because it is by an untrained and innocent eye, or by an over-educated sophisticate trying to amaze us by how 'simple' he or she can be.

🏛 Paris: Périgny-sur-Yerres (Dubuffet Foundation)
🔨 (159) £1,010/$1,596 – £1.28m/$2,073,600
🪓 £2,797,619/$4.7m in 1990, *Pèse cheveu* (oil p., 1962)

DUCCIO DI BUONINSEGNA AG
active 1278–1319 Italian

Key early Sienese painter who influenced all those that came afterwards (just as Giotto influenced Florentine artists).

☽　He tells a story with tenderness and humanity. He is not as innovative in style or technique as Giotto, who was his contemporary, but he is a better narrator of events. Look at the way the people act and react together, and the way he uses the setting as part of the narrative. The perspective and scale may be haywire, but the buildings still look real and lived-in, and may be arranged so as to divide up the constituent parts of the story.

🔎　Paints no-nonsense (slightly sceptical?) faces with long, straight noses, small mouths and almond-shaped eyes, which can be rather sly. His hand gestures help tell the story. Makes decorative use of colour, notably blue, red and pale green. Some of the oddities or quirkiness can be explained because his style is not actually of the Renaissance: it is essentially Byzantine and Gothic – that is, old-fashioned, but with a new twist, rather than completely new like Giotto's.

DUCHAMP Marcel MM
1887–1968 French

The father of Conceptual art. Applauded as one of the great gurus and heroes of the Modern Movement, but his work is possibly one of its greatest bores (it is possible to achieve both at the same time).

☽　The ragbag of his few works are now icons of the Modern Movement (notably the urinal). None are very interesting to look at per se, but Duchamp was the first to propose that the interest and stimulus of a work of art can lie solely in its concept or intellectual content – it doesn't matter what it looks like, as long as you can pick up the message.

🔎　To speak ill of Duchamp is to invite the wrath and derision of the entire modern art establishment. However, although he was significant in his day, in all honesty his work is quite limited and now looks distinctly tired. Not quite a case of the Emperor's clothes, but time to say that the suit is now threadbare and old-fashioned. A brilliant, charming but arrogant, intellectual thug who continues to mesmerise and intimidate the art world from beyond the grave.

Ⓐ　(33) £2,593/$4,095 – £993,789/$1.6m
⚒　£993,789/$1.6m in 1999, *Fountain (The Urinal)* (sculpture, 1917)

DUFY Raoul MM
1877–1953 French

Talented painter who in his early days might have made the big time with Braque and Matisse – but who lacked their grit. Best known for accomplished, colourful, decorative works, much admired by the fashionable *beau monde* of the 1920s and 1930s. Free, linear drawing; clear, floating colours; easy subjects such as horse racing and yachting. Prints and tapestry designs.

Ⓐ　(294) £291/$469 – £310,559/$500,000
⚒　£1.5m/$2,42m in 1990, *Le 14 Juillet au Havre* (oil p.)

DUGHET Gaspard OM
1615–75 French

Brother-in-law of Poussin. Very popular in the 18th century, but few works can be confidently attributed to him. Produced decorative landscapes in which he tries almost too hard to combine the heroic qualities of Poussin with the pastoral qualities of Claude. Ought to be very good, but frequently disappoints.

Ⓐ　(14) £2,484/$4,000 – £60,976/$100,000

1. Marcel Duchamp, *Fountain (Urinal)*, 1917
2. Gaspard Dughet, *Classical landscape with figures*, c.1672–5
3. Albrecht Dürer, *The Vision of The Seven Candlesticks*

🪓 £ 72,000/$ 108,000 in 1994,
*Italianate wooded river landscape
with fishermen on boat* (oil p.)

DÜRER Albrecht AG
1471–1528 German

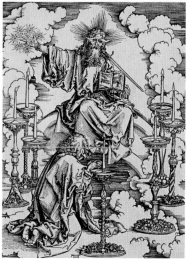

The greatest northern artist of the
Renaissance. Born (4 years before
Michelangelo) in Nuremberg, he was
prolific, tenacious, immensely ambitious
and very successful. Follower of Luther.
Went on key visits to Italy in 1494 and
1505.

🖐 Uniquely and subtly synthesised
(often in the same work) characteristics
of the old northern or mediaeval tradition
and the new Italian and humanist
discoveries. Look for northern features
– apocalyptic imagery; emotional
expression; complexity of design; crisp,
angular line; minute observation of detail.
Note also the Italian features – dignified,
composed, assured figures and faces;
soft, rounded modelling; perspective and
foreshortening; classical architecture;
New Testament subjects; nudes.

🔍 Highly gifted but self-conscious
as a painter, he was greater, more at ease
and more innovative as a printmaker –
produced powerful woodcuts and
pioneering engravings. Was a brilliant
draughtsman and painted exquisite
watercolours. His portraits have strong
lines; curious, lopsided faces with
enlarged eyes that have liquid surfaces;
beautiful, strong hands and feet. He
was fascinated by landscape, plants
and animals, and anything unusual.
Also look for objects as symbols.

🏛 Munich: Alte Pinakotek
London: British Museum (prints)
Vienna: Albertina (watercolours)
Ⓐ (157) £1,534/$2,163 –
£262,195/$430,000

79

🪓 £262,195/$430,000 in 1999,
Goddess Isis kneeling with hands folded (drawing)

DYCE William NH
1806–64 British

Born in Scotland, educated in London and Rome. Made his reputation as a portrait painter but wanted to be a religious painter. Director of Government School of Design (commission for rebuilt Houses of Parliament). Anticipated the Pre-Raphaelites' interest in early Italian art and detailed realism.

🪓 £3,200/$5,120 in 1995,
Fisherfolk (oil p. 1830)

DYCK Sir Anthony van AG
1599–1641 Flemish

Antwerp-born infant prodigy from a family of silk merchants. Best remembered for his portraits, especially those of the ill-fated court of King Charles I of England (who was beheaded in 1649). He died relatively young.

🔹 As well as portraits, look for religious and mythological subjects (the stock in trade of all artists of the time). Also painted rare landscape watercolours. His brilliant but restrained technique reflects the elegance, fineness and impeccable taste and breeding assumed by his sitters – those subtly elongated fingers, bodies, noses and poses, and the rich but unflashy silks and satins. Even his martyrs suffer with perfect manners.

🔍 Notice that air of aristocratic privilege (still around today). Van Dyck set the ultimate role model, much copied in (notably British) portraiture and life: the aloofness, disdain and reserve adopted by people wishing to appear consciously set apart. These faces never smile; they know their duty and they will fight to retain their privileges to the end (the Divine

Right to Rule). Painted wonderfully sensitive images of children. Realistic details, especially hair.

🏛 London: National Gallery
Edinburgh: National Gallery of Scotland
🪓 £800,000/$1.24m in 1989,
Portrait of Mary, Princess Royal (oil p.)

EAKINS Thomas MM
1844–1916 American

Philadelphia born and bred. Studied in Paris and Spain; was a gifted teacher at the Pennsylvania Academy. Said by some to be the greatest of all American artists, but he was little honoured in his lifetime. Pragmatic but difficult, unyielding personality. Keen boatman.

🔹 His frank, candid portraits are of people from a fairly narrow social circle.

He had more interest in status, achievement and position in society than in personality – and responded best to achievers (he was one himself). His middle period (from 1869 onwards) features matter-of-fact successful professionals; his later period is more dreamy. Had a deep interest in science, medicine, and how things work. Used human anatomy, motion and perspective to make his pictures work.

ꝑ Look for imaginative poses and movement; workman-like hands; rich, dark colour harmonies; atmospheric 19th-century interiors. He uses extra objects or incidents to tell the story behind a portrait, and light to animate compositions. Likes colour and emotion but is even more interested in shadows – notice how he uses them to create space. Has any other painter observed shadows so accurately?

ⓐⓥ (3) £3,793 /$5,500 – £31,788 /$48,000

⚒ £1,893,490/$3.2m in 1990, *John Biglin in a Single Scull* (drawing, 1873)

EARL Thomas NH
1751–1801 American

Prominent member of a family of craftsmen and artists; loyalist who quit America for England in 1778, returning in 1785. Notable for portraits of Connecticut patrons – typically, a plain likeness in their own familiar setting. His sketches of the sites of the battles of Lexington and Concord were turned into popular prints. Bigamist, carouser, failed businessman.

⚒ £139,073/$210,000 in 1996, *Portrait of John Phelps* (oil p. 1792)

EGG Augustus Leopold NH
1816–63 British

Best known for moral tales of Victorian life – small scale and carefully painted – warning about the shame that befalls those who are 'bad' (offend social proprieties) and the reward for those who are 'good' – a function now performed by TV soap opera rather than 'art'.

ⓐⓥ (1) £2,500/$3,750

⚒ £7,500/$13,425 in 1991, *Victim – scene from le diable boiteux* (oil p. 1842)

ELSHEIMER Adam OM
1578–1610 German

Popular, early practitioner of small-scale ideal landscapes. Spent his working life in Italy. Very influential on artists such as Rubens, Rembrandt and Claude. Lazy – should have painted more pictures.

⚜ Full of the kind of remarkable precision and detail that you see when looking down the wrong end of a telescope. All his works are painted on copper plates, which allows such fine detail (he must have had brushes with only one bristle).

ꝑ Often used several sources of light in one picture, such as sunset and moon, daylight and torchlight. Painted charming trees, which look like parsley.

ⓐⓥ (2) £2,438/$3,657 – £7,418/$10,617

⚒ £271,084/$450,000 in 1990, *St Jerome in the Wilderness* (oil p.)

EMIN Tracey CS
1963– British

She of the now notorious unmade bed. Candidate for (but not winner of) Turner Prize, Tate Gallery 1999. All her work is a public and manic working out (exorcism) of her traumatically unhappy youth and adulthood (rape at 13; endless promiscuity; transient relationships; abortion). Is it art or a cry for help? Where does she go from here?

⚜ Can a cry for help, alone, make art? Van Gogh cried for help, but used art as a

means of attempting self-reconstruction and had a vision of a better world he wished to create for himself and others. Without this sort of reaching out, there is always a danger of simply lapsing into self-indulgence and self-pity – which may be necessary personally, but it isn't art.

- Ⓐ (6) £800/$1,208 – £95,000/$136,800
- ⤴ £150,000/$252,000 in 2000 , *Unmade bed* (sculpture, 2000)

ENSOR James MM
1860–1949 Belgian

Talented loner remembered for his eccentric, brightly coloured, nervously painted and macabre imagery (skulls, skeletons, self-portraits, suffering Christ), much of it deriving from childhood memories of objects in his parents' souvenir shop. Best work between 1885 and 1891 (he tends to repeat himself after that). Belated recognition. High-quality drawings and engravings.

- Ⓐ (58) £330/$522 – £122,093/$200,233
- ⤴ £420,000/$705,600 in 1998, *Pierrot et squelettes* (oil p., 1907)

ERNST Max MM
1891–1976 German

One of the leading Surrealists, initially a member of Dada in Cologne. Lived in France after 1921 (and in the USA from 1941 to 1956).

◑ His witty and inventive experimentation unites subject and technique to great effect. Pioneer of the Surrealist desire to explore the subconscious and create a sense of disturbing out-of-this-world reality. His experimental techniques were a means of activating or liberating his own imagination and, by extension, ours. Don't be tempted into an overly serious, analytical or historical approach to his work. Relax – enter into the imaginative play he sets up.

🔍 Look for his own childhood memories, such as forests and little bird 'Loplop'. Enjoy his unusual techniques: witty play with collaged images (one of the first to use them); frottage (rubbed patterns); and decalcomania (liquid paint patterns), where accident is used to liberate images in the subconscious. Early strange, figurative images that seem to be painted dreams. Later work is more abstract and lyrical, but loses bite. Better when small scale.

- Ⓐ (156) £735/$1,183 – £909,091/$1.3m
- ⤴ £1,165,854/$1.79m in 1989, *Les filles de l'artiste* (oil p.)

1

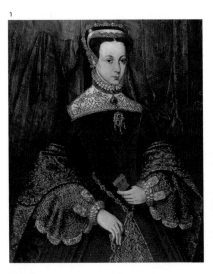

2

ESTES Richard CS
1932– American

The king of Photorealism. Uses many of the same techniques as Canaletto, but not place-specific. His views could be of any modern city.

🌑 His fine, detailed paintings of the modern urban streetscape look at first sight as though they are merely enlarged photographs – but they are not. Estes paints from photographs to create a highly complex, composite view that heightens reality in a way impossible in a single photograph, but it gives the illusion of freezing a split second, as does a photo.

🔍 Produces carefully organised compositions that divide the scene into distinct areas – for example he might create a diptych. Uses a multipoint perspective or viewpoint and reflecting windows to show what is happening outside the picture frame, behind the back of the viewer. Note the absence of human figures and activity. Rich, intense colour harmonies. Within his self-imposed limitations he creates haunting, moody images that have beauty and detachment.

💰 (10) £5,031/$7,500 – £295,775/$420,000
🔨 £295,775/$420,000 in 2000, *Gourmet Treats* (oil p. 1977)

EWORTH Hans OM
c.1520–c.1574 Flemish

Antwerp born. Arrived in England in 1549. Difficult to identify. Look for very pale faces with tight, hard eyes; carefully observed and outlined figures, encased in lavish costumes and jewellery.

🔨 £12,000/$23,640 in 1990, *Portrait of a gentleman aged 27 with fur trimmed cloak by table* (oil p., 1556)

EXTER Alexandra MM
1882–1949 Russian

Leading member of Russian avant-garde. From Kiev, but well travelled (Paris, St Petersburg, Western Europe). Effective emissary between the avant-garde movements in Russia and the West. Active studio in Kiev. Left Russia in 1924. Sophisticated work with strong French-Italian appearance and sensibility. Designs for book illustrations, theatre, film, ceramics, textiles.

💰 (5) £2,300/$3,703 – £60,000/$84,600
🔨 £690,000/$1.78m in 1989, *Composition* (works on paper)

EYCK Jan van AG
c.1390–1441 Netherlandish

Artist-cum-diplomat in service of Philip the Good, Duke of Burgundy. Obscure origins. Only known work is from 1430s onwards. Key exponent of Netherlandish art and oil painting.

🌑 First painter to portray the merchant class and bourgeoisie. His work reflects their priorities, such as having their portraits painted; taking themselves seriously (as donors of altarpieces, for example); art as the imitation of nature; art as evidence of painstaking work and of craftsmanship; prosperity and tidiness; wariness; restrained emotion. Had a brilliant oil-painting technique, which he was the first to perfect – luminous, glowing colours and minute detail.

🔍 His three-quarter pose of face brought new realism to portraiture. Painted Madonnas that look like house-wives, and saints that look like business-men. Precise delineation of all facial features, especially the eyes. Was fascinated by ears (they are miniature portraits) and by folds in cloth. Notice the fall of light that unifies the objects and models them. Convincing but empirical perspective. Note also the

inscriptions on paintings and the rich symbolism.

- 🏛 London: National Gallery
Ghent (Belgium): St Bavon Cathedral
Paris: Musée du Louvre
- 🪓 £90,090/$1m in 1985, *The Three Maries at the Sepulchre* (oil p.)

FABRIANO Gentile da AG
c.1370–1427 Italian

The most accomplished exponent of the International Gothic style. Worked all over Italy. Most of his work is lost or destroyed.

- 🌑 Was able to turn a work of art into a highly luxurious object (a characteristic of the International Gothic style) rather than a window on the world (Renaissance). Some of his work could almost be fabulous textiles woven with gold thread.

- 🔍 Notice his use of tooled gold and patterned textiles, the flat and static quality of the figures and background (no real space, perspective or movement). Created delicate, unreal figures with pink cheeks. Paid great attention to natural detail – animals, birds, plants – which he recorded with delicacy and sympathy.

- 🪓 £345,572/$497,624 in 1986, *L'annonciation* (oil p.)

FABRITIUS Carel OM
1622–54 Dutch

Had a tragically short life, and less than 10 authenticated works are known. Immensely talented – Rembrandt's best pupil. Painted portraits, still lifes, genre, perspectives. Died in a gunpowder explosion in Delft, near his studio, which destroyed most of his work.

- 🌑 Used thick impastoed paint next to thin glazes (like Rembrandt). Preferred cool colours to Rembrandt's dark reds and browns. Sometimes silhouetted a dark figure against a light background (Rembrandt liked light figures against a dark background).

- 🪓 £598,006/$771,428 in 1985, *Mercure et Argus* (oil p.)

FABRO Luciano CS
1936– Italian

Currently working on elegant, refined, carved sculptures using traditional materials, such as marble. Takes delight in visual and physical properties of material. Interested in craftsmanship and aesthetics – a contemporary interpretation of a tradition that goes back to classical Greece. His work needs sunlight to bring it to life.

- 🌑 Enjoy his work for what it is. Let it play freely on your imagination through your own eyes. Close your ears to the wordy jargon of those cataloguers and curators who spend more time looking at keyboards and playing with words than looking at works of art. These works have all the gloriously refined qualities of haute couture: they are an open invitation for the eye and imagination to have a truly fulfilling private feast.

- 🪓 £42,484/$65,000 in 1993, Efeso (sculpture, 1986)

FANTIN-LATOUR Henri OM
1836–1904 French

Painter of allegories inspired by music (especially Wagner), still lifes and stodgy, wooden portraits with sitters who look distinctly uncomfortable or bored. Flowers and fruit are highly worked and end up looking artificial. Benefitted from close connections with his more gifted artistic contemporaries.

- AV (63) £403/$646 – £2,237,762/$3.2m
- 🪓 £2,237,762/$3.2m in 2000, *Bouquet de fleurs* (oil p., 1889)

1

2

3

Ⓐ (140) £801/$1,282 –
£650,000/$936,000

🔨 £953,405/$1.49m in 1989,
Mellingen (oil p., 1910)

FELIXMÜLLER Conrad MM
1897–1977 German

Committed anti-bourgeois painter
who used art as an instrument of social
and political agitation. Painted images
of the harshness of modern industrial
life and landscape, and of persecuted
intellectuals. Makes his point through
crude colour, expressive distortion and
fragmentation. Persecuted by Nazis,
rehabilitated in Adenauer's Germany.
A familiar 20th-century story.

Ⓐ (44) £1,082/$1,742 –
£158,000/$227,520

🔨 £115,000/$189,750 in 1999
*Selbstbildnis mit meiner Frau Londa
und meinem Sohn Titus* (w/c, 1923)

FEININGER Lyonel MM
1871–1956 American/German

New York born and based, but spent most
of his life in Germany (1887–1937). Quiet,
personal style, in appearance akin to a
broken glass pane, in which buildings
and seascape are the central subject.
Blended Cubist fragmentation of form (he
studied in Paris) and the misty light and
dreaminess of Romanticism (his German
heritage). Founder member of the
Bauhaus. Talented printmaker (etchings).

🌑 Influenced set designs for early
films such as Max Reinhardt's *Cabinet of
Doctor Caligari.*

FERGUSSON John Duncan NH
1874–1961 British

One of the four Scottish Colourists
(with Cadell, Hunter and Peploe).
Self-taught. Travelled a lot in early life
(France, North Africa). Influenced by
French post-Impressionism, especially
Cézanne. Developed from freely painted
to structured colour. Sincere and
dedicated artist who, though derivative,
combines spontaneity, calculation,
observation and modernity.

- ⓐⓥ (80) £550/$809 – £125,000/$182,500
- ⚒ £125,000/$182,500 in 2000,
 Crème de menthe, Café d'Harcourt
 (oil p., 1909)

FILDES Sir Luke NH
1843–1927 British

Very successful and popular pillar of
the establishment who freshened stale
Victorian academic tradition with a whiff
of acceptable new French ideas – loose
paint handling, modern subjects, and an
interest in light. Portraits, landscapes,
social themes. His *Doctor* was one of the
most internationally popular paintings
of the late 19th century.

- ⓐⓥ (4) £480/$797 – £1,220/$1,951
- ⚒ £250,000/$462,500 in 1992,
 The Village Wedding (oil p., 1883)

FISCHL Eric CS
1948– American

Produces large-scale figurative
work deliberately creating a sense
of awkwardness, embarrassment,
tension and self-consciousness through
subject and technique. Old-fashioned,
deliberately inept, seeming, style.
Subjects suggest 'soft porn' stories
of taboo and shameful private acts
and fantasies. Alludes to, but does
not confront, discomforting issues
of race, sex and class.

- ⓐⓥ (14) £4,012/$6,500 –
 £608,108/$900,000
- ⚒ £608,108/$900,000 in 2000,
 Noonwatch (oil p., 1983)

FISCHLI Peter and WEISS David CS
1952– and 1946– Swiss

Artistic duo who produce installations
occupying an entire gallery that may well
look exactly like equipment or material
that the builders and decorators have
stacked together while preparing the
building (in fact everything is made from
polyurethane and clay, and meticulously
painted). They also make films and
photos of tourist attractions. Banal
reality subverted and subtly distorted.

- ⓐⓥ (7) £4,225/$6,000 –
 £56,338/$80,000
- ⚒ £56,338/$80,000 in 2000, *Untitled,
 Sausages* (Photographs, 1979)

1

FLANAGAN Barry CS
1941– British

Inventive, witty, free-spirited artist, with a strong sense of the absurd. Reacted against Caro's art-school, steel-girder orthodoxy. His early, irreverent assemblages are made from sand, hessian, rope and glass. Now he is famous for his bronze leaping, boxing or cavorting hares, which parody traditional heroic statuary and have the same frisky fun as the artist himself.

- Ⓐ (9) £2,500/$4,050 – £220,000/$332,200
- ⚒ £220,000/$332,200 in 2000, *Drummer* (sculpture, 1989)

FLAVIN Dan MM
1933–96 American

Noted for constructions using plain and coloured fluorescent tubes, and neons, usually arranged across a corner of a darkened empty room. Claimed to be playing with the space of the room; illuminating dull corners (of life?), and expressing mystical notions about light. Early nostalgic references to Russian Constructivists.

2

- Ⓐ (26) £1,181/$1,700 – £211,268/$300,000
- ⚒ £211,268/$300,000 in 2000, *Alternate Diagonals of March* (sculpture, 1964)

FLINCK Govaert OM
1615–60 Dutch

A pupil of Rembrandt in the 1630s and strongly influenced by him in style and subject matter, but generally lighter, more elegant and less serious or gloomy. Prolific and much esteemed in his own day. Recent revival of interest due to reattributions by the Rembrandt Commission – several so-called Rembrandts are now said to be by Flinck.

- Ⓐ (5) £2,800/$4,536 – £34,000/$53,380
- ⚒ £211,039/$325,000 in 1996, *Young man holding Ottoman short sword* (oil p., 1644)

FONTANA Lucio MM
1899–1968 Argentinean/Italian

An unknown who in middle age became a significant figure in postwar European art, finding a successful if limited 'formula' that was in tune with the mood of the times.

- ◑ Most famous for monochrome canvases with single or multiple precision cuts, and for canvases and supports that have been pierced or lacerated. Modest scale. Can be very good indeed – but can be oh, so dull! Better when several works are seen together – a single work can look merely superficial or silly. Limited idea, which he used best when it was new. Later work becomes very coarse and tired.

- 🔎 The cuttings and piercings had a meaning in the 1960s, as part of a (then new, but now worn out) exploration of the meaning of existence and the role

1

2

3

4

FOUJITA Tsuguharu (Leonard) MM
1886–1968 Japanese/French

Tokyo born, of a Samurai family. Went to Paris in 1913. Mixed with avant-garde artists such as Chagall, Modigliani and Soutine. Developed a delicate, personal, expressive style, which notably synthesised Western and Japanese traits; nudes, still lifes, quality lithographs. Called himself Leonard – after Da Vinci. Look indeed for wistful, pointed faces, reminiscent of Leonardo's.

Ⓐ (134) £695/$1,066 –
 £590,062/$950,000
🔨 £3,254,438/$5.5m in 1990,
 Jeune fille dans le parc (oil p., 1957)

FRAGONARD Jean-Honoré AG
1732–1806 French

Precocious, successful, happily married – much favoured by the *ancien régime* for his easy-to-enjoy, virtuoso and titillating private paintings. Rejected the trappings

of art. Perhaps they are now best seen as engaging period pieces with an innocent 1950s or 1960s view of the creative act and gesture as a bid for freedom (and he was over 50 when he started them). His earlier ceramic work searches for a freedom of expression, but he needed a different medium to find full utterance.

Ⓐ (177) £520/$765 –
 £620,000/$936,200
🔨 £620,000/$936,200 in 2000,
 Concetto spaziale, all alba Venezia era tutto d'argento – at dawn, Venice was all in silver (oil p., 1961)

of official art. Died in poverty after the French Revolution.

🕭 The participants in his pictures of love and seduction may be in contemporary dress, from mythology, or have no clothes at all. He likes pink cheeks and heaving bosoms, sidelong glances, passionate embraces, and futile resistance. Even his drapery, landscape backgrounds, foliage and clouds froth with erotic intensity.

🔎 His exciting, nervous but confident style of painting admirably suit his subjects. Uses a seductive pink-and-green palette; and soft, dappled light, which prefigures Renoir's. Paints charming hands with long, delicate fingers that enjoy touching with great sensuality. Note the little lap dogs and the fleshy statues that seem to want to join in the fun. Also look for the occasional early work in a much more 'correct', official style – which he deliberately chose to abandon.

🏛 Paris: Musée du Louvre
　　London: Wallace Collection
Ⓐ (40) £973/$1,401 – £4.8m/$7,776,000
🔨 £4.8m/$7,776,000 in 1999,
　　Le verrou – The Bolt (oil p., c.1778)

FRANCIS Sam MM
1923–94 American

Large-scale abstracts in which splattered and dribbled pure translucent colour floats with weightless ease over a white background, conjuring up a magical, open, light-filled space. Took up art as therapy while recovering from spinal injuries as a World War 2 fighter pilot – inspired by play of light across the hospital ceiling and in the Pacific sky.

Ⓐ (160) £1,491/$2,400 –
　　£1,925,466/$3.1m
🔨 £1,925,466/$3.1m in 1999, *Towards disappearance I* (oil p.1958)

FRANKENTHALER Helen MM
1928– American

Well-known second generation Abstract Expressionist painter who explored Abstract Expressionism's decorative, rather than its soul-searching, possibilities.

🕭 In her large-scale abstracts the canvas is stained, not painted. She produces bold, simple, confident designs and has an assured technique. Deliberately leaves areas of raw white canvas to allow colours to breathe. Combines loose staining with free calligraphy. Her works are immediately visually appealing – redolent of the open air and nature – and don't claim to be more than they are.

🔎 Enjoy the elegance, assurance, good taste and correct breeding of these seductive works – you know she has studied and followed the example of the 'proper' masters of her time. The claims for her influence can be overstated: she is an accomplished practitioner rather than a major talent. Transformed the raw edge of the New York School into an art of haute couture (and nothing wrong with that, as long as it doesn't pretend to be more than that).

Ⓐ (26) £1,840/$3,000 – £76,159/$115,000
🔨 £386,905/$650,000 in 1990, *Yellow Caterpillar* (oil p.)

FREUD Lucian CS
1922– British

The senior living British painter. German-born grandson of Sigmund Freud, the founder of psychoanalysis. Became a British subject in 1939.

🕭 His main subject is the human figure, often naked, posed artificially in a studio. Sometimes paints views from windows, but anything other than the human figure he considers 'frivolous'. All his models are known to him personally, so there is an intimate sense of deep

knowledge (love even?), not detachment. His work reveals extraordinary powers of concentration (which is not the same as intensity). Powerful portraits.

🔎 Look how carefully the eyes are painted and how much of the inner person they reveal, even when closed. How well he knows all those blemishes, bulges, lumps, private parts of the flesh that we study and examine intimately in our own bodies, but rarely see or care to look at in others. He knows every corner of his studio and the space that the models occupy. He knows exactly what he can do with his paint – and what he can't.

🅐 (28) £2,000/$3,000 – £1,851,852/$3m
🔨 £3,271,605/$5.3m in 1998, *Large Interior, W11* (oil p. 1981)

FRIEDRICH Caspar David AG
1774–1840 German

Now the best-known German Romantic landscape painter, but neglected in his own day. He came into his own later, influencing late-19th-century Symbolists.

🌙 Meticulous and careful painter of small pictures, but full of big ideas. His Romantic relationship with nature was intensely spiritual and Christian, and loaded with symbolism. His work is also full of yearning: for the spiritual life beyond the grave; for greatness; for intense experience. Although he studied

nature's details closely, all his landscapes are imaginary or composite – painted out of his head, not sitting in front of nature.

🔎 Look for his symbolism, for instance, oak trees and Gothic churches as Christianity; dead trees as death and despair; ships as transition from the here and now to otherworldliness; figures looking out of windows or at the horizon as yearning. Times of day and the seasons, when one state is about to become another. Sunrise turning to sunset or winter turning to spring, as spiritual transition and hope of resurrection.

🅐 (4) £1,054/$1,560 – £700,000/$1,155,000
🔨 £2.1m/$3,213,000 in 1993, *Spaziergang in der Abenddamerung* (oil p.)

FRITH William Powell NH
1819–1909 British

Popular painter, admired by Queen Victoria, famous for his detailed, panoramic chronicles of Victorian life (railway stations, races, the seaside). Refreshingly unpretentious, unambitious and free from moral comment. Used photographs but was reluctant to admit it. Unwisely also tried to do history and moral paintings.

🅐 (13) £750/$1,125 – £23,000/$35,640
🔨 £70,064/$110,000 in 1995, *The Pet Fawn* (oil p.)

1

> *Close your physical eye, so that you may first see your picture with the spiritual eye – then bring to light what you have seen in the darkness, that its effect may work back, from without to within.*
> CASPAR DAVID FRIEDRICH

FROST Terry CS
1915– British

Leading St Ives Group painter. Sensitive early works with gentle, fundamental shapes and colours abstracted from nature, often invoking sensations of movement, flight or waves. Later work is more purely abstract. Takes inspiration from the natural world. Wants to convey the ecstatic and poetic experiences he has found in nature.

🌑 You could go round a Terry Frost exhibition looking for modern art influences and colour theories (they are there to be found and that is all some people do), but what a waste of an opportunity that would be. If you go round looking for sunlight, water, leaves and woods, and your memory or evocation of them and their interaction with you, your sight or your emotions, you will be as uplifted and restored as if you had spent your ideal day in the country.

🅐 (69) £300/$468– £15,000/$22,500
🔨 £18,000/$28,800 in 1995, *Zebras' Time to Drink* (oil p. 1995)

FRY Roger Eliot NH
1866–1934 British

Scientist-turned-art historian-turned-painter. Central figure of the Bloomsbury set, with all their strengths and weaknesses in spades (see Vanessa Bell). More influential as a writer and critic than as a painter – in fact, his paintings rarely rise above the amateur.

🅐 (6) £1,500/$2,460– £6,000/$9,600
🔨 £22,000/$36,520 in 1990, *Garden scene* (oil p., 1915)

FULTON Hamish CS
1946– British

Takes long, difficult walks in uninhabited landscapes and shares his experience in the form of rather bleak, austere, large, black-and-white photographic presentations with written text. Sincere in aim, but the form seems to be stronger than the content. Very much 'in' with the art establishment.

🅐 (2) £2,516/$4,000 – £8,805/$14,000
🔨 £10,714/$18,000 in 1996, *Silent Horizon; Northern Iceland* (photographs, 1995)

FUSELI Henry (Johann Heinrich Füssli) NH
1741–1825 Swiss/British

Swiss-born eccentric. Inspired by Michelangelo, Shakespeare and Milton. Highly dramatic interpretations of literature in which facial expression and intense, overdeveloped body language is all (odd prefiguring of the illustrative techniques of 20th-century comic-book illustrators). A defective technique has ruined many of his oil paintings.

🌑 Produced wonderful drawings; also had a special line in female cruelty and bondaged males. Was obsessed with women's hair.

🅰 (13) £3,500/$5,285 –
£91,633/$137,450

🔨 £442,308/$690,000 in 1995,
*Satan Starting from Touch of Ithuriel's
Lanec, Paradise Lost* (oil p., c.1779)

GABO Naum (Naum Neemia Pevsner) MM
1890–1977 Russian

Peripatetic, self-taught pioneer of Russian
Constructivism. Lived in Russia, Germany,
Paris, London and the USA. Worked closely
with his elder brother, Antoine Pevsner.
His 3-D work emphasises modern
materials (such as Plexiglas), space,
light and kinetic movement. Expresses
sophisticated aesthetic values plus social
ideals – a vision of a transcendental order.

🅰 (4) £16,000/$25,280 –
£290,000/$458,200

🔨 £290,000/$458,200 in 1999, *Vertical
Construction no. 1* (sculpture, 1962)

GADDI Taddeo OM
c.1300–c.1366 Italian

Giotto's principal follower (and godson?).
Gaddi popularised Giotto's tough
realism by making it picturesque and
decorative, adding anecdotal details
and emphasising the storytelling side
of picture making.

🏛 Florence: Santa Croce (frescoes of
the Baroncelli Chapel)

🅰 (2) £89,655/$130,000 –
£383,435/$625,000

🔨 £1.8m/$3,114,000 in 1991,
*The Bromley Davenport altarpiece –
The Man of Sorrows, Saints Peter,
Francis, Paul and Andrew* (oil p.)

GAINSBOROUGH Thomas AG
1727–88 British

Best known for his portraits (which he
could sell), but his heart was more in
landscapes (which were difficult to sell).

Fashionable and successful. Musical
and amorous.

🌑 Gainsborough's sensibility
and instinct, and his imaginative,
experimental craftsmanship were the
antithesis of Reynolds's intellectualism
and bad technique. His portraits after
1760 are of natural, untheatrical poses –
gorgeous best clothes and hats,
sympathetic observation and response
to character in a face (especially that
of a pretty woman). His landscapes are
imaginary, lyrical, poetic – a conscious
escape from a hard day's labour. Lovely,
free chalk drawings. Also prints.

🔎 Wonderful paint handling, used
very thinly, freely and sketchily, enabling
him to capture the shimmer of silks and
satins, the rustle of breeze-touched
foliage, the natural blush on a girl's cheek,
or powder and rouge on a matron's face.
Parallels with early Mozart (1756–91):
interweaving of structure and texture;
light-hearted seriousness; physical
pleasure in being alive. His early works
lack the easy relaxation of the later
works: they are charming but the
portrait figures look like dolls and
the landscapes concentrate on detail
rather than atmosphere.

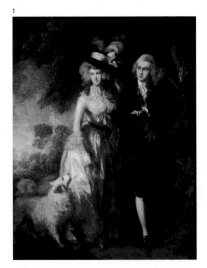

1

A deep feeling cannot be interpreted instantly; dream over it, seek its simplest shape.
PAUL GAUGUIN

🏛 London: National Gallery; Victoria
and Albert Museum; Kenwood
🅐🅥 (36) £2,278/$3,600 – £1,158,537/$1.9m
🏹 £1.6m/$2.73m in 1988,
*Portrait of Mrs Drummond
holding a sketchbook (oil p.)*

GAUDIER-BRZESKA Henri MM
1891–1915 French

Born in France, settled in London in 1910.
A potential (and now idolised) talent,
who perished in the trenches, at the age
of 24. Might have been one of the great
masters, or perhaps never more than
a gifted adolescent. He produced a
few highly original, experimental and
energetic carvings and drawings, inspired
by primitive art and avant-garde ideas
(especially 'truth to materials').

🅐🅥 (22) £360/$569 – £2,765/$4,423
🏹 £45,000/$68,850 in 1996,
Amour (sculpture, 1913)

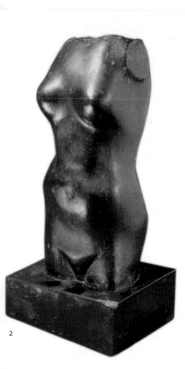

2

GAUGUIN Paul AG
1848–1903 French

Successful stockbroker who, at the age of
35, abandoned his career and family to
become an artist. Yearned for the simple
life and died, unknown, from syphilis, in
the South Seas. Had a decisive influence
on the new generation (including Matisse
and Picasso).

◑ His best work is from his visits
to Pont-Aven, in Brittany (especially in
1888) and from Tahiti in the 1890s.
Powerful subjects expressed with a
strong sense of design; bold, flattened,
simplified forms; intense, saturated
colours. Constant search for a personal
and spiritual fulfilment, which remained
unsatisfied. Highly attracted to Tahitian
feminine beauty, and many works are as
full of sexual as spiritual yearning. Also
produced interesting wood carvings,
pottery and sculpture.

🔎 Although an acute observer of
nature he believed that the source of
inspiration had to be internal, not
external (which sparked a major quarrel
with Van Gogh). Hence look for symbolic,
not natural, colours; complex, sometimes
biblical, symbolism. Plenty of scope for
detective work on his visual sources,
among them: South American art,
Egyptian art, mediaeval art, Cambodian
sculpture, Japanese prints and Manet.

🏛 Paris: Musée d'Orsay
🅐🅥 (83) £1,762/$2,855 –
£3,178,000/$4.8m

3

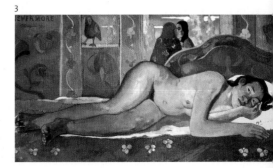

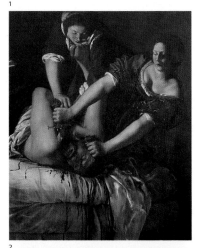

1

🔨 £13,496,934/$22.4m in 1989,
Mata Mua, In Olden Times (oil p., 1892)

GENTILESCHI Artemisia OM
c.1597– c.1651 Italian

Daughter of Orazio Gentileschi, she was
a better painter. Had a dramatic life (raped
at 19 and tortured during the subsequent
court case to see if she was truthful).
Chose dramatic subjects, often erotic,
bloody and with a woman as victim or
gaining revenge. Stylistically close to
Caravaggio – made powerful use of fore-
shortening and chiaroscuro. First female
member of the Florentine Academy.

🅐🅥 (1) £140,000/$217,000
🔨 £380,000/$619,400 in 1998, *Portrait
of a woman playing the lute* (oil p.)

GENTILESCHI Orazio OM
1563–1639 Italian

Greatly esteemed Tuscan. Studied in
Rome. Much influenced by Caravaggio,
but without his wild energy and
imagination; domesticated Caravaggio's
excesses. Look for large-scale decorative
works, simplified subjects and
compositions, cool colours, sharp-edged
draperies and unconvincing realism.
Became court painter to Charles I of
England in 1626 – a safe choice artistically.

🅐🅥 (2) £50,000/$72,000 –
£2.2m/$3,322,000
🔨 £4.6m/$6,992,000 in 1995,
The Finding of Moses (oil p.)

GÉRICAULT Théodore AG
1791–1824 French

A true Romantic: unorthodox,
passionate (about horses, women and
art), temperamental, depressive, virile
and inspiring. Had an early death (fell
off a horse). Was wealthy and only
painted when he felt like it.

2

🌙 Géricault had two main subjects:
horses and moments of danger or
uncertainty (and often combined both).
His early work was much influenced
by Rubens (movement and rich colour)
and Michelangelo (muscles and
monumentality). Scandalised French
art and the political establishment and
changed the rules of art with *The Raft
of the Medusa* – the first rendering of
a contemporary political subject in a
manner truly comparable with the
grandest history painting. Also produced
stunning, innovative lithographs.

🔍 His compositions are memorably simple: he often uses silhouette against a dramatic sky and lifts the eye up to a single point of climax near the top of picture. He depicts soulful human beings and horses (the expression in the horse's eye is the same as in the human's) – note his trick of turning the human face one way and the horse the other. His strong sense of colour and lively paint handling were sometimes ruined by the use of bitumen and poor-quality technique (was a lazy student, should have studied harder).

🔨 (30) £1,738/$2,764 –
£228,728/$363,678

🖌 £3.2m/$5.21m in 1989, *Portrait de Laure Bro, née de Comères* (oil p.)

GERTLER Mark NH
1891–1939 British

Talented artist from a poor, Jewish, immigrant family. Came to inhabit the fringes of the snobbish Bloomsbury set. Shared their interest in modern French art and painted better than they did. Figure studies (back views of nude) and still lifes. Good design and paint handling. Committed suicide.

🔨 (9) £1,200/$1,944 – £27,000/$43,200
🖌 £55,000/$90,750 in 1997,
Boxers (oil p., 1918)

GHIRLANDAIO Domenico AG
1449–94 Italian

Early Florentine Renaissance painter who achieved success with an old-fashioned, realistic storytelling style. Taught Michelangelo.

🌜 His frescoes were commissioned as decoration for important public buildings. Consequently many are still in situ. Used contemporary settings, dress, manners, faces and portraits to illustrate religious subjects. Look for homely, domestic pictures, which could be

illustrations to a story – a forerunner of the Dutch and 19th-century genre.

🔍 Painted serious, well-fed, middle-class people, like the successful and conservative-minded patrons who commissioned these works. His figures have long hands, wrists and legs. In tempera uses long, widely spaced strokes that follow the main curves and contours. Do not confuse with his brother David (1452–1525), who was left handed and so used hatching that goes from top left to bottom right.

🏛 Florence: Santa Maria Novella; Santa Trinita. Rome: Sistine Chapel (all fresco series)
🖌 £133,040/$318,000 in 1980, *S. Pietro Martire* (oil p.)

GIACOMETTI Alberto MM
1901–66 Swiss

Key postwar European figure. Agoraphobic. Expressed the vulnerability and fragility of humankind in works that combine absolute freedom with existential fear.

🌜 Best known for his nervously modelled, elongated figure sculptures. As a painter produced small-scale monochromatic figure paintings (portraits of friends and relations); still lifes; landscapes – all in a very personal, loose, sketchy and tentative style – which at the same time carry complete assurance and are the result of painstaking observation. Also produced drawings, which are more spontaneous.

🔍 Do the works reveal anything about the sitter or object, or are they ultimately the vehicle by which Giacometti explores and reveals himself, his grappling to comprehend what is seen and felt, and the sense of existential isolation that was one of the major emotional and aesthetic experiences and states of being of the time?

1. Domenico Ghirlandaio, *The Birth of St John the Baptist*
2. Gilbert and George, *Street*, c.1983
3. Luca Giordano, *The Crucifixion of St Peter*
4. Giorgione, *The Sleeping Venus*, 1508–10

Ⓐ (142) £592/$983 – £9,090,910/$13m
🔨 £9,090,910/$13m in 2000,
Grande femme debout I
(sculpture, 1960)

Exploiting it? Or pandering to chattering-class voyeurism? Their work may rapidly begin to look very dated. Are they Hogarth's successors? Do they have a true message, or is their inability to

1

2

GILBERT AND GEORGE (Gilbert Proesch and George Pasmore) CS
1943– and 1942– British

Highly successful, narcissistic couple who regularly appear in their own work as two cheap-suited 'nerds'. They have a big international following. Started as real-life 'living sculptures'.

◑ Their large 'photopieces' (produced since 1974) are made by an unknown process and are technically very impressive. Subject matter comes out of inner-city decay and is often deliberately 'in-yer-face' and offensive to all sides: to liberals (racist overtones, admiration for Thatcherism, swastikas, crude Little England nationalism) as much as to old school conservatives (overt homosexuality with young boys, turds, ridicule of religion and the monarchy).

🔍 Their work unquestionably reflects something significant about British society and its art world (1970s to the 1990s), but what? Are they criticising the physical, moral, social and educational decay of society (the period when Britain became 'a nation state equivalent of Woolworths'?)? Are they praising it?

set an agenda a telling comment in itself on present-day British society?

Ⓐ (18) £2,800/$4,228 – £155,000/$223,200
🔨 £145,000/$218,950 in 2000,
Bloody life no. 7 (photographs, 1975)

GILMAN Harold NH
1876–1919 British

Leading English post-Impressionist who applied a politely toned-down version of the post-Impressionists' colourful palette and thick brushwork (for example, Van Gogh's) to quintessentially English scenes of daily life. Founder member of the Camden Town Group.

Ⓐ (4) £800/$1,320 – £8,500/$11,985
🔨 £100,000/$150,000 in 1994,
Interior, Mrs Mounter (oil p., 1917)

GINNER Charles NH
c.1878–1952 British

Founder member of the Camden Town
Group. Produced very tight, inflexible,
thickly painted landscapes and urban
scenes. Very buttoned up, very British,
despite being born and educated
in France.

- (6) £1,378/$2,067 – £13,000/$20,800
- £30,000/$42,900 in 1993,
 Factories and Barges, Leeds
 (oil p., 1916)

GIORDANO Luca OM
1634–1705 Italian

Prolific and energetic, created very
theatrical, large-scale work; successful
decorator of palaces (especially ceilings).
Loved mythological subjects, which
enabled him to emphasise dramatic
action, bold compositions, contrasts of
light and dark, silhouettes, violence and
lust, and subjects that polarise good and
evil. Nicknamed 'Luca Fa Presto' (Luke
works quickly).

- (23) £712/$1,026 –
 £151,724/$220,000
- £270,000/$453,600 in 1997,
 The Raising of Lazarus (oil p.)

GIORGIONE (Giorgio Barbarelli) AG
c.1476–1510 Italian

The young, short-lived genius of
the Venetian School, who ranks in
achievement, significance and
importance with the greatest of the
Renaissance painters. Very few works
are known to be his for certain.

His small-scale, mostly secular,
pictures are consciously poetic, lyrical
and mysterious – carefully observed
portraits of youthful and sensitive
young men being beautiful. Dream-like
landscape settings. The *Dresden Venus*
(Gemäldegalerie, Dresden) and
La Tempesta (Accademia, Venice)
opened the door for the development
of the nude, landscape and mythological
painting on which so much of Western
art has depended.

To own an authentic Giorgione
has been one of the supreme ambitions
of collectors since the Renaissance, so
just think how many pictures have falsely
or mistakenly had the label 'Giorgione'
attached to them (and still do?). It is
impossible to identify a recognisable
technique (so few works known for
certain, plus wicked restorations and
overcleanings). Look for that indefinable,
dreamy Giorgione mood, plus a passion
for observing the real world.

3

4

GIOTTO DI BONDONE AG
c.1267–1337 Italian

The painter who brought a new level of realism to art that would establish the framework for Western art until 20th-century Modernism changed the rules. But why were his ideas not taken up for almost a century – until Masaccio?

❧ He portrayed (supposedly) real events enacted by lifelike people who express believable emotions and who occupy recognisable settings and spaces. He looked, painted what he saw and opened up a new 'window on the world' (as opposed to the old Byzantine world of puppet-like figures, symbolic expressions and gestures, and crowded, artificial 'spaces'). The impact, even now, is directness, simplicity, accessibility, believability; in a word: LIFE.

🔍 Look for what he does so well: faces expressing genuine emotion; meaningful gestures; strong, self-explanatory story lines (like early silent movies, you only have to look to know exactly what is going on); the sense of space around and between figures; how shape and movement of incidentals, such as trees and rocks, support the main action or emotion. Large bones and well-built, solid figures. Be aware of his difficulties – for instance, he had no knowledge of perspective or anatomy.

🏛 Padua: Arena Chapel. Assisi: San Francisco. Florence: Santa Croce

GIOVANNI DI PAOLO OM
active 1420–82 Italian

'The El Greco of the Quattrocento.' Sienese painter who adopted a deliberately old-fashioned style, in reply to the influential 'modern' style of Duccio. Developed a charming, decorative and convincing narrative style, in which the spaces, perspective, scale, emotions and logic of the 'real' world are deliberately ignored.

🅐🅥 (1) £551,724/$800,000
🏹 £375,000/$600,000 in 1997, *Franciscan saint meeting St James the Greater. Franciscan saint levitating before the crucifix* (oil p., a pair)

GIRTIN Thomas NH
1775–1802 British

Potentially a rival to Turner, but died of consumption at the age of 27. Painted brilliant watercolours that pushed the interpretation of landscape and watercolour technique through to new frontiers. Had a wonderful sense of colour and of the noble grandeur of nature.

🅐🅥 (8) £380/$543 – £12,000/$18,000
🏹 £260,000/$468,000 in 1990, *Jedburgh Abbey from the south east* (w/c)

GLACKENS William James NH
1870–1938 American

Philadelphia born; studied in Paris and was a protégé of Robert Henri. Started his career as a newspaper illustrator. Produced attractive and competent images of everyday New York life (interiors and exteriors), overtly derived from Manet and the Ashcan School. His work is popular imagery or illustration aspiring to the level of art (which most of what we call art, is).

🅐🅥 (22) £432/$700 – £297,297/$440,000
🏹 £933,735/$1.55m in 1998, *Vacation Home* (oil p. 1911)

GOBER Robert CS
1954– American

Maker of objects and installations, well regarded and much exhibited on the international circuit.

❧ Explores various fashionable ideas, such as subversion of conventions

1

2

3

and social norms (the happy family as oppressive rather than beneficial), gay politics, green and conservation issues. Some of his objects look like found objects but are in fact made by Gober; others are everyday objects that overtly don't work (like an unconnected sink).

🔎 Does the work at times risk becoming too humourless, oblique, obscure and overly didactic? Does he sometimes seem to say: 'Today, class, we are going to consider issues of normality and abnormality in contemporary society and strategies of how we might debate those issues by creating objects that will subvert our normal expectations.' Which interests him more: his strategies or the human issues? Aren't some of his chosen social issues very parochial?

🅐 (18) £2,676/$3,800 – £528,169/$750,000
🔨 £528,169/$750,000 in 2000, *Deep basin sink* (sculpture, 1984)

GOES Hugo van der AG
active 1467–82 Netherlandish

Obscure genius about whom little is known (spent his last years in a monastery, going mad). Only work known for certain to be by him is the *Portinari Altarpiece* (c.1475), which was commissioned for a chapel in Florence and introduced Italian artists to new ideas and techniques they had never seen before: oil paint, fine, natural detail and different symbolism (but they soon learned).

🌑 The *Portinari Altarpiece* is of an unusually large scale for a Netherlandish painting (commissioned to be standard size of Italian triptych); there are Portinari men (members of a prosperous Florentine mercantile family) in the left panel, women in the right (each with

99

I have tried to paint the terrible passions of humans by means of red and green.
VINCENT VAN GOGH

patron saints); the composite central panel has Virgin and Child (naked child on floor is a northern idea), Joseph and shepherds (an Italian idea); the Magi are at the back of the right panel.

🔍 The kneeling man (right panel) is Tomasso Portinari (agent in Bruges for the Medici bank – he was reckless and the bank was closed). The kneeling woman (right panel) is his wife, Maria. The men look troubled; the women have fashionably high foreheads and pale faces. The very wobbly space and odd changes of scale in the central panel perhaps suggest the artist was in difficulty with such a large-scale work? Much symbolism: scarlet lily as blood and passion of Christ; discarded shoe as holy ground; purple columbine as Virgin's sorrow, and so on.

🏛 Florence: the Uffizi (*Portinari Altarpiece*)

GOGH Vincent van AG
1853–90 Dutch

Happy child who became grim, impoverished, melancholic, difficult to love, suicidal – but painted works that are now among the world's best known, best loved and most expensive. Took up painting at the age of 27. Wanted his art to be a consolation for the stresses and strains of modern life.

🌙 His subjects are wholly autobiographical, tracing every moment and every emotion in his life. He had an instinctive, self-taught, hurried style that is instantly recognisable: used paint straight from the tube, applied as thick as furrows; strange perspectives; firm outlines, like a child's drawing; thrilling use of colour, which takes on a life of its own. Learned how to distort form and colour in order to express inner feelings.

🔍 He was able to endow inanimate objects with human personality (as did

his favourite author, Charles Dickens), so that his yellow chair becomes a symbol or image of Van Gogh himself. Had a passionate belief in the importance of first-hand observation (which can be electrifying); but also used colour symbolism (especially yellow). Had a huge output (800 paintings and 850 drawings – 200 paintings in last the 15 months alone). Wrote obsessive letters to brother, Theo, which often explain work in detail.

🏛 Amsterdam: Van Gogh Museum Otterloo (Holland): Kröller-Müller Museum
🅰 (21) £38,889/$56,000 – £11,111,112/$18m
🔨 £44,378,696/$75m in 1990, *Portrait du Dr Gachet* (oil p., 1890)

GOLDIN Nan CS
1953– American

Takes large-scale photographs, often in series that create a visual diary of her social circle, travels and emotional crises. She is specially concerned with so-called taboo (gay, lesbian or transvestite) relationships and public awareness of their intimacies. Not voyeurism or narcissism. Honest, often moving, and beautifully crafted.

🅰 (79) £1,856/$2,822 – £42,547/$68,500
🔨 £42,547/$68,500 in 1999, *Cookie Mueller* (photographs, 1990)

GOLDSWORTHY Andy CS
1956– British

Artist who works mostly in the open air with, and in response to, natural materials and particular places – instead of making art with materials such paint, canvas or bronze, he makes it with leaves, ice, trees or stones.

🌙 His deeply sensitive response to nature, places and seasons is in the

English Romantic landscape tradition (like Constable or Palmer) but he offers new forms and interpretations in tune with contemporary times. He literally weaves together the materials he uses in ways that rival even nature's own ingenuity and beauty. Most works are made for or left out of doors where, as he intends, they eventually melt away, fall over or disintegrate.

🔍 Makes photographic records of

1

these outdoor works, which he presents in book form as beautiful images and objects in themselves. Also produces work for gallery spaces and urban settings, though these tend to be less successful and can be met with (understandable?) incomprehension. Has worked successfully in northern Canada, Australia, USA, Japan and Europe, and at the North Pole (like Turner, he has a love of wild and out-of-the-way spaces).

🅐 (2) £2,000/$3,020 – £7,000/$11,340
🔨 £7,000/$11,340 in 1999,
Snow slabs stood on end, Grise Fjord, Ellesmere Island. Waiting for wind, Ellesmere Island (photographs, 1989)

GOLUB Leon cs
1922– American

Produces vast paintings on loose canvas with larger-than-life-size figures, simple designs, and layers of scraped and reworked paint. His subject is a complex

2

condemnation of violence, power and officialdom, now and always (note references to ancient Greece and Rome). Much influenced by the political protest movements of the 1970s, such as Vietnam and Chile.

🅐 (8) £859/$1,400 – £26,000/$41,080
🔨 £29,801/$45,000 in 1992,
White Squad III (oil p. 1982)

GONCHAROVA Natalia MM
1881–1962 Russian

Leading member of Russian avant-garde – well born and connected (links to Pushkin family tree). Well travelled in Europe and had an openly radical lifestyle. Settled in Paris (together with Larionov, her life-long

To me Art's subject is the human clay, /And landscape but a background to a torso;
All Cézanne's apples I would give away/For one small Goya or a Daumier.
W. H. AUDEN

companion and collaborator) in 1915. She was versed in early Cubism, Fauvism and Futurism. Used a progressive, visual language with a consciously strong, Russian peasant, religious-icon accent. Bold, strong, earthy, masculine colours.

- 🅰 (41) £409/$663 – £154,098/$248,098
- 🪓 £235,000/$385,400 in 1996, *River Landscape* (oil p., 1909-11)

GONZALEZ-TORRES Felix MM
1957–96 Cuban/American

The acme of political correctness: Cuban, gay, urban; had sad untimely death (Aids). Currently very fashionable. His work is conceptual, featuring piles of sweets or paper (which you can take), photographs, light bulbs, and so on. Said to explore issues of illness, death, love, loss – life's sadness and transience – with a poetic aura.

- 🌑 How significant are the works? Maybe they achieve their stated ends, but maybe they don't quite do so unless accompanied by curatorial handouts, catalogues or didactic writings – in which case who is creating the art work, the artist or the curator? Well and sincerely intentioned, but in the end may amount to very little of any public significance (like most of human activity).

- 🅰 (9) £9,000/$14,580 – £1,056,338/$1.5m
- 🪓 £1,056,338/$1.5m in 2000, *Untitled, Blood* (sculpture, 1992)

GORDON Douglas CS
1966– British

Makes videos in which the main parameter is the elongation of time – an antidote to the rapid sequencing used in commercial film or TV. Thus he has shown Hitchcock's *Psycho* slowed down to run over 24 hours. Also uses early medical films and own videos of human body or movement. The idea is that dragging out through time gives new meaning and insight.

- 🅰 (1) £11,000/$17,820
- 🪓 £11,000/$17,820 in 1999, *Douglas Gordon sings the best of Lou Reed and the Velvet Underground* (photographs, 1993)

GORE Spencer Frederick NH
1878–1914 British

Most versatile member of the Camden Town Group, with a wide range of subject matter (portraits, music halls, domestic interiors) and an instinctive feel for the flat colours and simplified shapes so dear to modern French art. His premature death was a sad loss for British modern art.

- 🅰 (6) £6,400/$10,368 – £55,000/$88,550
- 🪓 £55,000/$88,550 in 1999, *Mornington Crescent* (oil p., c.1910-11)

GORKY Arshile MM
1904–48 Armenian/American

Emigrated from Turkey to the USA in 1920. Original lyrical, gentle and poetic abstract painterly style, deriving inspiration from landscape and nature. Natural colours, biomorphic forms (influence of Miró and Surrealism). Tragic early death (like many fellow Abstract Expressionists); committed suicide after cancer, car accident and disastrous studio fire.

- 🅰 (17) £1,000/$1,600 – £1,408,451/$2m
- 🪓 £2,364,865,000/$3.5m in 1993, *Year after Year* (oil p., 1947)

GORMLEY Anthony CS
1950– British

Artist of increasing stature who has never been afraid to go against the grain of fashion.

◑ His characteristically (but not exclusively) life-size human figures have no specific features and are made of metal, visibly soldered together in static poses. They are casts of the artist's own body. He is wrapped in cling film, then cloth, then coated with wet plaster, which dries. He is then cut out of the resulting mould, which is reassembled, and lead or other metal is pressed into the void, or beaten to take his form, and the pieces are welded together.

🔎 His strange, enigmatic pieces have a moving presence, perhaps because of their very stillness, understatement and a quality of being both specific and general at the same time. Gormley studied Buddhism in India, and there can be little doubt that he is an artist trying to say something (in which he may or may not succeed) rather than to play to a market. His 20-metre (65 ft)-high *Angel of the North* dominates the main A1 road on the approach to Tyneside.

◑ (16) £460/$736 – £50,000/$79,000
🔨 £50,000/$79,000 in 1999, *Facing world* (sculpture, 1986)

GOSSAERT Jan (also called MABUSE) AG
c.1478– c.1532 Flemish

Had a crucial role in the development of Flemish painting by introducing Italianate ideas (albeit a bit derivative). Came from Mauberge in Hainault, hence the name Mabuse.

◑ His work is a fascinating (sometimes uncomfortable) synthesis of: 1) northern skills and vision – acute observation; fine oil technique; clear, precise draughtsman-ship à la Dürer; and 2) after visit to Rome in 1508–9, Italian aspirations –idealisation of figures and faces; perspective; classical architecture and details; firm modelling and subtle shading with light. Had a more conservative portrait style.

Ⓐ (1) £124,138/$180,000

🔨 £920,245/$1.5m in 1998, *Madonna and Child enthroned accompanied by six music-making angels* (oil p.)

GOTTLIEB Adolph MM
1903–74 American

Well-known Abstract Expressionist. Too schematic to be one of the great artists. He had two styles: 1941–51 – pictographs, loose compartments filled with schematic and symbolic shapes (he was much into Freud and Surrealism); 1950s onwards – imaginary semi-abstract landscapes, typically with a simple, round, celestial body floating above loosely painted earthly chaos.

Ⓐ (14) £3,667/$5,500 – £140,845/$200,000
🔨 £208,333/$350,000 in 1996, *Coalescence* (oil p., 1961)

GOYA y LUCIENTES Francisco José de AG
1746–1828 Spanish

Solitary and lonely figure. Court painter to the king of Spain and admirer of the French Enlightenment. Became stone deaf at the age of 48. Produced a wide range of powerful work, and

was one of the greatest portrait painters of all time.

❂ His overriding interest was human appearance and behaviour. He showed (and understood profoundly) youth and age, hope and despair, sweet innocence and the most savage aspects of man's inhumanity to man (is there any other artist who has such a range of understanding?). His art is about Spain and its obsessions in his own time, but also about all times. He is hauntingly memorable because he is never judgemental (simply showing human behaviour as it is), and because his way with paint, colour, prints, drawings, is always ravishingly beautiful to look at, even when his subject matter is horrific.

𝒫 All portraits set up a relationship between the sitter, the artist and the viewer. Usually you, the viewer, are the one who looks at the sitter and asks the questions. With Goya (only Goya?) one has the uneasy sensation that the relationship is reversed; his sitters are looking at the viewer, you, and asking the questions – or worse, they look through you and ignore you altogether. They are examining you and your views on human behaviour as much as you are examining them and their views.

🏛 Madrid: Prado
London: British Museum (prints)
🅰️ (19) £1,553/$2,516 – £521,472/$850,000
🔨 £4.5m/$7m in 1992,
Bullfight – Suerte de Varas (oil p.)

GOYEN Jan van OM
1596–1656 Dutch

One of the most important Dutch landscape painters. Prolific and much imitated. Had many pupils. Repeated same motifs frequently – Dordrecht, sand dunes, ships and Nijmegen River. Painted in subdued browns and greys, enlivened by a flash of red or blue. His paintings have attractive light, space, air and cloud

movement. Uses high viewpoint and low horizon. Likes gnarled oaks.

🅰️ (55) £475/$684 – £450,000/$661,500
🔨 £1.15m/$1,874,500 in 1998, *Village on the banks of river with ferryboat and peasants* (oil p.)

GOZZOLI Benozzo di Lese AG
c.1421–97 Italian

Down-to-earth early Renaissance Florentine. Good craftsman who enjoyed what he saw.

❂ Painter of high-quality altarpieces and predella panels. Liked crowded scenes, which enabled him to show off a combination of brilliant, decorative qualities and carefully observed solid figures, with no-nonsense faces.

𝒫 His figures have good hands (with long fingers) and good feet, and are firmly placed on the ground. Note how he arranges crowds well, and likes the tops of heads, particularly if bald, or with a hat or helmet.

🏛 Florence: Palazzo Medici (fresco series); the Uffizi
🔨 £25,000/$36,750 in 1993,
Study of male nude (drawing)

GRANT Duncan NH
1885–1978 British

Prolific member of the Bloomsbury set with considerable potential talent, which, sadly, he frittered away. Supremely self-confident and unselfcritical. At his best is 'interesting', and his work before 1920 is highly decorative. Later work can be embarrassingly bad – no better than a Sunday painter.

🅰️ (81) £460/$745 – £21,000/$33,180
🔨 £32,000/$55,000 in 1992, *Portrait of Vanessa Bell. Corner of the Inn, Kings Lynn* (oil p., double-sided)

1. Jan van Goyen, *An Estuary with Boats*
2. Benozzo di Lese Gozzoli, *The Journey of the Magi to Bethlehem*, c.1460
3. El Greco, *St Joseph and the Christ Child*, 1597–9

GRAVES Nancy NH
1940–95 American

Seriously talented out-of-the-mainstream painter and sculptor who was fascinated by natural history, nature and fossils. First achieved fame in 1968 with life-size camel creatures covered in sheep or goat skin.

Later made lost wax castings of seedpods, bones and leaves, which are combined in strange constructions with other materials and painted. Also made camouflage paintings where creatures are hidden in Pointillist dots. Explored poetry in nature and metamorphic possibilities of sculptural materials and animals.

● (7) £1,366/$2,200 – £16,049/$26,000
⚒ £59,375/$95,000 in 1994, *Chimera* (sculpture, 1983)

GRECO EL (Domenikos Theotocopoulos) AG
1541–1614 Greek/Spanish

Born in Crete. Trained in Venice, but worked in Spain, hence the name El Greco (the Greek). Intense, arrogant, intellectual, spiritual. A one-off, with a bewilderingly wide range of sources. Favoured by Philip II of Spain, instigator of the Inquisition, until he fell out of favour in 1582.

◑ Art historians can have a good time trying to piece together the sources: directly applied colour (Titian), writhing figures (Michelangelo and Parmigianino), fragmented spaces and jewel-like acid colours (Byzantine mosaics and icons).

wordly appearances were a better aid to devotion than naturalism. His portraits reveal the essence and idea of a person rather than a strict likeness. Look for the thrilling draughtsmanship and the tense probing line that outlines his forms.

🏛 Madrid: Museo del Prado
Toledo: Cathedral; Museo del Greco

Ⓐ (4) £731,707/$1.2m – £3.5m/$5,285,000

🔨 £3.5m/$5,285,000 in 2000, *Christ on the Cross* (oil p.)

GREEN Anthony CS
1939– British

Author of quirky paintings that chronicle his own suburban domestic life. The bizarre perspectives, odd-shaped canvases and complete lack of any artistic or theoretical pretension is engaging.

Ⓐ (8) £300/$486 – £3,600/$5,940

🔨 £7,200/$11,592 in 1997, *Thirteenth wedding anniversary* (oil p.1974)

GREUZE Jean-Baptiste AG
1725–1805 French

Best known for his sentimental storytelling genre pictures and titillating images of young children. Played to a pre-French Revolution audience that turned luxury and idleness into an art form. Became very successful. Had an unpleasant personality.

But to touch the real El Greco, you have to forget this, and think and be excessively spiritual, and enter a world of visionary Christianity. Only then will you appreciate his genius and the significance of his superb technical skills.

🔍 The elongated figures, hands, feet and faces are not intended to describe, but to reveal the inner spirit. The soaring compositions are about the ascent from the material to the divine. The strange colours are a reflection and revelation of spiritual light. He believed that other

🔵 His chief feature is excesses of emotion – overexpressive faces and overdramatic gestures. You know what feeling he tries to convey (or do you, in fact?) but, like bad acting, it can seem so false you may well be moved to laughter rather than tears.

🔍 Many weaknesses: false emotion, bad composition, poor drawing, unattractive colour. In fairness, he did make some striking portraits, which are good and worth looking for.

🏛 Paris: Musée du Louvre
Montpellier: Musée Fabre
London: Wallace Collection

🅰 (31) £1,051/$1,482 –
£276,699/$445,485

🔨 £552,147/$900,000 in 1998,
Portrait of Benjamin Franklin (oil p.)

GRIMSHAW Atkinson NH
1836–93 British

Painter of skilful, atmospheric, northern (especially Yorkshire) townscapes, notably at twilight and after rain; also lush portraits. Popular in his own day because he cunningly combined the two 'must have' styles of the day: Whistler's dreamy Aestheticism and detailed realism. Popular now because his paintings are so nostalgic. Strongly influenced by photography (which he used).

🅰 (43) £600/$966 –
£345,000/$552,000

🔨 £345,000/$552,000 in 1999,
Sixty Years Ago (oil p., 1879)

GRIS Juan MM
1887–1927 Spanish

Third in the hierarchy of the inventors of Cubism (after Picasso and Braque), concentrating almost exclusively on still life.

🌑 Masterly reinterpretation of the traditional still life. Stand back and see how his meticulously crafted, stylish, highly decorative pictures look like expensive jewellery; they are often (and very effectively) shown in elaborate frames like mounts for brooches. Stand close to them and play the Cubist game of piecing together the final image from the fragmented images and clues.

🔎 He often used a dark palette to great effect, especially blacks and blues. His works have complex geometric designs and grids, with the images slipping in and out of the different planes. Playful use of lettering and speckled patterns. His brilliant and inventive *papier collés* get better as they get older, browner and more antique. Somehow reminiscent of French 18th-century marquetry furniture and its fine craftsmanship?

🅰 (25) £789/$1,239 –
£2.8m/$4,424,000

🔨 £2.8m/$4,424,000 in 1999,
Tasse, verres et bouteille (oil p., 1914)

GROSZ George MM
1893–1959 German

Best remembered as the biting and original chronicler of the sad and corrosive period of German history between 1918 and the rise of Hitler.

🌑 Small-scale works (especially prints and drawings) in a consciously artless, angular, modern style ('modern' in the sense of uncomfortable, provocative and anarchic). They chronicle the uncomfortable truth behind the respectable bourgeois façade. He was fascinated by street life yet, for all his apparent criticism of it, he seems to end up loving the ugly corruptness he records – he shows little sympathy for the victims.

🔎 Note the repetition of certain stock types and faces. He employs poisonous colours and an artless style to create a feeling of instability and menace. Early user of photomontage. His terrifying personal World War 1 experiences made him a pessimist, misanthrope and political activist (Communist). His style softened c.1924, after marriage and fatherhood. He emigrated to the USA in 1933 and reverted to being a graphic artist again.

🅰 (112) £245/$346 –
£600,000/$990,000

🔨 £1.3m/$2,041,000 in 1996,
Wildwest (oil p., 1916)

GRÜNEWALD Mathis
(Mathis Neithardt - Gothard) AG
c.1470–1528 German

Obscure, austere, religious fanatic who painted works of powerful spiritual intensity. Now regarded as one of the all-time great painters, but overlooked until the 20th century. Worked for the Archbishop of Mainz. Died of the plague.

☽ His overwhelming masterpiece – the *Isenheim Altarpiece* – is in Colmar, near Strasbourg. His altarpieces express his single-minded religious fervour (he became a Lutheran) but are full of visual contradictions and anachronisms, especially imagery lacking precedent or following. Little interest in 'realism' or 'modern' Renaissance ideas – his style has more in common with the mediaeval world and with 20th-century German Expressionism (which he influenced).

🔎 Distorted scale to convey emotion or significance. Intense colours, ranging from pitch black to bright yellow, to express mood. His distorted bodies and anguished hands and feet express inner torment or suffering. The settings range from the bare and almost abstract to the highly detailed. The demons come out of an imagined mediaeval hell and are mixed with faces or details that have the qualities of first-hand observation of the Italian Renaissance.

🏛 Colmar (France): Unterlinden Museum (*Isenheim Altarpiece*)

GUARDI Francesco AG
1712–93 Italian

Prolific Venetian view painter and best-known member of a family of painters. Was widely collected in the 18th century, but his paintings sold for half the price of Canaletto's.

☽ His charming Venetian scenes capture the spirit of the city more

by atmosphere and mood than by topographical accuracy. The cool, misty, relaxed, small-scale style is in complete contrast with the intense, busy, sharp and bigger-scale style of Canaletto (their works are usually hung together).

🔎 Note the inaccurate perspective and seeming indifference when people or buildings get out of scale; suppression of detail; loose, flickering style of painting; and hazy, cool colours and sombre palette.

🅰 (24) £928/$1,309 – £3,128,834/$5.1m
🔨 £8,937,960/13,943,218 in 1989, *Vue de la Giudecca et du Zattere à Venise* (oil)

GUERCINO Giovanni Francesco Barbieri
(Il Guercino) OM
1591–1666 Italian

Came from Bologna. Self-taught and successful in his own day. Now regarded as one of the most important 17th-century Italian artists, but was neglected until recently. At his best in his early work, which is lively, natural and has exciting light; also produced wonderful drawings. The Bolognese Pope summoned him to Rome in 1621; thereafter he lost his spontaneity and became boringly classical. 'Guercino' means 'squint-eyed'.

🏛 Windsor (UK): Windsor Castle, Royal Collection (for drawings)
🅰 (34) £500/$735 – £131,034/$190,000
🔨 £176,282/$275,000 in 1995, *Jacob Mourning over Joseph's Coat* (oil p.)

GUTHRIE Sir James NH
1859–1930 British

One of the Glasgow Boys (with Cameron, Henry, Lavery and Melville). His early and most interesting works are naturalistic landscapes and anecdotal portraits of fellow villagers, much influenced by the French Barbizon School of plein-air painters. From 1885 turned to

1

2

3

portraiture. Was influenced by Whistler and Velásquez (mainstream fashion) and became the leading Scottish portraitist of the day.

🅐 (4) £450/$666 – £7,000/$11,480
🔨 £70,000/$105,700 in 1992,
 To Pastures New (oil p.,1883)

GUSTON Philip MM
1913–80 American

A well-regarded and influential artist whose work has had several distinct and different phases.

🌑 His early work is figurative. In about 1950 he became an Abstract Expressionist, producing shimmering, nervously painted, high-minded abstract paintings. In about 1970 he returned to figuration, with crude, but perversely poetic, cartoon-like imagery that conjures up a bizarre world of everyday junk remnants.

🔎 It is difficult to explain Guston's changes of direction other than as autobiographical. He was probably working out the consequences of a traumatic childhood (father's suicide, brother's death, memories of Ku Klux Klan). His crudity perhaps reflects an element of self-loathing?

🅐 (15) £1,553/$2,500 –
 £309,859/$440,000

🔨 £922,619/$1.55m in 1996, *Beggar's Joys* (oil p.,1954)

GUTTUSO Renato MM
1912–87 Italian

Much praised in the 1950s when considered by many (left wing) critics to be on the cutting edge of the avant-garde; his social realist works were seen as an antidote to American gestural abstraction, thus he does capture something specific about postwar European art and politics. His originality declined rapidly after the late 1950s, when he became too derivative (too many borrowings from Picasso and Goya).

🅐 (70) £544/$840 – £75,000/$108,750
🔨 £90,325/$147,229 in 1997, *Studio e paesaggio, mattino nello studio, autoritratto* (works on paper, 1961)

1

HAACKE Hans CS
1936– German/American

German-born Conceptual artist (and occasional painter) who settled in the USA in 1963. His early work was presented in 3-D, which interacted physically with the gallery environment (such as water condensing in Perspex tanks). He became politicised by the 1968 Paris student riots and from then on presented works that interacted politically with the museum environment.

🌑 His cool and factual presentations draw attention to the political, commercial and financial agendas of museum trustees or corporate sponsors, and how these influence museum policies on acquisition and display. He caused telling and worthwhile outrage and frisson in the 1960s and 1970s. His dogged persistence with the same agenda into the 21st century now seems rather lame and boring. He made a good point 30 years ago, but should have moved on to new targets for new times.

🅰️ (2) £1,563/$2,500 – £4,000/$5,800
🔨 £4,000/$5,800 in 2000, *Mobil, On the Tracks* (works on paper, 1980)

HALS Frans AG
c.1581–1666 Dutch

Stay-at-home self-portraitist who never moved from Haarlem, Holland. One of the first masters of the Dutch School (preceded Rembrandt). Although successful, he was constantly in debt (because he had eight children?).

🌑 Painter of portraits and group portraits (especially of the 'Civic Guards', all-male social clubs) and of members of the newly established Dutch republic, who usually look pink-cheeked, well fed, well dressed, happy and prosperous. Also painted genre figures of single children and peasantry. Was very influential in the late 19th century when his style, having been totally out of fashion, became much admired by young artists such as Manet.

🔎 His exciting, lively, but simple poses are full of animation. He had a unique (for the time) sketchy painting technique, straight onto the canvas, with broad brush strokes and bright colours adding to the sense of vivacity; yet he still captured the appearance and feel of different textures: plump flesh, pink cheeks, the shimmer of silk and satin, the intricacy of lace and embroidery. Beautifully observed, well-formed, expressive eyes.

🏛️ Haarlem (Netherlands): Halsmuseum
Amsterdam: Rijksmuseum
🅰️ (4) £548,781/$900,000 – £7.5m/$11,625,001
🔨 £7.5m/$11,625,001 in 1999, *Tieleman Roosterman in black doublet, white ruff* (oil p.1634)

HAMILTON Ann CS
1956– American

Creator of large installations (very labour intensive – uses armies of volunteers)

110

that address our preoccupation with how spoken and written language dominates our perception and interpretation of the world to the detriment of other forms of knowledge – such as understanding through our other senses. The communal activity of the making is part of the strategy and significance.

- 🅰️ (3) £7,042/$12,000 – £16,901/$24,000
- 🔨 £16,901/$24,000 in 2000, *Untitled* (sculpture, 1993)

HAMILTON Gavin NH
1723–98 British

Scottish born, resident in Rome; archaeologist, painter, picture dealer. A pioneer of the international, archaeological, and severely intellectual branch of neoclassicism, but outpaced by other, better, painters. Also painted portraits and conversation pieces endowed with an austere charm.

- 🔨 £22,876/$35,000 in 1993, *Hygieia* (oil p.)

HAMILTON Richard CS
1922– British

Former intellectual guru of British Pop art who still holds court. Has an austere, rather self-conscious style, which can come across as aloof and patronising. Seems to have a need to address his work to the high priests of the art world rather than the public at large (an odd attitude for one who claimed to be a true 'pop', that is popular, artist).

- 🅰️ (7) £1,235/$2,000 – £4,808/$7,762
- 🔨 £88,000/$148,720 in 1998, *Glorious techniculture – Hers is a lush situation III* (oil p./collage)

HANSON Duane CS
1925–96 American

Maker of hyperrealistic sculptures (since 1967). A modern reworking of the 'everyday life' realism much loved by Victorian middle classes. His early work was strongly political.

🌙 Creator of unnervingly lifelike, life-size sculptures of people who are almost indistinguishable from the gallery-goers who look at them. His subjects are tourists, shoppers, construction workers, children – middle America at work and play. He took moulds from live models, which were then cast in polyester resin or bronze and painted; he then added real accessories (such as shoes and clothes). His stated aim was to ennoble the commonplace and ordinary by turning it and its inhabitants into art.

🔍 Slow worker – a single figure could take a year to complete. Note the realism of flesh textures, such as bruises, varicose veins, hair on forearms or legs. His figures are often in movement but always self-absorbed and introspective (even when in a group); sometimes they are asleep. The impact comes in part from his astonishing technical skill, in part from his contemporaneity. How powerful will these works be when they eventually look like historical figures, not part of the here and now?

- 🅰️ (2) £52,795/$85,000 – £74,534/$120,000
- 🔨 £81,699/$125,000 in 1993, *Photographer* (sculpture)

HARING Keith CS
1958–90 American

Haring was formally trained and first made his mark as a graffiti artist in the New York subway. In later life he was principally interested in marketing his easily recognisable images (simplistic pin men with thick black outlines,

1

2

participating in various inconsequential activities) via T-shirts, badges, and so on, including a shop in New York. The epitome of art and the artist as a brand image. Although he died from Aids 10 years ago, the marketing goes on unabated as if he were still alive.

💰 (102) £409/$602 – £147,887/$210,000

🔨 £147,887/$210,000 in 2000, *Untitled* (oil p., 1983)

HARNETT William Michael NH
1848–92 American

The most famous of the American trompe-l'oeil painters. His hyperrealist depiction of objects with raking light emphasises illusion and three-dimensionality. Chose old, worn objects and unpretentious bric-à-brac (with an occasional crumpled dollar bill) – the appeal of nostalgia in a changing world. His pinboards are a tour de force of skilful deception.

💰 (1) £118,750/$190,000

🔨 £457,317/$750,000 in 1996, *Still Life with Tankard* (oilp., 1885)

HARTLEY Marsden NH
1877–1943 American

The greatest American artist of the first half of the 20th century; original, mystical, homosexual.

🌙 His early Impressionist work was followed by paintings that were strongly influenced by the German Expressionists, with whom he had become friendly (Kandinsky and Jawlensky in Berlin and Munich c.1913). Experimented with abstraction. His 'Portrait of a German Officer' series (which commemorates his male lover) is the major monument of early American Modernism. Later produced several important series of paintings in Provence (France), New Mexico and Maine. Used vigorous brush strokes and jarring colour combinations, such as rust and acid green.

💰 (24) £926/$1,500 – £1,398,601/$2m

🔨 £1,398,601/$2m in 2000,
Abstraction (oil p., 1913)

HARTUNG Hans MM
1904–89 German

One of the first painters of gestural abstraction.

🌙 Hartung's style is spontaneous, neat, wiry, free, with pencil lines crawling over the paper and brush strokes that have some of the characteristics of Chinese calligraphy but are never uncontrolled or arbitrary. His strong sense of (complex) composition and colour identifies him as European rather than American. His aim was to create images expressing his innermost being.

🔍 His paintings are not always as spontaneous as they look: they may be enlarged versions of small, free sketches, in which he replicates the gestures or accidental marks (but does that make the end result any less valid?).

🅐 (117) £802/$1,283 –
£170,000/$275,400
🔨 £823,409/$1,424,497 in 1990,
T 47-10 (oil p., 1947)

HASSAM Childe NH
1859–1935 American

America's foremost Impressionist artist, who painted more than 4,000 works (oil and watercolours). Best remembered for his late (post-1917) 'flag paintings', where brightly coloured, richly painted flags at war-time parades act as an exciting visual motif and symbol of patriotism. In his earlier work his emphasis was on contre-jour.

🌙 Next to the French, the Americans were the best and largest group of Impressionists, but they were late in the day by 20 years – post-1890s as they did not often visit Paris until the 1880s.

Before that tended to learn their art in Germany.

🅐 (47) £1,750/$2,800 –
£979,021/$1.4m
🔨 £4,417,178/$7.2m in 1998,
Flags, Afternoon on the Avenue (oil p.)

HATOUM Mona CS
1952 – Lebanese

Involuntary refugee working in London. Creates installations and videos whose subjects are about exile, loneliness and authoritarian politics, which she interweaves and interlinks with an examination of the undemocratic boundaries of traditional art practices.

🅐 (8) £2,800/$4,424 –
£91,549/$130,000
🔨 £91,549/$130,000 in 2000,
Silence (sculpture, 1994)

HAYMAN Francis NH
1708–76 British

Theatrical-scenery painter at Covent Garden Opera House, who branched out into portraiture and history painting. Had a lively, sensitive style, combining Rococo artificiality and everyday reality. He was the first librarian of the Royal Academy.

🅐 (2) £6,200/$9,362 –
£9,000/$14,040
🔨 £145,000/$214,600 in 1993,
Portrait of David Garrick and William Windham (oil p., 1745)

HEADE Martin Johnson NH
1819–1904 American

An important Luminist and long-lived hack portraitist who 'came good' after meeting Frederick Church in 1859. Best known for his haunting landscapes of flat lands with low horizons. Author of

simple, clear compositions – wide, open spaces where each element is placed with the utmost precision. Had a special ability to show that mysterious, ominous light that precedes a storm.

◗ Travelled to Brazil where he did notable paintings of hummingbirds and orchids.

🅐🅥 (11) £927/$1,400 –
£912,162/$1.35m
🔨 £912,162/$1.35m in 2000,
Magnolias on a wooden table (oil p.)

HEARTFIELD John (Helmut Herzfelde) MM
1891–1968 German

Artist and journalist, founder of Dada in Berlin in 1910, but perhaps best known for developing political photomontage in the 1920s and 1930s. Took refuge in England from 1938 –1950. Settled in East Germany from 1950.

◗ Had an intense social and political commitment (left-wing, anti-Nazi). He anglicised his name as a protest against German nationalism. Highly original manipulator of media imagery, words and lettering, producing biting and memorable satire, highly expressive of its age.

🔎 Notice the economy and modesty of means: he knew exactly what he wanted to say and went for the jugular with one simple, unforgettable image – less is more (a rule often ignored by less gifted exponents of photomontage).

🔨 £5,500/$7,920 in 2000,
Family, Sunday Walk (w/c, 1919–21)

HECKEL Erich MM
1883–1970 German

A leading German Expressionist (member of Die Brücke). Untrained. Persecuted by the Nazis. Painted powerful, pessimistic

images of nudes, portraits, sickness and anguish, with a corresponding fierce and angular style and strident colours. His landscapes are more decorative. More lyrical after 1920 (he was a medical orderly in World War 1; war and waning youth took the passion and verve out of him). Maker of very fine prints.

🅐🅥 (150) £329/$543 –
£1.1m/$1,584,000
🔨 £1.1m/$1,584,000 in 2000,
Dangast, village landscape
(oil p., 1909)

HEEM Jan Davidsz de OM
1606–84 Dutch

Utrecht born, he lived and worked in Antwerp from 1636. Was famous and successful with his still-life paintings of flowers and groaning, exquisitely laid tables. Had many pupils and imitators.

🅐🅥 (4) £2,600/$3,666 –
£158,537/$260,000
🔨 £3,389,830/$6m in 1988,
Banquet Still Life (oil p., 1642)

HEEMSKERCK Maerten van AG
1498–1574 Dutch

Leading Haarlem painter of his day. His works are portraits, altarpieces and mythologies. Was totally transformed by a visit to Rome, 1532–6. Look for classical profiles; Michelangelesque, muscular figures; emotional (unrealistic) faces, gestures and colours (hot reds, strong pinks, turquoise blue). Adopted Italian idealisation rather than northern realism.

🅐🅥 (2) £17,000/$26,350 –
£145,000/$224,750
🔨 £412,797/$652,219 in 1987,
Portrait de femme vue à mi-corps
(oil p.)

1. Jan Davidsz de Heem, *Still Life of Dessert*, 1640
2. Martin Johnson Heade, *Seascape: Sunset*, 1861

HELION Jean MM
1904–87 French

Reputable but minor painter of the School of Paris whose works have a strong period feel and look.

🌀 Pre-1939 work is mainly Geometric Abstraction, strongly influenced by Léger

subjects (note his portraits of 'my people' – Irish peasants, Chinese coolies, American Indians). Had a direct 'real' style, using dark tonal contrast, limited colour and liquid brush strokes. Leader of the Ashcan School.

🌀 Henri links Eakins (he studied at Pennsylvania Academy) and Manet

1

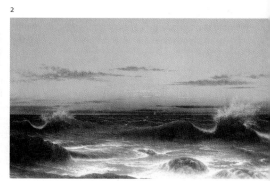

2

and Mondrian. After 1945 he painted very formally arranged figurative works of expressionless men and women, in activities and relationships that are suggestive of deep meaning, but inexplicit.

🔎 Had a strong underlying sense of design and his drawings are bold and confident. The technique in his figurative work is consciously unrefined, but not crude, with a stencilled, graphic, cartoon-like quality.

🅰️ (88) £525/$856 –
£57,034/$85,551
🔨 £310,493/$506,103 in 1990,
Nu accoudé (oil p., 1948)

HENRI [pronounced Hen Rye] Robert NH
1865–1929 American

Charismatic, hard drinking, rebellious, anarchic (his father was a card sharp) but a great teacher and believer in young people. Chose down-to-earth, urban

(he was in Paris from 1888 to 1890) and his students: George Bellows, Stuart Davies, Edward Hopper, Rockwell Kent, Man Ray and Trotsky (yes, Trotsky).

🅰️ (19) £345/$500 –
£140,625/$225,000
🔨 £199,367/$315,000 in 1992,
Skipper Mick (oil p.)

HENRY George NH
1858–1943 British

One of the Glasgow Boys and an enthusiast for Japanese art (he visited Japan in 1893/4 – 10 years before Puccini wrote *Madame Butterfly*). Produced accomplished landscapes and figure studies. Their decorative and simplified forms, muted tones and calculated intensity of feeling reflect a prevailing fashion for Whistler-type art for art's sake experience and for Japan.

🔨 £82,000/$119,720 in 2000,
Poinsettia (oil p.)

HEPWORTH Dame Barbara MM
1903–75 British

Leading member of the first generation of British modern masters. Expressed in sculpture, for the first time, the tradition of English Romantic landscape. She was much honoured and revered both in her lifetime and subsequently.

☾ Look for a deeply emotional response to and identification with nature and landscape. Her inspiration came from light, seasons, natural materials, mysteries of nature. She searched for (and found) fundamental essences and elements. These were distilled and abstracted, for instance into simplified forms and pure colour – like Matisse (she had contact with the French avant-garde in 1932), although Hepworth's starting point was nature, not the human figure. Made some geometric carvings in the 1930s; also beautiful drawings.

🔎 She had a lifelong belief in truth to materials – taking stone, wood, bronze (after 1950) and making apparent the unique quality of each individual piece, adapting the final form to its own peculiarities. Initiated and developed pierced form to explore materials and evoke nature's mystery and organic growth. Used strings to express emotional response and tension. Greek titles, after visit to Greece (1953), indicate respect for classical tradition.

💰 (18) £1,780/$2,883 – £278,146/$420,000
🔨 £278,146/$420,000 in 2000, *Family of Man, Ultimate Form* (sculpture, 1970)

HERON Patrick NH
1920–99 British

Revered and respected as one of the pioneers of large-scale postwar abstract

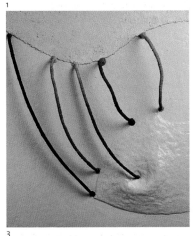

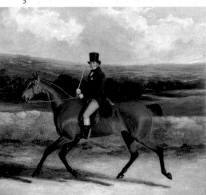

*I realize how hung up I am about always feeling what I do is wrong, not good enough [. . .];
always that it will break, wear badly, not last, that technically I failed. It does parallel my life
for certain.* EVA HESSE

art in the UK. Had a difficult, combative
personality.

🖾 Creator of a prolific and impressive
body of work that is intensely visual,
colourful, and inspired by personal
emotion and things seen. Sought to
bridge the gap between European
aesthetic sensibility and American
direct rawness (and falls between two
stools as a result?). If possible see his
work in daylight (preferably sunlight)
so the individual colours and colour
contrasts and interactions reach their
full potential of Mediterranean intensity.

🔍 His most powerful work date from
the late 1960s and early 1970s – big works
with intense, simple, hard-edge colour
forms that generate intense colour
sensations and pulsating spaces (stand
close to them for the full power to
develop in your eye). His earlier work
shows the inspiration of landscape,
seascape and the light of Cornwall. His
final 'scribbled' work shows the impact of
personal trauma (illness, death of wife).
Everything was created with very great
(but not always obvious) technical
exactitude.

🅐 (13) £1,700/$2,720 –
£28,000/$45,360
🔨 £41,000/$67,650 in 1997,
*Blue Painting, November-
December 58* (oil p.)

HERRING John Frederick (senior) NH
1795–1865 British

Coach driver and sparetime painter
who became a professional artist in
1820. Was patronised by the nobility for
portraits of their horses and for racing
and hunting scenes. Prolific, but had a
chequered career financially; ultimately
prospered and acquired a (leased) country
estate – hence the late non-sporting
landscapes. Three painter sons were
less successful.

🅐 (47) £1,300/$1,950 –
£210,000/$310,800
🔨 £1,490,066/$2.25m in 1996,
The Start of the Epsom Derby
(oil p., 1835)

HESSE Eva MM
1936–70 German/American

Short-lived, deeply sensitive (and perhaps
troubled) young woman of fragile health
(she died of cancer), who has temporarily
become a cult figure. She and her work
epitomise one type of high art of the
1960s.

🖾 She had deadly serious intention
and personal expression, but at times
was totally impenetrable. Creator of a
wide range of work: abstract paintings,
sculpture and Minimalist, Conceptual
constructions – perhaps the sign of
a lost soul searching for her own
reality. Her work addressed her own
anxieties and experiences: Nazi
persecution; being a refugee in New
York; her parents' divorce; her mother's
suicide; being a professional woman
in a male world; her own painful divorce;
her determination to be an outsider.

🔍 She was committed to the
handmade, but the concept was more
important than the details. Her work
makes constant allusion to female sexual
anatomy. Employed repetitive binding
with strings and ropes. Hated decoration,
hence the materials she used and the way
they are used – works are (deliberately?)
repellent to sight and touch. The serious
and personal intentions are laudable, but
is there not a danger with such artists
that they will communicate directly only
to a small group of kindred spirits and
have little to say to 'outsiders'.

🅐 (9) £6,897/$10,000 –
£211,180/$340,000
🔨 £1,183,432/$2m in 1997, *Unfinished,
Untitled, or Not Yet* (sculpture)

HEYDEN Jan van der OM
1637–1712 Dutch

Prosperous inventor and designer of fire engines and lighting for whom painting was a secondary activity. Best known for meticulous, small-scale topographical and capriccio views of towns (in the Netherlands and Rhineland), and still lifes.

☽ Famous for dexterous painting of walls and masonry. Sets warm, sharp, detailed bricks against blue skies and fluffy white cloud – satisfying contrasts of warm and cool, hard and soft. His standard composition is of buildings closing in on one side with an open area leading out of the picture on the other – another good use of contrast.

Ⓐ (4) £14,000/$22,960 – £119,389/$193,410
⚒ £600,000/$1m in 1997, *Düsseldorf, view of the Jesuit church of St Andreas* (oil p., 1666)

HICKS Edward NH
1780–1849 American

Had a Quaker upbringing in Pennsylvania (and became a Quaker minister in 1811). Learned the trade of decorative coach painting. Best known for his *Peaceable Kingdom* paintings illustrating Isaiah 11:6–9 (words are sometimes inscribed round the picture) – the belief in a peaceful coexistence. Quakers disapproved of art, but illustrating Isaiah was OK.

☽ Painted 60 different versions of *Peaceable Kingdom* between 1816 and 1849. The animals' expressions change from tense and fearful to sad and resigned, reflecting the current political divisions among the Quakers; in the background William Penn concludes a treaty with the Indians. Late in his life Hicks also painted depictions of the Declaration of Independence and Washington crossing the Delaware River.

Ⓐ (1) £352,761/$575,000
⚒ £468,750/$900,000 in 1990, *Penn's Treaty* (oil p.)

HILLIARD Nicholas NH
1547–1619 British

Principal portrait painter during reign of Elizabeth I. He was especially known for miniatures, which he produced in quantity to pay the bills for a large family.

☽ Look for innovative oval format, symbolism, French elegance, fine outline. There are some life-size portraits of Elizabeth I.

🏛 London: Victoria and Albert Museum
Ⓐ (2) £887/$1,285 – £48,000/$75,360
⚒ £160,000/$230,400 in 1993, *Man clasping hand from cloud, possibly Lord Thomas Howard* (miniature)

HILTON Roger NH
1911–75 British

Producer of gutsy, independent paintings, sometimes abstract, sometimes with rudimentary female or abstract forms. Delighted in colour, paint, female form, causing offence, and maintaining a rough humour in the face of considerable personal problems.

Ⓐ (41) £320/$470 – £13,000/$20,540
⚒ £25,000/$49,000 in 1990, *Untitled* (oil p., 1970)

HIROSHIGE Ando AG
1797–1858 Japanese

One of the best-known (in the West) masters of the art of the Japanese woodblock print. Prolific (made over 5,000 prints). Greatly influenced progressive European artists at the end of the 19th century (Monet and Van Gogh, for example).

◑ Claims that his art is a serious discussion of death and decay. Has undoubtedly an uncanny ability to comment on NOW – his current works touch that sensitive nerve of fears over the health industry, genetic engineering, getting old and infirm etc. Equally, he and his work have the fascination of a freak show at a circus. Is he saying something

◑ Created simple but subtle designs with firm outlines, solid colours and shallow spaces. Notable for his landscapes which encapsulate atmosphere and his poetic reverence for nature. At his best in depicting mist, rain and snow.

🅐🅥 (14) £1,780/$2,670 – £3,236/$186,000

🪓 £17,500/$28,000 in 1995, *Shinobazu pond at twilight* (works on paper)

HIRST Damien CS
1965– British

Current biggest young name in the UK. Famous for cows preserved in formaldehyde, but he makes 'art' with almost anything – cigarette butts, paint, video… An able entrepreneur who knows his market. Repetitive use of f**** words when interviewed. As an artist and personality, he will probably auto-destruct eventually.

long lasting, or is his art as significant as an executive toy? The comparisons with great artists such as Picasso are silly.

🔎 Credibility in London's contemporary art world requires name-dropping familiarity with 'Damien' and 'Rachel' (Whiteread). There is a fiercely aggressive and competitive international art market with tons of private and public money to spend, voracious appetite for headline-grabbing publicity and big exhibition spaces to fill. For them, Damien and Rachel deliver the goods and wow the media. Whether their work amounts to more than fashion statements remains to be seen.

🅐🅥 (52) £800/$1,208 – £478,873/$680,000

🪓 £540,000/$750,000 in 2000, *In Love – Out of Love* (sculpture)

1

2

HITCHENS Ivon NH
1893–1979 British

Sensitive painter who made a slow, patient progress from figuration to abstraction. His main theme was landscape, often in a long horizontal format, in which colour and form are increasingly abstracted to simple elements. Very English. Among the first in England to sustain a development of post-Cubist painting. Also painted still lifes and nudes.

- ⓐ (36) £300/$486 – £40,000/$64,000
- 🔨 £40,000/$64,000 in 1999, *Floral Still Life* (oil p., 1932)

HOBBEMA Meyndert OM
1638–1709 Dutch

Last of the major Dutch landscape painters of the 17th-century golden age. Gave up professional painting when he married (1668) and became a wine gauger instead. Limited and repetitive range (with the odd exception) of finely painted dark landscapes featuring watermills and cottages round a pool, with old, overgrown trees and occasional figures.

- ⓐ (2) £16,234/$24,513 – £184,049/$300,000
- 🔨 £3.4m/$5.27m in 1994, *Wooded landscape with cottages* (oil p.)

HOCKNEY David CS
1937– British

Genuinely gifted, with an acute eye and fertile imagination. Once the bad boy of British art, now a respected elder statesman. Sadly, he seems to have decided not to extend his talents (like Degas) and has settled to live the good life on undemanding potboilers (like Millais).

🌙 A truly great draughtsman – focused, precise, observant, free, who has a brilliant ability to extract only the essentials. Timely reminder of the pleasure and novelties of seeing, and recording perception with feeling, still important for art even after 500 years. Has stunning technique with pencil, pen and crayon and an immaculate sense of colour. Can make the commonplace memorable and moving. Chooses auto-biographical subjects (like his current hero, Picasso).

🔍 At his best when he acts the draughtsman (drawing, prints and paintings). Brilliant observer and re-creator of light, space and character in portraits, but not as convincing (though never uninteresting) when he tries to work solely from the imagination or to be a painterly painter (from the 1980s onwards). Inspired designer of sets for

I think I've had a permanent affair with the art of the past and it goes hot and cold [...]
The truth is, the art of the past is living; the art of the past that has died is not around.
DAVID HOCKNEY

theatre, opera, ballet. Currently experimenting with Cubism and photography – is this a new direction or a dead end?

- 🄰🄵 (155) £360/$576 – £405,405/$600,000
- 🪓 £1.2m/$2m in 1989, *Grand Procession of Dignitaries in the semi-Egyptian Style* (oil p., 1961)

HODGKIN Sir Howard CS
1932– British

Painter and printmaker. Colourful decorative works embracing many of the established idioms of classic modern art – bright colours, gesture, frame integrated into the work itself. For some it is nothing more than fashionable designer art. For others it is innovative abstraction, inspired by a sensitive response to people and situations.

- 🄰🄵 (23) £2,177/$3,200 – £370,000/$584,600
- 🪓 £370,000/$584,600 in 1999, *Interior with Figures* (oil p., 1977–84)

HODLER Ferdinand MM
1853–1918 Swiss

Talented painter of monumental figure paintings, portraits and landscapes.

- ☽ Painted modern narratives and allegories with a confident drawing style and strong outlines. Powerful, intensified colour; his hatched brush strokes and broken colour give optical vibrancy. Untroubled by self-doubt, but sometimes fall into the trap of the pompously overserious statement. Liked silhouetted figures or mountains against a sky.

- 🄰🄵 (77) £265/$427 – £894,309/$1,296,748
- 🪓 £1,629,956/$2,705,727 in 1998, *Lake Silvaplaner* (oil p., 1907)

3

HOFMANN Hans MM
1880–1966 German/American

Pioneering, but only moderately successful, abstract painter (style never fully resolved – principally large squares modified by thick pigment and bright colour). Hugely gifted and influential as a teacher. The key figure in bringing news of the European giants (like Picasso) to the younger generation of soon-to-be American Abstract Expressionists.

- 🄰🄵 (26) £1,119/$1,600 – £320,988/$520,000
- 🪓 £404,762/$680,000 in 1996, *Gloria in Excelsis* (oil p., 1963)

HOGARTH William AG
1697–1764 British

The 'father of English painting'. Quirky, argumentative anti-foreigner, with a tough childhood in London. Talented both as a painter and printmaker, he laid the foundation stones that led to Reynolds and the Royal Academy.

- ☽ Best known for his portraits (individual and group) and modern, moral subjects – slices of contemporary life, which were often developed as a series (for instance, 'The Rake's Progress' and 'Marriage à la Mode'). In neither does he idealise or criticise; he shows people and their behaviour for what they are,

with humour and humanity, like a good piece of popular theatre (note how figures are arranged as on a stage set). A down-to-earth painter with down-to-earth techniques and subjects.

🔎 Brilliant as a storyteller. Also a very fine handler of paint, producing confident drawing and colour-rich textures. Painted attractive, open faces in portraits and was especially good representing children. Showed engaging, anecdotal details and 'warts and all' realism, but we are left to draw our own moral conclusions. Look for the flowing, serpentine lines – the 'line of beauty', which was his 'signature' and a major characteristic of art and design in the mid-18th century.

🏛 London: National Gallery; Tate Britain; Sir John Soane's Museum
🅐🅥 (1) £35,000/$52,850
🪓 £365,000/$602,250 in 1991, *The Edwards Hamilton family on terrace in Kensington* (oil p.)

HOKUSAI Katsushika AG
1760–1849 Japanese

Better known in the West than in Japan as one of the masters of the woodblock print. Prolific producer of prints and books, but principally a painter (nearly all his painted work was destroyed in a fire in 1839). He had many subjects but is noted for inventing the landscape print, which, like Hiroshige's work, greatly influenced the progressive artists of the second half of the 19th century, such as Monet and Van Gogh.

🌙 His subtle designs are more dependent on simple shapes and gradations of tone than bold outline. He liked a powerful central subject, such as Mount Fuji, a waterfall or a bridge.

🪓 £90,000/$150,300 in 1997, *Red Fuji* from 'Fugaku Sanju-Rokkei' (works on paper)

HOLBEIN Hans AG
c.14978–1543 German/Swiss

Forced to leave Switzerland because of the Reformation, Holbein came to England and established himself successfully as the propaganda portrait painter of the era of Henry VIII. Died of the plague. Little is known about his life.

🌙 Famous above all for his portraits (many of his early religious works were destroyed during the Reformation). There are interesting parallels with official court photographs of the mid-20th century (such as the work of Cecil Beaton): masterly, memorable, posed, officially commissionned images (in sharp focus) of the monarch and ruling officials, which are self-chosen icons of the

1

political and constitutional system. Also produced more informal and flattering (but never too relaxed) soft-focus images of the high society that surrounded the court.

🔎 Note the way he draws and models with light (as does a photographer); the remarkable sharp-focus detail (stubble on a chin, fur); intense lighting; wonderful feel for structure of a face and for the personality inside it. Portraits before mid-1530s are full of objects (sometimes symbolic); later they are flattened designs on a dark background (like postage stamp images?). The famous album of

80 drawings at Windsor contains the lovely, soft-focus, informal portraits.

🏛 Windsor (England): Windsor Castle, Royal Collection
Ⓐ (2) £1,811/$3,024 – £96,552/$140,000
🔨 £1.45m /$1,957,500 in 1984, *Portrait of a Scholar* (w/c)

HOLZER Jenny CS
1950– American

Presenter of aphorisms (brief pithy sayings) immaculately laid out for public display in the form of advertising, hoardings, T-shirts, fly posters, museums and public buildings. Her work is most effective with moving LED lights. Her underlying message revolves round love, sex, death and war.

🌙 Slick presentation makes for compulsive viewing. The simplicity of individual words effectively interacts with the deliberate ambiguity of the overall message. Walks a tightrope between poetry and banality.

Ⓐ (16) £898/$1,284 – £47,297/$70,000
🔨 £44,643/$75,000 in 1990, *Selection from Survival Series* (sculpture)

HOMER Winslow AG
1836–1910 American

One of the great 19th-century painters. Interpreted nature in a way that convincingly reflects the American pioneering spirit. Well travelled in the USA, England and the Bahamas. Self-taught.

🌙 Creator of highly satisfying, virile images: sea paintings of the Atlantic Coast; images of down-to-earth, practical people, especially when coping with adversity; modern women; robust children. Made a pragmatic exploration of light and colour, and produced strong, well-designed and boldly painted pictures. Also painted exquisite, fresh, fluid watercolours. His work has a strong narrative content (he started as a magazine illustrator) but he lifted his art beyond the ordinary by infusing it with a sincerely felt, underlying moral message and a subtle ambiguity of meaning.

🔍 His no-nonsense practical painting is completely in tune with its subject matter, time and place. Has an enviable ability to simplify and leave out unnecessary detail. Uses strong contrasts of light and shade with assurance. Note the solid, unhesitating draughtsman and frequent use of a silhouetted figure, often in heroic attitude. He employs the imagery of children as a metaphor for the future of America. Note also how his style and subjects grow larger, stronger, more confident and more free with age and experience .

🏛 New York: Metropolitan Museum of Art
💰 (20) £3,741/$5,500 – £2.75m/$4.4m
🔨 £2.75m/$4.4m in 1999, *Red Canoe* (drawing, 1889)

HONTHORST Gerrit van NH
1590–1656 Dutch

Only member of the Utrecht School to establish an international reputation. Studied in Rome 1610–12. Much favoured by royal and aristocratic patrons for his history paintings and allegorical decorations. Best remembered now for striking treatment of illumination by artificial light – especially good when he hides light source and plays with silhouette.

💰 (8) £7,317/$12,000 – £280,000/$434,000
🔨 £280,000/$434,000 in 1999, *Portrait of laughing violonist* (oil p., 1624)

HOOCH Pieter de AG
1629–83 Dutch

Perennially popular Dutch master – one of the best-known and best-loved genre painters. He died insane, but little is known of his life.

🌙 His best and most widely known work dates from his years in Delft (1654 to early 1660s), and is of sunny courtyards and sunlit interiors, celebrating well-behaved middle-class life. Before 1655 he painted lowlife peasant and soldier scenes. After 1665 portrayed rich interiors with a bogus view of pseudo-aristocratic life. His very late work is feeble.

🔍 Observe the way he plays with and enjoys space and light – he creates views from one room or area to another and uses the geometric patterns of tiled floors and paved courtyards to construct the illusion of space, leaving the foreground uncluttered and flooding them with warm light. He designs careful compositions with well-placed verticals, horizontals and diagonals. Uses carefully worked-out geometric perspective, usually with a single vanishing point, and makes discreet use of symbols and emblems.

💰 (5) £32,000/$50,240 – £160,000/$248,000
🔨 £4m/$6.24m in 1992, *Courtyard of house in Delft with young woman and two men* (oil p., 1658)

HOPPER Edward MM
1882–1967 American

Taciturn, monosyllabic, New York inhabitant with small-town puritan upbringing who became a successful and quintessential American painter.

🌙 His imagery is the American urban landscape and its inhabitants, and also Cape Cod. Marvellous observation and recording of light (perhaps most notably harsh, electric light). Spare, lean, tough technique (like many of his subjects). Strong colour sense and ability to create tense confined spaces. Influenced by photography and the movies (avid movie-goer) and Impressionism (visited Paris in 1906–7 and 1909–10).

🔍 How is he able to make the commonplace and banal so uneasy,

significant and memorable? Is it his magic way with light? His ability to simplify and generalise – to express a universal mood, not just an anecdotal story? His subtle space distortions that create a sense that something is wrong or about to happen?

🔨 £1,145,833/$2.2m in 1990, *South Truro Church* (oil p.)

HOPPNER John NH
1758–1810 British

Hot-tempered portrait painter of royalty and aristocracy (German parents, childhood at court of George III) who had precocious talent. Chose simple poses and was a good painter of character; spot-lit faces with dark backgrounds.

Similar talents are shown by the great black-and-white movie producers (like Hitchcock) – one of his pictures could be stills from a movie.

🏛 New York: Whitney Museum
🅰🅥 (19) £2,548/$4,000 –
£258,741/$370,000

Moody, sketchy landscapes. Note the Venetian influence: free brushwork, impasto, luscious and warm colour. His best period was post-1790.

- ⓐⱽ (6) £1,724/$2,500 – £45,000/$70,200
- ⤳ £62,000/$122,140 in 1990, *Portrait of Mademoiselle Hilligsberg by window in interior* (oil p.)

HORN Rebecca CS
1944– German

Creator of highly original installations incorporating machines that move, click, whirr, flick paint or flap wings and are generally surprising or unpredictable. Her work is compulsive viewing, entertaining and unnerving, and has the ability to set off odd and possibly alarming or subversive trains of thought (which is what she is after). Machines need perfecting (too many breakdowns).

- ⓐⱽ (7) £746/$1,245 – £24,691/$38,000
- ⤳ £24,837/$38,000 in 1993, *Untitled Shoes* (sculpture, 1989)

HOYLAND John NH
1934– British

Exponent of anglicised version of American abstraction. His large-scale works emphasise the activity of the artist working energetically on the surface of the canvas. Early work uses rich fields of colour, simple shapes and staining; his later work is increasingly wild. Refuses to grow old, which is good in that his recent work is full of energy; but bad because, like an aging hippy, this old 'youth' can seem forced and false.

- ⓐⱽ (17) £750/$1,058 – £4,500/$7,290
- ⤳ £6,000/$9,780 in 1991, *Untitled* (oil p., 1971)

HUDSON Thomas NH
1701–79 British

For a brief period (c.1740–55) was London's leading fashionable portrait painter. His use of stock formulae and employment of drapery painters to make the costumes make him seem wooden and unimaginative when compared with his most famous pupil, Joshua Reynolds. Avid collector of old-master paintings and drawings (especially Flemish), and works by contemporary artists.

- 🔎 His formula for face painting consisted of brush strokes which followed the contours of the face – vertical for noses, horizontal for mouth and chin, diagonal for cheeks.

- ⓐⱽ (13) £1,973/$2,979 – £30,000/$48,000

1

- ⤳ £41,000/$63,550 in 1996, *Portrait of Elizabeth Harwick, standing in landscape and holding rose* (oil p.)

HUME Gary CS
1962– British

Another, now not so quite young man, on the cutting edge from the Goldsmiths

College stable (*see also* Fiona Rae and Damien Hirst).

🌑 He chooses straightforward images (taken from magazines or old masters, so it is said), which are painted on large reflecting surfaces with household paint in a very flat, simple style. Works have the advantage of standing out recognisably in a mixed show, and at a distance appear to be meticulously painted; on close examination, however, they turn out to be remarkably slapdash. A perfect example of post-modern style and aesthetic.

🔍 Part of the intrigue is that you can see yourself in the reflecting surfaces (deliberate ploy by the artist and a winner at a private viewing or exhibition). If you want to praise him, you say 'smart, flip, knowing' and carefully avoid the words 'trite, banal, slight'. You might, however, feel he is still doing what are really art-school exercises (albeit very well) and that he wins by satisfying the consumer market's craving for something big, easy and recognisable.

- Ⓐ (8) £10,000/$15,800 – £98,592/$140,000
- 🔨 £98,592/$140,000 in 2000, *Pauline* (oil p., 1996)

HUNDERTWASSER Fritz (Friedrich Stowasser) MM
1928–2000 Austrian

Produced small, detailed, richly coloured, ornamental and jewel-like abstract works, often with a spiral motif, which is organic and labyrinthine in character (a deliberate metaphor for the self-regenerative processes of life). Used mixed media, gold and silver, wrapping paper and jute. Refreshingly romantic and lyrical.

- Ⓐ (130) £1,536/$2,214 – £130,000/$196,300
- 🔨 £130,000/$196,300 in 2000, *Autofahrer in der Nacht* (oil p., 1963)

HUNT William Holman NH
1827–1910 British

Founder member of the Pre-Raphaelite Brotherhood and its most consistent exponent. Religious, obsessive and stubborn, producing work with insistent moralising and didactic themes. A true Victorian, who verges on greatness but whose obsession with detail and colouring can be intense to the point of unpleasantness.

- Ⓐ (3) £647/$971 – £5,400/$8,478
- 🔨 £1.7m/$2.72m in 1994, *The Shadow of Death* (oil p., 1873)

HUNTER Leslie NH
1877–1931 British

One the four Scottish Colourists (with Cadell, Fergusson and Peploe). At the age of 13 he left Scotland for San Francisco and a career as an illustrator, but returned in 1906 when an earthquake destroyed all his work on the eve of his first one-man show. Was self-taught. Preferred colour and fluidity to structure – sought to bring colour to Scottish greyness. A moon reflecting the bright suns of Manet and Matisse.

- Ⓐ (2) £1,200/$1,740 – £38,000/$55,100
- 🔨 £48,000/$79,680 in 1998, *Still Life of Assorted Fruit and Roses* (oil p.)

HUYSUM Jan van OM
1682–1749 Dutch

One of the most prolific flower painters, he gained an impressive international reputation. Ornamental bouquets of assymetrically arranged flowers, not necessarily of the same season. Smooth enamel-like paint; cool tones; vivid blues and geens. A few fruit pieces and landscapes. Whenever possible worked directly from life rather than from previous studies.

 (11) £1,043/$1,700 –
£320,000/$496,000

 £1,787,710/$3.2m in 1992,
*Flowers in a terracotta vase on a
marble plinth* (oil p.)

IMMENDORF Jorg CS
1945– German

Creator of heavily painted Expressionist
work that is essentially traditional
and derivative (of 1920s German
Expressionism and Beckmann).
Addresses political issues such as the
divided Germany or the environment.
Typical imagery is a café interior with
an anonymous crowd, and symbolism
of watchtowers, uniforms, barbed wire
and eagles.

 (24) £329/$526 –
£28,094/$44,950

 £98,976/$193,993 in 1990, *Tor I,
Design* (works on paper, 1979)

INDIANA Robert (John Clark) CS
1928– American

Remembered for the brief period when
he created imagery of simple words
and numbers painted on a large scale
in blazing colour. Work is flat, razor-
edged and heraldic; has effective, eye-
bombarding optical impact. Often uses
a single, monosyllabic command – EAT;
LOVE; DIE. Influenced by billboard signs.
Very Pop art, very 1960s; now very dated.

 (10) £709/$1,121 –
£88,028/$125,000

 £168,919/$250,000 in 1993,
*The black diamond American dream
No 2* (oil p.)

INGRES Jean-Auguste-Dominique AG
1780–1867 French

One of the major heroes of French
art and the master of high-flown

academic illusionism. Great admirer
of Italian Renaissance and Raphael.
Tortured, uptight personality.

His work conveys total certainty.
His subjects were well established
and officially approved: portraits, nudes
and mythologies, all painted with the
high degree of 'finish' required by the
Academy. He created the most
manicured paintings in the whole
history of art – everything is carefully
arranged (hair, hands, poses, clothes,
settings, faces, smiles, attitudes, even
light itself). Also produced some of
the most exquisite drawings ever
made, with total mastery of line
and precise observation.

Notice the way he (usually,
but not always) manipulates this
artificial idealism and fuses realism
with distortion so that the end result
is alive and thrilling, and never dead
academicism. Note the chubby hands
with tapering fingers (they can look
like flippers), the strange necks and
sloping shoulders. Had an interest
in painting figures that are reflected in
mirrors – maybe his (and his society's)
whole world was that glassy reality/
unreality of the looking glass?

Paris: Musée du Louvre
Montauban (France): Musée Ingres

 (20) £1,535/$2,456 –
£382,044/$618,911

 £1.3m/$2,132,492 in 1989,
Jupiter et Thétis (oil p.)

INNES Callum CS
1962– British

Internationally acclaimed young
Scottish painter who draws inspiration
from the shifting quality of light on the
E ast coast of Scotland. His early work
is figurative with elements of personal
mythology and landscape. His recent
work is abstract and involves eroding
a monochrome ground of paint with

turpentine, applied by brush or allowed to run in rivulets.

- Ⓐ (8) £1,800/$2,592 – £13,000/$19,630
- ⚒ £13,000/$19,630 in 2000, *Exposed* (oil p., 1997)

small- to medium-sized religious pictures and portraits. Worked in Gerrit David's studio. His Virgins have narrow chins, heavy eyelids, small mouths. Combined Gothic elements (such as

INNES James Dickson NH
1887–1914 British

Short-lived (tuberculosis), eccentric, latter-day romantic visionary. Welsh born and close friend of Augustus John. Produced small-scale landscapes, mostly of Wales, painted at speed with confident short brush strokes and bright colours. Was influenced by the works of the French post-Impressionists and Matisse (he was in France in 1908 and 1911).

- Ⓐ (4) £900/$1,332 – £16,000/$4,480
- ⚒ £24,615/$47,015 in 1992, *Bala Lake* (oil p., 1911)

ISENBRANDT Adriaen OM
c.1490–1551 Flemish

Shadowy figure from Bruges who was reputedly famous and well-to-do. There are few authenticated works by him and they are of uneven quality. Was best at

spiky, decorative rocks) with Renaissance details (such as classical columns).

- Ⓐ (2) £65,000/$100,000 – £68,966/$100,750
- ⚒ £361,963/$590,000 in 1998, *The Nativity, Saints Jerome and Catherine of Alexandria* (oil p.)

JAWLENSKY Alexei von MM
1864–1941 Russian

One of the minor masters of Modernism, much influenced by Kandinsky and Matisse. Sensitive, mystical, small-scale works, with simplified forms, pure colours and bold blue outlines. Note his birth date – later than you might think – he was the same age as Matisse and Kandinsky.

- Ⓐ (72) £294/$464 – £550,000/$907,500
- ⚒ £1.1m/$1,826,000 in 1997, *Still Life With Cake* (oil p., 1905)

JOHN Augustus NH
1878–1961 British

Truly gifted and one of the best draughtsmen of any period. His romantic bohemian temperament made him an increasing misfit – should have lived in the first half of 19th century, not the 20th. His wonderful early pieces show his great originality and talent; after 1918 it went to seed and he ended up doing competent, unexceptional work – although always recognisably John.

◗ His best works are his early drawings and the sensitive, simplified, intensely coloured landscapes – a personal interpretation of post-Impressionism. Painted society portraits with style and panache. Unjustly underrated – deserves reinstatement.

◍ (56) £333/$497 – £38,000/$53,580
🗡 £92,000/$149,040 in 1997, *Head of Girl* (drawing, 1906)

JOHN Gwen NH
1876–1939 British

Sister of Augustus John and mistress of Rodin. Author of tight, overintense (neurotic?), minutely worked, rather monochromatic portraits and interiors. Had a sensitive talent, although limited in range and currently overrated compared with her brother.

🏛 Cardiff (UK): National Museum of Wales. London: Tate Britain
◍ (12) £650/$1,047 – £10,000/$14,500
🗡 £165,000/$265,650 in 1990, *The Seated Woman* (oil p.)

JOHNS Jasper CS
1930– American

Key figure in postwar American art and a founding father of Pop art. Very influential, very much admired.

Is (and will be) to American 20th-century art what Poussin is to 17th-century French art.

◗ His paintings and objects constantly question the nature of perception and aesthetic experience. His art is cerebral, philosophical and (necessarily?) closed and self-referential. He loves polarities – works that are simultaneously cerebral and sensual, light-hearted and serious, simple and complex, beautiful and banal, realistic and illusionistic. He also plays with the relationship between words and images.

🔎 The classic Johns are his early American flag paintings. They caused great excitement because no one could work out (and still can't?) whether they were paintings or objects, abstract works of art or literal reproductions of the flag, banal or deeply emotional. Like a modern philosopher, he enjoys these riddles about definitions. He can work on a small scale (the beer cans), or a large scale (through canvases with objects attached). Used encaustic (wax) technique for his early work.

◍ (110) £1,618/$2,346 – £4,012,346/$6.5m
🗡 £8.61m/$15.5m in 1988, *False Start* (oil p.)

JONES Allen CS
1937– British

One of the founders of Pop art. Uses simple, figurative imagery, often with erotic charge (likes fetish symbolism – high heels, body-clinging garments, and so on), combined with bright, bold, 'modern' abstract colour. Very much a product of the swinging London of the 1960s and not ashamed to continue the theme.

◍ (14) £300/$436 – £14,000/$22,680
🗡 £28,409/$44,886 in 1995, *Orange Skirt* (oil p., 1964)

JONES David NH
1895–1974 British

A Roman Catholic convert with a fragile personality (wounded in 1916, breakdown in 1933) who created very delicate, questioning watercolours and poems with religious and visionary content. The refinement of this pale,

Combined tradition (finely detailed northern technique, overloaded symbolism, stiffly posed figures and draperies) with progressive ideas (landscapes and rocky formations, Italian-style modelling with light, extravagant costumes, detailed surfaces). Note cosy, homely details.

1

2

complex work is always in danger of becoming too precious. Possibly more at ease with words than visual art.

- Ⓐ (15) £300/$468 – £16,500/$26,070
- ⚒ £16,500/$26,070 in 1999, *Blaeu bwch* (w/c, 1926)

JOOS van CLEVE OM
c.1490–1540 Netherlandish

Popular, Antwerp-based painter of devotional altarpieces and portraits.

(2) £3,262/$4,926 –
£220,690/$320,000

£227,273/$350,000 in 1993,
*Christ on Cross with Mary,
Mary Magdalen and Saint John
the Evangelist* (oil p.)

JORDAENS Jacob OM
1593–1678 Flemish

Leading painter in Amsterdam after
the death of Rubens, whose style he
emulated (was an assistant to Rubens).
By comparison his work seems hectic
and badly organised, without any clear
visual and emotional focus. Best when
not being too ambitious (for instance,
in genre scenes). Good portraits. Large
output from commissions, but quantity
took precedence over quality.

(26) £1,031/$1,475 –
£190,000/$286,900

£770,000/$1,155,000 in 1996,
The Four Doctors of the Church (oil p.)

JORN Asger MM
1914–73 Danish

Founder member of CoBrA. Boldly and
freely painted, intensely coloured,
consciously gestural works, sometimes
abstract, sometimes with figurative
imagery. In the forefront of European
art until the mid-1960s, when Pop art
became the fashion.

(101) £576/$910 –
£120,096/$189,600

£245,000/$404,250 in 1997,
Nothing Happens (oil p., 1962)

JUDD Donald (Don) MM
1928–94 American

Created sculptures by giving instructions
for the industrial production of modular
(often large) box-shaped objects in
polished metal and Plexiglas, which are

often stacked and cantilevered. They
are simple, minimal, with proportions
and spaces based on mathematical
progressions, and all of a piece in
shape, colour and surface. The works
are detached and cool, with no human
presence or reference.

🏛 Marfa (Texas, USA): Chinati
Foundation

(37) £1,988/$3,200 –
£521,127/$740,000

£521,127/$740,000 in 2000,
Untitled (sculpture, 1970)

KAHLO Frida MM
1907–54 Mexican

One of the best-known Mexican
painters, who created powerful,
figurative images that synthesised
her sufferings, both physical (crippled
in a car accident at the age of 15) and
emotional (stormy marriage to Diego
Rivera), with an exploration of themes of
Mexican politics and identity. Is her art
merely parochial, or does it touch deeper
levels of emotion?

(2) £15,603/$22,000 –
£460,123/$750,000

£1,847,134/$2.9m in 1995,
Autretrato con chango y loro
(oil p., 1942)

KANDINSKY Wassily AG
1866–1944 Russian

One of the pioneers of the Modern
Movement and reputedly the painter
of the first abstract picture. Lived in
Germany 1896–1914 and 1922–33, and
taught at the Bauhaus in the 1920s.

🔊 Notice how he worked towards
his abstract work slowly, from
increasingly simplified figurative work
through to sketchy abstracts and then
hard-edge abstract. Had a complex,
multifaceted personality. For example,

he cultivated an intellectual rather than instinctive approach to art, backed up by much theoretical writing, but at the same time he had a strong physical sensitivity to colour, which he could hear as well as see (a phenomenon called synaesthesia).

🔍 Stand close to the paintings, let them fill your field of vision, then try to relax the eye and the mind so the colour and shapes reach that part of the brain that responds to music – don't attempt to see them as design, or analyse them, but float into them and let yourself go. If you have never looked at a picture this way before, it can be a strange, exhilarating, spiritual experience – but it will need time and patience.

🏛 New York: Guggenheim Museum
Munich: Stadtische Galerie
⊕ (81) £1,563/$2,234 –
£750,000/$1,185,000
🪓 £11,242,604/$19m in 1990,
Fugue (oil p.)

KAPOOR Anish cs
1954– British/Indian

Born in Bombay but settled in the UK. Creator of original 3-D objects in which colour, space and the interplay between the visible and invisible predominate – high-quality toys for adults, in the best sense.

🌑 His strange-looking objects are made from materials such as steel, fibreglass or stone. Sometimes they are deceptively simple. They can have highly polished or intensely pigmented surfaces. They can also be on a large scale. To find your way into them, be prepared to suspend disbelief – stop seeing them as man-made objects (although the way they are conceived and made is interesting in itself) and allow them to act freely on your perception and imagination. Go on, play with them.

🔍 If you let go and allow your mind and eye to follow their own course – rather as you may have been able to do as a child, looking at the sky and clouds – there is a lot there. Enjoy thrilling and strange spaces to sink into, colourful 'magic kingdoms' to explore, the familiar made strange. Lots of simple, unthreatening, genuinely 'out of this world' experiences. A fresh and inspiring affirmation of art's role in celebrating and creating some *joie de vivre*.

⊕ (3) £12,422/$20,000 –
£50,000/$75,500
🪓 £50,000/$75,500 in 2000,
Untitled (sculpture, 1985)

KAPROW Allan cs
1927– American

First practitioner of Performance and Conceptual art in the USA. Started as an Abstract Expressionist but then realised Abstract Expressionism had run out of steam. Elevated Dada-type happenings to large-scale theatrical events, such as students eating jam smeared on a car body. Very 1960s; very ephemeral. Any works you see in museums are strictly a documentation of past events.

🪓 £444/$769 in 1991, *Woman Seated* (works on paper, 1954)

1

2

KATZ Alex CS
1927– American

Veteran, very visual, American figurative painter who reruns traditional themes and techniques in a contemporary American idiom.

◑ Replays, with genuine inventiveness, themes and ideas beloved of the French Impressionists and post-Impressionists (Manet, Monet and Seurat, especially): airy landscapes, the middle class at play, fascination with recording the effects of light. Direct wet-in-wet oil technique; colour harmonies and dissonances; open brushwork that jumps into a focused image at a distance. Look for the self-absorbed faces, gestures and intriguing psychology that you find in Manet.

🔎 He is to French art what Californian Cabernet Sauvignon wine is to French Bordeaux – not necessarily better or worse, but noticeably different: on a bigger scale, more direct, less complex. Enjoy his works for what they are: a refreshing, eye-filling pleasure, with a distinguished and recognisable pedigree. Try to see the paintings by daylight, and also notice the sketches done from life, which he works up into large scale in the studio.

Ⓐ (17) £938/$1,500 –
£46,584/$75,000
🔨 £77,181/$115,000, *Summer picnic* (oil p., 1975)

KAUFFMANN Angelica NH
1741–1807 British

Best known for work done during her stay in England (1765–80), when she was very successful with elegant, delicate portraits, history paintings and decorations, in the style of Reynolds, for Adam houses. She was partial to sentimental figures with pink faces and cheeks.

Ⓐ (24) £376/$594 –
£128,378/$190,000
🔨 £120,000/$229,200 in 1992, *Portrait of Lady rushout and her daughter Anne seated in landscape* (oil p.)

KELLEY Mike CS
1954– American

Creator of the usual round of installations, drawings and texts, plus references to diverse sources, such as Christianity, Surrealism, folk art, traumatic autobiography (you name it, he's used it). Said to investigate relationships between enjoyment and guilt, suppression and sublimation, normality and abnormality. Opposes the ubiquitous merchandising and packaging of culture.

◑ Maybe it is a brilliant exposé of 'life's complex contradictoriness'. Maybe it is a classic case of muddled thinking and perception (in which case someone is bound to argue that muddled thinking is a brilliant exposé of life's complex contradictoriness).

⊕ (27) £1,800/$2,844 – £93,168/$150,000
⚒ £93,168/$150,000 in 1999, *The Sublime, The Sublime Framed* (works on paper, 1983)

KELLY Ellsworth CS
1923– American

One of the contemporary masters who has continued the exploration of colour started by Matisse. Shows that the traditional values of painting – technical perfection, visual pleasure, spiritual uplift – are still alive and well.

◑ His very simple large canvases are saturated with pure colour. Let the eye and the mind relax fully and absorb the colours, shapes and razor-sharp edges. Enjoy them for what they are and let them play on the imagination, stretch the eye and stretch the mind's eye. Look at them close to and from a distance. Look at the meticulously painted surfaces (he always uses oil paint for richness of colour).

🔍 His works are sometimes to be enjoyed as objects seeming to float on the wall; sometimes to be seen as spaces through the wall giving onto fields of blue (sky or sea?), or red (earth or fire?). He mixes his own colours, and what he creates is a final distillation of something once seen in the world (especially architecture). It uplifts the eye and the spirit – as refreshing as chilled Champagne. The canvases must be in pristine condition (damage and dirt ruin the purity and experience).

⊕ (31) £1,548/$2,214 – £686,620/$975,000
⚒ £686,620/$975,000 in 2000, *Falcon* (oil p., 1959)

KENTRIDGE William CS
1955– South African

Son of prominent anti-Apartheid lawyer with German/Jewish cultural roots. Much praised internationally and active in a variety of media: film, animation, set design, acting, theatrical productions, video. Powerful Expressionist charcoal and pastel drawings. Influences from Hogarth, Goya, Daumier. Impressive cycle of films (1989–96) which are allegories of South Africa's political upheavals.

⊕ (6) £1,220/$1,841 – £63,380/$90,000
⚒ £63,380/$90,000 in 2000, *Felix in Exile – history of the main complaint* (sculpture, 1994)

KIEFER Anselm CS
1945– German

Creates very large-scale, gloomy, superficially simple images, thickly painted, often with applied or collaged material. The intention is to draw your imagination in via perspectives, textures and layers, to confront difficult conceptual issues, such as Nazi horrors and guilt for the Jewish Holocaust.

1. R. B. Kitaj, *The Ohio Gang*, 1964
2. Yves Klein, *Sponge*, 1961
3. Paul Klee, *Ad Parnassum*, 1932

1

2

3

A sort of modern history painting. Uses art as a means of expunging the past.

☻ Look for the Hans Makart of our times.

🅐🅥 (25) £11,972/$17,000 – £330,000/$475,200
🔨 £440,000/$699,600 in 1995, *Die Konigin von Saba am Strand von Juda* (works on paper, 1983-86)

KIENHOLZ Edward MM
1927–94 American

Best known for his creation of environments with real-life objects, in which the people are replaced by figures moulded from fibreglass, with their heads and faces replaced by fishbowls, clocks or bottles. Coats everything with a slimy, repellent, fibreglass resin and conveys a deeply disturbing sense of urban and human desolation and decay.

🅐🅥 (19) £600/$870 – £10,345/$15,000
🔨 £61,765/$105,000 in 1998, *Boy, Son of John Doe* (sculpture, 1961)

KING Philip CS
1934– British

Important member of the 1960s avant-garde, which sought to challenge the thinking and values that its members considered then conservative and stodgy. Currently president of the Royal Academy.

◗ Bold and adventurous work that makes a public statement and is challenging and sometimes aggressive. His sculpture is about sculpture – art for art's sake. His style has changed in his recent work, although he continues to probe the same issues as before.

🔎 See how he poses questions. What can you make sculpture from? Can it be coloured? Do you put it on a plinth or do you sit it directly on the ground? What can you do with new materials? How can you escape convention? Where are the boundaries between painting and sculpture?

⤳ £8,200/$13,694 in 1991, *Through* (sculpture)

KIPPENBERGER Martin CS
1953–97 German

Creator of drawings, paintings, installations and performances, who often worked in close collaboration with friends and other artists. Was provocative, cynical and anti-authority, attempting to raise the trivial and 'subcultural' to the status of high art (he was not the first to do this – it has been one of the mainstream activities of artists since 1900). His last work, *MetroNet*, is of an imaginary, underground railway world.

🅐🅥 (36) £264/$372 – £403,727/$650,000
⤳ £403,727/$650,000 in 1999, *Untitled* (oil p., 1988)

KIRCHNER Ernst Ludwig MM
1880–1938 German

A key member of Die Brücke, he was sensitive, prone to mental and physical breakdown (terrible war experiences). Chronicled and expressed the schizophrenic mood of his times (1910s–1930s), in a highly charged, tense, Expressionist style. Chose urban, middle-

class subjects. Had a sketchy, wiry technique, making use of heightened, intensified colour. Committed suicide.

🅐🅥 (199) £413/$653 – £1.55m/$2.23m
⤳ £1.8m/$2,980,000 in 1997, *Street Scene. Portrait of Graf* (oil p., double sided 1913-14)

KITAJ Ronald Brooks CS
1932– American/British

US born, settled in the UK in 1960s. Maintains and advances a definition of art that is central to European painting in the 'grand manner' – life drawing, literary subjects, exposition of human, intellectual and moral issues. Sees himself as a martyr crucified by ignorant British critics (with some justification).

◗ He has a very personal style. Makes large-scale 'exhibition' pieces, with many personal and biographical references, sometimes hidden. There are cross-references to literature and philosophy, sometimes to specific passages. Concerned with the Jewish diaspora. Fine draughtsman and instinctive colourist. Independent of eye and mind, and (to his credit) difficult to pigeonhole. His refusal to compromise strikes some as arrogant – is this why he was recently savaged by art critics in Britain (but not in the USA)?

🅐🅥 (7) £1,000/$1,600 – £60,000/$90,600
⤳ £220,000/$341,000 in 1994, *Value, Price and Profit* (oil p., 1963)

KLEE Paul AG
1879–1940 German

Prolific author of drawings, watercolours and etchings. Was a dedicated teacher (Bauhaus) and a talented poet and musician. Had a fey, spiritual character and was one of the most original pioneers of the Modern Movement.

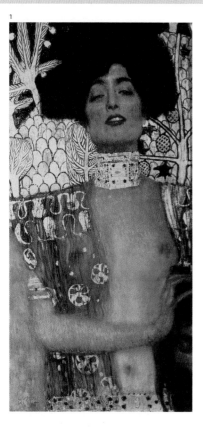

1

you back to the realm of childhood imagery, imagination and humour. You will return to adulthood immensely refreshed, enriched and stimulated.

Ⓐ (104) £1,597/$2,364 – £1,481,482/$2.4m
🔨 £2.8m/$4,788,000 in 1989, *Auftrieb und Weg, Segelflug* (oil p.)

KLEIN Yves MM
1928–62 French

Untrained (except at judo), uneducated, short-lived, megalomaniac dreamer who had a brief high-profile and influential presence.

🌒 His paintings, objects and records of 'happenings' (notably those saturated with his trademark YKB 'Yves Klein Blue') give a unique, intense glow. The rhetoric he and his supporters used is huge: blue is the infinite immateriality of the heavens; blue fills the space between object and viewer with spiritual energy; blue leads to Zen-like transcendental experience, and so on. With a leap of imagination similar to his own, this is possible. Also known for scandalous behaviour.

🌒 Creator of the chamber music of modern art – finely wrought small-scale works in many media, which are reminiscent in some ways of mediaeval manuscript illumination (perhaps he drew on this tradition?). Note his quirky, personal imagery and the delicate, unpretentious abstracts. His work is always very sensual, visually and mentally, and delightfully and poetically odd. Had an exquisite colour sense and produced neat, precisely worked surfaces.

🔍 Is the attraction of his objects the aesthetic and spiritual experience they seek to convey? Or is it that they were and remain as instantly recognisable and as chic as the Gucci loafer or Chanel No.5 – all of them proclaiming the possessor to be a (self-elected) member of the international club of connoisseurship and savoir-faire? Is this the first example of art as a high-class fashion accessory. And, if so, is it any the worse for that?

🔍 Don't try to understand or intellectualise Klee – just enjoy his work and follow him wherever he chooses to take your eye and imagination (one of his well-known writings is called 'Taking a line for a walk'). Above all, let him take

Ⓐ (86) £329/$514 – £4,295,775/$6.1m
🔨 £4,295,775/$6.1m in 2000, *Re I* (works on paper, 1958)

KLIMT Gustav AG
1862–1918 Austrian

Leading Viennese painter who broke away from convention to found the Viennese Sezession movement and develop a highly original, sensitive style. Some of his best projects were interior decoration.

2

🕦 The intense, introverted subject matter reflects Klimt's own personality (oversexed, workaholic) and *fin de siècle* Vienna (neurotic, idle, adulterous, gossipy, deeply conservative, but also packed with original talent and fresh ideas from Freud, Richard Strauss, Mahler, and so on). It also expresses his wish to explore modern sensibility and break free from old, stifling taboos and restrictions and his wish to demolish the snobby distinction between the fine artist and the craftsman.

🔎 Klimt's brilliant, inventive technique reflects his training (at the School for Decorative Arts, where he learned craft techniques) and his fascination with Egyptian art (flat and decorative) and Byzantine art (gold and mosaic). Notice the sensitive hands,

hidden faces, private symbolism – he worked through suggestion rather than description in order to touch the inner feeling rather than the outward show.

🏛 Vienna: Österreichische Galerie Belvedere

⬥ (54) £1,340/$2,157 – £1.9m/$3.13m

🗡 £13.2m/$21,384,000 in 1997, *Schloss Kammer am Attersee II* (oil p., 1909)

KLINE Franz MM
1910–62 American

Leading Abstract Expressionist who grew up in the industrial coal mining region of Pennsylvania. Studied in Boston and London. Lived a lonely life in New York and died young.

🕦 At first sight, his big black-and-white abstract paintings from the 1950s and 60s look like enlarged Chinese calligraphy. Typical of their time, they are gestural, personal, spontaneous, moody, full of existential angst. But further acquaintance shows that this is the opposite of what they are.

🔎 Kline was not spontaneous. He worked out the compositions and placing of the brush marks very carefully. Painted well-balanced, serene pictures with astonishing cerebral and sensual harmony. It is noticeable how visitors to a Kline exhibition become deeply engaged with the works and each other, and chat and smile.

⬥ (22) £1,235/$2,000 – £1,619,718/$2.3m

🗡 £1,566,265/$2.6m in 1989, *Scudera* (oil p., 1961)

KNELLER Sir Godfrey NH
1646–1723 German/British

German born, but settled in England at the age of 30. Became principal state

portrait painter from the reign of Charles II to George II. Established a successful formula (polite, mask-like faces with repetitive mouths and eyes) that emphasised status rather than realism or personality. Many substandard works were produced by studio assistants.

⊛ (22) £1,341/$2,200 – £52,987/$85,838

🔨 £161,812/$263,754 in 1997, *Portrait of King George I of England* (oil p., 1721)

🌑 The luminous calm hides a quiet national pride and a strong sense of moral virtues. Both sentiments are essential Biedermeier qualities and are revealed in his attention to detail, emphasis on cleanliness and orderliness (which is probably unreal and over-exaggerated), and understated symbolic details.

🏛 Copenhagen: Statens Museum for Kunst

⊛ (11) £266/$428 – £204,248/$322,712

1

2

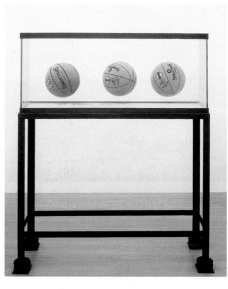

KØBKE Christen MM
1810–48 Danish

Short-lived (died of pneumonia), gifted painter who caught the prevailing Biedermeier middle-class taste for reassuring portraits of themselves and their dwelling places. The liveliest works are his sketches from nature (from which he made finished exhibition paintings). Travelled in Italy in 1838–40. Rejected by the Academy.

🔨 £204,248/$322,712 in 2000, *View from a window in Eckersberg's studio* (oil p., 1829)

KOKOSHKA Oskar MM
1886–1980 German

Same generation as Sigmund Freud, also from Vienna. Best known for his powerful Expressionist portraits and self-portraits, very freely painted and rich in colour. Also painted landscapes and

townscapes. Responded best to strong, famous faces and views. Was a deep-thinking, deep-feeling humanist.

- ⊛ (39) £510/$734 – £280,000/$403,200
- ✕ £1.66m/$2.7m in 1989, *Dresden, Neustadt I* (oil p.)

KOLLWITZ Käthe MM
1867–1945 German

One of the great printmakers (especially of black-and-white woodcuts). Also sculptor. She placed emphasis on strength: of emotion, of the human body (she saw it as monumental) and gave importance to expressive hands and faces. Chose personal themes – mother and child, son's death (World War 1), self-portraits. She was politically committed, a social reformer (but never revolutionary), and much honoured (except by the Nazis).

- ⊛ (146) £679/$1,073 – £24,845/$40,000
- ✕ £67,227/$110,924 in 1997, *Aus vielen Wunden blutest du, o Volk, Akstudie* (w/c, 1898)

KONINCK Philips OM
1619–88 Dutch

Pupil of Rembrandt who learned from the master's landscape etchings and went on to produce a formula for large-scale panoramic landscapes of Holland: high viewpoint; horizon across middle; scudding clouds; small figures to increase sense of vast space; alternating bands of light and dark to give receding space. Good, but not great.

- ⊛ (6) £1,923/$2,750 – £20,833/$30,422
- ✕ £900,000/$1,404,000 in 1992, *Panoramic river landscape* (oil p.)

KOONING Willem de MM
1904–97 Dutch/American

Rotterdam-born painter and decorator who went to New York in 1926 and became an artist. One of the most consistent and longest lived Abstract Expressionists.

☽ Produced his best work between 1950 and 1963. One of the few artists to achieve a genuine synthesis between figuration and abstraction – the image (most famously, the woman) and the abstract expressive gesture coexist and interact as equal partners, with total sureness and intensity of purpose. After 1963 he lost control and direction, turning out work with arbitrary gestures, flabby colours and splodgy decoration. His last paintings were, sadly, feeble (he had Alzheimer's).

🔎 Wonderful colour sense, using thrilling and unusual colour juxtapositions and complex textures and interweaving of paint, which are a pleasure to look at. He creates a truly exciting balance and tension between uncontrolled freedom and conscious control; between aggression and beauty; between abstraction and figuration (as skilled, daring and breathtaking as a high-wire act). In the complexity of paint and imagery lurk subtle layers of meaning. Who can or will explain the tortured female?

- ⊛ (47) £1,866/$3,005 – £2.88m/$4.1m
- ✕ £11,898,735/$18.8m in 1989, *Interchange* (oil p.)

KOONS Jeff CS
1955– American

Good-looking, clever, witty, articulate, popular, skilled at self-publicity, successful. Former salesman and Wall Street commodity broker; now one of the darlings of the contemporary art

1

world. Married La Cicciolina (famous Italian porn star and politician).

�３ He glorifies and deifies the banal consumer object as a work of art. For instance, he presented pristine vacuum cleaners in the airtight, fluorescent-lit museum cases usually reserved for precious objects; he cast an inflatable toy rabbit as a polished sculpture like a Brancusi; he presented a kitsch Michael Jackson model like a Meissen figurine; and filmed himself and his wife making love in a sanitised Disney-like setting. Has an obsession with newness.

🔎 His work displays layers of clever, deliberate symbolism: the pristine vacuum cleaner = phallic (male) + sucking (female) + cleaning (purity or goodness) + brand new (virginity and immortality). He comments on consumer society's relentless promotion of success and the luxury life style – and also how art functions, since commodities can be turned into high art, and art into commodities. Cunningly satisfies bourgeois consumer narcissism as successfully as the luxurious still lifes of Dutch old masters did.

🅐 (29) £492/$792 – £1,024,845/$1.65m
🏹 £1,024,845/$1.65m in 1999, *Pink Panther* (sculpture, 1988)

KOSSOFF Leon CS
1926– British

A somewhat shadowy and neglected figure, who has been influenced by his Jewish cultural heritage. The human figure is always central to his work, which is of high quality, very thickly and crudely painted, in a strongly Expressionist style. He is inclined to gloominess, although his swimming-bath series are full of life.

🅐 (12) £500/$800 – £50,000/$79,000

🏹 £190,000/$300,000 in 1992, *Childrens' swimming pool, 11 o'clock Saturday morning, August 1969* (oil p., 1969)

KOSUTH Joseph CS
1945– American

The ultimate and extreme theorist of Conceptual art. Creates situations where words, photos or objects may be placed side by side but rejects all notions of creating 'works of art', however minimal. He is concerned only with abstract intellectual concepts: thus serious writing about art is art itself; an artist's only function is to question the nature of art.

🅐 (7) £37,162/$55,000 – £74,534/$120,000
🏹 £74,534/$120,000 in 1999, *One and Three Stools* (sculpture, 1965)

KOUNELLIS Jannis CS
1936– Italian

Leading member of Arte Povera who creates strange objects and constructions out of materials such as blankets, mattresses, sacks and blood,

and likes to show evidence or traces of flames and smoke. His intention is to draw attention to, and make one think about, the dark side of 20th-century experience, especially social deprivation and spiritual starvation.

🅐 (30) £968/$1,548 –
£400,000/$664,000
🔨 £622,900/$1,058,940 in 1990,
Senza titolo (oil p.)

KUHN Walt NH
1880–1949 American

A barnstorming bicycle racer, newspaper cartoonist and artistic impresario, and one of the first to bring an awareness of the European avant-garde to the USA (he co-organised the ground-breaking Armory Show in 1912). His own artistic achievement was modest: author of clowns and circus figures à la Picasso; landscapes and still lifes à la Matisse. Much graphic work.

🅐 (17) £313/$500 –
£50,000/$80,000
🔨 £177,215/$280,000 in 1992,
Clown with Drum (oil p., 1942)

KUPKA Frank MM
1871–1957 French/Czech

Natural anarchist who settled in Paris at the age of 24 and stayed for ever. One of the first to create a true abstract art,

characterised by solid, geometric blocks of colour. He had the potential to develop as a great pioneer of abstraction, but lacked the underlying philosophical drive and single-minded dedication to fulfil it – he was distracted by too many ideas.

🅐 (63) £418/$677 –
£204,969/$330,000
🔨 £631,692/$1.03m in 1990,
Contrastes gothiques (oil p.)

LANCRET Nicolas OM
1690–1743 French

Chief follower of Watteau's style, but more prosaic – painted only the day-to-day (albeit elegant) reality, whereas Watteau was able to transform reality and endow it with the magic of poetry and dreams. Cruder colour than Watteau's. Liked theatre subjects. Popular with aristocratic collectors.

🅐 (12) £1,104/$1,800 –
£392,638/$640,000
🔨 £453,988/$740,000 in 1997,
La halte des chasseurs/Huntsman and his servant (oil p.)

LANDSEER Sir Edwin NH
1802–73 British

Hugely successful and much admired by Queen Victoria. Had a prolific output of sentimental portraits and animal

2

3

and sporting pictures (particular affinity with Highland cattle, stags, lions and polar bears). Was ideally in tune with his times – his animals express the key Victorian virtues: nobility, courage, pride, success, conquest, male dominance and female subservience.

🌙 His small, plein-air sketches, done rapidly on the spot, are as good as anything by Constable or French contemporaries.

⊕ (23) £338/$500
– £520,000/$743,600
🔨 £720,000/$1,072,800 in 1994,
Scene on Braemar, highland deer (oil p.)

LANE Fitz Hugh NH
1804–65 American

Leading member of the Luminist School. A master of the frozen moment when time apparently stops – creator of scenes of eerie unpopulated stillness, with a golden light that suffuses all. Also finely detailed paintings of ships and coastlines. The visual equivalent of transcendentalism in literature – the search for the essence of a reality beyond mere appearance.

⊕ (4) £175,000/$270,000 –
£2,432,433/$3.6m
🔨 £2,432,433/$3.6m in 2000,
The Golden Rule (oil p.)

LANFRANCO Giovanni OM
1582–1647 Italian

Key figure who established the enthusiasm for large-scale illusionistic decoration of churches and palaces in Rome and Naples. He painted crowds of figures on clouds floating on ceilings, with extreme foreshortening and brilliant light. Huge scale, excessive, inspiring – his work needs to be seen in situ.

🏛 Rome: Church of Sant' Andrea della Valle; of San Carlo ai Catinari Naples: Chapel of San Gennaro (Duomo); Church of San Martino
⊕ (6) £5,500/$8,305 – £45,210/$72,336
🔨 £59,375/$95,000 in 1997,
Saint Ursula holding a banner and a palm branch (oil p.)

LANYON Peter CS
1918–64 British

St Ives Group painter of sensitive, semi-abstract, freely painted landscapes and seascapes with a floating quality, which are as much indebted to his love of flying as to Cubism and Abstract Expressionism. Also made some constructions and collages. Died in a gliding accident.

⊕ (14) £400/$632 – £20,000/$30,000
🔨 £95,000/$160,550 in 1990,
Coast Wind (oil p., 1957)

LARIONOV Mikhail MM
1881–1964 Russian

Best remembered as the founder of Rayonism (one of the briefly flourishing sub-Cubist movements before 1914), which showed objects broken up by prisms of light. Otherwise his work is not memorable.

⊕ (26) £362/$535 – £32,498/$47,772
🔨 £83,000/$133,630 in 1987, *Rayonist Head of a Soldier* (works on paper)

LARSSON Carl NH
1853–1919 Swedish

Key Swedish artist whose idealised illustrations of his own country cottage (rustic furniture, scrubbed floors, wife's designer textiles, simplicity) were internationally influential and established the idea of the Scandinavian style. Earlier in his life he painted large-

1. Louis Le Nain, *Peasant Family*, c.1643
2. Sir Thomas Lawrence, *Portrait of Arthur Wellesley, 1st Duke of Wellington*, 1814
3. Georges de La Tour, *The New Born Child*, late 1640s

🔨 £110,656/$171,516 in 1995,
The Sacrifice of Manoah (oil p., 1624)

LA TOUR George de OM
1593–1652 French

Shadowy figure with few attributed works, many in poor condition. In fashion with art historians, who are in the process of reconstructing his *oeuvre*. Major master or overrated enigma?

💧 His work has two points of focus: peasant scenes (pre-1630s); nocturnes with spectacular handling of candlelight (post-1630s). Also painted cardsharpers and fortune-tellers. Beware of copies and imitations passing as the real thing.

🔍 Note how he paints peasants and saints with unnerving realism: wispy, greasy hair; lined brows and convincing old, dry skin; distinctive horny fingernails and peasant hands; sinister, cunning piggy eyes. Uses strong and beautiful chiaroscuro and lighting and flat, non-existent backgrounds. Unconvincing when painting young flesh – the faces are wooden and mask-like. Master at creating virtuoso candlelight effects

scale decorative, allegorical murals. Also portraits and self-portraits. Became manic depressive after 1906.

💿 (30) £350/$559 –
£292,648/$424,340
🔨 £857,143/$1,345,714 in 1989,
Near Kattegat (w/c)

LASTMAN Pieter OM
1583–1633 Dutch

Chiefly remembered as Rembrandt's most influential teacher. Painted lush, narrative pictures, full of gesture and facial expression (*see* Rembrandt), but spoiled by overfussy anecdotal detail.

💿 (1) £2,138/$3,421

(such as the way it makes a hand translucent).

> 🏷 £1.7m/$3,094,000 in 1991, *Blind hurdy-gurdy player in profile* (oil p.)

LAVERY Sir John NH
1856–1941 British

One of the Glasgow Boys (with Cameron, Guthrie, Henry and Melville). Belfast born; son of a failed publican; orphaned at the age of 3. Studied in Glasgow and made it to the top artistically and socially as a gifted and inventive portrait painter. Had an easy, energetic and fluid style, which brilliantly captures and promotes the lifestyle of leisured ease and elegance enjoyed by his Edwardian sitters (including royalty).

> ⓐ (49) £900/$1,458 – £900,000/$1.3m
> 🏷 £1.2m/$2,016,000 in 1998, *Bridge at Grez* (oil p., 1883)

LAWRENCE Jacob CS
1917–2000 American

The first voice of an authentic art by and for African–Americans. Born in Atlanta, resided in Harlem. Researched and understood the Great Migration and Ku Klux Klan persecution. He is most famous for the 'Migration' series – 60 small powerful paintings in a spare, lean, modern style with intense colours, which are strengthened by their understatement and the lack of any expression of hatred.

> 🏷 £156,250/$250,000 in 1999, *Bar-B-Que* (works on paper, 1942)

LAWRENCE Sir Thomas AG
1769–1830 British

Precociously talented son of an inn keeper, who went on to become the leading portrait painter of the day. Overproduction lead to uneven quality.

> ◑ His paintings have style, elegance and haughty confidence. He was the chosen portrait painter of the ruling class of the richest and most powerful nation on earth – they believed it and he confirmed it. They were also hungry for aesthetic experience: his portraits revealed this side of their personalities and gave a strong aesthetic thrill (they still do).

> 🔎 Observe the way he conveys the above: inventive, dramatic, self-conscious poses; flowing dresses, flowing hair; heads confidently turned on overlong necks, to show off; long arms; finely formed, sloping shoulders; rich colours; luscious, flowing paint applied with total confidence and sensual pleasure; above all, dark eyes, with crisp, white highlights that are deep pools of romantic experience and feeling.

> ⓐ (27) £602/$1,000 – £400,000/$640,000
> 🏷 £600,000/$1,092,000 in 1988, *Portrait of Prince Regent* (oil p.)

LE NAIN brothers OM
Antoine (c.1588–1648), Louis (c.1593–1648) and Mathieu (c.1607–77) French

Painters of large-scale mythologies, allegories and altarpieces, but best known for smaller-scale portrayals of peasant groups sitting in an interior, doing nothing much, with dignity. Note the factual style; sensitivity when handling light and colour; pleasing and detached powers of observation. They were admired by Cézanne.

> ⓐ (1) £74,234/$110,000 (Mathieu Le Nain)
> 🏷 £113,990/$194,922 in 1990, *Trois musiciens jouant du luth* (oil p.) by Mathieu Le Nain

1. Edward Lear, *The Temple of Venus and Rome*, 1840
2. Sir Peter Lely, *Anne Hyde, Duchess of York (1637–71)*
3. Fernand Léger, *The Mechanic*, 1920
4. Leonardo da Vinci, *Mona Lisa*, c.1503-6

LEAR Edward NH
1818–88 British

Best known as a writer of limericks and
works such as *A Book of Nonsense* – but
was also a serious painter of accurately
detailed, zoological and topographical
works, especially of Italy and the Middle
East (where he travelled widely).

Talented watercolourist, producing clear
washes over pen and ink sketches.

- ⓐ (68) £300/$477 – £38,000/$57,380
- 🔨 £210,000/$319,200 in 1993,
 Pyramids Road, Gizeh (oil p., 1873)

LÉGER Fernand AG
1881–1955 French

One of the giants of the Modern
Movement and an ardent believer
in the moral and social function of art
and architecture. Refreshingly cheerful
and extrovert.

◑ His ambition was to create a new democratic art for and about ordinary people. He achieved it through strong, straightforward imagery, style and technique: the modern, blue-collar worker and his family at work and play, plus the machine-made objects of their world. Shows muscular happiness and spiritual joy in an ideal world where work and play become one (if it can be so for children, why can it not be so for adults?).

⌕ He was simple but not simplistic. He had a modern, moral message, which was romantic and idealistic but also challenging (a fresh restatement of 'man the measure of all things'). Produced simple images and designs that contain sophisticated spatial and colour relationships. Also made beautiful and strong drawings, stage sets, tapestries, murals, films, books and posters – he believed art should touch and transform all corners of everyday life. Portrayed hands as pieces of machinery. His early Cubist work was pioneering.

⊗ (184) £1,240/$1,959 – £2.47m/$4m
➤ £8.5m/$13.2m in 1989, *Contrastes de formes* (oil p.)

LEIGHTON Lord Frederic NH
1830–96 British

The first British painter to be made a Lord. Was educated in Europe. Aimed to be, and was called, the Michelangelo of his day. Adept at art politics and diplomacy. Very successful.

◑ His works are immaculate and faultless in every way: they display wonderful technique and draughts-manship; superb, sophisticated and inventive handling of light, colour, composition; correct academic subject matter (portraits, biblical and mythological themes). So why are his pictures so often cold, aloof and soulless? Because overt support for the status quo always wins support from those with most to lose – but lasting fame requires real innovation.

⌕ Look for borrowings from (also homages to) Michelangelo and from other great Italian and French masters (Titian, Ingres). Also notice the places where he lets go and, instead of playing the pompous, god-like, so-called great artist, is himself: sketches from nature, occasional quirky oil painting, enjoyment of painting white textures.

1

It is then that the warmth and freshness that are absent from his 'official' works begin to come across.

⊕ (16) £400/$660 – £1.2m/$1,812,000

⚒ £25,000 in 1956 *The Bracelet* (oil p., 1894); *The Bracelet* (same painting): £1.2m/$1,812,000, in 2000

2

LELY Sir Peter NH
1618–80 British

German born of Dutch parents, whose real family name was Van der Faes. Settled in England in the early 1640s. The principal portrait painter for Charles II, Lely was especially notable for his fashionable female portraits, which show richly dressed, slightly raffish-looking women with heavy eyes and long, mobile fingers. Studio assistants were responsible for much poor-quality work in his name.

◐ A few very fine early works show his talent for landscape and observation of unimportant faces. When on form, he had a wonderful feel for light.

🏛 London: National Maritime Museum, Greenwich; Hampton Court Palace
⊕ (19) £1,329/$2,100 – £48,000/$72,480
⚒ £360,000/$543,600 in 1992, *Girl playing the orbo-lute* (oil p.)

LEONARDO DA VINCI AG
1452–1519 Italian

Unique, perhaps lonely, genius. The universal Renaissance man: scientist, inventor, philosopher, writer, designer, sculptor, architect and painter. Had such a fertile mind that he rarely completed anything, and there are relatively few paintings by him. Changed the status of the artist from artisan to gentleman.

◐ The common thread in his work was an insatiable curiosity to find out how everything operates – whether the human body, flight, natural phenomena, perceptions or art – and then to put this into practice (as witness his keenly observed anatomical drawings and his plans for flying machines and so on). His paintings are multilayered, investigating these subjects; they also explore beauty, ugliness, spirituality (he was not a Christian), man's relationship with nature and God, and 'the motions of the mind' (psychology). He was technically inventive, but careless.

🔎 Why is the *Mona Lisa* so important? It created a sensation (c.1510) because it was lifelike in a way that had never been seen before. It comprises a brilliant bag of technical and perceptual innovations (the use of oil paint, a relaxed pose, soft and shadowy figure with no outlines, two landscapes) and demands that the viewer's imagination should supply the inner meaning and missing visual detail. It set a new standard – and it reaffirms that art you have to interact with creatively is always best.

🏛 Paris: Musée du Louvre (*Mona Lisa*) London: Royal Collection (drawings)
⚒ £200,000/$318,000 in 1995, *Caricature of the head of an old man. Head of boy* (drawing, double sided, 1507)

LEUTZE Emmanuel Gottlieb NH
1816–68 American/German

German born, Philadelphia raised; he returned to Düsseldorf in 1841 to study history painting and remained there (making it a Mecca for US artists). Was noted for his large, memorable, easy-to-understand, patriotic scenes of American history (especially the iconic *Washington Crossing the Delaware*). Would have made a great movie director. Was anti-slavery and racism.

- Ⓐ (1) £9,091/$14,636
- ✦ £15,663/$26,000 in 1998, *Queen Elizabeth I and Sir Walter Raleigh* (oil p., 1848)

LEWIS John Frederick NH
1805–76 British

Best-known member of a prolific artistic dynasty, who was famous for his impressive scenes of Egyptian markets, bazaars and harems, painted with intricate watercolour technique (clever use of gouache) and obsessive detail. Also produced less good oils. His early work has sporting, wildlife and topographical subjects. Visited Spain and Morocco (1832–4); lived in Egypt (1841–51).

- Ⓐ (17) £650/$1,034 – £171,779/$280,000
- ✦ £750,000/$1.26m in 1996, *Lilium Auratum* (w/c, 1871)

LEWIS (Percy) Wyndham NH
1882–1957 British

Painter, writer and journalist. An angry young man who, with his fellow Vorticists, brought Modern art to Britain. Later became a right-wing misfit and admirer of Fascism.

- ◑ His work is always angular and awkward, rather like the artist himself.

His powerful and original early work was among the first abstract art in Europe. He was also the author of very strong drawings and paintings of World War 1 battlefields (he was an official war artist). Interesting later portraits.

- � Note his skilled spiky draughts-manship and his personal and inventive use of Cubist and Futurist styles and ideas. Inventive, creative use of faceted space and figures. Interesting exploration of the concept of the man-cum-machine. But perhaps he never really found a subject that would sustain his art and in the end was happier with words than images.

- Ⓐ (12) £750/$1,193 – £34,000/$51,000
- ✦ £45,000/$73,350 in 1993, *Timon of Athens – The Thebaid* (w/c, 1912)

LEWITT Sol CS
1928– American

Pioneering Minimalist, now one of the 'Grand Old Men'. At first sight his structures and wall drawings look as if they are merely mechanical applications of established mathematical systems, but they are not.

- ◑ He creates a type of pure beauty that comes out of an order that is logical but not rigid or predictable. He starts with a system, ratio or formula, which can be quite arbitrarily chosen, and employs assistants to make the modular structure or wall drawing that follows from it. His works can be on a large or small scale, but the bigger and more complex the better; they are completely self-referential and self-contained.

- � You can take the works intellectually and try to unravel the system, or you can take them visually for what they are and enjoy their unexpected, peaceful beauty and the

way in which they generate light as well as space – thus creating a sense of emotional openness and purity. His wall drawings are created for each new location and then whitewashed out. His early work was in monochrome or white; he gradually introduced colour and his recent work is richly colourful (and less pure and less effective as a result?).

- Ⓐ (67) £697/$997 –
 £43,919/$65,000
- ✎ £89,286/$150,000 in 1990,
 B 2, 5, 8 (sculpture)

1

2

LICHTENSTEIN Roy MM
1923–97 American

Leading American Pop artist with an instantly recognisable style, which at first sight (but not for long) seems to be just large-scale blow-ups of comic-book images.

🌑 Great ability to contradict expectations with wit and elegance – nothing is what it seems. He transforms the comic-book images (traditionally dismissed as mere trash) into elegant large-scale paintings, which are in the tradition of a serious art gallery experience. Achieves this by the sophistication of his technique and the probing nature of his subject matter (Caravaggio and Manet did something similar in their days).

🔎 Note how he turns the mechanised impersonality of the comic-book image into something very personal. He organises, redefines and exaggerates his images with the skill and knowledge of an old master. Has a meticulous technique: highly controlled black outline; use of Ben Day dot; intense colour. Deep interest in life, love and death (traditional high-art subjects), and in modern American society. He parodies other artists and (like Manet) plays with art history.

- Ⓐ (211) £705/$1,128 –
 £1,552,795/$2.5m
- ✎ £3,273,810/$5.5m in 1990, *Kiss II*
 (oil p., 1962)

LIEBERMANN Max MM
1847–1935 German

Successful painter of middle-class daily life and places – updated replay of Dutch 17th-century and Biedermeier art. Produced freely painted, not very difficult paintings, which reassured his clients and appeal to modern day nostalgia. Used the earth-colour palette

1

2

3

trained as goldsmiths and then worked for the great French patron of the period, Jean, Duc de Berry, at a time of great political turmoil.

❂ Their two great works are *Les Belles Heures* and *Les Très Riches Heures*. They used old forms (illustrated Books of Hours) but with fresh and stunningly innovative illustrations – scenes of everyday life (courtiers and peasants), unusual biblical events, first-hand observation from life, landscapes of real places (such as the Duc's châteaux). Their brilliant colours and meticulous technique marry perfectly with their subjects.

of the old masters, not the modern rainbow palette of the French Impressionists.

🔨 (115) 282/$409 –
£734,924/$1,087,540

⚒ £734,924/$1,087,540 in 2000,
Tennis Court in Noordwijk (oil p., 1911)

**LIMBOURG brothers
(Paul or Pol, Herman, Jean)** AG
active 1390s–c.1416 French

Family of pioneering illuminators who

🔍 Their best-known work now is the 'Months' from *Les Très Riches Heures* because they are most accessible to a secular society and look wonderful in reproduction. Note how they used advanced contemporary Italian ideas such as landscape background (one or the other brother went to Italy); and anticipated Netherlandish art – story-telling, fine detail and observation. Their work and patronage reflect the notion that, for the wealthy, commissioning and

collecting art is a celebration of God's glory and an act of true devotion.

🏛 Chantilly (France): Musée Condé (*Les Très Riches Heures*). New York: The Cloisters (*Les Belles Heures*)

LINDNER Richard MM
1901–78 German/American

German-Jewish refugee who settled in Paris in 1933 and New York in 1941. His mother ran a corset-fitting business. Collector of toys and masks. Best known for his quirky, polished style (derived from working as a magazine illustrator), which show puppet-like fantasy figures, especially busty women. Had an over-heated sexual imagination. Was big in the 1960s and is now unjustly neglected.

🄐🅅 (12) £1,212/$1,902 – £148,148/$240,000
🔨 £254,545/$420,000 in 1998, *Untitled no. 1* (oil p., 1962)

LINNELL John NH
1792–1882 British

Romantic landscape painter who was successful commercially. He provided artistic and financial support to Blake and Palmer. Was an eccentric, argumentative, radical non-conformist, best known for his rural landscapes, often showing labourers at work or rest. He believed that landscape paintings could carry a religious message – hence their intense visionary quality.

🄐🅅 (24) £300/$498 – £16,500/$23,925
🔨 £52,000/$77,480 in 1994, *English Woodlands* (oil p., 1868)

LIPCHITZ Jacques MM
1891–1973 French

Talented sculptor of Lithuanian origin. He settled in Paris in 1909 and emigrated

to the USA in 1941. He was an early, sensitive and personal interpreter of Cubism in traditional materials (plaster, stone, terracotta and bronze) in the 1920s. This led to a more figurative, arabesque style; then to a flirtation with Surrealism and, finally, to complex Symbolism. He was always original, if sober and monumental.

🄐🅅 (29) £400/$621 – £461,538/$660,000
🔨 £461,538/$660,000 in 2000, *Harlequin à l'accordéon* (sculpture, 1914)

LIPPI Filippino AG
c.1457–1504 Italian

Son of Filippo Lippi. Successful, but his style had become out of date by the end of his life.

🌙 His religious subjects show all the standard technical qualities of early-Renaissance Florentine painting (*see* Filippo Lippi). He painted important fresco series and a few portraits.

🔎 Observe his sweet, innocent young faces with soft, gentle eyes; the good bone structure in male faces; the characteristic forward inclination of heads. Above all, note his wonderful hands and fingers, which really do look as though they touch, feel and grasp.

🏛 Florence: Santa Maria Novella Rome: Santa Maria sopra Minerva (both cities for fresco series)
🄐🅅 (1) £600,000/$906,000
🔨 £600,000/$906,000 in 2000, *The Rest on the Flight to Egypt* (oil p.)

LIPPI Fra Filippo AG
c.1406–69 Italian

An important early-Renaissance Florentine whose work forms a bridge between Masaccio and Botticelli.

❧ His sincerely felt religious works expressed worship of God by sensitive interpretation of the New Testament and by mastery of all the chief technical interests and developments of the period (all of them, including the artist's skill, being a gift from God): perspective; landscape; proportion; communication between human figures; finely painted decorative detail; carefully drawn drapery folds.

🔎 Look for the chubby figures with slightly glum youthful faces, and eyes that look as though they never blink. Note his love of rich detail – marble floors, gold grounds, decorated costumes.

🏛 Prato (Italy): Cathedral (fresco series); Spoleto (Italy): Cathedral (frescoes)
🔨 £1,200/$1,884 in 1995, *Saint John the Baptist with numerous other saints* (oil p.)

LISSITSKY El MM
1890–1941 Russian

A pioneering Modernist architect and artist. Creator of Constructivist abstractions, which develop the links between art, design and architecture, and between art as a material and spiritual experience.

🅐🅥 (8) £1,698/$2,682 – £85,890/$140,000
🔨 £325,444/$550,000 in 1990, *Proun No. 95* (works on paper)

LOCHNER Stephan OM
c.1400–51 German

Shadowy early German painter about whom little is known and to whom few works are attributed for certain. Author of religious works of soft, rounded figures with slightly silly, chubby faces; glowing colours; rich, gold backgrounds; somewhat fussy natural and anecdotal detail.

🏛 Cologne

LONG Richard CS
1945– British

Leading British land artist with much early success. He was a winner of awards and achieved international recognition in his 30s, but now, at 50+, has gone rather quiet.

❧ An artist with very serious intentions. He works with the land, visiting it and bringing bits of it (rocks, sticks, mud) back to the art gallery; he then assembles these objects in aesthetic configurations (typically, large-scale stone arrangements in a circle or line, or walls 'painted' with the mud). His earlier work is in photographic form, recording marks made by him on and in the landscape he walked over.

🔎 Is he, as some claim, a development of the Constable – Wordsworth tradition (man's harmony with nature) or is he the opposite? Does his art represent the modern city dweller's incomprehension of, and puzzlement at, nature – seeking to cover it in urban developments, transform it into municipal parks (however sensitively done), and bring it back to the city art gallery in chunks and buckets (like an astronaut returning to base after a visit to the moon)?

🅐🅥 (8) £567/$907 – £10,500/$15,120
🔨 £79,882/$135,000 in 1991, *Standing red slate circle* (sculpture with 42 stones)

LONGHI Pietro OM
1702–85 Italian

Italian counterpart to Hogarth and Lancret in that he successfully caught the 18th-century taste for small-scale

scenes of everyday life – in his case, Venetian goings-on from aristocracy to lowlife. They still sparkle with spontaneity and sharp, dispassionate observation.

🅐 (6) £8,930/$12,859 – £191,036/$305,658

🔨 £191,036/$305,658 in 1999, *Interior scene with family* (oil p.)

LONGO Robert cs
1953– American

Creator of large-scale reliefs, montages and paintings, each of which is polished, slick and highly contrived. Some are abstract, some are figurative. All have the appearance of being serious works of art, but they raise the suspicion that they do no more than ape the mannerisms of art – just as soaps and sitcoms on TV convincingly ape life's reality, though you know their 'reality' is a sham.

🅐 (11) £1,828/$2,578 – £37,037/$60,000

🔨 £83,333/$140,000 in 1990, *Men Trapped in Ice* (works on paper)

LOO Carle (Charles-André) van OM
1705–65 French

Youngest and most successful member of a family of four who dominated French painting in the mid-18th century but is now, rightly, forgotten aesthetically – his success owed more

2

to quantity than quality or inspiration. He painted royal portraits, massive altar-pieces and some boudoir scenes. Carle's nephew, Louis Michel (1707–71), is now rated as highly by the art market.

🅐 (12) £692/$1,094 – £153,374/$250,000

🔨 £153,374/$250,000 in 2000, *Venus requesting Vulcan to make arms for Aeneas* (oil p.)

**LORENZETTI brothers
(Pietro and Ambrogio)** OM
active 1319–48 Italian

Two brothers from Siena who followed in the steps of Duccio di Buoninsegna,

but with more realism and expression. They had shadowy lives (there is a difficult chronology for extant work) and both died of plague. Ambrogio's work is warmer and less solemn than

1

his brother's; his most important works are the frescoes of *Good* and *Bad Government* (Palazzo Pubblico, Siena) – the first Italian paintings where landscape is used as a background.

🔨 £406,250/$650,000 in 1997, *Christ enthroned before a Franciscan monk* (oil p.) by Pietro Lorenzetti

LORENZO MONACO OM
c.1370–1425 Italian

A highly gifted monk (*monaco* is the Italian word for 'monk'). Creator of altarpieces and illuminated manuscripts (look for a love of detail; fine technique; luminous blues, reds, golds; rhythmical,

decorative line). His poetic imagination strove to unite the natural with the supernatural, and decorative Gothic with Giotto's realism. At his happiest when working on a small scale – predella panels and manuscripts.

🏛 Florence: the Uffizi; Galleria dell'Accademia
🔨 £340,0000/$571,200 in 1988, *St Jerome in the Wilderness* (oil p.)

LOTTO Lorenzo AG
c.1480–c.1556 Italian

Minor and uneven Venetian with a difficult personality (hypersensitive, solitary, pious). Was much travelled. Died forgotten. Same generation as Titian.

🌑 His portraits, altarpieces and allegories have sumptuous colours and a rich, robust style, but often have uncomfortable compositions with overcramped spaces and inexplicable changes of scale. He never quite made all the parts work together. There are influences from many of his contemporaries, but too many borrowings that he never fully absorbs, so that his work can look like a mishmash of everyone else (especially Titian, Raphael and Dürer). At times it even comes close to caricature.

🔍 Was at his best in portrait painting, especially conjugal double portraits. He liked searching, soulful expressions and was obsessed by hand gestures and fingers. Works have uncertain anatomy (heads, necks, bodies don't connect convincingly), but good landscape details and bold modelling with light. Look for the stunning oriental carpets in his paintings of interiors. Was much admired by Bernard Berenson, who made a detailed study of his work.

⚫ (1) £120,000/$194,400

🔨 £120,000/$194,400 in 1999,
*Portrait of young man in brown
mantle, dark cap, holding letter* (oil p.)

LOUIS Morris MM
1912–62 American

Creator of large-scale lyrical works. The
subject matter is colour, which is trickled
and floated onto bare canvas in such
an inventive way that, if you suspend
disbelief, the pigment can seem to be
rivers, waterfalls, liquid mists of fresh
pure colour (if you can enjoy a landscape,
why not this?). Easy-going but satisfying.

🅐🅥 (5) £124,224/$190,000 –
£267,606/$380,000
🔨 £565,476/$950,000 in 1990,
Nun (oil p.)

LOUTHERBOURG Jacques Philippe de NH
1740–1812 French/British

Strasbourg painter and stage designer
who settled in England in 1771 and
produced stagey landscapes and
seascapes. Important as a link between
the old Arcadian classical landscape
traditions and the new realism and
Romanticism of Turner and Constable.
One of the first to celebrate the delights
of English native scenery.

🅐🅥 (13) £639/$964 – £8,589/$14,000
🔨 £53,892/$90,000 in 1990,
*Coastal landscape with numerous
figures, said to be Fête of Tunny
fishers at Marseilles* (oil p.)

LOWRY Laurence Stephen NH
1887–1976 British

Quirky painter who became critically
and commercially successful with his
instantly recognisable scenes of the
bleak north of England – industrial
landscapes inhabited by busy 'stick'
people. His 'spontaneous naïvety'

appeals to critics and intellectuals, his
everyday directness to popular taste.
At his best he is very good indeed, at
all levels.

🏛 Salford (England): Lowry Centre
🅐🅥 (151) £550/$886 – £1.75m/$2.8m
🔨 £1.75m/$2.8m in 1999,
Going to the Match (oil p., 1953)

LUCAS Sarah CS
1962– British

A laddish young woman (combat
trousers, cropped hair, drinks, smokes)
who creates a tough 'in yer face' art of
social realism, via installations, recycled
rubbish, and so on. Describes the rough
urban world of the socially excluded,
uneducated and unloved. She knows
the world well through upbringing and
choice, but does not indulge in pity or
self-pity.

🅐🅥 (12) £1,892/$2,800 –
£45,000/$67,950
🔨 £45,000/$67,950 in 1999,
Self-Portrait with Fried Eggs
(photographs, 1996)

LUKS George NH
1867–1933 American

Braggart and pugnacious, noted for
hard drinking (said to have died from
injuries in bar room brawl); was also
a vaudeville comedian. Created Ashcan
School scenes of New York lower-class
life, but ignored the reality of poverty
and overcrowding, favouring the
romance of teeming humanity, male
supremacy and adventure. Note his
bravura brushwork. Painted notable
watercolours of his native Penn
mining country.

🅐🅥 (13) £375/$600 –
£59,375/$95,000
🔨 £355,030/$600,000 in 1990,
Knitters, High Bridge Park (oil p.)

A truly poetic canvas is an awakened dream.
RENÉ MAGRITTE

MACDONALD-WRIGHT Stanton NH
1890–1973 American

Avant-garde American painter who studied in Los Angeles and went to live in Paris in 1913. Had a brief moment of glory when he developed an eye-catching abstract style called Synchronism – a kaleidoscopic symphony of swirling fragmented rainbow colours – derived from French artists such as Delaunay. Lost the plot on return to the USA in 1919.

- Ⓐ (7) £2592/$4,250 – £25,000/$40,000
- ✎ £260,355/$440,000 in 1990, *Conception Synchromy* (oil p.)

MACKE August MM
1887–1914 German

Leading German Expressionist of Der Blaue Reiter group and the most French in outlook and expression – a joyful, rather than anguished, agenda (Rhinelanders are more cheerful?). Made lyrical use of clear, vibrant colour and figurative subject matter. A possibly great talent, but he died, aged 27, in the first German offensive in World War 1.

- Ⓐ (24) £2,149/$3,395 – £2.6m/$3,744,000
- ✎ £2.6m/$3,744,000 in 2000, *Market in Tunis* (oil p., 1914)

MACLISE Daniel NH
1806–70 British

Irish born, charming and popular. Made a sound reputation as a history painter, notably with literary subjects from Shakespeare. Worked on murals for the newly rebuilt Houses of Parliament. Was a close friend of Charles Dickens.

- Ⓐ (12) £400/$644 – £320,000/$512,000
- ✎ £320,000/$512,000 in 1999, *King Cophetua and the beggar maid* (oil p.)

MAES Nicolaes OM
1632–93 Dutch

Best known for his early genre paintings which often show kitchen life below stairs, or old women asleep (very popular at the time). Later in life went in for small, elegant, French-style portraits. Strong chiaroscuro (he was a pupil of Rembrandt) and soft focus. Liked painting kitchen utensils. Good, but not great.

- Ⓐ (25) £625/$987 – £95,000/$153,900
- ✎ £460,000/$708,400 in 1994, *Old woman making lace in kitchen* (oil p.)

MAGRITTE René MM
1898–1967 Belgian

Leading Surrealist painter who made a virtue of his bowler-hatted, cheap-suited provincialism. Famous for use of everyday objects plus deadpan style, creating mildly disturbing images suggesting the dislocated world of dreams.

- ◑ Painted small(ish) oil paintings. Deliberately banal technique, without aesthetic virtue – imagery is everything. Transformed the familiar into the unfamiliar by weird juxtapositions, changes of scale and texture, and contradiction of expectation. The titles of his works (sometimes chosen by friends) are designed deliberately to confuse and obscure. His best work dates from the 1920s and 1930s. Change of style after 1943. Worked as a freelance advertising artist from 1924 to 1967.

- ✑ Used classic Freudian symbols and references – death and decay (coffins, night); sex (naked women, pubic parts); phallic symbols (guns, sausages, candles). Themes of claustrophobia (closed rooms, confined spaces = sexual repression?); yearning for liberty (blue sky, fresh landscapes). Witnessed his mother's suicide when he was 13. Married. His work risked to become a tired formula (his very

1. **August Macke**, *The Hat Shop*
2. **Nicolaes Maes**, *The Listening Housewife*, 1656

the art of the great masters of the Venetian Renaissance and the 17 and 18th centuries, to create decorative allegories and historical images that promised (but in the end, failed to deliver) great talent and emotional content. Despised by avant-garde artists such as Schiele and Klimt.

- ⌂ Vienna : Österreichische Galerie Belvedere
- Ⓐ (17) £433/$693 – £155,000/$223,200
- 🔨 £155,000/$223,200 in 2000, *Fraienportrat in ägyptischem Kostum* (oil p.)

MALEVICH Kasimir AG
1878–1935 Russian

The most important Russian avant-garde painter of the Modern Movement.

◐ From 1913 to the late 1920s he developed a new type of abstract art and the aesthetic and social philosophy of Suprematism. This new art reflected the search for a new utopia in which all the old, familiar values were to be replaced by new social organisations and new beliefs. The new Soviet world was to have been designed by and for engineers, both social and mechanical.

🔍 Don't try and read the simple abstract forms in a literal or material way. See them as shapes floating in space, independent of gravity, ready to regroup or twist and turn, or plunge into infinity. If you can do this, you can experience the excitement and optimistic uncertainty of this revolutionary period, bravely facing an unknown future.

- ⌂ Amsterdam: Stedelijk Museum New York: MoMA
- Ⓐ (6) £3,103/$4,500 – £10,264,902/$15.5m
- 🔨 £10,264,902/$15.5m in 2000, *Suprematist Composition* (oil p., 1919–20)

late work is), but is saved by an active imagination and a sense of the absurd.

- Ⓐ (90) £1,051/$1,661 – £2.1m/$3,318,000
- 🔨 £3,939,394/$6.5m in 1998, *Valeurs personnelles* (oil p., 1952)

MAKART Hans OM
1840–84 German

Highly successful Viennese painter who delighted his rich clientele by plundering

MAN RAY (Emmanuel Radinsky) MM
1890–1976 American

Creator of memorable avant-garde
Surrealist images, usually through
photography (but also paintings, films,
objects). Was inventive (imaginatively
and technically), witty and anarchic.
Cultivated a carefree persona with the
maxim that the least possible effort
would give the greatest possible result.
Painted documentary portraits of the
Dada and Surrealist heroes.

1

◉ His fascinatingly ambiguous
subject matter and style portray modern
(sometimes seamy) urban and suburban
life and people, or parodies traditional
themes dear to the heart of academic
artists. At his best he does both at the
same time. Had a brilliant, very personal,
very visual and sketchy painting
technique, with large areas of flat colour.

🔎 His work is a paradoxical
combination of intimacy and aloofness
(one of Manet's personal characteristics
was wanting to be accepted in official art
circles but his whole approach to art and
those in authority ensured that he wasn't).
Thus many paintings show one or more
people in a scene of great intimacy or
drama, but someone is often withdrawn
or preoccupied and not immediately
involved in what is going on. Has anyone
ever used black so lusciously and with
such visual impact?

2

Ⓐ (83) £1,075/$1,742–
£270,000/$391,500
🔨 £480,000/$763,200 in 1995,
Le beau temps (oil p., 1939)

🏛 Paris: Musée d'Orsay
Ⓐ (23) £870/$1,400 – £13,286,715/$19m
🔨 £15,483,872/$24m in 1989, *La rue
Mosnier aux drapeaux* (oil p., 1878)

MANET Édouard AG
1832–83 French

Hugely important, very influential, key
figure in late 19th-century Paris. Spurned
by official art circles, he was a father
figure for the young avant-garde.

MANTEGNA Andrea AG
1431–1506 Italian

A highly individual master of the early
Renaissance who worked for the dukes
of Gonzaga at Mantua. An austere
intellectual.

❧ His panel paintings are highly individual interpretations of standard Renaissance subjects such as altarpieces and portraits. He had a dry, scholarly style, which got obsessed with detail, especially when it came to the archaeology of classical antiquity and geology (but scholars do get obsessed by minutiae). His frescoes are wonderful large-scale schemes for churches and villas. Pioneering printmaker – with superb engraving technique, which suited his style perfectly.

🔎 Notice the extraordinary outcrops of rock and the way he could make everything (even human flesh) look like carved stone (late monochrome works consciously look like bas-relief sculpture). Stunning mastery of scientific perspective and foreshortening – seen at its most impressive (in situ) in his large, decorative schemes, which are more relaxed than the panel paintings.

🏛 London: Hampton Court
Mantua (Italy): Ducal Palace
⊕ (1) £2,559/$4,094
↗ £7.5m/$9,525,000 in 1985, *Adoration of the Magi* (oil p.)

MANZONI Piero MM
1933–63 Italian

Cherubic-looking aristocrat who was a short-lived (cirrhosis of liver) experimental artist in the forefront of releasing art from traditional ideas, processes and forms.

❧ He created objects and ideas that are now the commonplace of mainstream, official art, but were genuinely cutting-edge in the late 1950s and 1960s: strange white objects with no specific meaning, made by dipping material in kaolin or plaster; devices or strategies to preserve the evanescent (like the artist's breath) and challenge the idea of art as a tradable commodity; incorporating public and environment into a work of art. He was blessed with delicacy and humour.

↗ £500,000/$840,000 in 1998, *Achrome* (sculpture, 1961)

MARC Franz MM
1880–1916 German

Key member of Der Blaue Reiter group. Author of richly sourced, very personal art, which explores a vision of a unified world in which animals and the rest of nature exist in perfect harmony. Combined progressive French Cubist structure, Matisse-like expressive colour, Kandinsky's spiritualism and old-fashioned German Romantic notions of nature. Was killed at Verdun.

⊕ (29) £2,167/$3,099 – £4.6m/$7.59m
↗ £4.6m/$7.59m in 1999, *Der Wasserfall: Fraeun unter einem Wasserfall* (oil p., 1912)

MARDEN Brice CS
1938– American

Leading American abstract painter who is not easy to pigeonhole and has not got stuck in a rut like many of his contemporaries.

❧ His earlier works are single spreads of voluptuous colour or combinations of rectangular forms (panels) playing on the rectangular nature of his canvas. Uses velvety, textured paint (also beeswax and encaustic) for these. Titles often refer to art history – he believes a continuity exists across all paintings. The link between the earlier and later work is Marden's ability to achieve a sophisticated and involving visual experience that goes beyond the work itself.

🔎 His recent works take a new direction. At first sight or in isolation they look just like other examples of overpraised, messily painted abstracts. But linger with a group, ignore the tedious curator-speak about Pollock

and Chinese calligraphy, and let them be what they are: see how the lines become like the rhythmic moving patterns on the surface of clear deep water; how the colours have the hues of autumn leaves. Let your eye and mind reminisce about landscape.

- Ⓐ (19) £2,162/$3,200 –
 £1,197,183/$1.7m
- 🪓 £1,197,183/$1.7m in 1999,
 Tour III (oil p., 1972)

MARLOW William NH
1740–1813 British

Successful, topographical painter in watercolour and oils. Much travelled in the UK, France, Italy. Produced successful Grand Tour souvenir views, seascapes, river scenes and portraits of country houses. Created satisfying, balanced compositions and was able to capture the cool light and well-ordered topography of England, as well as the intense light and rougher topography of Italy.

- Ⓐ (4) £1,000/$1,590 –
 £18,000/$28,080
- 🪓 £55,195/$85,000 in 1996,
 Saint Peter's, Rome (oil p.)

MARQUET Albert MM
1875–1947 French

Disciple of Matisse, who developed an appealing and poetic style: strong, simple design; clear, harmonious colour; the elimination of unnecessary detail (Matisse compared him favourably with the Japanese artist Hokusai). Small-scale works in oil and watercolour. The scenes of Paris, around the Seine, and French ports are the most effective and popular.

- Ⓐ (122) £300/$495 –
 £233,776/$356,400
- 🪓 £839,454/$1.31m in 1989,
 Le carnaval à Fécamp (oil p., 1906)

MARTIN Agnes CS
1912– American/Canadian

Much admired painter of gentle, lyrical abstracts, which reflect her search for spiritual purity and her rejection of material encumbrances and cares. Lives a simple life in New Mexico.

🌑 Her largish, square-shaped canvases of pure, pale colours and simple design are intended to reflect the qualities she values. They are beautiful, with a strange and haunting luminosity, but are as much presences to be experienced as objects to be looked at. Let your mind go free, as it does when contemplating the ocean or a waterfall.

🔍 Notice the soothing delicacy with which these paintings are made: paint gently stroked on, leaving fur-like traces of the brush; precise pencil marks creating something close to those organic traces, webs and honeycomb structures found in nature; subtle colour gradations like sunlight on early-morning mist or snow; horizontal lines suggestive of landscape spaces.

- Ⓐ (15) £16,250/$26,000 –
 £878,378/$1.3m
- 🪓 £878,378/$1.3m in 2000,
 Drift of Summer (oil p., 1965)

MARTIN John NH
1789–1854 British

Famous in his own day (but then went completely out of fashion). Overdramatic detailed representations of apocalyptic events from history – they anticipate the Hollywood spectaculars of Cecil B. de Mille. They win commendations for special effects rather than content. His work combines impressive scale and imagination with architectural detail and tiny figures. His mezzotints are also impressive.

- Ⓐ (8) £750/$1,238 – £25,000/$40,000

🔨 £98,000/$161,000 in 1991,
The Destruction of Pharaoh's Host
(w/c, 1836)

MARTIN Kenneth and Mary NH
1905–84 and 1907–69 British

Husband-and-wife. She is noted
for constructions and reliefs, he for
mobiles and paintings. Both created
using preconceived, rational
mathematical systems, thus revealing
the poetry inherent in mathematics.
They used synthetic and industrial
materials, but without real exploration
of them. She explored the cube, often
slicing and cutting it.

scale decorative illustrator, not least of
illuminated manuscripts.

🌙 Look for the qualities you might see
in illuminated manuscripts (despite the
difference in scale): glowing colour; lively
drawing; a precise, closely worked line;
meticulous observation of detail;
rhythmic, flowing golden draperies.
His all-consuming emphasis was on
decoration for sumptuous overall effect.

🔍 It is interesting to compare his work
with that of his exact contemporary,
Giotto, because, lovely as it is, it lacks
everything that is in Giotto: Simone's
figures are artificial, with convoluted
poses and gestures; faces are stylised

1

2

🅐 (1) £4,000/$5,640
🔨 £4,000/$6,320 in 1995,
Mobile Reflector (sculpture, 1953)
by Kenneth Martin
🔨 £3,500/$5,705 in 1997,
Expanding Form (sculpture, 1955)
by Mary Martin

and without genuine emotion; the
storytelling is overanecdotal and lacks
deep meaning; everything is arranged for
decorative effect, not to create ideas of
space, form and movement. Simone's
work was the final chapter of the past;
Giotto's was the future.

MARTINI Simone OM
c.1285–1344 Italian

One of the leading painters from Siena
and a follower of Duccio. Although he
experimented with new ideas (such as
perspective), he was essentially a large-

MASACCIO
Tommaso Giovanni di Mone AG
1401–28 Italian

The greatest of the early-Renaissance
Florentines, he revolutionised the art of
painting during his short lifetime and

was the bridge between Giotto and Michelangelo. Masaccio is a nickname meaning 'Big ugly Tom'. He left very few known works.

1

2

4

3

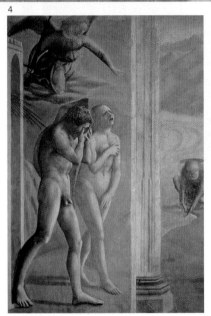

intellectual curiosity that are as relevant today as 500 years ago. His simple, well-ordered compositions in which the human figure is the central feature accord with the Renaissance principle that human beings are the measure of all things.

◐ His deeply moving pictures can plumb the most basic and profound of human emotions. He painted believable and dignified human figures, expressing qualities of feeling, emotion and

🔎 The individual expressions on the faces show minds and emotions at work – enquiring, doubting, suffering – also

expressed simultaneously through gestures and hands (but why are the hands so small?). Creates believable spaces, which human figures dominate with authority. Uses light to model draperies and figures (instead of outline, so helping them to look real). Was the first painter to understand and use scientific perspective; ditto for foreshortening.

🏛 Florence: Brancacci Chapel (fresco cycle); Santa Maria Novella

MASOLINO
Tommaso di Cristoforo da Panicale OM
c.1383–1447 Italian

Best remembered as collaborator of Masaccio. He had a graceful figure style learned by working with the sculptor Lorenzo Ghiberti and made skilful use of perspective. He was an accomplished modeller of flesh and hair, and had an interest in everyday details.

🏛 Rome: San Clemente (fresco cycle) Como (Italy): Castiglione Olona
🔨 £171,975/$270,000 in 1995, *Prophet or Evangelist* (oil p.)

MASSON André MM
1896–1987 French

Artist whose reputation and influence is better known than his work. Was deeply affected by World War 1 injuries. Became a leading Surrealist, exploring the irrational and subconscious in intense, finely wrought paintings and drawings. Liked experimentation and spontaneous action; disliked order. Lived in the USA after 1940, where he made a big impact on young Abstract Expressionists.

💲 (97) £385/$615 – £240,000/$379,200
🔨 £566,632/$883,945 in 1989, *La femme paralytique* (oil p.)

MASSYS (or METSYS) Quentin AG
c.1466–1530 Flemish

Important painter of unknown origins. Brought Italian refinement to northern realist tradition (visited Italy; admired Leonardo's way with soft light and his interest in the contrast between ugliness and beauty). Best known for animated portraits of tax collectors, bankers, merchants and wives, with an understated bite of satire (the influence of Erasmus, whom he met?). Opulent details.

💲 (2) £6,297/$9,194 – £8,718/$13,862
🔨 £240,000/$403,200 in 1988, *The Virgin at Prayer* (oil p.)

MATHIEU Georges CS
1921– French

Initiator of Art Informel and Abstraction Lyrique. Very much in vogue in 1950s, but looks dated now. Effective calligraphic, abstract paintings of impulsive marks made at high speed (often with paint squeezed directly from the tube) on a monochrome background. More decorative rather than deeply meaningful art (and what is wrong with that?). Honest decoration is surely preferable to turgid deep meaning.

💲 (77) £250/$405 – £36,000/$58,320
🔨 £89,151/$145,317 in 1990, *Peinture* (oil p., 1952)

MATISSE Henri AG
1869–1954 French

The King of Colour – celebrated the joy of living through colour. Major hero of the Modern Movement and one of its founders. Professorial and social, but not convivial and a bit of a loner.

◑ Look for his life-enhancing joyous combination of subject matter (notably

1

the open window, still life and female nude), and his glorious colour which takes on a life of its own and is free to do its own thing, without necessarily imitating nature. Explored colour independently from subject matter and turned it into something you want to touch and feel. His late gouaches on paper cutouts enabled him to carve into colour. Also a brilliant and innovative printmaker and sculptor.

🔍 His work explores the full range of what colour can do, by crowding, juxtaposing, intensifying, relaxing, purifying, heating, cooling. Look for white spaces around bright colours, allowing them to 'breathe' and reach their full visual potential. The open brushwork is deliberate, to give movement and life to the colour and to register Matisse's own presence and activity. Any simplification is deceptive – only reached after much thought and alteration.

🏛 Paris: Musée d'Art Moderne. Philadelphia: Barnes Foundation
Ⓐ (397) £1,484/$2,136 – £11,972,392/$17m
🔨 £11,972,392/$17m in 2000, *La robe persane* (oil p., 1940)

MATTA Roberto Sebastián Echaurren CS
1911– Chilean

Revolutionary spirit who settled in France (1933) and became an early Surrealist. Author of strange dream-like paintings, with complex spaces and totem-like figures. Has a poetic agenda: searching for links between the cosmos, the eroticism of the human body and the human psychic space. Intends his work to exalt freedom and aid mankind's struggle against oppression.

Ⓐ (90) £1,000/$1,600 – £146,667/$220,000
🔨 £961,539/$1.5m in 1995, *Disasters of Mysticism* (oil p., 1942)

MATTEO DI GIOVANNI OM
c.1435–95 Italian

One of the most prolific and popular painters of the Sienese School.

● Compared with contemporary Florentines, he had a rather awkward and traditional style. His work shows the influence of modern ideas (perspective, foreshortening, movement, expression) uncomfortably combined with old-fashioned ones (gold grounds, figures placed one above the other, elaborate decoration). Look for open mouths, flowing draperies; experiments with foreshortening.

🔨 £46,000/$88,780 in 1990, *Madonna and Child with Holy Bishop Young Martyr and Two Angels* (oil p.)

What I dream of is an art of balance, of purity and serenity, devoid of troubling or depressing subject matter, an art which could be for every mental worker, for the businessman as well as the man of letters, for example, a soothing, calming influence on the mind, something like a good armchair which provides relaxation from physical fatigue. HENRI MATISSE

2

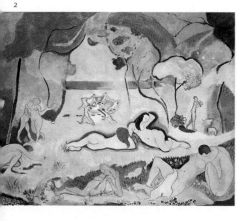

MAURER Alfred NH
1868–1932 American

The saddest casualty of early Modernism. Son of a successful, reactionary, artist father who churned out a good line in horses for popular prints. Went to Paris at the age of 40, discovered Modigliani, Matisse, Gertrude Stein, and painted good-quality work himself. In 1914 he returned home, impoverished, and had to live with his father's endless criticism. Dad died aged 100; Alfred committed suicide shortly afterwards.

- ⓐ (11) £1,311/$2,110 – £46,875/$75,000
- 🔨 £467,742/$725,000 in 1994, *The Beach* (oil p., 1901)

McQUEEN Steve CS
1969– British

A film-maker and video artist who works in black-and-white, without sound. Projects large-scale images in a 'closely controlled environment' (curator-speak for a dark room) so as to involve the spectator in the image (so what's new?). Said to be exploring the language of film and cinematic conventions. Has a dry, intellectual agenda, which won him the prestigious Tate's Turner Prize.

McTAGGART William NH
1835–1910 British

Scottish born, Edinburgh based. Best remembered for freely painted, fresh-coloured landscapes and seascapes. He sought (like Constable) to express a deeply sensed personal response to nature. Priorities included his native Scotland, boyhood memories, and the importance of the child's innocent eye and feeling. Very good at showing light reflecting on water. Fine watercolours.

- ⓐ (25) £600/$906 – £140,000/$224,000
- 🔨 £190,000/$307,800 in 1997, *Mist Rising off the Aran Hills* (oil p., 1883)

MEIDNER Ludwig MM
1884–1966 German

'The most Expressionist of the Expressionists'. Radical, left-wing Jew who was reviled by the Nazis. Took refuge in England in 1939. Intellectual, painter, poet and teacher. Created powerfully painted images of burning towns and ravaged landscapes – apocalyptic prophecies of the destruction his generation and race would witness. Returned to Germany in 1953.

- ⓐ (19) £743/$1,063 – £145,000/$208,800
- 🔨 £700,000/$1.1m in 1996, *Apokalyptische Landschaft. Selbstbildnis* (oil p., double sided, 1911-12)

MELVILLE Arthur NH
1858–1904 British

One of the Glasgow Boys (with Cameron, Guthrie, Henry and Lavery). Studied in Paris, then travelled through Egypt, Spain and Turkey. Developed an effective, easy, relaxed and decorative style – simplified forms, clear colour, and coloured shadows. His work reflects *fin de siècle* fashion.

167

1

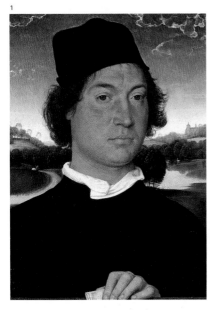

2

Particularly effective in watercolour, where he developed a technique of using coloured droplets and dabbing with sponges.

🔨 £37,000/$57,350 in 1996, *The Bride and King Cophetua* (w/c)

MEMLING (or MEMLINC) Hans AG
c.1430–94 Flemish

A prolific, Bruges-based successor to Van der Weyden, from whom he borrowed a repertoire of motifs and compositions.

🌖 His large altarpieces are rather too rigid, with stiff figures like statues. Was better at small devotional pictures (full of life, with good space) and small portraits (he learned from manuscript illuminations). Liked soft textures (his drapery has soft, not crisp, folds); soft hair; soft landscapes and smooth, rounded, demure, idealised faces. Decorative, rather than intense, style.

🔍 Look out for his interesting skies of intense blue, melting to white on the horizon; clouds like chiffon veils; small, almost unnoticeable birds; pronounced eyelids. His motifs such as garlands of fruit and flowers held by putti are borrowed from the Italian Renaissance (from Mantegna?).

🔨 £170,000/$265,200 in 1992, *The Virgin and Child enthroned with two angels* (oil p.)

MENGS Anton Raphael OM
1728–79 German

'The German Raphael', one of the founders of neoclassicism and one of the foremost artists of his day. Worked in Germany, Italy and Spain, and was a committed teacher, with an active studio. Wrote an influential theoretical treatise.

🌖 He is the proof (if it is needed) that having all the right credentials – being well taught, well thought of in official circles and obeying all the currently correct aesthetic principles – does not lead to lasting fame. His religious paintings, mythologies and portraits consciously aimed to contain the best of Raphael (expression), Correggio (grace) and Titian (colour). In a way they do, but in spite of their competence they also end up looking lifeless and contrived.

All his statues are so constrained by agony that they seem to wish to break themselves.
They all seem ready to succumb to the pressure of despair that fills them.
AUGUSTE RODIN *on* MICHELANGELO

🔍 Note his meticulous execution with a paint surface that looks like polished lacquer. His compositions and poses are so carefully calculated as to be merely stagey: notice how in the portraits the head often turns in one direction while the hands and body turn in the other. Painted flesh and faces that look impossibly and perfectly healthy. Rich textures and colours (especially a velvety royal blue, rich bottle-green and dusky pinks).

🅐🅥 (6) £1,254/$2,069 – £26,525/$42,972
🏹 £98,000/$144,060 in 1993,
Truth (works on paper)

MERZ Mario CS
1925– Italian

Leading member of Arte Povera who in the 1960s and 1970s created works that addressed geographical and environmental issues – notably metal-framed 'igloos' covered with clay, wax branches, broken glass etc. Produces transient, temporary work to reveal art as a process of change (like nature itself) and the artist as nomad. There are references to Fibonacci numbers (an infinite sequence of numbers in which each number equals the sum of the previous two).

🅐🅥 (10) £2,454/$3,460 – £49,689/$80,000
🏹 £90,000/$146,700 in 1990,
Seifenblasende Kuh (works on paper)

METSU Gabriel AG
1629–67 Dutch

High-quality painter of small-scale intimate scenes of well-ordered, well-mannered Dutch households.

🌙 Carefully organised compositions and meticulous technique and palette that reflect the lifestyle of the Dutch bourgeoisie. Many of the objects and still-life details have symbolic meaning; if there is lettering or a document, it is meant to be read as part of the meaning of the picture (a neat way of drawing you into the intimacy and secrecy of the scene).

🔍 Note his liking for dark interiors – rooms with windows closed or curtains drawn, or a dark corner. Uses a warm and very personal range of colours, especially reds and browns.

🅐🅥 (3) £300/$432 – £920,000/$1,426,000
🏹 £920,000/$1,426,000 in 1999,
Officer paying court to a woman in interior (oil p.)

MICHAUX Henri MM
1899–1984 Belgian

Author of highly original, experimental, introverted paintings. Sought to use art as an escape from the material world. Worked very rapidly, without reconceptions; used wash and diluted inks for his watercolours, as they do not allow for revision or second thoughts. After 1956 he sometimes worked under the influence of the hallucinogenic drugs mescaline.

3

🔵 (62) £318/$515 – £17,000/$27,540
🔨 £39,000/$65,910 in 1990,
 Composition (works on paper)

MICHELANGELO BUONARROTI AG
1475–1564 Italian

The outstanding genius (and infant prodigy), who cast his influence over all European art until Picasso broke the spell and changed the rules. Sculptor first, painter and architect second. Workaholic, melancholic, temperamental, lonely.

�*/ Profound belief in the human form (especially that of the male) as the ultimate expression of human sensibility and beauty. His early work shows the human being as the measure of all things: idealised, muscular, confident, quasi-divine. Gradually that image becomes more expressive, more human, less perfect, fallible and flawed. Never a natural painter – he conceived the figure in sculptural terms and used light to model it, so it could be the design for shaping a block of marble.

🔍 In his paintings he uses fiery reds, oranges, yellows against grey or blue; employs a wet-in-wet oil paint technique. Look for: tempera hatching, reminiscent of a sculptor exploring volume; brilliant draughtsmanship exploring outline, contour and volume; beautiful and expressive hands; twisting poses, full of latent energy; faces expressing the full range of human emotions. Endlessly inventive – he never repeats a pose (although he borrows some from famous Greek and Roman sculptures).

🏛 Florence; Rome (especially Sistine Chapel)
🔵 (1) £7.4m/$11,174,001
🔨 £7.4m/$11,174,001 in 2000,
 The Risen Christ (works on paper)

MIDDLEDITCH Edward NH
1923–87 British

Leading member of the so-called Kitchen Sink School of the 1950s, his work was considered high fashion and slightly shocking before 1956. Created thickly and clumsily painted images of working-class life in austere postwar Britain in gloomy colours. His work was a conscious reaction against la-de-da abstraction and neo-Romanticism. The visual equivalent of the Angry Young Men of 1950s theatre.

🔵 (6) £420/$697 – £1,800/$2,970
🔨 £4,000/$6,440 in 1990,
 The Butcher (oil p.)

MILLAIS Sir John Everett NH
1829–96 British

Infant prodigy who became extremely fashionable, rich and famous. Founder member of the Pre-Raphaelite Brotherhood and pillar of the Royal Academy (became its President in 1896).

🌙 His early work (up to the 1850s) is genuinely Pre-Raphaelite, with a meticulous tight style, strict observation of nature; choice of moral themes. The later work is more freely painted, with subjects overtly designed to catch the fashion of the times and sell well – sentimental scenes, historical romances, portraits (he needed the money with 8 children and a lavish lifestyle to support).

🔍 His virtuoso craftsmanship and attention to detail (natural and historical) makes it all look so easy. Look out for delightful, often humorous, sketches; note also the commercial prints made from his paintings which sold as well as current-day rock-group recordings.

🏛 London: Tate Britain; Birmingham: City Art Gallery; Liverpool: Walker Art Gallery; Manchester: City Art Gallery
🔵 (12) £1,600/$2,560 – £1.9m/$3.04m
🔨 £1.9m/$3.04m in 1999, *Sleeping* (oil p.)

MILLET Jean François AG
1814–75 French

Son of a Normandy farmer, who painted the final scenes of a rural world and lifestyle (which he knew and understood well), at the moment when it was beginning to disappear because of the industrialisation of France.

☽ His small-scale works describe a self-contained world of humble people working on and with the land. He portrays, depending on your point of view, either the dignity or the cruelty of manual peasant labour. Shows a magical stillness, silence and peace which is not overloaded with drama or symbolism.

🔎 Notice the low viewpoint, so you feel you are standing on the same land as the people you see. Freshly observed light; sense of direct contact with the land, the light and the atmosphere. He works directly onto the canvas – so you can often see pentimenti (alterations), the way he works the paint and his carefully

considered line. (It is as if his style and working methods were a sort of parallel with the way his peasants work the land.)

Ⓐ (48) £393/$558 – £250,000/$360,000
🔨 £2,052,980/$3.1m in 1996, *La cardeuse* (oil p.)

MINTON John NH
1917–57 British

An uneven talent in the uniquely British tradition of the 'gifted amateur'. Romantic, wealthy, but faced with a hostile world: homosexual at a time when such acts were illegal, and his style of art (narrative, landscape and figures) was going out of fashion in favour of urban abstraction. Worked best in watercolours and book illustration. Committed suicide.

Ⓐ (24) £300/$435 – £16,500/$26,730
🔨 £20,000/$39,200 in 1990, *Summer Landscape* (works on paper, 1943)

1

2

MIRÓ Joan MM
1893–1983 Spanish

Leading Surrealist painter and sculptor: experimental, unconventional, influential. Searched for a new visual language, purged of stale meanings and appealing to the senses. Prolific. Worked in a wide range of media and scale (from tiny to enormous).

◗ Best known for his abstract and semi-abstract works – highly structured, poetic, dreamy; simple forms floating on fields of colour. Try to let your eye and mind sink into them, towards a new dimension and level of consciousness. Don't analyse or read them – let the forms suggest anything (especially something biological, sexual, primitive). Enjoy the naughty thoughts, humour, silliness, colour, beauty, light, warmth. He is trying to connect you with joy and freedom.

𝒫 Is he ever entirely abstract, or do the forms always suggest something? He uses a limited number of forms, but repeats and makes rhymes of them (like music and verse). Draws on an (unconscious) memory bank of natural and landscape forms, which suggest generative power in nature and earthly or celestial symbolism. Experimented with 'magic realism' before breaking through to a new style c.1924. Surprisingly tight, neat signature – revealing an inner desire for self-control?

🅐🅥 (541) £577/$929 – £2,530,864/$4.1m
➤ £5,483,870/$8.5m in 1989, *L'oiseau au plumage déployé vole vers l'arbre argenté* (oil p., 1953)

MODIGLIANI Amadeo MM
1884–1920 Italian

Neurotic, spoilt, tubercular, drug-addicted, woman-beating, poverty-stricken but talented pioneer who achieved a genuine and satisfactory synthesis between the priorities of the old masters and those of modern art.

◗ He created very recognisable portraits (mostly of his artistic friends and mistresses) and splashy nudes, both highly stylised, simplified, painterly, poetic, decorative and moody. Notice the inclined heads with long faces on long necks; elongated noses; almond-shaped eyes with a glazed and far-away stare, which show the influence of his original, gifted, carved stone sculptures and his study of African and Oceanic art. Good sculptures (was self-taught). Sensitive drawings.

𝒫 His work shows a clever combination of many influences: African art; Art Nouveau; Matisse-like simplification; Cézanne- and Cubist-like fragmentation of space around the figures; Picasso-like intensity and a confident, fluent line. Had the caricaturist's enviable knack of capturing an essential character with adeft, economical exaggeration. Had an ambition to be a portraitist, like Sargent. Would he have gone on to greater things or was he burned out? His early death probably saved his reputation.

🏛 Milan: Mattioli Collection
🅐🅥 (62) £4,417/$7,200– £9,930,071/$15.25m
➤ £9,472,051/$15.25m in 1999, *Nu assis sur un divan* (oil p., 1917)

MOHOLY-NAGY László MM
1895–1946 Hungarian/German

Lawyer-turned-artist and theoretical writer (like Kandinsky). Geometric Abstract artist who was a leading member of and teacher at the Bauhaus. Sought to create order and clarity by means of abstraction, design, architecture, typography, constructions and photography. Settled in Chicago in 1937.

🅐🅥 (46) £719/$1,092 – £650,000/$981,500
➤ £650,000/$981,500 in 2000, *A XI* (oil p., 1923)

MONDRIAN Piet AG
1872–1944 Dutch

One of the pioneers of pure abstract art. Austere, reclusive character who hated the green untidiness of nature. Theoretically and intellectually influential in his lifetime. Had no commercial success.

◐ The most familiar works are the abstracts of the 1920s and 1930s. They have simple elements: black, white and primary colours only, horizontal and vertical lines. His aim was to find and express a universal spiritual perfection, but his imagery has become a commonplace of 20th-century commercial design. Look out, also, for his late, jazzily colourful work, completed in New York. His slow and painstaking progress through Symbolism and Cubism to abstraction repays patient study.

○ You have to see Mondrian's work in the flesh to understand it. Reproductions make his abstracts look bland, mechanical and easy, with immaculate, anonymous surfaces. In fact, you can (and are supposed to see) the brush marks, the alterations, the hesitations – the struggle to achieve, in every case, that harmonious balance and purity that he desperately wanted but found so hard to attain. Note also the deliberate small scale and intimacy of most of his work.

Ⓐ (17) £4,167/$6,667 – £383,523/$613,636
⚒ £5,645,162/$8.75m in 1989, *Façade in Tan and Grey* (oil p., 1913)

1

2

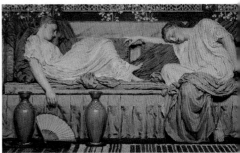

MONET Claude AG
1840–1926 French

True leader of the Impressionists –
constantly exploring 'What do I see and
how do I record it in painting?'

◐ Monet had a never-ending interest
in observing and painting that most
elusive quality, light – notably in the
'Series' paintings, where he painted the
same subject dozens of times, under
different light conditions (the Rouen
Cathedral, haystacks, scenes in London).
Spent 40 years (the second half his life)
creating his garden, at Giverny, from
scratch – a subject that he could control
in every detail (except the light). He would
sit in the middle of it and paint it.

🔍 Stand back and enjoy the imagery –
familiar and nostalgic for us now, but
challenging and modern in its day. Stand
close up and enjoy the complexity, texture
and interweaving of paint and colour.
Note the thick, crusty paint, which gets
thicker as the light gets more interesting
– particularly when it catches the edges
of objects.

🏛 Paris: Musée d'Orsay; Musée
Marmottan; Giverny (near Paris) for

Monet's house, studio and garden.
🅐🅥 (68) £3,241/$5,120 –
£14,569,538/$22m
🔨 £18m/$29,520,000 in 1998,
*Bassin aux nympheas et sentier au
bord de l'eau* (oil p., 1900)

MONINOT Bernard CS
1949– French

Creator of 3-D constructions and 2-D
designs on and under glass, which explore
aspects of two- and three-dimensionality.
The 3-D works look good when heavily
spotlit so as to cast interesting shadow
patterns.

🅐🅥 (2) £1,580/$2,259– £1,880/$2,951
🔨 £2,559/$4,274 in 1998,
À ciel ouvert (works on paper)

MOORE Albert NH
1841–93 British

Well-travelled, capable and canny artist who managed to pick his way through the competing demand of the Pre-Raphaelites, traditional academicism and Whistler's aesthetics. Attractive, decorative paintings which have pleasing colour harmonies and good technique; they often feature diaphanously draped semi-classical young women, intended purely to please the eye and aesthetic sensibility.

🔵 (5) £1,000/$1,600 – £177,914/$290,000
🔨 £368,098/$600,000 in 1997, *Quartet, painter's tribute to the art of music* (oil p.)

MOORE Henry MM
1898–1986 British

A tough, gritty, ambitious Yorkshireman, one of the best-known British modern masters. His work is a popular choice for international sculptural monuments but it looks best when in a landscape setting rather than a gallery.

☽ His romantic response to nature and the human figure is often expressed as a synthesis of the two, so that his forms can be read simultaneously as organic nature (rocks, cliffs, trees), and as human figures. He consciously rejected Renaissance notions of ideal beauty, but was much influenced by Mexican, Egyptian and English mediaeval sculpture. Direct carving and truth to materials were an imperative of his early work; this was gradually replaced by a desire for monumentality.

🔍 Observe his interest in 3-D spatial construction and pierced form – walk around the sculptures (whether large or small) to look at and investigate the constantly changing relationships between the different parts. Moore was fascinated by the reclining nude, and mother and child images. A superb sculptural draughtsman, who

investigated ideas in his drawings. Flirted with Surrealism in the 1930s; made important war drawings in the 1940s. Went into sad decline when he used assistants for his late public monuments.

🔵 (204) £1,739/$2,800 – £2,298,137/$3.7m
🔨 £2,298,137/$3.7m in 1999, *Two-Piece Reclining Figure* (sculpture, 1969)

MORAN Thomas NH
1837–1926 American

Self-taught, Irish-English émigré, raised in Philadelphia. Made his reputation after a pioneering visit to Yellowstone (1871), depicting its natural grandeur in the style of Turner's Romanticism. His superb watercolours are built up from pencil underdrawing and were much influenced by Turner. He also painted scenes of Venice (Turner again), Long Island and California.

🔵 (28) £556/$900 – £664,336/$950,000
🔨 £1,612,903/$2.5m in 1994, *The Cliffs of Green River, Wyoming* (oil p., 1881)

MORANDI Giorgio MM
1890–1964 Italian

Reclusive, isolated and gifted, best known for his post-1920 still lifes of simple objects (such as bottles) of great delicacy and seductive, poetic simplicity. Small scale, low-key; almost monochrome, almost abstract, to be enjoyed in silence, like music. Good pre-1920 metaphysical paintings. Beautiful etchings.

🔵 (67) £2,495/$3,567 – £760,000/$1.1m
🔨 £798,817/$1.35m in 1990, *Natura morta* (oil p., 1938)

MOREAU Gustave OM
1826–98 French

Intense, talented, prolific, workaholic and successful. Was determined to revive the

tradition of history painting (actually in terminal decline) and to be a rival of the greatest old masters.

◐ Noted for erudite, imaginative, literary and mythological subjects. His idiosyncratic style is half way between the strange fantasy world of Bosch and the surreal dream world of Max Ernst. His work is sometimes dark and mysterious, sometimes bright and shimmering, but always sinister, oozing romantic decadence and symbolism. Used deeply worked surfaces and textures with inventive impasto, glazes and colours that unlock his imagination.

🔎 He produced a huge quantity of sketches and watercolours: these preceded his finished oil paintings, either as experiments, or to work out the final design and details. His late watercolours (and some unfinished oils) are as free and sketchy as modern abstraction. He was active at the same period as the Impressionists, who were everything he was not. A gifted teacher, he influenced

🔨 £1,592,357/$2.5m in 1989, *Le poète et la sirène* (oil p.)

MORETTO da BRESCIA (Alessandro Bonvicino) OM
c.1498–1554 Italian

Painter from Brescia, in the foothills of the Venetian Alps, whose art was influenced by the countryside he lived in. From Venetian art he took poetic portraits, idealisation, rich colour, textures and landscape; from northern art he took altarpieces with Reformation subjects, realism and minute detail. Ultimately his work suffers from too many influences, which he never fully resolved.

MORI Mariko CS
1967– Japanese/American

Creator of strange, technically immaculate cibachrome or video images, which project a fantasy world

1

2

many who seem impossibly far removed from his style (such as Matisse). Was much influenced by a tour of Italy (1857–9).

🏛 Paris: Musée Gustave Moreau
🅐🅥 (4) £3,317/$5,240 – £120,000/$192,000

that is a cocktail of futuristic science fiction, retro, Barbie dolls, kitsch, fashion, realism, and West and East. Her own extravagantly dressed image is central. She claims to be projecting an image of Utopia and the necessity of believing in utopias and optimism.

🌑 Can Utopia be so anodyne? This is not a vision of Utopia that sets out to reform the key moral, social, political and environmental issues. It is the dream world of the global mega-shopper whose ambition is the latest 'must have' brand. It is effective, but deeply narcissistic.

🅐 (11) £1,605/$2,600 – £70,000/$101,500
🔨 £70,000/$101,500 in 2000, *Play With Me* (photographs, 1994)

MORISOT Berthe MM
1841–95 French

Member of the Impressionists circle and effective hostess and go-between to the writers, poets and painters in their circle. Attractive, free, delicate style derived from Manet (she married his brother, Eugène). Her works are, in effect, an autobiographical diary.

🅐 (22) £2,462/$3,938 – £2,797,203/$4m
🔨 £2,797,203/$4m in 2000, *Cache-cache* (oil p., 1873)

MORLAND George NH
1763–1804 British

Successful London painter who developed a popular line in sentimental genre scenes ('fancy pictures'), showing attractive but improbable incidents of cottage life, gypsies, hunts and smugglers. His work is of uneven quality. His dissolute life led to declining powers and an early death.

🅐 (41) £309/$500 – £41,667/$60,000
🔨 £115,000/$180,550 in 1995, *The Story of Laetitia* (oil p., 1786)

MORLEY Malcolm CS
1931– British

UK born, now lives in New York. Started to

3

paint in prison; subsequently studied at the Royal College of Art in London. His early work is Photorealist, working from actual photos – squared up, with the image surrounded by a frame of blank white canvas. Since the late 1970s he has adopted a freer style by working from his own squared-up watercolours. Chooses autobiographical themes.

🅐 (14) £1,689/$2,500 – £155,280/$250,000
🔨 £318,436/$570,000 in 1992, *Vermeer, portrait of the artist in his studio* (acrylic)

MORONI Giovanni Battista OM
c.1525–78 Italian

Artist from Bergamo who is best remembered as an accomplished painter of low-key realist portraits, with good precise detail, in which the sitters are allowed to speak for themselves without too much manipulation by the artist. Had a wide range of sitters, including middle and lower classes.

Note his preference for figures silhouetted against a plain background.

- Ⓐ (1) £170,000/$256,700
- 🔨 £719,895/$1,101,440 in 1995, *Portrait de Prospero Alessandri* (oil p.)

**MORRIS Sir Cedric
(9th Baronet of Clasemore)** NH
1889–1982 British

Self-taught, self-styled 'bohemian', painter and dedicated horticulturalist in East Anglia. Painted landscapes, townscapes, portraits, animals, birds and flowers (especially irises). He typically used a bold motif on a contrasting background, with economy of means and bright colour. He fought against the values of polite English society – tastefulness, prudery, hypocrisy.

- Ⓐ (21) £620/$911– £10,100/$16,800
- 🔨 £18,000/$25,740 in 1993, *Milly Gomersall* (oil p., 1936)

MORRIS Robert CS
1931– American

Produces large-scale simple forms, either geometric and hard-edge, or curvilinear and soft-edge (such as mounds of hanging felt). He creates the blueprint, others make the pieces. He wants you to focus on an analysis of your perception and/or of the decision-making process by which he arrives at final form – the classic agenda for Minimal art, of which he was a pioneer.

- Ⓐ (5) £341/$487 – £18,310/$26,000
- 🔨 £35,061/$57,500 in 1990, *Untitled* (sculpture)

MORSE Samuel Finley Breese NH
1791–1872 American

Painter of moderate talent who studied in Italy. Aspired to reform art education and give America good taste. Wanted to be recognised for grand allegorical works, but had to rely mainly on portraits of the merchant class for income. Gave up painting in 1837 to pioneer wireless telegraphy and invent Morse Code.

- Ⓐ (1) £692/$1,100
- 🔨 £27,807/$52,000 in 1990, *Rachel Pomeroy Campbell* (oil p.)

**MOSES Grandma
(née Anna Mary Robertson)** NH
1860–1961 American

Self-taught farmer's wife from Virginia in Vermont who, in the 1930s, aged 70 + (and to her surprise?) became a celebrity. Her paintings are in a naïve style with nostalgic images of idyllic rural life, full of women and children. She copied details from popular prints; her work was in turn endlessly reproduced as greeting cards, wallpaper and fabrics.

- Ⓐ (24) £2,657/$4,250 – £69,930/$100,000
- 🔨 £120,805/$180,000 in 1993, *Country Fair* (oil p., 1950)

MOTHERWELL Robert MM
1915–91 American

Urbane, erudite, fluent, influential painter, writer and philosopher who was a leading Abstract Expressionist. He married Helen Frankenthaler.

- ◑ His abstract paintings, drawings and collages are always elegant (with a self-conscious refinement and savoir-faire that runs the risk of becoming precious). His work ranges from small-scale intimate collages to grand large-scale paintings. Seeks a strong, visual impact and intrigue as a means of opening up with the viewer a dialogue of discovery of things seen, ideas and issues. Enjoys paint, accident, the unexpected, calculated simplicity. Restrained use of colour.

1

2

MOUNT William Sidney NH
1807–68 American

The premier genre painter of mid-19th-century America. Lived in Long Island and produced scenes of rural life which appealed to New York city-dwellers. His images of farm life, horse dealing, music making, and his sensitive portrayals of African–Americans farmers appealed to a public hungry for expressions of national self-awareness and self-consciousness. Clear, precise draughtsmanship and colours.

- ⓐ (6) £1,644/$2,400 –
 £244,755/$350,000
- ⚒ £555,725/$800,000 in 1983,
 The Trap Sprung (oil p., 1844)

MÜLLER Otto MM
1874–1930 German

An important but short-lived contributor to the German avant-garde (Die Brücke), 1906–14. Powerful images of nudes in landscapes. 'Primitive', rough texture, bold outline and colour, deriving from Matisse and the Cubists. Painted gypsy subjects after 1920.

- ⓐ (40) £1,940/$3,104 –
 £370,000/$610,500
- ⚒ £1m/$1.62m in 1997, *Zigeunerinnen am Lagerfeuer* (oil p., 1927)

🔎 His major achievement,
The Spanish Elegies' series of paintings (more than 150 canvases done over a lifetime), are built around symbolic contrasts (such as ovoid and angular shapes). They form a deeply emotional response to the Spanish Civil War and his realisation that civilisation can regress. The collages he built around wine labels, cigarette wrappers and music (he did not smoke and could not read music but liked the appearance of these items) are a diary of association and memorabilia, not an autobiography.

- ⓐ (45) £1,818/$3,000 –
 £50,314/$80,000
- ⚒ £632,910/$1m in 1989,
 Elegy to the Spanish Republic No. 125 (oil p., 1974)

1. Juan Muñoz, *Dwarf with a Box*, 1988

MULREADY William NH
1786–1863 British

Highly accomplished, Irish-born painter, best known for anecdotal, rural and domestic scenes, often the interior of a humble cottage depicted in picturesque, peasant disorder. His late works focus on the theme of childhood and education (he was a single parent, so had first-hand knowledge). He was much influenced by the Dutch masters, whom he copied, and Wilkie.

- 🅰️ (5) £458/$673 – £3,840/$6,221
- 🔨 £38,000/$60,420 in 1995,
 Idle Boys (oil p., 1815)

MUNCH Edvard AG
1863–1944 Norwegian

The best-known Norwegian and Scandinavian painter, and a forerunner of Expressionism. His early life was tortured by sickness, death, insanity, rejection, unhappy love affairs and guilt – a textbook case for Freud.

🌓 Observe the way he worked through his neuroses in his paintings. The best, most intense, works are before his nervous breakdown in 1908. They are full of recognisable (almost cliché) images of isolation, rejection, sexuality and death, but he had a rare ability to portray such intimate emotions in a universal way, so that we can recognise and even come to terms with our own inner fears, as well as being able to touch his. He made anxiety beautiful.

🔎 The sketchy, unfinished style (using scrubby paint, with scratch marks from the handle of the brush), alongside simple and balanced compositions reveals much of his inner uncertainty and search for peace and stability. Look for intense colour combinations, strange flesh colours, an obsessive interest in eyes and eye sockets, phallic symbols. Don't overlook his woodcuts, which exploit the grain of the wood and are some of the most accomplished and confident things he did.

- 🏛️ Oslo: Munch Museum; National Gallery
- 🅰️ (138) £1,467/$2,377 – £388,500/$613,830
- 🔨 £4,216,868/$7m in 1996, *Girls on Bridge* (oil p., 1902)

MUNNINGS Sir Alfred NH
1878–1959 British

Brilliant and successful artist who believed (like his clientele) that anything 'modern' was a horrible mistake. Though blind in one eye, he had acute vision. Socially he saw only what he wanted to see. A controversial President of the Royal Academy.

🌓 He is remembered primarily for his hunting and racing portraits of humans and horses. He had rare flashes of inspiration, but too often his work lapses

1

180

into a stock formula: half-way horizon, human upper torsos and heads plus horses' heads and ears silhouetted against a sky piled high with clouds. Though fascinating as social documents such paintings are his least interesting artistically. He always painted a good 'picture', just as some writers always write a good 'story'.

🔍 At his best when he was at his most informal and inventive – in his pictures of horse fairs, local races, landscapes or gypsies. Within them (and tucked away in portraits), note his genius for capturing a specific light effect, the play of light on landscape or horse flanks, movement, unexpected viewpoints and spontaneous slices of life. He never doubted his own talent or the values that he celebrated (and it shows).

🏛 Dedham (Essex, England): Sir Alfred Munnings Art Museum
⍉ (97) £280/$448 – £2,437,500/$3.9m
🔨 £2,437,500/$3.9m in 1999, *Lord and Lady Mildmay of Flete, with their children* (oil p.)

MUÑOZ Juan CS
1953– Spanish

Born in Madrid; studied in London and New York. Creator of large-scale installations that fill a whole gallery – such as marquetry floors with extreme false perspective, constructions with architectural elements (such as iron balconies) that have distorted scale, and groups of figure sculptures in unexplained silent relationships. He creates feelings of disequilibrium, danger and absurdity.

🌑 If the new museums of modern and contemporary art are no longer places for individual, spiritual and aesthetic refreshment, nor for genuinely eye-opening artistic and political challenge, but are effectively adult adventure playgrounds driven by management targets for admissions, budgets, shop sales, fund raising and commercial sponsorship (and why not? – everyone and everything must move with the times), then these (and other similar works) are good-quality content for them.

🔨 £74,405/$125,000 in 1997, *From One to Five, Two* (sculpture, 1991)

MÜNTER Gabriele MM
1877–1962 German

A leader of Der Blaue Reiter group and Kandinsky's partner and mistress from 1903 until 1914. During this time she painted bold, expressive, original and colourful still lifes and landscapes. She broke for good with Kandinsky in 1917 and ceased to paint.

🏛 Munich: Lehnbachhaus
⍉ (48) £1,600/$2,320 – £397,351/$600,000
🔨 £397,351/$600,000 in 2000, *Kind mit Puppe* (oil p., 1909)

MURILLO Bartolomé Esteban AG
1617–82 Spanish

Considered in his lifetime, and until about 1900, greater than Velásquez and as good as Raphael. Now the poor man's Velásquez. Born and bred in Seville. Pious family. Widowed at the age of 45. Produced acres of soft-focus sentimental religious pictures for the home market. Fewer, better, genre scenes (good, line in ragamuffins), done for the export market. Good portraits.

🌑 A Murillo revival campaign is currently under way. It is not difficult to extol his confident, masterly, way with colour, paint handling light and strong compositions. The genre scenes are appealing as subjects; they influenced Reynolds and Gainsborough. But it is an uphill struggle now to find virtue in the overly sweet and sometimes sickly

religious pictures. And they get worse as he gets older – maybe widowhood made him excessively misty-eyed about young mothers and children.

- 🏛 Seville (Spain): S. Francisco; S. Maria la Blanca. London: Dulwich Picture Gallery (for genre)
- Ⓐ (8) £1,000/$1,480 – £289,655/$420,000
- 🔨 £2.2m/$4,246,000 in 1990, *Saint Joseph and Christ Child* (oil p.)

MURRAY Elizabeth CS
1940– American

Produces paintings employing traditional materials manipulated with elaborately shaped stretchers (often in biomorphic shapes) and surfaces with two or more levels. Uses thick paint with scumbled impasto. She believes content is more important than style and so she plays about with, or makes reference to, art history (such as Cubism) and other artists (such as Frank Stella). Energetic, witty and mannered.

- Ⓐ (8) £1,398/$2,250 – £36,620/$52,000
- 🔨 £65,089/$110,000 in 1991, *Sleep* (oil p.)

MYTENS Daniel NH
c.1590–c.1647 Dutch/British

The major portrait painter in England before Van Dyck. Dutch born and trained. Arrived in London c.1618 and worked for Charles I. Painted elegant, rather stiff, formally posed portraits (but with insight into personality), which introduced a hitherto unknown level of realism to English art. His best works are his late full-length portraits, which are powerful, assured and fluent.

- Ⓐ (2) £5,874/$8,517 – £38,000/$57,380
- 🔨 £50,000/$91,000 in 1988, *Portrait of young boy in maroon dress and white ruff with spaniel* (oil p., 1627)

NADELMAN Elie NH
1882–1946 American

Gifted Polish sculptor of great charm. Moved to Paris in 1904 and emigrated to the USA in 1914. His Parisian style was eclectic in the classical Greek tradition. In the USA married an heiress and became a pioneer collector of folk art. He himself created charming folk art – inspired wood sculptures (with a hint of the Hellenistic). Lost everything financially in 1929.

- 🌙 His sculptures often have the silhouettes of figures in Seurat's paintings. His work is an interesting and successful synthesis of ancient and modern, the common denominator being a search for purity in form and materials.

- Ⓐ (13) £778/$1,300 – £182,432/$270,000
- 🔨 £1,511,628/$2.6m in 1987, *Tango – couple dancing* (sculpture)

NASH John NH
1893–1977 British

Self-taught younger brother of Paul Nash. Produced tight, evocative, very English landscapes, thinly painted, often tentative, with a charming awkwardness. Had a genuine feel for the poetry of landscape, but the emotion is always restrained. Gentle, unpretentious and candid work, with good observation of detail. At his best in the 1920s and with watercolour. Was an official war artist. Also did very good book illustrations.

- Ⓐ (31) £360/$533 – £9,000/$13,500
- 🔨 £27,000/$46,440 in 1992, *Yarmouth Docks* (oil p.)

NASH Paul NH
1889–1946 British

One of the best British artists of the first half of the 20th century, successfully blending an English pastoral vision with

an awareness of European modern art. The voice of 'I am English first and foremost, of Europe but not in Europe.'

☀ His small-scale works in oil, pastel or watercolour show a deeply personal first-hand response to landscape, coastline, sun and moon, and to objects in nature such as trees, bark, leaves, flowers, fungi and shells. He was careful in every sense and very English, of a certain type: self-contained, serious, gentle, parochial, romantic, polite, self-assured, independent but not too progressive. Lean, spare, well-focused imagery and style. Earthy English palette.

🔍 Worked as an official war artist in both world wars. Strongest response was to trench landscape and its destruction in World War 1 and to flight and aircraft in World War 2. His poetic ability to transform one object into another by association and his capacity for juxtaposing the unexpected links him to the Surrealists. Note his enviable ability to abstract from nature and organise his perceptions, feelings and paintings in such a way as

to capture the essential feel of a place – the so called 'genius loci'.

🅰 (24) £400/$624 – £70,000/$113,400
🔨 £75,000/$121,500 in 1997, *Mineral Objects* (oil p., 1935)

NAUMAN Bruce CS
1941– American

One of the gurus of the official art world. His aim is to examine, document and involve the viewer in experiences of pointless activity, humiliation, stress and frustration.

☀ He works in many media – video, performance, conventional sculpture, neon… you name it. Claims to be communicating his observations of human nature and examining our perceptions of it, but focuses on activities that are pointless, repetitive and deliberately inept. Fair enough, but does it add up to anything of significance,

anything more than the trivial and banal? If the answer is 'that's the point' then isn't it just an exercise in perversity?

🔍 To answer the above, trust your own judgement; ignore museum labels and their overanxious insistence on significance (translation – we have committed significant money and professional credibility to this; if it isn't deemed to be significant and profound, we will look like complete idiots). Better still, as this is overtly public art, to study the reactions of gallery-goers. Are they engaged and interested? Dismissive and disinterested? They will tell you if his strategies amount to anything meaningful.

🅰️ (23) £1,645/$2,730–£324,324/$480,000

🔨 £1,190,476/$2m in 1997, *Good Boy, Bad Boy* (sculpture, 1986)

NASMYTH Alexander NH
1758–1840 British

Scottish-born, talented painter during the golden age when Edinburgh was the 'Athens of the North'. Was a teacher-cum-stage-designer-cum-architect, wholly in tune with his times in that he blended classical landscapes with Scottish scenery and historic buildings. Also used landscape settings. Good technique and original ideas.

🅰️ (12) £500/$725 – £9,639/$16,000

🔨 £21,000/$22,680 in 1985, *Town of Stirling on the River Forth* (oil p.)

NEEL Alice NH
1900–84 American

Humourless realist portraitist. Her stilted style has a superficially modern appearance achieved by deliberately awkward flattened space; thick, clumsy, paint handling, and the use of strident colours. Her overearnest search for 'truth' resulted in the distortion of reality,

and the only flattery or consolation for her sitters was to have been asked to pose in the first place.

🔨 £11,905/$20,000 in 1997, *Untitled – Portrait* (oil p., 1963)

NEER Aert van der MM
1603–77 Dutch

Specialist in night scenes (gloomily imaginative, with ghostly full moon or lit by burning candles) and winter landscapes (atmospheric, with pale cold colours and lots of skaters). Oddly unsuccessful as a painter. Also failed as an innkeeper and went bankrupt.

🅰️ (7) £13,000/$21,060 – £400,000/$620,000

🔨 £2.1m/$3,528,000 in 1997, *Winter landscape with figures on path and ice* (oil p.)

NEVELSON Louise (Louise Berliawsky) NH
1899–1988 American

Long lived, Kiev born (family emigrated to the USA in 1905). Brought up with wood (the family business was timber) and was always dedicated to being a sculptor (to the point of abandoning her husband and child). She only discovered her signature style in the 1950s – open-sided boxes made into reliefs, each box

2

containing an assortment of forms created from wood scraps, and painted in monochrome, usually black.

◑ Her sculpture is most impressive when on a large scale. It is distinguished work that carries in it the sort of accumulated experience and mysterious gravitas that comes with old age. It must be absorbed slowly just like the company or wisdom of the ancients. This is a welcome reminder that no one is ever too old to be creative: she did not even find herself until she was in her 50s, and her best work was done in her 70s and 80s.

Ⓐ (47) £1,188/$1,900 – £86,093/$130,000
⚒ £119,048/$200,000 in 1997, *Dawn's Wedding Chapel IV* (sculpture, 1959-60)

NEVINSON Christopher Richard Wynne NH
1889–1946 British

Difficult personality who had a brief flowering as a leading member of the English avant-garde when he produced good-quality work influenced by Cubism and Futurism (1912–14). Some of his best work was produced as an official war artist during World War 1. He was stylistically innovative and hard hitting – but he lost it after 1916, when he became pedestrian and mannered.

Ⓐ (26) £450/$719 – £180,000/$257,400
⚒ £180,000/$257,400 in 2000, *Sunday Evening, Punts on the Thames at Henley* (oil p., c. 1924)

NEWMAN Barnet MM
1905–70 American

Leading Abstract Expressionist who developed a personal style of large-scale Colour Field painting, which attempted to touch emotions and aspirations that are beyond the power of words to express.

◑ Look for everything or nothing. If you see the intense colour fields with the simple vertical stripes as nothing more than that, you will not see much. But if you see, for example, the red background drawing aside to reveal an expanding opening into an infinite blue space (the blue stripe), or the yellow stripe as a flash of cosmic light, and are prepared to follow after it with your imagination, then you will see everything.

🔎 As with many art forms (especially abstract art), you have to be prepared to suspend disbelief (and why not?) to be able to touch the inner meaning of the work. If you are not blessed with a strong imagination and can't get to grips with the spiritual, cosmic and infinite, don't waste time with Newman and move on to an artist you find more sympathetic – but please respect Newman for his beliefs and his ability to touch some people profoundly.

Ⓐ (3) £2,454/$4,000 – £6,944/$10,000
⚒ £1,774,194/$2.75m in 1995, *The Word II* (oil p., 1954)

1. Emil Nolde, *The Dancers*, 1920
2. Sir Sidney Nolan, *Kelly in Spring*, 1956

NICHOLSON Ben MM
1894–1982 British

Doyen of the St Ives School and one of the leaders of Britain's first generation of modern artists. Son of Sir William Nicholson; married Barbara Hepworth in 1934.

☽ Chose traditional subject matter (landscapes and still lifes) for his paintings, reliefs and drawings. Moved easily between a pared-down figuration and pure abstraction, making interesting and understatement on the unruly appearance of the European avant-garde, making it as well-tailored as a Savile Row suit and as well-mannered as a game of gentlemen's cricket (both express deep passions as well as reserve). Does the fact that his work looks equally at home in modern or traditional, country or urban, British or European settings suggest that it is bland – or does it mean it is the essence of international savoir faire?

🏛 London: Tate Britain

1

2

💿 (51) £600/$960 – £172,840/$280,000
🔨 £1.1m/$1,936,000 in 1990, *La boutique fantastique* (oil p., 1964)

use of materials and scratched textures. The lean, athletic look and a sense of calculation rather than spontaneity were central to his competitive persona, which enjoyed playing games (ball and psychological). His work shows an evident debt to modern European art – Cubism, Mondrian and Braque.

🔍 Notice the way in which he imposes English virtues of politeness

NICHOLSON Sir William NH
1872–1949 British

Highly accomplished painter of landscapes, portraits and still lifes, with an easy, fluid, intimate style and a wonderful eye for observation, composition, colour and light – and an ability to edit out the superfluous. Successful, and knighted for his achievements. Also made poster and

theatre designs, and woodblock prints. Ben Nicholson's father.

- Ⓐ (15) £600/$960 – £155,000/$232,500
- ✎ £155,000/$232,500 in 2000, *Flower and Glass Jug* (oil p., 1935)

NOLAN Sir Sidney CS
1917–92 Australian

Widely travelled and acclaimed, Nolan is one of the few contemporary artists to have established a place for narrative, mythological painting, notably the 'Ned Kelly' (romantic Australian outlaw) series. His distinctive style combines abstraction and figuration, and conveys a strong sense of the heat and emptiness of the Australian landscape. Expressive brushwork and colour.

- Ⓐ (148) £338/$484 – £476,190/$719,048
- ✎ £476,190/$719,048 in 2000, *Death of Constable Scanlon* (oil p., 1954)

NOLAND Kenneth MM
1924– American

Creates simple, direct works in which the impact is purely visual and comes solely from colour on the canvas – there is no 'meaning', drawn line or spatial depth. He plays with colour variations, and simple, dynamic shapes (such as a bull's eye or a chevron) and their relationship to the shape or edge of canvas. He also plays with irregular-shaped canvases. Very American, very good.

- Ⓐ (28) £1,000/$1,450 – £507,042/$720,000
- ✎ £1.17m/$1.85m in 1989, *Empyrean* (oil p., 1964)

NOLDE Emile MM
1867–1956 German

Pioneering Expressionist and member of Die Brücke. His art hides a unique

radical–regressive complexity. Was very interested in non-European 'primitive' art (he made a South Seas expedition in 1913) but he believed in racial purity and the concept of a master race.

◗ Expressionism done with flair. He shares Expressionism's strengths (spontaneity, passion, visual challenge) and its weaknesses (too strident, soon runs out of steam). Creator of landscapes, seascapes (his best work) and figure painting (influenced by primitive art and dance). Uses bright, clashing colours and thick paint, resulting in simplification and a conscious crudeness. Has a superb instinct for colour, which is most apparent when his work is seen from a distance.

🔍 His early work was on the cutting edge of the avant-garde, but he never developed – he was painting the same work in 1940 as in 1910 (but only Beckmann was able to sustain original levels of Expressionist creativity and freshness after the age of 40) . Was a fully paid-up Nazi and never understood why they rejected his art – perhaps he was (sadly) a curious case of arrested development, artistically and politically? Was also a highly talented watercolourist (secretly painted over 1,000 remarkable watercolours between 1941 and 1945).

- 🏛 Seebüll (Germany): Stiftung Ada und Emil Nolde
- Ⓐ (195) £459/$739 – £1,28m/$2,023,967
- ✎ £1.28m/$2,023,967 in 1999, *Christ and the Sinner* (oil p., 1926)

OFILI Chris CS
1968– British

Produces largish-scale technically complex works – layers of paint, resin, glitter and collage. Famously uses elephant dung in the painted surface, or under the picture as a support (the result of a trip to his cultural homeland, Zimbabwe, in 1992). Addresses issues of

black identity and experience via cultural references to the Bible, jazz and porn. He has potential, but as yet it is undeveloped.

- Ⓐ (7) £1,086/$1,650–
 £75,000/$121,500
- ⚒ £75,000/$121,500 in 1999,
 Untitled (oil p., 1998)

O'KEEFE Georgia MM
1887–1986 American

Influential – but a one-off artist, outside the mainstream of modern art. Her work will be remembered and valued far longer than that of many other 20th-century names currently in fashion or overpraised.

◑ Her intense and exotic imagery lies in that intriguing area between figuration and abstraction. She made very powerful images of nature and architecture, which have a strong period feel of the 1920s, 1930s and 1940s. Her ability to simplify and intensify colour, movement and pattern has something in common with the best of the classic Disney cartoons, notably *Fantasia*, with which her work was contemporary (Walt Disney:1901–66).

𝒫 Many of her paintings have the shifting and fantastic qualities seen in cloud patterns in the sky. Look for plants and flowers (often in close-up), mountains, animal bones. Notice how she transforms all of them into something that has a strong unreal, even surreal, poetic life: mountains become flesh; plants become organisms like sea anemones; skulls live and see. Unusual and intense colour combinations; bold simple patterns.

- Ⓐ (3) £13,158/$20,000 –
 £489,511/$700,000
- ⚒ £2m/$3.3m in 1997,
 From the Plains (oil p., 1919)

OLDENBURG Claes CS
1929– American

Born in Europe, but brought up in the USA (his father was appointed Swedish Consul in Chicago, 1936). One of Pop art's most original and inventive talents.

◑ His highly original creations work on several levels by constantly reversing normal expectations. He starts with commonplace consumer-society objects (such as a hamburger or a typewriter) and metamorphoses them into something strange and comical by altering their scale, texture or context. Also asks questions about what constitutes a painting, sculpture, work of art or consumer object.

𝒫 He enjoys paradox and contradiction. He mocks the self-absorbed seriousness of consumer society but is always teasing and humorous, never threatening. Compulsive drawer, even as a child, forever imagining transpositions that carry witty and significance resonances – such as a woman's lipstick that becomes a rocket with a warhead and doubles as a sculptural monument in a public place.

- Ⓐ (41) £839/$1,200 –
 £186,335/$300,000
- ⚒ £248,322/$370,000 in 1994,
 7-up (sculpture, 1961)

OLITSKI Jules CS
1922– American

Russian born. Trained in old-master painting techniques. Creator of large-scale decorative abstract paintings. Uses a stain and spray-gun technique, which creates a field of atmospheric colour that seems to dissolve the picture surface. There is often a band of rich pigment along one edge or at a corner. Sensual, slightly precious and self-conscious work.

ⓐ (11) £587/$921 – £15,528/$25,000

↗ £190,476/$320,000 in 1990,
Strip Heresy (oil p., 1964)

OLIVER Isaac NH
c.1565–1617 British

Son of a Huguenot goldsmith who
settled in England in 1568. Painter of
miniatures (portraits, and mythological
and religious images). Was a pupil of
Hilliard, but adopted a different style,
with strong shadows. His life revolved
around the courts of Elizabeth I and
James I. A visit to Venice in the 1590s led
to a softer style and richer colours.

ⓐ (1) £240/$364

↗ £40,000/$60,000 in 1996, *Young
gentleman in black silk doublet, black
earring* (w/c miniature, 1615)

OPIE John NH
1761–1807 British

Son of a Cornish carpenter, who became
a fashionable and successful portraitist.
Also painted peasant and historical
scenes. His greatest talent was his ability
to catch a significant expression.
He was middle of the road, worthy,

professor-at-the-Royal-Academy type. His
work is little known now.

ⓐ (6) £2,600/$3,692 – £10,976/$18,000

↗ £39,000/$60,450 in 1994, *Captain
Morcom of Polberro Mine showing
copper ore to Thomas Daniell* (oil p.)

OPPENHEIM Meret MM
1913–85 German

Will always be remembered for her
Surrealist fur tea cup (*Objet*, 1936).
Produced engaging, delicate, whimsical
work on many themes and in many
media and styles – individually slight
but collectively expressing her refusal
to be categorised and pinned down.

Had a free spirit and disliked prescribed roles, especially for women. Witches and snakes are recurring images.

Ⓐ (7) £327/$519 – £7,692/$12,154
🔨 £44,400/$65,257 in 1994,
A Pair of Fur Gloves
(sculpture, 1936)

ORCHARDSON Sir William Quiller NH
1832–1910 British

Gifted Scottish portrait painter who made a successful career in London. Best remembered now for storytelling pictures (one of the last of the line). Had a special line in the ups and downs of middle-class marriages (a popular topic in *Punch* satirical magazine). His work shows interesting, sketchy, delicate handling of paint. Was admired by Degas.

Ⓐ (3) £380/$623 – £5,500/$8,250
🔨 £30,000/$50,700 in 1997,
Reflections (oil p., 1894)

OROZCO Gabriel CS
1962– Mexican

Creator of installations and objects. Typically he takes a well-known object and by altering it significantly makes it more interesting or beautiful and also completely dysfunctional. Takes photographs of situations that he sets up in order to explore the relationship between objects. One of many artists playing clever games with our expectations of 'reality'.

Ⓐ (6) £1,857/$2,730 – £52,817/$75,000
🔨 £52,817/$75,000 in 2000, *Horses Running Endlessly* (sculpture, 1995)

OROZCO José Clemente MM
1883–1949 Mexican

One of the three great Mexican muralists

(with Diego Rivera and David Alfaro Siqueiros). His public-building murals, in a cold and austere style, are based on his experiences of the Mexican Revolution and Civil War, showing the struggles and sacrifices of the people and the pain of needless suffering.

Ⓐ (2) £6,250/$10,000 – £11,250/$18,000
🔨 £225,166/$340,000 in 1992,
Acordada - Caballos y Zapatistas
(oil p.)

1

2

ORPEN Sir William Newenham Montague NH
1878–1931 British

Artist whose early promise was unfulfilled. Author of anecdotal paintings, which are 19th century in content, 20th century in style. Technically gifted and a great draughtsman. His early work is brilliant and accomplished. Sadly, he was out of step with his age (like Augustus John) and his later work never really came together – being constantly on the verge of descending into caricature and bathos.

- ⏺ (47) £391/$566 –
 £520,000/$842,400
- 🔨 £650,000/$1,059,500 in 1998,
 A Mere Fracture – In the Newsroom, Fitzroy Street, The Fracture (oil p.)

OSTADE Adriaen van OM
1610–84 Dutch

Haarlem-born specialist in good-natured, uncritical, lowlife scenes of peasants having a good time in their hovels or taverns. Rich, earthy colours suit the mood. Both the peasants' behaviour and Ostade's technique improve as his work develops (perhaps marrying a well-to-do woman toned down his style and subjects).

- ⏺ (21) £447/$662 – £260,000/$382,200
- 🔨 £1,153,846/$1.8m in 1995, *Peasant family in cottage interior* (oil p., 1661)

OSTADE Isaak van OM
1621–49 Dutch

Adriaen's brother and pupil. Chose similar peasant subjects in his early work. Later on he developed a line in silvery-grey landscapes, with good atmosphere and busy human activity.

- ⏺ (5) £769/$1,100 –
 £980,000/$1,479,800
- 🔨 £2m/$3.3m in 1997, *Waggoner and other figures halted at inn* (oil p., 1646)

PAIK Nam June CS
1932– Korean

Once a young 'bad boy' with an instinct for public scandal; now he has 'grand old man' status. His first interest was music (John Cage). From the 1960s he has wanted to turn TV from a medium for passive mass audiences into an individual and dynamic medium, like painting. He uses the TV screen like collage and creates large-scale installations with banks of screens. Pioneering and impressive.

- ⏺ (18) £615/$972 –
 £36,212/$53,231
- 🔨 £41,750/$70,557 in 1991,
 Sister (sculpture)

PALADINO Mimmo CS
1948– Italian

Creator of consciously individual, showy, expressively painted, colourful, large-scale figurative work made up of dislocated parts of animals, death masks and bodies. Has a personal, mythical and mystical agenda, which is probably (and deliberately?) impenetrable. Leading member of the Italian Transavanguardia movement.

- ⏺ (38) £371/$601 –
 £33,951/$55,000
- 🔨 £133,929/$225,000 in 1990,
 Pozzo di eroi (sculpture)

PALERMO Blinky (Peter Heisterkamp) CS
1943–77 German

Short-lived refugee from Communist East Germany to Düsseldorf (1954). Was a disciple of Beuys. Had a charismatic personality and adopted the pseudonym (Palermo) of a notorious boxer and Mafioso. Made objects, fabric works and abstract paintings. Had a utopian dream using art as a means of modern salvation. Perhaps another case where ambition ran too far ahead of the achievement.

Ⓐ (7) £2,686/$4,029 –
£170,000/$256,700

🔨 £257,669/$420,000 in 1998,
Untitled (sculpture, 1967)

PALMA VECCHIO Jacopo OM
1480–1528 Italian

Short-lived (for an artist), well-regarded painter of the greatest period of Venetian art, of the same generation as Titian. His less good grandnephew was Palma Giovane (1544–1628).

☽ High-quality pictures that are well executed and decorative, but have the misfortune to be emotionally empty (the fate of many artists who just fail to reach the first rank). Had great success with half-lengths of sumptuous blondes masquerading as goddesses and saints (high Venetian fashion of the day).

🔍 Look for skilful drawing, pleasingly soft and harmonious colouring, and mastery of all the skills of perspective and the human figure etc. But his most elaborate works, however, seem to be no more than an accumulation of small-scale visions and fine details, and lack the boldness and grandeur they seem to be striving for.

Ⓐ (2) £6,081/$9,608 – £42,683/$70,000

🔨 £180,000/$293,400 in 1991,
Sacra Conversazione – Madonna and Child with St John the Baptist and St Catherine (oil p., double sided)

PALMER Samuel NH
1805–81 British

Child prodigy from Kent (the 'Garden of England'). Had a very intense pastoral and Christian vision – nature as the gateway to a revelation of paradise. Made exquisite, magical, small drawings in the 1820s, with microscopic details. After his marriage, in 1837, he turned to a less intense, classical, pastoral vision.

Ⓐ (6) £3,046/$4,600 –
£680,000/$1.02m

🔨 £680,000/$1.02m in 2000,
Oak Tree and Beech, Lullingstone Park (works on paper, 1828)

**PANAMARENKO
(Henri van Herwegen)** CS
1940– Belgian

Eccentric visionary who designs weird Leonardo-like machines. They do not work in reality but they do wonders for the imagination. The theme is liberating humanity from physical constraints by suggesting ways to jump further, to fly, to defy gravity, to reinvent time and space, and so on. These machines are also rather beautiful.

Ⓐ (5) £2,340/$3,743 – £6,007/$9,491

🔨 £73,620/$120,000 in 1998,
Flugobjekt – Rakete (sculpture, 1969)

PANINI (or Pannini) Giovanni Paolo OM
c.1691–1765 Italian

Highly successful view painter, contemporary with Canaletto, who anticipated neoclassical taste. Worked in Rome, was much admired by the French. Had a good line in picturesque ancient ruins, and views and events in modern Rome. His drawings were much sought after in his day.

Ⓐ (20) £550/$864 –
£810,000/$1,225,500

🔨 £810,000/$1,255,500 in 1999,
Interior of Pantheon, Rome, looking north from main altar towards entrance (oil p., 1732)

PAOLOZZI Sir Eduardo CS
1924– British

Born in Edinburgh, son of an Italian immigrant family who had settled in Scotland. Passionate, consistent,

generous. A founder of Pop art and one of the great (though underrated) artists of the second half of the 20th century.

◑ His sculptures, constructions and prints (lithographs) are kaleidoscopes of images and ideas. At their heart is a dialogue about the human condition in

the modern world. The fragmentation and unexpected juxtapositions of images are never arbitrary but part of a clearly thought-out strategy, commenting on questions such as: How do we fit into our fragmentary modern world? How do we use our powers over life and death? Can technology be poetic?

🔍 This is the art of a quick-firing, endlessly demanding imagination, which gets more alert with age. To connect with it, be willing to be as freely imaginative yourself, ready to see and revise all your familiar certainties. Look for the clues: the

1

From Parma, in northern Italy – like his contemporary, Correggio.

◗ Look for beautifully executed, refined, elegant, contrived and precious works. He was especially great as a portraitist, projecting a cool, reserved and enigmatic image. His religious and mythological paintings are a paradoxical combination of real and unreal – his art starts with acute observations from life, which he then transforms into fantasies – like a musical composer making variations on a theme. Also produced small-scale panel paintings, large frescoes and brilliant, prolific drawings.

2

life and loves of Hollywood idols that equal those of Greek gods (we still need mythology); the references to other fertile minds (for example, Burl Ives, who combined folk, band, classical music); and to places of imagination (such as museums).

Ⓐ (9) £700/$1,015– £34,000/$49,300
✗ £34,000/$49,300 in 2000, *Large Frog* (sculpture)

PARMIGIANINO (Girolemo Francesco Maria Mazzola) AG
1503–40 Italian

Short-lived, precocious, much admired ('Raphael reborn') and very influential.

🔎 Notice the recurrent, bizarre elongated human figures, their impossibly long necks and knowing looks (especially in his late work, which was considered very beautiful at the time). Look for the distorted and convoluted perspectives and variety of scales (his style was the epitome of Mannerism). Had a sophisticated line in erotica. His drawings are full of energy, movement and light: he loved drawing as an activity, for its own sake, as well as a tool.

🏛 London: British Museum (drawings)

🔨 £800,000/$1,272,000 in 1995, *Madonna and Child* (oil p.)

PASMORE Victor CS
1908–98 British

Interesting pioneer of British abstraction. Started as a spare-time painter (1927–37), then became a full-time figurative painter who went abstract in 1948 (a difficult decision for him). His line and form are very sensitive (oversensitive and contrived?). His spare, cool, calculated, consciously artificial works now look dated.

🅰️ (15) £1,400/$2,100–£26,000/$39,000

🔨 £200,000/$330,000 in 1997, *The Studio of Ingres* (oil p., 1947)

PATENIER (or Patinir) Joachim OM
c.1480–c.1525 Flemish

The first painter to make landscape the principal theme. His works have a bird's-eye viewpoint, with improbably craggy inhabited mountains, blue distances with heavy clouds and cold seas, and tiny-scale hermits, holy families, sometimes with Christ tucked in somewhere – fantasy at its most endearing. High-quality, detailed technique. There are few attributed works, but he had many imitators.

🔨 £85,890/$140,000 in 1998, *Pamoramic landscape with St Jerome* (oil p., Studio of Patenier)

PATER Jean-Baptiste-Joseph OM
1695–1736 French

Poor man's Watteau (he was Watteau's pupil). Chose similar subjects and had a similar style, but his drawing and use of colour lack confidence. His work hasn't got the depth of feeling and the richness of colour that is the hallmark of Watteau.

🅰️ (8) £1,200/$1,908 – £304,878/$500,000

🔨 £306,748/$500,000 in 1998, *Fêtes champêtres with ladies bathing in brook, and with ladies and gentlemen listening to music* (oil p., a pair)

3

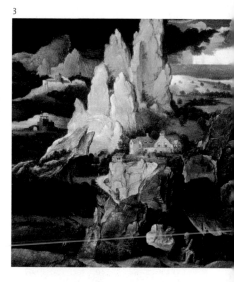

PEALE Charles Willson NH
1741–1827 American

Energetic and insatiably curious. Not only a painter, but a cultural entrepreneur (he founded the first American museum and put on street shows), scientist and revolutionary. He fathered 10 children, 8 of whom (as well as 9 other relations) became artists. Was Philadelphia based, a friend of Jefferson, and the son of an embezzler.

👁 Painted commemorative images of the American Revolution – portraits and miniatures of its heroes (most notably Washington) and descriptive scenes of key events. Also portraits of his family. Was inspired by Reynolds, West and Copley (Peale studied in London in 1766–71); his modest talent as an artist was outweighed by the quantity

and cultural and historical significance of his output. (He was well aware of this and fully prepared to benefit from it.)

- ⊛ (1) £19,255/$31,000
- ➶ £257,168/$410,000 in 1986, *Portrait of David Rittenhouse* (oil p.)

PEALE Rembrandt NH
1778–1860 American

Most gifted son of Charles Willson Peale (and like him a successful showman). Made many visits to Europe and had meetings with famous artists, including Jacques-Louis David. Painted sober-serious portraits, notably of Washington, whom he met. Produced numerous replicas and versions of the statesman – especially 'portholes', where Washington's image is set in an oval stone surround.

1

- ⊛ (9) £1,375/$2,200 – £593,750/$950,000
- ➶ £2,483,222/$3.7m in 1985, *Rubens Peale with a Geranium* (oil p., 1801)

PEARLSTEIN Philip CS
1924– American

Leading figurative painter with a raw,

objective style depicting the human body as it appears, with the minimum of interpretation.

- ➲ Notice the artificiality within the reality: highly finished surfaces (rather than imitation of perceived textures), hidden or cut-off faces, odd viewpoints. The artificiality forces the question 'why?', which in turn demands an answer or interpretation. Pearlstein claims to have given dignity back to the figure by rescuing it from Expressionist and Cubist distortion and from pornographic exploitation. His early (pre-1960s) work is Abstract Expressionist.

- ⊛ (7) £375/$600 – £16,149/$ 26,000
- ➶ £31,250/$52,500 in 1990, *Two Nudes on a Mexican Blanket* (oil p., 1972)

PECHSTEIN Max MM
1881–1955 German

Leading member of Die Brücke. Painter and engraver who also designed decorative projects and stained glass. Was called 'the Giotto of our time'. Characteristic flat style, using pure, unmixed colours and lyrical subject figures, nudes and animals in a landscape. Influenced by Matisse and Oceanic art. Became commercially successful, thereby alienating his fellow avant-garde artists.

- ⊛ (100) £304/$457 – £750,000/$1,237,500
- ➶ £760,000/$1,261,600 in 1997, *Two Girls. Seated Girl* (oil p., double sided, 1909-14)

PELLEGRINI Giovanni Antonio OM
1675–1741 Italian

Well-travelled (Germany, Vienna, Paris, Netherlands, England) Venetian painter. Bright, appealing, airy, illusionistic, decorative compositions on a large scale (very much the Venetian tradition, but brought up to date) which were

influential in creating a fashion and
demand for this type of work, especially
in England.

- ⓐ (11) £500/$0735 – £60,000/$93,000
- 🔨 £300,000/$489,000 in 1998,
 Venus, Cupid and Faun (oil p.)

2

PENCK A. R. (Ralf Winckler) CS
1939– German

Born in East Germany (his earliest
memory is of the fire bombing of
his home town of Dresden in 1945).
Refugee to the West. Self-taught.
Creates highly individual works that
have a consciously primitive and crude
appearance. His hallmarks are his stylised,
spindly silhouetted figures; archaic
symbols; fragmented writing. Has
a personal political agenda, which
is not always easy to fathom.

- ⓐ (60) £257/$ 414 –
 £33,871/$54,194
- 🔨 £90,000/$153,900 in 1998,
 Standard I (oil p.)

PENROSE Sir Roland MM
1900–84 British

Rich and eccentric painter, writer,
dilettante, connoisseur and collector –
another shining example of the uniquely
British 'gifted amateur'. A friend of Picasso

3

and Ernst, he was a champion of
Surrealism. Painter and maker of rather
good (if derivative) Surrealist works.

- ⓐ (4) £373/$608– £1,418/$2,027
- 🔨 £5,000/$8,400 in 1996,
 Self-Portrait (works on paper, 1949)

PEPLOE Samuel John NH
1871–1935 British

One of the four Scottish Colourists (with
Cadell, Fergusson and Hunter); studied
in France. Known principally for his
striking still lifes with fruit, vases, fans,
books and bowls, painted in an angular
and structured manner. He was more
concerned with abstract design and
accents of bright colours played off

against black-and-white than by the subjects themselves. Also painted townscapes and seascapes.

- Ⓐ (14) £1,900/$3,078 – £120,000/$175,200
- 🔨 £120,000/$175,200 in 2000, *Still life with Benedictine bottle and fruit* (oil p.)

PERMEKE Constant MM
1886–1952 Belgian

Leading Belgian Expressionist painter and sculptor who lived in England 1916–18. Painted heavy, sombre landscapes and seascapes, peasants, fishermen and circus artistes, often using dark reds and browns. His paintings have a monumental form that aspires to sculpture. He sought to

achieve spiritual intensity and to illustrate the pathos of the human condition. Also made powerful charcoal drawings. Sculpture is weak after 1935.

- Ⓐ (35) £601/$949 – £19,231/$30,769
- 🔨 £110,000/$174,900 in 1989, *Les toits rouges* (oil p.)

PERUGINO Pietro (Pietro Vannucci) AG
c.1445–1523 Italian

Hardworking, prolific, middle-ranking painter from Perugia, Umbria. Trained in Florence. Raphael was trained in his workshop.

🌑 His religious pictures are painted in a soft, pretty, simplified and sentimental (oversweet?) style, which

tends to become routine – he reused figures from other compositions. His portraits can be very good, tough and direct. His work declined in quality in later years.

🔍 Look for slender figures with gently tilting heads and the weight on one foot; oval-faced Madonnas; delicate fingers with an equally delicate touch and often a genteelly crooked little finger; lips pressed together, the bottom one fleshy; feathery trees and skies that are milky on the horizon, graduating to deep blue at the zenith.

🔨 £3.1m/$5.58m in 1990,
Albizzi Pietà, Dead Christ with Virgin Mary and other figures (oil p.)

PESELLINO Francesco di Stefano OM
c.1422–57 Italian

Shadowy Florentine about whom little is known. Chiefly remembered as a painter of cassoni (elaborately decorated Italian Renaissance marriage chests, sometimes with lids and sides painted by leading artists). Painted balanced compositions, but the figures seem overposed, with vacant eyes and faces. The only documented work by him is an altarpiece in the National Gallery, London.

💰 (1) £335,235/$482,738
🔨 £335,235/$482,738 in 2000, *Triumph of Fame, Time and Religion* (oil p.)

PETO John Frederick NH
1854–1907 American

A brilliant trompe-l'oeil painter who specialised in old books and pinboards. He was a contemporary of Harnett (their works were often confused). Peto's work is softer with slightly fuzzy outlines, and also darker in mood – symbolic meanings can be read in the way objects are juxtaposed and disintegrate. He was obsessed with the image and significance of Abraham Lincoln.

💰 (8) £3,546/$5,000 – £218,750/$350,000
🔨 £308,642/$500,000 in 1997, *Rack picture with Telegraph, letter and postcards* (oil p., 1880)

PEVSNER Antoine MM
1886–1962 Russian/French

Leading exponent of Russian avant-garde non-objective art. Creator of 2-D and 3-D pieces. Fascinated by modern technology and engineering, he made conscious use of modern materials such as Perspex, glass and iron. Note his mastery of the dynamics of spherical surfaces, the way he loves to use projections in space and expresses the poetry of technology, especially flight. He left Russia (together with his brother, Naum Gabo) in 1921 and settled in Paris in 1923.

🏛 Paris: Musée d'Art Moderne
💰 (8) £428/$642 – £72,581/$108,871
🔨 £75,000/$143,250 in 1992, *Formes abstraites* (oil p.)

PHILLIPS Tom CS
1937– British

Fashionable artist and designer who produces somewhat self-conscious work that plays with words and imagery. Process and chance are said to be harnessed (or is it imposed?) and tend to dominate the content. Interesting work, but it can be passionless and self-satisfied, in danger of becoming overpleased with its own existence, and never really getting anywhere.

🔨 £8,000/$14,800 in 1991, *The Quest for Irma I-V* (works on paper)

PICABIA Francis MM
1879–1953 French

Quixotic, anarchic character, best remembered for his involvement with Dada. Flirted with Cubism, Expressionism and Surrealism. His most effective work was in his 'machine style' phase (1913–20s), when he used the inspiration of technical drawings to produce telling images that comment ironically on man's relationship with machines (often with erotic overtones).

💰 (102) £314/$508 – £520,000/$748,800
🔨 £2,577,873/$4.15m in 1990, *Petite Udnie* (oil p.)

PICASSO Pablo AG
1881–1973 Spanish

Undisputed master and chief innovator of the Modern Movement. You have to go back to Michelangelo to find anyone of equal genius or stature. Convivial and energetic; many relationships with women, not always happy. Vast output of work – was equally inventive as painter, sculptor, printmaker, ceramicist and theatre designer.

◑ His work displays a bewildering range of technical and stylistic originality: mastery of classicism, Symbolism, Expressionism; inventor of Cubism; anticipator of Surrealism. He made a wide-ranging 20th-century (post-Freudian) response to the human figure and the human condition – there are lots of intimate references to sex and death, sometimes blissful, sometimes anguished. All Picasso's work is highly autobiographical, but he has the rare ability to turn self-comment into universal truths about mankind.

🔎 There are three possible themes to explore: 1) the daily autobiography, from ambitious half-starved young hopeful to sexually frustrated old man; 2) the ease with which he switches from traditional images and techniques to the most avant-garde, and back again; and 3) the relationship between his painting and sculpture. There is a tendency to judge him by his (easily displayed) painting, whose quality declines after 1939, whereas his true forte is in (more difficult to display) 3-D work, which gets better in his later life. Many paintings are ideas itching to be realised in 3-D.

🏛 Paris: Musée Picasso. New York: MoMA
🅰 (1370) £559/$ – £39.2m/$55.6m
🔨 £39.2m/$55.6m in 2000,
 Femme aux bras croisés (oil p., 1901-2)

PIERO DELLA FRANCESCA AG
c.1420–92 Italian

One of the greatest masters of the early Italian Renaissance. Acted as town

1

2

councillor in his beloved native Sansepolcro. Well appreciated in his lifetime; currently very much in fashion. Few works remain and many are severely damaged.

◗ His religious works and portraits have special qualities of stillness and a dignified serenity resulting from deep Christian belief, and a humanist interest in man's independence and observation of the world. Had a passionate fascination with mathematics and perspective, which he used to construct geometrically exact spaces and strictly proportioned compositions. Loving, instinctive feel for light and colour.

🔎 His figures and faces are reserved, aloof and self-absorbed (a reflection of Piero's own slow, hard-working, intellectual character?). Was interested in new ideas and experiments as a means of reaching greater spiritual and scientific truths. Look for his ability to fill mathematical spaces with light; his meticulous mastery of technique (fresco, tempera, oil, and precise line). Nothing was left to chance – he recorded everything with total certainty and care.

🏛 Sansepolcro (Italy): Museo Civico
Arezzo (Italy): San Francesco

3

PIERO DI COSIMO AG
c.1462–c.1521 Italian

Out-of-the-ordinary early-Renaissance Florentine who led a bohemian lifestyle and was fascinated by primitive, prehistoric life. A prime example of the artist as a craftsman.

◗ He painted portraits, altarpieces and mythologies. Especially endearing and memorable are his love of animals and birds, his observations of nature and his storytelling. His strange, mythological fantasy pictures are unique; they are entirely fanciful and can have disturbing suggestions of struggle and violence. Nobody knows what they mean or why they were painted, so we are free to interpret them as we like.

🔎 How do you interpret the strangely ambivalent role played by animals in his pictures? Note the charming landscape details that look as though they have come out of a woven mediaeval tapestry. Many of his works were done as decorative panels for furniture (such as cassoni) or rooms, hence their elongated shape.

💰 (1) £103,448/$150,000
📈 £30,000/$54,900 in 1987, *Madonna and Child enthroned with Saints* (oil)

PINTURICCHIO Bernardino di Betto OM
c.1454–1513 Italian

The last serious artist from Perugia and Umbria. Prolific, ambitious, highly skilled, but not in the forefront of new ideas and ultimately second rank.

◗ A master of fresco painting and supremely skilled at fitting his decorative scheme to the space of the room. Hence he gives a particularly vivid sense of looking through the wall at a busy bustling scene, full of incident. Enjoy his intense and childlike realism, attention to detail, and love of anecdotes and

storytelling – and believe you have walked into the daily life of Umbria in the 15th or 16th century.

🔎 Notice his carefully planned and executed perspectives (geometric and aerial); his facility in recording almost microscopic details he has observed in nature. He had an uninhibited love of decoration and colour – painted lavish and brilliant decorative borders, which influenced Raphael.

🏛 Rome: Vatican. Siena: Piccolomini Library of the Cathedral
🟢 (1) £3,472/$5,000 –
🔨 £102,564/$160,000 in 1995, *Madonna and Child with Infant St John Baptist, other saints* (oil p.)

PIPER John NH
1903–92 British

Serious, well-regarded painter and printmaker notable for very personal, stylised, romantic imagery of landscape and architecture. Was also a book illustrator and stage designer. Once the epitome of acceptable modernity, his work now looks dated, but will come back into fashion one day.

🟢 (141) £380/$551 –
£23,000/$36,340
🔨 £34,000/$57,210 in 1997, *Newhaven* (works on paper)

PIRANESI Giovanni Battista AG
1720–78 Italian

Architect, archaeologist and printmaker (etchings). Venetian born. Settled in Rome in 1740, and made a reputation from popular prints of ancient and modern Rome. Used inventive imagery, which moved from archaeological exactitude to dramatic, overwhelming Romantic grandeur, made all the more powerful by a brilliant technique and a mastery of perspective, light and shade.

His most original works are images of fantastic prisons (1745–61), which are Surrealist before time.

🟢 (23) £1,597/$2,364 – £200,000/$310,000
🔨 £200,000/$310,000 in 1999, *Studies of four figures, three standing and one seated pointing to left* (works on paper)

PISANELLO Antonio Pisano OM
c.1395–1455 Italian

Very popular with princely courts as a painter, decorator, portraitist and medallist, but very few works now survive.

🌀 His work has qualities similar to those of illuminated manuscripts. It is good for an inconclusive art-historical debate: is he the late flowering of the International Gothic style or the pioneer of early Renaissance? (It is more profitable to forget the debate and just enjoy what you can, when you can.)

🔎 Notice his fascinating direct observation from life, and meticulous, fresh draughtsmanship, especially of animals, birds and costumes. Painted flat, decorative backgrounds like tapestries, using fresh colours. His portraits have distinctive profiles, which relate to his pioneering of the art of the portrait medal.

🏛 Verona: San Fermo; Sta Anastasia London: National Gallery Paris: Musée du Louvre (drawings)
🔨 £110,000/$212,300 in 1990, *A nobleman attended by knights and a knight fallen from his charger in a landscape* (works on paper)

PISSARRO Camille AG
1830–1903 French

Reclusive, curmudgeonly and unsettled artist who nonetheless takes his place as one of the major Impressionists and post-

1. Camille Pissarro, *The Avenue de L'Opéra, Paris*, 1898
2. Giovanni Battista Piranesi, *Carceri IV*, 1760

1

experiments with Divisionism, then back to Impressionism.

🔍 He often chose high viewpoints (such as cityscapes painted from windows). His developed palette is quite chalky and pale, with predominant greens and blues. Surfaces are thickly painted (sometimes patchily) with a sketchy look, as if they could be worked further if he could decide what to do with them (a sign of his uncertainty?). Note the play of contrasts in content: rural against industrial; transient against permanent; natural against artificial; old against new; warm against cool.

Ⓐ (149) £471/$678 – £2,097,902/$3.2m
🔨 £3,502,825/$6.2m in 1991,
Le printemps. L'été. L'automne. L'hiver
(oil p., 1872, a set of four)

2

PISSARRO Lucien NH
1863–1944 British/French

Camille's eldest son, taught by Manet and Cézanne. Settled in England in 1890 and became part of the New English Art Club and Camden Town Group. Produced pleasing but unchallenging and derivative work. His father's and Seurat's influences are most noticeable.

Ⓐ (26) £1,450/$2,393 –
£310,000/$499,100
🔨 £390,000/$643,500 in 1997,
The Tomatoes (oil p., 1893)

Impressionists. Always an anarchist and always poor.

☯ Chose a wide range of subjects: landscapes (Seine Valley), modern cityscapes (Paris, Rouen – note the factory chimneys), still lifes, portraits, peasant scenes (especially laundresses). Was most confident in later work, but never really settled into a style with which he was completely at ease or that was completely his own. He progressed from dark, early landscapes to Impressionism and to

PISTOLETTO Michelangelo CS
1933– Italian

Conceptual artist best known for work using mirrors arranged so that the spectator keeps on seeing him/herself, notably: polished sheets on which lifesize photographed images of people are overlaid, thereby creating a relationship between image and spectator. Effective, puzzling and amusing, but not as profound as claimed.

INTERVIEWER: *'Why don't you paint nature?'*
JACKSON POLLOCK: *'I am nature!'.*

⬥ (11) £807/$ 1,300– £42,000/$61,560
✦ £46,581/$76,392 in 1990, *Gabbia*
(works on paper, 1974)

PITTONI Giovanni Battista OM
1687–1767 Italian

Poor man's Tiepolo. Had a flashy, richly coloured, loosely painted style, which is more a mishmash of earlier Venetian artists and borrowings from Tiepolo than truly original. His work was much sought after in his lifetime, both at home and abroad, demonstrating that commercial and critical success is sometimes (often?) achieved by showing off, rather than through talent.

⬥ (8) £2,000/$3,100 –
£145,000/$213,150
✦ £155,000/$244,900 in 1989,
The Continence of Scipio (oil p.)

PLENSA Jaume CS
1955– Spanish

A good example of the new academic modern orthodoxy that is heavily promoted by the official art establishment.

◗ He works with large-scale industrially made objects made to look significant, portentous and profound by being displayed in isolation or attached to big white walls in large official spaces. He 'uses' steel, glass and neon light, but the artist is only the designer: the physical creation is done anonymously, presumably in a factory. Accept them for what they are: objects designed or made to create an impression, not to express a significant human belief.

🔎 If you remove the words that embellish the pieces ('Rembrandt', 'womb', 'desire', 'Giotto', 'a fool sees not the same tree a wise man sees') and concentrate on the pieces themselves, what do they amount to? Profundity or banality? Is this art with deep meaning, or a clever

exercise in marketing and packaging? Is this a good example of the way art establishments are mesmerised by big, slick machines?

⬥ (14) £627/$1,047 – £5,000/$7,950
✦ £13,953/27,209 in 1990,
Lau II (works on paper, 1990)

POLKE Sigmar CS
1941– German

His family migrated from East to West Germany in 1953. Produces large-scale work, which often appears to be a chaotic appropriation of images from consumer society, painted onto unorthodox grounds (such as woollen blankets or furs). Claims to be attacking cliché-ridden banalities of current society and aspires to make contact with a higher spiritual level of consciousness.

⬥ (74) £596/$941 –
£1,013,514/$1.5m
✦ £1,013,514/$1.5m in 2000,
Zwei Frauen (oil p., 1968)

POLLAIUOLO Antonio AG
c.1432–98 Italian

Shadowy figure who, with his brother Piero (c.1441–96), ran one of the most successful workshops in Florence (they must have worked and co-operated together, so it is not always clear who did what). Between them they were painters (principally Antonio), sculptors, engravers, goldsmiths and designers.

◗ Had a pioneering interest in anatomy and landscape, choosing subjects to display these interests and skills to the full – the male, nude or semi-naked, doing something that shows straining, muscles and sinews. Shows front, side and back views in the manner of an anatomical analysis (he is said to have dissected corpses to study anatomy – a daring and risky venture at the time).

1. Antonio Pollaiuolo, *Hercules and the Hydra*
2. Giovanni Battista Pittoni, *The Delivery of the Keys to St Peter*
3. Jackson Pollock, *Number 20*, 1949

🔍 Look for bodies in movement or under physical tension, which is also expressed in the sinewy arms and legs and the expressions on the faces; good, strong hands and knobbly knees. Created sculptural 3–D figures – he was interested in the figure in the round.

1

POLLOCK Jackson AG
1912–56 American

'Jack the Dripper'. Pioneering abstract painter of the New York School. A tortured, monosyllabic, alcohol-dependent soul, swinging between sensitivity and machismo, elation and despair.

◗ His work is at its best when on a large scale (such as 12 x 24 ft), as it is only then that the passionate, heroic, monumental nature of his achievement becomes apparent. (A child of five cannot conceive or create on this scale.) He put the canvas on the floor and stood in the middle with a large can of household paint – he consciously wanted to be 'in' the painting and to become physically part of it.

🔍 Look for the rhythms and flow in the threads of paint (they may be instinctive but they are not arbitrary or careless).

2

Also painted detailed landscapes and had an interest in spatial recession, but his work jumps abruptly from foreground to background and he never worked out how to use the middleground.

1

2

How many separate layers of paint can you see? It is just about possible to reconstruct his movements, and so be 'in' the painting at second hand. But why are there never any footprints?

🏛 New York: MoMA. Venice (Italy): Peggy Guggenheim Foundation
🅐 (5) £2,448/$3,500 – £397,351/$600,000
🔨 £6,325,302/$10.5m in 1989, *Number 8* (w/c, 1950)

PONTORMO Jacopo (Jacopo Carucci) AG
1494–1557 Italian

A Florentine, from Pontormo. Nervous, hysterical, solitary, melancholy, slow, capricious and hypochondriacal, he was also a talented painter (good enough, anyway, to have studied with Leonardo). Taught Bronzino.

🌑 Painted altarpieces, religious and secular decorative schemes for churches and villas, and portraits. Took Michelangelo's and Dürer's classicism and energy and contorted them into beguiling works with irrational compositions – figures in complicated but frozen poses – and bright, high-key colours (acid greens, clear blues and pale pinks). Was consciously radical and experimental – in line with his temperament and the political and social moods of his time. Brilliant drawings. Very good portraits – with elongated and arrogant poses, and sharp observation of character.

𝒫 Pontormo was one of the originators of the wayward style now known as Mannerism. (Like most good artists he did not care what style he painted in – he just got on with it). His work was out of fashion in the 18th and 19th centuries, but has returned to favour in the 20th. ('Mannerism' was not invented or defined until the 20th century.)

🏛 Florence: the Uffizi; churches. Paris: Musée du Louvre (drawings)
🔨 £20,253,164/$32m in 1989, *Portrait of Duke Cosimo I de' Medici* (oil p.)

POONS Larry CS
1937– American

Creator of large abstract paintings that are a synthesis of Colour Field and Op art – they have flat, all-over colour, which is overlaid with small, specific colour

shapes placed according to a system (not always easy to work out) that generates optical effects. Sometimes paints the after-images that the eye 'sees' but are never in fact there.

- Ⓐ (4) £2,579/$4,178 – £3,750/$6,000
- ⚒ £101,266/$160,000 in 1989, *Jessica Hartford* (oil p.)

POPOVA Luubov Sergeevna MM
1889–1924 Russian

Key member of Russian avant-garde who died young. Brought to Russia the Cubist idiom which she assimilated in Paris 1912–13. Produced bold, virile works, not unlike those of Léger, which articulate the interchange between abstraction and figuration, machines and the human figure, primary colours and earth colours. Also a stage, textile and book designer.

- Ⓐ (3) £4,848/$8,000 – £50,000/$81,000
- ⚒ £946,746/$1.6m in 1990, *Cubist Cityscape* (oil p.)

PORTER Fairfield MM
1907–75 American

Well-to-do, well-educated family man (with 5 children) who worked mostly in Long Island and Maine. Studied in Europe and was a patrician socialist. Produced distinguished figurative work of domestic or studio interiors and landscapes, which radiate reticence, intelligence, subtle colour, acute observation of light and a knowledgeable kinship with old and modern masters.

- Ⓐ (12) £5,000/$8,000 – £156,250/$250,000
- ⚒ £156,250/$250,000 in 1999, *Interior scene with dress pattern* (oil p., 1969)

POTTER Paulus OM
1625–54 Dutch

The best ever painter of cows (also did sheep, goats, horses). Most remembered for a few extraordinary, life-sized monumental animal pictures, but actually better and more at ease on a small scale. Good at weather and atmospheres; accurate observation of light and time of day. Also vanitas-type still lifes.

- Ⓐ (4) £976/$1,600 – £89,655/$130,000
- ⚒ £980,000/$1,519,000 in 1996, *Two cows and a bull in a meadow* (oil p., 1647)

POURBUS Frans OM
1569–1622 Flemish

Most famous member of a talented family: his grandfather, Pieter (1510–84), painted allegories, altarpieces and portraits; his father, Frans (1545–81) produced portraits and altarpieces.

3

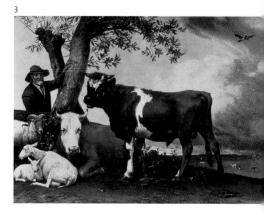

Pourbus painted portraits for the courts of Brussels, Mantua and Maria de Medici. Formal work, with brilliant technique and detail, and a predilection for rich, elaborate costumes and jewellery.

- Ⓐ (1) £4,394/$7,117
- ⚒ £70,196/$104,591 in 1993, *Repas de famille* (oil p.)

POUSSIN Nicholas AG
c.1593–1665 French

The founder of French classical painting. Immensely influential until (and including) Cézanne, presenting the standard to be lived up to. Lived and worked in Rome.

◑ His paintings are severe, intense and highly intellectual in subject matter, style and references: complex allegorical subjects with a moral theme; constant references to classical antiquity; a hidden geometrical framework of verticals, horizontals and diagonals into which the figures are placed and by which they are tied together. Note how the figure groups are positioned flat on the surface of the picture, like a carved bas relief (another classical reference).

🔍 The figures, although notionally in motion, have the stationary quality of statues. Poussin liked well-sculpted nudes, especially muscular backs, arms and legs, and drapery that could have been carved out of marble. The interweaving arrangement of arms and legs are like an intellectual puzzle (which belong to whom?). The dark-reddish quality of many works is because he painted on a red ground, which is now showing through the oil paint that has gone transparent with time.

🏛 Paris: Musée du Louvre
London: National Gallery
Madrid: Museo del Prado
Ⓐ (5) £3,870/$5,534 – £3,719,512/$6.1m
➶ £3,719,512/$6.1m in 1999,
The Agony in the Garden (oil p.)

PRENDERGAST Maurice NH
1859–1924 American

Shy, reclusive, deaf but active professionally (artists' committees etc.). Introduced French post-Impressionism to the USA (visited Paris in the 1880s). Blended bits of Gauguin, Bonnard and Seurat, producing works with flat, decorative surfaces, outline figures, soft colours and brushwork; static compositions with figures borrowed from art history and scenes of the well-to-do at play.

◑ Highly stylised works, at their best on a small scale – brilliant watercolours, which are like mosaics of joyous virtuosity. His larger-scale oils can be a bit leaden. Later work flirts with Cubism and abstraction.

Ⓐ (19) £625/$1,000 – £1,048,951/$1.5m
➶ £1,075,949/$1.7m in 1989,
Telegraph Hill (w/c)

PRETI Mattia OM
1613–99 Italian

Accomplished painter of large-scale decoration that successfully combines the realism of Caravaggio and the theatricality of grand Venetian painting (it sounds unlikely, but he showed it could be done and thereby had much influence on the development of exuberant Baroque decorations). Worked principally in Rome, Naples and Malta.

Ⓐ (6) £2,600/$4,186 – £227,212/$364,422
➶ £750,000/1,185,000 in 1989,
The Liberation of Saint Peter (oil p.)

PROVOST Jan AG
c.1465–1529 Flemish

Major original early northern Renaissance painter – pre-Italian influences. From Bruges; met Dürer in 1521; follower of Massys. Painter of altarpieces, with figures that are lifelike (for the time). Look for precise drawing (he trained as a miniaturist); delicate modelling; good colour; long fingers bent at second joint; tender faces with wide cheeks and prominent lower lip; airy landscapes.

Ⓐ (1) £54,582/$78,052
➶ £228,916/$380,000 in 1990,
The Nativity (oil p.)

PUVIS DE CHAVANNES Pierre OM
1824–98 French

Internationally sought after in his day as the leading painter of large-scale murals to decorate public buildings. His smaller works were also admired by young avant-garde painters such as Seurat, Gauguin and Munch.

🌙 His statuesque figures in landscapes are the direct descendants of the great

classical tradition. He had a very recognisable dry technique, using a chalky white colouring with a stiff style that made his work look like a fresco. His was a valiant but ultimately unsuccessful attempt to make the classical and academic tradition relevant to the modern world. Tried to touch big emotions, such as hope and despair, but missed the target; his work now looks at best decorative, at worst lifeless.

🔎 His archaic, flat style searches for a 'modern' simplification of form and colour and a timeless monumentality for the figure, detached from literary connections; it was only in the next generation (Matisse) that this would be fully unlocked. To do his work full justice, it needs to be seen in situ in the elaborate Beaux-Arts Renaissance-revival buildings that he decorated (and which were themselves to be overtaken by the simplified architecture of Modernism).

🏛 Paris: Hôtel de Ville (murals); Sorbonne University; Panthéon; Musée d'Orsay
Boston: Public Library (murals)
🔨 £521,472/$850,000 in 1998, *L'enfance de Sainte Geneviève* (oil p., 1874)

QUINN Marc CS
1964– British

Best known for making casts of his own body using, for example, his own blood, faeces, ice or bread. The smart argument is to say that this reflects a deep awareness of death, life etc. and that he is reviving figurative sculpture. This might be true or it might be an example of a sharp Cambridge graduate with narcissistic tendencies jumping on a bandwagon.

◑ Much contemporary work – like this – seems to be almost confrontationally repellent. This may have deep significance, but it is worth remembering that one of the most popular exhibits at the fair also was repellent – the bearded fat lady.

➤ £33,000/$56,430 in 1998, *The Origin of Species* (sculpture, 1993)

RAE Fiona CS
1963– British

Member of the currently fashionable 30-something generation who went to Goldsmiths College, London. (Someone should make a *Friends*-type TV soap about them.)

◑ Her very busy, large-scale, brightly coloured paintings are full of bits taken from other (famous) artists and are thus easily recognisable by anyone with a smattering of art knowledge (traces of Matisse, Miró, De Kooning, and so on); they also incorporate bits of popular culture (such as adverts). She uses bright paint with terrific gusto and energy; it is dribbled, splashed or brushed.

🔎 If you want to be 'in', you say things like: 'She plays with our expectations of painting and the cultural baggage it carries.' But… paintings about painting(s), however energetic, are frankly old hat. And yet her work is so chaotic and evolving that you feel it could go somewhere worthwhile; on the other hand, is she just supplying a narrow group of critics and a manipulative consumer art market with what it currently wants? And how long is that going to last?

Ⓐ (7) £800/$1,208 – £14,000/$20,160

➤ £16,000/$26,880 in 1998, *Untitled, Purple and Orange* (oil p., 1994)

RAEBURN Sir Henry NH
1756–1823 British

1

Best-ever Scottish portrait painter. No-nonsense character, just as happy playing golf or speculating in property (went bankrupt). First Scots painter to be knighted.

◑ Note the matinée-idol style of portraiture – heroic stances and soft focus with 'alone but self-assured' poses, often against dramatic skies and landscape backgrounds. His work is at its best with handsome, strong-jawed male figures, looking vaguely dishevelled and adopting the stern, faraway look. He was never at home with female sitters, who often look dull and plain, but was very good with children. Figures are bathed in light and animated by a brilliant ever-inventive,

theatrical play of light over face and costume.

🔍 Look for pink faces and rich colours. He has a strong, confident, broadly brushed technique using square brushes straight onto coarse canvas, without underdrawing – he paints directly from life, with carefully observed tones and shadows. His best works have no alterations or reworkings – he becomes messy and clumsy when he is forced to make changes. His no-nonsense, confident method is in harmony with the temperament he see in (or imposes on?) his sitters. Note single dab of bright highlight on noses.

🔨 (18) £679/$1,100 – £45,000/$73,800

🏷 £173,077/$270,000 in 1995, *Portrait of Sir George Steuart Mackenzie, 7th Bt* (oil p.)

RAMSAY Allan NH
1713–84 British

Interesting and successful Scottish portrait painter who worked in Edinburgh

2

and London. He is currently in fashion, though not as great as some would claim.

🌑 His early work is often very laboured and derivative, and his official full-length portraits are rather wooden. His later work, from the 1760s onwards, is better. At his best with small and intimate three-quarter-length portraits, especially of women; these have a lovely softness, charm and delicacy, in spite of the plain settings and his inability to do anything interesting with hands. Do the portraits reveal anything, or are they just very sophisticated still lifes?

🔍 The turn of the head on the body gives life to the figures, in spite of repetitive and unimaginative poses. His intensity of observation is worthy of the best still-life painters: note the detail on the costumes; the careful painting of objects; the eyes, where even the colour of the iris is noted exactly; the beautiful use of light. Had a tender feel for colour, using exquisite pinks, blues and silvery greys.

🔨 (9) £14,000/$21,750 – £380,000/$608,000

🏷 £500,000/$760,000 in 1993, *Portrait of Sir Edward and Lady Turner seated holding lace and basket* (oil p., 1740)

RAPHAEL (Raffaello Sanzio) AG
1483–1520 Italian

'Il Divino'. A child prodigy who died young, but one of the greatest masters of the High Renaissance and therefore of all time. Profoundly influential; helped raise the social status of artists from craftsmen to intellectuals.

🌑 He had complete mastery of all Renaissance techniques, subjects and ideas, and used and developed them with apparent ease: deep, emotional and intellectual expression; total Christian belief; harmony; balance; humanity; superb draughtsmanship. In short, he projected an ideal at almost every

level – which is why he was held up as the model for all ambitious artists until the overthrow of academic art by the Modern Movement.

🔍 Notice how everything has a purpose, especially how he uses contrast to heighten our perception and feeling (one of the oldest and most successful artistic devices): stern men and sweet women; stillness and movement; contemplation and activity; curved line and straight line; tension and relaxation. Observe too the continuity in his works – how a gesture, pose or movement begun in one part of the body, or in one figure, is carried a stage further in another.

🏛 Rome: Vatican Stanze; Villa Farnese (fresco series). London: Victoria and Albert Museum (cartoons)
🅐 (2) £13,750/$371,622 – £22,000/$550,000
🪓 £4.8m/$7.92m in 1996, *Study for the Head of an Apostle* (drawing)

RAUSCHENBERG Robert cs
1925– American

Major pioneering postwar artist. Prolific, creative and influential. Very New York.

Committed to international co-operation for social change and human rights.

◗ Produces a very consistent, personal and visual work. Explores how to make materials (screen printing, paint, found objects, papers, fabrics or metals) and images (from contemporary media images, words, abandoned urban detritus) work together. The whole constitutes a chronicle of his own activities and of his culture and times. Like Canaletto, he produces works that mirror a particular society, reflecting, distorting or glamorising it, and are sought after by its members as souvenirs.

🔍 Has a passionate involvement, with an underlying innocence (not naïvety) – takes evident delight in collecting material and putting it together, without self-consciousness or rules (like a child). His best work is beautiful to look at (great colour sense), technically intriguing, layered (visually and in meaning), memorable, and puzzling in the best possible way. But he has declined since the 1980s, producing technically slick work that can be overblown, mechanical and impersonal.

🅐 (88) £400/$640 – £745,342/$1.2m
🪓 £3,905,325/$6.6m in 1991, *Rebus* (works on paper)

REDON Odilon MM
1840–1916 French

One of the principal *fin de siècle* Symbolist artists. A Surrealist before his time.

◗ His *oeuvre* falls into two parts – pre- and post-1894. His early small-scale black-and-white drawings and prints have neurotic, introspective subject matter (he had a classic Freudian, sickly, unhappy childhood). After 1894 he overcame his neuroses and his art blossomed into radiant colour and joyful subject matter. His inspiration always came from the inner mind, not the outer eye. Today, he is better known for his later work.

🔍 His poetic, contemplative works have no specific meaning. His fascinating early subject matter anticipates Surrealism – floating heads, curious creatures, strange juxtapositions, all drawn from the depths of the imagination (and from Symbolist writers such as Poe and Baudelaire). Observe his very fine drawing and print techniques,

2

with beautiful tonal treatments. Later, he developed an exquisite pastel technique and the ability to produce saturated, unreal colours of astonishing richness and intensity. Also look for use of accident.

🎨 (76) £1,910/$3,095 –
£594,406/$850,000
🔨 £1,354,839/$2.1m in 1989,
Vase de fleurs (w/c)

REINHARDT Ad MM
1913–67 American

Dogmatic intellectual who believed in the complete separation of art and life. Had various styles, which finally developed (in the 1950s) into austere, abstract images of all-over colour (usually red, black or blue) with scarcely perceptible images (squares,

3

rectangles), made from infinitesimal variations of a single shade – supposedly the purest state possible for a painter.

🎨 (4) £13,580/$22,000 –
£352,113/$500,000
🔨 £1,369,048/$2.3m in 1990,
Abstract painting (oil p.)

REMBRANDT
(Rembrandt Harmensz van Rijn) AG
1606–69 Dutch

The greatest, but most elusive, Dutch master. His personal life was increasingly touched with tragedy. The Rembrandt Commission currently argues over how many works he painted – a flawed enterprise: you cannot resolve

1. Pierre Auguste Renoir, *Le Moulin de la Galette* (detail), 1876
2. Frederic Remington, *Aiding a Comrade*, c.1890
3. Guido Reni, *Lady with a Lapis Lazuli Bowl*
4. Rembrandt, *Self-Portrait*, 1661–2

evoke deep, heart-rending emotions. He never flinched, even in front of the toughest subjects (the Crucifixion, or his own face). Faces and gestures are the key – he was fascinated by the way faces reveal inner states of mind, and how hand and body language convey emotion. He was also interested in showing emotional crises and moral dilemmas – you sense that he has experienced the intense feelings he portrays.

🔍 Observe his emotional manipulation of light and shade – light being warming, purifying, revealing, spiritual; shadow being the domain of the unexplained, the threatening, the evil. He was enthralled by the activity of painting; early work is detailed, later work is looser in style. His palette is distinctive: rich, warm, earthy

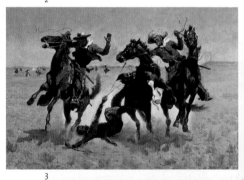

disputed attributions by majority vote in committee. Also one of the great printmakers. His subjects were biblical history (his preference), portraits and landscape.

☽ He had a unique ability to find all humanity beautiful, in a way that can

and comforting. He was intrigued by human skin, especially the fleshy areas around the eye and nose in old faces (no other artist has ever painted them with such care and so convincingly).

🏛 Amsterdam: Rijksmuseum;
The Hague: Mauritshuis

Ⓐ (310) £1,534/$2,163 –
£18m/$26,460,000

🏹 £18m/$26,460,000 in 2000,
*Portrait of a lady aged 62, perhaps
Aeltje Pietersdr, Uylenburgh, wife of
Johannes Cornelisz* (oil p., 1632)

REMINGTON Frederic NH
1861–1909 American

The most famous painter of the cowboy West. Also made sculptures. Was haunted by the notion that he was a mere illustrator (which in truth he was), rather than a 'proper' artist – his late works experiment unsuccessfully with Impressionism and arty ideas. Was pro the US cavalry, unsympathetic to Indians. Bigoted. Friend of Theodore Roosevelt.

☻ Remington was a great myth-maker who liked to promote the idea that he was a former cowboy, US cavalry officer, but in fact he was Yale educated and lived mostly in New York. His images of the 'good' whites protecting 'their' territory against the savage 'foreign' Indians were consciously adopted by Hollywood cowboy-movie directors.

Ⓐ (42) £953/$1,544 –
£2,937,500/$4.7m

🏹 £2,937,500/$4.7m in 1999,
Reconnaissance (oil p., 1902)

RENI Guido AG
1575–1642 Italian

One of the principal Bolognese masters. Greatly inspired by Raphael, he was much admired in the 17th and 18th centuries, and much despised in the 20th.

☻ His images of intense and idealised (unreal and artificial) emotional experiences are usually religious. His mythological works do not have the same intensity, but are highly polished. He himself was very beautiful but remained celibate – qualities that are reflected in his paintings, which convey a remote and unapproachable beauty. Are they too self-consciously slick, posed and theatrical for popular 20th-century taste?

🔎 Look for eyeballs rolling up to heaven (as a means of signalling intensity of feeling), and a surprisingly subtle and sensitive paint handling.

🏛 Rome and Bologna (museums and churches)

Ⓐ (10) £443/$700 –
£90,625/$145,000

🏹 £2m/$2.44m in 1985, *David with the Head of Goliath* (oil p.)

RENOIR Pierre-Auguste AG
1841–1919 French

One of the first Impressionists who soon developed an individual and un-Impressionist style. Most remembered for his lyrical paintings of pink, buxom young girls. Very prolific.

☻ He is the greatest ever master of dappled light, which pervades all his work, giving it a seductive, sensual and soft-focus quality. The early works have bite and observation; the late works become rather repetitive. Did he never become bored by all that comfortable, pink, female flesh, which can make one think of soft feather cushions and Turkish Delight?

🔎 See how the sensuality of his technique marries with the subject matter: long, free brush strokes of warm colour, which caress the canvas. Note the blushes on the cheeks and the obsession with small, firm breasts. The early works have cooler colours, more black and less mush.

🏛 Philadelphia: Barnes Collection.
Paris: Musée d'Orsay

Ⓐ (247) £513/$754 – £5,298,014/$8m

⚒ £42,011,832/$71m in 1990,
Le Moulin de la Galette (oil p., 1876)

1

the poses of well-known examples
of Greek and Roman sculpture or the
Madonna and Child. Was especially
good with children, but terrible – even
laughable – as a 'history' painter.

🔍 He made inventive use of hands
and gesture to bring life and character
to his figures. Had an early commitment
to the example of Italian art because
of its generalising, idealising qualities
(his famous *Discourses* are all about
this); but in 1781 he went to Flanders and
Holland, and afterwards one can see the
influence of Rubens and Rembrandt
on his work. Had poor technique – his
pictures are often in bad condition
because of his use of inferior materials
such as bitumen and carmine.

🏛 London: National Gallery; Tate Britain

Ⓐ (28) £1,200/$1,920 – £1.5m/$2.26m

⚒ £1.5m / $2.26m in 2000,
*The Archers – double portrait of John
Dyke Acland and Thomas Townsend
Viscount Sydney*

REYNOLDS Sir Joshua AG
1723–92 British

Best known for his portraits. Raised the
status of portraiture, the arts generally
and the social standing of artists in
Great Britain. A discriminating collector
of old-master prints and drawings. Social
and well connected. Unmarried. The first
President of the Royal Academy.

🌑 His principal achievement is the
brilliant way he used allusion and cross-
references to enhance the dignity of his
sitters and to turn portraiture into a type
of history painting, with lots of references
to classical mythology, antique statues
and architecture. His sitters are often in

RIBERA José (or Jusepe) de AG
1591–1652 Spanish

Spanish born, Ribera settled in Spanish-
owned Naples where he was known as
'Lo Spagnoletto'. He was the major
Neapolitan painter of the 17th century.

🌑 Is particularly good at martyrdom,
shown through powerful images of
resigned suffering. Sometimes the
subject matter is repelling, but the
technique is exquisite and this results in
an almost unbearable 'can't look but must
look' tension. He makes brilliant use of
chiaroscuro and tenebrism (light coming
from a single source above), and was an
early exponent of realism – his saints and
philosophers are real people from the
streets of Naples. Observe his marvellous
painting of textures and surfaces.

🔍 Paints old men's faces wonderfully,
with utterly convincing, leathery flesh

2

faces, necks and hands. Notice how the brush strokes follow the contours of the flesh, across a brow, down an arm. He couldn't do convincing women's or boy's flesh and faces, though. Is the brighter, Venetian-style palette that he adopted from the 1630s a step forward or a step backward? Be aware that many of his pictures have darkened with time.

🏛 Naples: Capodimonte Museum
 Madrid: Museo del Prado
Ⓐ (7) £18,692/$30,841 –
 £1,172,414/$1.7m
🔨 £2.5m/$4.5m in 1990, *Martyrdom of St Bartholomew* (oil p., 1634)

RICCI Marco OM
1676–1729 Italian

Nephew of Sebastiano Ricci. Worked in England 1708–16 and collaborated with his uncle on religious and mythological pieces. Developed his own line of fresh, frothy, light-filled fantasy or semi-topographical landscapes.

🏛 Windsor (England): Windsor Castle, Royal Collection
Ⓐ (17) £2,616/$4,159 –
 £140,000/$205,800

🔨 £193,750/$310,000 in 1997, *Wooded landscape with gentlemen in carriage on road* (oil p.)

RICCI Sebastiano OM
1659–1734 Italian

Eighteenth-century decorative painting at its best. Run-of-the-mill religious and mythological paintings. Serves up an engaging eyeful of fresh colour, easy compositions and attractive young people. His work has no pretentious moralising or intellectualising – he does not attempt the (for him) impossible. Venetian, he firmly worked in the Venetian tradition.

🏛 Windsor (UK): Windsor Castle, Royal Collection
Ⓐ (7) £8,500/$13,090 –
 £184,049/$300,000
🔨 £360,000/$622,800 in 1991, *The Last Communion of Saint Mary in Egypt* (oil p.)

RICHARDS Ceri NH
1903–71 British

Quiet and sensitive Welshman whose work worthily reflects the light of such suns as Picasso and Ernst. Produced interesting paintings (landscapes and interiors), constructions and prints. Was much influenced by music (Debussy) and thought abstraction able to evoke the sounds of nature (such as the sea and the wind in the grass) as well as its visual feel.

Ⓐ (13) £420/$672 – £10,000/$14,500
🔨 £13,500/$20,520 in 1992, *Welsh Landscape* (oil p., 1945)

RICHTER Gerhard CS
1932– German

Refugee from Communist East Germany (1961). Trained as an orthodox Communist trompe-l'oeil social realist, then had to assimilate Western Modernism. Often

pigeonholed with cutting-edgers now in their 30s and 40s, but in fact is old enough to be their father.

🌙 Produces three different types of work: schematic, Minimalist abstracts; splashy, messy abstracts; finely painted soft-focus photographic imagery (most typical). What is not in doubt is his technical ability and high critical esteem. What is less clear is his meaning (he seems to deny any). Supporters say the deadpan blurriness shows his 'dialectical tension' and virtuous ambivalence. Detractors ask how is it that such supposedly 'important' work can be so boring?

💰 (125) £845/$1,368 –
£3,169,014/$4.5m

✎ £3,169,014/$4.5m in 2000,
Der Kongress, Professor Zander
(oil p., 1965)

RICKETTS Charles NH
1866–1931 British

Theatre designer, writer, collector and aesthete who painted in a self-conscious, dark, old-master style. Set up a private press (Vale Press) for illustrated journals and books blending mediaeval, Renaissance and Art Nouveau. Rival to Beardsley as an illustrator; close friend of Charles Shannon. Regretted turning down offer of directorship of National Gallery.

✎ £7,000/$10,780 in 1996, *Cutters racing off the Royal Yacht Squadron's headquarters. Cutters becalmed* (oil p., a pair, 1875)

RILEY Bridget CS
1931– British

Eminent major abstract painter with a strong international reputation, and a lifelong dedication to the exploration of the visual and emotional properties of colour.

🌙 She creates intensely visual abstract paintings whose appearance and form (large scale, stripes, blocks of colour) do not result from any theory or formula but are a means of using colour and form to create sensations of light and space. Reproductions simply do not work. You have to stand in front of the paintings, move around them, relax the eye and allow the space and colour sensations to work on you and for you. It is demanding, but go with it – it is thrilling.

🔍 The colours interact at their edges (stripes = longest possible edge) and generate the illusion of other colours or jumps of colour. Some colours jump forwards, others back. Dark (often black) stripes create a rhythmic pulse across the surface. There is emotional as well as visual involvement. The inspiration is the shimmer and subtlety of light in nature: the work allows you to capture it (or your memory of it) afresh.

💰 (17) £2,625/$4,200 –
£95,000/$137,750

✎ £95,000/$137,750 in 2000,
Tambourine (oil p., 1988)

RIOPELLE Jean-Paul MM
1923– Canadian/French

Has lived and worked in France since the late 1940s. Creates thick, impastoed paintings (making much use of palette knife) with heavy, diffracted colours. His works are abstract pre-1970s, with increasing figurative references thereafter. His subjects are derived from, and deeply rooted in, earth and nature – he is influenced by Inuits and northern Canadian icy landscapes. Prolific. Also produces etchings, lithographs, sculptures.

💰 (60) £855/$1,376 –
£190,000/$307,800

✎ £843,374/$1.4m in 1989,
Untitled (oil p.)

2

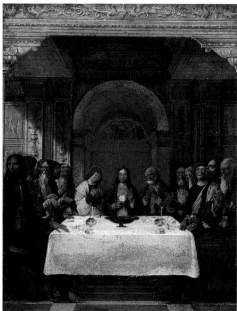

RIVERA Diego MM
1886–1957 Mexican

A giant – physically (6 ft, 21 stones); in terms of his charismatic personality (political revolutionary and turbulent love

life); and in the quantity and scale of his work. Mexico's most important painter, representing social realism at its most convincing. A Marxist, loved and financed by US mega-capitalists.

◑ The large-scale murals he created in the 1920s and 1930s were designed for public spaces and express a utopian view of society – they are political statements of art in the service of society. His vision was a union between Mexico's Indian history and a machine-age future in which past, present and future, nature, science and humanity, male and female, and all races and cultures, coexist in harmony. He revived the art of monumental, true fresco, physically and conceptually.

⌕ The way he turns his vision into vast, crowded images, is truly miraculous. He synthesised first-hand knowledge of pre-Columbian art, Modernism (Cubist space), realism and early-Renaissance frescoes (monumental, simplified forms of Giotto, Masaccio, Piero) into brilliantly organised and controlled decorative pageants, with a

storyteller's instinct for memorable detail. Also produced seductive, smaller-scale easel paintings and sketches: portraits, figures, narrative scenes and still lifes.

🏛 Mexico City (fresco decorations in public buildings). Detroit (USA): Institute of Arts

Ⓐ (36) £435/$700 – £433,333/$650,000

🠦 £1,783,439/$2.8m in 1995, *Baile en Tehuantepec* (oil p., 1928)

RIVERS Larry CS
1923– American

Multifaceted bohemian: painter, poet and jazz musician from a Russian-Jewish émigré family. Now an influential guru. Creates versatile and many-sided works, which are difficult to summarise – they can switch, within the same work, between figuration and abstraction, sharp detail and lush brush strokes. One of the parents of Pop art, he was also one of the first to use mass-media imagery. Also reworks famous hackneyed paintings.

⊕ (28) £745/$1,162– £47,297/$70,000
✗ £252,976/$425,000 in 1990,
Africa I (oil p., 1961)

ROBERTI Ercole de' OM
c.1450–96 Italian

A court painter to the d'Este family in
Ferrara. Shadowy figure, with very few
works firmly attributed to him.

◑ Look for meticulous, fine detail
and poetic sensibility; the careful placing
of figures in space – well-proportioned
with good movement; long, fine fingers.
He was interested in perspective,
architectural details, and the way
buildings are constructed.

𝕞 Milan: Pinacoteca di Brera (for the
Madonna Enthroned with Saints
altarpiece, 1480)

ROBERTS William NH
1895–1980 British

Individual Modernist who developed an
interesting and curiously homely version
of the working man/urban life/machine-
age imagery and style pioneered by Léger.
His early experience as an advertising-
poster designer is (too?) evident, and his
weakness is that he established a formula
that became overrepetitive. Member of
pioneering Vorticists, c.1914.

⊕ (28) £340/$551–£36,000/$57,600
✗ £75,000/$124,500 in 1990,
Birth of Venus (oil p.)

ROBINSON Theodore NH
1852–96 American

The leading American Impressionist
painter. Made several visits to France
between 1876 and 1892 and was a close
friend of Monet, whom he met at Giverny
in 1887. Painted landscapes and vignettes
of village and farm life. He found East

Coast American light too bright compared
with the light in France, and had difficulty
painting it. His later years were marred by
ill health and poverty.

◑ In the USA he was a pioneer, but his
Impressionist style is cautious by French
standards – compositions are rather static
and brush strokes too carefully considered.
Sometimes worked from photographs,
which he used by squaring up – traces
of the grid can occasionally be seen on
the canvas.

⊕ (9) £2,740/$4,000 –
£418,919/$620,000
✗ £666,667/$1m in 1994,
The Gossips (oil p., 1891)

RODCHENKO Aleksandr Mikhailovich MM
1891–1956 Russian

Active Bolshevik with strong ideals.
Believed that art must be in the service
of the Revolution to create an ordered,
technological society, and must be
objective, impersonal and non-represen-
tational. He carried these ideals through
into fine art, advertising, photography and
collage. Always demanded active partici-
pation from viewers. Rejected by Stalin.

𝕞 Moscow
⊕ (7) £3,223/$4,609 – £68,323/$110,000
✗ £300,000/$504,000 in 1988,
Line (oil p., 1920)

RODIN Auguste AG
1840–1917 French

The glorious triumphant finale to the
sculptural tradition that starts with
Donatello. Rightly spoken of in the same
breath as Michelangelo (though they
were different: Michelangelo carved,
Rodin moulded). Shy, workaholic,
impoverished beginnings, untidy, friend
of poets, physically enormous. Became
an international celebrity and was
deeply attractive to smart women.

🕊 He carried out an extraordinary and enriching hide-and-seek exploration with the processes of his art, and the relationship between intellectual and artistic creativity. His famous set-piece projects (such as the *Gates of Hell*) evolved over many years. Also sculpted portraits, nudes and small models, which show ideas in evolution. Observe the was he uses the fluidity of clay and plaster (even when cast in bronze) to magically release his figures, human feelings and the unknown forces in nature. Was fascinated by biological procreativity.

🔍 Note his stunningly beautiful recreation of (large) hands, embraces, kisses and whole body poses as an expression of human libido and anima (he always worked from life, even when borrowing from antiquity or classics). Bases are important because he makes his forms grow out of them. Washes his figures in light (try and see them in natural light). Used studio assistants or commercial firms to make large-scale versions of his original models – what you see may never have been touched by Rodin (he wanted to disseminate his work widely).

🏛 Paris: Musée Rodin; San Francisco (USA): Palace of the Legion of Honor
Ⓐ (202) £976/$1,572– £2,732,919/$4.4m
🔨 £2,732,919/$4.4m in 1999, *Eve* (sculpture, 1880)

ROMNEY George NH
1734–1802 British

Another wannabe history painter. Died insane, with a deep sense of failure. Remembered as a portrait painter: in the 1770s and 1780s he was considered the equal of Reynolds and Gainsborough. Created lively compositions, but never got to grips with the personality of his sitters.

🔍 Recognisable features are hands that are clasped, or fingers pressed together; pastel colours, especially pink

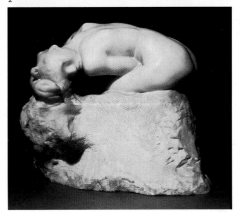

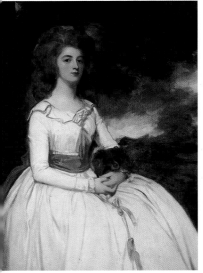

and blue (such as sashes against white dresses); girls with coy, sideways glances.

Ⓐ (34) £334/$534 – £88,000/$137,280
🔨 £480,000/$811,200 in 1997, *Master Pelham, portrait of John Cresset Pelham* (oil p.)

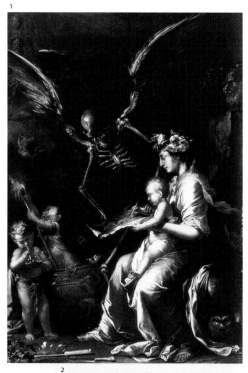

1

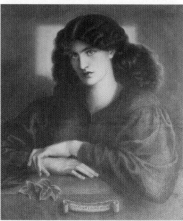

2

ROSA Salvator OM
1615–73 Italian

One of the first wild men of art – quarrelsome, anti-authority, self-promoting, lover of the macabre. Poet, actor, musician, satirist. Now best remembered for large, dark, stormy, fantastic mountainous landscapes and unpleasant witchcraft scenes (both much collected in the 18th and early 19th centuries). He was said to have fought by day and painted by night.

Ⓐ (21) £491/$800 – £103,448/$150,000
🔨 £400,000/$696,000 in 1992, *Portrait of artist wearing doublet, cap, torn glove and sword* (oil p.)

ROSENQUIST James CS
1933– American

Leading Pop artist. Was initially trained and very successful as a New York billboard painter and designer. Creates large-scale works that are chronicles of an era (1960s). Pieces together immaculately painted layers of commonplace imagery, which jump in scale, and because of their seeming disconnections are resistant to (but demanding of) interpretation.

Ⓐ (44) £1,020/$1,642 – £170,000/$256,700
🔨 £1.33m/$1.9m in 1986, *F-111* (oil p.)

ROSSELLI Cosimo OM
1439–1507 Italian

Well-known early-Renaissance Florentine, but firmly in the second division. Painted run-of-the-mill religious works. His figures have stylised, obsessively painted hair and a curiously tired and drawn look around the eyes.

Ⓐ (1) £5,000/$7,550
🔨 £300,000/$489,000 in 1998, *Crucifixion with Madonna, John the Baptist, Mary Magdalen, Andrew and St Francis* (oil p.)

ROSSETTI Dante Gabriel NH
1828–82 British

Painter, poet and the leading Pre-Raphaelite. Had a complicated love life and died of alcohol and drug abuse.

 He is best known for images of erotic *femmes fatales* painted from the 1860s onwards, though he also went in for Romantic mediaeval themes. His early Pre-Raphaelite work is somewhat stiff and awkward.

 His *femmes fatales* are characterised by luscious lips, sinuous hands and thick, glistening hair. Brilliant draughtsman but his painting technique is a bit suspect. Look for works of much intensity (the most desirable state of existence for artistic folk at that time). Fine, detailed and heavily worked watercolours.

🏛 London: Tate Britain
Birmingham (UK): City Art Gallery
Manchester (UK): City Art Gallery
◉ (12) £538/$850 –
£2.4m/$3,624,000
✒ £2.4m/$3,624,000 in 2000,
Pandora (works on paper, 1869)

ROTHENBERG Susan CS
1945– American

Former dancer who came to prominence as a painter in the mid-1970s and who is now much displayed. Her large-scale works usually contain a single image of a human or animal form, emerging out of a hazy background, and on the point of mutating into something else. Weird, vaguely disturbing, and symptomatic of the American love of anxious self-analysis.

◉ (11) £2,069/$3,000 –
£87,838/$130,000
✒ £272,189/$460,000 in 1991,
Cabin Fever (oil p.)

ROTHKO Mark AG
1903–70 American/Russian

Melancholic Russian émigré who settled in the USA at the age of 10. Became a leading member of the New York School and pioneer of Colour Field abstract painting. Committed suicide.

 His deceptively simple abstract paintings have deliberately plain, soft-edged shapes and luminous, glowing colours. His work is at its best seen on a large scale, completely filling a space such as the Rothko room at Tate Modern or the chapel at St Thomas University, Houston, Texas. Look for his early work to see how slowly and carefully he reached this final, very personal, expression.

🔍 Treat the works with the respect and care with which they were created and give them time to reach you – the same way you allow music time to soak in. Move around them so as to get to know them; stand close to the works, relax, wait, so that the colour completely fills your field of vision and seeps through your eyes into your mood and feelings. Rothko said his paintings were about 'tragedy, ecstasy and doom' – about fundamental (and romantic) emotions and passions.

🏛 London: Tate Modern
Houston (Texas, USA): St Thomas University. New York: MoMA
◉ (12) £3,200/$4,640–
£8,783,784/$13m
✒ £8,783,784/$13m in 2000,
Yellow Over Purple (oil p., 1956)

ROUAULT Georges MM
1871–1958 French

Important French painter with a highly individual style. An unhappy loner who deliberately stood outside the mainstream of Modern art. Saw art as a genuinely religious activity.

1

🔵 Chose losers and the exploited as his subjects, notably clowns, prostitutes, the judiciary and criminals, expressing through them his bleak view of life and the activities and rituals used by human beings as they prey on each other in the struggle for survival. Was one of the very few committed Christian artists of the 20th century.

🔍 His dark palette (especially sombre red and blue-green) reflects his gloomy subjects. He uses faces to convey expression. The black outlines and his choice of colours give a deliberate appearance of stained glass to his paintings – there is an icon-like quality in his figures. (He trained as a stained-glass maker and his spiritual home was the mediaeval, not the modern world.)

🔵 (83) £427/$688 – £216,049/$350,000
🪝 £812,183/$1.6m in 1990,
Fille de cirque (oil p.)

ROUSSEAU Théodore OM
1812–67 French

Important pioneer of plein-air painting and principal figure of the Barbizon School (thereby linking Constable to Monet). He allowed nature to speak for herself, abolishing the convention of inserting human figures in order to animate or interpret the landscape. Trod a difficult and not always successful path between Romanticism and realism.

🔵 He was excited by woods and trees, and sought to convey both the spirit (Romanticism) and appearance (realism) of nature growing and vegetating. Distinguish between the small-scale sketches made on the spot and the larger detailed works made in the studio. Dramatic skies, such as one finds on autumn evenings. Some works have darkened with time.

🔵 (45) £350/$564 – £210,526/$320,000
🪝 £210,526/$320,000 in 2000, *Sunset over the Barbizon Plain* (oil p., 1860)

ROUSSEAU Henri (Le Douanier) MM
1844–1910 French

Minor customs official who took up painting on retirement, to supplement his pension. He was lionised by the young avant-garde (Picasso *et al.*) because of the childlike vitality of his work.

🔵 His work has an unconscious (genuine) naïvety. He painted like a child, but on a bigger scale. He had all the qualities of a child, including the 'art is my favourite subject' enthusiasm; wobbly perspective; smiley faces; big signature; obsession with arbitrary detail (every leaf on a tree, or every blade of grass) and a desire to please. He usually worked around a simple idea with a central single object.

🔍 He did what most children grow out of, or are taught not to do; he is a

reminder that we may flourish best and achieve unexpected recognition if we are what we are and do not constantly strive to be what we are not.

🏛 Paris: Musée d'Orsay
Ⓐⓥ (3) £24,000/$36,240 –
£102,131/$150,132
🔨 £2.7m/$4,023,000 in 1993, *Portrait de Joseph Brummer* (oil p., 1909)

ROWLANDSON Thomas NH
1756–1827 British

Prolific draughtsman and printmaker; chronicler of British 18th-century life and morals. Had huge technical facility, eager enthusiasm for life and a great eye for detail and character. Expressed all his observations with admirable economy of line. Walked the tightrope between observation and caricature with skill. Genuinely funny.

Ⓐⓥ (109) £300/$444 – £14,000/$21,840
🔨 £42,000/$69,300 in 1991,
Life-Class at the Royal Academy (w/c)

ROZANOVA Olga Vladimirovna MM
1886–1918 Russian

A leading member of the early Russian

avant-garde and disciple of Malevich. St Petersburg born and based, she never visited Western Europe. She had a passionate belief in abstract art and the dawn of a new age of creativity. Look for bright, intense, prismatic colours and abstract, fragmented shapes, which often float freely on a white background. She was also involved in industrial design.

Ⓐⓥ (1) £6,588/$10,672
🔨 £9,000/$15,210 in 1990,
Composition (collage)

RUBENS Sir Peter Paul AG
1577–1640 Flemish

Extraordinary, widely-travelled, gifted man of many talents: painter, diplomat, businessman, scholar. Had a huge output and a busy studio with many assistants, including Van Dyck. <u>The</u> illustrator of the Catholic faith and divine right of kings.

🌑 His large-scale set-piece works, such as altarpieces and ceiling decorations, must be seen in situ in order to experience their full impact and glory. However, do not overlook his many sketches and drawings, which are miracles of life and vigour, and the genesis of the major works. Rubens's work is always larger than life, so enjoy the energy and enthusiasm he brought to everything he saw and did. Was never hesitant, never introspective . A wonderful storyteller.

🔎 There are three possible themes to explore.
1) Movement – inventive compositions with energetic diagonals and viewpoints; colour contrasts and harmonies that activate the eye; figures at full stretch both physically and emotionally.
2) Muscles – gods looking like Superman, muscular Christianity in which well-developed martyrs suffer and die with enthusiasm.
3) Mammaries – he never missed a chance to reveal a choice breast and cleavage.

Note also the blushing cheeks, and the business-like eye contact in the portraits.

- 🏛 Munich: Alte Pinakothek
 Antwerp (Belgium)
- Ⓐ (18) £9,202/$15,000 –
 £4,601,227/$7.5m
- 🔨 £4,601,227/$7.5m in 2000, *Portrait of a Man as the God Mars* (oil p.)

RUISDAEL Jacob van OM
1628–82 Dutch

Principal Dutch landscape painter of the second half of the 17th century. Melancholic. Had a secondary career as a surgeon. Nephew of landscape painter Salomon van Ruysdael.

❧ Look for a certain amount of stock imagery, although he manages to be quite inventive within the formula: mountains, waterfalls, beaches and dunes, seascapes and winter scenes. His work is essentially descriptive (no hidden symbolism) with a yearning for grandeur. Worked on panel pre-1650, subsequently on canvas.

🔎 He favours skies with rain clouds and flying birds (not convincing – it looks like a stage backdrop). Is more naturalistic than his predecessors – it is possible to identify species of trees in his paintings (note how he likes rotten trees and broken branches). Attracted to massive forms. Often uses a low viewpoint to silhouette features against the sky. His work has dark tones (it is painted on dark priming).

- 🏛 Amsterdam: Rijksmuseum
- Ⓐ (16) £4,167/$6,500–£609,756/$1m
- 🔨 £736,196/$1.2m in 1998,
 Winter landscape with frozen canal, farmhouses and windmill beyond (oil p.)

RUSCHA Edward CS
1937– American

Oklahoma boy who went LA hip in 1956.

His early work is Pop – icily perfect images of gasoline stations and billboards, plus booklets of photos of similar subjects. His recent work plays with images and words, for instance a painting of water may have that word spelled out in a trompe-l'oeil spill of water. Uses unconventional media such as fruit juice instead of watercolour.

- Ⓐ (57) £1,974/$3,000 –
 £260,870/$420,000
- 🔨 £260,870/$420,000 in 1999,
 Lisp (oil p., 1968)

RUSKIN John NH
1819–1900 British

Most important as a critic and writer. As a painter had a central belief in the supremacy of truth to nature (not the same as a slavish imitation of nature), but abandoned this belief after 1858. His intensely observed and detailed watercolours reflect his passion and knowledge of geology and architecture.

- Ⓐ (16) £1,300/$1,950 –
 £95,000/$152,000
- 🔨 £95,000/$152,000 in 1999,
 Lake Lucerne, Switzerland (w/c)

RUSSELL Charles M NH
1864–1926 American

Premier painter of the American West – alongside Remington but very different: Russell was self-taught, had genuinely worked as a cowboy, was sympathetic to Indians and had a sense of humour. Good at working in oils, but superb in watercolour. He didn't hit his stride until 1900, but then got better and better. Also produced high-quality sculptures.

- Ⓐ (64) £949/$1,500 –
 £812,500/$1.3m
- 🔨 £812,500/$1.3m in 1999,
 Price of his Hide (oil p., 1915)

1

RUYSDAEL Salomon van OM
c.1600–70 Dutch

Prolific and well-known painter of landscapes and riverscapes. Uncle of the better known Jacob van Ruisdael.

◗ He painted scenes that sum up a preconceived idea of Holland (water, flat lands, big skies) – applying a standard formula that was very popular with Dutch collectors. There are also a few late still

3

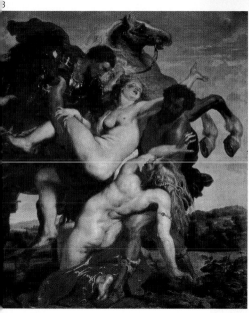

2

lfes with hunting themes.

◗ The riverscape formula inventively juggles the following elements: compositions that always have a diagonal axis; mature trees on a river bank; rowing boats with fishermen; sailing boats with flags; cows; buildings on horizon (town, windmill, church); cloudy skies; evening light on horizon; reflections in water. He painted with broad, sweeping brush strokes, using thin paint on a light ground; the grain of the panel often shows through.

☻ (13) £2,500/$4,000 – £689,655/$1m
⚒ £2.1m/$3,465,000 in 1997, *Extensive River Landscape* (oil p., 1644)

RYDER Albert Pinkham NH
1847–1917 American

Erratic bohemian character who painted brooding romantic scenes, such as Jonah and the whale, Siegfried and the Rhinemaidens, boats on stormy moonlit seas. Used jewel-like colours and thick, cumbersome paint, but bad technique

1. Salomon van Ruysdael, *River landscape with fishermen at work*
2. Albert Pinkham Ryder, *By the Tomb of the Prophet,* c.1882
3. Pieter Jansz Saenredam, *Interior of the Marienkirche in Utrecht,* 1638

and the use of bitumen mean that most of his paintings are damaged beyond repair. Was considered to represent the height of poetic sensibility and was a guru figure for the likes of Hartley and Pollock.

📺 (2) £1,111/$1,800 – £1,420/$2,300
🔨 £1,420/$2,300 in 1999, *Lady of the Lake* (oil p.)

1

2

RYMAN Robert CS
1930– American

Self-taught abstract painter from Nashville, Tennessee, with a limited but highly visual theme. Musical enthusiast (Charlie Parker and Thelonius Monk). His works should be seen by daylight.

🌙 His paintings are about what paintings are made from, what paint can do and what they look like (and why not?).

So don't look for subjects, concepts, spirituality. Look instead at the way he uses oil paint (thick, thin, shiny, flat); his use of textured canvases, paper, metal surfaces, and so on; and how he fixes his pictures to the wall. It sounds banal, but actually they are beautiful to look at if you don't expect too much. Is it a dead end or a new beginning?

🔍 He wants his work to be shown by daylight so that the textured surfaces will look different and interesting as the light changes (white attracts light). Look at his choice of brush marks and surfaces and the way they change within the same work; also at what he does with canvas (stretched or unstretched, for instance). Look also at the edges and the way he incorporates his signature. The choice of frame, or lack of frame, is also his.

🏛 Schaffhausen (Switzerland): Hallen für Neue Kunst
📺 (11) £13,665/$22,000 – £236,486/$350,000
🔨 £1.33m/$2.1m in 1989, *Summit* (oil p.)

SAENREDAM Pieter Jansz OM
1597–1665 Dutch

Supremely gifted painter of architecture – both specific buildings in Dutch towns and interiors of identifiable churches (the once decorated Gothic buildings that were whitewashed to satisfy the Protestant belief in plainness). Made meticulous preliminary drawings and measurements. The light-filled church interiors are a metaphor for universal laws of mathematics and optics.

🔨 £4,572/$7,498 in 1996, *La danse des vierges folles* (oil p.)

SAINT-PHALLE Niki de CS
1930– French/American

Maker of cheerful and delightfully childishly exuberant large-size sculptures

– ideal for parks, playgrounds and public spaces. Bloated forms and amoeboid shapes are decorated decal-like with doodled drawings of human figures, animals and fantastic creatures. Uses glossy, bright, primary colours and gold or silver. She worked with and married Jean Tinguely.

◑ She is famous for creating with Tinguely a huge sculpture of a reclining female nude large enough for children to walk in and out of the vagina, and with an interior full of activities reminiscent of a funfair.

◔ (90) £1,193/$ 1,885– £97,521/$141,405
🏹 £194,346/$324,558 in 1990, *Last Night I had a Dream* (sculpture, 1967)

SALLE David CS
1952– American

Creator of large-scale figurative paintings, which are a ragbag of familiar, not very taxing, images culled from art history, adverts, design, porn, and so on, randomly put together (some as small physical inserts). Facile and technically feeble when examined closely at first hand, they fortunately for him look quite convincing as small-scale reproductions in books or catalogues. Highly fashionable.

◑ If you find this (or any other artist's work) awful or incomprehensible, but don't want to say so or to alienate yourself at private views, say 'He (or She) has a style that is distinctly his own' [which is always true]; 'he neutralises and subverts narrative and artistic conventions' [no one will dare disagree]; 'he appropriates art and images and simultaneously critiques them in his work' [people will be impressed, especially if they have no idea what you actually mean].

◔ (18) £1,491/$2,400 – £141,892/$210,000
🏹 £141,892/$210,000 in 2000, *Skintight Worldwide* (oil p., 1983)

SANDBY Paul NH
c.1725–1809 British

Founding father of the British watercolour tradition. Painted detailed, accurate, topographical views (notably of Windsor Castle and Windsor Great Park

3

1. Paul Sandby, *The Norman Gate and Deputy Governor's House*
2. John Singer Sargent, *Repose*
3. Andrea del Sarto, *Lamentation over the Dead Christ*, 1524
4. Sassetta, *The Mystic Marriage of St. Francis with Chastity, Poverty and Obedience*

1

2

🔗 In the 1880s and 1890s he succeeded with large-scale portraits of the *nouveaux riches* of the UK, USA and France, showing them at their glittering best, in flattering and relaxed poses. After 1900 he painted the English aristocracy but made them more formal and aloof. Grew bored with faces and spoiled clientele: look for his preferred small-scale plein-air landscape sketches, intimate glimpses of family and friends, and rapid charcoal portrait skecthes, post-1907. Also produced uninspired, time-consuming murals for public buildings in Boston (1890–1921).

🔍 He had a brilliant oil technique – his assured fluid paint, and bold compositions match the confident faces and expensive well-cut clothes of his sitters. His real interest was in light (he was friendly with the Impressionists, especially Monet) and precise matching of tones. Was trained in Paris to use the 'au premier coup' technique – one exact brush stroke and no reworking. His watercolour technique was less assured. Influenced by Hals and Velasquez. His work successfully bridges the divide between the old masters and Impressionism.

📈 (30) £550/$892 – £664,336/$950,000
📈 £6,158,537/$10.1m in 1996, *Cashmere* (oil p., 1908)

where his brother was a Ranger). His later work is freer and richer.

📈 (36) £294/$470 – £80,000/$128,000
📈 £340,000/$527,000 in 1996, *Gentlemen conversing on drive at Luton* (works on paper)

SARGENT John Singer AG
1856–1925 American

The last seriously successful portrait painter in the grand manner. Born in Florence, he lived mostly in Europe. Very talented, successful and rich. Captured the spirit of the golden age that perished in World War 1.

SARTO Andrea del OM
1486–1530 Italian

The last significant Florentine High Renaissance painter. Influenced in subjects, style and technique by Leonardo, Raphael and Michelangelo. Synthesised these influences to produce handsome, monumental, religious pictures and portraits, which are harmonious in colour, well balanced, grand in conception and scale, but lack real emotional depth and originality.

📈 (3) £1,390/$2,099 – £613,497/$1m
📈 £613,497/$1m in 2000, *Madonna and Child* (oil p.)

3 4

SASSETTA (Stefano di Giovanni) AG
c.1392–1450 Italian

The best painter of early-Renaissance Siena. Combined the old decorative style of the International Gothic with the new ideas from Florence.

🌑 Look for his charming uninhibited qualities – the kind that children show when making a picture: a delight in storytelling; lots of physical activity; spaces and perspective that don't quite work; sudden attention to unexplained detail; unsophisticated decorative colours.

🔎 Note the bright little eyes with prominent whites and, sometimes, faces with wide-eyed expressions; prissy, bowed-shaped lips and curious harp-shaped ears; stylised crow's-feet on older male faces.

SAVERY Roelandt OM
c.1576–1639 Flemish

Prolific, successful, much travelled (France, Prague, Vienna, the Alps).

He finally settled in Utrecht. Painted land-scapes – the wooded and mountainous scenes are notable for their brilliant cool blues. Also flowers and mythologies. Best known for his painting of animals, which he studied from life (including the dodo in Rudolph II's menagerie). Good landscape etchings.

🅐🅥 (8) £2,321/$3,412 – £220,000/$332,200
🔨 £220,000/$332,200 in 2000, *Orpheus Charming the Animals* (oil p.)

SCHAD Christian MM
1894–1982 German

Painter who also made collages and prints (woodcuts), and took photos in the manner of Man Ray. Best known for his Neue Sachlichkeit work – a cool, uncompromising critical depiction of the German bourgeois society of the 1920s. The exaggerated, emphasised detail serves to highlight its emptiness. The alienating spaces show how things and people become disconnected.

Ⓐ (2) £2,086/$2,941 – £6,000/$8,640
🔨 £300,000/$492,200 in 1998, *Bildnis einer Unbekannten* (oil p., 1924)

SCHIELE Egon AG
1890–1918 German

Intense, tragic, short-lived genius whose art expressed his own self-destructive, sacrificial personality and the

years ago. It attracted fierce opposition from conservative society, and Schiele was arrested and imprisoned on the charge of depraving children. He was, however, recognised and successful in advanced circles. He saw the human figure or spirit as animal rather than moral. Insisted on absolute freedom for creative individuality and self-determination. His art encapsulates Freudian imperatives of sex and death.

claustrophobic introspection of Sigmund Freud's Vienna. He died, together with his pregnant young wife, in the great flu epidemic.

🌑 His art concentrates on sexually intense subjects, including portraits, self-portraits, and (at end of his life) religious works. Look for isolated single figures, often in silhouette; couples or several figures in highly charged relationships; bodies in contorted positions; gaunt faces lost in inner thoughts; cityscapes in an Art-Nouveau style. A precocious, gifted draughtsman, he also made many drawings and watercolours. His paintings have a tense, nervous, probing outline, rapidly filled with colour, which gives them a strong sense of immediacy and urgency.

🔍 His work can still extract a genuine gasp, if not the shock or horror of 100

Ⓐ (58) £828/$1,200 – £6.5m/$9.36m
🔨 £6.5m/$9.36m in 2000, *Portrait of the Art Dealer Guido Arnot* (oil p., 1918)

SCHLEMMER Oscar MM
1888–1943 German

Leading member of the Bauhaus. Painter and sculptor. Most effective and at ease when designing for mural decorations or for theatre and ballet. He preferred simplification, the interplay of shape and form, and reflective inner states of mind, rather than expression and dramatic impact. Liked quiet exploration and experiment.

- (24) £1,534/$2,113 –
 £410,000/$591,400
- £1.8m/$3.08m in 1998,
 Grosse Sitzendengruppe I (oil p., 1915)

SCHMIDT-ROTTLUF Karl MM
1884–1976 German

Leading German Expressionist and member of Die Brücke. Noted for his forceful, angular, monumental style, which uses consciously harsh colour and aggressive simplification. His later style (after 1945) is softer and more fluid, but still involves intense colour. Was influenced by Munch and Negro art. Made powerful woodcuts and lithographs. Reviled by the Nazis.

- (116) £799/$1,182 – £427,632/$684,211
- £870,000/$1,383,300 in 1994,
 Einfahrt (oil p., 1910)

SCHNABEL Julian CS
1951– American

Much-hyped charismatic figure, considered very 'bankable' in the 'greed is good' boom of the 1980s. His energetic, thickly painted, figurative work has striking additions, such as broken crockery and black or red velvet. Claims to deal with weighty subjects, in the tradition of great art (Van Gogh, for instance). Fashionable, but forgettable in the long term.

- (39) £2,303/$3,500 –
 £201,863/$325,000
- £201,863/$325,000 in 1999,
 Portrait of a Girl (oil p., 1980)

SCHONGAUER Martin OM
c.1430–91 German

Son of a goldsmith who settled in Colmar, Alsace. Especially well known in his lifetime for his engravings, with precise lines and convincing volumes.

Borrowed from Flemish techniques and ideas (especially from Van der Weyden). Much influenced by Dürer. His later work has a more delicate, soft touch.

- (11) £1,534/$2,163 – £11,000/$15,950
- £89,655/$146,138 in 1998, *Carrying the Cross* (works on paper, c. 1480)

SCHUELER Jon CS
1916–92 American

One of the best of the second generation of Abstract Expressionists. Produced large-scale painterly abstracts and small watercolours, which are a cross-fertilisation of Rothko and late Turner. Had an intense and passionate belief in integrity and honesty. Was much influenced by the scenery and atmosphere of Western Scotland – his spiritual home.

- £399/$650 in 1997,
 Approaching Storm II (oil p., 1956)

SCHUETTE Thomas CS
1954– German

Artist who uses techniques and ideas from several disciplines. Makes sculptures, which range from small doll-like models to large pieces, drawings and architectural models in wood similar to doll's houses. The human figure, scale and presence is always apparent. His work encourages an open-ended, imaginative, non-aggressive questioning of the human condition and experience.

- (12) £1,238/$1,771 – £36,000/$54,360
- £125,000/$210,000 in 1998,
 Grosse Geister (sculpture)

SCHWITTERS Kurt MM
1887–1948 German

Pioneering, poetic, romantic loner, who used the fragments no one bothered with

to make sense of a world that he found politically, culturally and socially mad – Germany from 1914 to 1945. Ran a successful, pioneering advertising agency from 1924 to 1930. Died in England as a refugee. Was influential, especially in the 1960s and 1970s.

🌑 His small-scale 'Merzbilder' collages were created in great number and with extraordinary care, both in composition and content, and in their final, beautiful arrangement. He used material that he, literally, picked up in the streets of his native Hanover. His work of 1922–30 is more consciously constructed (and

1

a whole building filled with personal *objets trouvés* – a collage gone mad. (It was destroyed by Allied bombs in 1943; a successor near Oslo was destroyed by fire in 1951.) Poignant attempt to create a new beauty on the ruins of German culture.

🏛 Hanover: Sprengel Museum
Ⓐ (31) £1,420/$2,273 – £93,168/$150,000
🔨 £220,000/$327,800 in 1993, *Merzbild mit Kerze* (sculpture)

SCOTT Samuel NH
1702–72 British

'The English Canaletto' – his work has Canaletto's precision, lighting and anecdotal detail. Had only a limited range of viewpoints and subjects and is best known for his views of London and the Thames. Influenced early English watercolour painters such as Marlow. Also painted early Dutch-style maritime pictures (warships). Was a friend of Hogarth. Retired to Bath in 1769 with gout.

Ⓐ (2) £9,800/$15,190 – £18,474/$29,743
🔨 £390,000/$588,900 in 1996, *Westminster from Lambeth, the Abbey, Palace of Westminster* (oil p., 1748)

SCULLY Sean CS
1945– Irish/American

Noted for high-minded abstract art (he believes in pure painting as high art). The favoured form is large, simple, horizontal and vertical stripes, and the technique emphasises the qualities of paint through earthy grey colours and the subtle interplay of two and three dimensions. His works are sometimes made from separate panels. An 'art for art's sake' of great refinement.

Ⓐ (3) £3,289/$5,263 – £47,297/$70,000
🔨 £184,524/$310,000 in 1990, *Untitled* (oil p., 1985)

influenced by Russian Constructivism and Dutch De Stijl). Produced a few high-quality, traditional paintings and sculptures as a deliberate contrast to his avant-garde activities.

🔍 His early roots were in Dada, but he was never political, polemical or satirical. His work is always personal or autobiographical – the artist as a sacrificial victim or spiritual leader. His major (manic) project was 'Merzbau' –

SEBASTIANO DEL PIOMBO AG
c.1485–1547 Italian

Venetian ex-patriot and Titian's contemporary who settled in Rome when Michelangelo and Raphael were there. In 1531 obtained the sinecure of keeper of the papal seal (made from lead, or 'piombo', hence his nickname).

◗ He excelled at painting portraits – which can be magnificent. Otherwise he flirted with (relative) failure. He achieved a certain marriage of muscularity and poetry, which makes his figures look like soulful athletes, but the compositions, colours and figures became overblown as he strove unsuccessfully to keep up with his friend Michelangelo.

🔎 Look for rather fierce-looking, muscular people, with good strong hands; dramatic gestures and plenty of foreshortening. Interesting use of perspective. Rich colour and landscape backgrounds maintain his links with Venice. Is it a misfortune to be talented but not outstanding in an epoch of giants? Do they cause you to live in their shadow, and diminish your talent? Or do they inspire you to reach heights you would otherwise not have achieved?

🏛 Rome: Villa Farnese (fresco series)
🔨 £380,000/$695,400 in 1987, *Portrait of Pope Clement VII* (oil p.)

SEGAL George CS
1924–2000 American

Creator of environments that are like banal settings with real objects from everyday life – but in which the people are replaced by white plaster figures. He makes cast from real live people, wrapping them in plaster-soaked gauze bandages like a mummy. Powerful and sensitive evocation of the lonely anonymity of everyday life.

Ⓐ (15) £1,258/$1,900 – £216,216/$320,000
🔨 £216,216/$320,000 in 2000, *Movie Poster* (sculpture, 1967)

SERRA Richard CS
1939– American

The foremost American creator of sculpture for public spaces. Produces massive works, which have a commanding presence and are held together only by gravity.

◗ Look for huge, minimal, monumental slabs of metal, often exhibited in open urban spaces. They are unmissable and unavoidable – and often seem to be unstable, as though the pieces could

235

fall over. Take pleasure in his interest in massive weight and the way he likes to play with the sense and appearance of it: propped, balanced, rotated, moving, about to move, added to, subtracted from, towering, ground-hugging. He loves playing with the force and direction of weight.

🔎 He is also interested in the psychology of weight, in two ways: 1) observing the impact that his massive apparently unstable or dangerous objects have on viewers' own space and on their bodily and mental reactions to them (some people react with severe dislike and rejection); 2) as a metaphor for social realities, such as the weight of government control or personal tragedy. Some of his works have caused public controversy and legal actions have been taken to have them removed.

🅐 (2) £26,398/$42,500 – £240,741/$390,000
🏹 £240,741/$390,000 in 1999, *Sign Board* (sculpture, 1969)

SERRANO Andres CS
1950– American

An artist with an obsessive interest in religion, basic bodily secretions, sex and death (the same as for the average 10– 16 year old?). He explores these subjects individually or in combination through strange, glossy, photographic images (notoriously a crucifix in a glass of urine). Technical accomplishment aside, his work is as shocking, provocative and unnerving in content as the attitudes of a 10–16 year old .

🅐 (37) £2,011/$3,017 – £100,000/$162,000
🏹 £100,000/$162,000 in 1999, *Piss Christ* (photographs, 1981)

SÉRUSIER Paul MM
1863–1927 French

His stiff, decorative style (firm outline,

bright, flat colours, simplification) is largely indebted to Gauguin, with lesser borrowings from Egyptian and mediaeval art. His favoured subject was Breton women at work. A disciple of Gauguin, who spread his ideas and was a founder member of the Nabis. Well-heeled and popular with fellow artists, but too hung up on theory – needed to loosen up his art.

🅐 (42) £521/$807 – £200,000/$316,000
🏹 £317,869/$438,659 in 1984, *Les petites baigneuses nues dans le torrent* (oil p.)

SEURAT Georges AG
1859–91 French

Shy, reclusive character who died suddenly from meningitis at the age of 31, having produced very great work. Driven by a love of theories. The originator of Pointillism and Divisionism.

🌑 His subjects are modern life and places. His work can seem austere and rigid, because he painted according to worked-out theories, not what he saw or felt. He applied the latest ideas of colour and optical mixing – painting separate dots of pure colour on the canvas (Pointillism), which mix and vibrate in the eye and are intended to give the same sensation as light itself. Used a formula of lines to express emotion: upward diagonal = happiness; downward diagonal = sadness; horizontal = calmness.

🔎 Colour theories don't work in practice because pigments lose their brightness and the mixing in the eye tends to end up as a grey mush. Why did he ignore the significance of vertical lines? He made wonderful drawings using soft black crayon on textured paper, and tiny free preliminary sketches for his big works. Used colour borders that complement the areas of colour in the picture. There is hidden symbolism and references to old masters in the set-piece figure paintings.

🏛 New York: Metropolitan Museum
of Art; Chicago: Art Institute
Paris: Musée d'Orsay

🅐🅥 (7) £5,298/$8,000 –
£19,753,086/$32m

1

🏹 £19,753,086/$32m in 1999, *Paysage,
île de la Grande Jatte* (oil p., 1884)

SEVERINI Gino MM
1883–1966 Italian

One of the creators of Futurism. Painter,
stage designer, writer and intellectual.
Long lived and adaptable.

🌑 His early work was dull, until he
discovered Impressionism (in Paris, 1906).
His most significant works are his Futurist
paintings, 1911–16, which have dynamic
subjects, such as trains, buses, city streets,
dancers and war machinery – all of them
animated by Cubist fragmentation and
strong colours. After 1916 his paintings
become less dynamic and more formally

pure, with precise adherence to
geometric rules. In the 1920s he made
mural decorations (especially mosaics
for churches), and in the 1930s grand
Fascist monuments.

🔎 His work is of uneven quality –
the Futurist paintings can be very good,
or else very formulaic and trite. His later
work is hardly known outside Italy. Like
other bright sparks of the early avant-
garde (such as Derain) he had only a
brief period of real significance. Does
a lasting reputation require longevity
and large output more than talent?
Fascist Italy (unlike its equivalent in
Germany or Russia) produced some very
fine architecture and public art. Why?
And does evil political patronage
irrevocably taint the art?

🅐🅥 (67) £559/$906 – £1.05m/$1,659,000
🏹 £1,952,663/$3.3m in 1990,
Mare-Danzatrice (oil p., 1951)

SEYMOUR James NH
1702–52 British

One of the first artists to paint exclusively
sporting pictures. The principal features
of his work are lively childlike ineptness,
attention to anecdotal detail, and a static
'frozen moment' quality – exactly what
often makes children's painting so
attractive and memorable. Self-taught.

🅐🅥 (6) £727/$1,055 – £360,000/$543,00
🏹 £380,000/$577,600 in 1996,
*Sterling, a grey racehorse held
by a groom* (oil p., 1738)

SHANNON Charles Hazelwood NH
1863–1937 British

Painter, collector, lithographer and
aesthete. Preferred old masters to
contemporary art and chose religious and
classical subjects. Was much influenced
by Titian (and a bit by Whistler). The
boyfriend of Charles Ricketts, whom he

assisted on publishing projects. Was also highly skilled in lithography.

🪓 £10,000/$15,100 in 1992, *Mermaid* (oil p.)

SHEELER Charles NH
1883–1965 American

Dour and romantic, a painter and photographer who turned the industrial landscape into works of art as carefully calculated, precise and free of human presence as any mass-produced objects. Worked for Henry Ford and shared his belief that factories are temples of worship. Replaced the sublimity of wild nature with the sublimity of the urban landscape.

Ⓐ (11) £4,908/$7,500 – £250,000/$400,000
🪓 £1,118,420/$1.7m in 1983, *Landscape* (oil p., 1931)

SHERMAN Cindy CS
1954– American

Leading New York artist beloved by art critics who swoon over the powerful manner in which she deconstructs and comments on women's role in a male-dominated consumer society.

◗ Produces very large-scale photographs, often in high-key colour. Works in series. She acts the parts, makes the sets, and takes the photographs herself. There is no other (and no male) involvement. In the early series she depicts herself as various media stereotypes and as ordinary girls and women. From 1985 she has produced series of grotesque images – teddy bears, dolls or toys in a stew of vomit or slime; dehumanised medical dummies; she does also parodies of old-master portraits.

🔍 She seems to have less of a specific agenda than most commentators wish

on her (perhaps it is this 'innocence of motive' that makes the work so perplexing and disturbing). She claims to have discovered this style of work almost by accident. Her grotesque images are said to be a commentary on consumerism's excessive binges and purges. Perhaps most reward is to be gained by going with her imagery, for instance try identifying with the stereotypes – runaway teenager, career girl, Ingres portrait, and so on.

Ⓐ (57) £1,724/$2,586 – £162,162/$240,000
🪓 £162,162/$240,000 in 2000, *Untitled* (photographs, 1989)

SICKERT Walter Richard NH
1860–1942 British

The leading British painter of the Impressionist and post-Impressionist period. Had personal links with French artists such as Degas. Produced important, high-quality works. Perhaps best described as French idiom spoken with a very strong English accent.

◗ He chose down-to-earth subjects – street scenes, cheap interiors, music halls and prostitutes, and painted them in an appropriately earthy manner, without glamour, with a disregard of fashion,

in a palette of muddy colours, and thick, heavily worked paint. He liked and used the sense of intimacy and unobtrusive observation that is one of the qualities of photography. The imagery for many late works was taken directly from newspaper photographs – a mistake, as it destroyed any sense of intimacy.

🔍 High-quality craftsman – his pictures are very carefully composed, sometimes with striking or unusual viewpoints, behind which lay much work and preliminary drawing. Note the careful and diligent application of paint in his work; his unusual colour combinations and interesting light effects. In his late work, look for the lines of the underlying grid he used for squaring up (enlarging) the photographs. Also made good etchings.

Ⓐ (45) £300/$486 – £60,000/$84,600

🔨 £200,000/$286,000 in 1993, *Brighton Pierrots* (oil p., 1915)

SIGNAC Paul MM
1863–1935 French

Patient follower and disciple of Seurat. Through his work and writings he was the chief promulgator of the theory and practice of Divisionism. He moved from observed outdoor scenes to studio-based subjects, and from small dots to larger brush strokes. Good plein-air watercolours. His own work was overly theoretical and tidy, but despite this he influenced others (Matisse, for instance). Dogmatic.

Ⓐ (118) £900/$906 – £1,111,111/$1,659,000

🔨 £2,424,243/$4m in 1998, *Concarneau, calme du matin* (oil p., 1891)

SIGNORELLI Luca AG
c.1441–1523 Italian

Intense, gifted, vigorous Florentine who was outclassed by two younger geniuses: Raphael and Michelangelo.

🌑 His religious and secular subjects were chosen to make the most of his interest in dramatic (overdramatic?) compositions. Observe the movement, muscles and gestures in his figures – but sometimes there is too much of this and the paintings are so crowded that the end result is bewildering rather than inspiring. Good draughtsmanship.

🔍 He emphasised the sculptural quality of the figures to the point where they sometimes look as though they have been carved out of wood. (Michelangelo always created flesh and blood, even at his most extreme.) Painted hands that look distorted by arthritis and mouths with set expressions.

🏛 Orvieto: Cathedral (fresco series)

🔨 £68,750/110,000 in 1997, *Bearded Prophet Holding a Scroll* (oil p.)

SIQUEIROS David Alfaro MM
1896–1974 Mexican

Prolific painter and writer who was deeply involved in progressive, political causes in Mexico in the 1920s and 1930s. He is revered as Mexico's greatest painter.

🌑 Produced solemn (gloomy?) works with strong political commitment – art in the service of the people's revolution. Look for monumental, sculptural peasants and faces; direct, earthy subjects. Was technically accomplished and quietly experimental (he made very early use of industrial paints and drip techniques). Unshakeably consistent in his style and belief.

🔍 His crowning achievements are the vast in-situ murals in Mexico, which are revolutionary manifestos in their own right and exploit daring, cinema-inspired angles and perspectives.

🏛 Mexico City (murals for public buildings)

🅐🅥 (15) £1,625/$2,616 – £113,333/$170,000

🔨 £113,095/$190,000 in 1996, *Mujer* (oil p., 1945)

SISLEY Alfred AG
1839–99 British/French

1

'The forgotten Impressionist' – the most underrated member of the group, then and now.

🌑 Look for places, structures and connections. Like Constable, Sisley only painted places he knew well and he particularly responded to the Seine and Thames valleys. He also liked well-structured compositions (notice the verticals, horizontals, diagonals). Used structural details like roads and bridges cleverly to take the eye through the landscape and link all the parts together.

🔍 Note the interesting colour combinations (especially pinks and greens, and blues and purples) he uses to produce the sensation of light.

🅐🅥 (42) £3,213/$5,173 – £2,119,205/$3.2m

🔨 £2,119,205/$3.2m in 2000, *Un jardin à Louveciennes, chemin de l'Etarche* (oil p., 1873)

SLOAN John NH
1871–1951 American

Member of the Ashcan School. Started as an illustrator and cartoonist with Socialist sympathies but was opposed to the idea of art as propaganda. Produced New York scenes of the working classes, but he modified harsh reality with an ideal of honest, cosy, vaguely erotic, urban

2

happiness. Good at catching fleeting moments. After 1914, worked in Santa Fe; after 1928 he lost the plot. Superb etchings.

🅐🅥 (26) £578/$850 – £1,351,351/$2m

🔨 £1,351,351/$2m in 2000, *Bleeker Street, Saturday Night* (oil p., 1918)

SMITH David MM
1906–65 American

Creator of beautiful, inventive, poetic works made from iron, steel and found objects, which he welded, manipulated and coaxed into constructions of great originality. His quiet modesty, honest beliefs and deep feeling touched his work with a profound sense of the presence of fundamental and universal forces,

and of human worth. One of the great modern sculptors.

 (9) £1,840/$3,000 –
£135,802/$220,000

£2,483,222/$3.7m in 1994,
Cubi V (sculpture, 1963)

SMITH Kiki CS
1954– American

Daughter of sculptor Tony Smith. Trained briefly as a medical technician. She is obsessed with bodily fluids and parts, such as blood and saliva. She either displays these in jars or makes paper cutouts that suggest skin, and wax figures that seem to drip secretions. The underlying agenda for this need to play with the repellent is not clear.

 (13) £965/$1,500 –
£108,108/$160,000

£130,435/$210,000 in 1997,
Pee Body (sculpture, 1992)

SMITH Leon Polk CS
1906–96 American

Early work is Surrealist; after 1954 he produced large-scale abstract paintings with geometric forms, areas of bright colour and shaped canvases.

 Walk around and enjoy an uncomplicated visual delight, allowing the works themselves to create a sense of space moving in all directions and in many dimensions.

 (5) £1,338/$2,140 – £3,086/$5,000
£23,810/$40,000 in 1990,
Pointed Accents (oil p.)

SMITH Sir Matthew NH
1879–1959 British

Underrated, authoritative and distinguished painter of still lifes and nudes, in a style that is English (reserved, fundamentally traditional), but with French flavours (hot or rich colours and fluid, luscious, free brushwork). Trained at Matisse's school in Paris; early work is bright and Fauvist in manner. A reclusive, shy personality.

 (23) £800/$1,199 – £29,000/$44,240
£38,000/$56,240 in 1993,
Peaches (oil p., 1935)

SMITH Richard CS
1931– British

Talented artist who produces paintings that can look like gloriously decorated or painted kites or tents – he draws attention to their similarity of material and construction (canvas, stretcher, strings, colour). Gives a new twist to the freedom possible in colour, support and surface. There are visions and inspirations of light, air, wind and flowing water. Also makes good drawings. Not fashionable. Underrated.

 (6) £620/$992 – £1,700/$2,720
£9,000/$14,490 in 1987,
First Fifth (oil p.)

SMITH Tony MM
1912–80 American

Architect (until 1950s), sculptor (from 1960s) and painter. Created simple, satisfying engineered structures (he designed and created the models, others built the end products). They are of varying size and scale but always with human proportions – romantic rather than minimal. Sleek black surfaces add a stylish, sophisticated presence. Space is as important as form.

 (2) £3,019/$4,800 – £24,691/$40,000
£50,676/$75,000 in 1993,
Throne (sculpture 1969)

SMITHSON Robert MM
1938–73 American

Pioneer land artist, who was tragically killed in his 30s. Had a pessimistic view of the world; foresaw it ending in a new ice age, not a golden age, reduced to self-destructive banality by the anonymity of urban developments and indifference to the environment. He reacted against this

1

by offering his workings on the land (and its documentation) as works of art.

- ⓐ (4) £2,254/$3,200 –
 £80,247/$130,000
- ↗ £147,239 /$240,000 in 1998,
 Double nosite, California and Nevada (sculpture 1968)

SNYDERS Frans AG
1579–1657 Flemish

The undisputed master of the Baroque still life. Became as rich and successful as his clients and so was able to consume and enjoy the produce he painted. Prolific and much imitated – there are many wrong attributions. Son of an innkeeper.

🜄 Look for market scenes; pantries; large-scale still lifes that literally groan and overflow with fruit, vegetables and fish, flesh and fowl, both alive and dead. Look also for the odd symbol of successful bourgeois capitalism, such as rare imported Wan Li Chinese porcelain. After 1610 he painted hunting scenes, but his best and most freely painted work came after 1630 – geometrically structured compositions, which contain fluidity, rhythm, balance, harmony and rich colour.

🔎 He was much influenced by his visit to Rome in 1608. Collaborated with other artists (for example, he sometimes added the still life or animal component of the image/narrative to Rubens's work). There is possible symbolism in the details (grapes as Eucharist, for instance); plus moralising messages, proverbs or animal fables. If you visit the market area of Brussels today, you will see shops and restaurants with just such lavish displays of produce – he painted embroidered reality, not far-fetched fantasy.

- ⓐ (9) £675/$1,100–£75,000/$121,500
- ↗ £909,091/$1.4m in 1996,
 Woman selling vegetables and fruit (oil p., 1627)

SOROLLA Y BASTIDA Joaquin MM
1863–1923 Spanish

Accomplished, prolific, and internationally acclaimed painter with an easy, fluent style. He successfully bridged the divide between old masters and modern ones (like Sargent and Zorn). Painter of beach scenes, landscapes, society portraits and

genre scenes, he had an envious facility with light effects. Shows a nice balance between (social) realism and idealism. Painted directly onto canvas – fast.

- 🏛 New York: Hispanic Society of America (murals)
- 🅐🅥 (42) £750/$1,208 – £617,284/$1m
- 🔨 £1.65m/$2,854,500 in 1990, *Playa de Valencia – Sol de Tarde* (oil p., 1908)

SOULAGES Pierre MM
1919– French

Large-scale heavily textured, gestural, painterly abstracts in which black is predominant. Intended to be more visual than emotional in impact – he considers black to be the means of making light and colour visible and alive.

- 🅐🅥 (29) £14,551/$23,863 – £190,000/$286,900
- 🔨 £220,000/$387,200 in 1990, *Peinture 41-58* (oil p., 1958)

SOUTINE Chaïm MM
1894–1943 French

Lithuanian-born Jew who worked in Paris. Undisciplined, tragic and depressive. Publicly unknown in own lifetime

although he was recognised and supported by a few dedicated collectors.

☞ Look for portraits, landscapes and flayed carcasses. He had a wide emotional range – from angelic choirboys to dead meat. His strange, highly individual painting style reveals his underlying unease and anxiety and a desire for peace. At a distance the paintings look controlled and neat, with a frame and ordered composition and colour, but close up the churning distortions and paint handling become dominant.

🔍 There is no self-indulgent expression, but an underlying purpose in the apparent madness. He had an acute colour sense and produced lovely harmonies of colour. His work shows uncontrolled distortion, but this is not arbitrary. Cracked painting surfaces show the speed with which he worked, painting over layers not yet dry. It is possible to detect a wide variety of influences, such as Cézanne, Bonnard, El Greco and Rembrandt.

- 🏛 Philadelphia (USA): Barnes Foundation
- 🅐🅥 (17) £801/$1,210 – £1.4m/$2,016,000
- 🔨 £1.4m/$2.31m in 1997, *L'homme au foulard rouge* (oil p., 1921)

SPENCER Gilbert NH
1892–1979 British

Stanley Spencer's younger brother, but he lacked Stanley's eccentricity and personal vision. Professor of painting at the Royal College of Art 1932–48. Best known for high-quality landscapes of the Thames Valley and Oxfordshire villages in the English pastoral tradition. His most interesting work was as a war artist, 1940–3.

- 🅐🅥 (9) £460/$681 – £10,000/$16,000
- 🔨 £10,000/$16,000 in 1999, *St Johns cottages from Southwell, Hampstead* (oil p., 1930)

SPENCER Sir Stanley NH
1891–1959 British

Difficult, argumentative but inspired personality with a unique and personal vision and great talent. Preached, practised and illustrated sexual liberation at a time when such things were 'not done'.

◑ His work shows British eccentricity as its best and most convincing. He had complete disregard for the prevailing conventions (social and moral, as well as mainstream artistic). Had an utterly personal agenda and unshakeable belief in his own vision and ability. The focus of his life and of his major work was round his home village of Cookham, which he saw as an earthly paradise and the centre of the universe. Cookham also provided the setting for his profound belief in the return of Christ for and among ordinary people.

🔍 Observe his humanity, humour and acerbic wit. He had a dry, careful, deliberately outdated technique inspired by early Italians, Pre-Raphaelites and Dutch and Flemish painters. Was a masterly and inspired draughtsman (using a squared grid on drawings to transfer their image to large-scale canvases). His best works are his religious and World War 1 subjects. Painted potboiler landscapes to earn money. Like all true visionary eccentrics, he managed to be simultaneously separate from his own time and era and totally of it.

🏛 London: Tate Britain; Imperial War Museum. Burghclere (Hampshire, UK): Sandham Memorial Chapel
Ⓐ (30) £300/$486 – £950,000/$1.5m
🔨 £1.2m/$1,992,000 in 1990, *Crucifixion* (oil p.)

SPERO Nancy CS
1926– American

Painter who has worked on paper since 1966 and made collages since 1970.

Her central themes are: women's inferior status in a male-dominated society; women's isolated roles (as mother, lover or prostitute); the imbalance of power between the sexes; the phallus as the symbol of destruction. The one ray of hope is erotic fulfilment, which briefly rises above these injustices.

Ⓐ (1) £483/$729
🔨 £11,000/$18,590 in 1990, *Lovers* (oil p.)

STAËL Nicolas de MM
1914–55 French

Orphaned Russian aristocrat émigré who took French citizenship in 1948. Started with admiration for old masters, not Modernism. Evolved a successful style that bridged the divide between figuration and abstraction, using thick, tactile paint, rich colours and simple forms (suggestive of landscape or still life). Committed suicide (because overwrought or overworked?). His work is neglected.

Ⓐ (27) £887/$1,286 – £950,704/$1.35m
🔨 £1.17m/$1.9m in 1990, *Syracuse* (oil p., 1954)

STEEN Jan AG
c.1626–79 Dutch

One of the best and most important Dutch genre painters. Also ran a tavern and owned a brewery. Prolific and popular.

◑ His lively and crowded scenes of taverns, feasts and households, with stock characters and facial expressions (rather like a TV soap opera – and maybe his works fulfilled a similar need), are instantly recognisable. But watch out also for portraits, mythological scenes, religious works and landscapes.

🔍 His lively and easy use of flowing, juicy painted fresh colours (rose red, blue-green, pale yellow) adds to the life of the paintings and reflects their character.

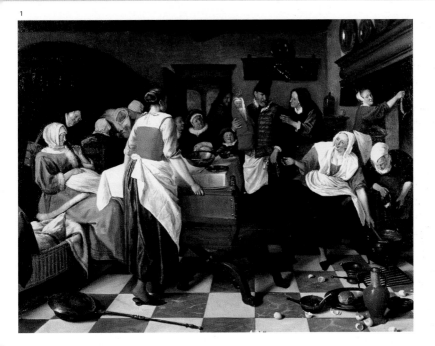

1. Jan Steen, *The Christening Feast,* 1664

There is plenty of symbolism in the genre scenes, which carry a happily unambiguous (sometimes heavy-handed) message about the effects of drunkenness, idleness, promiscuity, etc.

⊗ (11) £3,523/$5,636 – £250,000/$387,500

✦ £1,708,860/$2.7m in 1989, *Figures in an interior with man and woman seated at table playing cards* (oil p.)

STEER Philip Wilson NH
1860–1942 British

Museum curator (coins and medals) who turned to painting and studied in Paris in 1882. Eclectic, idiosyncratic, and the doyen of English Impressionism. Influenced by Whistler (pale tones), Degas (cut-off compositions), Monet and Sisley (broken brush strokes). His best works are decorative beach scenes. After 1895 he emulated the epic grandeur of old masters (Rubens, Constable, Turner and Watteau).

⊗ (22) £420/$664 – £80,000/$112,800
✦ £80,000/$112,800 in 2000, *Embarkation* (oil p., 1900)

STELLA Frank CS
1936– American

One of today's leading abstract painters. Prolific and very varied – but the constant theme is investigating what paintings are and what they can or ought to look like.

◐ His early work reduced painting to all but its most pure, minimal and indispensable properties: simple, flat, shaped, monochrome. He then introduced pure, bright, hard-edge colour with increasing complexity. After the early 1970s he started to investigate how impure a painting can be and yet still remain a painting, by making constructions that are rich interlocking clusters of shape and colour. Uses varied materials.

🔍 Likes to work on a large scale. Even at his most spontaneous, everything is

carefully worked out beforehand.
He steals ideas and techniques from
sculpture and architecture, but always
creates 'pictures' – his creations have a
back to the wall and are viewed from the
front. He says that the spatial complexity,
drama and vitality of Rubens and
Caravaggio are influences on his recent
work. Wholly self-referential: the subject
and content of his art is picture-making.

Ⓐ (77) £1,829/$3,000 – £915,493/$1.3m
⤢ £2.91m/$4.6m in 1989,
Tomlinson Court Park (oil p.)

STELLA Joseph NH
1877–1946 Italian/American

Born in southern Italy. Emigrated to
the USA in 1896. Studied in Paris in 1911,
where he discovered Modernism and was
befriended by Gino Severini. Brought
his whole-hearted and extremely
accomplished adoption of Futurist
philosophy and style back to the States.
Produced high-quality, original work
until the 1920s; then it declined as he
indulged in sugary visions of Catholic
Italy. Made very good silverpoints.

Ⓐ (14) £544/$800 – £23,649/$35,000
⤢ £39,394/$65,000 in 1997,
Joy of Living (oil p., 1938)

STEPANOVA Varvara Fedorovna MM
1894–1958 Russian

Second-generation avant-garde, and
the most schematic of the pioneering
Russian artists. She started as a painter
but became involved in industrial and
textile design, such as sports clothes.
Was political and believed abstract art
could unlock social and spiritual
transformations. Used spidery calligraphy
and earth colours. Her work has Bauhaus
connotations in subject and appearance.

⤢ £75,000/$126,000 in 1988,
Two figures (oil p., 1921)

STILL Clyfford MM
1904–80 American

One of the leading Abstract Expressionist
painters – intense, serious, painterly,
heroic, romantic and difficult to live with.
A sensitive intellect in a rugged exterior
(the American male ideal?). He was
brought up in the big open spaces of
Alberta, Canada and Washington.

1

2

◑ His early figurative work explored
the relationship between humans and
landscape. His later large-scale (for their
time) abstract paintings are heavily
worked, having rough surfaces with thick
paint. Used intense colours and simple
'imagery' consisting of 'flames' or 'flashes'
of colour on a field of single colour, with
a vertical format for both the paintings
and the 'images'. His works manifest
a deliberate cragginess, intransigence,
awkwardness and individualism which
reflect both the character of the artist

and the agenda shared by his fellow Abstract Expressionists.

🔍 You have to spend time with the paintings and be prepared to meet the artist half way. He saw art as a moral power in an age of conformity; life as a force pitted against nature – especially earth and sky. Thus the vertical 'necessity of life' arises from the horizontal. He continued the 19th-century tradition of Romantic landscape.

🅐 (3) £54,054/$80,000 – £1,047,297/$1.55m
🔨 £1,047,297/$1.55m in 2000, *Untitled* (oil p., 1947)

STUART Gilbert NH
1755–1828 American

Penniless uneducated son of a Rhode Island tobacconist. Was a heavy drinker, often in debt, bad-tempered and addicted to snuff. Was also a highly successful portrait painter and America's first virtuoso exponent of the grand manner.

🌒 He learned his trade in Edinburgh (1772) and London (1775) as an assistant to Benjamin West. Produced Romantic, dignified portrait images of independence and self-assurance, softly modelled and silhouetted against a plain background. Almost all the emphasis is on the clean, pink, well-scrubbed faces. He was adept at giving the uncanny illusion of being in the presence of the sitter. Painted portraits of almost every contemporary American of note, especially Washington. Of his 114 portraits of Washington, only 3 were made from life; the rest are replicas.

🔍 Characteristic features and touches are a pinkish-green palette; a white dot on the end of a shiny nose; a beam of light shining on a forehead; and rapid execution without preliminary drawing.

🏛 Boston: Museum of Fine Arts (for the famous unfinished head of Washington, 1796, which features on the dollar bill)

🅐 (7) £3,000/$4,800 – £125,000/$200,000
🔨 £633,803/$900,000 in 1986, *Portrait of John Jay* (oil p.)

STUBBS George AG
1724–1806 British

3

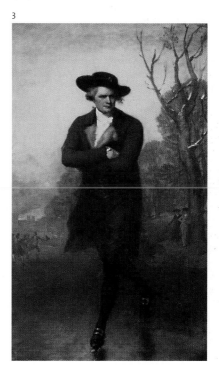

The greatest-ever painter of the horse, hunting, racing and horsebreeding. Also painted scenes of rural life. Successful, with powerful patrons, but always a loner. His book, *Anatomy of the Horse* (1766), is one of the most remarkable published works of art and science.

🌒 His deep personal fascination with the anatomy and character of the horse touched something more widespread and profound: man's relationship with

nature (wholly dependent on the horse until the invention of mechanical power) – plus the mid-18th-century belief in rational investigation as a means of understanding the natural world and comprehending the qualities of beauty. Produced wonderful, measured, modest pictures which exemplify the saying 'beauty is truth, truth beauty'.

🔎 His paintings are models of rational beauty: rhythmic organisation of composition; subtle, careful, half-concealed geometry of horizontal and vertical structures around which play curving cadences (like Mozart); loving observation of space, anatomy and the unspoken relationship between animal and man. Stunning draughtsmanship. The exquisite, harmonious, gentle colour has too often been tragically destroyed by insensitive cleaning and restoration.

🅐 (7) £9,091/$13,000 – £2.5m/$3.58m
🏹 £2.9m/$4,611,000 in 1995, *Portrait of the Royal Tiger* (oil p.)

SUTHERLAND Graham NH
1903–80 British

His work is a fascinating example of English tradition and modern idiom cohabiting – and more successfully than is usually admitted. Sutherland's landscapes reveal a fascination with organic forms and metamorphosis. His portraits (his best work?) show a fascination for facial forms that contain the inner personality (like a fossil in a rock). Underrated.

🅐 (71) £460/$677 – £45,000/$72,000
🏹 £75,000/$124,500 in 1998, *Palm and House* (oil p., 1947)

SUVERO Mark di CS
1933– American

Creator of large-scale sculptures for public spaces. Uses materials of the construction industry and leaves bolts and welds deliberately visible. Seeks to achieve a synthesis of balance and tension; also to express the strength and power of human aspiration, tenacity and personal experience. Constructs as he goes along, without preliminary models.

🔾 With the help of his brother and artist friends, he began using I-beams and working on a monumental scale after a near fatal accident in 1960 left him confined to a wheelchair. He learned to walk again through sheer determination.

🅐 (9) £789/$1,200 – £99,338/$150,000
🏹 £277,778/$425,000 in 1993, *Che Farò Senza Eurydice* (sculpture, 1959)

TANGUY Yves MM
1900–55 French

Self-taught Surrealist who from c.1927 evolved (but never developed further) a highly recognisable style of imaginary landscapes (or are they sea bottoms?) populated by weird and curiously compelling half-vegetable, half-animal forms.

🅐 (36) £1,773/$2,571 – £1.4m/$2,268,000
🏹 £1.4m/$2,268,000 in 1999, *Un grand tableau qui représente un paysage* (oil p., 1927)

TANNING Dorothea CS
1910– American

Max Ernst's wife (1946–76). Chose surreal subjects built around female forms and adolescent fantasy. Evokes a consistent sense of brooding unease, metamorphosis and hidden presences. Her paintings have sublime colour, a dashing technique and seductive surfaces. Since 1960 she has made sewn-fabric soft sculptures, like monstrous dolls or toy animals belonging to an alien race. Underrated.

🅐 (2) £12,422/$20,000 – £16,352/$26,000

£41,068/$71,047 in 1990,
The Philosophers (oil p.)

TANSEY Mark CS
1949– American

Produces large canvases in thin, washy
paint with the monochromatic tones
of old photographs. Works in a self-
conscious, dead-pan, illustrator's style.
His subjects are absurd imaginary events
in art history, such as New York School
artists receiving the formal surrender
of the European artists on a World War 2
battlefield. More an in-joke for the art
world than art.

⟐ (4) £4,180/$6,270 –
£60,811/$95,000
✦ £122,905/$220,000 in 1992,
The Myth of Depth (oil p., 1984)

TÀPIES Antoni MM
1923– Spanish

Talented self-taught artist whose best
work dates from the 1950s and early
1960s, when he used coarse materials
to produce sombre heavily textured
canvases expressing the uncertain,
stressful mood of Cold War Europe.
His later work is less convincing because
it is less in tune with the times. Much
so-called avant-garde art of the 1970s
and 1980s is anticipated by Tàpies.

🏛 Barcelona: Fondaçio Antoni Tàpies
⟐ (82) £294/$467 –
£300,000/$453,000
✦ £443,299/$753,608 in 1990, *Bois et
marron troue* (works on paper)

TATLIN Vladimir Evgrafovich MM
1885–1953 Russian

Heroic, legendary founder of Russian
Constructivism. He was in Paris in 1913
and was much influenced by Picasso
and Futurism. Famous for his relief

constructions, especially corner reliefs,
and his never-built tower (*Monument
to the Third International*). Made stage
and industrial designs in the 1920s .
Believed in art at the service of the
Revolution. Deadly rival of Malevich.
Died in oblivion.

✦ £18,000/$28,980 in 1987,
Projet de construction (drawing)

TENIERS David (the younger) OM
1610–90 Flemish

Best remembered for lively small-scale
paintings of peasant and guardroom
scenes (and depicting them misbehaving,
as in *Boors Carousing*). Also, after 1651,
detailed views of the picture galleries of

Archduke Leopold Wilhelm (Regent of
the Netherlands). Late work is weak.

⟐ (29) £380/$600 –
£2.7m/$4,185,000
✦ £2.7m/$4,185,000 in 1999,
*Archduke Leopold Wilhelm and the
artist, Archducal Gallery* (oil p., 1653)

TERBORCH (or Ter Borch) Gerard AG
1617–81 Dutch

Precocious, well travelled (Italy, Spain, England, Germany), successful. One of the finest and most inventive masters of the Dutch School.

�), His small-scale, very beautiful, restrained and gentle genre scenes show self-absorbed moments of

1

a lingering question over the secrets or affections that are being shared; his love of a lady's neck and light reflecting off a surface. See how he uses gentle symbolism but without overt moralising.

2

3

a mundane world raised to immortality by art. One senses from the acuity of his observation and the minute care with which he painted that he viewed this world, its people, its foibles, its ordinariness and its objects (not forgetting the dogs) with the greatest of affection and pleasure.

🔎 Look for harmonies of brown, gold and yellow and of silver and grey-blue, exquisitely balanced against dark backgrounds; his love of detail; the rendering of fabrics and the way clothes are made; his ability to draw us quietly into his intimate world and leave

🔨 (5) £4,861/$7,000–
 £58,621/$85,000
🔨 £2.5m/$4.2m in 1997,
 Music Lesson (oil p.)

TERBRUGGHEN Hendrick OM
1588–1629 Dutch

The most important painter of the Utrecht School, who was deeply influenced by Caravaggio's subjects and style (he spent 10 years in Italy). His early work has hard, raking light, which throws detail into sharp relief. His later work is softer and quieter, sometimes to the point of stillness and silence. Was fascinated by reflected light.

⚒ £500,000/$800,000 in 1997, *Boy Violonist* (oil p., 1626)

THIEBAUD Wayne CS
1920– American

Painter of portraits, landscapes and still lifes, lavishly executed in thick, buttery paint and clear, bright colours. Takes a loving but unromantic interest in the anonymous faces and products seen in the supermarket, cafeteria or deli. His simplified style comes from his early experience as an advertising artist and cartoonist. Paints clear light, and thick blue shadows you feel you can touch.

🔨 (25) £1,852/$3,000 – £236,486/$350,000
⚒ £962,733/1.55m in 1997, *Bakery Counter* (oil p., 1962)

THORNHILL Sir James NH
1675–1734 British

Ambitious and successful. The only English exponent of fashionable, illusionistic Baroque wall and ceiling paintings for public buildings (which include the Painted Hall of Wren and Hawksmoor's naval hospital in Greenwich, London) and country houses. Retired from painting in 1728 to become an MP and country squire. Produced quality work, but it lacks the necessary histrionic drama and sense of excess (the British always believed that foreigners do that sort of thing better).

4

🔨 (4) £900/$1,440 – £26,250/$42,000
⚒ £26,250/$42,000 in 1999, *Capriccio with Saint Paul before Agrippa* (oil p.)

TIEPOLO Giovanni Battista (Giambattista) AG
1696–1770 Italian

Last of the great Venetian decorators in the Renaissance tradition. Easy-going, happily married (to Francisco Guardi's sister), quick and astonishingly gifted. Was successful, sought after and rich, but his work is now out of fashion and very underrated.

🌙 His great decorative schemes in situ (Venice, the Veneto, Würzburg, Madrid) are a truly miraculous combination of fresco and architecture on a vast scale, where walls and ceiling seemingly disappear to reveal a celestial, luminous, shimmering vision of happily radiant gods, saints and historical and allegorical figures in an epic fantasy world. They constitute one of the greatest artistic experiences of all time.

🔍 Observe his brilliant storytelling and perspectival illusion. He has a confident,

1. Jacopo Robusti Tintoretto, *Susanna Bathing*, 1555–6
2. Giovanni Domenico Tiepolo, *The Harnessing of the Horses of the Sun*
3. James Tissot, *Reading the News*, c.1874

resolute technique and uses luminous colours. His large-scale schemes were the result of team work (the painting of the architectural settings being especially crucial). The preliminary sketches show a deft, delicate technique with flickering dark outlines, which weave under and over colour, giving life and crispness. He loves rich textures, doe-eyed females, muscular men, theatrical gestures – but always avoids cliché and frivolity.

🏛 Würzburg (Germany): Residenz. Madrid (Spain): Royal Palace
🅰 (52) £1,076/$1,700– £1,226,994/$2m
🔨 £1,226,994/$2m in 1999, *Madonna of the Rosary with Angels* (oil p., 1735)

1

TIEPOLO Giovanni Domenico (Giandomenico) OM
1727–1804 Italian

Son of Giovanni Battista, with whom he worked on major projects and whose style he successfully imitated. He flourished in his own right (but without his father's celestial inspiration and vision), preferring scenes of everyday life and witty anecdote. Skilled draughtsman and printmaker.

🅰 (39) £1,595/$2,249 – £280,000/$434,000
🔨 £550,000/$874,500 in 1995, *The Tiepolo Family* (oil p.)

TINGUELY Jean MM
1925–91 Swiss

Creator of bizarre, unpredictable, clanking machines, made from junk, which move and whizz, sometimes to the point of self-destruction. His work is highly original and very humorous. Used rubbish as material and subject matter of art. Thought that change is the only constant in life. Delighted in expressing an anarchic freedom (against his neat, orderly native Switzerland?). Married and worked with Niki de Saint-Phalle.

🅰 (71) £264/$395 – £29,326/$47,507
🔨 £160,000/$265,600 in 1997, *Untitled, Welded Sulpture Fountain* (sculpture, 1968)

TINTORETTO Jacopo Robusti AG
1518–94 Italian

His father was a dyer (*tintore*) – hence his nickname, Tintoretto. Very little is known about his life. Although unpopular and unscrupulous, he was one of the major Venetian painters in the generation following Titian. Very prolific.

🌑 In his monumental and vast religious works and mythologies everything is treated with the drama, verve, panache, scale – and sometimes the absurdity – of grand opera. (He used a model stage and wax figures to design his extraordinary and inventive compositions.) His late religious work tends to be gloomy. His thick, hasty brushwork and exciting lighting show his passionate involvement. Painted fine portraits of notable Venetians, but his busy studio also produced many dull efforts.

🔍 When you find an extraordinary or off-centre composition, try standing or kneeling to one side so that you view the work from an oblique angle: he designed works to be seen in this way, especially if they were big works for the small or narrow spaces of Venetian

churches, where the congregation would be both kneeling and looking up or forward to works hung on the side wall. There can be poor anatomy in the portraits – with hands that don't belong to the body.

🏛 Venice: Scuola di San Rocco; Ducal Palace; Accademia

AV (5) £57,927/$95,000–£144,092/$230,548

🔨 £550,000/$825,000 in 1994, *The Raising of Lazarus* (oil p.)

TISSOT James NH
1836–1902 French

2

French born, but lived in London between 1871 and 1882 where he became a highly successful, fashionable painter of small-scale polished depictions of society (especially slim-waisted women) at play. Had a brilliant technique, which compensated for lack of depth and insight. His late religious conversion following the death of his much painted mistress led to Bible illustrations.

🔨 £3,018,868/$4.8m in 1994, *Le banc de jardin* (oil p., 1880)

TITIAN Titiano Vecellio AG
c.1487–1576 Italian

Supreme master of the Venetian School, and arguably the greatest painter of the High Renaissance and of all time. One of the few (the only?) painters whose reputation has never gone into eclipse or been overlooked.

🌑 He had a miraculous ability with rich colour and luscious paint and was constantly innovative, using new

3

subjects or brilliant reinterpretations. Had a Shakespearean response to the human condition showing us tragedy, comedy, realism, vulgarity, poetry, drama, ambition, frailty, spirituality – and always so convincingly. He was a genius at creating a psychological relationship between figures so that the space

1

2

🔨 £6.8m/$12,376,000 in 1991,
Venus and Adonis (oil p.)

TOBEY Mark MM
1890–1976 American

Sensitive artist who developed a very
personal abstract style, serene and
luminous, out of small calligraphic marks
and gestures. This did not happen until
the mid-1940s when he was aged 50+
(he was a contemporary of Picasso,
rather than Pollock). Was influenced
by spiritual faith (a convert to Bahai),
Far East calligraphy, Amerindian art
and Japanese woodcuts.

🅐🅥 (47) £500/$795 –
£80,247/$130,000
🔨 £80,247/$130,000 in 1999,
Untitled (oil p., 1965)

TOMLIN Bradley Walker cs
1899–1953 American

First generation Abstract Expressionist.
His paintings have heavy, abstract
calligraphic strokes, often in white on
a dark background. Was an active
theoriser – he emphasised the desirability
of romantic self-expression – but
struggled against the more pretentious
attitudes (so for the titles of his works

3

between them crackles with unspoken
messages.

🔎 Study the faces and the body
language – portraits with a thrilling
likeness (who was it I met or saw who
was just like that?); also idealisation and
understanding of the hidden secrets of
his subjects' characters. Was he too wise
or discreet to tell quite all that he knew?
Gods and saints seem to be as much
human as divine (and therefore
understandable and approachable).
Never belittled anyone or anything.
Superman the measure of all things.

🏛 Madrid: Museo del Prado
Vienna: Kunsthistoriches Museum
London: National Gallery
🅐🅥 (4) £1,800/$2,628 –
£2.2m/$3,322,000

he used numbers, rather than mystical or Jungian mumbo-jumbo).

🅐 (2) £5,102/$7,500 – £6,790/$11,000
🔨 £83,333/$140,000 in 1996,
No. 5 (oil p., 1951)

TOULOUSE-LAUTREC Henri de AG
1864–1901 French

The epitome of the bohemian artist: the crippled aristocrat who haunted the Parisian cafés and brothels and commemorated their inhabitants with an art of supreme quality.

🌑 There is an extraordinary immediacy and tension in his work, resulting from his mastery of his subject matter and technique. The prostitutes and drunks, although sometimes close to caricature, are shown without sentiment or criticism – he loved and understood them. The brilliant, wiry draughtsmanship and thin, nervous paint seem to reflect their uncertain, shadowy world; you sense that he was part of that world, not just an observer.

🔎 The economy of the brush strokes and the simplicity of the materials are as direct and basic as his subjects. He used paint thinned with turpentine that allowed fine, rapid marks, and unprimed cardboard, which he did not try to disguise – exploiting its rawness and colour and the way it absorbs diluted oil paint.

🏛 Paris: Musée d'Orsay. Albi (France): Musée Toulouse-Lautrec
🅐 (206) £455/$655– £5,629,139/$8.5m
🔨 £8,098,160/$13.2m in 1990, *Danseuse assise aux bas roses* (works on paper, 1890)

TOWNE Francis NH
c.1739–1816 British

Painter of imaginative watercolours, which are notable for their simplicity and strong sense of design – more 20th than 18th century in feel. They have clear outlines, in waterproof ink, and clear washes of colour. Most were preliminaries to projected bigger oil paintings that never materialised. He was interested in precise light effects for a particular time of day. Little known in the 18th century.

🅐 (4) £2,200/$2,860 – £84,000/$137,760
🔨 £84,000/$137,760 in 1999, *Lake Albano – morning sun rising over Rocca del Papa* (w/c, 1781)

4

TRUMBULL John NH
1756–1843 American

Ambitious, pretentious, unfortunate (blessed with an uncanny sense of bad timing) and finally embittered. The first college graduate (Harvard) in the USA to become a professional painter (although his parents thought art to be a frivolous and unworthy activity).

◑ His main aim was to excel in history painting, but this was going out of fashion. He took as his subjects the recent history of the triumphs of revolutionary American colonies. Completed 8 of a projected series of 13 and was commissioned by an unenthusiastic Congress to do 4 for the rotunda of the Capitol in Washington. Struggled to achieve success – had to earn his way as a portrait painter, which he disliked.

🔍 Look for stagey compositions, theatrical lighting, and good and convincing faces done from life. (In another age he would have gone to Hollywood to make B-movies.) Why the bad timing? He served with Washington, but then went to London and was arrested as a rebel and very nearly executed. Went back to the USA, then returned to London in 1808 – but any hope of success was dashed by the War of 1812.

🏛 Washington D.C.: Capitol; Yale (USA): University Art Gallery
Ⓐ (1) £1,538/$2,200
🔨 £$183,098/$260,000 in 1986, *Portrait of John Adams* (oil p.)

TUNNARD John NH
1900–71 British

Textile designer and jazz musician who turned to painting in 1929. Settled in Cornwall in 1933 and became an expert field botanist. His best work dates from the 1930s when he created a consciously designed and personal world influenced by Surrealism, modern design ideas and the technology of radio and aeronautics. Produced period pieces, which improve with time.

Ⓐ (33) £1,200/$1,800 – £24,000/$33,840
🔨 £24,000/$33,840 in 2000, *Painting* (oil p., 1944)

TURA Cosmè (Cosimo) OM
c.1430–95 Italian

The first important painter to come from Ferrara. Most of his work has been lost. Had a hard, overelaborate style and used crisp lighting and strange,

1

2

artificial colours. Look for figures with prominent chins and claw-like hands; weird, unnatural folds in garments; crazy architectural settings with grotesque figures.

🏛 London: National Gallery

TURNBULL William CS
1922– British

Sculptor and painter who is difficult to pin down. Started with sculpture influenced by primitive and totemic art; moved on to Colour Field painting, then Minimalist

structures; also Caro-like painted steel. Claims a spiritual dimension through his interest in Eastern philosophy. His work is interesting, but too eclectic and derivative to carry any real conviction.

⊛ (5) £1,600/$2,592 – £32,000/$48,000

⚒ £32,000/$48,000 in 2000, *Ulysses* (sculpture, 1961)

TURNER Joseph Mallord William AG
1775–1851 British

The champion of Romantic landscape and seascape. The greatest British painter yet (apologies, Constable).

◑ Observe his ability to portray nature in all her moods, from the sweetest and most lyrical to the stormiest and most destructive. He had a deep, personal response to nature, using a wide-ranging source of inspiration (from Scotland to Italy). Applied a remarkable range of working methods, with fascinating technical and stylistic innovation, especially in his watercolours and later work. Had a never-ending interest in light, and a deep reverence for the old masters, especially in his early work.

🔍 Look for the sun – where it is; what it is doing; its physical qualities as light, but also its symbolism (rising, setting, hiding, warming, frightening; of a northern winter, of a Mediterranean summer, and so on). His early 'old master' style changes dramatically after his visit to Italy in 1819 (brighter palette, freer style and imagery). Note the detail in finished watercolours. Complex personal – sometimes secret – symbolism. He left sketchbooks that show his working process.

🏛 London: Tate Britain; Clore Gallery

⊛ (34) £429/$700 – £300,000/$483,002

⚒ £6.7m/$9,045,000 in 1984, *Seascape, Folkestone* (oil p.)

TURRELL James CS
1943– American

Produces gallery installations and land-art creations that are light-filled spaces. Wants to capture the physical reality (rather than the illuminating quality)

3

of light (natural and artificial). You, the viewer, are to move about and become so involved and absorbed that you experience a different level of consciousness (spiritual or cosmic).

⊛ (5) £2,390/$3,849 – £67,568/$100,000

⚒ £67,568/$100,000 in 2000, *Raetho* (sculpture, 1967)

TWACHTMAN John NH
1853–1902 American

Melancholic, romantic, solitary. Was from Cincinnati, but studied in Germany in the 1870s – hence his dark, Germanic, early work, which enjoyed a vogue in middle America. In the 1880s he studied

in Paris, where he was much influenced by Monet and Whistler. Had a perceptive understanding of French Impressionism and was the most inventive of American Impressionists. His snow scenes are as good as Monet's.

1

scribbles and marks, sometimes incorporating bits of text and diagram. If you require order, clarity, structure and specific meaning, you will hate it; if you like improvisation, hints, whispers and teases, you will love it. His claims of significant influence from Leonardo are special pleading.

- ⓐ (36) £1,975/$3,200 – £2,298,137/$3.7m
- 🔨 £2,976,190/$5m in 1990, *Untitled* (works on paper)

UCCELLO Paolo (Paolo di Dono) AG
1397–1475 Italian

Early-Renaissance Florentine, nicknamed *uccello* ('the bird'), instantly recognisable for his schematic use of perspective and foreshortening.

🌑 His overtheoretical application of the science of perspective tends to swamp all other considerations, and can make his work look rather wooden and the figures toy-like. But the sheer enthusiasm and gusto with which he used perspective stops his pictures from becoming dry or boring. His wife, however, complained that he loved his perspectives more than her.

🔍 Does he use a single viewpoint for the perspective, or are there several? Forget perspective and foreshortening for a moment and enjoy instead his strong sense of design and attention to decorative detail. Sadly, many of his works are in very poor condition. They are also often hung at the wrong height in galleries so that his carefully worked-out perspective effects are visually ruined. (If necessary, sit or lie on the floor and work out the proper viewpoint.)

- ⓐ (8) £1,867/$2,800 – £342,657/$490,000
- 🔨 £381,945/$550,000 in 1986, *Last Touch of Sun* (oil p.)

TWOMBLY Cy CS
1928– American

Much admired for his highly personal style consisting of apparently random

🏛 Florence: Santa Maria Novella; Duomo (frescoes); the Uffizi

What a sweet mistress is this perspective (said by him as he refused to follow his wife to their bedchamber). PAOLO UCCELLO

UDALTSOVA Nadezhda Andreevna MM
1886–1961 Russian

Leading member of Russian avant-garde who remained faithful to the Cubist lessons she learned in Paris in 1912.

She was not tempted to expand the boundaries and possibilities of Cubism, as her colleagues did, nor interested in using art in the service of the Revolution or for new industrial design. Produced work that is well and truly French, but ultimately unadventurous.

- Ⓐ (4) £1,500/$2,265 – £4,200/$6,342
- 🔨 £34,000/$55,420 in 1990,
 Collage, lettre de Russie
 (works on paper)

UECKER Günther CS
1930– German

His typical work (after 1955) consists of nails hammered into a board that are arranged in patterns reminiscent of electromagnetic fields. Monotony and repetition are deliberate and integral to

his work. He is motivated by Zen and visions of purity and silence; it is his personal belief that he should establish harmony between people and nature.

- Ⓐ (20) £388/$583 – £28,443/$43,234
- 🔨 £44,000/$65,560 in 1993,
 Weisses Phantom (scultpure, 1962)

UGOLINO DI NERIO (or Da Siena) OM
active 1317–27 Italian

Sienese; a close follower of Duccio, with a similar style, but his work is not as good. Its narrative is less well focused, its colours are less clear, and the faces and gestures lack Duccio's precision.

- 🔨 £110,000/$200,200 in 1990,
 Crucifixion (oil p.)

UTAMARO Kitagawa AG
1753–1806 Japanese

The great master of the Ukiyo-e woodblock print. Produced compelling, delicate, frequently erotic images of women and their admirers. Note the elegant, elongated figures; and intense relationships communicated through poses, hands and faces. He successfully combined sophisticated design with psychological awareness. His dissipated lifestyle led to a falling off in quality.

- Ⓐ (1) £393/$637
- 🔨 £140,000/$233,800 in 1997,
 Beauty with Cat (prints)

UTRILLO Maurice MM
1883–1955 French

Popular painter known for not very challenging, crustily painted views of Montmartre, characterised by sharp perspectives and deserted streets. His best work was c.1908–16. Later work is less gloomy and contains small

1

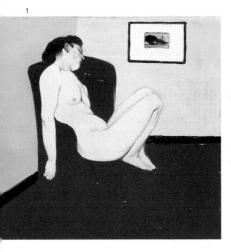

2

figures. Had a personal history of
mental instability.

- Ⓐ (177) £727/$1,156 –
 £199,629/$293,454
- ✸ £748,487/$1,296,612 in 1990,
 Le Café de la Tourelle à Montmartre
 (oil p., 1911)

VALADON Suzanne MM
1865–1938 French

Circus artiste-turned-model (for Renoir,
Toulouse-Lautrec *et al.*) who became a
painter. Produced unsentimental, uncom-
plicated portraits and nudes, with strong
colours and outlines. Mother of Utrillo.

- Ⓐ (35) £1,478/$2,364 – £37,234/$53,989
- ✸ £103,659/$170,000 in 1990,
 Nature morte au compotier
 (oil p., 1918)

VALLOTTON Félix MM
1865–1925 Swiss

There was a short period when he was
at the forefront of new ideas (1890–1901),
painting scenes of everyday life in original,
simplified form (he disliked straight lines,
preferred curves, round table tops, etc.).

Was influenced by Japanese prints and
the French Symbolists. Produced good,
often satirical, prints; otherwise
forgettable, traditional, realistic works.

- Ⓐ (102) £347/$552 –
 £1,016,260/$1,473,577
- ✸ £1,016,260/$1,473,577 in 2000,
 Sur la plage (oil p., 1899)

VARLEY John NH
1778–1842 British

Sublime Romantic watercolour painter,
whose landscapes are contemporaneous
with Turner's and who similarly began
the development from topographical
drawings to fully-developed watercolour
painting. Was most influential as a
teacher (of Linnel, Cox, Holman Hunt *et al.*).

- Ⓐ (68) £300/$453 – £9,000/$14,400
- ✸ £52,000/$79,040 in 1996,
 *Views of Bamburgh Castle,
 Northumberland* (w/c, 1808)

260

VASARELY Victor MM
1908–97 Hungarian/French

One of the key figures in the creation
of Op art in the 1950s. Produced hard-
edge abstract paintings designed to give
powerful, optical effects and illusions that
can often be explored and activated by
moving around the paintings. Satisfying,
but limited.

🅐 (106) £264/$422 – £19,505/$29,880
🔨 £120,000/$195,600 in 1990,
 Cintra (oil p.)

VAUGHAN Keith NH
1912–77 British

Slightly sad figure with considerable
talent as an artist but whose potential
never developed fully, perhaps because
he became too successful at supressing
his desires. His sombre work was
significant, especially in postwar, Cold
War gloom – mainly darkly painted,
semi-abstract monumental male figures,
to which he was (unhappily) attracted.

🅐 (50) £300/$480 – £11,000/$17,820
🔨 £40,000/$72,000 in 1991,
 Erotic Fantasies (works on paper)

VELASQUEZ (or VELÁZQUEZ)
Diego Rodríguez AG
1599–1660 Spanish

The great Spanish painter of the 17th
century whose life and work were
inextricably linked with the court of
King Philip IV. Not prolific. Very influential
on late-19th-century French avant-garde
painting.

👁 Observe the extraordinary and
unique interweaving of grandeur,
realism and intimacy, which ought to
self-cancel but result in some of the
finest official portraits ever painted.
Notice the grand poses, characters
and costumes; eagle-eyed observation
(he never flatters or idealises); and
a feeling of sensual intimacy through
seductive colours and paint handling.
His religious and mythological paintings
sometimes fail to convince because he
was simply too realistic.

🔍 Great sensitivity to light, which
is recorded with pin-sharp accuracy in
his early work and evoked by loose and
flowing paint in later work. See how he
makes ambiguous and mysterious use
of space, which has the effect of drawing
the viewer into the picture and therefore
closer to the figures. Is better with static,
solitary poses than with movement or
people supposedly communicating with
each other. There are sensational colour
harmonies (especially pink and silver) in
his late work.

🏛 Madrid: Museo del Prado
🅐 (1) £4,939,025/$8.1m

3

🔨 £4,939,025/$8.1m in 1999,
 Saint Rufina (oil p.)

VELDE Esaias van de OM
c.1591–1630 Dutch
One of the founder members of the
realist school of Dutch landscapes.
His soft, monochromatic scenes (often
in winter) are characterised by a feeling
of natural, unstagey open space and

atmosphere. Showed good detail, especially in the anecdotal figures going about their daily business.

- 🆎 (9) £1,300/$2,106 – £274,390/$450,000
- 🏹 £274,390/$450,000 in 1990, *Rocky landscape with travellers and horsemen on path* (oil p., 1616)

VELDE Willem van de (the elder) OM
1611–93 Dutch

Talented maritime painter, but eclipsed in popular esteem by his oil-painter son. His principal achievements are drawings of ships and small craft, and pen paintings in ink on white canvas or oak panel. The paintings have meticulous, accurate detail. He spent much time at sea with the Dutch fleet. Emigrated with family to England (c.1672) to escape political confusion in Holland.

- 🆎 (2) £4,942/$7,956 – £100,000/$155,000
- 🏹 £598,160/$975,000 in 1998, *Dutch harbour in a calm with small vessels inshore* (works on paper)

VELDE Willem van de (the younger) OM
1633–1707 Dutch

Precocious son of hard-working maritime-painter father. His early work concentrates on accurately drawn and carefully placed fishing vessels on tranquil seas, with large light-filled skies. After 1670 he produced portraits of particular ships, naval battles and storms at sea. His later work (after 1693) is more freely painted. Worked extensively from his father's drawings.

- 🆎 (11) £400/$644 – £1.45m/$2,349,000
- 🏹 £1.45m/$2,349,000 in 1999, *The morning gun, small English man-o-war firing a salute* (oil p., 1673)

VENEZIANO Domenico OM
c.1400–61 Italian

Important and very influential Venetian who worked in Florence. Almost nothing is known about him now and there are only two known works surviving. Was more interested in constructing with light and colour than with modelled form and perspective.

- 🏛 London: National Gallery Florence: the Uffizi

VERMEER Jan AG
1632–75 Dutch

Now regarded as the finest Dutch genre painter, but he was not famous in his own lifetime and was unrecognised until the end of the 19th century. Less than 30 works are known for certain to be by him.

- 🌙 Apart from a few early works he constantly reworked the same theme: the corner of a room with that unique, exquisite, tantalising observation of the organisation of space, the fall of light and enigmatic human relationships. One has a sense of being an unobserved intruder – looking into a time capsule and into a moment of human intimacy that is as alive today as it was then.

- 🔎 Would the paintings work if they were any bigger, or would the organisation and intimacy fall apart? Look for the way light catches a pearl, lace, silk, or a gold frame. He deliberately places figures in a way that makes them slightly distanced in space and mood. One of the few painters to genuinely make time stand still. Makes superb use of cool, smokey blues.

- 🏛 Amsterdam: Rijksmuseum The Hague: Mauritshuis Washington: National Gallery

VERNET Claude-Joseph OM
1714–89 French

Established a successful formula for rather stagey, evocative views of Italianate landscapes, coastlines and especially shipwrecks, much admired by 18th-century collectors. His major project

(commissioned by Louis XIV) was 16 views of major French seaports (1753–65).

🏛 Paris: Musée de la Marine
Ⓐ (28) £366/$582 – £1.2m/$1,994,000
➤ £1.2m/$1,994,000 in 1999, *Le soir – Mediterranean harbour at sunset with fisherfolk* (oil., 1752)

VERONESE (Paolo Caliari) AG
c.1528–88 Italian

One of the major Venetians and one of the greatest-ever creators of decorative schemes. So called because he came from Verona. He had a huge output.

❥ See his work in situ – in one of his large-scale decorative schemes, such as a Venetian church or a nobleman's villa. Don't look for profound meaning or a deep experience; let your eye have a feast and enjoy the glorious visual and decorative qualities. Try and spot some of the illusionistic tricks and remember that these works were intended to go hand in hand with a particular building – with its space, architectural detail and light.

🔎 Look for the posh people (his clients), surrounded by their servants, rich materials and classy architecture. Look at the faces. Have they become bored by too much good living and leisure? These are the last days of the really good times for the Venetian Empire. Is that why the dogs and animals often seem more alive than the people? The deities and Madonnas he portrays are no more than Venetian nobility in fancy dress.

🏛 Venice: Accademia, Doge's Palace, churches; Vicenza: Villa Maser

💰 (7) £4,294/$7,000–£275,862/$400,000

🔨 £1,626,506/$2.7m in 1990, *Cupid Disarmed by Venus* (oil p.)

VERROCHIO Andrea del AG
c.1435–88 Italian

Son of a brickmaker. Trained with a goldsmith, whose name he took. Became a leading Florentine painter,

1

goldsmith and (principally) sculptor. Had a large workshop where Leonardo trained. Authentic paintings by him are very rare.

💡 His altarpieces show an overall mood and style of refinement, grace, freshness and delicate idealism. They have a dreamy, faraway atmosphere, which is reflected in the eyes and expressions on the faces. He portrayed two types of face and body: epicene youth and craggy, tough warrior. Also painted similarly fresh, delicate landscapes and skies that contrast with craggy outcrops and rocks. Look for clear outlines and bright colours.

🔎 Note his love of fine detail, showing in expensive fabrics decorated with gold thread and jewellery. Notice the bow-shaped lips pressed together; the stylised curly, wiry hair; the refined hands that are touching each other or others; poses that imply movement through weight being placed on one foot or one leg. His figures seem modelled and conceived as sculpture.

VIEIRA DA SILVA Maria Elena MM
1908–92 Portuguese

Produced thickly worked abstract pieces built around underlying grids. Her output is personal, lyrical, introspective – characteristic of much of the work that originated in Europe in the 1950s.

💰 (47) £1,624/$2,630 –£180,000/$259,200

🔨 £450,000/$792,000 in 1990, *Souterrain* (oil p., 1948)

VIEN Comte Joseph-Marie OM
1716–1809 French

One of that band of competent artists who bridge the gap between styles (Rococo and neoclassicism, in his case) without establishing a significant place in either. Produced delicate, whimsical works, which are softly neoclassical in subject and setting, but Rococo in their mood and lack of seriousness.

*His style in sculpture and painting was somewhat hard and crude, as if he had acquired
his skill rather by indefatigable study than by any natural gift or facility.*
GEORGIO VASARI *on* ANDREA DEL VERROCHIO

2

3

4

🅐🅥 (5) £4,392/$6,983 –
£33,784/$50,000

🔨 £203,874/$379,205 in 1992,
*La toilette d'une jeune mariée dans
le costume antique* (oil p., 1777)

VIGÉE-LEBRUN
Marie-Louise-Élisabeth OM
1755–1842 French

Successful portrait painter in last years
of the *ancien régime* and a member of
the French Academy. Best at somewhat
sentimental lushly coloured portraits
of fashionable women (said to have
painted Marie Antoinette 25 times).
Left France in 1789 to tour Europe. Wrote
a good autobiography.

🅦 (9) £4,334/$6,285 –
£121,622/$180,000

🔨 £401,130/$710,000 in 1991,
*Portrait of Hyacinthe Gabrielle
Roland, Countess of Mornington*
(oil p., 1791)

VINCENT George NH
1796–1832 British

Short-lived member of the Norwich
School. Painter of busy, anecdotal, cool
and silvery landscapes. Crome's best
pupil, and one of the best landscape
painters of his day. Scottish scenes
after a visit to Scotland in 1819. Had

poor health and bad debts forced him
into prison in 1824.

🅐🅥 (13) £380/$547 – £5,800/$9,396

🔨 £11,500/$21,965 in 1992,
*View of the Needles, Isle of Wight,
from Christchurch* (oil p.)

VIOLA Bill CS
1951– American

One of the very few to use video
to genuinely creative effect. Tackles
age-old subjects such as birth, death
and human relationships, with
experience and understanding, and
builds up imagery in ways analogous
to the processes of a painting. Also
uses the technology to involve the
viewer in creating the final image.
Moving, perhaps even profound, work.

1

⬧ One of the reasons why he is so successful and so convincing is that he does not use the video medium and technology as an end or phenomenon in itself. He has something he wishes to say about the human condition and uses video technology to express it (just as others might choose painting or sculpture). Like all the best artists, he is totally in control of his chosen medium and can take it to the edge of its limitations.

🔨 £8,500/$14,110 in 1997, *The Passing* (photographs, 1991)

VIVARINI family OM
active 15th century Italian

Venetian family of painters. Antonio (c.1415–84) and younger brother Bartolomeo (c.1432–c.1499) produced large, old-fashioned, polyptych altarpieces with stiff figures and elaborate carved frames. Antonio's son Alvise (c.1445–1505) produced more modern work in the style of Giovanni Bellini. Good example of traditional craftsmen's business producing work to please a conservative clientele.

🔨 £78,313/$130,000 in 1990, *Head of St Francis* (oil p.) by Antonio Vivarini

VLAMINCK Maurice de MM
1876–1958 French

Volatile and boastful character who made a brief splash as one of the avant-garde Fauve artists in France c.1905–6.

⬧ His early landscapes are full of colour, thickly and freely painted, and with strong simplified designs. They express the mood of adventure and experimentation that captured the imagination of progressive young French artists at the time. His later landscapes degenerated into a boring formula; superficially they look modern, but they are not.

🔍 Separate the subject matter (which is actually not very innovative) from the way it is painted (which is), and maybe question the reason for this balance between old and new. He used a not very

2

subtle palette of four colours – red, blue, yellow and green – but wove them together to create a strong visual 'fizz'.

- ⒜ (213) £646/$950 – £502,513/$793,970
- 🔨 £6.67m/$10,721,805 in 1990, *Les pêcheurs à Nanterre* (oil p.)

3

VOS Marten de OM
c.1531–1603 Flemish

Leading painter in Antwerp. Combined Flemish realism and detail with Italianate subjects, grandeur and idealisation (visited Rome, Florence and Venice 1552–8). Painted altarpieces (vertical, with elegant elongated figures); portraits (worldly Flemish burghers and plain backgrounds); mythologies (large in scale, ambitious and decorative).

- ⒜ (6) £949/$1,500 – £40,000/$58,800
- 🔨 £80,000/$117,600 in 1993, *Calumny of Apelles* (oil p.)

VUILLARD Édouard MM
1868–1940 French

Shy, highly talented painter and printmaker who was in the forefront of new artistic ideas up to 1900, after which he retreated into his own comfortable, intimate world.

☽ He is best known for his glimpses of middle-class life – mostly cluttered domestic interiors with people sewing, reading, relaxing or hiding. Had a nervous style, with busy surfaces that flicker with light or allow the image to build up like a mosaic. Was fascinated by repeating patterns, such as woven material or wallpaper. Rich, earthy palette. Warm sense of colour.

🔎 In his early work he pioneered simple design, strong colour and energetic brushwork. He was an enthusiastic photographer and his works show this influence, having a snapshot-like quality.

- ⒜ (135) £500/$709 – £1,888,112/$2.7m
- 🔨 £4,516,129/$7m in 1989, *La table de toilette* (oil p.)

WADSWORTH Edward NH
1889–1949 British

Successful member of the avant-garde who ran through the voguish styles of his time: geometric and Cubist pre-1914; representational in the 1920s; figurative Surrealist in the 1930s; abstract in the 1940s. Rather good work, in a derivative way. His skill at Cubist fragmentation led him to design and paint ship camouflage in World War 1.

- ⒜ (4) £1,000/$1,620 – £22,000/$4,500
- 🔨 £150,000/$274,500 in 1992, *The Cattewater, Plymouth Sound* (oil p.)

1

WALL Jeff CS
1946– Canadian

Produces immaculate cibachrome photographs presented in steel frames and illuminated from behind by fluorescent tubes. The expectation created by their detailed photographic realism is that they are 'from life'. In fact they are carefully selected and posed artificial tableaux, maybe using actors. A neat play on what is reality and what is art.

- Ⓐ (1) £176,056/$250,000
- 🔨 £176,056/$250,000 in 2000, *The Well* (photographs, 1989)

WALLIS Alfred NH
1855–1942 British

Cabin boy turned rag-and-bone merchant who started to paint at the age of 70, after his wife died. His work is genuinely naïve, notably simple ships painted on bits of board with household paint. Had an instinctive feel for design and picture making, and was taken up by Ben Nicholson and friends. Died unhappy, alone and disturbed.

- Ⓐ (6) £4,500/$7,110 – £8,800/$12,760
- 🔨 £23,500/$38,305 in 1998, *Coastal Steamer* (oil p.)

WARD James NH
1769–1859 British

Brother-in-law of George Morland. Memorable mostly for large-scale pictures of animals, and landscapes bursting with Romantic drama and emotion, notably the vast *Gordale Scar* (Tate Britain) with bulging-eyed heroic cattle, exaggerated cliffs and stormy skies. He was not appreciated in his time – died in poverty – although he was an inspiration to Géricault.

- Ⓐ (18) £320/$515 – £92,000/$131,560

- 🔨 £231,707/$380,000 in 1996, *Adonis, King George III's Favourite Charger* (oil p.)

WARHOL Andy AG
1928–87 American

A neurotic surrounded by drug addicts, but a key figure: his work represents one of art's turning points, changing the role of the artist and his or her way of seeing and doing things, as did Leonardo in the 16th century and Courbet in the 19th century. A great voyeur.

- 🌑 Look for instantly recognisable, talented work. His images were drawn from the world of Hollywood, films, TV, glamour, mass media and advertising (Marilyn Monroe, Chairman Mao, the Coca Cola bottle, Campbell soups, etc.). He deliberately recalled and exploited the values of the world by using its visual language: bright colours, silkscreen technique, repetition, commercial simplification and compelling (sometimes shocking) images. Was also a (mediocre) fashion designer and film-maker.

- 🔎 He set up a new role model for the

artist (much aspired to by today's young stars): no longer the solitary genius expressing intense personal emotion (as Picasso and Pollock did), but the artist as businessman – the equal of Hollywood film stars and directors and Madison Avenue advertising executives. Son of

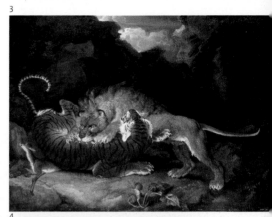

Czech immigrants, he acted out an American dream cycle – pursued a driving need to be famous and rich, like his subjects, and ended up destroying himself.

🏛 Pittsburgh (USA): Andy Warhol Museum

AV (656) £304/$486– £2,957,747/$4.2m

🔨 £9,722,223/$15.75m in 1998, *Orange Marilyn* (works on paper, 1964)

WATERHOUSE John William NH
1849–1917 British

Eminent High Victorian 'Olympian' ('the name given to London Royal Academy artists who had an interest in illustrating subjects from Greek and Roman mythology). Had a large-scale lavish, richly coloured technique, with chunky rapid brushwork. Was fascinated by the image of the enchantress. Liked drama – the psychological tension generated between a single figure and an attentive group, for instance.

AV (8) £1,200/$1,956 – £6m/$9,060,001

🔨 £6m/$9,060,001 in 2000, *St Cecilia* (oil p.)

WATTEAU Jean-Antoine AG
1684–1721 French

The most important French painter of the first half of the 18th century. Created a fresh, new, unassuming style, which was badly needed at the time. Had a poor family background and indifferent health. Trained as a scene painter at Paris Opéra.

❧ He invented the *fête galante* – a sort of stage set and dream world of perfectly mannered human love and harmony with nature, which is nevertheless grounded in acute observation of reality and never sentimental. Note how by gesture, light and facial expression, he counterpoints frivolity with a profound melancholy

suggesting the deeper issues of humanity (as Mozart did). His pastel colours and delicacy with the brush perfectly echo his subject.

❥ His forms are often tantalisingly half-suggested and require completion in the imagination (as in love, where a half-spoken sentence or a snatched glance can be made to mean everything). His statues seem on the point of becoming flesh and

blood and joining the human activity. He made exquisite red-and-black chalk drawings, gouaches and pastels done from life – used as a repertoire for his paintings. The nearest that painting came to music before abstract art.

🏛 Paris: Musée du Louvre
London: Wallace Collection
Ⓐ (12) £813/$1,162 – £2.2m/$3,234,000
🔨 £2.2m/$3,234,000 in 2000,
Le Conteur, artist from the Commedia dell'Arte in a landscape (oil p.)

WATTS George Frederick NH
1817–1904 British

Aimed to emulate the grandeur and achievements of Titian and Michelangelo,

and was known in his day as 'England's Michelangelo'. Produced portraits, allegories and landscapes that reflect the influence of his two exemplars but can now seem pompous and overambitious. He was a true Victorian Olympian in his ambitions, style and weaknesses. His portraits are his best work and have stood the test of time. Late in life he made sculptures.

Ⓐ (25) £300/$453 – £200,000/$320,000
🔨 £790,000/$1,121,800 in 1986, *Hope* (oil p.)

WEARING Gillian CS
1963– British

Social realist who takes photos or videos of people and uses the tension created by this situation to encourage them to reveal their inner thoughts, dreams and anxieties. She has some simple strategies, such as asking people to write their thoughts on a card; she also uses complex techniques, such as dubbing adult speaking faces with the voices of teenagers. Very slick presentation.

❥ From what you see there is no way of knowing whether she is filming innocent bystanders or competent actors with a script. She says not the latter but how can you know? Or is not knowing part of the fascination? Behind the serious claims for meaningful social comment there may be nothing more than patronising voyeurism by the audience and playing up to the camera by the subjects/actors and artist herself – public amusement at the expense of others' anxieties and misfortunes.

Ⓐ (6) £5,500/$7,975 – £8,500/$13,770
🔨 £8,500/$13,770 in 1999, *I'm desperate – signs that say what you want them to say* (photographs, 1992)

WEBER Max NH
1881–1961 American

Russian born, gifted. Studied with
Matisse (in Paris 1905–8) and produced
important Cubist paintings, being one
of first Americans to work in the modern
idiom. His later work is Expressionist
(à la Soutine), with Jewish subjects based

2

on Russian memories. He moved easily
between established styles – a common
sin, which produces pleasing results
but compromises originality.

- Ⓐ (14) £2,318/$3,500 –
 £39,877/$65,000
- 🔨 £84,848/£140,000 in 1997,
 The Visit (oil p., 1920)

WEENIX Jan OM
1640–1719 Dutch

Don't confuse him with his father,
Jan Baptist Weenix (1621–63), who went
to Italy from 1642 to 1646 and returned
to Holland, calling himself Giovanni
Battista. Jan the Younger never set
a foot in Italy but continued his father's

successful line in Italianate courtyards
and seaports occupied by people in
contemporary dress. Also painted
elaborate still lifes and hunting trophies.
Very skilled at painting textures, such
as silk, marble, silver and glass.

- Ⓐ (11) £1,689/$2,669 –
 £270,000/$418,500
- 🔨 £300,000/$456,000 in 1995,
 *Dead hare on plinth by urn, fruit birds,
 boy bearing fruit* (oil p., 1705)

WEIGHT Carel NH
1908–97 British

3

Stalwart supporter of the Royal Academy
and its tradition of figurative, storytelling
pictures.

- 🌙 His scenes of strange incidents,
 set in the London suburbs of Clapham
 and Battersea, usually at dusk, involve
 loneliness, fear, attack and escape,
 sometimes ghosts, and a general feeling
 of eeriness. The drawing and colouring
 are gauche and unsophisticated –
 perhaps deliberately – and reflect well
 the drabness of the streets and houses,
 as well as the lives that search for
 excitement and fulfilment within their
 narrow confines.

- Ⓐ (55) £400/$600 – £15,000/$22,500
- 🔨 £29,000/$48,720 in 1990,
 Sunday-go-to-Meeting (oil p.)

WEIR Julian Alden NH
1852–1919 American

The most academically successful
American Impressionist. Studied in
Paris. Conservative in technique and
temperament. His early work was
much influenced by Manet; later work

1

is closer to Monet. Was most successful
in his smaller works, particularly in water-
colour and silverpoint. Became President
of the National Academy of Design.

🅐🅥 (12) £494/$800 – £121,019/$190,000
🔨 £249,914/$400,000 in 1987,
 Nassau, Bahamas (oil)

WELLIVER Neil CS
1929– American

Produces large-scale paintings of
dense uninhabited woodland interiors
in the Maine landscape, usually in winter
or early spring. Does small-scale oil
sketches on the spot. Also works up
large-scale charcoal drawings and
finished oils in the studio, in the

manner of the Renaissance masters
and Constable. He never makes
corrections on the finished work.

🌑 Smart commentators claim
that the dense patterns in his work
come close to those of Jackson Pollock
– that he is really a cutting-edge new
abstractionist. Is this true or simply
a prize example of the clever-clever
intellectualising that bedevils the art
world? Forget the silly jargon. Enjoy
him for what he is – an artist who has
a passionate visual and emotional
response to landscape and a highly
personal way of sharing this with
others through his art.

🔨 £16,369/$27,500 in 1990, *Untitled*
 (oil p.)

WENTWORTH Richard CS
1947– British

Author of quite widely seen work
that fits into an easy category much
in vogue in the early 21st century: the
juxtaposition of found manufactured
objects and industrial materials. Titles
are sometimes drawn from children's
stories. There is some satisfaction to
be had in trying to work out what
connection (if any) there is between
the selected objects and the titles.

🔨 £4,500/$7,605 in 1990,
 Red Titch (sculpture, 1989)

WESCHKE Karl CS
1925– German/British

Refugee whose childhood was scarred
by war and prison camps. He settled
in Cornwall in the 1950s and produced
gloomy figurative paintings with a
sketchy, unfinished quality. Used sombre
colours and lonely, isolated subjects.

🔨 £2,800/$4,480 in 1996,
 Sea Painting (oil p., 1967)

well with the public and collectors and shook up less progressive artists. He later anticipated Romanticism by introducing melodramatic subjects of death and destruction with powerful contrast of light and shade. Was also a popular portraitist.

🅰️ (6) £307/$500 – £51,829/$85,000
🔨 £1.65m/$2,607,000 in 1987, *Portrait of Sir Joseph Banks* (oil p.)

WEYDEN Rogier van der AG
c.1399–1464 Netherlandish

The greatest and most influential northern painter of his day. Set the standard by which the rest are judged. Brussels based. Worked for the dukes of Burgundy. Had a large workshop and was much imitated.

🌙 Look for the presence of Christ in contemporary life and powerful tension between reality and unreality. The meticulous detail of cloths, clothes, fingernails and hair, faces drawn from life, anecdotal detail create an illusion of reality. But the stiff poses, cramped spaces and static expressions are wholly unreal. Is it this tension that draws the eye so magnetically into the drama and the serious aspiration of the religious message (itself an interplay of the real and unreal)?

🔍 Note also his superb portraits, each with minute, natural individuality – especially the fingernails, knuckles, red-rimmed eyes and stitches on clothing. He was also fascinated by architectural and sculptural detail. See how he uses facial expression and poses that are appropriate to the emotion expressed, showing tear-streaked faces and an understanding of grief; observe how one figure echoes the poses and gestures of another, as if in emotional sympathy. He adopted a softer, more relaxed style after 1450 (Italian influence after visit to Rome).

WEST Benjamin NH
1738–1820 American

Pennsylvania born and the first American artist to achieve international recognition. European trained and based after 1760, he became the second President of the Royal Academy, London (after Joshua Reynolds) and was employed by George III (who lost the American colonies). His work is an acquired taste for modern eyes.

🌙 His art is second-hand – derived if not exactly copied from others. He was gifted with an enviable ability to sniff out what was going to be immediately next in fashion and to produce it. Thus he was always in the public eye and successful. His early large-scale works often portray obscure literary subjects and have a stiff, rather flat and wooden style that caught the taste for the neoclassical.

🔍 Note how (from 1770 onwards) he cleverly adapted neoclassicism by delivering the same heroic message via subjects from modern rather than ancient history – this went down

1. James Abbott McNeill Whistler, *Nocturne in Black and Gold, the Falling Rocket*, c.1875
2. Sir David Wilkie, *The letter of introduction* (panel), 1813
3. Richard Wilson, *Snowdon*

🏛 Madrid: Museo del Prado; Escorial
Berlin: Staatliche Museen

WHISTLER James Abbott McNeill MM
1834–1903 American

Small, egocentric, quarrelsome, witty and dandy. Born in the USA, later lived in Europe (France and England). Leading figure of the Aesthetic Movement, he developed a new style of painting and role for the artist. Was a contemporary of Oscar Wilde.

☽ Look for painting as an aesthetic object and experience – the subject matter taking second place to the visual pleasure of colour and form. Note the subtle harmonies of soft colour, carefully placed shapes and suppression of detail. He chose simple subjects, expressive of mood. His portraits say little about the

sitter's personality. Why was he so tentative? Was he never at ease with painting? Arguably his best works are his prints, where he never lacked self-confidence.

🔍 The thin paint surface belies the fact that he worked and reworked his pictures, wiping away his efforts until he had reached his notion of perfection (which must have been agonising for his portrait sitters). Some works are still in their original frames, designed by Whistler to harmonise with the painting. Look for his famous 'butterfly' signature, which he used after 1870. Much influenced by Japanese art, Velasquez and Manet (he had to be up to date and in the forefront of fashion).

🏛 London: Tate Britain
Glasgow: Hunterian Museum
Washington: Freer Gallery
🅐 (46) £442/$707 – £1,756,757/$2.6m
🪓 £1,756,757/$2.6m in 2000, *Harmony in Grey, Chelsea in Ice* (oil p.)

WHITELEY Brett NH
1939–92 British/Australian

Painter, sculptor and printmaker of extreme sensibility who became a cult figure but also increasingly alienated from society. He created sensual, erotic, figurative works, which symbolise human estrangement. Used animal imagery as an analogy for human depravity, and incorporated waste material in some works as an acerbic comment on artistic and social conventions.

🅐 (148) £377/$569 – £711,462/$1,145,455
🪓 £711,462/$1,145,455 in 1999, *The Jacaranda tree, on Sydney Harbour* (oil p.)

WHITEREAD Rachel CS
1963 – British

One of the most fashionable of the 30-something British artists who have gained international attention. Much featured in the media.

2

3

◗ She creates single-minded work of very serious, austere appearance. Makes physical casts in concrete, resin, rubber, and so on, of everyday objects and spaces (yes, spaces), such as the inside of a bath, spaces under chairs and, most famously, the inside of complete rooms of a Victorian house (the house was then demolished by the local authority). The rationale is that she makes concrete the ordinary, banal spaces we inhabit and on which we leave the imprint of our existence.

🔎 So far has had one good and worthwhile idea, which has caught attention and which she has explored in a dedicated and conscientious manner. But do the actual objects she creates have lasting merit? Will what she creates turn out to be profound or just parochial? Where on earth does she go next? Is she a seven-day wonder, or at the beginning of a long and memorable career? Such unanswerable questions are the stuff and fun of an involvement with high-profile contemporary art.

ⓐ (12) £1,700/$2,754 –
£62,112/$100,000
🔨 £120,000/$201,600 in 1998,
Untitled, Square Sink (sculpture, 1990)

WILKIE Sir David NH
1785–1841 British

Scottish, direct, down-to-earth and ambitious. His individual style, which embraced the narrative subjects of everyday life and loaded them with authentic detail, was very influential throughout Europe. His manner became more contrived and Romantic after a visit to the Continent in 1825–8. Was much admired by the Prince Regent (George IV) who bought Wilkie's paintings and ignored Turner and Constable.

🏛 Edinburgh: National Gallery of
Scotland
ⓐ (14) £380/$600 –
£200,100/$286,200
🔨 £280,000/$470,000 in 1998, *The
artist's parents – double portrait of
the Rev. and Mrs David Wilkie* (oil p.)

WILSON Richard NH
c.1713–82 British

The first major British landscape painter. Produced lovely direct and typographical views and sketches, which were influenced by Dutch masters. He is especially known for successful set-piece works that are a synthesis of idealised

1. Peter de Wint, *Lincoln*
2. Franz Xavier Winterhalter, *Empress Eugénie surrounded by her Ladies in Waiting*
3. John Wonnacott, *The City of London from the Lloyd's Building*

1

2

3

classical formulae and actual places.
His work shows great sensitivity to light,
notably during and after his visit to Italy
in 1750–7, but it can become overfamiliar
and repetitious.

🏛 Cardiff: National Museum of Wales
London: Tate Britain
Oxford: Ashmolean Museum

🅐 (12) £680/$1,027 –
£130,000/$208,100

🔨 £190,000/$286,900 in 1996,
*Welsh landscape with cottages
near lake* (oil p., 1744)

WILSON Jane and Louise CS
1967– British

Twin sisters whose work is a research
into the manipulative influence and
methods of film, TV, music, advertising
and state politics. They work principally
with video, life-size photographs (C-prints)
and installations in which they
themselves may act out different roles.
They are especially concerned with the
role of women and women as the object
of male fantasy.

🅐 (6) £4,730/$7,000 –
£22,000/$35,640

🔨 £22,000/$35,640 in 1999,
*Stasi City, interview corridor,
Hohenschonhausen Prison*
(photographs, 1997)

WINT Peter de NH
1784–1849 British

Gifted artist of Dutch extraction. Popular
both in his own lifetime and subsequently
as a watercolour painter (he also
produced a few disappointing oils).
Went on extensive sketching tours
throughout the UK, especially in East
Anglia, the north of England, the Thames
Valley and Wales. Painted attractive,
naturalistic landscapes with deep-toned
colours, some sketchy, some finely
finished. Also illustrated books.

🅐 (60) £300/$432 – £24,000/$34,320

🔨 £25,000/39,500 in 1998,
Lincoln Castle (w/c)

WINTERHALTER Franz Xavier NH
1805–73 German

Smooth-mannered, highly popular
Munich-trained portrait painter, notably
of the European monarchy (English,
Belgian and French) in their 19th-century

golden age. He captured their preferred self-image – royalty as bourgeoisie. His work brilliantly combines formality, intimacy and anecdote. Was a rapid worker, straight onto canvas, with an effortless, impersonal style. Also made lithographs.

Ⓐ (5) £1,195/$1,972 – £60,000/$97,200
🏹 £981,595/$1.6m in 1997, *Jeune fille de l'Ariccia* (oil p., 1838)

WINTERS Terry cs
1949– American

Creator of freely painted, colourful and large-scale abstracts. His early works are derived from organic and geological forms (crystals, cells, DNA). His more recent works are complex spiderwebs of lines, which derive from computer graphics and fractal geometry. His art is more complex and skilled than appears at first sight: he cleverly maintains balance, tension and depth in space and colour.

Ⓐ (11) £1,923/$3,000 – £91,216/$135,000
🏹 £91,216/$135,000 in 2000, *Picture Cell* (oil p., 1997)

WOLS Alfred Otto Wolfgang Schulze MM
1913–51 German/French

A lost soul, typical of the many dispossessed, destitute and unhappy people who were victims of political and social upheavals in central Europe at this era. Found solace in artistic activity and drink. Born in Germany but resident in France.

☽ He made small-scale works in oils and watercolours. The oils are often composed of compulsive pouring, smearing, spraying and scratching. The watercolours frequently have an obsessive concern with detail. What distinguishes Wols from many lesser jotters and scribblers is the quantity,

consistency and integrity of his work. Unrecognised in his lifetime, he persisted with and pioneered a new style of expressive abstraction.

🔎 He was remarkable for his attention to detail. Every mark, even in the freest of his abstractions, is there for a reason. (This is real integrity.) Try to see a group of works together: the end result,

4

individually and collectively, is a remarkable record of someone using art to rise above the hardships that killed many others – literally or spiritually. Together they are strangely beautiful and moving to look at and be with.

Ⓐ (20) £3,029/$4,481 – £19,733/$31,179
🏹 £530,000/$932,800 in 1990, *Untitled* (oil p.)

WONNACOTT John cs
1940– British

His work is everything that cutting-edge art is not. He is a real 'old-fashioned' painter of portraits, landscapes and cityscapes, and studio interiors. He is fascinated by perception – what and how we see, and how to record it – and also is obsessed by perspective. He chooses or sets up subjects with challenging perspectives (often with reflections) and explores them like a terrier gnawing at a bone.

1. **John Wootton,** *The Duke of Rutland's 'Bonny Black',* c.1720
2. **Joseph Wright of Derby,** *An Experiment on a Bird in the Air Pump,* 1768
3. **Andrew Wyeth,** *Sea Boots,* 1976
4. **Philips Wouwermans,** *Landscape with Kermis (The Rustic Wedding)*

⟐ He is a man with a mission. What would be a dry intellectual exercise in others becomes a dizzying and exciting journey through space. His disconcerting spaces are 'real' – he starts by using a sheet of Perspex, which he holds up in front of his subject and on it notes exactly and only what he sees. Will probably be remembered long after many younger stars have passed into oblivion.

🔨 £62,00/$9,424 in 1996, *Estuary Window, Nightfall* (oil p.)

Combined Keatsian Romanticism with archetypal interwar avant-garde interests. Studied in Paris (knew Picasso, Diaghilev, Cocteau). Joined the circle of Ben Nicholson. Had a successful *faux naïf* figurative style, especially in his scenes of Cornwall, Brittany and dreamy young fishermen. Produced strong drawings. Had a powerful sense of colour.

AV (30) £420/$680 – £72,000/$115,200

🔨 £72,000/$115,200 in 1999, *Marseilles Harbour* (oil p.)

WOOD Christopher NH
1901–30 British

Talented and emotionally unstable (was addicted to drugs; committed suicide).

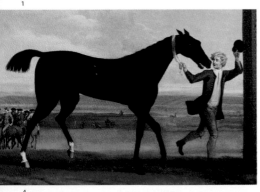
2

1

3

4

WOOD Grant NH
1892–1942 American

Painter of fantastical, childlike landscapes. Also portraits, prints, murals and stained glass. His quirky work reflects old-fashioned virtues: sobriety, strict parents and sexual morality. He had a painstaking, stiff, old-fashioned style, often working in tempera. Iowa raised, he was the (closet gay) altar boy of American regionalism.

🌑 *American Gothic* is as famous in American art as the *Mona Lisa* is in Italian art, and just as enigmatic. Does it parody the chaste and sober virtues it proclaims or is it admiring them? His work never reveals the answer, and he never confessed to anyone.

🏛 Chicago: Art Institute (for *American Gothic*)
🅰 (46) £1,852/$3,000 – £94,595/$140,000
⚒ £992,064/$1.25m in 1985, *Arbor Day* (oil p., 1932)

WOODROW Bill CS
1948– British

Fashionable 'name' who takes thrown-away everyday technology (such as old washing machines), which he cuts and shapes into representations of other seemingly unrelated objects. Works intuitively and adds other objects or paint, or both. Look for hidden or implicit symbolic references to the moral and social state of urban society, either in general or relating to a particular work.

🅰 (2) £1,220/$2,000 – £9,259/$15,000
⚒ £9,259/$15,000 in 1999, *Junk Dunk* (sculpture)

WOOTTON John NH
1682–1764 British

Shrewd, successful, sociable painter of classical landscapes, and especially of group hunting scenes and horse portraits for which he pioneered the stock formula beloved of later 18th and 19th centuries. Also painted some battle scenes.

🏛 Gloucestershire (UK): Badminton House
🅰 (7) £5,000/$8,000 – £255,000/$408,000
⚒ £255,000/$408,000 in 1999, *Earl of Coningsby with hunter in Hampton Court Park, Herefordshire* (oil p.)

WOUVERMANS Philips OM
1619–68 Dutch
Very successful (made a fortune). Was noted for his finely painted small-scale landscapes peopled with horses and riders, or featuring battle or hunting scenes. (Look for his trademark white horse.) Note his simple, careful compositions – a clear, white sky; a harmonious, hilly landscape; foreground figures. Elegant colouring. Unpretentious decorative art at its best.

🅰 (14) £2,485/$4,150 – £280,000/$411,600
⚒ £705,522/$1.15m in 1998, *Extensive river landscape with soldiers* (oil p.)

WRIGHT John Michael NH
1617–94 British

A talented Catholic portrait painter who spent the 1640s and 1650s in Rome and France and learned the virtues of allegory and elegance. He established a successful practice at the time of Charles II (1660) and James II. Was the exact contemporary of Sir Peter Lely, but had a more direct and realistic style that was never quite suited to fashionable taste. Died in poverty.

🅰 (3) £14,000/$22,400 – £290,000/$437,900
⚒ £290,000/$437,900 in 2000, *Portrait of Lord Mungo Murray in*

highland dress holding a flintlock gun with sword at his side (oil p.)

WRIGHT Joseph 'Wright of Derby' NH
1734–97 British

Talented and versatile painter, but out of the mainstream. Developed new and

WYETH Andrew CS
1917– American

Son of famous book illustrator. Popular and much collected. First achieved fame with the watercolours he painted in Maine in the late 1930s. Has a brilliant realist technique, but is unjustly derided by many contemporary critics and curators.

1

3

original subjects: night scenes, scientific experiments and early industrial forges. His paintings often have unusual light effects and offer fascinating insights into the Age of Reason and the nascent Industrial Revolution. Painted goodish, occasionally great, portraits.

- 🏛 London: National Gallery; Tate Britain
 Derby (UK): Museum and Art Gallery
- Ⓐ (10) £4,500/$6,750 –
 £210,000/$300,300
- 🪓 £1.3m/$1,625,000 in 1984,
 *Mr and Mrs Thomas Coltman
 about to set out on a ride* (oil p.)

🌒 His subjects are carefully chosen and all have deep personal meaning. At first sight they may look ordinary, but part of Wyeth's magic is his ability to make the commonplace hauntingly memorable. He is unconcerned by fashion or being up to date. His large-scale paintings are done in tempera (not oil), which is painstakingly slow to work with, allowing him to exploit his love of fine detail and focus on the quality of draughtsmanship rather than painterliness.

4

🔍 Observe the way he heightens realism by using strong design and unusual, artificial compositions; note also the way he contrasts fine detail with large areas of abstraction. His watercolours and dry-brush paintings are painted in a frenzy (they are often tossed onto the ground, which is why they may have smudges, tears or attached pieces of vegetation).

🏛 New York: MoMA for *Christina's World* (1948)

ⓐⓥ (30) £567/$850 – £540,541/$800,000

🔨 £956,790/$1.55m in 1997, *Christina Olson* (oil p., 1947)

YEATS Jack Butler NH
1871–1957 Irish

Brother of poet W. B. Yeats. Best known for lovingly painted scenes of Irish life and lore – horse fairs, gypsies and myths. His early work features virile draughts-manship and strong, flat colours. Later work has loose, expressive brushwork and is less naturalistic. Was a good observer of character and faces.

ⓐⓥ (87) £342/$547 – £1.12m/$1,814,400

🔨 £1.12m/$1,814,400 in 1999, *Wild Ones* (oil p., 1947)

ZOFFANY Johann (John) NH
c.1734–1810 German/British

German born painter who established his career in Rome and London from 1760. He lived in India 1783–9 and made a fortune painting native princes and British colonialists. His delightful informal group portraits are his best works – they capture the ease and prosperous confidence of Georgian upper-class society. Look for good anecdotal details such as costumes, and sporting, artistic and literary activities.

ⓐⓥ (2) £13,000/$20,450 – £1m/$1.6m

🔨 £2.8m/$4.34m in 1989, *Group Portrait of John, 14th Lord Willoughby de Broke, and his family* (oil p.)

ZORN Anders MM
1860–1920 Swedish

Prolific, talented and very successful, with a popular line in worldly-looking, fleshy nudes in plein-air settings. Also painted elegant portraits of the rich and famous. He had a virtuoso, free, paint technique, which cleverly (like Manet) suggests 1) equality with the old masters (Titian) and the modern (the Impressionists); and 2) (false) spontaneity. Made brilliant watercolours and etchings.

ⓐⓥ (49) £408/$661 – £617,193/$987,509

🔨 £1.6m/$2,608,000 in 1990, *Les baigneuses* (oil p., 1889)

ZUCCARELLI Francesco OM
1702–88 Italian

Florentine painter of Venetian-style high quality. Produced sugary, softly

coloured, easily painted pastoral
landscapes and cityscapes. Was much
admired by collectors of his day
(especially the English, who made him
a founder member of the Royal Academy).
Once spoken about in the same breath as
Canaletto, he is now virtually forgotten.

- ⓐ (16) £1,800/$2,646 –
 £101,351/$150,000
- ↗ £190,000/$313,500 in 1997,
 *Wooded landscape with
 washerwomen by river* (oil p., 1742)

ZURBARÁN Francisco de OM
1598–1664 Spanish

'The major painter between Velasquez
and Murillo' (interpret this as code
for good, not great). His principal patrons
were Spanish religious orders. Like
Caravaggio, his work has a hard-edged
realism, bright light and shade
(chiaroscuro), and demonstrates a
smooth technique and care for precise
detail. It has dramatic visual impact, but
lacks convincing emotion. Died out of
fashion and in financial difficulty.

- ⓐ (4) £49,080/$80,000 –
 £250,000/$400,000
- ↗ £1,165,644/$1.9m in 1998,
 Saint Dorothea (oil p.)

SUBJECTS
AND
STORIES

Aaron

The elder brother of Moses and the prototype Jewish priest. He wears a robe with a fringe of golden bells, a turban or papal tiara, and carries a censer and flowering wand.

☞ Golden Calf; Moses

Abacus

A counting frame. One of the attributes of Arithmetic.

☞ Liberal Arts

Abel

See Cain and Abel

Abraham

The first great Hebrew patriarch. White-haired, bearded figure who carries a knife. Action-packed life, but look above all for the moment when, to test his loyalty, God ordered Abraham to sacrifice his son Isaac. God intervened at the last minute and Abraham sacrificed a ram caught in a thicket, instead. The story was considered to foretell or symbolise God's sacrifice of Christ.

☞ Hagar and the Angel

Abundance

A female figure holding a cornucopia and surrounded by children, representing the benefits of peace, justice and good government. Present day rulers please note.

☞ Cornucopia

Achilles

The Greek hero of the Trojan War and the lead figure in Homer's *Iliad*, who was killed in a plot. The Trojans proposed a peace deal to end the war: Achilles was to marry the Trojan king Priam's daughter, but as Achilles knelt to make a sacrifice to Apollo he was shot in the heel by Paris

1

(Priam's son), Apollo guiding the arrow. (Achilles failed to realise that Apollo was currently supporting the Trojans.) Why the heel? His mother (Thetis) was a sea nymph and at his birth she tried to make him invulnerable by dipping him in the River Styx. It worked, except for where she held him – by the heel.

☛ Apollo; Feast of the Gods; Hector; *Iliad*; Nymphs; Paris; Peleus; Priam; Styx; Thetis; Trojan War; Vulcan

Acis

See Galatea

Actaeon

A young prince keen on hunting who had the misfortune to glimpse the virgin goddess, Diana, naked. She turned him into a stag so that he was torn to pieces by his own hounds. A popular subject, which shows that the ingredients (in no particular order) of sensational stories never really change: nudity, violence, accidental misfortune, revenge, the battle of the sexes, death.

☛ Diana

Adam and Eve

The first man and woman, created by God on day six of the Creation, along with the animals. Look for God touching Adam or breathing into his nostrils. Eve was made from Adam's rib – look for Adam in a deep sleep as the rib is removed, or Eve emerging from Adam's side. They were fatally tempted in the Garden of Eden and fell from grace.

☛ Cain and Abel; Expulsion; Garden of Eden; Naming of the Animals; Noah; Paradise; Temptation; True Cross

Adonis

The most beautiful young man ever a genetic freak – he was the result of an incestuous union), with whom Venus fell in love (Cupid's fault). Adonis was killed by a wild boar when out hunting,

2

so Venus caused his blood to create the first anemone. Look for Venus trying to stop him leaving for the hunt or grieving over his dead body with the anemone. Presents a good artistic challenge: the image of perfect male beauty in a young man at the moment of transition between boyhood and adulthood.

☛ Cupid; Venus

Adoration of the Magi

The Magi are the three wise men, or kings, from the East who followed the stars to Christ's birthplace in the stable at Bethlehem. Look for the oldest of the three, Caspar (King of India), who gives a gift of gold; Balthazar (King of Arabia), the negro, with myrrh; and the youngest, Melchior (King of Persia), with frankincense. Note their sumptuous

1. Gentile da Fabriano, *The Adoration of the Magi*, detail of *Virgin and Child with Three Kings*
2. Bartolomé Esteban Murillo, *The Adoration of the Shepherds*
3. Hans Baldung Grien, *The Ages of Man and Death*

1

Eastern costume, their turbans, sometimes their camels and the fine goldsmiths' work of the containers of their gifts. Imagery is sometimes used to show the submission of temporal (kingly) authority to the Church.

☞ Nativity

Adoration of the Shepherds

The archangel Gabriel told a group of shepherds of the birth of Jesus and they went to the stable in Bethlehem

2

to pay homage. Look for the gifts they sometimes bring, such as a sheep, eggs or a jug of milk.

☞ Gabriel; Nativity

Aeneas

The hero of Virgil's *Aeneid*. He was a Trojan prince (father Anchises, mother Venus) who escaped by sea with a group of companions when the Greeks sacked Troy. After many adventures they landed in Italy and became the legendary ancestors of the Romans. Look for various episodes in his adventures, especially his love affair with Dido and his descent into the Underworld. Also, look for him rescuing his family from the burning ruins of Troy.

☞ Dido; Trojan War; Underworld; Vulcan

Aeolus

The god who controlled the winds.

Agamemnon

The victorious Greek commander in the Trojan War.

☞ Achilles; Iphigenia; Trojan War

Genius is childhood recaptured at will.
CHARLES BAUDELAIRE

Agatha

Christian virgin saint who rejected the love of a Roman governor and was badly tortured, including having her breasts cut off (she holds them in a dish). Her death was accompanied by earthquakes and volcanic eruptions.

Ages of Man

Usually portrayed as Three Ages or Seven Ages. Look for various permutations of babies, children, young lovers, warriors, old men and old women. You may also find the figure of Death lurking in the background. The message is simple: earthly life, youth and beauty are transient. Death is the one absolute certainty for all living creatures.
☛ Death; Vanity

3

Ages of the World

There were four according to Ovid, but the third is not usually illustrated. Golden Age – man lives in innocent harmony with nature who supplies all his needs; Silver Age – man learns to look after himself in a simple way and learns the difference between right and wrong; Bronze Age – things begin to go wrong; Iron Age – now, a world full of greed and deceit.

Agnes

Christian saint and virgin martyr. This is a complicated story: briefly, she was courted by but refused to marry the son of a Roman prefect. His father condemned

her to be thrown into a brothel, but her nakedness was hidden by her hair, which suddenly lengthened, and her virginity was protected by a shining light and divine intervention. In the end she was beheaded. The white lamb with her has nothing to do with the story; it appears only because the Latin name for lamb – agnus – is like Agnes.

Agony in the Garden

Between the Last Supper and his arrest, Jesus went to the Mount of Olives to pray. The Agony (from the Greek word for contest) is his spiritual struggle. His human nature feared the physical suffering he was about to undergo, but his divine nature understood its necessity. Look for

Peter, James the Greater and John the Evangelist asleep nearby, possibly Judas approaching with soldiers, and a vision of the chalice and wafer of the Christian Communion.
☛ Betrayal; Eucharist; James the Great; John the Evangelist; Judas Iscariot; Last Supper; Peter

Alchemist

The principal (unaccomplished) task of the alchemist was to find a substance called the philosopher's stone, which would miraculously turn cheap metals into gold and silver, and prolong human life. Alchemists are still around today, but operating under different professional

1. Peter Paul Rubens, *Battle of the Amazons and the Greeks*
2. Fra Filippo Lippi, *Madonna and Child with Angels*
3. Lorenzo di Credi, *Annunciation*

1

Alpha

The first letter of the Greek alphabet. Can be seen on the pages of an open book held by God, together with Omega, the last letter. Alpha and Omega symbolise God as the beginning and end of all things.

Amazons

A legendary race of warrior women who were good with horses and bows and arrows. They were finally defeated by the (male) Athenians led by Theseus. Look for a fierce battle on a bridge with plenty of violence and nudity.
☛ Labours of Hercules; Theseus

Ambrose (c. 338–397)

One of the four Fathers or Doctors of the Church. Look for a bishop holding a pen or book; he carries a three-knotted scourge for beating heretics. Look also for the beehive (when he was a baby a swarm of bees entered his mouth, which made him very eloquent).
☛ Doctors of the Church

names and with more sophisticated techniques to trap the foolish.

Alexander the Great (353 – 323 BC)

The ultra-cool military genius and empire builder from Macedonia who died at the age of 32. Among his many memorable exploits are the taming of the white horse Bucephalus, cutting the Gordian knot with his sword, showing mercy to the captured family of his enemy Darius, and marrying Roxana.
☛ Bucephalus; Calumny of Apelles; Darius; Gordian knot

Amor

See Cupid

Andrew

Saint Andrew was the first disciple to follow Christ. He lived to a ripe old age but was finally crucified on an X-shaped cross, to which he was tied, not nailed. The patron saint of Greece and Scotland. He may carry a rope or a net (he was a fisherman).
☛ Death of the Virgin; Disciple; Feeding of the Five Thousand

All Saints

Refers to all those (whether official saints or not) who have fought successfully for Christianity and been received into Heaven.

Almond

Symbolises the purity of the Virgin Mary.
☛ Mandorla; Virgin Mary

Andrians

The wine-loving inhabitants of the island of Andros in the Aegean. Bacchus is said to have made an annual visit, causing a water fountain to turn into wine.
☛ Bacchus

and eventually married a Moor, thereby making her Christian suitor Orlando furious ('furioso').

Angels
God's agents, who convey his messages and carry out his errands. They nearly always have wings, haloes, are young, beautiful and female-looking (although they are sexless). They have a complicated hierarchy and order of precedence, like the armed forces.
☛ Cherubim; Gabriel; Harp; Lute; Michael; Raphael; Seraphim

Anger
One of the Seven Deadly Sins.
☛ Deadly Sins

Andromache
Hector's wife. Hector was a devoted husband. Andromache saw him slain by Achilles and was, understandably, grief-stricken.
☛ Hector; Trojan War

Andromeda
The daughter of an Ethiopian king who had the misfortune to be chained to a rock as a sacrifice to a sea monster. However, she was saved in the nick of time when Perseus, who happened to be flying by, spotted her, fell instantly in love, slew the monster, and cut her free.
☛ Perseus

Anemone
Usually indicates death. Red anemones in a crucifixion symbolise the shedding of Christ's blood.
☛ Adonis; Crucifixion symbols

Angelica
A principal character from the epic poem *Orlando Furioso* by Ariosto (1474–1553). She was the daughter of a pagan king

Animals
See Cleansing of the Temple; Creation; Francis of Assisi; Naming of the Animals; Noah; Orpheus

Anne
The mother of the Virgin Mary.
☛ Birth of the Virgin; Golden Gate

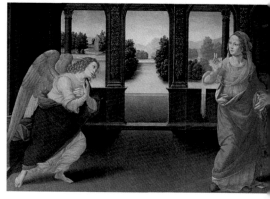

Annunciation
The scene where the archangel Gabriel, sent by God, tells Mary she will conceive

289

1. Martin Schongauer, *The Temptation of St Anthony*
2. Pol de Limbourg, *Death, one of the Four Riders from the Apocalypse,*
 detail from *Les Très Riches Heures*
3. Nicolas Poussin, *Arcadian Shepherds*

a child who will be Jesus. The account by Saint Luke describes how Mary's reaction to the news develops from disquiet,

1

through reflection and inquiry, to passive submission. Look out for which of these is shown.
☞ Annunziata; Gabriel; Virgin Mary; Visitation

Annunziata

After the archangel Gabriel made his announcement to Mary and she conceived, he departed. The 'Annunziata' was then left alone, in a state of grace, to ponder what had happened. Look at the imagery of Mary, alone, with a faraway look, possibly three-quarters length, with the emphasis on her face and expression.
☞ Annunciation

Antaeus

Giant who tried to interfere with Hercules' 11th labour. Antaeus was

invincible as long as part of him touched the ground – so Hercules held him in the air until he died.
☞ Labours of Hercules

Anthony (or Antony) Abbot, also known as Anthony the Great (251–356)

Egyptian-born Christian saint who withdrew in solitude to the desert, and so is regarded as the founder of monasticism. Look for a bearded old man with a T-shaped stick (crutch), a bell and a pig. He underwent many temptations and hallucinations in the desert, such as being attacked by demons. His erotic visions have, hardly surprisingly, been inspiring for artists.

Anthony (or Antony) of Padua (1195–1231)

Friend and follower of Saint Francis. Known for preaching to the fishes.
☞ Francis of Assisi

Ape

In Christian art an ape indicates Satan, paganism and man's sinfulness. Look for an ape with an apple in its mouth. Can also symbolise the art of painting (copying). Apes carrying out human activities imply folly.
☞ Apple; Satan; Senses

Aphrodite

See Venus

Apocalypse

The Revelation of St John the Divine (written in the 1st century AD) foretold the Apocalypse, when Christ would come again and destroy the wicked. It has never happened but the idea or image has often been used by Christians and the Church in times of difficulty. The literary account is full of powerful, surreal and violent imagery as battle is waged, but look especially for the four horsemen as agents of divine wrath

I have no love of reasonable painting. There is in me some black depth which must be appeased.
EUGÈNE DELACROIX

2

– the 'conqueror', 'war', 'famine' and 'death'.
☛ Last Judgement

Apollo
Mr Perfect, being the ideal example of masculine beauty and of rational, civilised behaviour. Good at games, lessons, work, music and the arts. Very successful with women (and men), but not reliable. He usually has long, curling hair and shows off his body. Often wears a laurel crown (symbol of success) and carries a lyre (musical talent); wears a halo. The son of Zeus and the goddess Leto and the twin brother of Diana, Apollo is also the god of prophecy and has healing powers. The Greeks treated Apollo and the sun god Helios as separate. The Romans merged them so Apollo became the sun god.
☛ Achilles; Clytie; Daphne; Diana; Helios; Marsyas; Midas; Niobe; Olympus; Parnassus

Apostle
See Disciple

Apotheosis
The ultimate way of praising a ruler. You show him ascending to Heaven to sit with the gods after his death. Popular with the Romans, and in the 17th century when they believed in the Divine Right of Kings (that kings were divine or were the agents of God or the gods). Look also for symbols or representations of their virtues, such as justice or courage.

Apple
The fruit of the Tree of Knowledge, given by Eve to Adam. When held by the infant Jesus, it signifies his role as the redeemer of mankind from the original sin (sometimes an orange is shown instead). A golden apple features large in antiquity.
☛ Fig; Hesperides; Judgement of Paris; Temptation

Arachne
The first spider. Originally she was a young woman, gifted at weaving, who was stupid enough to challenge the goddess Minerva to a contest. She wove a tapestry showing life on Mount Olympus that was so good that Minerva lost her cool and tore it to pieces, whereupon Arachne hanged herself – but then Minerva relented and changed her into a spider, hanging from its thread.
☛ Minerva; Olympus

Arcadia
An isolated district of Greece, which

3

291

1. Sebastiano Ricci, *Bacchus and Ariadne*
2. Antonio Vivarini, *The Birth of St Augustine*

1

became an ideal pastoral paradise
in literature and poetry, ruled by Pan,
where the mundane cares of the world
are non-existent; it is filled with sunshine,
love and fulfilment, but not immortality.
Look for the carved inscription *Et in
Arcadia ego* meaning 'Even in Arcadia,
I, Death, am everpresent'.
☛ Et in Arcadia ego; Pan

Ares
See Mars

Ark of the covenant
Gold plated wooden chest which
housed the two stone tablets containing
the Ten Commandments, given to Moses
by God. They were taken to Jerusalem
by David, and placed in the holy inner
sanctum of the Temple of Jerusalem
by Solomon.
☛ Ten Commandments

Ariadne
Daughter of King Minos of Crete. She
had two love affairs: first with Theseus,
whom she rescued from the Minotaur's
labyrinth by giving him a ball of wool,
but who abandoned her on Naxos; then
with Bacchus, who found her on Naxos
and consoled her (she then married him).
Look for Bacchus arriving in his chariot
with his drunken followers. He also took
her crown and threw it into the sky,
where it became a constellation.
☛ Bacchus; Minotaur; Theseus

Arrow
Cupid fires arrows to cause his victims
to fall in love. Both Apollo and Diana
carry a bow and arrow. Several saints
carry arrows or are pierced by them.
☛ Achilles; Apollo; Cupid; Daphne;
Diana; Giles; Parts of the World; Sebastian;
Ursula

Artemis
See Diana

Artemisia
Wife of King Mausolus. Symbolic of
a widow's devotion. When he died she
erected a monument (mausoleum) to his
memory at Halicarnassus, which became
one of the seven Wonders of the World.
She mixed his ashes with liquid and drank
them, thereby becoming a living tomb.
Look for her holding a cup or a goblet.
☛ Wonders of the World

292

Ascension of Christ

Forty days after his Resurrection, Christ ascended from Earth (the Mount of Olives) into Heaven. On Earth look for 11 amazed disciples, plus the Virgin possibly between Saints Peter and Paul. In Heaven look for Christ full-faced, blessing with his right hand, surrounded by senior (possibly musical) angels. He may hold the banner of the Resurrection.

☛ Paul; Pentecost; Peter; Resurrection; Virgin Mary

Ass

Humble beast of burden but ridden by many distinguished figures. Unfairly thought to be slow and stupid.

☛ Anthony; Cain and Abel; Entry into Jerusalem; Flight into Egypt; Nativity; Obedience; Samson; Silenus; Sloth

Assumption of the Virgin

Three days after her death the body and soul of the Virgin Mary were taken up to Heaven by angels. Look for the archangels Gabriel and Michael, who may be present, and the disciples gathered round an empty tomb.

☛ Coronation of the Virgin; Death of the Virgin; Gabriel; Michael

Atalanta

Super-athlete and friend of Meleager. She got rid of her suitors (and remained a virgin) by challenging them to a race in which the male loser was punished by death. She always won until Hippomenes, encouraged by Venus, outwitted her. He dropped three golden apples during the race; Atalanta stopped to pick them up, and so was beaten. On their first coupling in a cave she and Hippomenes were turned into the first lions.

☛ Meleager; Venus

Athena (Pallas Athene)

See Minerva

Atlas

The unfortunate Titan who was condemned to carry the world as punishment for revolting against Jupiter. Perseus changed him into a mountain range.

☛ Jupiter; Perseus; Titan; Calypso

Augustine (354–430)

Middle-aged intellectual saint, bishop of North Africa and a most important theologian. Often shown in bishop's garb with mitre and crozier. The most picturesque story about him relates how he watched a child on a beach trying to fill a hole in the sand with water from a shell. When told it was a futile task, the child replied: 'No more futile than trying to fathom the mystery you are thinking about!' (Augustine was thinking about the Trinity). His attribute is a flaming heart, indicating religious passion.

☛ Doctors of the Church; Trinity

Aurora (Greek: Eos)

The goddess of the dawn, who arises early each day and leads her brother Helios, the sun god, into the heavens. She rides in a chariot (two or four horses), or on Pegasus. The morning dew drops are the tears she sheds for her son who was killed in the Trojan War.

2

☞ Cephalus and Procris; Helios; Horae; Pegasus; Trojan War

Avarice

Usually a blindfolded woman holding a purse.

☞ Deadly Sins

☞ Andrians; Ariadne; Ceres; Greek and Roman gods; Jupiter; Maenads; Marsyas; Midas; Nymph; Olympus; Satyrs; Seasons; Semele; Silenus

Bagpipe

In a still life, often a phallic symbol.

1

2

Bacchanal

A drunken party.

☞ Bacchus

Bacchus (Greek: Dionysus)

The god of wine. Look for a naked boy wearing a crown of vine leaves and grapes; he rides in a triumphal chariot drawn by leopards or asses, with a procession of drunken revellers, including Ariadne and Silenus. Father was Jupiter; mother was Semele, who died during pregnancy so Bacchus was brought up by nymphs and satyrs.

Banner of the Resurrection

Long white flag with a red cross on it, symbolising victory over death.

☞ Resurrection

Baptism

The Baptism of Christ. Look for him, naked but for a loin cloth, standing in the water. Many other people are present – as this was a general baptism. Look for the moment when Saint John the Baptist pours water on his head, and a dove descends from Heaven. What you can neither see nor hear is the voice of God

1. Caravaggio, *The Young Bacchus*, c.1589
2. Piero della Francesca, *Baptism of Christ*, 1450s

saying: 'Thou art my son, my beloved;
on thee my favour rests.'
☛ Fish; Holy Ghost; John the Baptist

Barbara
Christian saint with a tough, heathen
father who locked her up in a tower.
She escaped and, as he was about to
kill her with his sword, he was struck
dead by lightning. Look for her carrying
a miniature tower. Protectress against
storms and lightning. Father may be
shown with a turban and curved
(heathen) sword. She may also have
a cannon, as she is the patron saint
of armourers and gunmakers.

Bartholomew
Christian saint. The only interesting
features are that he might have gone to
India (unlikely), and that he was flayed
alive. He carries a knife and possibly his
flayed skin over his arm.

Bat
Flying mouse, signifying fickleness
or inconstancy.
☛ Ignorance; Lobster; Moon

Bathsheba
A story of adultery. David fell in love with
the wife of one of his senior officers and
ordered her to make love to him. She
became pregnant. David arranged for
her husband to be put into the front line
of battle and he was killed. David married
Bathsheba. Their child died and David did
penance. The story is often used as an
excuse for painting a nude woman.
☛ David

Beatitudes
See Sermon on the Mount

Beggars
Beggars appear quite often, but usually in
a supporting role. Poverty is represented
by a beggarwoman holding a stone. Look
for the miracle of Christ healing a blind
beggar by mixing dust and spit and
putting it on the beggar's eyes.
☛ Dives and Lazarus; Martin

Bellerophon
Another of those handsome Greek heroes
who got into trouble with women. He
rejected the advances of the king's wife,
so she accused him of rape and he was
made to fight the Chimera, on the theory
that he would be killed. He won, with the
help of Pegasus, and performed some
other good deeds – but it did not do him
much good, as in the end he went into
a gradual decline.
☛ Chimera; Pegasus

Belshazzar
Disreputable, high-living, pagan
Babylonian king who had a fright in the
middle of a banquet. A hand (the Hand of
God) appeared out of nowhere and wrote
on the wall a series of words meaning 'You
are weighed in the balance and found
wanting.' Shortly afterwards he was killed
in battle and lost his kingdom.

Benedict (c. 480–c. 547)
Italian who founded the first Western
monastic order (Benedictines), with
irrevocable vows of poverty, chastity
and obedience. Usually shown as an old
man with a white beard and a black or
white cloak. In a life full of incidents,
he is best remembered for healing the
sick (including the mentally ill) and
avoiding attempts to poison him.

Bernard (1090–1153)
Eloquent, noble Burgundian who
founded a monastery. Emphasised
frugality and disapproved of ornament
in places of worship. Usually shown
young, without a beard, and in a white
robe, maybe with a beehive, a chained

1

the arrest of Christ in the garden of Gethsemane, after his Agony (prayers). Look for Christ kissed by Judas (to identify him to the soldiers), Simon Peter cutting off the ear of the high priest's servant, and the flight of the disciples from the garden.
☞ Agony in the Garden; Judas Iscariot

Birth of the Virgin
Mary's parents were Joachim and Anne. They were married for 20 years and childless. Look for a well-to-do room with Anne in bed, surrounded by midwives and neighbours.
☞ Anne; Joachim; Virgin Mary

Blindfold
Implies indifference for whatever reason. A blindfolded Cupid can signify pure love as opposed to lust, but it may be that love is blind. Stupidity, ignorance, avarice and so on are blind. Justice is blindfolded (impartial); Fortune is blindfolded (capricious).
☞ Cupid; Fortune; Ignorance; Justice; Nemesis

Blood
The Christian symbol of man's redemption. Christ shed his blood to save the world from sin.
☞ Adonis; Anemone; Chalice; Circumcision; Crucifixion; Crucifixion symbols; Eucharist; Senses; Temperaments

Boar
The attribute of lust.
☞ Adonis; Hercules; Lust; Meleager

Boreas
Old, grey-haired and bearded man personifying the north wind and winter.

Bread
Principally one of the elements of the Eucharist.

dragon or three mitres. His motto is *Sustine et abstine* ('Bear and forbear'). Usually seen looking pale and intense, with Christ or the Virgin Mary appearing in a vision.

Bernardino (1380–1444)
Patron saint of Siena, well known as a successful preacher. Look for an emaciated old man dressed as a Franciscan.
☞ Francis of Assisi

Bethseda
Pool in Jerusalem with miraculous healing powers, the place where Christ ordered the paralytic man to take up his bed and walk. Usually shown with an architectural feature such as colonnades.
☞ True Cross

Betrayal
Highly charged and active scene of

☞ Eucharist; Feeding of the Five Thousand; Last Supper; Supper at Emmaus

Breasts
A female with many breasts, neatly stacked like dates in a box, is Diana of Ephesus, the goddess of fertility. Mercy presses milk from her breasts. Charity nurses several children at them.
☞ Charity; Lust; Mercy; Milky Way

Bridle
See Nemesis; Temperance

Bubble
A soap bubble signifies the brevity of life.

Bucephalus
Alexander the Great's white horse.
☞ Alexander the Great

Butterfly
A metaphor for the resurrected soul; or for the brevity of life.
☞ Caterpillar; Horae; Pandora

Caduceus
A rod or wand with wings at the top and two snakes coiled round it. Carried by Greek messengers, notably Mercury, because it ensured safe passage. Also a symbol of healing (still used in the medical world).
☞ Mercury

Caesar (c.102 – 44 BC)
Gaius Julius Caesar was the most significant Roman ruler, expending and consolidating the power and territory of the Roman Empire. He was murdered in the Senate, in Rome, by Brutus and Cassius. Symbolises the supreme achievements of military command and statesmanship. Something of a role model for monarchs and dictators.

☞ Cleopatra; Triumphs of Caesar

Caiaphas
The High Priest of the Jews. After being arrested, Christ was brought before Caiaphas. Jesus told Caiaphas he was the son of God, and Caiaphas said that the statement was blasphemous and technically punishable by death.
☞ Trial of Christ

Cain and Abel
The first offspring of Adam and Eve. Cain was a farmer, Abel a nomadic shepherd. They both made offerings to God but, for some inexplicable reason, God refused Cain's offering but accepted Abel's. In the end, Cain hit and killed Abel with either a club or the jaw bone of an ass.
☞ Adam and Eve

Callisto
Diana had female attendants whom she expected to be as chaste as herself. Callisto, one of the entourage, was seduced by Jupiter and, as Diana and her attendants went around naked, Diana could not help but notice the pregnancy. Not pleased, Diana turned Callisto into a bear and set her hunting dogs on her, but Jupiter snatched Callisto away in the nick of time.
☞ Diana

Calumny of Apelles
Apelles was the most famous painter of ancient Greece and court painter to Alexander the Great. Nothing by him survives, but his ability to produce convincing illusions was legendary and captured the imagination of Renaissance painters. One of his most famous works was reputed to have been an allegory of calumny (false accusation). Several Renaissance painters attempted to recreate the 'Calumny of Apelles', working from a written description of his work.
☞ Alexander the Great

Calvary
The name of the hill just outside the city walls of Jerusalem where, according to the Bible, Christ was crucified. Called Golgotha in Hebrew.
See Crucifixion; Road to Calvary

Calypso
A nymph, the daughter of Atlas. She detained, and entertained, Ulysses for seven years, on his way home.
☛ Atlas; Ulysses

Camel
Appears in many scenes where the artist wants us to think of Asia or North Africa (for instance, Egypt).
☛ Adoration of the Magi; Parts of the World

Candle
Can have many religious meanings: often symbolises Christian faith or charity. In a still life it refers to the fleetingness of life, especially if extinguished or smoking.
☛ Charity; Psyche; Seraphim; Vanity

Cardinal's hat
Red with a very wide brim.
See Jerome

Cards
Games of cards or playing cards indicate idleness.

Carnation
Carried by a sitter in a portrait, carnations indicate that he or she is betrothed.

Carrying the Cross, Christ
See Stations of the Cross

Carthage
Town and empire in North Africa (modern Tunisia), which came to rival that of the Romans but was defeated by them.
☛ Dido; Hannibal; Scipio

Castor and Pollux (the Gemini)
Twin brothers (whose parents were Leda and Jupiter). Fearless and inseparable.
☛ Leda and the Swan

Caterpillar
The progression from caterpillar to chrysalis to butterfly is a metaphor for man's own life cycle on Earth, leading to death and spiritual resurrection. Look for it especially in still-life paintings.
☛ Butterfly

Catherine of Alexandria (4th century BC)
Saint and virgin martyr, and the patroness of education and learning, supposedly of royal birth. She was so clever she converted 50 pagan philosophers to Christianity in a debate in which they were supposed to have destroyed her faith. As a result they were burned at the stake and she was beheaded by the Roman Emperor, Maxentius. He also tried to torture her by tying her to a wheel studded with iron spikes, but a thunderbolt from Heaven destroyed the wheel before if was used. Look for the wheel, especially, and also for learned symbols such as books, a globe or mathematical instruments.

Catherine of Siena (1347–1380)
Born in Siena, Italy, and a member of the Dominican Order, she devoted her life to the care of the sick and suffering. She wears a white tunic and veil and a black cloak. Look for a rosary, books and the stigmata, which resulted from a vision. Often shown receiving

a marriage ring from the infant Christ.
- ☛ Stigmata

Cauldron
A number of saints had the misfortune to be boiled in oil in a cauldron. Medea had regular brew-ups in hers.
- ☛ Cecilia; George; John the Evangelist; Medea

1

Cecilia (Cecily)
Virgin saint, although married (had strong powers of persuasion rather than frigidity). Patron saint of music. Look for her holding a musical instrument of some sort, especially a portable organ.
- ☛ Cauldron

Centaurs
Creatures from Greek mythology – half man (upper half), half horse (lower half) – who went in for loutish behaviour.

They behaved atrociously when they were guests at a wedding given by the peace-loving Lapiths (friends of Theseus). Look for a monumental punch-up, with a centaur trying to abduct the bride. The centaurs lost the battle. Moral: in the end, civilisation triumphs over barbarism.
- ☛ Theseus

Cephalus and Procris
Complicated story about a newly married couple in whose minds the goddess Aurora sowed the seeds of suspicion and jealousy. There are two versions: one ends in happiness and reconciliation, the other in grief when Cephalus mistakenly kills Procris while out hunting.
- ☛ Aurora

Cerberus
The many-headed dog with a serpent's tail who guarded the entrance to the classical Underworld and Christian Hell.
- ☛ Hades; Hell; Hercules; Leviathan; Underworld

Ceres (Greek: Demeter)
Greek goddess of agriculture. Look for a well-endowed Earth Mother figure, with possibly a cornsheaf or crown of corn, cornucopia, sickle, or with a chariot pulled by dragons or a snake. May be accompanied by Bacchus. Her daughter Proserpine got into a bit of trouble.
- ☛ Bacchus; Cornucopia; Dragon; Greek and Roman gods; Olympus; Proserpine; Snake

Chalice
Cup containing the actual or symbolic blood of Christ. A woman (perhaps with a helmet) holding a chalice (or a cross or an open book with a cross on it) represents faith.
- ☛ Crucifixion symbols; Eucharist; Faith; Virtues

Chameleon

Lizard-like creature that changes colour according to its surroundings. The ancients believed it lived only on air.
☞ Four Elements

Charity

A woman holding a candle, or a flaming heart, or a vase with a flame coming out of it, represents true charity, which is the love of God and one's neighbours.
☞ Breast; Virtues

Charity of Saint Nicholas

Charming tale which explains why pawnbrokers have three golden balls outside their shops. A nobleman was so penniless he turned his daughters into prostitutes (he couldn't afford dowries). Nicholas threw three bags of gold (or golden balls) through the daughters' windows on three successive nights – and everyone lived happily ever after.
☞ Nicholas of Myra

Charon

In Greek mythology, the shambolic old man who ferried the souls of the dead across the River Styx to the Underworld. Look for his boat, often shown as a punt.
☞ Hades; Styx; Underworld

1

Chastity

A virtue represented in many different ways. Look for a young woman who may be wearing a veil, carrying a sieve, holding a shield, trampling a pig (lust), as Daphne, as Diana, binding Cupid, or as a vestal virgin.
☞ Benedict; Cupid; Daphne; Diana; Ermine; Margaret; Moon; Pomegranate; Triumph of Chastity; Triumph of Love; Vestal virgins

Cherry

The fruit of paradise, given as a reward for virtue.
☞ Paradise

Cherubim (sing. cherub)

Senior angels (coequal 1st out of 9 ranks). Traditionally dressed in blue or gold (yellow) and holding a book. In later Christian art they turn into chubby little pink creatures, not much different in appearance from Cupid.
☞ Angels; Cupid; Putti; Seraphim

Chimera

A fire-breathing monster with a lion's head, goat's body and dragon's tail. Killed by Bellerophon.
☞ Bellerophon

Chloe

See Daphnis

Chloris

A nymph whom Zephyr took as his bride, thereby transforming her into the goddess Flora.
☞ Flora; Zephyr

Christ

'The Anointed'. A name given to Jesus.
See Jesus

Christopher

Well-known big, strong, bearded
Christian saint who carried the infant
Christ on his shoulders across a river.
The patron saint of travellers.

Chronos

See Saturn

Cimon

A good-looking but coarse young
man who became civilised by marrying
Iphigenia. An uncomplicated story
of love at first sight.
- Iphigenia

Circe

A beautiful witch with a magic potion
that turned men into beasts. When
Ulysses landed on her island she turned
his men into pigs. She tried it on him, but
he had been given an antidote. He then
talked Circe into giving his men their
human forms again
- Glaucus; Ulysses

Circumcision

The Law of Moses required male babies
to be circumcised as a symbol of the
covenant between God and the children
of Israel. Look for a temple scene with
Mary holding the one-week-old Christ
child, and the priest holding a knife close
to Christ's genitals. The significance is
that this is the first occasion on which
Christ shed his blood.

Clare

Austere and very pious follower of
Saint Francis.
- Francis of Assisi

Cleansing of the Temple

The Temple in Jerusalem had
become a place of commerce full of
moneychangers and animal traders
(who sold animals and birds for sacrifice).
This angered Christ, so he threw them all
out. Look for a scene of confusion, with
Christ in the middle, probably holding
a whip, with animals and birds all over
the place. One of the few times Christ
is shown angry.

Cleopatra (69 – 30 BC)

Famous Queen of Egypt – unbelievably
beautiful, rich and clever. She seduced
and made a fool of Anthony, Caesar's
so-called friend. Look for them together,
as she dissolves a pearl in a goblet of
wine to show how rich she is. They were
defeated in battle by Augustus and
both committed suicide (he fell upon
his sword when a false report told him
Cleopatra was dead; she held a poisonous
asp to her bare breast, refusing to
witness Augustus' triumph when she
realised that all was lost).

Clock

Indicates the passage of time, of course,
but also stands for temperance – doing
nothing to excess.
- Temperance

Clytemnestra

A nasty piece of work. Daughter of
Leda, sister of Castor and Pollux.
Married Agamemnon. Took a lover while
Agamemnon was away at war. Helped
her lover murder Agamemnon when he
returned. Was herself murdered by her
son, Orestes. Her daughter was Electra.
☛ Agamemnon Castor and Pollux; Leda;

Clytie

Daughter of a Babylonian king who
loved but was abandoned by Apollo. She
wasted away and became the sunflower,
always turning her face towards the sun
(Apollo) which is what sunflowers do.
☛ Apollo

Coconut

An antidote to poison.

Columbine

A flower which is said to look like a dove
in flight and so can represent the Holy
Ghost.
☛ Holy Ghost

Compasses

A device for drawing circles and arcs, and
measuring distances between points.
In portraiture, compasses denote an
architect or navigator. It is the attribute
of astronomy, geometry, maturity and
prudence.
☛ Liberal Arts; Muses; Prudence

Constantine the Great (c. 274–337)

The Roman Emperor who ruled from
Constantinople (Istanbul), and who first
allowed Christian worship in the Roman
Empire in 313. Came to power after
defeating Emperor Maxentius in a battle
on the Tiber, near Rome. Look for: his
dream before the battle – he saw a cross
in the sky and heard a voice saying 'By this
sign thou shalt conquer'; his baptism by
Pope Sylvester; his monogram of an X

and P superimposed (actually the Greek
letters chi and rho, being the first two
letters of Christ's name).
☛ True Cross

Continents

See Parts of the World

Coral

Said to have been created when Perseus
put Medusa's head down on the ground.
Also said to be a protection from the evil
eye, and so was hung round children's
necks (look for the Christ child wearing it).
☛ Medusa; Parts of the World; Perseus

Coriolanus (5th century BC)

Look for a scene with two women and two
boys arguing with a soldier. Coriolanus
was a Roman general who got into a lot
of political trouble. Banished from Rome,
he returned with an enemy army of Volsci.
His family persuaded him to call off the
attack. He ended up being seen as a
traitor by both sides and was, inevitably,
executed by one of them. A moral story:
family values are good, treachery is bad.

Corn

Ceres is crowned with corn. Summer is
full of corn. Corn indicates abundance.
Cain offered God a sheaf of corn. In
Christian art, corn and vine together
symbolise the Eucharist.
☛ Abundance; Ceres; Months; Seasons;
Virgin and Child

Cornucopia

The Horn of plenty, out of which tumble
the fruits of nature.
☛ Abundance; Ceres; Fortune; Four
Elements; Parts of the World; Seasons

Coronation of the Virgin

The Virgin Mary crowned by God or Christ,
like a queen, surrounded by angels and

1

2

Creation

According to the Book of Genesis,
God created the world in six days and
rested on the seventh.
Day 1: He divided light from darkness.
Day 2: He divided the waters above and
below the firmament.
Day 3: He created dry land and vegetable
matter.
Day 4: He created the sun, moon and stars.
Day 5: He created birds and fishes.
Day 6: He created all animals, including
man and woman.
A poetic, not a scientific, truth, but not
necessarily less believable and possibly
a great deal more inspirational.
☛ Adam and Eve

senior saints. Follows her death and
Assumption.
☛ Assumption of the Virgin; Death of
the Virgin; Virgin Mary

Cosmas and Damian

Cosmas and his twin brother Damian
were physicians who were martyred for
their Christian faith. They usually wear
the physician's gown – dark red and lined
with fur – and a red hat; they may carry a
box of ointment or a surgical instrument.
Protectors against plague and disease.
☛ Roch; Sebastian

Crane

Large, grey wading bird with long legs,
neck and bill.
See Vigilance

Cross

Symbol of Christ's sacrifice and the
Christian religion.
☛ Crucifixion; True Cross

Crow

Hope personified. Its call sounds like
'crass, crass' – crass meaning 'tomorrow'
in Latin. Also a messenger of Apollo.
☛ Apollo; Hope

Crown

See Ariadne; Crown of Thorns; Cybele;
Fame; Hope; Humility; Ignorance; Laurel;
Virtues

Crown of Thorns

At the end of Christ's trial by Pilate,
the soldiers dressed him in a regal

garment, placed a crown of thorns on his head, mocked him, beat him and spat at him.

☞ Ecce Homo; Instruments of the Passion; Man of Sorrows; Mocking of Christ; Pontius Pilate

Crucifixion

Central to Christian belief is the Crucifixion of Christ on the Cross. In Jesus, God was made man, and he suffered and died to save the sins of the world. Hence the Crucifixion is one of the principal subjects of Christian art. It can be depicted as a narrative (with many possible symbolic overtones), or a single image for contemplation and devotion.

☞ Calvary; Crucifixion story; Crucifixion symbols; Deposition; Man of Sorrows; Raising of the Cross; Stations of the Cross

Crucifixion story

Look for the two thieves who were crucified at the same time; the soldier who stabbed Christ's side; another soldier who offered Christ a sponge

soaked in wine; the soldiers who cast lots to see who should take Christ's tunic; the Virgin Mary (possibly swooning) and Saint John; Mary Magdalene possibly kissing Christ's feet. Various saints and donors who have nothing to do with the story are sometimes added.

☞ Crucifixion; Crucifixion symbols; Instruments of the Passion; Longinus; Thomas

Crucifixion symbols

Look for Adam's skull at the foot of the Cross (he is said to have been buried there); the blood from Christ's wound being caught in a chalice, or a chalice standing at the foot of the Cross; sun and moon (New Testament and Old Testament). Sometimes there is a pelican. Sometimes on Christ's right (the left of the picture as you look at it) are symbolic representations of good; on his left, representations of evil.

☞ Anemone; Chalice; Pelican

Cuckoo

Indicates a deceived spouse.

☞ Juno

Cupid (Greek: Eros)
The god of love, usually shown as
a pretty curly-haired young boy or infant,
with wings. His arrows caused people
to fall in love. Look for his bow and
arrow, and quiver. He is sometimes
blindfolded or asleep (love is blind). His
role is not always specific – he is just
around whenever love is in the air. Look
for the scenes of Cupid with his mother,
Venus; learning to read or being educated
(by Mercury); being punished by Venus
for causing havoc with his arrows;
running to her after being stung by
a bee (he was trying to steal a honeycomb
– she told him his arrows caused more
pain than a bee sting).
☛ Daphne; Diana; Greek and Roman
gods; Knot; Mars; Mercury; Psyche; Putti;
Triumph of Chastity; Venus

Cybele
Earth goddess from Asia Minor,
worshipped in Rome, whose followers
went into a frenzy of self-mutilation.
Look for flowers, a turreted crown, and
a chariot pulled by lions.

Cyclops (pl. Cyclopes)
A race of very unattractive one-eyed
giants, reputedly from Sicily. They worked
at Vulcan's forge.
☛ Polyphemus; Vulcan

Cythera
An (actual) island off the southern coast
of Greece where Venus is supposed to
have drifted ashore after her birth, and
one of her many centres of worship.
☛ Venus

Daedalus
Legendary brilliant Greek craftsman.
Designed the Minotaur's labyrinth
and the wings for his son, Icarus.
☛ Icarus; Minotaur

3

Damian
See Cosmas and Damian

Damocles
Courtier of King Dionysius of Syracuse.
He praised the king's good fortune over-
extravagantly, so Dionysius invited him
to a banquet and made him sit under a
sword suspended from the ceiling by a
single thread. Why? To make him realise
that the fortunes of all people, however
powerful, are equally precarious.

Danaë
Perseus' mother. Danaë was the daughter
of a king of Argos and it was prophesied
that her offspring would kill the king,
so he shut her up in a tower. But Jupiter
visited her as a golden shower, made
love to her, and Perseus was the result.
A much-painted erotic subject, of no great
significance in itself. (Perseus did kill the
king – but accidentally, when throwing
a discus.)
☛ Jupiter; Perseus

1

to fall in love with her, and simultaneously caused Daphne not to want Apollo. Apollo chased Daphne. She ran away and asked her father (a river god) for help. He changed her into a laurel tree. Look for an attractive girl with branches sprouting from her arms or legs, or both; and maybe Cupid firing a gold arrow (love) and a lead arrow (rejection).

☞ Apollo; Chastity

Daphnis and Chloe

A pair of slightly soppy young lovers, dressed as shepherd and shepherdess, playing pan pipes.

☞ Pan

Darius (d. 330 BC)

Darius III Codomannus, King of Persia, was defeated by his enemy Alexander the Great in battle and later killed by his own men. Alexander captured his wife and children but treated them kindly.

☞ Alexander the Great

David

Means 'beloved' in Hebrew. The politician who created Israel first time round, and became its king. Shepherd boy turned guerrilla fighter turned statesman. Good at music (wrote the Psalms). Usually shown playing a stringed instrument, notably a harp. Seen by early Christians as a prefiguration of Christ. Best known as the boy who slew the 8ft-tall Goliath (the champion of the Philistines) by hitting him on the forehead with a stone thrown from a sling. Look for him firing the fatal shot, or carrying Goliath's severed head home in triumph.

☞ Ark of the Covenant; Bathsheba; Isaiah; Jesse; Philistines; Samuel; Saul

Deadly Sins (Seven Deadly Sins)

The Seven Deadly Sins are pride, avarice, lust, anger, gluttony, envy and sloth.

☞ Anger; Avarice; Envy; Gluttony; Lust; Pride; Sloth; Vices

Danaïdes

The 50 daughters of Danaus, king of Argos. Unhappy at being forced to marry them off to the 50 sons of his twin brother, Aegyptus, Danaus ordered his daughters to murder their new husbands on their wedding night (only one disobeyed). As punishment for their crimes, the Danaïdes were condemned to endlessly fill with water a vessel which had no bottom. NB: Danaë is the daughter of another king of Argos.

Dandelion

Bitter-tasting plant; Christian symbol of grief.

Daniel

One of the four greatest prophets. Rose to power in exile, in Babylon. Was thrown into a den of lions (because of a political plot against him). He survived – look for God's messenger bringing him food. Personifies Justice.

☞ Justice, Prophets; Susanna

Daphne

A nymph who was Apollo's first love, but who got away. Cupid caused Apollo

Death

A winged male figure in a black robe -
called Thanatos by the Greeks, brother
of Hypnos (Sleep).
☞ Triumph of Death

Death of the Virgin

The Virgin Mary lived to a good old age,
and longed to be reunited with her Son.
She is usually shown dying peacefully
in a house, attended by Saints John, Peter
and Andrew. Occasionally Christ is also
present.
☞ Andrew; Assumption of the Virgin;
Coronation of the Virgin; John the
Evangelist; Peter

2

Deceit

A vice that is represented by a monster
with a reptile's body but the face of a man
or woman. May carry a mask and can also
be an old woman hiding behind a mask.
☞ Vices

Demeter

See Ceres

**Democritus and Heraclitus
(5th century BC)**

Democritus and Heraclitus were a pair
of Greek philosophers. Democritus was
always laughing in amusement at the
follies of mankind; Heraclitus was
always gloomy.

Demons

The servants of Satan. Usually shown
as nasty little, possibly black, figures,
maybe with wings, horns, tails and forks.
Look for them coming out of the mouth
of the sick or insane who are being cured
by saints, or generally wherever evil is in
the air.
☞ Descent into Limbo; Last Judgement;
Miracle of the Fisherman; Satan

Deposition

The taking down of the dead body
of Christ from the Cross, prior to his
entombment. Look for those who helped:
Joseph of Arimathea (richly dressed with
a hat), who obtained permission from
Pilate to take down the body; Nicodemus
(a Pharisee who supported Jesus); and
on the ground, the Virgin Mary with
her companions Mary Magdalene and
Saint John.
☞ Crucifixion; Entombment; Pietà

Descent into Limbo

Complicated notion, popular in mediaeval
times, that on his death Christ descended
into the outer regions of Hell (Limbo).
Look for him in a hellish region with Satan
and demons scattering in all directions,
and with various well-known figures such
as Adam, Eve, Moses and John the Baptist
coming to greet him (he brings them
back from the dead).
☞ Adam and Eve; Hell; John the Baptist;
Moses; Satan

Devils
See Demons

Diana (Greek: Artemis)
The twin sister of Apollo and a major goddess, personifying chastity. She may appear as the virgin huntress (with bows

1

and arrows, and hunting dogs or a stag), or as the moon goddess, also a virgin, with a crescent moon on her brow. She carries a shield to ward off Cupid's arrows.
☞ Actaeon; Apollo; Callisto; Chastity; Cupid; Endymion; Greek and Roman gods; Iphigenia; Meleager; Niobe; Nymphs; Olympus

Dido
Legendary queen who founded Carthage. Fell in love with and married Aeneas when he turned up, shipwrecked, on her shores. He eventually left and she committed suicide. Look for the scene of her dramatic death: she built a huge

bonfire out of the belongings he left behind (including their bed), lit it, jumped onto it, and stabbed herself with Aeneas' sword. In the distance, look for the ships sailing away. You may also see Iris descending on a rainbow to cut a lock of Dido's hair and release her soul.
☞ Aeneas; Iris

Dionysus
See Bacchus

Disciple
One of the 12 original followers of Christ: Andrew, Bartholomew, James the Great, James the Just, John, Judas, Jude, Matthew, Peter, Philip, Simon and Thomas.

Dispute in the Temple
See Doctors

Distaff
The rod that holds the wool from which thread is spun. The archetypal symbol of obedient domesticity.

Dives and Lazarus
The scene: the house of a rich man (Dives), where a poor man (Lazarus) is begging. The action: Lazarus is threatened and sent away hungry. Conclusion: Lazarus goes to Heaven, Dives goes to Hell.
☞ Hell

Doctors
Philosophers, not medics. Look for a young Jesus (supposed to be 12 years old, but allow for artistic licence) having a learned debate with the Jewish scribes in the Temple in Jerusalem. He may be counting points on his fingers, and Mary and Joseph may be in the background about to take their son away (he had wandered off on his own). First example of Christ teaching.

Doctors of the Church

The saints who interpreted the Gospel
and spread Christ's word: Ambrose,
Augustine, Gregory the Great and Jerome.
☛ Ambrose; Augustine; Gospel; Gregory
the Great; Jerome

Dog

Many people are accompanied by dogs,
so the presence of a dog can have many
meanings, which should not be confused.
Several saints have dogs (usually part of
the story). Classical gods who were keen
on hunting have faithful dogs. In the
appropriate setting a dog can indicate
fidelity (especially marital) – but it can
also indicate envy.
☛ Fidelity; Labours of Hercules;
Margaret; Melancholy; Roch; Senses;
Temperaments; Tobias

Dolphin

Often seen in pictures where the sea
and sea people feature strongly.
☛ Galatea; Jonah; Neptune; Nymph

Dominic (c.1170–1221)

Spanish nobleman and saint who
founded the Dominican Order of
Preachers. Wears a white tunic under
a black hooded robe and holds a lily and
a book. May also hold a rosary (string of
beads), which he is supposed to have
invented.

Dove

A bird with many roles and meanings.
Noah released a dove from the ark after
the Flood and it returned with an olive
branch – hence the well-known peace
symbol. In Christian art it symbolises
the Holy Ghost. Cooing doves represent
love or lust.
☛ Holy Ghost; Lust; Marriage of the
Virgin; Noah; Trinity

Dragon

Nearly always bad. In Christian art
a symbol of the devil – a dragon slain
or trodden underfoot is evil conquered.
Also appears in several mythological
stories illustrating heroism.
☛ Andromeda; Bernard; George;
Margaret; Martha; Michael; Theodore

Drawing (Discovery of the Art of)

A silly story. According to the Roman
writer Pliny the Elder, the daughter
of Butades (a potter) fell in love with
a young man and traced the profile of
his face on a wall from the shadow
thrown by a lamp. Butades filled in the
outline with clay and produced the first
sculpted relief - and that's how drawing
and sculpture were invented.

Dryads

See Nymphs

Eagle

See Ganymede; John the Evangelist;
Jupiter; Pride; Prometheus; Senses

1

Easter

The Christian church's festival that celebrates the Resurrection of Christ.
☞ Egg; Entry into Jerusalem; Pentecost; Resurrection

Ecce Homo

Look for Christ, bound, beaten, richly robed or part naked, with a crown of thorns, perhaps weeping with compassionate resignation. This is the moment when Pontius Pilate presented him to the crowd saying 'Ecce Homo' ('Behold the Man'). He also said he found no case against Christ, but the chief priests and the crowd shouted back 'Crucify Him!'. Christ is shown in all his humanity in order to engage the viewer and so set him on the road to redemption.
☞ Crown of Thorns; Pontius Pilate

Echo

See Narcissus

Egg

Symbolises rebirth in almost any context – which is why they are a big thing at Easter.
☞ Easter; Leda and the Swan

Elijah

Powerful Hebrew prophet who was tough on those who worshipped idols rather than God. Look for him dressed in animal skins or a white-and-brown tunic, maybe with the ravens that fed him in the desert or with the chariots and horses of fire that eventually carried him up to Heaven.
☞ Prophets; Transfiguration

Elisha

Elijah's disciple.

Elizabeth

The elderly mother of John the Baptist.
☞ Massacre of the Innocents; Visitation

Elysium (Elysian Fields)

The place in Greek mythology to which heroes (and later on, anyone righteous) were sent by the gods with the gift of immortality. Look for a bounteous land of perfect happiness on the banks of the River Oceanus, at the end of the Earth.
☞ Underworld

Endymion

A very beautiful youth, sent into eternal sleep by Jupiter, so that he would preserve his beauty. Diana visited him every night, but only to look – never to touch.
☞ Diana

Entombment

After Christ's body was taken down from the Cross, it was laid in a newly prepared tomb. Look for his body wrapped in clean sheets, with Joseph of Arimathea, Nicodemus, the Virgin Mary, Mary Magdalene and John the Evangelist.
☞ Deposition; John the Evangelist;

Joseph of Arimathea; Mary Magdalene; Nicodemus; Virgin Mary

2

Entry into Jerusalem
Christ's ride into Jerusalem in triumph – before his trial and Crucifixion – on Palm Sunday, the Sunday before Easter. Look for him riding on an ass or donkey, a cheering crowd, and children carrying palm branches. A few days later the crowd turned against him.
☛ Palm; Passion; Trial of Christ

Envy
A deadly sin. Look for an old hag gnawing at a heart.
☛ Deadly Sins

Eos
See Aurora

Erato
The muse of lyric poetry.
☛ Muses

Eris
Goddess of strife – a most unpleasant-looking woman with a very bad attitude.
☛ Feast of the Gods; Judgement of Paris

Eros
See Cupid

Ermine
The fur of the stoat, which goes white in winter. Attribute of purity and chastity – virgin saints wear cloaks lined with ermine; portraits of virtuous ladies may include one.
☛ Chastity; Senses

Esau
A hunter with a hairy body. His brother Jacob lived among the tents and cheated him of his birthright. Their ageing, senile, father Isaac wanted to give his (irrevocable) final blessing to Esau. His wife, Rebecca, overheard and when Esau was out hunting she disguised Jacob by dressing him in Esau's clothes and covering his hands and neck in goatskins to make them seem hairy. Isaac was fooled and blessed Jacob by mistake. The story is said to be symbolic of the conflict between church and synagogue.

Esther
Highly complex story of a young Jewish girl who married a Persian king, Ahasuerus, and with great courage pleaded with him not to massacre the Jews. Look for a scene in the royal chamber with Ahasuerus holding out a gold sceptre to signify his agreement to her plea, and Esther swooning with relief.

Et in Arcadia ego
'Even in Arcadia, I, Death, am ever present.' Inscription on a tomb in an Arcadian setting, perhaps being inspected or discussed by a group of figures.
☛ Arcadia

Eucharist

The sacrament central to Christian worship. Commemorates the action and words of Christ over the bread and wine at the Last Supper. The eating and drinking of bread and wine (the body and blood of Christ) signifies the mystical union of God and Man.
☞ Last Supper

1

Europa

See Rape of Europa

Eurydice

A charming wood nymph who married Orpheus. When she died from a snake bite, she descended to the Underworld. Pluto gave Orpheus permission to fetch her, on condition he did not look back until they reached the upper world. Of course, the silly boy did – and Eurydice disappeared forever.
☞ Nymphs; Orpheus; Pluto; Underworld

Eustace

Roman soldier and Christian convert. The moment of revelation for him was during a hunting expedition when he saw a shining crucifix between the antlers of a white stag.
☞ Hubert

Evangelists

Matthew, Mark, Luke and John. The four saints who knew Christ and wrote the Gospels of the New Testament, narrating his life.
☞ John the Evangelist; Luke; Mark; Matthew

Expulsion, The

See Temptation

Eye(s)

One in a triangle – God the Father.
Two in a dish – Saint Lucy.
☞ Lucy; Trinity

Ezekiel

Prophet. Became one after having a vision of God enthroned among four creatures with the faces of a man, a lion, an ox and an eagle. Usually portrayed as an old man with a white beard.
☞ Prophets

Faith

Always shown as a woman. May hold one or more of the following: cross, chalice, font, open book (Scriptures), candle (light of faith), helmet (anti-heretic protection). May rest her foot on a stone block (secure foundation). May be shown opposite Idolatry (man worshipping a monkey or man holding an idol).
☞ Virtues

Falcon

Symbol of pride and greed.

Fame

Serious-looking female who carries a trumpet and palm branch. Occasionally wears a crown or sits on a globe, or both.
☞ Palm; Pegasus; Triumph of Fame

Fates

Three bossy, ugly old women who determine your destiny at birth. You see them together spinning a skein of wool (the thread of life), measuring its length, and cutting it off. Death may also be hovering in the background.

☞ Death; Meleager

Father Time

See Saturn

Feast of the Gods

A famous banquet with all the gods and goddesses present to celebrate the marriage of Peleus and Thetis (Achilles' parents). An uninvited guest, Eris, goddess of strife, turned up and ruined the party. She threw down a golden apple and so set in train the events leading to the Trojan War.

☞ Achilles; Eris; Judgement of Paris; Peleus; Thetis; Trojan War

Feeding of the Five Thousand

A famous miracle, when Christ preached to a crowd of 5,000, and Philip and Andrew asked how they were going to feed them. Christ took five loaves and two fishes brought by a small boy. The disciples distributed the proceeds as Christ broke the food up. Everyone was fed, and there were 12 baskets left over. There are many interpretations of the incident.

☞ Andrew; Philip

Feet

Bare feet imply Christian poverty and humility.

☞ Last Supper

Fidelity

Woman holding a golden seal and a key (representing trust between master and servant). She may also have a dog.

☞ Dog; Magpie

Fig

Alternative to the apple of the Tree of Knowledge; Adam and Eve wore fig leaves.

☞ Adam and Eve; Apple; Temptation

Finding of Moses

The pharaoh of the day ordered all male babies of the Israelites to be put to death, so Moses' mother put him in a basket and hid him in some bulrushes on the River Nile. He was found by the pharaoh's daughter, and by a roundabout route was returned to his mother.

☞ Moses

Fish

Early symbol of baptism, and of Christ himself. The letters of the the Greek word for fish form in Greek the initials of the words Jesus/Christ of/God the/Son/Savior. Fishes occur in several stories, popular with painters.

☞ Anthony of Padua; Feeding of the Five Thousand; Hippocampi; Jonah; Miraculous Draught of Fishes; Peter; Tobias

Flagellation

Christ was tied to a column in the house of the Roman governor, Pontius Pilate. Before being taken away to be crucified, Pilate ordered him to be beaten. Note the artistic problem: how to depict Christ being beaten on the back while showing his face at the same time.

☞ Crucifixion

Flaming heart

Sign of religious passion; also charity. Venus is sometimes shown holding a flaming heart.

☞ Augustine; Charity; Venus

Flight into Egypt

After the birth of Christ, and the threat by Herod the Great to kill newborn children, Joseph took Mary and the baby

1

Jesus to safety in Egypt. Look for Mary and Jesus riding an ass lead by Joseph, or resting under a palm tree in a landscape that is otherwise decidedly un-Egyptian. A theme with many variations.
☛ Massacre of the Innocents

Flora

Goddess of flowers. Married to Zephyr, she lived in a flower garden, which he gave her.
☛ Flowers; Seasons; Zephyr

Flowers

En masse may represent four seasons, five senses, brevity of life, and so on. Singly may have specific symbolism.
☛ Anemone; Carnation; Columbine; Dandelion; Iris; Lily; Narcissus; Poppy; Rose; Seasons; Senses; Sunflower; Violet

Fortitude

Look for a female figure dressed as a warrior with a helmet, shield, spear and sword. May also be fighting a lion.
☛ Pillar; Virtues

Fortune

A female figure, notoriously unreliable. Look for her blindfolded, standing or sitting on a globe – maybe with nautical bits and pieces, because she was fickle with the fate of ships.
☛ Virtues; Wheel of Fortune

Four Elements

Earth, Air, Fire, Water. Popular subject for series painting, with lots of scope for free invention and decoration.
1) Earth – fruits of the Earth, such as cornucopia, harvesting, agriculture, women (Ceres), fertility gods.
2) Air – birds, chameleons, Juno and her peacock, children playing with toy windmills and blowing bubbles.
3) Fire – forges and thunderbolts, Vulcan, Phoenix.
4) Water – Neptune with Triton, nereids, dolphins, hippocampi, river god with urn, people fishing.
☛ Ceres; Chameleon; Cornucopia; Hippocampi; Juno; Neptune; Nymph; Phoenix; Triton; Vulcan

Francis of Assisi

One of the most easily recognisable Christian saints. He wears a brown or grey cloak with a girdle with three knots (the vows of poverty, chastity and obedience). Bears the marks of the stigmata. Also look for a crucifix (which he may carry), a lily and a skull. Famous for being a wild and rich young man who renounced all worldly pleasures ('O Lord make me chaste, but not yet'), and for his love of animals and birds.
☛ Anthony of Padua; Clare; Stigmata

Fruit

En masse signifies abundance, summer, the sense of taste. Individual fruits often have specific Christian symbolism.
☛ Abundance; Apple; Charity; Cherry; Cornucopia; Fig; Gluttony; Grapes; Peach; Pomegranate; Quince; Seasons; Senses

Furies

Goddesses of vengeance. Lived in the Underworld and came up from time to time to pursue and punish the wicked.

Gabriel
Archangel who was God's chief
messenger. He often carries a lily.
☞ Adoration of the Shepherds; Angels;
Annunciation; Assumption of the Virgin;
Sepulchre

Gaea (Gaia)
The ultimate Earth Mother.
☞ Saturn; Uranus

Galatea
A beautiful sea nymph with a complicated
love life. She loved a Sicilian shepherd,
Acis, but was loved by Polyphemus (ugly
one-eyed giant). Polyphemus discovered
Galatea and Acis making love, and in a fit
of jealousy killed her with a rock. She is
often portrayed ignoring her complicated
love life, triumphantly standing on a
cockle shell with all sorts of sea creatures
giving her (and themselves) a good time.
☞ Nymphs; Polyphemus; Triumph

Ganymede
Look for a beautiful boy or young man
being carried by an eagle (Jupiter). Jupiter
fell in love with him, and carried him off
to Olympus to become his cupbearer.
☞ Jupiter; Olympus

Garden
A depiction of the Virgin Mary in an
enclosed (walled) garden is a reference
to her virginity.
☞ Virgin Mary

Garden of Eden
The earthly paradise into which Adam
and Eve were placed by God, and from
which they were expelled because
they gave in to temptation.
☞ Adam and Eve; Naming of the
Animals; Paradise; Temptation

George (3rd century BC)
Many memorable depictions of a soldier
in armour, on a white horse, slaying
a wicked-looking dragon or/and with a
beautiful princess waiting to be rescued
in the background. He has no wings as
only saints have wings– George was
only recently made a saint.
☞ Michael; Miracle of the Fisherman

Gethsemane
See Betrayal

Giles (dead c. 700 BC)
White-bearded, white-robed, animal-
loving saint, the patron of lepers, beggars
and cripples. Famous for nursing a
wounded deer, which the king had
shot with an arrow.

Girdle
With three knots, worn by a monk, who is
Saint Francis.
See Francis of Assisi

2

1

Glaucus

A Greek fisherman who mistakenly ate some magic grass and so became a merman or sea centaur. Fell in love with Scylla, who did not reciprocate. Jealous Circe, who loved Glaucus, turned Scylla into a monster to put him off.
☛ Centaur; Circe

Globe

Holding or resting a foot on a globe often means domination in a worldly or spiritual sense.
☛ Catherine of Alexandria; Fame; Fortune; Liberal Arts; Muses; Nemesis; Truth

Gluttony

A deadly sin. Look for a fat person (male or female) stuffing him- or herself with food, sometimes to the point of being sick. Several animals (such as pigs, bears, hedgehogs) are supposedly the image of gluttony.
☛ Deadly Sins

Goat

Represents lust. Lustful people have goat-like features such as hairy legs, horns and hooves. The sign of December and of Capricorn.
☛ Pan; Satyrs

God the Father

The first person of the Trinity, who is traditionally depicted with long, white hair and a flowing beard. Technically he should be the representation of God in Old Testament scenes (before Christ's birth) and Christ should be the representation of God in New Testament scenes. But you can have Christ represented in Old Testament scenes (this is theologically all right because 'all things were made by him') and God the Father represented in New Testament scenes about the Virgin Mary. Complicated.
☛ Trinity

Golden apples
See Atalanta; Paris

Golden Calf
The idolatrous ornamental animal made by Aaron for the Israelites to worship, when Moses was away talking to God. Moses destroyed it in anger.
☞ Aaron; Moses

Golden Fleece
See Jason

Golden Gate
Look for an elderly couple, Joachim and Anne (the parents of the Virgin Mary), embracing with a kiss at the gate decorated with gold of an unknown city. Some claimed that it was this kiss alone that bought about the conception of the Virgin Mary.
☞ Immaculate Conception

Goldfinch
Held by the Christ child it signifies the soul of man, and the red spot on its breast is his blood. May be held by the Christ child on a string to signify that man's soul does not fly away at his death, but remains attached to God.
☞ Virgin and Child

Golgotha
Hebrew for Calvary.
See Calvary

Goliath
See David

Good Samaritan
This is possibly the most famous of all Christ's parables. Message: love your neighbour as yourself. Story: a traveller is attacked by robbers and left to die by the roadside. He is ignored by everyone who should help him, but a Samaritan (the traditional enemy of the Jews) stops, attends to his wounds, takes him to an inn and pays the bill.

Gordian knot
Alexander the Great captured the city of Gordium where there was a chariot bound up with cords. It was said that whoever untied the cords would rule the world. Alexander literally cut through the problem by severing the knots with his sword.
See Alexander the Great

Gorgons
See Medusa

Gospel
The account of the life and the teaching of Christ, set out and told, with variations, by Matthew, Mark, Luke and John in the first four books of the New Testament.
☞ John the Evangelist; Luke; Mark; Matthew

Grapes
Often symbolise the wine of the Eucharist, especially if shown with ears of corn to symbolise the bread.
☞ Eucharist; Months; Seasons

Greek and Roman gods
Most of the gods from Greek and Roman antiquity are referred to in later art and literature by their Roman (Latin) names because the classical myths were best known through Latin authors such as Ovid. Over time there has been a merging of the identities of Greek and Roman deities. The old Roman divinities were a bit boring, so were made more exciting by 'borrowings' from the much richer and more extensive narrative of Greek mythology.

Gregory the Great (c. 540–604)
Tall, dark-haired, beardless pope.
The dove of the Holy Ghost perches
on his shoulder (inspiring his writings).
Introduced celibacy for the clergy, the
Gregorian chant, and Christianity
into England. Developed the idea
of purgatory.
☛ Doctors of the Church; Purgatory;
Trajan

1

Gridiron
See Lawrence

Griffin
A creature with the head, wings and claws
of an eagle, and the body and lower parts
of a lion. Can symbolise Christ's duality –
the divine (bird) and the human (animal).
☛ Hippogriff

Hades
King of the Underworld, also known as
Pluto. The Underworld itself.
☛ Cerberus; Pluto; Underworld

Hagar and the Angel
Hagar was the mother of Ishmael
(Abraham's eldest son). Both were
banished by Abraham for making fun
of Isaac, Abraham's younger son by Sarah.
While travelling they ran out of water.
Hagar put Ishmael under a bush to die,

but an angel appeared and showed
them a nearby well. Don't worry if the
picture shows a lush setting at odds with
the story: the excuse to paint a landscape
took priority over accuracy. Forget the
story, enjoy the scenery.
☛ Abraham

Hair (long, flowing, woman's)
Covering her whole body symbolises
Mary Magdalene and penitence; long
and unbound symbolises virgin saints
or brides (wedding portraits).
☛ Mary Magdalene

Halo
The gold disc or circle (representing
light) seen around the head of a saint
or other holy Christian person. Also seen
round the heads of classical sun gods
and Roman emperors.

Hammer
Used in Vulcan's forge; and to nail Christ
to the cross.
☛ Crucifixion; Helena; Vulcan

Hand
Emerging from a cloud – *see* Trinity.
Writing on a wall – *see* Belshazaar.

Hannibal (247 – 182 BC)
The legendary Carthaginian military
leader who famously invaded Italy
(218 BC) from North Africa by marching
with elephants northwards through
Spain, then over the Pyrenees and the
Alps, into Northern Italy. Came within
an ace of destroying the might of the
Roman Empire, but failed and eventually
committed suicide.
☛ Carthage

Hare
Represents reproduction, like the rabbit.
☛ Lust

If I create from my heart, nearly everything works: if from my head, almost nothing does.
MARC CHAGALL

Harp
Stringed instrument played by refined people such as angels, royalty and nobility, and by David.
☛ David; Marsyas; Muses

Harpy
A monster with the head and breasts of a woman, and the wings and claws of a bird.

Heart
Always signifies love, either sexual or spiritual.
☛ Anthony; Augustine; Charity; Cupid; Envy; Ignatius of Loyola; Peach; Teresa; Venus

Heaven
The dwelling place of God or the gods, and the blessed.

Hebe
A daughter of Jupiter and Juno, she is the goddess of youth. She acted as a handmaiden (general dogsbody) to the gods. Look for her carrying a jug from which Jupiter's eagle drinks.
☛ Juno; Jupiter

Hector
Commander of the Trojan army, and a devoted father and husband to Andromache. Killed in battle by Achilles. Look for him saying goodbye to his family before the battle, or his dead body being dragged behind Achilles' chariot. (His aged father, Priam, asked for the body back and eventually got it.)
☛ Achilles; Andromache; Trojan War

Hedgehog
See Gluttony; Senses

Helen
'The face that launched a thousand ships.' Daughter of Leda and Jupiter and famous for her beauty. She married Menelaus, king of Sparta; Paris was besotted by her and carried her off against her will when her husband was away. The Greeks sent out an expeditionary force to get her back, which is how the Trojan War started.
☛ Jupiter; Leda and the Swan; Paris; Trojan War

2

Helena (c. 255–330)
Mother of Constantine the Great. The finder of the True Cross – hence look for an elderly woman holding a hammer and nails.
☛ Constantine the Great; True Cross

Heliodorus
A Syrian who was sent to Jerusalem to rifle Solomon's temple. However, he was attacked in the temple by a terrifying

319

1. Frederic Leighton, *Garden of the Hesperides*, c.1892

horse and rider, and collapsed. Said to prefigure Christ's cleansing of the Temple.

Helios

The Greek sun god (Sol for the Romans) whose identity became merged with that of Apollo. His sisters were Luna (goddess of the moon) and Aurora (goddess of the dawn). The Greeks believed that Helios, accompanied by Eos, drove a two- or four-horse chariot across the sky each day.
☛ Apollo; Aurora; Phaeton

Hell

The kingdom ruled over by Satan, where the souls of the damned are sent to be tortured in everlasting fire. As a subject, offers plenty of scope for depicting every known sin and perversion, often with great imagination.
☛ Cerberus; Last Judgement; Leviathan; Satan

Hephaestus

See Vulcan

Hera

See Juno

Heracles

See Hercules

Heraclitus

See Democritus

Heraclius (c.575–641)

Eastern Roman Emperor from 610–41. Lost most of Roman Eastern Mediterranean to the Arabs. Able administrator who set up a new system of hereditary military service for the peasantry, which proved successful in resisting the onslaught of Islam, and thus preserved Europe's infant Christian civilisation. Hero of mediaeval legend, largely because of this connection with the True Cross.
☛ True Cross

Hercules (Greek: Heracles)

Hyperactive, muscle-bound legendary Greek superhero – the personification of physical strength and courage, rather than beauty. (Mythological equivalent of Arnold Schwarzenegger, always successful with Mission Impossible. Notice how often his body is too big for his head.) The child of an adulterous relationship: his mother was Alcmena (mortal, already married); his father the god Jupiter, who deified Hercules when he died. Look for Minerva (moral strength), who was his protector. Hercules usually carries a big club and wears a lion skin like a cloak. An archetypal overachiever (trying to live up to his father).
☛ Antaeus; Cacus; Greek and Roman gods; Jupiter; Labours of Hercules; Milky Way; Omphale; Prometheus

Hermes

See Mercury

Hero and Leander
Leander (boy) loved Hero (girl). He used to swim the Hellespont (entrance to the Black Sea by Constantinople) to meet her as she held a torch to guide him. He was drowned one stormy night and, when Hero realised, she drowned herself too.

Herod Antipas (21 BC– AD 39)
Son of Herod the Great. Pontius Pilate's boss, with whom the buck ought to have stopped. Pilate did not know what to do with Christ when he came up for trial, so he sent the case up to Herod. Herod did not know what to do either, so he treated Christ badly, put him in an expensive robe, and sent the case back to Pilate, telling him to get on with it. Made a fool of himself over Salome and John the Baptist. A weak governor.
☛ John the Baptist; Massacre of the Innocents; Salome; Trial of Christ

Herod the Great (73–4 BC)
A tyrant, ruled Judea and, according to the Bible, ordered the massacre of every male baby in Jerusalem. Father of Herod Antipas.
☛ Massacre of the Innocents

Herodias
Herod Antipas' second wife and mother of Salome by her first husband who was Herod Antipas' half brother. A nasty piece of work.
☛ Herod Antipas; Salome;

Hesperides
Daughters of the evening. Hercules stole the golden apples that grew in their garden.
☛ Hercules

Hestia
See Vesta

Hippocampi
Fabulous sea creatures, with the front end of a horse and the rear end of a fish. They pulled the chariot of Neptune and Galatea.
☛ Four Elements; Galatea; Jonah; Neptune

Hippogriff
A mediaeval monster with the head, claws and wings of a griffin and the body of a horse.

Hippolytus
Soldier who became a Christian when he saw Lawrence being barbecued. Later became a martyr when he was torn to pieces by wild horses.
☛ Lawrence

History
A major muse. Look for a female carrying a book, maybe with a trumpet, perhaps with wings and a laurel crown. She may have her foot resting on a cube (stability) or she may even be carried on the back of old Father Time.
☛ Muses

Holofernes
See Judith

Holy Family
Mary, Joseph and the baby Jesus together.
☛ Joseph; Virgin Mary

Holy Ghost
The third person of the Holy Trinity.
☛ Baptism; Columbine; Dove; Gregory the Great; Pentecost; Trinity

Holy Grail
The cup used by Christ at the Last Supper, which was later owned by Joseph

of Arimathea.
☛ Joseph of Arimathea ; Last Supper

Homer

The great epic poet of ancient Greece (c.850 BC). His narrative poems *The Iliad* and *The Odyssey* are two of the major sources of inspiration for European art. Represented as a blind white-haired old man.
☛ *Odyssey*; Trojan War; Ulysses

Honeycomb

See Cupid; John the Baptist

1

Hope

Look for a female with eyes raised heavenwards and hands clasped in prayer, maybe reaching out for, or being offered, a crown (perhaps by an angel). Look also for an anchor or a ship – early sea journeys were the essence of hope.
☛ Crow; Pandora; Virtues

Horae

Pretty young girls, the daughters of Luna and attendants of Aurora, who represent the seasons. Look for them carrying suitable fruits and flowers;

may have butterfly wings.
☛ Aurora; Luna

Horatii

Look for three warrior brothers (the Horatii) swearing allegiance to defend the State (Rome) by entering into mortal combat against three other brothers (the Curatii), who represent Rome's enemy (Alba Longa). The Horatii won, but that lead to complications as some Horatii and Curatii brothers and sisters were variously married or betrothed to each other. An unhappy story in human terms, but an example of loyalty to the state taking precedence over family loyalties.

Horse

Man's noblest animal companion and servant. After the human figure, the living form most represented in art. Specific horses include Bucephalus and Pegasus. There are many scenes where horses are a major feature.
☛ Apocalypse; Aurora; Bucephalus; Centaur; George; Heliodorus; Hippolytus; Hubert; Luna; Martin; Minerva; Parts of the World; Paul; Pegasus; Perseus; Phaeton; Pride; Wooden Horse

Hortus conclusus ('enclosed garden')

See Garden

Hourglass

Signifies the passing of time, leading ultimately to death.
☛ Rat; Triumph of Time

Hubert (656–727)

Worldly, pleasure-seeking young man, keen on hunting, who became a Christian when he met a stag with a crucifix between its antlers (it was also Good Friday). The story may have been borrowed from Saint Eustace. Later became Bishop of Liège. Patron saint of hunters.
☛ Eustace

2

Hubris
Arrogance, presumptuousness –
the kind of pride that leads to a fall.
☛ Nemesis

Humility
Look for a woman with downcast eyes,
perhaps treading on a crown and holding
a lamb. May be paired with Pride.
☛ Feet; Pride; Virgin and Child

Hypnos
See Sleep

Icarus
The famous high flyer. Was imprisoned
on Crete with his father, Daedalus. To
escape, Daedalus made wings out of
feathers and attached them to their
bodies with wax. Daedalus told Icarus
not to fly too near to the sun, but he did.
The wax melted, the wings dropped off,
and Icarus fell into the sea and drowned.
Moral: don't fly too high, and listen to
your parents.
☛ Daedalus

Ignatius of Loyola (1491–1556)
Spanish nobleman and founder of the
Society of Jesus (the Jesuits) whose prime
mission was teaching the young and
defeating the Protestants. His emblem

is a heart crowned with thorns.
☛ IHS

Ignorance
Look for a fat, unpleasant female
or hermaphrodite, either eyeless or
blindfolded, wearing a crown. Flying
bats (which have limited vision)
symbolise ignorance.

IHS
The sacred monogram, an abbreviation
of the Greek word for Jesus. Also said
to stand for 'Iesus Hominem Salvator'
('Jesus the Saviour of Man'). Adopted
by the Jesuits as their symbol in the
16th century.
☛ Ignatius of Loyola

Illiad, The
Extraordinary epic poem by Homer
describing the siege and capture of
Troy. The oldest surviving source of Greek
mythology along with *The Odyssey*,
also by Homer.
☛ Achilles; Helen; Hector; Homer;
Odyssey; Paris; Priam; Trojan War

Immaculate Conception
The conception of the Virgin Mary in
the womb of her mother, Anne. Because
she was the mother of Christ she had

to be pure – conceived without sexual desire. (Note, this is not the conception of Christ.)
☞ Golden Gate; Virgin Mary

Innocence
Usually shown as a young girl with a lamb, perhaps washing her hands.
☞ Sacred and Profane Love

1

INRI
The inscription fastened to the cross on which Christ was crucified: 'Iesus Nazarenus Rex Iudaeorum' ('Jesus of Nazareth, King of the Jews').
☞ Crucifixion

Instruments of the Passion
The objects referred to in the story of Christ's Passion - notably nails, crown of thorns, lance, scourge, pillar (reference to flagellation), hammer, rope, dice, cock, head of Judas, Pilate's washbasin.
☞ Crucifixion story; Flagellation; Judas Iscariot; Passion; Peter; Pontius Pilate

Io
Yet another Greek king's daughter seduced by Jupiter. This time he changed himself into a cloud – so look for a nude girl embracing a cloud. Juno (Mrs Jupiter) became suspicious, so Jupiter changed Io into a heifer, which Juno cunningly asked for as a gift, knowing Jupiter could not refuse her. Juno made the hundred-eyed giant Argus watch over Io, but Argus was murdered by Mercury. In memory of him, Juno took his eyes and set them in the tail feathers of his peacock.
☞ Juno; Jupiter

Iphigenia
A human-sacrifice story. She is the daughter of Agamemnon – he has to sacrifice her to the goddess Diana (who is displeased with him), so that he and his army can set sail for Troy. It is not clear whether Diana relents and saves Iphigenia at the last minute or not.
☞ Agamemnon; Cimon; Diana

Iris
The goddess of the rainbow. In Christian art, the Virgin Mary is sometimes seen with an iris, instead of a lily.
☞ Dido; Lily

2

Isaac
A great Hebrew patriarch who was the son of Abraham, husband of Rebecca, and father of Jacob and Esau.
☞ Abraham; Esau; Hagar and the Angel; Jacob; Rebecca

Isaiah
A grey-haired and bearded old man, holding a book or scroll. He is the Old Testament prophet who foretold the birth of Christ. He may also hold a tree, referring to the family tree of Jesse and David from which Mary and Christ were descendants.
☞ David

Ivy
Evergreen plant, thus representing immortality. Bacchus and the satyrs wear wreaths of ivy.
☞ Bacchus; Satyrs

Jacob
Hebrew patriarch. He defrauded his older twin brother, Esau, of his birthright and by a trick obtained the blessing that his old father, Isaac, had intended for Esau. Look for him kneeling or seating at his father's bedside. Well known for his dream about a ladder ascending to heaven. God spoke to him from the top and promised land to his descendants – the Israelites. He also had a mysterious all-night wrestling match with a man who turned out to be an angel. Its meaning has never been clear, but it makes for a dramatic image, and conveys the idea of the struggle

between good and evil, wrestling with the conscience, and so on.
☞ Esau; Joseph

James the Great
One of the 12 disciples. Supposedly went to Spain and was buried at Compostella. May carry a pilgrim's staff, hat, cloak and wallet, sometimes a sword. Look also for his symbol of the scallop shell. Beheaded in AD 44 .
☞ Agony in the Garden; Disciple; Miraculous Draught of Fishes; Transfiguration

James the Just
Another disciple, held to be Jesus' brother (artists sometimes show a family likeness). Martyred when beaten to death with a stick like a flat bat used to beat cloth. He is often shown with such a stick. Patron saint of hatmakers.

Janus
Look for a figure with one head but two faces, back to back (looking two ways at once). Roman god who guarded the home and blessed the beginning of any venture, such as January for the start of the year. Can also suggest past and future time.

Jason
Led the Argonauts (aboard the ship *Argo*) to capture the Golden Fleece from a Black Sea king. They succeeded thanks to the king's daughter, Medea, who was

1. Tintoretto (Jacopo Robusti), *Joseph and the Wife of Potiphar*
2. Tintoretto (Jacopo Robusti), *The Birth of St John the Baptist*
3. Dosso Dossi, *The Apparition of the Virgin*, detail showing St John the Evangelist
4. Rogier van der Weyden, *The Entombment*, detail showing Joseph of Arimathea, c.1450

cardinal's hat and a lion. He pulled
a thorn from the lion's foot and they
became firm friends.
☛ Doctors of the Church

Jesse
David's father. Prophesied that a Messiah
would grow from his family tree. Look
for Jesse asleep, with a tree growing
from his loins, leading via David to
the Virgin Mary and Christ.
☛ David; Isaiah

Jesus
The Son of God, born of man (thus a
human being), who suffered and died
upon the Cross, by God's wish, to save
the world from its sinful behaviour.
He ascended to Heaven, and sits at the
right hand of God.
☛ Crucifixion; Trinity; Virgin Mary

also a witch. She made Jason promise
to marry him if she helped him in his
quest; he promised; they won the
Golden Fleece and Medea returned to
Greece with them and married Jason.
Look for various incidents in the story,
especially the Fleece hanging from
a tree guarded by a dragon.
☛ Medea

Jeremiah
Old, somewhat miserable, prophet who
taught that the spiritual salvation of the
Hebrews would only occur as the result
of suffering.
☛ Prophets

Jerome (c. 342–420)
One of the four Fathers or Doctors
of the Christian Church. You see him
dishevelled and almost naked in the
desert beating his breast with a stone;
or sitting in his study; or wearing
cardinal's robes, holding a model of
a church. Somewhere there will be a

Jewels

Symbol of earthly possessions and all that they imply.
☞ Parts of the World; Sacred and Profane Love; Vanity

Joachim

The father of the Virgin Mary.
☞ Birth of the Virgin; Golden Gate; Immaculate Conception; Virgin Mary

Job

Prime example of the long-suffering, patient, upright, faithful human being. Would his faith in God withstand adversity? Satan said it would not, and tested him with every possible misery: he lost his house, servants and property; his children died; he was covered in painful boils; he was despised by his wife and friends. Satan was wrong – Job never renounced his faith. Look for scenes of his varying miseries. (He had his reward and got his health and property back – but presumably not his children.)
☞ Satan

John the Baptist

The young man who foretold the coming of Christ, and baptised those who were penitent in the River Jordan. Was imprisoned by Herod Antipas, whose stepdaughter, Salome, asked for (and received) Saint John's head as a reward for her wonderful dancing. He is often shown as a baby with Mary and the Christ child (his mother was a friend of Mary's). Or you see him as a thin and bedraggled young man wearing an animal skin and possibly holding a honeycomb – the results of retiring to the desert to pray. Usually holds a reed cross and may also hold a lamb.
☞ Baptism; Elizabeth; Herod Antipas; Judith; Lamb; Last Judgement; Salome; Zacharias

John the Evangelist

One of Christ's first disciples (not to be confused with John the Baptist). At the Last Supper he rested his head on Christ's chest. He is often shown as young and effeminate (no beard), with long hair and a red cloak. As an old (bearded) man he wrote the fourth Gospel of the New Testament and the Book of Revelations. His symbols are the eagle and a book or

4

scroll. He was boiled in a cauldron of oil by the Romans but he emerged unharmed and rejuvenated. Look for him sitting naked in a pot watched by the Roman Emperor and his senators.
☞ Agony in the Garden; Assumption of the Virgin; Cauldron; Entombment; Lamentation; Transfiguration

Jonah

A man sent by God to preach to the heathens, but he failed to do as instructed. God punished him by sinking his boat in a storm, and he was swallowed alive by a big fish (not necessarily a whale). While in its belly Jonah repented, and after three days the fish spat him out. Christ said the story prefigured his own death and Resurrection.
☞ Hippocampi

1. Lucas Cranach (the elder), *Judith with the head of Holofernes*, c.1530
2. Jacob Jordaens, *The Lamentation*, c.1650
3. Albrecht Dürer, *Hercules and the Stymphalian birds*, 1600 (Labours of Hercules)

Joseph

The husband of the Virgin Mary and foster father of Jesus. Carpenter by trade. Look for a middle-aged or elderly man with the tools of his trade, a lily (chastity) and a flowering rod or wand. Supposed to have died aged 111.
☛ Doctors; Flight into Egypt; Marriage of the Virgin; Massacre of the Innocents; Nativity; Presentation in the Temple; Virgin Mary

Joseph (with the technicolour coat)

Young man from the Old Testament, with popular and romantic life history. Briefly, his brothers hated him (spoiled brat), so they sold him into slavery and told dad (Jacob) he was dead (smeared his coat with goat's blood, said he was eaten by a wolf). Joseph prospered in Egypt, but was falsely accused of raping his slave master Potiphar's wife; was sent to prison but made a reputation for himself as an interpreter of dreams and was employed by the pharaoh as chief administrator. Final, complicated, reconciliation with brothers and dad in Egypt; dad blessed Joseph's two sons.

Joseph of Arimathea

Well-to-do disciple who had permission from Pontius Pilate to take Christ's body down from the Cross (he is richly dressed and usually wears a hat). Caught the blood from Christ's wound in a cup (the Holy Grail). Founded the first church in England at Glastonbury.
☛ Deposition; Entombment; Lamentation; Holy Grail

Joshua

After the death of Moses, Joshua led the Israelites, captured Jericho (by walking round it seven times, blowing trumpets and shouting so loud that the walls fell down), and then captured the Promised Land, Canaan.
☛ Moses

Judas Iscariot

The disciple who betrayed Christ for 30 pieces of silver. He later hanged himself out of remorse. Look for a dark middle-aged man, possibly with a yellow cloak. May well sit alone on the other side of the table at the Last Supper.
☛ Agony in the Garden; Betrayal; Last Supper; Pentecost

Jude

The patron saint of lost causes. Preacher and martyr. Look for a saint carrying the club or lance that killed him. Not to be confused with Judas.

Judgement of Paris

At the Feast of the Gods, Eris threw down a golden apple marked 'To the fairest'. Jupiter said to Mercury: 'Take the apple to Paris and make him decide.' There were three candidates, each of whom tried to bribe Paris. Juno offered land and riches; Minerva offered victory in battle; Venus offered the love of any

1

woman Paris chose, and described the charms and beauty of Helen. Paris offered the apple to Venus and so became besotted with Helen – whom he captured, setting off the Trojan War.
☛ Feast of the Gods; Helen; Juno; Jupiter; Mercury; Minerva; Paris; Trojan War; Venus

3

Judgement of Solomon
See Solomon

2

Judith
Powerful, glamorous widow who saved the Jews from the Assyrians. She tricked the Assyrian commander, Holofernes, into thinking she was on his side and, when he tried to seduce her after a banquet, chopped his head off. As well as being a good blood-and-guts scene, it can also imply the victory of virtue over sin. Look for a severed head, usually in a basket (if the head is on a plate, it is Saint John the Baptist's).
☛ John the Baptist

Juno (Greek: Hera)
Chief goddess – sister and wife of Jupiter. Mother of Mars. Tries endlessly to get her faithless brother and husband back. Stately rather than beautiful. Usually seen with a crown, peacock(s), a magic belt (to make her attractive to Jupiter), pomegranate (fertility), a sceptre and a cuckoo (deceived spouse). Protectress of women, marriage and childbirth.
☛ Greek and Roman gods; Hebe; Hercules; Io; Judgement of Paris; Jupiter; Mars; Milky Way; Narcissus; Olympus; Peacock; Tiresias; Vulcan

Jupiter (Greek: Zeus)
The supreme, all-powerful god of the classical world. Noble and merciful, he was also an insatiable womaniser, which infuriated his wife Juno. To satisfy his desires he often turned himself into other creatures. Had a traumatic and Freudian childhood – his mother had to flee from his child-eating father, Saturn, and he was brought up on milk and honey by nymphs; Juno was also his sister. You usually see him with an eagle, a sceptre, hurling thunderbolts, or a combination of these.
☛ Bacchus; Callisto; Danaë; Ganymede; Greek and Roman gods; Hebe; Helen; Hercules; Io; Juno; Leda and the Swan; Mars; Minerva; Muses; Nymph; Olympus; Pandora; Perseus; Phaeton; Prometheus; Psyche; Rape of Europa; Saturn; Semele; Thetis; Tiresias; Vulcan

Justice

One of the four cardinal virtues. Look for a blindfolded woman carrying a sword and scales (powerful and impartial).

☛ Abundance; Apotheosis; Daniel; Peace; Virtues

Key

See Fidelity; Martha; Peter

Knot

According to context, often symbolises the ties of love and marriage. Cupid often knots people together, literally or symbolically.

☛ Cupid; Francis of Assisi; Gordian Knot; Mars; Venus

Labours of Hercules
(The Twelve Labours of Hercules)

Undertaken by Hercules for King Eurystheus as a penance for slaying his own children in a fit of madness. The labours were as follows:

1) Strangled the Nemean lion.
2) Slew the many-headed Leraean hydra (monster resembling a water snake).
3) Captured the Arcadian stag.
4) Captured the Erymanthian boar.
5) Cleaned the filthy Augean ox stables.
6) Shot the Stymphalian birds.
7) Captured the flame-belching Cretan bull.
8) Tamed the human flesh-eating mares of Diomedes.
9) Won the girdle of Hipployta (Queen of the Amazons).
10) Captured the oxen of the human monster, Geryon.
11) Captured the golden apples of the Hesperides.
12) Captured the many-headed dog, Cerberus.

☛ Amazons; Antaeus; Cerberus; Hercules; Hesperides; Triumphs of Caesar

Lamb

When carrying a flag or banner with a red cross, symbolises Christ's Resurrection and victory over death.

☛ Agnes; Humility; Innocence; John the Baptist; Patience; Resurrection

Lamentation

The scene that immediately follows the Deposition. Look for the body of Christ stretched out on the ground or on a rock, surrounded by mourners, with the Virgin (and maybe John the Evangelist) holding his head, Mary Magdalene holding his feet, Joseph of Arimathea holding a cloth and Nicodemus holding a jar of spices.
See also Pietà

Laocoon

Look for a group consisting of an old man (Laocoon) and two boys wrestling with snakes. A Trojan War story and turning point. Laocoon, a priest, warned against bringing the wooden horse into Troy. Shortly afterwards two big snakes swam ashore and strangled Laocoon and his sons. Trojans thought Minerva was angry with them and brought the wooden horse (full of enemy Greeks) into the city to please her.

☛ Minerva; Trojan War; Wooden Horse

Lapiths

See Centaurs

Last Judgement

Confidently predicted, but yet to happen. Christ is due to reappear (the Second Coming), when all the dead will be resurrected and Christ will judge the living and the dead according to their behaviour on Earth. Look for Christ sitting in judgement surrounded by saints, disciples, patriarchs; the Virgin Mary (perhaps also John the Baptist) pleading for those about to be judged; the dead being resurrected (woken by angels blowing trumpets); Saint Michael weighing souls; sinners on Christ's left

(your right) going down to Hell; the righteous going to sit at Christ's right hand (your left).

☛ Hell; John the Baptist; Michael; Resurrection; Virgin Mary

Last Supper

The meal at which Christ ate with his 12 disciples for the last time, on the eve of his arrest. Look for the two main, alternative, incidents: Christ consecrating (blessing) the bread and wine, which becomes the central symbolic rite of the Christian religion; and the moment of horror when he announces that one of them (initially unnamed) will betray him. The disciples on either side of Christ are usually John and Peter. Also look for Christ washing his disciples' feet (usually with Peter, raising his hands in protest at Christ's humility).

☛ Agony in the Garden; Betrayal; Eucharist; Holy Grail; John the Evangelist; Judas Iscariot; Peter

Laurel

A laurel crown is worn by those who achieve victory. In portraiture indicates that the sitter is artistic or literary.

☛ Apollo; Daphne; History; Muses; Orpheus; Truth

Lawrence (Latin: Laurentius) (died in 258)

Look for young saint being roasted on a gridiron (like a barbecue) by the Romans. Supposed to have said that he was done enough on one side, so please would they turn him over – he may be shown in the act of being turned over. Patron saint of Florence (San Lorenzo).

Lazarus

The brother of Mary Magdalene, raised from the dead by Christ. He had been buried for four days, so look for him coming out of his cave or tomb and removing the cloth he was wrapped in. Also look for the amazed people; sometimes they hold their noses against the smell of a decomposing body.

☛ Martha; Mary Magdalene

Leander

See Hero and Leander

Leda and the Swan

The swan is Jupiter. Leda is the daughter of a Spartan king. He has his way, she lays eggs, and the hatch is Castor and Pollux, Helen of Troy and Clytemnestra.

☛ Castor and Pollux; Clytemnestra; Helen; Jupiter

Leviathan

In Jewish mythology, a monster whose gaping jaws were the entrance to Hell.

☛ Hell

1. Joos van Cleve, *Madonna and Child*, c.1525–30

Joseph; Milky Way; Thomas Aquinas; Virgin Mary

Lion

King of the animals and glorious to look at – consequently the subject of many stories of heroism and valour, and the attribute of many saints. Finds its way into many pictures.

☞ David; Fortitude; Jerome; Labours of Hercules; Mark; Parts of the World; Pride; Samson; Temperaments; Wrath

Lo Spasimo

The Virgin Mary swooning as she sees Christ carrying the Cross on the road to Calvary.

☞ Calvary

Lobster

Indicates fickleness and inconstancy.

☞ Bat; Moon

Longinus

The Roman soldier who pierced Christ's side with a lance when he was on the Cross.

☞ Crucifixion story

Lot

Never look back, only forward. Complicated Old Testament story: God told Lot and his family (good) to flee from Sodom and Gomorrah (bad), which He was about to destroy, but on one condition – they were not to look back. Lot's wife did, and she was turned into a pillar of salt. Lot's two daughters then thought, mistakenly, that they and their father were the only people left on Earth, so they made him drunk and seduced him in order to perpetuate the human race. Look for a scene with two young beauties, an old man and a burning city.

Liberal Arts

Seven in total, presided over by Philosophy. Represented by women holding the appropriate attribute. Collectively constitute the traditional mediaeval or Renaissance curriculum for higher education:
1) Grammar (books, whip).
2) Logic (snakes, scales, flowers).
3) Rhetoric (book, sword, shield).
4) Geometry (compasses, ruler, globe).
5) Arithmetic (abacus, writing slate).
6) Astronomy (globe, sextant, armillary sphere)
7) Music (musical instrument).
Look for artists trying to add painting as an 8th.

☞ Philosophy

Lily

Symbol of purity, especially associated with the Virgin Mary.

☞ Dominic; Francis of Assisi; Gabriel;

Lucifer
See Satan

Lucy (died in 303)
The saint who carries two eyes in a dish (for no particularly good reason). She gave all her riches to the poor, which so enraged her fiancé that he denounced her for being a Christian. She suffered endless tortures and was finally stabbed in the throat with a dagger.

Luke
One of the four evangelists. Recognisable from his attribute, a winged ox. Look for him writing his Gospel or painting a picture of the Virgin Mary. Luke was supposed to have been a painter and a physician – thus he is the patron saint of artists and doctors.
☞ Evangelists

Luna (Greek: Selene)
Goddess of the moon – look for a crescent moon on her forehead. She may have a chariot pulled by a black horse (night) and a white horse (day).
☞ Diana; Greek and Roman gods; Helios; Horae

Lust
For early Christians, the supreme deadly sin. Classical gods regarded it as acceptable. The Renaissance took a fairly relaxed attitude. Many quick-off-the-mark animals symbolise lust, such as apes, boars, cocks, doves, goats, hares, pigs and rabbits. A repellent image of lust is a woman having her breasts and genitalia eaten by toads.
☞ Deadly Sins; Temperance

Lute
A pear-shaped guitar. Often used by angels. A lute with a broken string signifies discord or argument.
☞ Liberal Arts; Muses; Senses

Lyre
Stringed instrument invented by Mercury; used by Apollo and Orpheus, among others.
☞ Apollo; Mercury; Muses; Orpheus

Madonna
See Virgin Mary

Maenads
Badly behaved drunken women who accompanied Bacchus.
☞ Bacchus

Magdalene
See Mary Magdalene

Magi
See Adoration of the Magi

Magpie
Represents fidelity (they stay together in pairs).

Man of Sorrows
A devotional image of Christ displaying his bleeding wounds such as a crown of thorns, nail marks in his hands, and lance wound in his side.
☞ Crown of Thorns; Crucifixion; Longinus

Mandorla
An almond-shaped frame that may surround Christ or the Virgin Mary at moments of intense spirituality.
☞ Ascension of Christ; Assumption of the Virgin; Transfiguration

Manna
When Moses lead the Israelites out of Egypt they began to starve in the desert. God provided food in the night, in the form of manna from Heaven. The

Israelites woke up to find the ground covered in something that looked like frost and tasted like wafers made with honey. Look for them scooping it up into bowls and baskets.

☞ Moses

Margaret
Popular virgin. Her punishment for chastity was to be thrown into a dungeon where a dragon (actually Satan) ate her, but her faith caused the dungeon to burst open and she walked out unharmed. (She was later beheaded.) Patron saint of childbirth. Look for a dragon under her control.

☞ Dragon

are two famous incidents supposedly involving Venetians: the miracle of the fisherman and the rescue of a slave. Mark's attribute is a winged lion. Look for a youngish man with dark hair and beard, maybe carrying a book.

☞ Evangelists; Gospel; Miracle of the Fisherman; Rescuing a Slave

Marriage of the Virgin
Mary, Christ's mother, marrying Joseph. Mary is young, Joseph middle-aged. Mary had a number of suitors, amongst whom she was to choose by a sign: the one whose rod flowered. Joseph places a ring on her finger and holds a stick (rod), which is flowering and has a dove sitting among the flowers. Behind Joseph are the failed suitors (look for one breaking his rod, and another about to hit Joseph). Behind Mary are her virgin companions.

☞ Joseph; Virgin Mary

Mark
One of the four evangelists. He was martyred in Alexandria where he went to preach. His remains were eventually brought to Venice in the 9th century AD – he is the patron saint of Venice, so often appears in Venetian paintings. There

Mars (Greek: Ares)
The god of war – unpleasant and aggressive. Disliked by everyone, including his parents Jupiter and Juno, but not Venus, who fell in love with him. Look for the big embrace, and Cupid

taking away his weapons and armour (love conquers all). Look also for a net: Venus was married to Vulcan when she fell for Mars. The former set a trap in the form of an invisible and unbreakable net that only he could handle. Mars and Venus were caught together in his net and the Olympian gods were summoned to have a look at the humiliated lovers.

☞ Cupid; Greek and Roman gods; Juno; Jupiter; Olympus; Romulus and Remus; Venus; Vulcan

Marsyas

A satyr and friend of Bacchus. Gifted flute player, who unfortunately was challenged by Apollo to a musical contest – harp versus flute – to be judged by the Muses. The winner was to be able to impose any penalty on the loser. Apollo won (surprise, surprise) and ordered Marsyas to be flayed (skinned) alive.

☞ Apollo; Bacchus; Muses; Satyrs

Martha

Sister of Mary Magdalene. Hyperactive housewife holding a bunch of keys or

3

a cooking ladle. Successfully killed a dragon by sprinkling it with holy water from a brush.

☞ Dragon; Lazarus; Mary Magdalene

Martin (c.316–c.400)

Look for a saint dressed as a bishop or as a Roman soldier, often on a horse. Also, look for the occasion when he cut his cloak in half and gave one half to a shivering beggar. He gave up his life as a soldier to preach. Founded many monasteries. May have a goose at his feet (he was born in November).

Mary

See Virgin Mary

Mary Magdalene

A rich, vain, immoral woman who repented of her sins. The archetypal image for the repentant sinner in Christian art, she appears in many narrative scenes, or on her own with noticeable long hair and holding a jar of ointment. She annointed Christ's feet with precious ointment in the house of Simon the Pharisee and wiped them with her hair. She listened to Christ's word when he visited her and her sister Martha, and was told off by Martha for not being busy in the kitchen. She was present at the Crucifixion, and later recognised Christ by the empty tomb after the Resurrection – he told her not to touch him but to inform the disciples about what had happened.

☞ Crucifixion story; Deposition; Entombment; Lazarus; Martha; Noli me tangere; Sepulchre

Marys, The Three

See Sepulchre

Mask

A symbol of deceit – because it is a disguise. Tragedy and comedy are represented by masks with expressions

1. Peter Paul Rubens, *Perseus and Andromeda*, detail of Medusa's reflection in Perseus' shield
2. Veronese, *Mercury, Herse and Aglauros*, c.1576–84
3. Rogier van der Weyden, *St Michael Weighing The Souls*, detail from *The Last Judgement*, c.1451

of gloom and mirth respectively.
☛ Deceit; Muses; Night

1

Mass

The Christian formal celebration of the Eucharist, conducted by a priest.
☛ Eucharist

Massacre of the Innocents

Bloodcurdling scene of Roman soldiers slaughtering babies, usually in a palace courtyard. When Herod the Great learned of Christ's birth he was frightened and ordered all the babies in Bethlehem to be slaughtered. Look for Herod giving orders and, possibly, a mother making her escape with her baby – they are Elizabeth and John the Baptist (Mary, Joseph and Jesus had already left for Egypt).
☛ Flight into Egypt; Herod the Great; John the Baptist

Matthew

One of the four evangelists. The tax man who became a disciple and wrote the first Gospel. He may hold a purse (tax collecting) or an axe (he was beheaded). His attribute is a winged person.
☛ Evangelists; Gospel

Maurice

Dark-skinned (Maurice = moorish), Roman soldier who commanded the famous Theban legion; all the soldiers were executed by the emperor because they refused to worship pagan idols. A martyr. Patron saint of Austria.

Medea

Jason's wife. He deserted her. She was a witch and, in seeking her revenge on Jason, murdered their children, his new wife, and Jason's father. She also killed his uncle Pelias.
☛ Jason

Medusa

One of three sisters (called Gorgons) whose appearance was so horrendous – Medusa had snakes on her head, instead of hair – that whoever looked at her directly was instantly turned to stone. Perseus was able to chop her head off because he only looked at her reflection in his polished shield. Look for him holding up the severed head, sometimes with Minerva (who gave him the shield) close by. Pegasus sprang from Medusa's dead body. Freud said the snakes were phalluses, and that she represented the paralysing fear of castration.
☛ Coral; Minerva; Pegasus; Perseus

2

Melancholy

A female, the daughter of Saturn. Usually shown with wings and a dog, and looking gloomy, maybe with her head in her hands.
☞ Saturn; Temperaments

Meleager

Unfortunate young man for whom almost everything went wrong. His royal father upset Diana, so she sent a wild boar to destroy the country. Meleager and his friends hunted it and killed it. He gave the head and pelt to his girlfriend Atalanta. This caused a quarrel with the others, during which Meleager killed his two uncles. The Fates had decreed at his birth that Meleager would die only when a log of wood that was burning was finally consumed. His mother, sensibly, took it out of the fire and kept it. After the quarrel she was told, incorrectly, that Meleager was dead. So she, unwisely, threw the log onto a fire: Meleager died.
☞ Atalanta; Diana; Fates

Mercury (Greek: Hermes)

The messenger of the gods. Look for an elegant and athletic young man with winged sandals, winged hat, and a magic wand with two snakes coiled round it (called a caduceus). He had many roles: teacher (taught Cupid to read); trickster and cattle thief (god of commerce); took the souls of the dead to Charon in the Underworld; musician (invented the lyre); patron of travellers.
☞ Apollo; Caduceus; Charon; Cupid; Greek and Roman gods; Judgement of Paris; Lyre; Olympus; Pandora

Mercy

Female figure, usually robed, sometimes paired with Truth. May be pressing milk from her breast.

Michael

Archangel. The warrior angel of the church militant, and the angel who weighs up the souls of the dead (sometimes you see a pair of scales). Often shown wearing armour or chain mail, and holding a shield, sword or spear. Sometimes seen fighting and overcoming Satan, who may be represented as a dragon. Do not confuse

3

with Saint George, who has no wings (until recently George was not a fully recognised saint).
☞ Angels; Assumption of the Virgin; George; Last Judgement; Satan

Midas

Particularly stupid Greek king who was granted a wish by Bacchus. He asked that everything he touched would turn

to gold, but then realised too late that it meant he could not eat and drink. Bacchus relented and rescinded the wish. Midas was then stupid enough to favour Pan over Apollo in a musical competition, so Jupiter gave him ass's ears.
☛ Apollo; Bacchus; Pan

Milky Way
The luminous band of stars that stretches across the night sky. Said to have been created when the infant Hercules sucked so hard at Juno's breast that milk spurted out (she wasn't his mother, but that's another story). The few drops that fell to Earth created the lily.
☛ Hercules; Juno

Minerva (Greek: Athena, Pallas Athene)
The goddess of wisdom. Look for a rather severe female (chaste, a virgin – rather like a maiden aunt) wearing armour and a helmet, holding a shield, perhaps decorated with Medusa's head, which Perseus gave her. Her father was Jupiter (she sprang fully armed from his head, which no doubt surprised him). May well have an owl, books and a snake. Patroness of various household crafts and the arts in general. Guardian of various heroes, and of the city of Athens.
☛ Arachne; Hercules; Judgement of Paris; Jupiter; Laocoon; Liberal Arts; Medusa; Olympus; Perseus; Wisdom

Minotaur
The famous bull-headed monster that belonged to King Minos and lived in a labyrinth in Crete. Young men and maidens were regularly sacrificed and fed to the monster. Slain by Theseus. The king's daughter, Ariadne, gave Theseus a ball of wool so that he found his way back out of the labyrinth.
☛ Ariadne; Daedalus; Theseus

Miracle of the Fisherman
A legendary miracle, which saved Venice. During a terrible storm, three strangers (they were in fact Saints Mark, George and Nicholas) told a group of Venetian fishermen to row them out to sea. They met a boat full of demons who intended to destroy Venice. The strangers exorcised the demons, the storm ended, and Saint Mark gave the ring to one of the fishermen to give to the Doge (chief magistrate of Venice) as proof of the miracle. Look for the storm scene, especially the terrified demons, or the scene where the fisherman gives the ring to the Doge.
☛ George; Mark; Nicholas of Myra

Miraculous Draught of Fishes
Christ was on Peter's boat preaching to those on the shore. Afterwards he told those on the boat to lower their nets. They were doubtful, but the nets came up full of fish. This led to Christ's famous remark, 'You will be fishers of men' – meaning: spread the word of Christianity. Look for James the Great and John in a nearby boat helping to land the fish. Sometimes said to have occurred after Christ's Crucifixion (as one of his reappearances).
☛ Crucifixion; James the Great; John the Evangelist; Peter

Mirror
Held by the Virgin Mary, symbolises her virginity and flawlessness.
☛ Pride; Prudence; Senses; Truth; Vanity; Virgin Mary

Mocking of Christ
Do not confuse with the crowning with thorns – the mocking came earlier. On this occasion it was the high priests and the Jews, not the Romans, who mocked him and spat at him.
☛ Crown of Thorns

Monkey
See Ape

1

Months
The activities usually associated with each month are as follows.
January: tree felling or feasting; February: grafting fruit trees; March: pruning vines or digging; April: training vines; May: falconry or scything grass; June: haymaking; July: cutting corn or threshing; August: harvesting or ploughing; September: gathering or treading grapes; October: sowing seed or putting wine in barrels; November: gathering wood or fattening pigs; December: digging the fields or getting ready for Christmas.

Moon
Symbol of chastity, the attribute of Diana and the moon goddess Luna. Sometimes means fickleness or inconstancy.
☛ Bat; Creation; Crucifixion symbols; Diana; Lobster; Luna

Morpheus
Greek god of dreams. Son of Hypnos.
☛ Night; Poppy; Sleep

Moses
Jewish leader, best known for leading the Israelites out of captivity in Egypt, and for the Ten Commandments. Recognisable as an old man with white hair and a long beard, possibly with rays of light sprouting from his head and carrying a rod or wand and stone tablets. His life was seen as foreshadowing that of Christ.
☛ Finding of Moses; Golden Calf; Manna; Ten Commandments; Transfiguration; True Cross; Water from a Rock

Muses
Nine nymphs who lived on Mount Parnassus, daughters of Jupiter, who were the source of creative inspiration in the arts. Look for attractive women with the following attributes:
1) History (book, crown, trumpet);
2) Music (flute, trumpet, garland);
3) Comedy (masks, scroll);
4) Tragedy (masks, dagger, horn);
5) Dance and song (harp, flowers, stringed instruments);
6) Lyric poetry (tambourine, lyre);
7) Astronomy (globe and compasses);

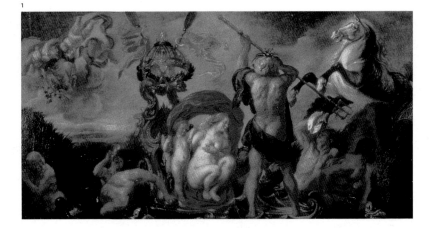

8) Epic poetry (trumpet, books, laurel crown); and

9) Heroic hymns (portable organ, lute). They all have elaborate first names that are difficult to remember.
☞ Jupiter; Marsyas; Parnassus; Pegasus

Musical instruments

Often indicate love. Stringed instruments are brought to life by stroking and have female-looking curves; pipe instruments are phallic.

Myrtle

Evergreen bush that symbolises eternal love. Sacred to Venus.
☞ Venus

Naiads

See Nymphs

Naming of the animals

Adam named all the animals in the Garden of Eden before he and Eve were expelled (he may be shown writing the names in a book). You can sometimes tell where artists come from by studying what they put into this ideal garden.
☞ Adam and Eve; Garden of Eden

Narcissus

A sad story. Echo fell in love with the young and beautiful Narcissus. Jealous Juno punished Echo by making her only able to repeat the last words spoken to her; thus she couldn't speak to Narcissus or make a proper answer. He spurned her, inevitably. He was punished by being made to fall in love with his own reflection. He was so besotted by it, he pined away and died. Echo was so heartbroken she wasted away, until only her voice was left behind. Look for Narcissus gazing into a pool. Where he died, the first narcissi flowers bloomed.

Nativity

The birth of Christ. One of the most familiar of Christian images, central to the Christmas story and often loaded with symbolic and narrative detail. Look for the stable setting (no room in the inn); night time, but the Christ child in a manger glowing with light; Mary and Joseph attentive and adoring; the ox and ass looking on. It is later on that the shepherds and wise men turn up to pay homage. (Mary and Joseph were temporarily in Bethlehem, Joseph's birthplace, because of a census of the population being carried out by the Romans.)
☞ Adoration of the Magi; Adoration of the Shepherds; Joseph; Virgin Mary

Nemean lion
See Labour of Hercules

Nemesis
One of the daughters of Night, who brought about the downfall of those who acted rashly due to excessive pride (hubris). Look for a naked woman with a blindfold, wings, a globe, and a bridle or rope.
☛ Hubris; Night

Neptune (Greek: Poseidon)
The god who ruled the seas (keep him happy or you will get shipwrecked). Look for a well-built old man, with long flowing hair, carrying a trident (three-pronged fork). He may be riding a dolphin, or riding in a chariot drawn by sea horses.
☛ Four Elements; Greek and Roman gods; Hippocampi; Nereids; Olympus; Polyphemus; Triton; Ulysses

Nereids
See Nymphs

Nicholas of Myra (4th century BC)
Role model for Father Christmas. Very popular saint and the protector of children, sailors and travellers. Bishop of Myra in Asia Minor. Buried at Bari in Italy. Look for a saint dressed like a bishop, with three golden balls or purses and perhaps an anchor or three pickled children.
☛ Charity of Saint Nicholas; Miracle of the Fisherman; Pickled Children

Nicholas of Tolentino
Augustinian hermit, slightly boring. Wears a black robe with a star pinned to it (one appeared at his birth). Holds a crucifix with lilies. Sometimes seen with two pigeons (he is said to have restored some roasted birds to life).
☛ Lily

Nicodemus
Well-to-do Pharisee who came to Christ privately for instruction. Look for Nicodemus and Christ sitting at a table at night by candlelight. Nicodemus also took part in Christ's burial.
See also Deposition; Entombment; Lamentation; Pharisee

Night
Look for a woman, probably dressed in black, carrying two children (Sleep and Death), maybe with poppies, an owl and a mask. Morpheus may be lurking in the background.
☛ Death; Morpheus; Sleep

Niobe
Profoundly stupid daughter of a dim-witted Greek king (Tantalus) who succumbed to overweening pride and, being related to the gods, claimed to be untouchable. So Apollo and Diana punished her by savagely killing her 14 children. She was so heartbroken she turned to stone, but the stone continued to shed tears.
☛ Apollo; Diana; Tantalus

Noah
Best known for building his ark, and taking on board two of every living creature. God had sent the Great Flood to destroy the world because he was so fed up with man's wicked behaviour, but told Noah to build the ark. It rained for 40 days and 40 nights, after which the ark came to rest on Mount Ararat. Noah sent out a dove, which returned with an olive branch (i.e. flood over, water level receding) and God put a rainbow in the sky as a promise he would not destroy the world again. Look for all these incidents, and the separate occasion (rather obscure in meaning) when Noah became drunk. Noah was Adam and Eve's grandson.
☛ Adam and Eve; Dove

Noli me tangere
'Do not touch me' – Christ's instruction to Mary Magdalene after he had risen from the dead.
☞ Mary Magdalene

Nymphs
In Greek mythology, beautiful young girls who were the spirits that inhabited nature. Dryads were wood nymphs; nereids were the nymphs of the Aegean Sea; naiads were the nymphs of fresh water. Diana and Calypso are attended by nymphs.
☞ Achilles; Calypso; Daphne; Diana; Eurydice; Galatea; Muses; Paris; Satyrs

Oak
Tree sacred to Jupiter.

Obedience
Represented by a female figure riding an ass with a millstone; or she may wear a yoke.
☞ Benedict; Francis of Assisi

Odysseus
See Ulysses

Odyssey, The
One of the most famous adventure stories of all time, in which Homer tells the story of Odysseus (Latin: Ulysses) returning home after the Trojan War – a journey that took him 10 years to complete.
☞ Homer; *Illiad*; Trojan War; Ulysses

Oedipus
The King of Thebes. As a baby he was sent out of Thebes to be killed because of a prophecy that he would murder his father and marry his mother. He survived, of course, and was adopted. As a young man he heard of the prophecy and so ran away from his adoptive parents thinking

they were his real ones. He then unwittingly killed his true father at a cross roads, solved the riddle of the Sphinx and saved Thebes. His reward was marriage to the widowed Queen of Thebes, who was, unknown to everyone, his true mother. Oedipus is usually shown

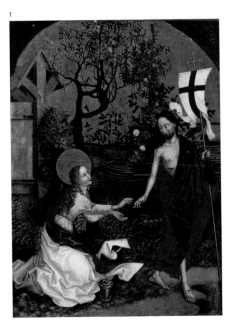

1

confronting the Sphinx, (Freud gave the name Oedipus to the complex he said we all have about our mothers or fathers, meaning that to become fully mature psychologically, you to have consciously break your dependence on and yearning for your mother or father.)

Olive (olive branch)
The symbol of peace.
☞ Dove; Noah; Peace; Wisdom

Olympus
The mountain in Greece on which the main classical gods lived. Each had a favourite haunt, but all were welcome at the court of Jupiter where assemblies

and feasts were held. The principal 12 gods of Mount Olympus formed a type of collective government. Instead of 'god of' think 'minister/secretary of state for' and you get: Jupiter (Prime Minister/President); Diana (deputy PM/vice-president); Apollo (media, sport and culture); Bacchus (leisure services); Mars (armed forces); Juno (women's issues); Ceres (agriculture); Pluto (social security); Minerva (education); Neptune (overseas trade); Mercury (transport and communications); Vulcan (industry). Today the word Olympus has come to simply mean 'the heavenly dwelling place'.
☛ Greek and Roman gods

Omphale

Queen of Lydia. At some point in his life Hercules was sold to Omphale as a slave. She made him her lover but, surprisingly, he became effeminate and took to wearing women's clothes. Pan tried to seduce this attractive 'woman', and got the shock of his life when he found 'her' to be an unresponsive Hercules.
☛ Hercules; Pan

Orange
See Apple

Orion

A giant of a hunter (Greek), who was blinded by a king whose daughter he tried to rape. He got his sight back when he travelled to the edge of the world and was touched by the rays of the rising sun.

Orpheus

Legendary Greek poet, famous for his musical talents. Look for a handsome youth with a laurel crown, playing a lyre or lute, surrounded by wild animals who are enchanted and tamed by his music (even the trees and rocks were enthralled). Married Eurydice and when she died he followed her into the

Underworld, with unfortunate consequences.
☛ Eurydice; Laurel; Lute; Lyre; Underworld

Owl

Attribute of Minerva, the goddess of wisdom. Also symbolises sleep.
☛ Minerva; Morpheus; Sleep; Wisdom

Ox

Unfortunate animal used by early societies as their main beast of burden and sacrifice. Various symbolic meanings in art, such as patience and sloth. Oxen also pull the chariot of Death.
☛ Death; Luke; Nativity; Patience; Sloth

Pallas Athene (Athena)

See Minerva

Palm

In classical art, a symbol of military victory. In Christian art, a symbol of victory over death.
☛ Entry into Jerusalem; Fame; Parts of the World

Pan

The god of the woods and fields, and the protector of flocks and herds. He had rustic features (goat's legs, pointed ears and horns) and lived in Arcadia. In essence an oversexed yokel who lived off the fat of the land. He chased Syrinx, who prayed for protection and was transformed into a bundle of reeds. Pan so liked the sound of the wind in them that he made them into a set of musical pipes – look for him holding pan pipes.
☛ Apollo; Arcadia; Midas; Omphale

Pandora

Attractive young girl who was responsible for all the evil in the world. Made from clay by Vulcan, and sent to

Earth by Jupiter (carried by Jupiter's messenger Mercury) with a box which she was told not to open. Silly girl – temptation got the better of her. She opened it and out flew all the evil in the world. She tried to shut the lid in vain, but managed to capture inside one creature – a butterfly, representing hope.
☞ Hope; Jupiter; Vulcan

Paradise
For Christians, Paradise is the place of rest and refreshment (usually depicted as a garden or an idealised landscape), where the souls of the righteous go after death, to rest at peace in the presence of God. Also used as a synonym for the Garden of Eden – where Adam and Eve were happy and free from sin before their temptation and expulsion.
☞ Adam and Eve; Arcadia; Cherry; Garden of Eden; Parnassus; Temptation

Paris
The Trojan prince (son of Priam) who caused the Trojan War. It was predicted at his birth that he would ruin Troy, so he was left on a hillside to die – look for him being discovered and brought up by shepherds. Was loved by a nymph, but he deserted her for Helen, Queen of Sparta, whom he abducted and took back to Troy (hence the war). Killed Achilles.
☞ Achilles; Helen; Judgement of Paris; Nymphs; Trojan War

Parnassus
The Greek mountain range sacred to Apollo and the Muses, and the abode of poetry and music. Look for a fertile hill top with a stream and a laurel grove in which sits Apollo surrounded by the Muses, with, sometimes, other gods nearby. A sort of paradise.
☞ Apollo; Greek and Roman gods; Muses

Parts of the World
Imagery much liked by 17th- and 19th-century Empire builders and Christian missionaries. The four parts of the world are always represented by a woman, and all four are surrounded by appropriate objects.
1) Europe – a queen wearing a crown, with a temple or a church, cornucopia, weapons, symbols of the arts and sciences (Europe rules the world).
2) America – a female with a feathered head-dress and a bow, a crocodile, and severed head pierced by an arrow.
3) Asia – a female crowned with flowers and jewels, with a palm, a camel, and a perfume-making censer.
4) Africa – a black-skinned female wearing coral and with a scorpion, a lion, a snake or an elephant.

Passion
The suffering and death of Christ on the Cross. In Christian art there are cycles of paintings that illustrate all the main events of the Passion, from Christ's entry into Jerusalem to his Ascension into Heaven – maybe 30 or more scenes in all.
☞ Ascension of Christ; Crucifixion; Crucifixion story; Entry into Jerusalem; Instruments of the Passion

Patience
A minor virtue. Look for woman with a lamb or an ox.

Paul
Look for a short, bald, untidy-looking saint (he was so described in real life; in time, artists tidied him up and made him handsome). One of the later apostles whose special mission was to spread the word of Christ. With Saint Peter he was joint-founder of the Christian church (Paul was the gentile, Peter the Jew). Usually carries a book or scroll, and a sword. Best known for his dramatic conversion to Christianity: he was a Roman official, and was on his way

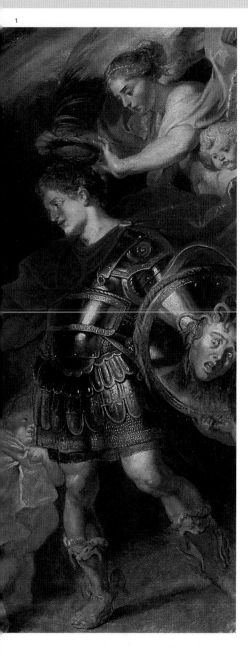

1

Peace

Look for a winged woman holding an olive branch and a dove, embracing Justice, near a cornucopia, or getting rid of weapons.
☛ Cornucopia; Dove; Justice

Peach

A peach with one leaf represents truth – the union of heart (the peach) and tongue (the leaf).
☛ Truth

Peacock

Attribute of Juno (she decorated its tail with the eyes of her faithful servant Argus). Because its flesh was supposed never to decay, it is a symbol of Christian immortality and the Resurrection.
☛ Four Elements; Io; Juno; Pride; Resurrection

Pearl

Much worn by Venus.
☛ Cleopatra; Venus

Pegasus

The winged white horse ridden by Perseus. Sometimes seen as a symbol of fame among the Muses.
☛ Aurora; Bellerophon; Fame; Medusa; Muses; Perseus

Peleus

Father of Achilles. A mortal who, with the help of Jupiter, seduced Thetis.
☛ Achilles; Feast of the Gods; Thetis

Pelican

The pelican piercing its breast to feed its young with its own blood symbolises the sacrifice made by Christ on the Cross.
☛ Crucifixion symbols

to Damascus to arrest Christians. Look for him falling from his horse as a light and a voice from Heaven tell him to follow God instead.
☛ Ascension of Christ; Peter

Penelope

Patient and faithful wife of Ulysses.

345

1

When he failed to return home after the Trojan War, he was presumed dead. Consequently she had many suitors, whom she held at bay by saying she must first finish weaving a shroud for her father-in-law. At night she unpicked it so that it was never finished. Look for her at her loom, surrounded by impatient suitors.
☞ Ulysses

Pentecost

The Christian church's birthday, 10 days after Christ's Ascension (50 days after Easter Day). The disciples were in a room when the Holy Ghost descended with wind and fire and, as well as being spiritually filled, they were able to speak many languages. Look for the dove of the Holy Ghost; the Virgin (representing the Christian church); 12 disciples (Matthias replacing Judas); 12 other figures representing the 12 nations of the world, each listening to their own language being spoken.
☞ Ascension of Christ; Holy Ghost

Persephone

See Proserpine

Perseus

Clean-cut, handsome young hero, boy-next-door type (but usually naked), best known for beheading Medusa and freeing Andromeda. Look for his winged feet and helmet, curved sword and polished shield. Son of Danaë and Jupiter.
☞ Andromeda; Atlas; Coral; Danaë; Jupiter; Medusa

Peter

Vigorous, earthy-looking fisherman, elderly saint, with grey curly hair and beard. Often wears a yellow or golden cloak. The leader of the 12 disciples and one of Christ's favourites. Spread the word of the Gospel, and with Saint Paul was co-founder of the Christian church. Was crucified upside down by Nero in AD 64. Holds a key or keys; if two, he holds the key to Heaven (gold) and to Hell (iron) – he has the power to forgive or condemn. Also look for a book, cross, crozier and a cock. On the eve of Christ's arrest, Jesus predicted, correctly, 'This night before the cock crows, thou shall deny me thrice.'
☞ Agony in the Garden; Ascension of Christ; Betrayal; Death of the Virgin; Hell; Last Supper; Miraculous Draught of Fishes; Paul; Transfiguration; Virgin Mary

Peter Martyr

A 13th-century friar from Verona who pursued heretics relentlessly, but was assassinated in a wood as a result of provoking two Venetian noblemen. Easily recognisable – he is the saint with a knife or hatchet in his head.

Phaeton

Son of Helios (sun god) who got into severe trouble. Persuaded his father to let him drive his chariot across the sky for one day. He lost control of the horses, and the Earth caught fire. Jupiter saved the day, but only by sending the burning Phaeton to his death in a river. Mourned by his sisters, who turned into poplar

trees, and by his friend Cygnus, who
turned into a swan.
Moral: don't lend your car to your son.
☞ Helios; Jupiter

Pharisees
Members of a pious society of Jewish
scholars. Pharisees took their religion
and its laws extremely seriously and
promoted the place of the synagogue in
religious life. They had a wide, popular
following. They were very suspicious of
Jesus and gave him a hard time.
See also Jesus; Nicodemus

Philip
Rarely seen, middle-aged disciple – one of
the first to follow Christ. Carries a cross.
He was crucified upside down.
☞ Feeding of the Five Thousand

Philistine
Member of the non-Semitic people of
Philistia (Ancient Palestine), who were
enemies of the Israelites. In more modern
parlance, someone who is indifferent to,
or ignorant of, things cultural and artistic.
☞ Samson

Philosophy
A female figure who wears a crown,
holds a sceptre, and either holds or is
surrounded by books. Her feet may be
resting on a globe. May wear a gown
decorated with flowers at the bottom,
fish in the middle and stars at the top.
☞ Liberal Arts

Phoenix
Legendary Arabian bird of immense
age, said to burn itself to death on a
funeral pyre and every 500 years or so,
a new young phoenix would then rise
from the ashes. Adopted by Christians
as a symbol of the Resurrection.
☞ Four Elements; Resurrection

Pickled children
Bizarre and unlikely tale. During a famine,
Saint Nicholas of Myra stayed with an
innkeeper who had murdered three
children and planned to feed their pickled
bodies to his guests. The saint restored
them to life, and the innkeeper fled.
☞ Nicholas of Myra

Pietà
The Virgin Mary alone with the body of
Christ after it had been taken down from
the Cross. The narrative scene where the
body of Christ is stretched out on the
ground with those who were involved in
the deposition is called the Lamentation.
☞ Deposition; Lamentation

Pillar
In Christian art a symbol of strength and

2

constancy; a broken pillar is the opposite. A statue or bust on a pillar means the subject is near the sky – and is therefore god-like.
☛ Lot

Pipe
As a musical instrument, is often a phallic symbol.

1

Pluto (also called Hades)
Brother of Poseidon and Jupiter. Stern and pitiless, but his name means 'giver of riches'. Ruler of the Underworld. His wife was Proserpine.
☛ Eurydice; Olympus; Proserpine; Underworld

Pollux
See Castor and Pollux

Polyphemus
A deeply unattractive giant who had only one eye (in the middle of his forehead –

he was a Cyclops), and who liked eating people. Ulysses and his companions were captured by him, and Polyphemus ate a couple of them. They escaped by making him drunk, and then drove a stake into his eye to blind him.
☛ Cyclops; Galatea; Neptune; Odyssey; Ulysses

Pomegranate
Fruit the size of a tennis ball, with a hard outer case, stuffed with seeds. Symbolises the Resurrection (the seeds regenerate the earth); chastity (well-protected seeds); unity of the church (many seeds inside one secure container).
☛ Chastity; Resurrection

Pontius Pilate
The indecisive Roman provincial governor who conducted the trial of Christ and condemned him to death. Famous for his public gesture of washing his hands of the whole affair.
☛ Flagellation; Herod Antipas; Trial of Christ

Poppy
Sleep-inducing flower associated with Hypnos and Morpheus.
☛ Morpheus; Sleep

Poseidon
See Neptune

Poverty
Usually shown as a female (old or young) in rags, with bare feet.
☛ Benedict; Francis of Assisi

Presentation in the Temple
Mary and Joseph took Jesus to the Temple to comply with various intricacies of Jewish law regarding first-born children. Look for pigeons, doves and candles as signs of purification. (This was not the

same ceremony as the circumcision.)
☛ Circumcision

Presentation of the Virgin

At the age of three the Virgin Mary was taken to the Temple, where she made various offerings and stayed for some time, being visited daily by angels. Look for her (looking older than her three years) climbing up the 15 steps of the Temple by herself, with maybe the High Priest Zacharias at the top and her parents looking on at the bottom.
☛ Zacharias

Priam

King of Troy.
☛ Achilles; Hector; Paris; Trojan War

Priapus

Fertility god with huge genitals – the protector of fertile nature, including vines, flocks, bees and gardens.

Pride

A deadly sin. Look for a female with a lion and eagle, a peacock or a mirror, or a combination of these. Look also for a rider falling from a horse.
☛ Deadly Sins; Humility

Procris

See Cephalus and Procris

Prodigal son

The most famous story of repentance and forgiveness. A rich man had two sons; he gave half his worldly goods to each. The younger son went off and wasted it 'in riotous living'. The elder stayed at home and was a good boy. Younger son came home in rags and was welcomed by his father. Elder brother not best pleased, but father placates him by saying that you should rejoice when what you have lost returns safely. Look for several scenes:

receiving the inheritance; riotous living; feeding pigs to keep body and soul together; the return home and the celebration party.

Prometheus

A Titan who modelled the first human being out of clay and who, according to one legend, stole fire from Vulcan's forge to bake it and give form to the human race. Was punished by Jupiter, who had him chained to a rock where an eagle came to eat his liver every day. Was rescued by Hercules.
☛ Hercules; Jupiter; Titan

Prophets

The Old Testament prophets proclaimed the will of God. The four greatest ones were Isaiah, Jeremiah, Ezekiel and Daniel.
☛ Daniel; Ezekiel; Isaiah; Jeremiah

Proserpine (Greek: Persephone)

Daughter of Ceres. Pluto fell in love with her and carried her off forcibly to the Underworld. Ceres went to look for her, causing the Earth to be barren until she found her. Pluto allowed her to return for four months a year, when the Earth burgeoned (an interesting explanation for the cycle of the four seasons).
☛ Ceres; Pluto; Seasons; Underworld

Prudence

A cardinal virtue. Look for a female with a snake, a mirror, compasses, or a book. More wisdom than caution.
☛ Virtues

Psyche

A beautiful young girl with whom Cupid fell in love. She was brought to his palace but he forbade her to look at him and only visited her after dark. She got curious and, as he slept with her, she lit a lamp but stupidly dropped hot oil on him, so he woke up and was very angry.

He left her and she wandered the Earth trying to find her lost love. Finally Jupiter arranged for her to be carried up to heaven and be reunited with Cupid.
☛ Cupid; Jupiter

Ptolemy
The greatest of the ancient astronomers.

Purgatory
The Christian spiritual remand home. The place where the souls of those who have not fully purged their earthly sins go, waiting for final judgement. Situated somewhere between Heaven and Hell.
☛ Gregory the Great; Hell; Trajan

Putti (sing. Putto)
Rather absurd chubby little pink children with wings (usually naked), scattered liberally over all sorts of art. They appear as mini angels in Christian art and as attendants of Cupid in secular art.
☛ Cherubim; Cupid

Queen of Sheba
See Solomon; True Cross

Quince
A golden pear-shaped fruit used for jams and jellies. Sacred to Venus and thus symbolic of fertility and marriage. If held by Christ, is the equivalent of an apple.
☛ Apple; Venus

Rabbit
Notoriously reproductive. Attribute of Venus.
☛ Hare; Lust; Venus

Rainbow
See Dido; Iris; Noah

Raising of the Cross
Was Christ nailed to the Cross when it was already in situ, or nailed to it when it was on the ground? No one knows the answer and artists have painted both versions of the Crucifixion story. In the latter version, there is a busy scene

1

in which a heavy cross is raised with Christ already nailed to it.
☛ Crucifixion

Rape of Europa
Europa was a mortal, and another of those many daughters of Greek kings whom the gods played fast and loose with. Jupiter fell in love with her, disguised himself as a white bull, played with her and her attendants on the sea shore (they dressed him up with garlands of flowers), and then took her out to sea and had his way with her. Sometimes she looks frightened, sometimes ecstatic.
☛ Jupiter

Raphael

An archangel whose name means
'God heals'.
☛ Angels; Tobias

Rat

A symbol of decay and the passing
of time.
☛ Night

Rebecca

The young woman who was chosen
to be Isaac's wife. An arranged marriage,
she was chosen by a diplomat who found
her drawing water from a well.
☛ Esau; Isaac

Remus

See Romulus and Remus

2

Rescuing a Slave

Look for a Christian slave being dragged
through the streets of Venice on his way
to his own public execution. Saint Mark
zooms down from Heaven like a fighter
pilot and rescues him. A miracle.
☛ Mark

Resurrection

On the third day after his Crucifixion,
Christ rose from the dead and returned
to Earth, where he stayed for 40 days. This
belief is central to the Christian religion.
No one witnessed the Resurrection,
but there are many accounts of his
subsequent meetings with those who
knew him. Christ is usually depicted as
standing on his tomb (or stepping out
of it), holding a banner with a red cross,
perhaps with soldiers sleeping beside it.
☛ Ascension of Christ; Crucifixion;
Easter; Jonah; Lamb; Noli me tangere;
Peacock; Phoenix; Sepulchre; Supper at
Emmaus; Thomas

River

See Achilles; Charon; Christopher;
Finding of Moses; Four Elements; John
the Baptist; Phaeton; River Gods; Styx;
Underworld

River god(s)

Popular image – a reclining, bearded
male, crowned with reeds and maybe
holding an oar, with an urn from
which the river flows.
☛ Daphne; Four Elements

Road to Calvary

Christ's journey from Pilate's house
to Calvary (the hill of Golgotha) where
he was crucified. There are different
versions of the story, so look for different
interpretations. Sometimes he carries
his own cross, sometimes it is carried by
Simon the Cyrenian. Look also for Roman
soldiers, two thieves, chief disciples,
Veronica, the Virgin and three Marys.
Sometimes Christ is shown triumphant,
sometimes crushed and suffering.
☛ Calvary; Pontius Pilate; Sepulchre;
Stations of the Cross; Veronica; Virgin
Mary

Roch (1293–1327)

French-born Christian saint. He nursed
the sick and so is a protector against
plague (he himself nearly died of plague).

1

Look for a youngish saint dressed for a pilgrimage, with a dog, and showing a dark infected spot on his thigh. The dog took care of him when he was sick.
☛ Cosmas and Damian

Romulus and Remus

Legendary founders of Rome, on April 21, 753 BC. Their mother was a vestal virgin who said she had been raped by Mars. They were thrown into the Tiber by their nasty great-uncle, but survived (the mother was thrown into prison). Brought up by a she-wolf and a woodpecker. Romulus killed Remus in a fight.
☛ Sabines; Vestal Virgins

Rose

A red rose signifies martyrdom; a white rose signifies purity. Often held by the Virgin Mary or the Christ child. Also an attribute of Venus.
☛ Venus; Virgin Mary

Ruth

An old Testament biblical woman, known for her modesty and virtue – which was duly rewarded by marriage to a good man, Boaz (she gleaned in his fields), who was also a rich farmer.

Sabines

One way of dealing with a declining birthrate. Romulus was worried about this, so he arranged a feast and invited his neighbours, the Sabines. At a given sign the young men of Rome carried off the Sabine maidens. They enjoyed what happened and became good wives and mothers – and even the Sabine menfolk were eventually reconciled. Wonderful opportunity for painting an active crowd scene with nudity. Usually misinterpreted now as a scene of mass sexual abuse. In fact, a story about the founding of an empire.
☛ Romulus and Remus

Sacra Conversazione

The Madonna and Child, surrounded by saints who either represent particular virtues, the Church, or the place or donor with which the altarpiece is associated.
☛ Virgin Enthroned

Sacraments

Christian acts conferring a state of grace. The Catholic church acknowledges seven: Baptism, Confirmation, Communion, Confession, Extreme Unction, Holy Orders and Matrimony. The Protestant Church only recognises Baptism and Communion.

Sacred and Profane Love

The two sorts of love. Sacred – chaste, contemplative and philosophical; look for a naked woman holding a flaming vase. In this instance nakedness signifies purity and innocence. Profane – sexual and sensual; look for a woman with jewels and rich clothing (symbols of earthly vanities).
☛ Venus

Salamander

A legendary lizard-like creature, impervious to fire, and capable of putting fire out. The emblem of King

Francis I of France in the early 16th century.

Salome

The stepdaughter of Herod Antipas, for whom she danced an erotic dance. Herod became so excited he said that Salome could have whatever she wanted. Herod's wife, Herodias, who disliked John the Baptist, made Salome ask for his head on a dish, and Herod could not refuse. Do not confuse with Judith.
☛ Herod Antipas; Herodias; John the Baptist; Judith

Salvator Mundi

Christ as the Saviour of the world. He holds an orb surmounted by a cross, and with his right hand makes the sign of benediction (blessing).

Samson

Usually remembered as a muscle-bound womaniser worthy of Hollywood. In fact, he was a judge mentioned in the Old Testament. Many legends are connected with his enormous strength: slaying a lion with his bare hands or slaying 1,000 Philistines with the jawbone of an ass. Out for revenge, the Philistines persuaded Delilah to find the secret of his strength – it came from his hair, which had not been cut since birth. Delilah seduced him and, when he was asleep, a Philistine came and shaved his hair off (sometimes Delilah is shown doing it). They then blinded him and threw him into prison. His hair regrew and when they taunted him he pulled down the building, killing himself and them.
☛ Philistine

Samuel

The Israelite prophet who chose David to be the King of Israel. Look for Samuel anointing the young David, with his seven brothers watching.
☛ David

Satan (or Lucifer)

God's chief enemy and the source of all evil. Was a good angel once, but went wrong and was thrown out of Heaven by God. Look for a grotesque creature – maybe red-coloured or clothed in semi-human form – with claws or hooves, a forked tail, horns and wings.

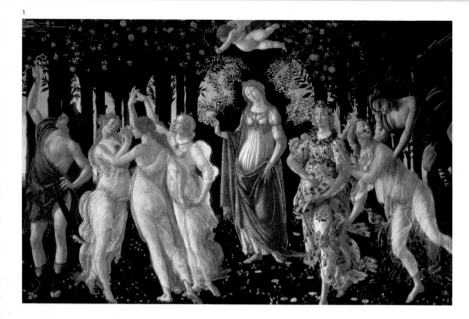

1. Sandro Botticelli, *La Primavera* (Seasons)
2. Andrea Mantegna, *Saint Sebastian*

☛ Ape; Demons; Descent into Limbo; Hell; Job; Margaret; Michael

Saturn (Greek: Chronos)
Ancient-looking god of agriculture, best known for eating his children. His wife (Gaea) predicted that one of his children would usurp him, so he ate them. However when Jupiter was born, Gaea smuggled her baby away and gave Saturn a stone wrapped in baby clothes to eat instead. Thus Jupiter was saved, and eventually overthrew his father. Also known as Chronos (Father Time), a very old man who carries a scythe.
☛ Gaea; Greek and Roman gods; Jupiter; Melancholy; Uranus; Venus

Satyrs
Lazy, drunken, lecherous creatures intent on having a good time and chasing nymphs. Satyrs look like goats, with hairy legs and feet, tails, beards and horns.
☛ Bacchus; Ivy; Marsyas; Nymphs

Saul
Melancholic king of Israel who was succeeded by David. David cheered him up by playing music and singing to him.
☛ David

Scales
People who sit in judgement often carry scales (to weigh things up).
☛ Justice; Liberal Arts; Michael

Sceptre
An official rod with an emblem at one end, carried by someone like a king, to signify his authority.

Scipio (237–183 BC)
Famous Roman general who defeated the Carthaginians and who was well known for his upright character. Look for the scene where he hands back a beautiful young Carthaginian girl, untouched, to her fiancé. She was given to him as a prize of war, but he said that the Romans were a moral people and that she must marry the man to whom

she was betrothed. A good decorative scene for marriage chests.
☛ Carthage

Scythe
Carried by Saturn, Old Father Time, Death and Summer.
☛ Saturn; Seasons; Triumph of Death; Triumph of Time

Seasons
Perennially popular subject with lots of scope. Although usually painted as a series, now often seen as singles. Look for the following. Spring – young woman, Flora, Venus, flowers, gardens, garlands. Summer – Ceres, fruit, corn, naked woman, reapers. Autumn – Bacchus, grapes and vines, wine press. Winter – Vulcan, old man, snow, fire.
☛ Bacchus; Ceres; Corn; Flora; Four Elements; Fruit; Months; Venus; Vulcan

Sebastian (died c. 288)
Roman soldier who became a Christian, and later a saint. He owned up to being a Christian and was condemned to death by a firing squad of archers with arrows (thus he is always shown). But what is not often realised is that the arrows did not kill him – although he was left for dead – because none of them pierced a vital organ. He was later clubbed to death for his beliefs, and his body thrown into the main sewer in Rome. Believed to be a protector against plague.
☛ Cosmas and Damian

Selene
See Luna

Semele
One of Jupiter's many lady loves, and the mother of Bacchus. Had the unique and unfortunate distinction that Jupiter made love to her as himself (rather than disguised as a swan, bull or other animal).

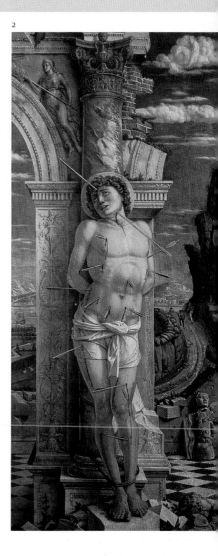
2

It was not a success. His thunderbolt set her on fire and reduced her to ashes.
☛ Bacchus; Jupiter; Thunderbolt

Senses
There are five: sight, sound, smell, taste and touch. Popular theme for still life and genre paintings, especially in the 17th century, with much scope for bravura painting of flesh, fur, fruit, and so on. Look in particular for the following. Sight – woman gazing in a mirror, eagle.

355

Hearing – woman playing a musical instrument, singers, stag.
Smell – woman smelling flowers, tobacco smokers, dog.
Touch – woman holding a hedgehog or ermine, blood-letting, cuddling.
Taste – woman holding a basket of fruit, drinkers, ape eating fruit.

Sepulchre
After Christ's Resurrection, the holy women found the tomb empty. Look for three women (the three Marys) who were companions of the Virgin Mary, including Mary Magdalene, but not the Virgin herself; an open cave or tomb; the archangel Gabriel in white robes telling them what has happened and instructing them to inform the disciples. They may be holding jars containing myrrh to anoint or embalm the body.
☛ Gabriel; Mary Magdalene; Resurrection

Seraphim (sing. seraph)
Senior angels (co-equal 1st out of 9 ranks). Traditionally dressed in red and holding a candle.
☛ Angels; Cherubim

Sermon on the Mount
Christ on a hill with his disciples around him, addressing a crowd below, telling them of the eight states of blessedness (the Beatitudes).

Seven Deadly Sins
See Deadly Sins

Shell
Mostly seen in connection with seafaring deities. Also worn by pilgrims as a badge in Christian art.
☛ Galatea; James the Great; Neptune; Triton; Venus

Sibyls
Young women from classical antiquity who had the gift of prophesy. Look for them carrying a book and wearing a turban. Twelve in all, named after various European and Middle Eastern locations. You find them in Christian art (for instance the Sistine Chapel ceiling) because they were considered to have foretold the coming of Christ. They may hold Christian symbols, such as instruments of the Passion.

Silenus
Look for a fat old man in a drunken stupor, riding an ass. A follower of Bacchus, but also wise, with the gift of prophecy.
☛ Bacchus

Simon
The most obscure of the disciples. Was martyred by being sawn in half.
☛ Disciple

Sirens
Beautiful creatures endowed with the body of a bird, the head of a woman, and an enchanting singing voice. They sat on a promontory overlooking the sea and irresistibly drew sailors to their death on the rocks below by singing magic songs. Ulysses was captivated, but his companions blocked their ears with wax and tied him to the mast of the ship. They survived.
☛ *Odyssey*; Ulysses

Sisyphus

Double-crossing king of Corinth, who was punished by the gods. He was made to push a huge stone up a hill until it rolled down the other side, so he had to push it up again...and so on for eternity.

Skeleton

Means only one thing – death.
☞ Triumph of Death

Skull

The symbol of death.
☞ Crucifixion symbols; Francis of Assisi

Sleep (Greek: Hypnos)

Look for his mother (Night), his brother (Death), and his son Morpheus, the god of dreams. All have wings and black robes; also a poppy and an owl. He may be reclining on a couch, under a canopy or near a river.
☞ Owl; Poppy

Sloth

A deadly sin. Sometimes represented by a fat figure on an ass, or by an ass, ox or pig.
☞ Deadly Sins

Snake

In Christian art usually a bad thing. In classical art a symbol of fertility.
☞ Ceres; Cleopatra; Eurydice; Labours of Hercules; Liberal Arts; Minerva; Parts of the World; Prudence; Temptation; Wisdom

Sol

See Helios

Solomon

The ultra-wise, exceedingly rich third king of Israel, who had many wives and concubines and idolatrous tendencies. Visited by the Queen of Sheba, who had to pay a visit to see just how wise and rich he was. Famous for his judgement: two women claimed that a baby belonged to them and Solomon was asked to decide which one was telling the truth. He told them to cut it in two and give each one half. One woman refused to agree because the baby would be killed; Solomon said that she must be the true mother.
☞ Ark of the Covenant; True Cross

Sophonisba

The daughter of a Carthaginian general who got into an appalling marital and political muddle, and ended it by drinking a cup of poison.

Sphinx

Strange beast with a lion's hindquarters, a woman's head and breasts, a serpent's tail, and an eagle's wings. It asked a riddle and devoured those who could not solve it (look for the victims' bones). Oedipus did give the correct answer, and the Sphinx was destroyed. The Egyptians showed the Sphinx as a lion with a human head, and treated it as a symbol of power and vigilance. The Greeks regarded is as a repository of mysterious wisdom. Freud said it was a metaphor for the dominant mother.
☞ Oedipus

Spider

See Arachne

Spinario

Famous antique Hellenistic statue, much copied since the early Renaissance, of a seated, naked young boy pulling a thorn out of his foot.

Sposalizio

See Marriage of the Virgin

1. Giovanni Domenico Tiepolo, *Christ's Fall on the Way to Calvary* (Stations of the Cross)
2. Giotto di Bondone, *St Francis Receiving the Stigmata*, 1296–7
3. Vincenzo Catena, *Supper at Emmaus*

1

SPQR

The inscription seen on the standards of Roman soldiers. It means 'Senatus Populusque Romanus' ('the Senate and People of Rome').

Stag

See Actaeon; Diana; Eustace; Hubert; Labours of Hercules; Senses

Star

The most famous star is the one that led the Magi to Christ's birthplace at Bethlehem. The stars in the heavens have been connected with gods (of all kinds) and holy people since the dawn of history.
☛ Adoration of the Magi

Stations of the Cross

Christ carried his cross through the streets of Jerusalem on his way to his Crucifixion. The Stations correspond to the 14 places where he stopped en route or incidents of the journey.
1) Condemned to death.
2) Carries the cross. 3) Falls.
4) Meets his mother.

5) Simon carries the cross.
6) Veronica wipes his face. 7) Second fall.
8) Women of Jerusalem weeping.
9) Third fall.
10) Stripped of garments.
11) Nailed to the cross.
12) Dies on the cross.
13) Taken down from the cross.
14) Placed in sepulchre.
☛ Crucifixion; Deposition; Road to Calvary; Veronica

2

Stephen
The first martyr, who was stoned to death. Look for a young gentle-looking saint, maybe carrying stones, and for the scene of his stoning by an angry crowd.

Stigmata
Marks on the hands, feet and body that resemble those received by Christ on the Cross. They sometimes appear as spontaneously bleeding wounds on exceptionally devout saints and mystics.
☞ Catherine of Siena; Crucifixion; Francis of Assisi

Stork
Bird that is supposed, when young, to have fed its ageing parents – thus a symbol of obligation to one's elders.

Styx
In classical antiquity, the river that the dead cross on their way to the Underworld.
☞ Achilles; Charon; Underworld

Sun
A woman who holds the sun (which is the source of all light) in her hand,

represents truth.
☞ Apollo; Aurora; Clytie; Creation; Crucifixion Symbols; Halo; Helios; Icarus; Phaeton; Truth

Sunflower
Now inextricably linked with Van Gogh, but symbolic long before his day. Can be a symbol of loyalty – because it turns to face (or follow) the sun.
☞ Clytie

Supper at Emmaus
The scene is three figures at a table. The central figure, Christ, blesses the bread; the other two are shocked and startled. After his Resurrection, Christ walked to Emmaus (near Jerusalem) and on the way met two of his former disciples, whose identity is not known for certain. However, they did not recognise him until they sat down to supper together at an inn at Emmaus (look for the innkeeper). At the moment Christ blessed the bread (which he had done for the first time at the Last Supper) they knew who he was – hence their surprise and embarrassment. Look also for the scene of the walk to Emmaus.
☞ Last Supper

3

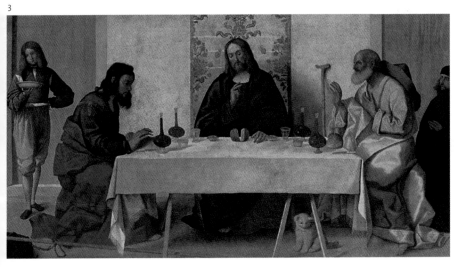

1

Susanna

A fictional story of the triumph of virtue over deceit and an excuse for a titillating portrayal of female nudity. She was a well-to-do wife who liked to go bathing naked in her garden. Two seemingly respectable old men plotted to seduce her: 'Sleep with us, or we will say we saw you up to no good with a young man.' She told them to get lost, so they lied about her and she was taken to court. The prophet Daniel did a Perry Mason in court and she was acquitted. Look for a garden, a beautiful nude and two dirty old men.
☞ Daniel

Swan

Renowned for its beauty. Supposed to be a music lover.
☞ Leda and the Swan; Phaeton; Venus

Sword

Indicates a fighter (such as a military commander, a saint or a martyr), or virtues worth fighting for.
☞ Alexander the Great; Fortitude; James the Greater; Justice; Paul; Perseus; Temperance

Tantalus

Foolish king of Lydia (Greece), punished by the gods for misdeeds, including the murder of his own son. He was condemned to stand for eternity in a pool of water, which recedes when he tries to drink – in a word, tantalising. Niobe's father.
☞ Niobe

Telemachus

Ulysses' son who went to look for his dad when he failed to come home after the Trojan War.
☞ Trojan War; Ulysses

Temperaments

A pre-scientific theory maintained that the body contained four fluids, which were responsible for different temperaments: phlegm – phlegmatic; blood – sanguine; bile – choleric; black bile – melancholic. Their production was influenced by the stars and dictated each person's character and temper. Look for representations of melancholy, which was considered the dominant and most desirable characteristic in artists and intellectuals.
☞ Dog; Melancholy

Temperance

Doing nothing to excess. Look for a woman pouring liquid from one jug to another (no excess alcohol); a torch and a jug of water (putting out the fires of lust); a clock (well-regulated life); a sword in its sheath; a bridle.
☞ Virtues

Art is a half-effaced recollection of a higher state from which we have fallen since the time of Eden. **SAINT HILDEGARDE (1098–1179)**

Temptation, The

God warned Adam not to eat the fruit of the Tree of Knowledge of Good and Evil in the Garden of Eden. But the snake (serpent) got round Eve, and she persuaded Adam to share it with her (the fruit is usually shown as an apple or a fig). So they discovered nakedness and sin, and God threw them out of this earthly paradise to face all the toils and troubles of mortal human life – notably childbirth, manual labour and death.

Look for figures clothed in leaves or skins; the angel who drives them out; and expressions of utter misery as they realise what they have done.

☛ Adam and Eve; Garden of Eden

Ten Commandments

Moses went up Mount Sinai to receive the Ten Commandments from God, which were written on two tablets of stone. It was while he was there that

2

the Israelites misbehaved with the Golden Calf. Moses gave them a gold plated chest (the Ark of the Covenant) to worship instead. The Ten Commandments (briefly) are as follows:
1) The don't's: have any other god but God; worship idols; take God's name in vain; kill; commit adultery; steal; lie; covet.
2) The do's: remember the Sabbath; honour your parents.
☞ Ark of the Covenant; Golden Calf; Moses

Teresa (1515–82)
Spanish Carmelite nun, born in Ávila, given to intense visions, notably an angel plunging a long spear with a flaming tip into her heart. Traditionally explained as the pure love of God; the Freudian explanation is sexual.

Theodore
Roman soldier and Christian convert and martyr. May have a dragon or crocodile at his feet. Former patron saint of Venice.

Theseus
Handsome young king of Athens, best known for killing the Minotaur. Also fought with the Amazons and Centaurs. Was mean to Ariadne.
☞ Amazons; Ariadne; Centaurs; Minotaur

Thetis
A sea goddess, who was Achilles' mother. Look for her on a peace mission from Achilles to Jupiter during the Trojan War.
☞ Achilles; Feast of the Gods; Jupiter; Peleus; Trojan War

Thomas
'Doubting Thomas' – a young disciple who refused to believe that Christ had returned to Earth after the Resurrection.

When Christ met him, he told Thomas to touch the wound he had received in his side when on the Cross. Thomas overcame his doubts and was convinced. He holds a builder's set square or ruler, a girdle, and the spear or dagger that killed him.
☞ Crucifixion

Thomas Aquinas
Theologian who wrote much of the basic doctrine of the Catholic Church. Look for a chubby Dominican with maybe a book or a lily and wearing a star.
☞ Dominic

Three Graces
Look for three beautiful young women (naked or transparently dressed), standing in a group so that you see the front view of the outer two and the back view of the middle one. They personify grace, beauty, generosity, loveliness… (everything that a properly brought up pre-modern age girl was supposed to be). Usually seen on their own, but sometimes also as the attendants of Venus.
☞ Venus

Three Marys, The
See Sepulchre

Thunderbolt
Pronged zigzag lightning, which can be thrown like a weapon. Used by Jupiter with great effect.
☞ Four Elements; Jupiter; Semele

Tiresias
Wise man of Thebes, in Greece, who had the unusual experience of coming across some snakes making love. As a consequence he was turned into a woman for seven years (the whole thing was a put-up job by the gods). Afterwards he said men had the better time

generally, but women had better sexual experiences. This annoyed Juno, who made him blind. Jupiter retaliated by giving Tiresias the gift of foreseeing the future.
☞ Juno; Jupiter

Titan
A member of the first human race.
☞ Atlas; Prometheus; Uranus

Tobias
Every parent's ideal teenager. Looked after his elderly parents and did what he was told. Went on a long journey to collect money owing to his father. Four scenes: 1) Setting out with a companion (who happened to be the archangel Raphael, but Tobias didn't know it) and a dog; 2) Nearly being swallowed by a huge fish, which he caught and gutted (the cooked innards eventually cured his father's blindness); 3) Marrying Sarah; she was bewitched and had killed seven previous husbands, but the cooked fish innards cured her as well; 4) Archangel Raphael eventually revealing his identity.
☞ Raphael; Tobit

Tobit
Elderly father of Tobias and a good man. Became blind when sparrow droppings fell into his eyes (purely accidental, not a punishment). Married to Anna.
☞ Tobias

Tower of Babel
The first skyscraper – early and naïve attempt to build a tower so tall it would reach heaven. God foiled the plan by making everyone involved speak different languages, so that they could not understand each other, and the building was never completed.

Trajan (c. 53–117)
Roman emperor whose son murdered the son of a widow. The widow demanded vengeance, so Trajan handed over his own son – but for some unexplained reason Trajan's soul went to purgatory. Five hundred years later, Saint Gregory released Trajan's soul through prayer. A story about the power of prayer.
☞ Gregory the Great; Purgatory

1

1. Francesco di Stefano Pesellino, *The Triumphs of Love, Chastity and Death*, c.1448
2. Francesco di Stefano Pesellino, *The Triumphs of Fame, Time and Eternity*, c.1448

Transfiguration

Look for a mountainous setting with Christ bathed in light, and below him Saints Peter, James the Great and John. Moses and Elijah stand at the sides. It was a dramatic visionary occasion when Christ deliberately showed his divine nature. What you cannot hear is the voice from Heaven that accompanied the bright light, saying: 'This is my Son.'
☛ Elijah; James the Great; John the Evangelist; Moses; Peter

Trial of Christ

After his arrest, none of the authorities knew what to do with Jesus, and he was passed from one judge or high priest to another. They all regarded him as a nuisance best got rid of, but there was no strict legal justification for condemning him to death.
☛ Caiaphas; Crown of Thorns; Entry into Jerusalem; Herod Antipas; Pontius Pilate

Triangle

In Christian art signifies the Trinity.

Tribute money

The trick question the Pharisees put to Christ: should the Jews pay taxes to Rome? Christ's knock-out answer: 'Render unto Caesar what is Caesar's; and unto God what is God's.' Look for a scene in the Temple with one or more menacing Pharisees holding coins.
☛ Pharisee

Trinity

The Christian doctrine that God is three in one: Father, Son and Holy Ghost. A difficult and abstract concept, and not easy to represent graphically. Jesus is relatively easy to portray, in contrast to the other two, who have never been seen. God the Father can be an eye (all-seeing), or a hand emerging from a cloud. Less inventively he is sometimes an old man. The Holy Ghost is a dove. Triangles (three-sided and pointed) also express three-in-oneness.
☛ Augustine

Triton

The son of Neptune. Half man, half fish, he blows through a twisted seashell to raise or calm the waves.
- ☞ Four Elements; Furies; Neptune

Triumph

The name of the victory parade through the streets of Rome that victorious Roman generals were allowed. The general rode in a chariot drawn by white horses, and all the gods, famous military heroes, artists and writers were also celebrated. Renaissance artists used the idea of the triumphal chariot for allegorical figures, especially Love.
- ☞ Entry into Jerusalem; Galatea;

Triumph of Chastity

Cupid kneels before Chastity, his wings tied, his bow broken, and blindfolded. The chariot is pulled by unicorns.
- ☞ Chastity; Cupid

Triumph of Death

A skeleton with a scythe rides in a chariot pulled by black oxen.
- ☞ Death

Triumph of Fame

A winged figure in a chariot drawn by elephants, accompanied by famous kings, poets, and so on.
- ☞ Fame

Triumph of Love

Look for Cupid shooting arrows with a chariot drawn by horses or goats.
- ☞ Cupid

Triumph of Time

An old man with wings, scythe and an hourglass, in a chariot drawn by quick-running stags.

Triumphs of Caesar

These represent worldly conquests, whereas the labours (or triumphs) of Hercules represent the victory of the soul over vice.
- ☞ Labours of Hercules

Trojan War

The ten-year war between the Greeks and Trojans, which the Greeks won. The equivalent of a modern world war or Star Wars in which the gods of Olympus (superpowers) took sides and used all the technology (including magic and the famous wooden horse) available to them.
- ☞ Achilles; Aeneas; Agamemnon; Andromache; Feast of the Gods; Hector; Helen; Illiad; Laocoon; Paris; Priam; Thetis; Ulysses; Wooden Horse

True Cross

A mediaeval legend tells the supposed story of the Cross on which Christ was crucified. Five 'scenes':
1) Adam takes a branch of the Tree of Knowledge from the Garden of Eden. It is handed down through the generations, even becoming Moses' pole.
2) The Queen of Sheba finds it in Jerusalem when visiting Solomon; by now it is a bridge. She recognises it and worships it.
3) The Cross is found floating on the Pool of Bethseda; from here it is taken to make Christ's Cross.
4) Helena, mother of Constantine the Great, discovers the Cross in the 4th century AD.
5) Emperor Heraclius finds it after beating the Persians in battle.
- ☞ Adam and Eve; Bethseda; Constantine the Great; Heraclius; Moses; Solomon

Trumpet

See Fame; Joshua; Last Judgement

Truth

A naked female wearing a laurel crown and resting her foot on a globe who may hold the sun, a mirror, or a peach with a single leaf.
☛ Laurel; Mercy; Mirror; Peach; Sun

Ulysses (Greek: Odysseus)

The original superhero: handsome, courageous, intelligent, successful, popular, and royal as well. With Achilles he successfully defeated the Trojans but had difficulty returning home by sea to his native Greece, because he upset the sea god, Neptune, by blinding his son, the one-eyed giant Polyphemus.
☛ Achilles; Circe; Neptune; *Odyssey*; Penelope; Polyphemus; Sirens; Telemachus; Trojan War

Underworld

The place where the souls of the dead finally end up. Ruled over by Pluto, and guarded by the monster Cerberus, it was situated on the other side of the River Styx. Sometimes seen as grey and forbidding (Hades); sometimes as the land of heroes (Elysium, or the Elysian Fields).
☛ Cerberus; Charon; Elysium; Eurydice; Pluto; Styx;

Unicorn

This legendary animal with a single horn was supposed to purify anything it touched and could only be captured by a virgin – which is why it is sometimes seen with the Virgin Mary.
☛ Virgin Mary

Uranus

His father was Saturn and his mother Gaea, with whom he had an incestuous relationship and produced the first human race – the Titans. Uranus threw his Titan sons into the Underworld, but Gaea got her own back by giving the youngest of them (Chronos II) a sickle, which he used to castrate Uranus.
☛ Gaea; Saturn; Underworld

Ursula

Daughter of the king of Brittany, massacred at Cologne with her 10,000 virgin companions. Look for a young girl, richly dressed, holding an arrow. Scenes sometimes represented in this improbable story are: Ursula and her father receiving ambassadors from England (she said she would marry the young English prince if he became a Christian and went on a pilgrimage to Rome with her and her 10,000 attendants – he agreed); and Ursula lying in bed and dreaming of martyrdom. Scenes of them in Rome with the pope, and of the massacre are also found.

1

Greek and Roman gods; Mars; Paris;
Sacred and Profane Love; Saturn;
Seasons; Three Graces; Vulcan

Veronica
She wiped Christ's face with her veil
as he was carrying the Cross to Calvary,
and his face became miraculously
imprinted on it.
☛ Road to Calvary; Stations of the Cross

Vesta (Greek: Hestia)
Virgin goddess of the hearth and home.

Vestal virgins (vestals)
Priestesses of the Temple of Vesta
(the goddess of the hearth), who were
sworn to perpetual virginity on pain
of death. Look for Tuccia (who carries
a sieve) and Claudia, both of whom
were falsely accused of adultery (but
lived). Sometimes vestal virgins carry
sticks to keep the hearth fire going.
☛ Chastity; Romulus and Remus

Via Dolorosa
See Stations of the Cross

Vices
See Deceit; Deadly Sins; Envy; Gluttony;
Vanity; Wrath

Vigilance
A good quality, especially in rulers.
Usually represented by a crane standing
watchfully on one leg.

Vine (and vine leaves)
Many meanings. In the Christian faith
Christ said: 'I am the true vine, you are
the branches'. Bacchus and Silenus
wear crowns of vine leaves. Noah sits
drunkenly in a vine arbour. Symbolic
of autumn and gluttony.
☛ Bacchus; Gluttony; Noah; Silenus

Vanity
A vice. Look for a naked woman reclining,
holding a mirror, maybe surrounded
by jewels.

Venus (Greek: Aphrodite)
The goddess of love. Mother of Cupid
(and often seen with him); married
to Vulcan. Born out of the sea (the
conception took place when Saturn's
genitals were thrown into the sea). She
floated to the shore on a scallop shell.
Look for a beautiful woman with doves,
swans or dolphins; holding a flaming
torch, rose, girdle, flaming heart, or
myrtle. Fell in love (at different times)
with Adonis, Anchises (their son was
Aeneas) and Mars. Often simply a
beautiful woman with no clothes on,
doing nothing special (reclining,
sleeping or at her toilet), made
respectable by being called Venus.
☛ Adonis; Aeneas; Cupid; Cythera;

Violet

A small, reclusive flower. Christian symbol of humility.

Virgin and child

One of the most popular Christian images (its basic human appeal is obvious), with many variations: suckling;

Virgin in prayer over the Christ child (Madre Pia); with a book of Wisdom (Mater Sapientiae); the Virgin seated on the ground (Madonna of Humility); the Virgin holding up the Christ child, who offers a blessing. They may hold, or be surrounded by, still life objects that have symbolic meanings.
☞ Apple; Bird; Cherry; Corn; Goldfinch; Grapes; Pomegranate; Walnut

Virgin Annunciate

See Annunziata

Virgin Enthroned

The Virgin Mary standing in glory or sitting on a throne, perhaps surrounded by saints, represents the idea of the Mother Church in authority over all mankind.
☞ Sacra Conversazione

Virgin Mary

The mother of Jesus Christ. Often shown wearing a robe of ultramarine blue – the most expensive colour available to artists of earlier periods. The most important and frequently illustrated events in her life are: the Immaculate Conception; Birth; Marriage; Annunciation; Nativity; Flight into Egypt; Crucifixion; Entombment; Resurrection; Death; and Assumption.
☞ Almond; Annunziata; Garden; Mirror; Rose; Unicorn; Visitation

Virgin Mourning (Mater Dolorosa)

The Virgin Mary alone, grieving for the dead Christ, possibly with seven swords piercing her breast or surrounding her head.

Virgin of Mercy

The Virgin Mary on a large scale, sheltering small-scale humans under her huge cloak, which acts as a tent, protecting them from the troubles and disasters of the world.

Virtues

The three theological virtues are Faith, Hope and Charity. The four cardinal virtues are Fortitude, Justice, Prudence and Temperance. Usually represented by a woman holding a suitable symbol.
☞ Charity; Faith; Fortitude; Hope; Justice; Prudence; Temperance

Visitation
Just after the Annunciation, the Virgin Mary visited her cousin, Elizabeth, to tell her the good news. Elizabeth was six months pregnant with Saint John the Baptist.
☞ Annunciation; Elizabeth; John the Baptist

Vulcan (Greek: Hephaestus)
God of fire (hence volcano). His parents were Jupiter and Juno. Was married to Venus, who made a fool of him by playing around. Look for him working at a forge assisted by Cyclopes, making arms and armour for the gods; also for Aeneas and Achilles. He was crippled from birth (resulting in a limp), so look for his crutch or deformity, or both.
☞ Achilles; Aeneas; Cyclops; Four Elements; Greek and Roman gods; Juno; Jupiter; Mars; Olympus; Pandora; Seasons

Walnut
The outer green case represents the flesh of Christ; the shell, the wood of the Cross; the kernel, Christ's divine nature.

Water from a rock
When Moses was leading the Israelites out of Egypt through the desert to the Promised Land they complained of thirst. God told Moses to strike a particular rock with his rod, which he did, and there was water for the people and the cattle. Good excuse for landscape painting, so ignore the lack of desert.
☞ Moses

Wedding Ring
See Catherine of Siena; Marriage of the Virgin

Wheel of Fortune
Look for figures on a wheel, such as a well-dressed optimistic one being carried up one side, and another, in rags, being tossed off the down side.
☞ Fortune

Wine
Together with bread, one of the elements of the Eucharist. Together with drunkenness, implies the presence, in body or spirit, of Bacchus.
☞ Bacchus; Eucharist; Grapes

Wisdom
Often represented by Minerva, perhaps with an olive branch and an owl. Alternatively, by a female with a book and a snake.
☞ Minerva; Prudence

Woman taken in adultery
Another trick question to Jesus by the Pharisees. The law of Moses punished adultery by stoning, but Jesus preached forgiveness. What to do, then, with the adulteress? Jesus replied: 'The one of you who is without sin can cast the first stone.' Look for a temple setting, a tarty woman, angry-looking Pharisees, and Christ, possibly writing his answer in the dust on the floor with his finger.
☞ Pharisees

Wonders of the World
The seven famous architectural and sculptural monuments of the ancient world:
1) The Pyramids of Giza;
2) The Hanging Gardens of Babylon;
3) The Statue of Zeus at Olympia;
4) The Temple of Artemis at Ephesus;
5) The Mausoleum of Halicarnassus;
6) The Colossus of Rhodes;
7) The Pharos lighthouse at Alexandria.
☞ Artemisia

Wooden Horse

To get into Troy, which was strongly defended, the Greeks built a wooden horse, hid soldiers inside, and left it outside the city gates of Troy. The Trojans, not realising, and intrigued, took it into their city, with disastrous consequences.

☞ Laocoon; Trojan War

Wrath

Usually a straightforward portrayal of an angry person attacking a defenceless innocent, who may be a monk.

Zacharias

The father of John the Baptist, and a high priest of the Temple in Jerusalem. An angel foretold the birth of his son when he was in the Temple, and he was so surprised that he was struck dumb until his son was born.

☞ John the Baptist; Presentation of the Virgin

Zeno (d. c.372)

Bishop of Verona, noted for his excellent sermons.

Zephyr

The gentle west wind of spring. Married to Flora.

☞ Chloris; Flora

Zeus

See Jupiter

GLOSSARY

Abstract art

A work of art with intellectual or emotional meaning (or both) that does not represent or imitate any visible object or figure. Good abstract art is not easy to get to grips with – you may need to see a large number of works (in an exhibition devoted to one artist, for example) to begin to see and understand fully what she or he is trying to express. One example in a mixed show is often meaningless, because all you can hope to notice are the eye-catching or superficial qualities of the art.

 Delaunay; Kandinsky; Kupka; Malevich; Miró; Mondrian; Pollock; Rothko; Stella (Frank)

Abstract Expressionism

The avant-garde art of the New York School, which flourished after World War 2: big, challenging, personal, emotional, painterly and influential.

 Gorky; Kline; De Kooning; Newman; Pollock; Rothko; Still

Abstraction

The word used when talking about an artist whose work distils natural forms or appearances into simpler forms, but who stops short of creating abstract art.

 Hepworth; Matisse; Nicholson; Wols

Abstraction Lyrique

The type of European painting of the 1940s and 1950s in which a loose and painterly abstraction was used to express subconscious fantasy.

 Burri; Mathieu; Michaux; Riopelle; Tàpies; Wols

Academic style

The highly polished, finely detailed style that was promoted by the conservative 19th-century academies. Most of it was worthy but boring. A lot of it was appallingly bad. Ingres was its supreme and brilliant master.

 Bouguereau; Cabanel; Ingres; Leighton; Puvis de Chavannes

Academicism

The clever but laborious reworking of established models. Exists in every age.

Academies, The

The official institutions, usually funded by a princely ruler or the state, set up to organise and promote exhibitions, art education and aesthetic rules and standards. Academies were enormously influential between the mid-17th and the end of the 19th centuries. The first such academy was founded in Florence in 1562. The academy par excellence was the *Académie française* (French Academy), founded in 1648 under Louis XIV, which became the model to be imitated, and a remarkable example of the imposition of a centralised bureaucracy on a creative activity. *See also* Museum of modern art; Royal Academy

2

3

it onto a canvas. Needs to be done on a large scale for maximum impact. Messiness and accidents are among its considered virtues.

🖪 Michaux; Pollock

Aerial perspective

The illusion of receding space created by the use of warm colours (such as reds) in the foreground and cool colours (such as blues) in the distance. Pinturicchio was one of the first to combine linear, or geometric, perspective with aerial perspective. Leonardo was the first to study aerial perspective scientifically.

🖪 Cuyp; Lorraine (Claude); Pinturicchio; Turner

Aesthete

Somebody who claims to be particularly sensitive to beauty and who thinks as a result that he or she is superior to others (Oscar Wilde, for example).

🖪 Whistler

Aestheticism, Aesthetic movement

See Art for art's sake

Aesthetics

According to the *Oxford English Dictionary*: 'the philosophy or theory of taste, or of the perception of the beautiful in nature'.

Acrylic

Modern synthetic emulsion paint that combines some of the characteristics found in traditional oil paint (such as thick impasto) with some of those found in watercolours (such as transparent washes). Hockney has been particularly successful with acrylics.

🖪 Hockney

Action painting

Painting produced by the emphatic physical activity of the artist, for instance, throwing paint or dripping

After . . .

'After Rembrandt' (or whoever) means a copy by someone other than Rembrandt of an actual work by Rembrandt, made at any date.

Airbrush

A tool that uses compressed air to spray paint. Can produce exceedingly fine gradations of colour, or a fine line.

🖪 Andrews

1

Alla prima
Painting onto a surface directly, without any underpainting or preliminary working out of the design.
🔲 Titian

Allegory
A work of art where symbols or symbolic messages are used to convey the 'meaning' of the work. Thus it alludes to more than is apparent at first sight. The hidden meanings, symbols and cross-references may not always be easy to follow, and may be deliberately obscure in the manner of a brain-teasing puzzle. Allegory and realism were combined with notable success by the Dutch 17th-century masters, and by 19th-century realists such as Winslow Homer.

Altarpiece
The picture or sculpture made to go behind or on an altar and so enhances its part in the act of Christian worship. Many are now seen removed from this context, in the setting of the secular art gallery. Altarpieces are often designed to be seen from a kneeling position, so the perspective and design is worked out accordingly (to look at them properly you need to kneel before them, even in an art gallery.)

Alto rilievo
See Relief

Ambiguity
Something that can be understood or seen in more than one way is ambiguous. When carefully and knowingly used by an artist, it is a quality that has great value. The word is much used currently in descriptions or explanations of contemporary art, where occasionally it has a genuine meaning or expresses a genuine virtue. However, it often seems to be a coded signal that the writer finds the message from the artist so obscure, meaningless or confused that it is virtually incomprehensible – but the writer is not allowed by his or her pay-master or ideological loyalties to say so.

Analytical Cubism
The works of Picasso and Braque of c.1907–12 in which they fragmented form,

1. (Allegory) **Winslow Homer**, *Snap the Whip*, 1872
2. (Anamorphic) **Hans Holbein**, *The Ambassadors*, 1533

but still used conventional painting techniques.
🖾 Braque; Picasso

Anamorphic
A perspective trick. An object depicted in anamorphic perspective looks distorted and unrecognisable when seen from the front. This is because the viewpoint for it is placed exxageratedly to one side, and only by looking at it from this point will the distortions correct themselves to produce a recognisable image. The best-known example of anamorphic perspective is the skull in the foreground of Holbein's *Ambassadors*.

Antique, Antiquity
Terms used to describe the art of ancient Greece and Rome.

Apotheosis
Elevation to divine status. Senior Christian figures and monarchs who require flattery are usually the prime candidates for images of apotheosis.

Applied art
Works of art that are deemed to be useful and ornamental, rather than intellectual or spiritual – such as furniture, ceramics, wallpaper, tapestries and metalwork.

Appropriation art
Objects, images or texts removed from their normal context and placed unchanged in a new one, thereby gaining (it is said) a new, highly charged significance. Often presented as a new 'cutting-edge' idea, it could also be said to be old hat – something artists have been doing since time immemorial – the caves of Lascaux being the first examples of appropriation art.
🖾 Polke

2

Aquarelle
French word for watercolour.

Aquatint
A method of printmaking that produces soft, often grainy, gradations in tone.
🖾 Goya

ARA
Associate of the Royal Academy, London. There are 30 at any one time.
See also RA; Royal Academy

Archaism
Imitating early, often primitive, styles.

Armory Show
The exhibition held in 1913 that introduced Modern art to the United States. So called because it was held in a famous army building in New York.
🖾 Kuhn

Arriccio
The smooth layer of plaster onto which the design of a fresco is made.

375

1. (Art for art's sake) **William Merritt Chase**, *A Friendly Visit*
2. (Arte Povera) **Jannis Kounellis**, *Untitled*, 1979
3. (Ashcan School) **John Sloan**, *McSorley's Bar*, 1912

Ars longa vita brevis

One of those semi-learned Latin phrases, more used historically than now, which is often said to mean 'Art is long-lasting, but life is short'. Actually it means 'Life is short and art takes a long time to create'.

Art brut

Crude pictures and graffiti on walls made by untrained amateurs and psychotics.
🖿 Dubuffet

Art Deco

The popular and fashionable decorative style of the 1920s and 1930s. Cinema designers loved it – Radio City Music Hall, New York, for instance.

Art history

An academic discipline that originated in the 19th century to discuss and analyse works of art in a historical context, and which now includes other fields such as feminism, political and socio-economic theories and psychology. Can be profoundly revealing and illuminating, but can also kill a work of art stone dead when it fails to acknowledge that true art – that which engages the imaginative experience of mankind – transcends mere history and academic theorising.

Art Informel

A type of European abstract painting of the 1940s and 1950s, which paralleled Abstract Expressionism in the USA. Had some general visual similarities,

1

Art for art's sake

The idea that art is not concerned with storytelling, morality, religion, spiritual or intellectual enlightenment and such like, but only with its own aesthetic properties of colour, form and so on. This was the central belief of the fashionable late 19th-century Aesthetic movement, which had a particular following from 'new money' collectors. Its two principal painters were notable aesthetes: Whistler (in Europe) and Chase (in the USA).
🖿 Chase; Dewing; Whistler

2

but lacked the scale, focus and drive of American art.
🖿 Dubuffet; Mathieu; Michaux; Riopelle; Wols

Art Nouveau

The highly decorative style (called Jugendstil in Germany, Liberty or Floreale in Italy and Modern or *style*

3

moderne in Russia) that was in the forefront of fashion in the 1890s. It was known as 'Art Nouveau' because it was consciously new and different. The French, Belgian, Italian and Spanish versions are organic and free-flowing whereas the German and Scottish versions tend to be geometric and detailed.
☑ Beardsley; Denis; Ensor; Klimt; Modigliani; Schiele

Arte Povera
Describes the work of the group of Italian avant-garde 1960s artists who made *arte povera* (poor art) – objects created from cheap and tacky materials. They had a strong political agenda – the elevation of humble materials and the elevation of the poorer social classes. Official commentaries often explain this art in language as impenetrable in meaning as the art works themselves – 'anti-elitist', 'dynamics of transformation', 'dialect of art and existence', 'exigencies of circumstance', and so on. The claims made for the significance of their work were and still are enormous. Whether the

claims were (are) fulfilled is another matter. Kounellis, who was one the leading proponents of *arte povera*, had a particular liking for sacking, blood, and marks made by flames and smoke.
☑ Boetti; Kounellis; Merz

Artist's proof
Limited-edition prints, exclusively for the artist's own use or sale. They are marked A/P and are not numbered.

Arts Council of Great Britain
Founded in 1945 to promote art. Government-funded but not government-controlled. Currently going through a difficult period (being pressured by the government) but fighting back.

Ashcan School
Important group of late-19th-century American painters and illustrators who believed that art should portray the day to day, and even the harsh realities of life

(especially city life and life in New York) and that artists should be seen to get their hands (and clothes) dirty. John Sloan was of the Ashcan School's best practitioners, but he tempered the harsh

1

2

truth with a vision of an ideal urban happiness.
🔸 Bellows; Glackens; Henri; Luks; Sloan

Assemblage
A 3-D picture made from different everyday materials.

Atelier
French word for studio.

Atelier libre
A studio where you pay a fee for organised group sessions to paint from a model, but where there is no tuition. Important feature of the Parisian avant-garde in the late 19th century.

Attribute
Symbol associated with a figure that enables it, for example, to be identified as a particular saint or god; thus Juno always has a peacock, St Catherine the wheel on which she was nearly crucified, and so on.

Attributed to . . .
'Attributed to Rembrandt' (or whoever) means that a work is probably by that artist, but there is still some doubt about how much of it was done by the master.

Attribution
An informed opinion as to the authorship of a work of art when there is no definite proof.
See also: Attributed to. . . ; By . . . ; Follower of . . . ; Manner of . . . ; Studio of . . .

Aureole
Circle of light surrounding the head or body of a holy figure.

Autograph
A work of art believed to be entirely by a particular artist.

Automatism
High-class doodling directed by the unconscious mind. Much in vogue with the Surrealists.
🔸 Ernst; Miró

Avant-garde
Art that is so innovative as to be ahead of the mainstream art of its time and rejected as unacceptable by the official

For me a painting must give off sparks, it must dazzle like the beauty of a woman or a poem.
One must not worry if it lasts, but whether it has planted seeds which give birth to other
things. A painting must be fertile. JUAN MIRÓ

system and institutions. Most work that is currently called avant-garde by the official museum and gallery system is not – simply because once officialdom adopts it and blesses it, it becomes part of the mainstream. The heroic period of the modern avant-garde was 1880–1960.

'Bad painting'

Name for a small group of artists with no fixed agenda who created messily painted figurative images as a reaction against Minimal art and Conceptual art in the 1970s. They were well named!

🖾 Longo; Morley; Salle; Schnabel

Baldacchino

Italian word for canopy. A fringed canopy in cloth or a structure in metal or stone that is fixed like a roof over an altar, a throne or a holy object.

Bambocciata

Small old-master painting (usually 17th century) of humble, peasant subject matter and street life. Named after a minor Dutch artist called Pieter van Laer (c.1592–1642), who worked in Rome and was nicknamed Bamboccio ('rag doll') because he was small and deformed.

Barbizon School

Group of progressive mid-19th-century French landscape painters who worked in and around the village called Barbizon in the forest of Fontainebleau, near Paris. The champion of the group was Théodore Rousseau, whose innovation was to allow landscape and nature to speak for themselves without human intervention.

🖾 Corot; Rousseau (Théodore)

Baroque

The dominant style of the 17th century. Look for: illusion, movement in space, drama, love of rich colour and materials; heaviness, seriousness, pomposity.

The Catholic Church used it to illustrate Christian religious subjects, and to proclaim the power of the established Church as it fought back during the Reformation. Hence the best examples of Baroque style are found where Catholic faith prevailed – Italy (especially Rome), Austria, Southern Germany, Central Europe, Spain and France. Absolute monarchs used it for secular subjects to proclaim their wordly power, and to celebrate the richness of their possessions and lifestyle. No one did Baroque still lifes better than Snyders.

🖾 Champaigne; Cortona; Rembrandt; Rubens; Snyders; Thornhill

Bas relief

See Relief

Bauhaus

The most famous modern art school on which so many others have since been modelled. It opened in Germany in 1919 and was closed by the Nazis in 1933. Highly influential in the fields of architecture and design. Tried to teach the virtues of simple, clean design; abstraction; mass production; the moral and economic benefits of a well-designed environment; democracy and worker participation.

🖾 Albers; Feininger; Kandinsky; Klee; Moholy-Nagy; Schlemmer

Beaux arts

The fine arts.

Belle peinture

Beautiful paint handling in the sense of a rather self-indulgent love of luscious paint, elegant brush strokes and a lively paint surface – perhaps at the expense of any other quality, such as subject matter and observation.

Ben Day
Cheap, simple printing process invented in 1879 by Benjamin Day, a New York newspaper engraver. Uses patterns of dots that differ in density to create a half-tone image. Employed extensively in

1

newspapers and magazines, and suitable for both black-and-white and colour. With a magnifying glass, the dot patterns are clearly visible.
☑ Lichtenstein

Biedermeier
The predominant style in Austria and Germany in the first half of the 19th century. Plain, bourgeois, modest, conservative, well made.

Binder
Material (such as oil) that holds particles of pigment together and so makes paint.

Biomorphic forms
Softly contoured organic (rather than geometric) forms used in abstract art.
☑ Arp; Gorky; Miró

Bistre
Brown pigment made from charred wood, used as ink or chalk.
☑ Rembrandt

Bitumen
Rich brown tarry pigment. Looks wonderful when fresh but it is disastrous, because it never dries and soon turns into a black, bubbly mess.
☑ Géricault; Reynolds; Ryder

Blaue Reiter, Der (The Blue Rider)
Important avant-garde group of German Expressionists, based in Munich c.1911. Wanted to put spiritual values into art and used abstraction, simplification and the power of colour as a means of doing this.
☑ Kandinsky; Klee; Macke; Marc; Munter

Bleed
1) What happens when one layer or area of colour seeps into another and changes it.
2) In printing, a picture or text that runs off the edge of the paper is said to bleed.

Bloom
Blue or white 'film' that develops on badly stored oil paintings.

2

The impact of the acute angle of a triangle on a circle produces an effect no less powerful than the finger of God touching the finger of Adam in Michelangelo.
WASSILY KANDINSKY

3

Bloomsbury set

The name of a group of English writers, artists, poets and designers, who practised and promoted modern French art in the 1920s and 1930s. Fascinated by themselves and their (relative for the times) sexual freedom, they had a very high opinion of their own importance, influence and creativity. Named after the district in London where they lived. Vanessa Bell was the best painter of the group.
🎨 Bell; Grant; Fry; Lewis (P. Wyndham)

Blot drawing

Using deliberate or accidental stains or blots on a piece of paper to get the imagination going.
🎨 Cozens; Leonardo

Body art

Art that takes the body as its subject or object (or both). Refers to such use in performance art, contemporary sculpture or video.
🎨 Burden

Body colour

Watercolour mixed with opaque white.

Bolognese School

Important 17th-century Italian school of artists based in and around Bologna, who successfully combined classicism and theatricality. Much admired in the 18th century; despised for most of the 20th. Look for Reni's favourite theatrical gesture: eyes and eyeballls rolling upwards.
🎨 Carracci; Domenichino; Guercino; Reni

Book of Hours

A prayer book used by laymen for private devotions. The hours refer to the times of day when prayers are said.

Bottega

The area of an old master's studio used by his apprentices.

Brücke, Die (The Bridge)

Important avant-garde group of German Expressionists based in Dresden, 1905–13, with radical political and social views expressed through modern, urban subject matter or landscapes and figures. Influenced by the latest Parisian ideas and primitive non-European art. Look for bright colours, bold outlines and deliberately unsophisticated techniques.
🎨 Kirchner; Heckel; Nolde; Pechstein; Schmidt-Rottluff

Brush

Instrument for applying paint that has been in use since the early Stone Age.

Brushwork

A painter's individual handling of paint texture, especially oils. Can be very distinctive – thin, thick, flat, juicy, rough, and so on – and a major element in an artist's style. Or can be virtually anonymous, even mechanical and boring.
🎨 Ingres (anonymous); Rembrandt (interesting)

1

Bucranium (pl. bucrania)
Decorative motif featuring the horned head or skull of an ox.

Buon fresco
True fresco – the real thing, painting into wet plaster.
See also Fresco; Mezzo fresco

Burin
The main tool used in engraving. You push it like a chisel and it ploughs out a line on the metal or wooden surface.

Burr
When you engrave a line with a burin, like a plough it leaves a ridge of dug-out material (burr) on either side of the furrow. If this is retained, the printed line has an extra rich, soft quality, though the burr soon wears away.

By . . .
One of the shortest but most important words in the commercial and academic art world. The description 'by Rembrandt' (or any other master) means that there is definite proof (or, at least, substantial evidence) that the artist painted it.
See also Attribution

Byzantine art
The artistic tradition that flourished in Byzantium (Constantinople), the capital of the Eastern Roman Empire, from AD c.330 to the mid 15th century. Notable for stylised depictions of Christianity and Imperial Rome in mosaics, frescoes and relief sculpture.

Cadmium
The metal cadmium was discovered in the early 19th century and from then on new cadmium pigments (yellow, orange and red) were produced. Popular because it was cheap and durable.

Calligraphy
The art of fine handwriting.

Camden Town Group
Small, progressive group of English painters who lived and worked in Camden Town, London, 1911–14. They were influenced by the post-Impressionists (indeed, Lucien Pissarro's father was a leading French post-Impressionist).
▨ Gilman; Ginner; Gore; Pissarro (Lucien)

Camera lucida
Latin for 'light chamber'. A machine for drawing and copying that uses a prism and gives the illusion of seeing a real object as if it were on a piece of paper.

Camera obscura
Latin for 'dark chamber'. A box-like device that projects an image through a small hole or lens onto a sheet of paper or other material so that its outline can be traced. Same principle as a simple photographic camera.
▨ Canaletto; Vermeer

Canvas
The material on which most largish pictures are painted. Inexpensive, flexible,

2

durable, shapeable. In common use by 1500. Linen is the traditional material; cotton duck has been used widely since 1945.

Capriccio
A fantasy townscape combining both real and imaginary buildings. Used to good advantage by decorative 18th-century artists such as Panini.
 Canaletto; Guardi; Heyden; Panini

Caravaggisti
Followers of Caravaggio, from all over Europe, who were influenced by his subjects, realism and dramatic lighting.
 Gentileschi; Zurbarán

Caricature
An exaggerated, ludicrous or satirical portrait.
 Carracci; Daumier; Hogarth

Carmine
A red pigment that is ostensibly good for flesh tones, but has the fatal disadvantage of rapidly losing its colour, which is why some of Reynolds' sitters look like white-faced ghosts.
 Reynolds

Carolingian art
Produced in Europe in the 8th and 9th centuries during the reign of Charlemagne (800–14) and his successors.

Cartoon
A full-size drawing that is used as the design for a painting or tapestry.
 Leonardo; Michelangelo; Raphael

Casein
Strong adhesive made from curd (milk).

1. (Cloisonism) **Émile Bernard**, *Breton Women on a Wall,* 1892
2. (Conté) **Georges Seurat**, *The Gleaners*

Cassone
Elaborately decorated Italian Renaissance marriage chest, sometimes with lid(s) and sides painted by leading artists.
■ Pesellino

Catalogue raisonné
A complete, annotated and scholarly catalogue of all known and attributed works by an artist.

Chalk
Soft, fine, grained rock used for drawing. The white variety is processed from calcium carbonate, the black from carbonaceous shale, and the red (sanguine) from haematite (iron ore).

Charcoal
Charred twigs or sticks used for drawing.

Chiaroscuro
Pronounced contrast between brightness and darkness. From the Italian chiaro (bright), oscuro (dark).
■ Bol; Caravaggio; La Tour; Rembrandt; Ribera; Zurbarán

1

Chinese white
White pigment with the same chemical components as zinc white but less transparent.

Chinoiserie
Works of art reflecting a fanciful idea of China. Especially in vogue in Europe from the late-17th to the mid-18th centuries.

Cibachrome
A colour print made from a slide. Usually large scale and with high definition and clarity.
■ Wall

Cinquecento
Italian for 15th century (1500–99).

Circle of …
'Circle of Rembrandt (or whoever)' means a work done in the artist's time and showing his influence.

Cire perdue
See Lost wax

Clair-obscur
French for chiaroscuro.
See Chiaroscuro

Classic
Much used and abused word. Sometimes it means logical, symmetrical, well established, archetypal; sometimes it means the moment of highest achievement by an artist or of a general style. Not an alternative word for classical.

Classical
Belonging to, or deriving from, ancient Greece and Rome.

*Collage is a method of taking the world apart and reassembling it in order that
one understands, and that order is ruled by one's emotions, intention and intellect.*
EDUARDO PAOLOZZI

Claude glass
A small, portable, dark, convex mirror.
Hold it up to a real landscape and you get
a miniaturised, subtle, coloured version of
it that looks a bit like a painting by Claude.
▪ Lorraine (Claude)

Cleaning
See Restoration

Cliché verre (or glass print)
A cross between photography, print-
making and etching. You draw the design
on a glass plate and print it onto light-
sensitive paper.
▪ Corot; Millet; Rousseau (Théodore)

Cloisonism
From the French *cloison*, meaning
'partition'. A style of painting in which
areas of pure colour are surrounded by
narrow bands of black or grey. Looks like
cloisonné enamel decoration of metals.
Although Gauguin took the credit for
inventing the style, and most fully
realised its possibilities, it was Émile
Bernard who first showed it to Gauguin.
▪ Bernard; Gauguin

Cobra
A group of post World War 2 European
avant-garde artists known for colourful,
expressive, abstract work. So called
because of the initial letters of their
native cities: COpenhagen, BRussels,
Amsterdam.
▪ Alechinsky; Appel; Jorn

Cognoscenti
From the Italian *conoscere*, 'to know'.
Those who have inside knowledge.

Coll.
From the collection of the person or
organisation named.

Collage
Photographs, bits of newspaper,
magazines, wallpaper and so on, pasted
down, and sometimes painted around
and over. An art form much used by
the Cubists.
▪ Bearden; Braque; Picasso; Rodchenko,
Schwitters

2

Colour Field painting
A type of Abstract Expressionism painting
whose principal feature is a large expanse
of colour, with no obvious point of focus
or attention.
See also Abstract Expressionism.
▪ Frankenthaler; Newman; Rothko

Colour wheel
A circular diagram showing the relation-
ships between primary, secondary,
tertiary and complementary colours. An
indispensable tool for anyone working
with colour.

Commercial art
Art commissioned exclusively for
commercial purposes, such as advertising
or packaging.

1

Complementary colours
Each primary colour – red, yellow, blue – has its own, exclusive, complementary colour – green, purple, orange. These are made by mixing the other two primaries. When the corresponding pair of primary and complementary colours are placed side by side, they cause an optical vibration in the eye and activate each other.

Composition
The arrangement of the shapes and areas of a picture, considered as surface pattern only.

Computer art
Works of art made with the aid of a computer.
🖿 Paik

Conceptual art
Works of art where the only thing that matters is the idea or concept. No value or merit is awarded in materials or to physical or technical skill. The problem for many people is that the ideas and concepts offered often seem utterly banal, and the works appear to have no visual or aesthetic interest. Came into fashion in the late 1960s; still very much the thing for many official art establishments and museum curators.
🖿 Beuys; Duchamp; Gonzalez-Torres; Hesse; Kosuth

Connoisseurship
Knowledge, understanding and appreciation of works of art, with emphasis on visual and aesthetic qualities.

Conservation
Creating the environment in which a work of art is properly looked after, without undue interference, and without the need to restore and repair. Not to be confused with restoration.
🖿 Michelangelo (Sistine Chapel)

Constructivism
Very important avant-garde movement (1917–21) concerned with abstraction, space, new materials, 3-D form and social reform.
🖿 Gabo; Pevsner; Tatlin

Conté
A French brand of chalk or crayon, named after Nicolas-Jacques Conté (1755–1805), the scientist who invented it. Seurat used black conté crayon on rough, grainy paper to create exquisite small-scale drawings, which show simplified forms and subtle gradations of tone.

Contemporary art
Usually taken to mean works of art produced since 1960.

Context art
Art that criticises the commercial activities and institutions of the art world with a view to investigating or revealing its political machinations and manipulations.

Contrapposto
From the Italian *contrapporre* meaning 'to oppose'. A pose in which the body below the hips is twisted in the opposite direction from the body above the hips.

Contre-jour
'Against the light' – looking at things

2

that are strongly lit from behind, and so almost silhouetted. Bingham's *Fur Traders* is a masterpiece of contre-jour, reflection and bathed light.

Conversation piece
A group portrait set in a room or a garden showing polite conversation or a related activity such as a tea party.
📷 Devis; Hogarth; Zoffany

Copy
An imitation of an original. May be honest, may be a forgery. *See also* Forgery

C-print
Colour print made from a colour negative.
📷 Wilson (Jane and Louise)

Coulisse
A compositional device (*en coulisse* is French for 'in the wings') in which rocks, trees, and so on are placed at the sides of a painting to lead the eye into the centre.

Craquelure
The network of cracks that can develop on the surface of old oil paintings.

Crayons
Chalks mixed with oil or wax.

Cross hatching
Criss-crossing parallel lines, which can be varied to create tone.

Cubism
The most significant art and design innovation of the 20th century. Similar in effect and consequence to the invention of the internal combustion engine, manned flight and wireless communications – all of them developed at about the same time. The principles of Cubism were

worked out in 1907–14. Early Cubism is noted for small-scale works and conventional subjects (still life, landscape, human figure), but with fragmented and chopped up forms, an effect that is sometimes like a jigsaw that has been put together with the pieces wrongly joined. You will hardly ever see any actual cubes. Analytical Cubism (1909–11) was painted; Synthetic Cubism (1911–14) used the contents of wastepaper baskets in addition. Picasso and Braque were the principal inventors of Cubism and although they went their separate ways after 1913, both of them continued to develop this style for the rest of their lives.

◪ Braque; Gris; Léger; Picasso

Curator
Someone who organises an exhibition, sets the agenda for it and chooses the participating artists.

Cutting-edge
This used to mean up-to-the-minute contemporary art that was original, incisive and clear sighted. Now (sadly) tends to indicate contemporary art whose principal feature is fashionable, headline-grabbing sensationalism and, frequently, a noticeable lack of originality.

Dada
The first of the modern anti-art movements. Deliberately used the absurd, banal, offensive and tatty to shock and to challenge all existing ideas about art, life and society. Originated in New York in 1915, and in Zurich in 1916.

◪ Arp; Duchamp; Ernst; Man Ray; Picabia

Danube School
The group of painters from middle Europe who developed landscape painting in the early 16th century.

◪ Altdorfer; Cranach

Deaccession
A work of art that has been catalogued as part of a collection needs a formal act of deaccession to undo the formality of officially cataloguing it. Whether or not museums should have the power to deaccession is a subject of hot debate.

Decalcomania
Technique in which paint is splashed onto paper with a big brush and covered while still wet with another sheet of paper before the two are rubbed together. The result is a pattern that looks like a weird, fantastic forest or jungle. Used by the Surrealists as a means of harnessing accidents to create spontaneous, unpreconceived subjects and forms.

◪ Ernst

Deconstruction
The currently fashionable idea that the true meaning of a work of art is found, not by examining what an artist professed to mean or tried to say, but by analysing the way he or she expressed it.

Decorative arts
See Applied art

Degenerate art ('entartete Kunst')
Nazi ideologues believed that any art which did not conform to a bourgeois ideal of well-crafted, figurative images portraying ideal heroism or comfortable day to day living was the product of degenerate human beings and perverted minds. An exhibition of modern and abstract art (with works by Beckmann, Dix, Grosz, Kandinsky, Mondrian and Picasso) was organised in Munich in 1937 to show how foul Degenerate art was. It backfired because it was unexpectedly popular and attracted huge crowds.

De gustibus non est disputandum
Latin maxim meaning 'There is no accounting for taste'.

Del., delin.
Found on prints after an artist's name. Means the artist drew the design, but that the print may have been made by someone else.

Dendrochronology
Technique useful for dating panel paintings, by counting the annual growth rings in the timber.

Device
An emblem or motto that an artist or printmaker uses instead of a signature.
▰ Whistler (butterfly device)

Didactic
Consciously teaching or instructing.

Difficulty
All major works of art are difficult in that they require time and effort, and test the perception, intellect and emotions of both creator and viewer. However, it does not follow, as some commentators seem to think, that because something is difficult to unravel or understand, it is therefore a major work of art.

Digital art
Art that uses computers and the Internet.
▰ Paik

Dilettante
Today a disparaging word to describe someone with a superficial and unserious interest in the arts. But in the 18th century it was used as a word of praise, denoting a deep and profound interest and pleasure not just in the visual arts but in the whole richness of human possibility.

Diorama
A peepshow with artistic pretensions. Can be the size of a small box or a large building.

1

Diptych
A picture made in two parts. An altarpiece that is a diptych usually has the two parts hinged together.

Disegno
Italian term covering both drawing and design. Skill in *disegno* was very highly valued in the Renaissance.
▰ Michelangelo; Raphael

Distemper
Powdered colours mixed with size; impermanent. Used by scene painters in

1

Dragging
Paint pulled across a surface in an uneven way so that the underneath layer of paint shows through.

Drapery man (drapery painter)
A studio assistant who painted the unimportant bits of drapery.

Draughtsman
Someone who draws, but you have to do it very well to deserve the name.

Dry brush
A technique whereby a watercolour brush is squeezed almost dry, to produce a fine opaque line.
▨ Dürer; Wyeth

the theatre. Old paintings in distemper have a very dark and dusty appearance.

Distressed
Smart way of saying 'in poor condition'.

Divisionism
A way of painting in which colour effects are obtained optically rather than by mixing colours on the palette: small areas of pure colour are put side by side on the canvas so that at a distance the eye cannot differentiate between them but mixes them together and so experiences another colour. More convincing as a theory than in practice. Seurat was the originator of Divisionism but died young, so Signac became its chief promulgator.
▨ Pissarro (Camille); Seurat; Signac

Donor
Somebody who commissions a work of art and gives it to an institution (such as a church). In the Renaissance the image of the donor was often included in the picture.

Dry point
A type of print technique. A metal plate is scratched with a sharp point, producing a burr. Often used to add extra touches to etching and engraving. *See also* Burr
▨ Rembrandt

Duck
A type of canvas, usually made of cotton.

Earth art
Fashioning land into a work of art. Cannot be exhibited in a museum or gallery, but photographs of Earth art projects are shown. Developed in the late 1960s.
▨ Long; Smithson; Turrell

Earth colours
Pigments such as ochre and umber made from earth.

Easel picture
A picture of a size to fit on and be painted at an easel in a studio – so in practice not much taller than two metres (6ft 4in).

Eclectic
Borrowing freely from a wide variety
of sources.
🔲 Carracci

Écorché
French for 'flayed'. A drawing or model
that shows a human or animal body
without its skin.

Edition
All the impressions made from a single
printing plate and issued at the same
time.

Eight, The
Important group of 8 avant-garde
American artists (Arthur Davies, William
Glackens, Robert Henri, Ernest Lawson,
George Luks, Maurice Prendergast, Everett
Shinn and John Sloan) formed in 1907 for
a New York exhibition, and which gained
notoriety. Some were part of the Ashcan
School; some were colourfully modern.
🔲 Ashcan School

Elevation
View of a building from one vantage
point.

Emblem
1) An object symbolising or suggesting
another object.
2) A picture, possibly with a motto or
set of verses, that spells out a message
of moral instruction. Very popular in
17th-century Holland.

Empathy
Transferring your feelings and personality
onto a person or a work of art.

Empire style
Grand imperial decorative style that
started in Paris and spread throughout
Europe. The style of choice in Napoleon's
era, it consisted of hyped-up neoclassicim
with the addition of other motifs, often
Egyptian. Sometimes called Regency
in England.

Emulsion
A medium containing materials that will
not mix naturally – such as oil and water –
but which are made to do so by adding an
emulsifying agent. Egg yolk is such an
agent; tempera is an emulsion.
See Tempera

Encaustic
Pigments mixed with molten wax and
fused to a surface. Much used by the
ancient Greeks. Has had a recent revival.
🔲 Johns; Marden

Engraving
Print technique. A sharp V-shaped tool
is pushed across a metal plate producing
precise, clear-cut lines. Widely used
since the early Renaissance. Dürer's
incomparable engraving technique
strongly influenced young Aubrey
Beardsley, who loved the dramatic and
erotic qualities of bold black-and-white
illustrations.
🔲 Beardsley; Dürer

Enlightenment (The)
In the mid 18th century, upholders of
The Enlightenment believed that human
reason could (and would) solve most
problems and create heaven on earth.
Also known as The Age of Reason.

Entartete Kunst
See Degenerate art

Entropy
Disorder. Scientific term high-jacked
by fashionable writers about art.
Scientifically it means that the amount

1

of disorder in the universe is bound to increase (second law of thermodynamics: heat is disordered energy). If you are faced with a work of art that is or seems irredeemably chaotic, but you want to give it and yourself a cutting-edge legitimacy, murmur 'entropy'. However, every time you use 'entropy' as a compliment, ponder the thought that one of the fundamental driving forces in all 'art' worthy of the name is a compulsion to create order out of material and psychological disorder. *See also* Gestalt.

Kelley

Environment art
Creating an environment (such as a room, but can be outside) so that the presence of the visitor in it becomes an integral part of the experience or event. Early works tended to bombard onlookers with light, sound, smell and touch, so they had to react. Developed in the 1960s. *See also* Installation

Kaprow

Esquisse
French word for sketch.

Etching
Print technique widely used since the 17th century. The line is first drawn by hand, then acid is used to make the line eat into the metal plate. It produces a delicate free-flowing line with a soft outline. Picasso's *Vollard Suite* is arguably the greatest achievement in all 20th-century etching.

Picasso; Rembrandt; Whistler

Euston Road School
English group founded in the 1930s who promoted realism à la Cézanne.

Coldstream; Pasmore

Ex-voto
Latin: 'from a vow'. A work of art made as an offering to a god, usually to ask a favour or as a thank you for a prayer answered.

Exc., Excudit
Latin for 'he executed it'. Found on prints, identifying the engraver or publisher.

Existentialism
The fashionable philosophy among the Western intellectual elite in the immediate postwar period. Says, in essence, that individuals are only responsible to themselves and therefore they are free, even obliged, to express themselves as personally and individually as possible. Very influential with avant-garde artists and writers of the time.
🖾 Giacometti; Pollock

Expressionism
Style conveying heightened sensibility through distortion of colour, drawing, space, scale, form or intense subject matter, or a combination of these. One of the principal strands of 20th-century German art.
See also Blau Reiter; Brücke

Eye level
Everything we see is at, above or below eye level. When looking at a figurative picture this needs to be worked out in order to read the objects and space relationships correctly.

Facsimile
An exact copy.

Facture
See Handling

Fake
A work of art deliberately made or altered so as to appear to be better, older or other than what it, in fact, is.
See also Forgery

Fancy picture
English 18th-century pictures of a single figure, or a group of figures in an open-air setting doing nothing very much other than looking sweet, appealing and picturesque.
🖾 Gainsborough

Fauvism
French avant-garde movement, which originated in 1905. One of the key early movements in Modern art. Decorative and expressive works full of bright colour and flat patterns, loosely painted. Fauve is the French word for wild beast.
🖾 Braque; Derain; Dufy; Matisse; Vlaminck

Fec., Fecit., F.
Latin for 'he/she made it'. Sometimes accompanies an artist's signature, as a sort of double declaration of authenticity.

Fête champêtre
French for 'outdoor feast'. A group of elegant ladies and gents having a relaxed and happy time in a landscape setting and evidently absorbed with each other, love and music. Much in vogue in 18th-century France. Also sometimes referred to as *fête galante*.
🖾 Lancret; Pater; Watteau

Fibonacci numbers
The sequence of numbers 1, 1, 2, 3, 5, 8, 13, 21 and so on, each number (except the first) being the sum of the two previous numbers. The sequence is found in natural organic growth and was discovered by a 13th-century Italian. Used by artists interested in environmental issues in the 1960s and 1970s.
🖾 Merz

Figurative art
Art that represents recognisable nature and objects. The opposite of abstract art.

Figure
The human form.

Fin de siècle
Refers to the jaded, decadent attitudes in vogue at the end of the 19th century.

Fine arts
Painting, sculpture and architecture.

Finish
A work of art that is executed in meticulous detail is called 'highly finished'.
▨ Ingres

Fixative
A transparent spray that fixes chalks, charcoal and pastel to paper, and stops them smudging and rubbing.

Fl., Floreat
Latin for 'he/she flourished'. If the actual birth and death dates of an artist are not known, it is customary to give the dates when he or she was known to be working (i.e. flourished). Same as 'active'.

Fluxus
International group of artists set up in Germany in 1962. Promoted 'happenings' with spectator participation. Opposed to anything that smacked of tradition or professionalism.
▨ Beuys

Follower of . . .
Somebody working in the style of a particular artist, but not necessarily a pupil or assistant.
▨ also Attribution; Manner of . . .

Foreshortening
A perspective trick. An extreme example is a painting that gives the illusion of an arm pointing directly at the spectator; in fact only the hand is shown, the arm being hidden behind the hand.
▨ Caravaggio; Lanfranco; Mantegna; Masaccio; Sebastiano del Piombo; Uccello

Forgery
Something made in fraudulent imitation of another thing already existing.
See also Fake

Form
The shape, size, movement, texture, colour and tone of an object.

Found object
See Objet trouvé

French Revolution
1789 – a key date. The most important political event of the 18th century, and a watershed for the arts, as for so much else in European history.

Fresco
Italian for 'fresh'. Painting on the wet plaster of a wall so that when it dries, the painting is the plaster. This has to be done rapidly and with absolute certainty, as there is no possibility for corrections other than hacking off the plaster and starting

1

2

again. Michelangelo's ceiling in the Sistine Chapel is fresco painting at its most magnificent.
See also Buon fresco; Mezzo fresco

Frottage
From the French *frotter*, 'to rub'. Making an impression of a textured surface by placing a piece of thin material over it and rubbing it with something like a wax crayon. Used by the Surrealists to stimulate ideas and painting.
🖼 Ernst

Futurism
One of the most important early avant-garde art movements. Originated in Italy 1909–15 and was widely influential. Noisily promoted a worship of machinery, speed, modernity and revolutionary change, using the latest avant-garde styles such as Cubism.
🖼 Balla; Boccioni; Lewis (P. Wyndham); Severini; Stella (Joseph)

Gamboge
A rich golden-yellow pigment.

Gender surfing
Mixing up sexual roles in order to entertain and amuse.

Genre
A particular category of subject matter – such as portrait, landscape, marine or history painting.

Genre painting
A type of picture that purports to show a reassuring glimpse of everyday life. Usually small-scale and intimate. Invented in 17th-century Holland and much in vogue in other prosperous bourgeois circles, such as 18th-century

3

France, Biedermeier Germany and 19th-century Britain. The French artist James Tissot was deservedly successful in the 1870s Victorian London.

🔳 Chardin; Greuze; Hooch; Maes; Terborch; Tissot; Vermeer; Wilkie

Georgian

A vague term much loved by estate agents and antique dealers meaning anything British, of the 18th and early 19th centuries, and therefore desirable – all British monarchs between 1714 and 1830 were called George, from George I to George IV.

Gesamtkunstwerke

Untranslateable German word meaning 'total work of art'. The idea is the creation of a totality in which architects, painters, sculptors, writers, musicians, poets etc. all make an equal contribution so that the whole is greater than the sum of the individual parts. Wagner was enthused by the idea – but with himself as the creative controlling genius.

Gesso

A white absorbent ground for painting in tempera or oil. Made from chalk or gypsum mixed with glue.

Gestalt

A one-word way of saying that the mind tries to turn chaos into order. It organises what it perceives and senses, and tends to make the final result greater than the sum of the individual parts. *See also* Entropy

Gesture painting

See Action painting

Gilding

Covering a surface with gold leaf.

Glasgow Boys

Progressive group of Scottish painters active from 1850 to 1918. United more by a common purpose than a shared style. Broke with stale academic convention and looked to vigorous new European styles. Much more adventurous than their English counterparts. David Young Cameron's landscape style of well-structured compositions, judicious use of chiaroscuro was strongly influenced by the group.

🔳 Cameron; Guthrie; Henry (George); Lavery; Melville

Glass print

See Cliché verre

Glazing

1) Old-master technique of covering a layer of already-dried oil paint with a transparent layer of a different colour. One of the reasons for the rich, resonant and subtle colour effects in old masters. A very strong, durable technique.
2) Putting glass, in a frame, over a picture to protect it.

Golden Section

A mathematical proportion thought to be very beautiful. Take a line AB and divide it by C so that the ratio AC : CB = AB : AC. In practice it works out at approximately 8/13. Widely used.

🔳 Poussin

1

1. (Glasgow Boys) **Sir David Young Cameron,** *Marble Quarry, Isle of Iona*
2. (Gouache) **Jacob Lawrence,** *John Brown Formed An Organisation Among The Coloured People of Adirondack Woods To Resist The Capture of Any Fugitive Slaves,* 1941
3. (Grand manner) **Sir Joshua Reynolds,** *The Infant Hercules Strangling the Serpents,* 1786-8

2

3

Gothic

The principal European style in the arts (and especially architecture) before the Renaissance, from the 12th to 15th centuries. Characterised by the soaring vertical and pointed arch. The underlying message is spiritual uplift and devotion.

Gothic revival

The reawakened interest in mediaeval art in the 18th and 19th centuries. Called by the French 'style troubadour'.

Gouache

Opaque watercolour. Ideal for Jacob Lawrence who wanted to work on a small scale with spare, lean and intense colours.
▨ Calder; Lawrence; Lewis (John Frederick); Matisse; Watteau

Graffito

Strictly speaking, 'graffito' (or 'sgraffito') describes any design scratched through a layer of paint or other material, to reveal a different ground underneath. The plural 'graffiti' nows describes unauthorised designs or words which are painted, sprayed, scratched, or scribbled onto walls or other publicly visible surfaces, sometimes by political activists, sometimes by vandals, and sometimes by those with highly sophisticated artistic and graphic skills.
▨ Basquiat; Dubuffet

Grand manner

An ambitious type of painting that promotes the idea of heroic characters and events, and resonates with implications of history, authority and greatness. History painting and portraiture are the usual subjects. Showy, eloquent and rhetorical; at its best convinces by overwhelming, at its worst looks insincere, artificial and ludicrous. Reynolds fervently believed in the merits of grand manner painting. He succeeded with it in his portraits, but failed spectacularly when it came to history painting.
▨ Copley; Kitaj; Reynolds; Sargent; Stuart

Grand Tour

Once-in-a-lifetime tour around Europe to see the major sights and works of art and to experience life. Very much the done thing in the early 18th and 19th centuries – especially by young English gentlemen, who returned home with quantities of works of art with which they filled their country houses. An elegant portrait painted in Rome by the Italian artist Batoni was the typical Grand Tour souvenir-cum-status symbol.

Graphic art

Art primarily dependent on the use of line, not colour, such as drawing, illustration, engraving and printmaking.

Grisaille

A painting made with different greys and no colours.

Grotesque

Decorative design incorporating fanciful human, animal and plant features. The inspiration was the designs found in excavated crypts of grottoes (hence the name) in Rome in the early 16th century, notably the Golden House of Nero. In the 18th century the word came to mean something ridiculous and unnatural.
 ◤ Raphael; Tura

Ground

1) The final, prepared surface of a support, which will be painted on.
2) Also the name of the substance used for such preparation.
The purpose of the ground is to create a smooth surface with a sympathetic texture for the artist to paint on, and which also isolates the paint from the support. A ground can be of any colour. The old masters traditionally used a middle tone so that they could paint brighter than the ground for highlights, and darker for shadows. Since Impressionism, grounds are usually

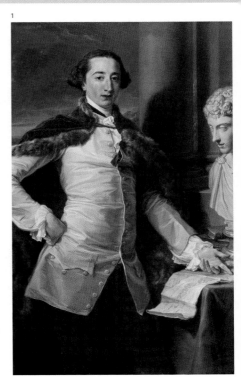

1

white, to make colours as bright as possible.
See also Primer; Sinking in; Support

Guild

Mediaeval organisation that trained and protected its members. Painters often belonged to the Guild of St Luke (he was the patron saint of painters). The High Renaissance masters despised them, and the academies took over their role.
See also Academies

Gum arabic

Binder used for watercolours – the gum comes from certain varieties of acacia tree.

Half-tone

Any tone or shade that lies between the extremes of light and dark.

Halo
Circle endowed with divine light
surrounding the head of a holy person.

Handling
The way a medium – such as paint, clay
or charcoal – is used and manipulated.
All artists have their own individual way
of handling their material, which is as
personal as handwriting.

Happening
'Artistic' event, supposedly spontaneous,
similar to a theatrical performance and
presented as a work of art. Typical 1960s
phenomenon. *See also* Fluxus.
⚡ Beuys; Dine; Kaprow; Klein;
Oldenburg; Rauschenberg

Hardboard
Compressed fibreboard – a cheap
alternative to canvas or panels. Called
masonite in the USA.

Hard-edge painting
Abstract painting using solid areas of
colour with clear, sharp outlines.
⚡ Kelly; Morris (Robert); Noland; Riley

Hatching
Parallel lines placed side by side in
differing densities, used in drawing to
create tone and shadow.

Hellenistic
Greek and Greek-influenced art of the 4th
century to the 1st century BC (sometimes
identified as the period from the death
of Alexander the Great in 323 BC to the
defeat of Antony and Cleopatra at Actium
in 31 BC).

Herm
Figure with a bearded head on a column
tapering from top to bottom, sometimes
with a big phallus. Named after the Greek
god Hermes.

Hieratic
From the Greek for 'priestly'.
1) Stylized conventional portrayal of
a religious figure.
2) Cursive form of hierogliphic script
used by the priests in Ancient Egypt.

High art
Every age proposes certain subjects or
styles (or both) as its own appropriate
and acceptable high art – art that is
very seriously intentioned and aims to
express a profound intellectual and
spiritual meaning. In the 18th century this
was history painting; in the 19th century,
landscape painting; in the early
20th century, abstract art; in the late 20th
century, Conceptual art. Whether or not
the aim is achieved is another matter –
sometimes the individual results never
rise above banality.
See also Conceptual art; Grand manner

High relief
See Relief

Historicism
An obsessive interest in the past, often
adopted by those unable to face the
present, let alone the future.

History
Our relationship with the past is
constantly changing. It is only recently
that we have characterised the past
as a series of separate epochs, removed
from the present, each with its own
unique values. Thus we now go to great
lengths to preserve the past as a relic
and call it a national heritage. Nowadays
we worship old art, antiques and
memorabilia, and officially approve of
'modern' types and styles of art that look
consciously different from the art of the

1

past. In earlier times there was perceived to be a continuum between past and present, which made history, mythology and antiquity part of the here and now.

History painting

Subjects of classical mythology, history and biblical themes. Until the end of the 19th century, any seriously ambitious painter had to succeed as a history painter or settle as an also-ran.
See also Grand manner; High art
◪ David; Moreau; Poussin; Reynolds; Turnbull; West

Hologram, holograph

A 3-D image produced by a complex process of light from a laser striking a special photographic image. Clever, but is it any more impressive than using paint to create the illusion of space or movement on a static flat surface?

Horizon line

The horizontal line across a picture that is at the artist's eye level.

Hudson River School

Loosely organised group of American painters whose founding father, Thomas Cole, painted much-admired picturesque views of the beautiful Hudson River Valley in Upper New York State in the 1820s, thereby establishing a new tradition for landscape painting in the USA. Most of

the artists associated with the school travelled widely throughout the USA and worked in New York. The group's vigour waned after the Civil War (1861–5). Thomas Moran established his reputation after a visit to Yellowstone Park in 1871.
◪ Bierstadt; Church; Cole; Moran

Hue

Commonly described as colour. Normal vision can differentiate between approximately 10 million different hues.

Icon

1) A sacred image – especially the images of Christ, the Virgin and the saints produced for the Greek and Russian Orthodox churches.
2) A highly influential and widely admired cultural image.

Iconoclasm

The destruction of images – either literally or metaphorically.

Iconography

The language of images or language created by images – especially symbols, allegory, and so on.

Iconology

The study or interpretation of iconography.

Ideal

That physical, intellectual or emotional perfection which humans can never achieve. It can only be imagined or aspired to, but art can represent it.
◪ Raphael

Illuminated manuscript

A handwritten text decorated with paintings and ornaments.

2

Illumination
The embellishment of a written text with gold, silver or colour.

Illusionism
Deceiving the eye into believing that what is painted is real.

Imitator of . . .
See Manner of . . .

Imp.
Latin for 'he has printed it'. Appears on prints, together with the name of the printer or publisher.

Impasto
Oil paint thickly applied (think of toothpaste).
🖾 Auerbach; Rembrandt; Van Gogh

Impression
A print made by pressing a plate or block onto a piece of paper.

Impressionism
The famous progressive movement that started the dethronement of Academic art. The Impressionists went back to nature with the intention of painting only what the eye could see and created small-scale works of contemporary scenes, landscapes freely and directly painted en plein air (outdoors), portrait and still lifes. Their hallmark technique is short brush strokes and a rainbow palette. The first exhibition was in 1874.
🖾 Caillebotte; Cézanne; Degas; Manet; Monet; Morisot; Pissarro (Camille); Renoir; Sisley

Imprimatura
A type of coloured primer applied over a white background.

Incunabula
Books printed before 1500, generally illustrated with woodcuts.

1

Indian ink
Black ink made with carbon particles. So-called because it was originally imported from India.

Indigo
A dark blue vegetable dye or colour made from a tropical plant of the pea family.

Installation
A work of art that integrates the exhibition space into its content. Currently the most pervasive form of official or museum art – probably for administrative and economic reasons as much as for artistic ones. The new museums of contemporary art usually have vast spaces to fill. It is much more economical and labour-saving for them to fill each space with one huge installation (particularly if you can persuade artists to set it up themselves) than to employ an army of people to hang, arrange (and keep a security check on) dozens of small-scale objects.
◪ Barney; Bourgeois; Chicago; Gober; Hirst; Lucas; Muñoz; Whiteread

Intaglio
A design that is cut into a surface such as metal, jewel or stone.

Intensity
The strength or brightness of a colour.

International Gothic
A style of painting in favour in the late 14th and early 15th centuries. Colourful, very decorative and rather artificial, with lots of realistic detail in costumes, animals and landscapes. It often depicts court life.
◪ Gentile da Fabriano; Limbourg brothers; Pisanello; Sassetta

Intimisme
Small-scale, Impressionist-style pictures showing domestic interior scenes.
◪ Bonnard; Vuillard

Inuit
Eskimo. Many Inuits now consider the name Eskimo (which means 'eaters of raw flesh') offensive.

In., Inv., Invenit
Latin for 'he created, designed, invented it'. Found on prints, together with the name of the artist who made the original design.

Irony
To convey a meaning by expressing the opposite. It is a term much used currently when commenting on contemporary art. As with 'ambiguity', it is often a way of masking the fact that the commentator may have no idea about what the artist is trying to say.
See also Ambiguity

'ism'
Shorthand way of referring to a succession of artistic movements from the late 19th century onwards – Impressionism, Fauvism, Cubism, Surrealism, Expressionism, and so on.

Isometric drawing
Technical drawing that keeps the scale of height, width and depth constant, and does not use perspective.

Italianate
Strictly speaking, a work of art that recalls the Italian Renaissance, but sometimes used to describe a work with an Italian character, especially a golden light. The Dutch artist Jan Both studied in Rome and introduced the arcadian Italianate landscape to Holland.

Jacobean
Works of art produced in England during the reign of James I (1603–25), and works in that style.

Japonism
The influence of Japanese art on Western art.
◪ Cassatt; Dewing; Gauguin; Tobey; Vallotton; Whistler

Journeyman
From the French *journée* (day). Someone employed to work by the day – perhaps a skilled worker who has completed his apprenticeship but is not yet a master craftsman.

Jugendstil
See Art Nouveau

Kaolin
Fine white clay used for making porcelain.

Key
A painting is in a high key if the colours are predominantly bright and light, and in a low key if dark and sombre. Like major and minor keys in music.

Kinetic art
Works of art with moving parts.
◪ Calder; Gabo

Kitchen Sink School
Group of British artists active in the 1950s, whose subjects were slummy interiors.
◪ Bratby; Middleditch

Kitsch
Mass-produced, decorative, popular, cheap knick-knacks, which are widely bought and condescendingly dismissed by the well educated as in sentimental, bad taste, rubbish. Art that has such characteritics or is deliberately 'vulgar' or 'trashy'.

Lacquer
Varnish made from natural resins. Tends to go yellow with age. Modern synthetic equivalents are also commonly referred to as lacquer.

Land art
See Earth art

Landscape
A painting in which natural scenery is the principal subject and the motivating idea. Began to come into its own in the 17th century, and by the end of the 19th century replaced history painting as the main aim of any ambitious young artist.
See also Barbizon School

Layers of meaning
See Ambiguity

Lay figure
A jointed wooden model of the human figure, often life-size, which could be dressed up and used in the studio in place of a live model. Like the dummies seen in shop windows.

Laying in
See Underpainting

Layout
Drawing or design that shows what the final appearance of a decorative scheme, advert, book cover or newspaper page will look like.

Lean
Oil paints with a low oil content. They look spare and lack bulk, just like a lean person.

Liberty
Italian name for Art Nouveau, so named after Liberty's store in London.
See also Art Nouveau

Life class
A group of artists drawing or painting from a live model.

Limited edition
An edition of a specific number of prints, each one numbered and marked. Thus

7/50 means the 7th print out of a limited number of 50. Nowadays sometimes used as a promotional hype or catch phrase to trap the unwary – do you seriously believe an edition of several hundreds or even thousands is 'limited'?

Limner
Out-of-date word for an artist. Usually describes a portrait painter, and probably a painter of miniatures.

Linear
Describes a work of art in which outlines predominate.

Linear perspective
See Perspective

Linocut
A relief print made from a piece of linoleum. Linoleum floor covering is nice to use because it is strong but soft, and carves well and more easily than a block of wood.
▰ Picasso

Lithography
This complicated printmaking process produces an image that looks as if it has been made with a soft or greasy crayon. Came into its own in the early 19th century.
▰ Daumier; Géricault; Schmidt-Rottluf

Local colour
The actual colour of an object. Local colour is changed and modified by light and shade, distance, the colour of nearby objects, and so on – so what you see may be rather different from the actual local colour.

Lost wax (cire perdue)
A complicated method of casting

sculpture. To oversimplify: make your model out of wax; encase it in a heat-resistant layer of plaster or clay; drill a hole in the plaster; heat it all up until you know the wax is melted; pour it out and fill the resulting space with bronze; let it cool; crack open the mould and there is your sculpture.

Low relief
See Relief

Luminists
A group of mid-19th-century American landscape and marine painters notable for a polished realism in which all signs of brush strokes were eliminated, and fine gradations of tone were used to produce luminous effects. The result is often one of eerie, breathless, clear stillness. Impending storms also feature.
🎨 Heade; Lane

Lunette
A semi-circular painting, such as a half moon. Usually a decorative element over a window or door.

Magenta
A brilliant red–purple. Named after the textile town in Northern Italy.

Mahlstick
A thick cane with a soft padded head (a bit like a drumstick). Used by painters to support an arm or wrist. The head can rest on the painting without damaging it.

Mandorla
An almond-shaped outline round the body of a holy person endowed with divine light, usually Christ.

Manga
Popular Japanese comics and cartoons.

Manikin
A small lay figure.
See also Lay figure

Manner of . . .
'Manner of Rembrandt' (or whoever) means that the work is in Rembrandt's style but done at a later date, by someone else.
See also Attribution; By. . .; Follower of. . .; Manner of. . .; Studio of. . .

Mannerism
The predominant style c.1520–1600: elongated figures, artificial poses, complicated or obscure subject matter, vivid colour, unreal textures, deliberate lack of harmony and proportion. Seen at its best in Italy and France.
🎨 Bronzino; Pontormo

Maquette
A small clay or wax model to show what a finished full-size sculpture will look like.

Marbling
A decorative effect that swirls coloured paints around so that it has the same sort of quality as the patterns found in coloured marble.

Marine painting
A seascape with a narrative action, such as a naval battle.

Marouflage
From the French *maroufle*, 'strong glue'. To pin a painted canvas to a wall or panel.

Masking
To protect one area of a work of art from what is being done to another area or to the work as a whole. Masking can be done by using protective tape or a varnish that can later be removed.

Masonite
See Hardboard

Master of . . .
A title given to an artist of unidentified personality, but one whose hand has been detected because a group of works are all in the same style. He is usually named after his best known work, his patron, or the region where he worked – e.g. the Master of the St Bartholomew Altarpiece.
🖿 Campin (Master of Flemalle)

Masterpiece
A work of art of outstanding quality. Originally it was the work that an artist had to submit to his guild to prove his ability so that he could become a master.
See also Guild

Mastic
Gum or resin.

Matt; matte
Not shiny or glossy.

Medium
1) (pl. media) The material worked with and manipulated to make a work of art – such as oil paint, watercolour, charcoal or clay.
2) (pl. mediums) A liquid that can be added to paints to make them act differently (for instance, to thin them or make them dry more quickly).

Memento mori
A reminder of death.

Metalpoint
A means of drawing using a fine needle of pure metal to make a mark on specially prepared paper.
See also Silverpoint

Metamorphosis
The change of something into something else, often the transformation of a human being or god into an animal or vegetation. Ovid's great book *Metamorphoses*, in which he narrates with compelling verbal imagery stories of the classical deities who often changed their form in order to achieve their desires, is one of the main sources of mythological imagery in art. Metamorphosis appeals to artists since the visual transformation of the known and familiar into something recognisable but beyond reality is one of art's great possibilities.

Metaphor
Using a subject or object in a work of art to bring to mind one that is not actually represented.

Metaphysical art
Italian avant-garde art movement of the 1920s that depicted a seemingly real world, but where all the spaces, relationships and situations are outside everyday human experience.
🖿 Chirico; Morandi

Mezzo fresco
Fresco painting, but onto dry plaster so that the paint is only partially absorbed.
See also Buon fresco; Fresco

Mezzotint
A type of print. It was used mostly in the 18th century in England for portraits and is recognisable by very rich blacks and good half-tones.
🖿 Gainsborough; Reynolds

Miniature
A very small picture, usually a portrait, very finely painted, usually on ivory, vellum or card. The term comes from the Latin 'minium' – the red lead that

produced the red ink used in mediaeval illuminated manuscripts to emphasise initial letters – it has nothing to do with the Latin minutus, 'tiny'.
⚑ Copley; Hilliard; Holbein; Oliver;

Minimal art
A type of art that first became fashionable in the 1960s, designed for gallery and museum exhibition. Usually three-dimensional, large-scale and geometric, with the slick, anonymous, precision qualities of manufactured or machine-made objects and little obvious visual significance or personal craftsmanship. The artistic significance lies in the ideas embodied but… see Conceptual art.
⚑ Andre; Flavin; Judd; LeWitt; Morris (Robert)

Misericord
A hinged seat found in church choir stalls. Look underneath for carvings, often of glorious quality.

Misericordia
Latin word for mercy.

Mixed media
Describes a work of art made with a variety of materials and techniques.

Mobile
A hanging sculpture with shapes or solids hung from wires or strings so that they move freely. If you see them, don't be afraid to blow on them so that they move and come to life (but do not touch them).
⚑ Calder; Martin

Modello
A small version of a large picture done to impress a patron and show what the commission will be like.

Modern art
The great flowering of Modern art occurred between 1880 and 1960, and it embraces all the avant-garde works produced at that time. It starts with Manet and the Impressionists and continues until the New York School. Three characteristics are worth mentionning:
1) A claim to break with the past – all other previous art movements emphasised their inheritance from, or rejuvenation of the art of the past.
2) A defiance of all existing art institutions and the creation of works of art which were 'homeless', in the sense that they belonged in no existing institution.

1

3) A plethora of styles and ideas. Modern artists were at their most active in those places where freedom of speech and thought was most at risk, or under threat.

407

Monochrome
See Grisaille

Monolith
A sculpture carved or cast as a single piece.

Monotype
A single print made by painting onto glass or metal and then transferring the image onto a piece of paper pressed over it.

Montage
Use of cut-up, ready-made photographic and printed images (such as magazine advertisements) arranged and stuck down to make a work of art.
☐ Bearden; Grosz; Heartfield; Longo

Morbidezza
Italian word for 'softness', used to mean soft-focus effects.

Mordant
From the French verb *mordre*, 'to bite'. An acid that eats away at a metal plate, for example.

Mosaic
A design or picture made of small bits of stone or coloured glass, or other materials. Widely used by the Greeks and Romans, and a favourite of Byzantine art.

Motif
A recurring or dominant theme, pattern or subject.

Mount
Works on paper are usually mounted on a piece of board and have a border between them and the frame. Good mounting and framing can bring a picture alive. In general, make the bottom border about 20 percent deeper than the others.

Multifaceted
See Ambiguity

Multiple
Catch-all term for editioned works of art that do not belong to traditional categories such as prints, cast sculptures or tapestries.

Mural
A painting on a wall or ceiling.

Museum of modern art
The dominant art institution of the second half of the 20th century. The first museum of modern art was MoMA, which opened in New York in 1929. They now exist all over the world and are as important and influential for contemporary art (and increasingly as dictatorial and stultifying) as the academies were in the 19th century.

Nabis
Group of progressive artists working in France c.1892–9. Believed in art for art's sake, decoration, simplification, emotion and poetry. The name means 'prophets' in Hebrew. Paul Sérusier was one of the group's founders and was much indebted to Gauguin and Bernard.
☐ Bonnard; Denis; Sérusier; Vallotton; Vuillard

Naïve art
Art that looks as if it is done by someone who has had no professional training – with childish subject matter, bright local colours, wonky perspective and unsophisticated enthusiasm. Can be genuine, but can be a consciously adopted pose – and it is not always easy to tell which is which. One is genuine and heartfelt, the other is artificial play-

acting. Douanier Rousseau, a retired customs official, was one of the genuine. ◪ Grandma Moses; Rousseau (Le Douanier); Wallis (all genuine)

Narcissism

Triumphant bourgeois capitalism invariably produces an art that is obsessed with its own way of life, image and material prosperity (true for 15th-century Netherlands, 17th-century Holland, Second Empire France and Victorian England;

at no time more true than today). Extravagant contemporary claims are also made for the quality and significance of the art (capitalist success is very dependent on convincing marketing).

Narrative art

Art that tells a story. Hogarth's narrative pictures, which he called 'modern moral subjects', depicting the follies of human behaviour, show how a good story never fails to appeal.

National Academy of Design

Founded in New York in 1825, to be the American equivalent of the Royal Academy in London.

Naturalism

The representation of nature with the least possible formal distortion or subjective interpretation.

Nature morte

French for still life.

Navicella

A representation of the story of Christ walking on the water.

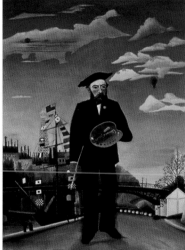

Nazarenes

Group of progressive young Germans who formed a group in 1809 to revive the spirit and techniques of early Christian and Renaissance art.

Negative space

The space between objects. In a painting or sculpture it can have as much significance or shape as the objects represented, and can be manipulated and coloured. Of great importance to artists, but often unnoticed or ignored by those looking at works of art (if you have difficulty seeing negative spaces, try

1

turning the work upside down and then look for them).

◪ Whiteread

Neoclassicism

The predominant fashionable style from about 1770 to 1830, emphasising the spirit and appearance of classical Greece and Rome. Tends to be severe, authoritative, didactic, well made and architectural (prefers straight lines). Succeeds best in architecture, furniture and sculpture; seen at its finest in England (the Adam style) and France (Louis XVI style).

◪ David; Hamilton; Mengs; Vien

Neo-Expressionism

A type of large-scale painting, fashionable in the 1970s, made in an aggressively raw and Expressionist manner, with surfaces heavily laden with paint and sometimes including objects, like smashed crockery. Lays claims to portentous or doom-laden subject matter.

◪ Baselitz; Clemente; Kiefer; Schnabel

Neo-Impressionism

Impressionist subject matter painted through the strict application of the scientific colour theories of Divisionism.
See also Divisionism.

◪ Seurat; Signac

Neo-Plasticism

The philosophy of De Stijl.
See also Stijl (De)

Neo-Romanticism

British painting of the 1930s, 1940s and 1950s that gave a modern interpretation to the romantic and visionary landscape tradition that stemmed from Blake and Palmer.

◪ Sutherland; Piper

Neue Sachlichkeit

German, meaning 'New Objectivity'. A stern, precise and detailed style, often socially critical in content, fashionable in Germany in the 1920s.

◪ Dix; Grosz; Schad

New English Art Club

Founded in Britain in 1886 as a progressive anti-academic group committed to spontaneity and plein-air painting.

◪ Clausen; Sargent; Sickert; Steer

2

3

New Objectivity
See Neue Sachlichkeit

New Realism
Term applied to a diverse group of European artists working in the 1960s who used disposable everyday materials to create unusual-looking works with obscure but vaguely symbolic or mystical meanings.
🖿 Arman; Christo; Klein

New York School
See Abstract Expressionism

Non-objective art
See Abstract art

Norwich School
Important group of landscape and sea-scape painters based in Norfolk c.1805–25. Inspired by the flat Norfolk landscape, with big skies, and by the Dutch masters. They were brilliant watercolourists. 'Old Crome' was the School's principal founder.
🖿 Cotman; Crome

Nude, nudity
The unclothed human body. As man is God's highest creation, painting and sculpting the nude has traditionally been the highest aspiration for art. Nudity implies dignity; nakedness implies shame.

Objet d'art
Small decorative objects such as snuff boxes, scent bottles and figurines.

Objet trouvé
An object found by chance (such as a piece of wood or even a bicycle wheel), which an artist uses or displays for its aesthetic merit.
🖿 Duchamp; Nash (Paul); Schwitters

Ochre
A pigment made from clay. Ranges from pale yellow to reddish brown depending on the clay. The stuff you buy in tubes is a sort of dirty yellow.

Odalisque
From the Turkish word *odalik* (oda =

chamber; lik = function). An Oriental
female slave, usually half-naked and
reclining. Ingres and Matisse both
favoured the subject. Ingres' celebrated
Grande Odalisque annoyed the public
and the critics because they thought
the anatomy was wrong.
 Ingres; Matisse

Oeuvre
An artist's entire output.

Oil
The principal oil used in painting is
linseed oil, which is made from flax seeds.
It is slow-drying (can take days or weeks)
and can go yellow with age. Poppy oil is
also widely used.

Oil paint
Oil painting, in the sense known
today, developed in the 15th century and
became the dominant type of painting
in the 16th and 17th centuries. Among
the advantages of oil paints are their
flexibility, versatility, portability, strength
and rich appearance, and the fact that

they are most pleasurable to work with.
Oil paints are made by mixing powdered
pigments with oil.

Old master
Strictly speaking describes any artist from
the early Renaissance to roughly the mid
19th century. Popularly speaking describes
any such artist whose reputation has
stood the test of time, although
reassessments and rediscoveries do occur.
For example, Vermeer was rediscovered
at the end of the 19th century. George de
La Tour is currently being reassessed.

Oleograph
A special type of print made on a textured
surface that deliberately imitates the look
of an oil painting.

Omega Workshops
An avant-garde British enterprise (c.1913-
15) that produced modern furniture, pots,
screens, and so on. A brave attempt, but
the products were often rather shoddy.
 Bell; Fry; Grant; Lewis (P. Wyndham)

OMP
1) Old master picture.
2) Ordinary member of the public.

Op art (abbrev. of Optical art)
A type of abstract art that was in the forefront in the 1960s. Typified by hard-edge paintings, often in black-and-white, which bombard the eyes and cause them to 'see' colours or shapes that are not actually there. Can be disorientating and exhausting to look at. Suited the psyche-delic experiences and bright lifestyles of the 1960s.
☑ Poons; Vasarely

Optical mixture
See Divisionism

Organic
What is usually meant is that everything in a work of art hangs together, with nothing extraneous or irritatingly out of place.

Original print
A print where the artist originates the image to be printed – not a reproduction of an already existing painting.

Orphism
An early Parisian-based abstract art movement in which loosely painted areas of rainbow colours were the dominant theme.
☑ Delaunay; Kupka; Picabia

Orpiment
Brilliant lemon-yellow pigment. Poisonous.

Orthogonal
A line that works as perspective, apparently leading the eye from the surface of the picture towards its vanishing point.

Overpainting
Layers of paint applied over the initial layers once they have dried, so that the layers don't mix.

Paint
Paint consists of colouring matter dispersed in a binder. There are many types of colouring matter and binders, which produce anything from watercolours to oil paints.

Painterly
A picture painted in a painterly manner is one in which the artist has deliberately used the physical properties of paint. Thus for oils it might be intensity or subtlety of colour, thick impasto and juicy swirls; for watercolour it might be transparency and washes.
See also Handling

Palette
1) The flat surface on which artists lay out and mixes their paints. Traditionally it is oval in shape with a hole for the thumb.
2) The term also refers to the range of colours that an artist uses. Most artists establish a preferred and limited range, which they get to know well and which is very recognisable, for example Monet used rainbow colours, Rembrandt used earth colours.

Palette knife
A knife with a blunt flexible blade used for mixing paint and for scraping paint off or spreading it on a canvas.

Palladian
Gutsy classical style influenced by or imitating the architecture of the Venetian Andrea Palladio (1508–80). Much in fashion in Britain in the first half of the 18th century.

1

Panel
A firm support (such as wood, board or metal) on which a picture is painted. Canvas, even when tightly stretched, is not firm.

Panorama
A scene or landscape painted on a cylindrical surface. The viewer stands in the middle with a 360-degree view and hopes to have the illusion of a real open-air view.

Pantograph
A simple tool for enlarging or reducing drawings in size by tracing their outline. It looks like four rulers hinged together.

Paper
First made in China AD c.100 and in the West in the 13th century. Paper is made from cellulose fibres, beaten to a pulp, and spread out in a thin film and dried. The best paper is still made from linen rag. Cheap paper is made from wood pulp and soon discolours and goes brown (like newspaper).

Papier collé
French for 'pasted paper'. Pieces of paper prepared by the artist – not newspaper cuttings or similar, as used in collage – stuck down and incorporated into a painting.
See also Collage
🖿 Braque; Gris; Matisse

Papier mâché
French, litt. 'chewed paper'. Shredded paper mixed with a flour-and-water paste to form a pulp that can be shaped into 3-D objects. These are lightweight but firm when the mixture dries.

Paradigm
Example or pattern.

Parchment
The skin of an animal prepared as

a material for writing or painting.
Parchment is usually sheep or goat;
vellum is cow.

Parquet
Thin wooden strips attached to the back
of a warped wooden panel to straighten
and strengthen it. Not used now, as
current wisdom is that it does more harm
than good.

Passage
A small but distinctive part of a work
of art.

Pasteboard
A stiff support made by pasting layers
of paper together.

Pastel
Powdered pigment mixed with gum or
resin. It is applied directly on paper and
then often smudged and softened with
the fingers, producing soft, chalky tones.
Fragile and easily damaged.
🖿 Carriera; Degas

Pastiche
A work of art created in the manner of a
specific artist, not a copy of a known work.

Pastoral
A scene portraying the life of shepherds
and country people in an idealised way.
The general atmosphere is usually sunny,
fertile, peaceful, innocent and carefree.
The French painter Claude Lorraine
originated the pastoral landscape in the
mid 17th century.

Patina
The mellow tone and slightly worn look
that surfaces acquire with age, especially
metal and wood. Usually considered to be
attractive.

Patron
Somebody who commissions works
of art from living artists – and so often
influences the content or appearance
of the work.

Pedestal
The base on which a statue is placed.

Pendant
A painting designed to make a pair with,
or companion to, another.

Pensiero
Italian for 'thought'. A preliminary
drawing or sketch.

Pentimento
Italian for 'repentance'. A mark or
alteration made during the creation of
a painting that is subsequently painted
over but which can be seen or detected,
maybe as a ridge in the paint, maybe
because the top surface becomes
transparent with age, or perhaps
through infrared photography or X-rays.

Perceptual art
Any art that places importance
on engaging the eye by the visual
appearance and visual interest of a work.
Conceptual art is more concerned with
ideas than with engaging the eye.

Performance art
The 1970s follow-on to 1960s
'happenings'; same sort of thing but more
structured, theatrical and sometimes
even scripted. There is still a lot of it about.
🖿 Beuys; Hatoum; Kaprow; Klein;
Mathieu; Morris (Robert); Nauman

Perspective
The basic rules of linear or geometric
perspective were established in the

Renaissance and are: a fixed, single viewpoint with lines that meet at a vanishing point, so creating the illusion of 3-D space on a flat surface.

◪ Angelico; Bellotto; Canaletto; Christus; Estes; Piero della Francesca; Uccello

Phalanx

Influential group of Munich artists, lead by Kandinsky in 1901, who were opposed to the old-fashioned Academy and all conservative views, and who organised exhibitions and ran a Modern art school.

◪ Kirchner; Kandinsky; Munter

Philistine

Somebody with a complete lack of interest in art or culture of any sort.

Photography

The invention of photography had a profound impact on artists, and at once raised a host of practical and aesthetic issues – for example, hack portrait painters were put out of business. Progressive artists such as Degas openly welcomed photography's influence and uses; others used it and pretended they had not. Some tried to rival its meticulous accuracy; others sought to record sensations beyond the reach of photography (Impressionists). Whether photography was 'proper art' was hotly debated (and still is by some) – Ingres said it could never be. The earliest surviving photograph was taken in France in 1827. Daguerre established it as a serious medium in 1837.

◪ Degas; Ingres

Photogravure

A commercial printing process invented in the 19th century.

Photomontage

A technique of cutting up photographs, newspaper pieces or advertisements and combining them with drawings and lettering to produce striking, provocative or illogical images. The German artist John Heartfield produced powerful work commenting on the turmoil and ideological struggles in Germany and Eatern Europe between the two World Wars.

◪ Ernst; Grosz; Heartfield

Photorealism

Paintings that look like large colour photographs but are in fact meticulously executed paintings. They often take shiny, reflecting surfaces as their motif. Became a popular style in the 1970s.

◪ Estes

Pictograph, pictogram

A pictorial symbol representing an object or idea. Road signs are a good example; so are hieroglyphs.

2

Picture plane

When a picture acts as a window onto a real or imaginary world, the picture plane is the equivalent of the sheet of glass that divides the spectator's world from the world of the picture.

Picturesque

Today means little more than attractive or charming. In the 18th century it embraced serious ideas about what was beautiful in nature, usually involving irregularity, informality and a bit of wildness. These notions had considerable influence on 18th-century English landscape design.

Pigment

The colouring matter in paint. It does not dissolve in the liquid that carries it, such as oil or water. Colouring matter that does dissolve is called a stain or dye.

P., Pinx., Pinxit

Latin for 'he/she has painted it'. Found on prints to show who painted the original picture that has been copied in the print.

Plaquette

A small cast metal relief, or replica, of a small work of art, usually in bronze or lead, which is applied as decoration to another object such as a piece of furniture or stone vase. Can be made in multiple copies. The sculptural equivalent of a print.

Plastic arts

Strictly speaking, only those arts that involve moulding and modelling (such as sculpture made from clay). In practice, it often refers to all the visual arts.

Plasticity

1) Any material that is pliable, stretchable and durable, so that it can be modelled and moulded, has plasticity.
2) A drawing is said to have plasticity if it gives a convincing illusion of a 3-D form.

Plate mark

In printmaking, the indentation left on a sheet of paper by the pressure of a metal plate or wooden block carrying the print design.

Plein air

A painting begun and completed in the open air, or one that conveys the qualities and sensations of open-air painting. Boudin's plein-air spontaneity was

*It was as if a veil had been suddenly torn from my eyes. I understood.
I grasped what painting was capable of being.*
CLAUDE MONET *after seeing a painting by* EUGÈNE BOUDIN

genuine and greatly inluenced the young Monet.
🔳 Boudin; Constable; Corinth; Corot; Guthrie; Landseer; Monet; Rousseau (Théodore); Sargent; Zorn

Pochade
A small oil sketch made out of doors in one sitting.
🔳 Bonington; Constable; Corot

Pointillism
Divisionism as practised by Seurat, Signac and Camille Pissarro.
See Divisionism

Pointing machine
A machine perfected in the 19th century that enabled the dimensions of a small 3-D model (sometimes made by the sculptor) to be mechanically transferred to a larger block of stone so that an exact but bigger version could be carved either by the sculptor or by someone else.
🔳 Rodin

PC, Political correctness
'PC' seeks to change public (and private) language, to ensure that minority groups and the physical, mental, and socially 'challenged' are spoken about in a non-judgemental and non-emotive manner.

Polychrome
Many coloured. Used especially in reference to painted sculpture.

Polymer paints
Similar to acrylics.

Polyptych
An altarpiece made of more than three panels that are hinged together.

Pop art
Predominant movement of the 1950s and 1960s, especially in the USA and UK. Played about with the popular fetishes of the consumer society (such as advertisements, comics and well-known brand images like Coca Cola). Often used quick and inexpensive commercial art techniques. The US version used exclusively contemporary imagery; the UK version carries a heavy dose of nostalgia and whimsy.
🔳 Blake (Peter); Caulfield; Indiana; Johns; Jones; Lichtenstein; Rosenquist

Poppy oil
An oil extracted from poppy seeds. Similar to linseed oil, but thicker, and even slower to dry.
See also Oil

Portfolio
A case, usually big and flat, for carrying works of art on paper.

Portrait
A likeness of a person or an animal. What is like, and what is not, is of course where the arguments begin.

Poster paint
Inexpensive, brightly coloured gouache.
See Gouache

Post-human
The buzz phrase to describe subjects that focus on media or consumer obsessions and new technology (such as computers, genetic engineering) and their influence on the human body.

Post-Impressionism
Catchy phrase that doesn't mean very much, except that it includes all the more or less progressive artists from about 1885 to 1905. Can be used as widely or as

narrowly as you please. The four principal post-Impressionists, who did indeed start with Impressionism and then sought to develop a more formal or symbolic style, are Cézanne, Gauguin, Seurat and Van Gogh.

⚡ Cézanne; Gauguin; Seurat; Van Gogh

Post-Modernism
The triumph of style over substance. Art and architecture (but literally anything or anyone in fashion, politics, music, literature – you name it) of the 1980s and 1990s and now, with nothing much to say of real substance or meaning (although it might be claimed otherwise), presented in a very cool, self-conscious, stylish (and overdesigned?) manner. Not art for art's sake, but style for style's sake. 'Branding' and designer clothes are very post-modern, as are many dot.com companies and many Internet websites.

Post-painterly abstraction
Cult word for American large-scale, colourful, simple-design abstract painting in the 1960s, either hard-edge, or loose, or lyrical.

⚡ Frankenthaler; Kelly; Louis; Noland; Olitski; Stella (Frank)

Potboiler
A work of art produced merely to earn the necessities of life – or in the case of the already successful, just to make money.

Pouncing
Pricking small holes in the drawn outlines of a cartoon. You can then transfer the design to another surface by sprinkling the cartoon with fine soot so that it falls through the holes and leaves a mark.

Precisionists
Group of American artists prominent in the 1920s and 1930s whose theme was modern industry and urban landscapes, portrayed in an idealised and romantic way with acute observation and a smooth, precise technique.

⚡ Demuth; Sheeler

1

Predella
In an altarpiece, the strip of small-size paintings set in the frame at the bottom of the main painting. They are usually narrative scenes related to the subject of the main painting.

Pre-Raphaelites
Small and influential group of young British artists who came together in 1848 and aimed to challenge conventional views by championing the artists who came before Raphael. Produced intense, detailed paintings with deeply meaning-ful or symbolic subject matter (often spiritual or religious) in bright colours and with painstaking technique. William Holman Hunt was the most serious and dedicated of the Pre-Raphaelites, and one of the most respected artists of the Victorian era.
☑ Hunt; Millais; Rossetti; Ruskin

Primary colours
Red, yellow and blue. In theory all other colours can be made from them – but coloured pigments and coloured lights can and do behave differently.

Primer
A primer is applied to a support to isolate the support from the ground and the final paint surface. Without a primer, raw canvas or raw wood would simply absorb the paint and/or react chemically with it, thereby making the artist's task impossible or even destroying it – unless, of course, the artist wants the effect of the paint being absorbed by (therefore staining) raw canvas or wood.
See also Ground; Sinking in; Support

Primitive art
Old-fashioned and politically incorrect way of describing the early or traditional art of societies, such as African tribes and the Inuits. In fact, most of it is highly sophisticated, if properly understood.
See also Naïve art

Print
The image made by pressing an inked or painted surface onto a piece of paper.

Problematic
Useful word and concept currently much used by critics and commentators, especially in the USA. Can mean there is a genuine problem that is worth discussing. More often it is a polite and coded way of saying 'meaningless'. If you find a work of art or someone's point of view incomprehensible or futile, don't admit defeat or tell the truth. Look serious and describe it as 'problematic'.

Profil perdu
French, litt. 'lost profile'. A head that is turned away so that the back of the head, together with the outline of the cheek and chin, can be seen – the rest of the profile being lost from view.

Proof
A trial print. It allows the artist and the printmaker to see what is happening. They can then make adjustments before arriving at the final version from which the print run will be made.

Provenance
The pedigree of a work of art – a list of who owned it and when.

Pure colour
Colour used straight from the tube without mixing.

Purism
Fashionable Parisian art movement of the 1920s. Used Cubist ideas to produce

figurative art (lots of still lifes) that was supposedly pure in design, form and colour. Most of it was rather boring and forgettable.

PVA
Polyvinyl acetate – man-made resin used as a paint medium and in varnishes and adhesives.

Quadratura
A painting on a ceiling or wall that gives the illusion of extending the real space of a room. Often includes illusionistic details or extensions of the architecture, such as columns.

Quadro riportato
Italian, litt. 'carried picture'. A picture painted on a ceiling to look as if it were an easel painting hung overhead.

Quattrocento
Italian for 15th century (1400–99).

RA
Full member of the Royal Academy, London. There are 40 at any one time; they have to give the Royal Academy a work that they have produced.
See also Royal Academy

Rayonism
Avant-garde Russian movement c.1913, which came near to abstraction, whose subject was light and rays of light.
🗹 Goncharova; Larionov

Ready-made
A mass produced object taken by an artist and turned into his/her own 'creation' by the addition of a signature or some other small alteration. The most famous ready-made is Duchamp's urinal,

which he called 'Fountain' and exhibited as a work of art in 1917.
See also Objet trouvé

Realism
1) Every generation seems to define realism in its own way. For example, Renaissance artists thought their art was real because they opened a 'window on the world', showing 3-D space and human emotion with an accuracy and intensity not seen before. On the other hand, some modern abstract painters thought they were more real by showing the reality that a picture is just paint on a flat surface. At the moment, some contemporary artists regard themselves as realists because they confront current social, green or gender issues… and so on.
2) Realism with a capital 'R' was the progressive movement in art and literature in the mid 19th century (especially in France) that was concerned with social realities, and showing fact rather than ideals and aesthetics. The early novels of Zola are a good example.
🗹 Courbet

Recession
The illusion of depth in a picture.
See also Aerial perspective; Perspective

Red chalk
See Sanguine

Reformation
Sixteenth-century religious movement that sought to modify Roman Catholic doctrine and practice. It led directly to the establishment of the Protestant churches.

Regency
See Empire style

Regionalism
American movement of the 1930s that was the first expression of a consciously independent American art. Its vision was a real American art, springing from American soil and seeking to interpret American life.
🖾 Benton; Curry; Wood

Relief
From the Italian *rilevare*, 'to raise'. Sculpture carved from a flat or curved surface so that part of the image projects. If the image projects slightly, it is known as bas relief (low relief). It it projects more boldly, it is known as alto rilievo (high relief).

Relief print
A print made from a block or plate in which the area not to be printed is cut away, leaving the part to be inked standing in relief.
🖾 Wood engraving; Woodcut

Relining
The process by which a damaged canvas is stuck down on a new one.

Remarque proof
A trial print on which an artist has written or drawn instructions as notes for what to do next.
🖾 Proof

Renaissance
French, litt. 'rebirth'. The flowering of new ideas in Italian art between 1300 and 1550, which has influenced the subsequent development of all Western art. The three key ideas that developed during the Renaissance with increasing sophistication were:
1) The work of art as a window on the world – the illusion of looking at space, light, the human figure or landscape.
2) Man as the measure of all things – human scale, proportion, emotion, ideals or spirituality as the central theme and yardstick for art.
3) Reverence for Christianity, the Bible and classical antiquity – the interpretation of the Christian message by illustrating the Old and New Testaments, and the adaptation and use of classical (Greek and Roman) ideas, literature and images.

Replica
In art-collecting terminology, a copy of a picture or sculpture, made by the artist himself.

Repoussoir
From the French *repousser*, 'to push back'. A figure or object in a painting that directs the eye to the main point of interest. Same as coulisse. *See* Coulisse

Representational art
Art that depicts recognisable objects and figures, although they may not necessarily be true to life.

Reproduction
A copy of a picture or print made by mechanical means, such as photography.

1

Reredos
The decorated screen behind an altar.
It is usually sculpted, sometimes painted,
and can take the form of a tapestry or
hanging or decorative metalwork.

Resin
The main ingredient of varnish. Natural
resins come from trees and plants.

Resist
Something applied to a surface to
prevent the penetration of liquids.
Usually a varnish, or a similar coating,
or masking tape.

Restoration
Repairing a work of art that has become
damaged through accident, decay or
neglect. The ethics of restoration are as
complicated as medical ethics. How
much transplanting, patching-up and
cleaning can occur before the object dies
aesthetically or becomes unrecognisable?
Best motto: if in doubt, leave well alone,
because once it is dead or ruined there is
nothing you can do. A terrifying number
of paintings have been ruined by over-
cleaning in the last 50 years, and as yet no
one has properly faced up to the fact. The
Mona Lisa had eyebrows – until an unwise
early restorer accidentally removed them.

Retable
An altarpiece of one or more fixed (not
hinged) framed panels.

Retardant
A medium that slows down the rate at
which paint dries.

Retardataire
From the French *retard*, 'delay'. Not up
to date.

1

Retinal painting

Another name for Op art.
See Op art

Retouching

Repainting very small areas of a picture that have become damaged.

Retro

An object made with current-day materials or technology. Its external appearance is stylised to make it appear as an authentic product of another era (especially the 1930s or 1940s); for instance, a transistor radio in a case that makes it look to be a 1930s wireless.

Retrospective

An exhibition that shows a comprehensive selection of an artist's works covering his or her whole life, or a particular period. Can make or break the artist's reputation or spirit: works that are incomprehensible or neglected when seen in isolation can blossom when seen in their full context; works that looked wonderful on their own can suddenly seem boringly repetitive when shown together. Picasso would not allow retrospectives, arguing that the only thing that mattered was what he was doing now.

Men of genius are not created by new ideas, but by an idea that possesses them...
One must be bold to extremity; without daring, and even extreme daring, there is no beauty.
EUGÈNE DELACROIX

Rocaille

A decorative motif using shells and rocks, or shell-like swirls and curls.

Rococo

The predominant style of the first half of the 18th century. Look for curves, pretty colours, playfulness, youth, elegance, fine craftsmanship, extravagance, carefree attitudes, and references to real and fanciful nature (flowers, leaves, rocks, birds, monkeys or dragons). Reached its fullest expression in 18th-century France (it is the Louis XV style) and central Europe (Bohemia). It pervaded all the visual arts: architecture, painting, furniture, porcelain, and so on. François Boucher, the protégé of Louis XV's mistress, Madame de Pompadour, produced Rococo's most sumptuous and decorative masterpieces.
◪ Boucher; Gainsborough; Guardi; Tiepolo; Watteau

Romanesque

The main style of Christian Europe in the 11th and 12th centuries, seen mostly in architecture and recognisable by thick walls, small windows and rounded arches. Look also for wall paintings, tapestries (such as the Bayeux tapestry), stained glass and illuminated manuscripts.

Romanists

A group of Flemish painters who went to Italy in the early 16th century and were influenced by the contemporary Italian art they saw there.
◪ Gossaert

Romanticism

The movement in art, music and literature in the late 18th and early 19th centuries that produced some of the greatest and best-loved works of art of all time. The Romantics believed in new experiences, individuality, innovation, risk-taking, heroism, freedom of imagination, love, and living life to the full. In painting and sculpture look for new and dramatic subjects, innovative styles and techniques, rich and vigorous colours and brushwork, and a tendency to see and experience everything as larger than life. Appealed particularly to the Northern European temperament and flourished in Germany, Britain and France. Delacroix is arguably the greatest French painter of the Romantic movement. His well-known painting of Liberty Leading the People is a key Romantic image, celebrating the uprising in Paris in 1830, which Delacroix himself witnessed at first hand.
◪ Constable; Delacroix; Friedrich; Géricault; Turner

Royal Academy

Prestigious organisation founded in London in 1768 to promote high standards in art, to run an art school, and to exhibit work by artists, both living and dead. Very successful in promoting British art in the 18th and 19th centuries. Privately funded and therefore never an instrument of state control. In the 20th century it gained

2

(rightly) a reputation for stuffiness and for being anti-modern, but it is now becoming more up to date.

⚐ Reynolds

Ruperstain

Paintings and drawings on rock walls, e.g. the cave paintings at Lascaux.

Sacra Conversazione

The Madonna and child surrounded by saints. They are all in a single space and aware of each other, though not necessarily communicating with each other. Much exploited in Venetian Renaissance art.

⚐ Mantegna; Bellini; Fra Angelico; Filippo Lippi

Salon

The French official annual public art exhibition, controlled by the Académie. Immensely influential, especially in the 19th century, when it was the bastion of conservative attitudes.

⚐ Academies; Impressionism

Salon d'Automne

Annual autumn exhibition of contemporary art in Paris. Much used by early pioneers of Modern art as a means of showing their work.

⚐ Bonnard; Marquet; Matisse; Rouault

Salon des Indépendants

Annual spring show of contemporary art in Paris. It is open to all comers, with no selection by a jury. Much used by early pioneers of Modern art as a mean of getting their work seen by the public.

⚐ Matisse; Redon; Seurat; Signac

Salon des Refusés

The exhibition held in Paris in 1863 that showed work by artists who had been turned down by the official Salon. One of

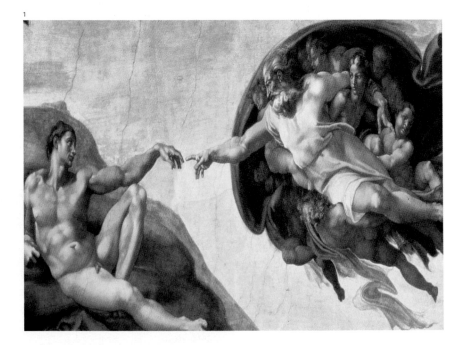

1

2

the key events in late-19th-century art.
 Cézanne; Courbet; Fantin-Latour; Manet; Pissarro (Camille); Whistler

Sanguine
Red chalk. Used finely it can produce exquisite small drawings. Michelangelo achieved a mastery of the medium, which was not seen again until the early 18th century, in France.
 Michelangelo; Rubens; Watteau

Sarcophagus
Stone coffin (Roman, Egyptian etc.), often decorated with relief sculpture.

Saturation
The degree of intensity of a colour.

Schema
A very basic diagrammatic drawing, such as an egg shape to indicate a head.

School
Group of artists whose work shows some similarities. A useful, but often very imprecise, term.

School of Fontainebleau
Group of 16th-century Italian, French and Flemish painters who decorated the Palace of Fontainebleau for Henri IV.
 dell'Abate

School of Paris
A useful term embracing the various artists, schools and movements who pioneered new ideas in Paris in the first half of the 20th century.

Scottish Colourists
Four progresssive Scottish painters who were active before 1914, producing high-quality work in bright colours with simplified stylisation that was much influenced by French Fauvism. Peploe spent several years in Paris, and was among the first to put modern French ideas into practice in Britain.
 Cadell; Fergusson; Hunter; Peploe

Sculp., sculpsit, sc., sculpebat
Latin for 'he cut it' or 'he carved it'. Found on prints to indicate the name of the person who made the plate or block. Sometimes found on sculpture to indicate an original carving, not a cast.

Sculpture
Three-dimensional work of art made by carving, modelling or constructing. Like a picture, it has no useful function in itself.

Scumble
A thin layer of oil paint dragged over a bottom layer of paint in such a way that the scumble breaks up, allowing the bottom layer to show through.

Seascape
A picture that takes the sea as its subject. If the subject is ships, it is called a marine painting.

1

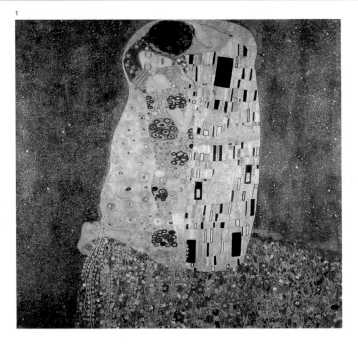

Secondary colours
The colours produced by mixing primary colours: blue + yellow = green; yellow + red = orange; blue + red = purple.

Secular
Belonging to the everyday world, not to the spiritual or religious world.

Seicento
Italian for 17th century (1600–99).

Semantics
The study of the meaning of words.

Semiotics
The study and interpretation of signs and the way they signal an underlying state of affairs, attitudes, observations, ideas and actions. A simple example is the way we all understand and react to the convention that a red traffic light means stop and a green one go.

Sepia
Brown pigment used for ink and watercolour. It comes from an octopus or cuttlefish, and fades easily.

Serigraphy
General term for the art of silkscreen printing.
See Silkscreen printing

Settecento
Italian for 18th century (1700–99).

Sezession
Groups of progressive German and Austrian artists who challenged the ideas and authority of the academies in the 1890s. In Vienna, Gustav Klimt, a leading member of the Sezession, explored the themes of love and sexuality, which obsessed both the conservatives and the radical modernisers.
◪ Klimt; Schiele

Sfumato
Soft outlines and a smooth, smoky transition between areas of colour.
🖼 Leonardo

Sgraffito
See Graffiti

Siccative
1) Adjective; means that it will dry – linseed oil is siccative, olive oil is not.
2) Noun; means a drying agent – something added to oil to speed up the rate at which it dries.

Significant form
The idea that beauty in a work of art lies solely in colour, composition and line. It was influential in early-20th-century English art and helped to develop abstract art.

Silhouette
Black paper cutout of the profile of a face, invented by a French Minister of finance called M. de Silhouette in the 18th century.

2

Silkscreen printing (or serigraphy)
A printmaking method in which ink or paint is squeezed through a fine mesh screen, usually made of silk, on which the design has been made. Invented c.1900 and used widely by modern artists, especially those with an eye for bold designs and bright colours.
🖼 Warhol

Silverpoint
A method of drawing using an instrument with a fine silver tip, which makes a fine grey line on specially prepared paper.
🖼 Dürer; Leonardo

Simile
In art, more or less the same as metaphor and allegory.
See also Allegory

Simulacrum
An illusionary image that is so effective that it supplants reality.

Simultaneous contrast
The effect whereby if you project a white light onto a screen already illuminated with a light in one of the primary colours, the white light will appear in that colour's complementary colour. For instance, if you project a white light onto a screen already illuminated with a blue light, the white light will appear orange.

Sinking in
This happens when oil is absorbed from paints into the ground – the canvas, for instance. It leaves the paint looking dry and dull.

Sinopia (pl. sinopie)
The underdrawing for a fresco; it is usually made in red ochre.

1

Size
Gelatine or animal skin glue – when melted and made into a solution it can be painted onto a surface to make it waterproof and suitable for painting on.
See also Distemper

Sketch
A rapidly executed work in any medium. Used by artists to sort out general ideas for a painting (or sculpture), or to note the essential features of it.
◪ Constable

Social realism
Describes works of art showing every day life, often its harsher aspects. In the 19th-century social realist pictures showed the labouring classes, prostitutes, sickness, death or adultery, painted in photographic detail. Today they are conceptual works addressing such issues as AIDS, gender, race, feminism, sexuality, anxiety and loneliness. In the 1850s and 1860s Ford Madox Brown addressed the issues of forced emigration from the UK, inspired by the departure for Australia of his sculptor friend, Thomas Woolner.
See also YBAs

Socialist Realism
The official art of the Communist dictatorship of the Soviet Union, mostly heroic portrayals of the Party faithful and ardent workers. Copied in other hard-line communist countries, such as Mao's China and Castro's Cuba.

Soft-ground etching
A type of etching producing an effect that looks like a pencil or chalk drawing. Complex technique and rare.
See Etching

Soft sculpture
Sculpture made from soft materials such as cloth, fur or felt.

Sopra porte
From the Italian, litt. 'over the doors'. Paintings made to go in the space above doorways – often landscapes or still lifes.

Sotto in su
Latin for 'from below upwards' – an illusionistic effect so that when you look up at figures painted on a ceiling they appear to float in space.
◪ Correggio; Mantegna; Tiepolo; Veronese

Soviet Realism
See Socialist Realism

Spatter
Paint flicked off the end of a brush.

Sprezzatura
From the Italian, meaning 'nonchalance', 'ease'. The ability to do things with speed and ease.

Squaring up

A reliable way of transferring a drawing accurately onto a larger surface. You draw a grid of squares over the drawing, and an equivalent grid with the same number of squares over the larger surface. Copy the contents of each square of the drawing into the equivalent square on the larger – and, hey presto, it works.
▰ Robinson; Sickert

Squeegee

A rubber blade or roller used for pressing the ink through a silkscreen to make prints.
▰ Silkscreen

Staffage

People or animals in a landscape that are incidental to the general theme or view but add scale or a bit of human interest, act as repoussoir, or help the perspective.
See Repoussoir

State

When working on a print, artists will often take an impression to see what is happening and help them decide what to do next. Each such impression is called a 'state' and may carry a number. Dedicated print collectors love them because they are rare and show how the artist arrived at the final state, which is the one that is printed in quantity.

Steel engraving

An engraved or etched copper plate that has been faced with steel by electro-plating to make it harder and therefore able to produce more impressions. Some of the softness and subtlety of the image is lost in the process.

De Stijl

Dutch for 'the style'. The most influential avant-garde art magazine in the 1920s, founded and promoted by a group of Dutch artists (it is also the name of their movement). Advocated a geometrical

2

1

2

type of abstract art, simplification, social and spiritual form.
Mondrian

Still life
A depiction of inanimate objects such as fruit, flowers, jugs, plates, bottles, or dead birds or animals. Seventeenth-century Holland liked lavish still lifes (and Jan Davidsz de Heem excelled at it). Simple ones were favoured in the Enlightenment. The pioneers of Modern art used them to break new ground in ways of seeing. The only Perceptual art subject that can be prearranged and (almost) totally controlled by the artist.
Cézanne; Chardin; de Heem

Stipple engraving
Ingenious marriage of engraving and etching techniques, which produces a print that looks like a chalk drawing. Much used in the 18th century for portraits.

Stippling
Small dots or strokes applied in differing densities to create areas of tone or of light and shade.

Street art
Works of art in public places, such as murals on buildings, graffiti, pavement art and 'happenings'.
See also Happening

Stretcher
The wooden frame over which canvas is stretched to make a surface for painting. Never forget to look at the backs of paintings – sometimes they are more interesting than the front, and the labels attached to stretchers can tell a history in themselves.

Structuralism
Buzz word for the study of the meaning of signs. Used to be called 'iconology'.

Studio of . . .
Describes a work made by the assistants in a master's studio. Looks as though it has been created by the master, but it has not and usually appears a bit mechanical, tired or overfamiliar.
See also Attribution; By . . .; Follower of . . .; Manner of . . .; Studio of . . .

Study
A preliminary drawing or painting made before going on to the final version, but worked out in considerable detail.

Sturm, Der
German for 'the storm'. Name of a magazine and art galllery in Berlin, which was a major influence in promoting German and foreign modern art in Germany between 1912 and 1932.

Style
A distinctive way of doing things, which can be analysed and its unique combination of characteristics identified. To be one of the memorable greats you need a style that is new, instantly recognisable, technically accomplished, easy to describe in words, and easy for the public and other professionals to mimic.

Style of . . .
In the same style as a particular artist, but not by that person.
See also Attribution; By. . . ; Follower of . . .; Manner of . . .; Studio of . . .

Subject, subject matter
The theme(s) of a work of art. An artist may be seeking to show ideas or issues that are wider or deeper than the actual objects and figures represented.

Sublime
A feeling of grandeur or awe induced by a work of art or nature – an aesthetic concept much discussed in the 18th century, reaching its fullest expression in the late 18th and early 19th centuries. Someone standing on a mountain top and gazing into a ravine that has a powerful waterfall, while storm clouds gather overhead, is a typical example and one much used in art. Turner lusted after sublime experiences, in both life and art.
◪ Friedrich; Martin; Turner

Successive contrast
Take a brightly coloured sheet of paper in a primary colour (red, for example). Stare at it for a minute, then look at a white wall. You will 'see' a ghost-like image of the sheet of paper in its complementary colour (green in this case). This automatic creation in the mind's eye of the complementary colour is called successive contrast.

Superrealism
See Photorealism

Support
A painting needs a support, which may be canvas, a wood panel, a copper sheet, paper, etc. The artist needs to prepare the support by painting onto it a primer, and then a ground, to create a suitable smooth surface on which the picture can be painted.
See also Ground; Primer

Suprematism
Russian avant-garde movement, pre-World War 1, that strove to create a new spiritual awareness by developing an abstract art based on simplified geometric form, simple colour and floating spatial relationships, unlike anything found in the material world.
◪ Lissitsky; Malevich

Surrealism
The leading avant-garde movement of the 1930s. It sought to reach a new 'super reality' by defying logic and accessing the unconscious (it was strongly influenced by Freud's theories). Used almost every artistic style from abstraction to realism. Magritte turned reality on its head by confounding normal experiences, but in a way that was more poetic than schocking.
◪ Arp; Dali; Delvaux; Ernst; Magritte; Man Ray; Masson; Matta; Miró; Tanguy

1

Symbolism

Started as a progressive movement in 19th-century French poetry (Rimbaud, Baudelaire, Mallarmé, Verlaine), which influenced a number of painters interested in the mystical and spiritual. Look for strange, enigmatic and allegorical subjects designed to play on the emotions and come close to the power of dreams. Gustave Moreau's forte was in erudite, imaginative, literary subjects, which ooze decadence – his studio later became a place of pilgrimage for the Surrealists.
🖾 Ensor; Moreau; Puvis de Chavannes; Redon

Synaesthesia

The rare ability to experience colour sensations as a physical (as opposed to an imaginative) experience when other senses such as taste and hearing are stimulated.
🖾 Kandinsky

Synchronism

American version of Orphism.
🖾 Macdonald-Wright; Russell

Synthesis

Bringing two or more separate things or ideas together to create another, different, one.

Synthetism

See Cloisonism

2

in short strokes so covering a large area is painstakingly slow. The favoured medium in early-Renaissance Italy until replaced by oil paint. Still used occasionally.
⚑ Clemente; Ghirlandaio; Michelangelo; Piero della Francesca; Wyeth

Tenebrism
A style of painting with bright lights and dark shadows as practised by Caravaggio and his Spanish and Neopolitan followers. Same sort of thing as chiaroscuro. Spanish-born José de Ribera, who settled in Naples, used dramatic lighting to emphasize his deliberate realism.
See also Chiaroscuro
⚑ Caravaggio; Ribera; Zurbarán

Term
See Herm

Terribilità
Italian for 'awe'. A sense of awe and foreboding about the human condition – in particular its essentially tragic nature, its unpredictability, the inevitability of pain and suffering, and the certainty of God's final judgement.
⚑ Michelangelo

Tertiary colours
The result of mixing a primary and a secondary colour (such as red and green) or two secondary colours (such as green and orange). The latter, in particular, results in muddy colours – browns, greys and blacks.

Tesserae (sing. tessera)
The small pieces of material used to make a mosaic.

Thumbnail sketch
A small, rapidly executed sketch that captures all the essential features of the subject.

Synthetic Cubism
The works done by Picasso, Braque and Gris c.1912–15, featuring fragments of newspapers, tickets, and so on, incorporated into paintings.

Tableau vivant
French, litt. 'living painting'. A depiction of a scene by silent and motionless costumed participants. Many old-master paintings can be turned into *tableaux vivants*.

Tachisme
From the French *tâche* for 'patch' or 'spot'. Group of postwar French painters, contemporary with the Abstract Expressionists, who produced freely painted abstract pictures. Interesting, but not major.
⚑ Mathieu; Soulages

Tempera
Emulsion made of powder pigments bound together with egg yolk and thinned with water. Very quick-drying, tough and permanent. Has to be applied

1

Tint

The variation in a colour made by mixing it with another.

Titanium white

White pigment with the purest whiteness and best opacity. Perfected in the 1920s and now the largest selling pigment.

Tondo

Italian, meaning 'round'. A circular painting or relief sculpture.

Tone

The lightness or darkness of a colour. Also described by referring to the lightness, value, intensity or brilliance of a colour.

Tooth

The degree of roughness of a painting support (such as paper or canvas).

Topography

The detailed depiction of an actual place. R. P. Bonington excelled at it, and produced luminous and detailed watercolours and oils of picturesque places such as Verona.

Transavanguardia

Italian movement of the late 1970s that sought to re-establish so-called traditional artistic priorities, such as expressive painting, colour, figuration and individuality. More a reaction against the anonymity of Minimalism than a coherent agenda for something.
◪ Clemente; Paladino

Trecento

Italian for 14th century (1300–99).

Trompe l'oeil

French, litt. 'deceives the eye'. A trompe-l'oeil painting is designed to trick viewers into thinking that what they see is the real thing.

Turpentine

Strong-smelling, quick-drying, thin liquid made from pine resin, used for diluting oil paints.

Ukiyo-e

Popular Japanese paintings and wood-block prints made in the 17th, 18th and 19th centuries. Decorative and brightly

coloured with strong designs, they portray courtesans, landscapes, animals and birds, narrative scenes etc. Ukiyo-e means 'floating world', but for some reason no Western writer seems able to explain convincingly the idea it enshrines. Hiroshige, one of the masters of Ukiyo-e, is noted for his poetic reverence of nature, and his deftness in expressing the effects of mist, rain and snow.

⚐ Hiroshige; Hokusai; Utamaro

Umber

A dark brown earth pigment. Raw umber is dark yellow-brown; burnt umber is dark reddish-brown.

Umbrian School

Italian artists who worked in and around Perugia in the 15th and 16th centuries.

⚐ Piero della Francesca; Raphael; Signorelli

Underpainting

Complete detailed design for a picture made in a dull monochrome then painted over to make the finished work.

Ut pictura poesis

Latin saying expressing the idea that paintings can fulfil the function of written texts, especially poetic and lyrical ones.

Utrecht School

A group of 17th-century Dutch artists who visited Rome and were strongly influenced by the works of Caravaggio. The leading member of the Utrecht School was Gerrit van Honthorst, who is especially known for his striking use of artificial light.

⚐ Honthorst; Terbrugghen

Value, colour value

The lightness or darkness of a colour: low value is dark; high value is bright.

Vanishing point

See Perspective

Vanitas

A still life containing symbolic references (such as skulls or extinguished candles) to death and the transitory nature of life.

2

1

2

Variant
A copy that is slightly different from the original.

Varnish
A hard-drying transparent protective substance, which is painted onto the surface of a painting to protect that surface and give the colours a unity of texture and appearance. Varnish is suitable for paintings on a panel or canvas, but it tends to make the pictures go darker with age.

Varnishing day
See Vernissage

Veduta
Italian, from *vedere*, 'to view'. A more-or-less accurate view of a town or city. The 18th-century artists who painted them were called *vedutisti*.
▨ Bellotto; Canaletto; Piranesi

Vehicle
The liquid that binds pigments together to make paint; oil, for instance.

Vellum
fine parchment made from the skin of a calf. (Same derivation as 'veal').

Verdigris
1) A poisonous, green or greenish-blue pigment made from copper; it is fugitive and eventually goes dark brown. First used by the ancient Greeks (it comes from *vert de Grèce*, green from Greece).
2) The greenish or bluish patina that forms on copper, brass and bronze.

Vermilion
Bright-red pigment made from mercury and sulphur. First made by the ancient Greeks.

Vernissage
French word for 'varnishing day'. This was the day before an exhibition opened, when artists added the finishing touches or final varnish to their work, which was already hanging on the wall. Nowadays *vernissage* is simply a chic name for private viewing.

Video art
A work of art made to be viewed on one or more television screens installed in a gallery. Claims to investigate and use the artistic possibilities of the medium – the unique colour, brightness and movement that television has. It

usually has no narrative or documentary content and so is utterly different from what you see on television at home.

Hatoum; Hirst; McQueen; Mori; Paik; Viola; Wilson (Jane and Louise)

Vignette
Either a small, usually figurative, design, such as a portrait or a still life, without a border and shading off at the edges, or a scene describing a brief, often domestic, narrative incident. Originally it meant a design of vine leaves and tendrils.

Vingt, Les
Influential avant-garde Belgian group of the 1880s who showed their own work alongside most of the progressive French artists from Manet onwards.

Ensor

Viridian
A bright-green chrome-based pigment, non-poisonous, introduced in the early 19th century.

Vorticism
Avant-garde British art movement, 1913–15. Took up Cubist and Futurist ideas and aimed to shake up the stuffy British art world and society generally.

Bomberg; Lewis (P. Wyndham); Nevinson; Roberts

Wash
Very watery watercolour or ink flooded onto paper from a brush to cover a large area. Ruskin used watercolour wash with great effect to capture the texture of architectural brick- and stonework, as well as light and atmosphere.

Watercolour
Any type of painting medium soluble in water is, technically, watercolour. What is

usually meant, however, are those works on paper with thin washes of transparent watercolour paint that the English find so appealing. The technique is fiendishly difficult. Notice how the greatest masters have the ability to combine luminous atmospheric effects and minute detail in the same work; for some reason no other medium can do this so successfully. Thomas Girtin was a genuine innovator, and potentially one of the greatest watercolour masters, but he died of consumption at the age of 27.

Cézanne; Girtin; Turner

Wet into wet
Painting wet paint into wet paint. In oils, this produces a very luscious, juicy result.

Manet; Ribera; Sargent; Velasquez

White lead
The most important pigment in the history of Western painting. The only white pigment available until the 19th century, made from lead strips. It absorbs X-rays and so allows X-ray photography to reveal what goes on under the visible surface of a painting.

White spirit
A turpentine substitute.

Wood engraving
A printmaking process that uses a block of very hard fine-grained wood, such as box. Look for small-scale works in black-and-white, which have minute and fine detail.

Woodblock print
Usually refers to Japanese woodcuts.

Woodcut
One of the most basic printing techniques, whereby the design to be printed is cut into a block of wood. Most

1

15th- and 16th- century prints, especially for book illustration, use the technique. It was replaced by metal engraving and then revived at the end of the 19th century. No one has ever surpassed the mastery of Dürer.

Cranach; Dürer; Gauguin; Holbein; Kollwitz; Munch; Schad; Schmidt-Rottluf

Workshop of . . .
See Studio of . . .

W.P.A.
Stands for Works Progress Administration, an American government scheme to give employment to artists during the 1930s Depression. Involved all the arts and sponsored 100,000 paintings, 2,500 murals and 2 million posters.

X-ray
A standard conservation and restoration technique. Because underpainting is often done with paints mixed with white lead, X-ray photographs will show what went on under the surface of a surface (since X-rays don't pass through lead). *See also* White lead

Xylography
Rarely used word for woodcut or wood engraving.

YBAs
Young British Artists. Band of so-called 'cutting-edge' artists who captured an international following in the 1990s, when they were mostly aged around 30. Many trained at Goldsmiths College, London. Work is mostly Conceptual. Themes tend to be current social issues. Very efficient at 'making art' but curiously passionless. They appeal to the new breed of contemporary public curators who are inclined to equate good curatorship with efficient corporate management. Behave as though art is a profession to be trained for (rather like accountancy). Risk turning art into a branch of State Approved Social Services.
See also Social realism

Hirst; Ofili; Whiteread

Yellowing
Oil paintings can darken or yellow with age. Yellowing is caused by old linseed oil or by dirt or by smoke (nicotine leaves a yellow deposit), or a combination of these.

Ziggurat
Ancient Mesopotamian pyramid-shaped tower with a square base.

Zinc white
An alternative pigment to white lead. It is not poisonous and is the least opaque of all white pigments.

ART ON THE INTERNET

List of illustrations

Index

ART ON THE INTERNET

What follows is a selection of sites that present, at the time of writing, some of the best information about art and artists on the Internet.

REFERENCE BOOKS AND PORTALS

One of the great strengths of the web is its ability to make quick searches of vast reference books. The Encyclopaedia Britannica is a good example of such a work that now resides entirely online [www.eb.com]. Publications such as the Dictionary of National Biography and the Oxford English Dictionary are being made gradually available online as new editions are compiled – again, they go together well with the capabilities of the web. Examples of the way an extremely effective search can be made across a number of dictionaries and encyclopaedias can be found at xrefer.com, and dictionary.com.

A 'portal' is a doorway into the web, having either a search facility or links to sites selected for relevance or quality – well-constructed portals are invaluable for finding what, if anything, is worth finding.

groveart.com

The Grove Dictionary of Art Online – a subscriber site offering one of the most valuable web resources for anyone interested in art. Powerful search facility of over 45,000 articles, written by leading art historians from around the world. Each article is thoroughly cross-referenced, with maps, charts and diagrams and external image links via a partnership with the Bridgeman Art Library. Also partnered with The Art Newspaper, and ArtNet (see page 445); a heavyweight triumvirate.

artcyclopedia.com

Canadian fine arts portal – comprehensive coverage of art and artists, focusing on European painting and sculpture. Searches give links to museums and art galleries where works can be seen, as well as image archives and other resources such as articles. Lists of galleries worldwide with websites, and a 'Current Art and Cultural Headline' listing that is updated regularly enough to be of use.

newmedia-arts.org

New Media Encyclopaedia site produced by leading museums in Paris (Centre Pompidou), Cologne, Geneva and Brussels; funded by the French Government

and the European Commission, comprising a trilingual catalogue of new media art (videos, films, computers etc.), with helpful glossary, chronology and bibliography. Also features many video clips. Site currently under construction, should be an impressive resource when up to pace.

artincontext.org
New York-based index of museums, galleries, dealers, artists and exhibitions. Find out where artists have shown and where you can buy their work. Lots of contact details, but unfortunately incomplete archives.

the-artists.org
Well-designed portal site for 20th-century and contemporary visual artists. Photographic portraits of artists are followed by well-selected links to web resources – although short, these lists are invariably helpful. Commercial arm links to online auctions, book and poster sales.

axis.org.uk
'The essential showcase for contemporary British visual artists'.
An Arts Council initiative, Axis is a growing register of contemporary British artists and craftsmen, with images, information, CVs and prices of works by around 3,000 artists. It is open to professional artists, and thus tends to promote reliable, marketable work. The site also hosts virtual exhibitions that, like the majority of online displays, are virtually interesting. Axis is a popular resource for all manner of dealers, arts management, gallerists and arts officers, and is an especially good place to pick up young meteors from the recent graduate directory.

artsjournal.com
'The Daily Digest of Arts & Cultural Journalism', based in Seattle. Links to arts stories from more than 180 English-language arts publications, available by topic and through an issue-based news archive. Publishes the 'Arts Beat' column, a compilation of the previous week's sportiest stories, available free as an email and delivered every Sunday evening.

cornucopia.org
British government-run portal to museum collections in the UK. Currently only a pilot site with information on about 50 museums, which can be searched by themes such as people and places. Promises to cover the collections of all the 1,700 museums registered with the Museums and Galleries Commission.

24hourmuseum.org.uk

Another government-funded portal to museums, galleries and heritage attractions in the UK, with a distinctly educational feel. Rather more useful than cornucopia, a well designed museum finder enables searches of UK museums by type of collection and region.

artupdate.com

Very simple UK-based weekly email listing service of current international exhibition openings. Links to gallery websites: a highly useful and reliable service.

ONLINE ARTS JOURNALS

theartnewspaper.com

Free web access to this seminal rag; articles grouped helpfully by subject, and a 'forum' where readers can submit their views. Although biased towards the art market, the Art Newspaper offers solid, no-nonsense coverage of arts events worldwide. Free weekly email newsletter with links to a digest of the previous week's news.

reviewny.com

'The critical state of the art in New York'. Published twice monthly, with an impressive list of contributors and simple clear design. The daily guide to openings and happenings builds up into a useful listing service for the New York art scene. Some articles are available free; a modest subscription enables full access and the possibility of a hard copy and even a deluxe binder.

ART MARKET

To some it may seem difficult to understand why anybody would buy something as immediate and physical as a work of art over the Internet – like buying shoes, or fish on a Monday, there is no substitute for holding, touching and sniffing. Most Internet sales are of prints and photographs, which are relatively inexpensive and look good on a screen. Despite this there is still a huge amount of money and enthusiasm being poured into online auction ventures.

artnet.com

Frankfurt-based portal to the commercial art world, featuring online auctions
and various subscribable auction databases. Extensive links to galleries
and auctions, as well as a sizeable proportion of the Grove Dictionary of Art
(see page 442) available free. Well-designed and approachable site founded
as a database by a group of art dealers in 1989, going online with the addition
of a magazine in 1995.

Icollector.com

Busy portal site for the art market, based around online auctions. Also
features directories of dealers and galleries, and a catalogue archive. Other
services include the Art Price Guide, and articles about the art world in general.
Established in 1994, Icollector was one of the first online auction sites, and
is only really rivalled by ArtNet for content and services. Whether it is
commercially viable to sell anything over the Internet has yet to be proved
by either.

countereditions.com

London-based site peddling affordable prints from well-known London
artists such as Tracey Emin and Gary Hume. Offering information, and even
specially commissioned video interviews with the artists, this is a refreshingly
focused and low-key commercial site.

printdealers.com

The site of the International Fine Print Dealers Association. Good resource
for learning more about prints, and how to locate dealers to buy the ones
you like. A meeting-place for dealers, collectors and enthusiasts.

artdealers.org

The Art Dealers Association of America, promoting 'connoisseurship,
scholarship and ethical practice'. US-based professional organisation.

whitecube.com

Site for the well-known London contemporary arts gallery, White Cube.
Lots of colourful animated graphics and a complex user interface (user
interface = the buttons and things you use to get around the site) tend to
conceal good resources including information about, and reproductions of,
works by the contemporary artists represented by the gallery, also showing
original video works by these artists.

MUSEUMS

Every gallery now has a website. Most of these are simply information leaflets transcribed unimaginatively for the web. Listed below are a number of sites that are developing into useful resources that may contain detailed information about collections, allow access to databases or host specially commissioned online projects.

rijksmuseum.nl

Nicely designed site, rather overanimated, but with excellent coverage of the collection. Entries for over 1,250 paintings and objects are joined by links to both other objects and a wealth of background information. Each object is fully covered by text, images, video and animation. An easily navigable and impressively constructed virtual tour gives a very good sense of the museum space. Thoroughly European, it is available in six different languages.

tate.org

Offers coverage of the collections at St Ives, Liverpool, and the two galleries in London, Millbank and Bankside. An evolving collections' database forms a useful backdrop to the Tate's contents, carrying images and short texts. The site also hosts online art projects complemented by critical texts. Following links to a feedback section takes you to the 'forum', where you are able to submit your views on Tate Modern and other issues of the day, although there is little meaningful debate or informative exchange.

louvre.fr

Well-designed site, with a great deal of information about the history of the Louvre and its collections. Although most of the site is available in a shaky English translation, the magazine, containing archives of interesting articles, is available just in French. A very good virtual tour, enabling 360-degree moveable views of most of the galleries, is both a lot of fun and useful for remembering how the paintings are displayed. The site also offers access to the Joconde database, containing information on 120,000 drawings, prints and paintings from over 60 museums over France.

thebritishmuseum.ac.uk

All the usual opening hours information, supplemented by Compass, a database of the British Museum's collections, currently covering 1,500 objects. Well-written and fully referenced entries make this a useful resource. Guided online tours suggest interesting routes around the online exhibits.

moma.org

Museum of Modern Art, New York. Somewhat limited in content, but nicely designed and containing well-presented information about the museum's collections.

metmuseum.org

Excellent site of the Metropolitan Museum of Art in New York, benefiting from their extraordinary collection of more than two million works of art. Over 3,500 of these can be seen in reproduction with informative, occasionally illuminating, accompanying information. The 'Timeline of Art History' stretches vertiginously back to 20000 BC, with information about the Apollo 11 Cave Stones (ca. 25500 – 23500 BC). At the time of writing the timeline has reached AD 500. A 'Virtual Reality Tour' of the American Wing is available, giving a good second-hand impression of the galleries.

nationalgallery.org.uk

Straightforward, easily navigable, if somewhat limited site of the National Gallery, London. The 'New Acquisitions' section is useful for keeping up with recent additions to the collection.

artic.edu

The Art Institute of Chicago, USA. Explore the galleries of this collection with a virtual tour, rather like being on a wobbly turntable with a pair of old binoculars.

getty.edu

Impressive site produced by the J. Paul Getty Trust, encompassing the Getty Museum and various Getty Institutes. The Museum section has excellent coverage of the collections, and allows numerous search types, leading to high-quality images and explanatory text. Difficult and technical terms are linked to a glossary. One of the few truly valuable art resources on the Internet today, and a model for all those museums that consider their opening hours and parking facilities of interest.

INTERNET ART

For those who believe that art is about objects in the real world, and would be disinclined to consider a screensaver of any artistic value, Internet art, now a considerable phenomena, will be of limited interest. Much of the best Internet art exploits both the supposed democratic aspect of the web, taking art outside of institutions such as museums and galleries, and also the emphemerality of the electronic medium. It is at its strongest when it questions the way that the worldwide web has been so uncritically accepted, commandeered for the purposes of commerce, and seen as a 'magic solution' to all manner of problems. Some would say that the web itself is an extra-ordinary, if not sublime artefact, the prodigal child of the home computer and the telephone.

ruskin-sch.milohedge.com/lab

Associated with the Ruskin School of Fine Art at Oxford University, The Laboratory is a platform for Internet art, as well as providing access to various symposiums, such as the Joseph Beuys Lectures and various other offline projects.

newmediacentre.com

Coming out of the Institute of Contemporary Arts in London, the New Media Centre features a changing programme of all the latest Internet and digital art. Contains well-compiled links to other websites featuring Internet and digital art. This is a good starting point for exploring the possibilities and range of the Internet as an artistic medium.

walkerart.org

The site of the Walker Art Center in Minneapolis hosts Gallery 9, a broad ranging 'project-driven' resource of artist commissions, exhibitions, lectures, community discussions, essays, etc. Walkerart also hosts the Digital Arts Study Collection, the initiative that launched äda'web, a pioneering artists' website, and has since instigated a number of projects that perform the difficult and often overlooked task of recording and preserving Internet art.

rhizome.org

Community-based site that promotes new media art. A strong emphasis on critical and theoretical contexts is backed up by online access to over 1,700 texts about new media art, although it isn't necessary to read them all. ArtBase is the on-site archive of Internet art, containing both links to Internet art currently online, as well as projects put onto the Rhizome site for

preservation purposes. The community aspect of the site takes place largely on the email lists, giving access to community discussions and also to the Rhizome Digest, an email journal of new media art, design and technology, published weekly and archived on-site since 1996.

jodi.org
Anarchic Internet activity with a refreshing lack of explanation.

endofpartone.com
London-based 'library' of new media art, including photography, video, sound and text work as well as pure Internet art. A joy to navigate, Endofpartone is evolving into a substantial, if localised, resource.

PICTURE LIBRARIES AND IMAGE ARCHIVES

bridgeman.co.uk
Website of the Bridgeman Art Library, one of the largest and most comprehensive picture libraries. Due to copyright restrictions pictures are only represented by squint-inducing thumbnails. The allied information, however, is comprehensive and useful in, tracking down the location of a painting, for example.

kfki.hu/arthp
This inscrutable address leads to the Web Gallery of Art: 7,300 digital reproductions of European painting and sculpture from 1150 to 1750, stored on the server of the Hungarian Academy of Sciences. The quality of the images is generally good, the information less so. A good feature is the viewing window that pops up to show images, enabling a zoom and scan to pick up detail.

John-Paul Stonard

The following picture credits are listed alphabetically by artist, for each section.

BAL = Bridgeman Art Library

Section 1 (Artists)

Miss Casenove On a Grey Hunter (oil on canvas)
Jacques-Laurent Agasse
Christie's Images/ Private Collection/ BAL

Homage to the Square: Joy, 1964 (oil on board)
Josef Albers
James Goodman Gallery, New York/ Private Collection/BAL
© DACS 2001

The Tepidarium, 1881 (panel)
Sir Lawrence Alma-Tadema
Trustees of the National Museums & Galleries on Merseyside/
Lady Lever Art Gallery, Port Sunlight, Merseyside/BAL

Beheading of Saint Catherine, c.1505
Albrecht Altdorfer
Kunsthistorisches Museum, Vienna/ BAL

The Annunciation (tempera and gold on panel)
Fra Angelico
Prado, Madrid/BAL

Child III, 1951
Karel Appel
Haags Gemeentemuseum, Netherlands/BAL © DACS 2001

Whimsical Portrait
Giuseppe Arcimboldo
Nostell Priory, Yorkshire/BAL

Office Fetish, 1985 (rotary telephones and metal poles)
Arman (Armand Fernandez)
Gift of Brant Thoroughbred Publications, Inc/The Detroit Institute of Arts/BAL © ADAGP, Paris and DACS, London 2001

Pair of still lives of flowers in decorative gold vases with lapiz cartouches (oil on canvas)
Juan de Arellano
Rafael Valls Gallery, London/Private Collection/BAL

Whooping Crane, from 'Birds of America'
John James Audubon
Victoria & Albert Museum, London/BAL

Head of Gerda Boehm (oil on board)
Frank Auerbach
Phillips, The International Fine Art Auctioneers/Private Collection/BAL

Skaters on a Frozen River
Hendrick Avercamp
Pushkin Museum, Moscow/BAL

Lying Figure, 1969 (oil on canvas)
Francis Bacon
© Estate of Francis Bacon/ARS, New York and DACS, London 2001

Everything Moves, 1913 (oil on canvas)
Giacomo Balla
Private Collection, Milan/BAL
© DACS 2001

The Ages of Man and Death
Hans Baldung Grien
Prado, Madrid/BAL

Katia Reading, 1968–76
Balthus (Balthasar Klossowski de Rola)
Private Collection/BAL

Madonna and Child: St Elizabeth and the infant St John the Baptist
Fra Bartolommeo (Baccio della Porta)
Christie's Images, London/BAL

Adieu, 1982 (oil on canvas)
Georg Baselitz
Tate Gallery, London 2001
© 2001 George Baselitz.

Pyro, 1984 (acrylic and mixed media on canvas)
Jean-Michel Basquiat
Private Collection/James Goodman Gallery, New York/BAL © ADAGP, Paris and DACS, London 2001

Self-Portrait in Olive and Brown, 1945 (oil on canvas)
Max Beckmann
Gift of Robert H. Tannahill/ The Detroit Institute of Arts, Detroit/BAL © DACS 2001

Procession in the St Mark's Square, detail of the Basilica, 1496 (oil on canvas)
Gentile Bellini
Galleria dell' Accademia, Venice/BAL

Madonna and Child Enthroned between Sts Francis, John the Baptist, Job, Dominic, Sebastian and Louis (the San Giobbe Altarpiece), c.1487 (oil on panel)
Giovanni Bellini
Galleria dell' Accademia, Venice/BAL

The Marketplace at Pirna, c.1764 (oil on canvas)
Bernardo Bellotto
Samuel H. Kress Collection/ Museum of Fine Arts, Houston, Texas/ BAL

Pennsylvania Station Excavation, 1909 (oil on canvas)
George Wesley Bellows
The Augustus Healy Fund B/ Brooklyn Museum of Art, New York/ BAL

Breton Women on a Wall, 1892
Émile Bernard
Josefowitz Collection, New York/ BAL

Four Blackboards, 1972 (chalk on blackboard)
Joseph Beuys
Tate Gallery, London 2001
© DACS 2001

Design for the cover of 'Musica Futurista' by Francesco Balilla Pratella (1880–1955), 1912 (tempera and ink on cardboard)
Umberto Boccioni
Pratella Collection, Ravenna/BAL

Mermaids at Play, 1886
Arnold Böcklin
Kunstmuseum, Basel/BAL

Allegory of the Arts
(ceiling painting)
Pietro da Cortona
Palazzo Barberini, Rome/BAL

La Rencontre or *Bonjour*
M. Courbet, 1854
Gustave Courbet
Musée Fabre, Montpellier/BAL

Dieppe
David Cox
The Potteries Museum and Art
Gallery, Stoke-on-Trent/BAL

Sunset over a River, 1650s (panel)
Aelbert Cuyp
Hermitage, St Petersburg/BAL

The Annunciation with St Emidius,
1486 (tempera and oil on canvas)
Carlo Crivelli
National Gallery, London/BAL

Madonna and Child, 1347
Bernardo Daddi
Orsanmichele, Florence/BAL

Sleep
Salvador Dalí
Ex-Edward James Foundation,
Sussex/BAL © Kingdom of Spain,
Gala – Salvador Dalí Foundation,
DACS, London 2001

Scene at a tribunal (watercolour)
Honoré Daumier
Private Collection/BAL

Christ on the Cross between St
John and St Francis (oil on panel)
Gerrit (or Gerard) David
Agnew & Sons, London/BAL

Thoughts for a Giant Bird
Alan Davie
© Alan Davie. Reproduced by
permission. Bonhams,
London/BAL

Kiss and Tell, 1989
(epoxy, timber, plywood and steel)
Richard Deacon
Arts Council Collection, Hayward
Gallery, London/BAL

The Rehearsal, c.1877
Edgar Degas
Burrell Collection, Glasgow/BAL

The Death of Sardanapalus, 1827
Eugène Delacroix
Louvre, Paris/BAL

Buildings Abstraction, Lancaster,
1931 (oil on board)
Charles Demuth
Founders Society purchase,
General Membership Fund/
The Detroit Institute of Arts/BAL

Mr and Mrs Hill, c.1750–51
(oil on canvas)
Arthur Devis
Yale Center for British Art,
Paul Mellon Collection/BAL

Boots (terracotta)
Jim Dine
Private Collection/BAL

Portrait of the Artist's Parents, 1924
Otto Dix
Niedersachsische Landesmuseum
Hanover/BAL © DACS 2001

The Apparition of the Virgin to
St John the Baptist and St John
the Evangelist
Dosso Dossi
Galleria degli Uffizi, Florence/BAL

Madonna and Child
(Rucellai Madonna), 1285
Duccio di Buoninsegna
Galleria degli Uffizi, Florence/BAL

The Dutch Housewife (or 'Woman
hanging a cockerel in the window')
Gerrit (or Gerard) Dou
Louvre, Paris/BAL

Fountain, 1917/64
Marcel Duchamp
Tate, London 2001 © Succession
Marcel Duchamp/ ADAGP, Paris
and DACS, London 2001

Classical Landscape with Figures,
c.1672–5
Gaspard Poussin Dughet
The Barber Institute of Fine Arts,
University of Birmingham/BAL

The Vision of The Seven Candlesticks
from 'The Apocalypse' or
'The Revelations of St John the
Divine', pub. 1498 (woodcut)
Albrecht Dürer
Private Collection/BAL

The Sermon of John the Baptist
(oil on copper)
Adam Elsheimer
Hamburg Kunsthalle, Hamburg/BAL

Oedipus Rex, 1922 (oil on canvas)
Max Ernst
Collection of Claude Herraint,
Paris/BAL © ADAGP, Paris and
DACS, London 2001

The Canadian Club, 1974, New York
Townscape
Richard Estes
Copyright © Richard Estes,
courtesy, Marlborough Gallery,
New York. Private Collection/BAL

Mary Fitzalan, Duchess of Norfolk
(1540–57), 1555 (oil on panel)
Hans Eworth (or Ewoutsz)
Private Collection/BAL

The Portrait of Giovanni Arnolfini
and his Wife Giovanna Cenami –
The Arnolfini Marriage, 1434
(oil on panel)
Jan van Eyck
National Gallery, London/BAL

Iconografia, 1975 (mixed media)
Luciano Fabro
Private Collection/BAL

Der Tod des Dichters Walther Reiner
Conrad Felixmüller
Reproduced by permission of the
family. Christie's Images, London/BAL

The Cricketer, 1982
(bronze, original cast in 1981)
Barry Flanagan
Leeds Museums and Galleries
(City Art Gallery), Leeds/BAL

A young Negro Archer, c.1640
(oak panel)
Govaert Flinck
Wallace Collection, London/BAL

The Bolt, c.1778 (oil on canvas)
Jean-Honoré Fragonard
Louvre, Paris/BAL

Blue Out of White, 1958
Sam Francis
Hirshhorn Museum, Washington
DC/BAL © Estate of Sam Francis/
DACS, London 2001

Girl with a White Dog, 1950–1
(oil on canvas)
Lucian Freud
© Lucian Freud/Tate London, 2001

The Stages of Life, c.1835
(oil on canvas)
Caspar David Friedrich
Museum der Bildenden Kunste,
Leipzig/BAL

*The Railway Station*T, 1862
(oil on canvas)
William Powell Frith
Royal Holloway and Bedford New
College, Surrey/BAL

High Yellow, 1955 (oil on canvas)
Terry Frost
Leeds Museums and Galleries
(City Art Gallery), Leeds/BAL

*Mr and Mrs William Hallett
(The Morning Walk)*, c.1785
(oil on canvas)
Thomas Gainsborough
National Gallery, London/BAL

Torso 2 (bronze)
Henri Gaudier-Brzeska
Phillips, The International
Fine Art Auctioneers/
Private Collection/BAL

Nevermore, 1897
Paul Gauguin
Courtauld Gallery, London/BAL

Judith and Holofernes (panel)
Artemisia Gentileschi
Museo e Gallerie Nazionali di
Capodimonte, Naples/BAL

Officer of the Hussars, 1814
(oil on canvas)
Théodore Gericault
Louvre, Paris/BAL

The Birth of St John the Baptist
(fresco)
Domenico Ghirlandaio
Santa Maria Novella,
Florence/BAL

Street, c.1983 (oil)
Gilbert and George
Visual Arts Library, London/
Royal Academy of Arts, London/
BAL

The Crucifixion of St Peter
Luca Giordano
Galleria dell' Accademia,
Venice/BAL

The Sleeping Venus, 1508–10
**Giorgione (Giorgio da
Castelfranco)**
Gemaldegalerie, Dresden/BAL

*The Gorge of Watendlath with
the Falls of Lodore*
(watercolour on paper)
Thomas Girtin
Ashmolean Museum, Oxford/BAL

East River Park, c.1902
(oil on canvas)
William Glackens
Reproduced courtesy of John H.
Surovek Gallery.
Dick S. Ramsay Fund/Brooklyn
Museum of Art, New York/BAL

Christ Child Adored by Angels,
Central panel of the Portinari
Altarpiece, 1475 (oil on panel)
Hugo van der Goes
Galleria degli Uffizi, Florence/BAL

Self-Portrait with Bandaged Ear,
1889
Vincent van Gogh
Courtauld Gallery, London/BAL

*Sycamore leaves stitched together
with stalks hung from a still green
oak* (c. 1983)
Andy Goldsworthy
© Andy Goldsworthy

*The Duke of Wellington
(1769–1852)* 1812–14 (oil on panel)
Francisco Jose de Goya y Lucientes
National Gallery, London/BAL

An Estuary with Boats
Jan Josephsz van Goyen
Harold Samuel Collection,
Corporation of London/ BAL

*The Journey of the Magi to
Bethlehem*, the left hand wall of
the chapel, c.1460 (fresco)
Benozzo di Lese di Sandro Gozzoli
Palazzo Medici-Riccardi,
Florence/BAL

St Joseph and the Christ Child,
1597–99
El Greco (Domenico Theotocopuli)
Museo de Santa Cruz,
Toledo/Bridgeman Art Library

*Girl with Doves (L'Innocence tenant
deux pigeons)*, 1800
(mahogany panel)
Jean-Baptiste Greuze
Wallace Collection, London/BAL

Christ on the Cross, detail from the
central Crucifixion panel of the
Isenheim Altarpiece, c.1512–15
(oil on panel)
**Matthias Grünewald
(Mathis Nithart Gothart)**
Musée d'Unterlinden, Colmar/BAL

*Venice: the Grand Canal with the
Riva del Vin and Rialto Bridge*
Francesco Guardi
Wallace Collection, London/BAL

The Woman taken in Adultery,
c.1621
**Guercino (Giovanni Francesco
Barbieri)**
Dulwich Picture Gallery,
London/BAL

Death of a Hero, 1953
(oil on canvas)
Renato Guttuso
Estorick Foundation, London/BAL

The Laughing Cavalier
Frans Hals
Wallace Collection, London/BAL

The Old Cupboard Door
William Michael Harnett
Sheffield Galleries and Museums
Trust/BAL

*George Rogers with his Wife,
Margaret, and his Sister, Margaret
Rogers*, c.1748–50 (oil on canvas)
Francis Hayman
Yale Center for British Art,
Paul Mellon Collection/BAL

Seascape: Sunset, 1861 (oil on canvas)
Martin Johnson Heade
Founders Society Purchase,
R.H. Tannahill Foundation fund/
The Detroit Institute of Arts,
Detroit/BAL

Still life of dessert, 1640
Jan Davidsz de Heem
Louvre, Paris/BAL

Involute I, 1946 (white stone)
Barbara Hepworth
Reproduced by permission
of the Hepworth Estate.
Private Collection/BAL

William Ward on Horseback, 1839
(oil on canvas)
John Frederick Snr Herring
Blackburn Museum and Art
Gallery, Lancashire/BAL

Tomorrow's Apples (5 in White),
1965 (enamel, gouache and mixed
media on board)
Eva Hesse
© Eva Hesse/Tate, London 2001

View of Schloss Leonersloot, Holland
Jan van der Heyden
Stadelsches Kunstinstitut,
Frankfurt-am-Main/BAL

Unknown man, flame background
Nicholas Hilliard
Ham House, Surrey/BAL

The Peaceable Kingdom, 1832–34
Edward Hicks
Philadelphia Museum of Art,
Pennsylvania/BAL

Landscape
Meindert Hobbema
Agnew & Sons, London/BAL

Foy Nissen's Bombay, 1975–7
(oil on wood)
Howard Hodgkin
Arts Council Collection, Hayward
Gallery, London/BAL

*Lake Thun and the Stockhorn
Mountains*, 1910
Ferdinand Hodler
Scottish National Gallery of
Modern Art, Edinburgh/BAL

'Fuji above the Lightning',
from the series '36 Views of Mt.
Fuji ('Fugaku sanjurokkei'), pub.
by Nishimura Eijudo, 1831, (hand-
coloured woodblock print)
Katsushika Hokusai
Fitzwilliam Museum,
University of Cambridge/BAL

Eight Bells
Winslow Homer
Private Collection/BAL

Concert for Anarchy, 1990
(painted wood, metal and
electronic components)
Rebecca Horn
Rebecca Horn/Tate, London 2001
© DACS 2001

Courtyard of a house in Delft, 1658
(oil on canvas)
Pieter de Hooch
National Gallery, London/BAL

Chop Suey, 1929
Edward Hopper
Whitney Museum of American
Art, New York/BAL

Wotan, 1977 (acrylic on canvas)
John Hoyland
Arts Council Collection, Hayward
Gallery, London/BAL

Venedigs Rattendrag, 1955
Friedrich (Fritz) Hundertwasser
Collection of Otto Heubell,
Wiesbaden/BAL

Madonna and Child (panel)
Adriaen Isenbrandt
Gallerie de Jonckeere, Paris,
France/ BAL

Three Flags, 1958 (oil on canvas)
Jasper Johns
Whitney Museum of American
Art, New York/BAL
© Jasper Johns/VAGA, New York
and DACS, London 2001

*What do you mean, what do I
mean*, 1968 (oil on canvas plus
airbrushed photograph)
Allen Jones
Private Collection/BAL

Black Frame, 1922 (oil on canvas)
Wassily Kandinsky
Musée National d'Art Moderne,
Paris/ BAL
© ADAGP, Paris and DACS, London
2001

Wolundlied, 1982
Anselm Kiefer
Saatchi Collection, London/BAL

Through (coloured plaster)
Philip King
Leeds Museums and Galleries
(City Art Gallery), Leeds/BAL

Street Scene
Ernst Ludwig Kirchner
Brucke Museum, Berlin/BAL
© Copyright by Dr. Wolfgang
& Ingeborg Henze-Ketterer,
Wichtrach/ Bern.

The Ohio Gang, 1964
(oil and graphite on canvas)
R. B. Kitaj (Ronald Brooks Kitaj)
6 1/8 x 6 1/4 inches (183.1 x 183.5
cm). Museum of Modern Art, New
York, Philip Johnson Fund/
Photograph © 2001 The Museum
of Modern Art, New York

Ad Parnassum (detail) 1932
Paul Klee
Kunstmuseum, Bern/BAL
Copyright © DACS 2001

Sponge, 1961
Yves Klein
Hamburg Kunsthalle, Hamburg/
BAL © ADAGP, Paris and DACS,
London 2001

Judith, 1901
Gustav Klimt
Österreichische Galerie Belvedere,
Vienna/BAL

An extensive landscape, 1666
Phillips de Koninck
National Gallery of Scotland,
Edinburgh/BAL

Women Singing II, 1966
(oil on paper laid on canvas)
Willem de Kooning
Tate, London, 2001 © Willem de
Kooning Revocable Trust/ARS, NY
and DACS, London 2001

Three Ball Total Equilibrium Tank,
1985 (glass, steel, sodium chloride
reagent, distilled water, 3
basketballs)
Jeff Koons
60 1/2 x 48 3/4 x 13 1/4 inches.
Tate, London, 2001 © Jeff Koons

The Joy of Living, 1905–6
(oil on canvas)
Henri Matisse
The Barnes Foundation, Merion,
Pennsylvania/BAL © Succession
H. Matisse/DACS 2001

Portrait of an Unknown Man
Hans Memling
Galleria degli Uffizi, Florence/BAL

Apocalyptic Vision, 1912
(oil on canvas)
Ludwig Meidner
New Walk Museum, Leicester City
Museum Service, Leicester/BAL

Self-Portrait
Anton Raphael Mengs
Hermitage, St Petersburg/BAL

A Soldier Visiting a Young Lady,
1653 (oil on canvas)
Gabriel Metsu
Louvre, Paris/BAL

Autumn Leaves, 1856
Sir John Everett Millais
Manchester City Art Galleries/BAL

The Gleaners, 1857 (oil on canvas)
Jean-François Millet
Musée d'Orsay, Paris/BAL

*Jeanne Hebuterne in a Yellow
Jumper*, 1918
Amedeo Modigliani
Solomon R. Guggenheim
Museum, New York/BAL

Composition in Red and Blue,
1939–41
Piet Mondrian
Christie's Images, London/BAL
© 2001 Mondrian/Holtzman Trust,
c/o Beeldrecht, Amsterdam,
Holland & DACS, London

The Haystacks, or *The End of the
Summer, at Giverny*, 1891
Claude Monet
Musée d'Orsay, Paris/BAL

Apples
Albert Moore
Christies Images/BAL

Reclining Figure, 1936 (elmwood)
Henry Spencer Moore
Wakefield Museums and
Galleries, West Yorkshire/BAL.
Reproduced by permission of the
Henry Moore Foundation.

Portrait of a Young Man, c.1542
(oil on canvas)
Alessandro Bonvicino Moretto
National Gallery, London/BAL

*Portrait of the Artist's Mother and
Sister*, 1869–70
Berthe Morisot
National Gallery of Art,
Washington DC/BAL

Cottage Door
George Morland
Royal Holloway and Bedford New
College, Surrey/BAL

Portrait of a Bearded Man in Black,
1576 (oil on canvas)
Giovanni Battista Moroni
Isabella Stewart Gardner
Museum, Boston, Massachusetts/
BAL

Dwarf with a Box, 1988 (terracotta
and wood sculpture)
Juan Muñoz
© Juan Muñoz/Tate, London 2001

The Good Shepherd, 1665
Bartolomé Esteban Murillo
Prado, Madrid/BAL

*Portrait of James, 2nd Marquess of
Hamilton (1589–1625)*
Daniel Mytens
Scottish National Portrait Gallery,
Edinburgh/BAL

Mineral Objects, 1935 (oil on
canvas) **Paul Nash**
Yale Center for British Art, Paul
Mellon Fund/BAL/Reproduced by
permission of the Tate, London

*The First Searchlights at Charing
Cross*, 1914 (oil on canvas)
**Christopher Richard Wynne
Nevinson**
Leeds Museums and Galleries
(City Art Gallery), Leeds/BAL

Kelly in Spring, 1956
(ripolin on board)
Sir Sidney Nolan
Arts Council Collection,
Hayward Gallery, London/BAL

Tänzerinnen (Dancers), 1920
(oil on canvas)
Emil Nolde
Staatsgalerie, Stuttgart/BAL
Copyright © Nolde-Stiftung
Seebüll.

The Marriage of Convenience, 1883
Sir William Quiller Orchardson
Glasgow Art Gallery and Museum,
Scotland/BAL

*Henry Frederick, Prince of Wales
(1594-1612), eldest son of King
James I of England (VI of Scotland)*
Isaac Oliver
Fitzwilliam Museum, University of
Cambridge, Cambridge/BAL

Buying Fish, 1669 (oil on canvas)
Adriaen van Ostade
Wallace Collection, London/BAL

The Frozen Lake, 1648
Isaak van Ostade
Hermitage, St Petersburg/BAL

Untitled, 1988
(mixed media on wood)
Mimmo Paladino
Private Collection/BAL

Lady with a Lute, c.1520–25
Jacopo Palma (Il Vecchio)
Collection of the Duke of
Northumberland/BAL

The Flock and the Star (pen and
brush in ink over pencil and ink)
Samuel Palmer
Ashmolean Museum, Oxford/BAL

Roman Capriccio (oil on canvas)
Giovanni Panini (or Pannini)
Ashmolean Museum, Oxford/BAL

Madonna with the Long Neck,
1534–40 (panel)
Parmigianino (Francesco Mazzola)
Galleria degli Uffizi, Florence/BAL

The Abstract, 1972
(etching and aquatint)
Victor Pasmore
Private Collection/BAL

St Jerome in a Rocky Landscape,
c.1515–24 (oil on panel)
Joachim Patenier (or Patinir)
National Gallery, London/BAL

A Concert (Le Concert Amoureux)
Jean-Baptiste Joseph Pater
Wallace Collection, London/BAL

*Portrait of George Washington
(1732–99)*, 1776
Charles Willson Peale
Brooklyn Museum of Art,
New York/ BAL

Female Nude, 1973
(acrylic on canvas)
Philip Pearlstein
Private Collection/BAL

Caesar Before Alexandria
(oil on canvas)
Giovanni Antonio Pellegrini
Birmingham Museums and Art
Gallery/BAL

Bien Visé (Good Shooting), 1939
Roland Penrose
Southampton City Art Gallery,
Hampshire/BALCopyright
© Estate of the Artist.

*The Madonna and Child with
a Swallow* (tempera on panel)
Francesco di Stefano Pesellino
Isabella Stewart Gardner
Museum, Boston,
Massachusetts/BAL

Still life with lanterns, after 1889
John Frederick Peto
Brooklyn Museum of Art,
New York/ BAL

A Satyr Mourning over a Nymph,
c.1495 (oil on panel)
Piero di Cosimo
National Gallery, London/BAL

Baptism of Christ, 1450s
(tempera on panel)
Piero della Francesca
National Gallery, London/BAL

Carceri IV, 1760 (etching)
Giovanni Battista Piranesi
On Loan to the Hamburg
Kunsthalle, Hamburg/BAL

The Avenue de L'Opéra, Paris, 1898
Camille Pissarro
Musée Saint-Denis, Rheims/BAL

The Delivery of the Keys to St Peter
(oil on canvas)
Giovanni Battista Pittoni
Louvre, Paris/ BAL

Hercules and the Hydra
Antonio Pollaiuolo
Galleria degli Uffizi, Florence/BAL

Number 20, 1949 (enamel on
paper laid down on masonite)
Jackson Pollock
James Goodman Gallery, New
York/ Private Collection/BAL
© ARS, NY and DACS 2001

Portrait of Cosimo I de' Medici,
c.1537 (panel)
Jacopo Pontormo
J. Paul Getty Museum, Malibu,
California/BAL

Architectonic Composition
Lyubov Sergeevna Popova
Leonard Hutton Galleries,
New York/BAL

The Young Bull
Paulus Potter
Mauritshuis, The Hague/BAL

Portrait of the Infanta Anna
Frans II Pourbus
Galleria e Museo Estense,
Modena/ BAL

Virgin and Child (panel)
Jan II Provost
National Gallery of Scotland,
Edinburgh/BAL

New England Village, 1912–14
(oil on canvas)
Maurice Prendergast
Wintermann Collection, Gift of Mr
& Mrs D.R. Wintermann/Museum
of Fine Arts, Houston, Texas/BAL

Sir Walter Scott (1771–1832), 1822
Sir Henry Raeburn
Scottish National Portrait Gallery,
Edinburgh/BAL

*The Painter's Wife, Margaret
Lindsay*, 1754–5
Allan Ramsay
National Gallery of Scotland,
Edinburgh/BAL

The Sistine Madonna, 1513
**Raphael (Raffaello Sanzio of
Urbino)**
Gemaldegalerie, Dresden/BAL

Bellini # 1, 1986 (intalgio printed
in colour on wove paper)
Robert Rauschenberg
Founders Society Purchase/
Graphic Arts Council Fund/
The Detroit Institute of Arts,
Detroit/ BAL
© Robert Rauschenberg/DACS,
London/VAGA, New York 2001

The Cyclops, c.1914 (oil on canvas)
Odilon Redon
Rijksmuseum Kroller-Muller,
Otterlo/BAL

Aiding a Comrade, c.1890
(oil on canvas)
Frederic Remington
Hogg Brothers Collection, Gift of
Miss Ima Hogg/Museum of Fine
Arts, Houston, Texas/BAL

Lady with a Lapis Lazuli Bowl
(oil on canvas)
Guido Reni
Birmingham Museums and Art
Gallery/BAL

Le Moulin de la Galette, 1876
(detail of the dancers)
Pierre-Auguste Renoir
Musée d'Orsay, Paris/BAL

Self portrait, c. 1780 (oil on panel)
Sir Joshua Reynolds
Royal Academy of Arts,
London/BAL

Venus and Cupid
Marco and Sebastiano Ricci
Chiswick House, London/BAL

Self-Portrait, 1661–62
Rembrandt Harmensz van Rijn
Kenwood House, London/BAL

Midsummer
(oil on linen, 164.5 x 159.5 cm),
Bridget Riley
Collection of 3i plc/BAL

The Institution of the Eucharist,
c.1490 (tempera on panel)
Ercole de Roberti (attr. to)
National Gallery, London/BAL

Miss Motes and her Dog Shep, 1893
(oil on canvas)
Theodore Robinson
Christie's Images/Private
Collection/ BAL

Andromeda, c.1885 (marble)
Auguste Rodin
Private Collection/BAL

Portrait of Mrs. Moody
George Romney
Christie's Images, London/BAL

Human Fragility, c.1656
Salvator Rosa
Fitzwilliam Museum,
University of Cambridge/BAL

The Lady of Pity, or *La Donna della
Finestra*, 1870 (pastel)
Dante Gabriel Rossetti
Bradford Art Galleries and
Museums, West Yorkshire/BAL

The Balck and the White, 1956
(oil on canvas)
Mark Rothko
Gift of Ruth and Frank
Stanton/Fogg Art Museum,
Harvard University Art Museums/
BAL © Kate Rothko Prizel and
Christopher Rothko/DACS, 1998

Child with a Puppet, c.1903
(oil on canvas)
Henri J. F. (Le Douanier) Rousseau
Kunsthalle, Winterthur,
Switzerland/BAL

Pictorial Construction, 1916
(gouache on paper)
Olga Vladimirovna Rozanova
Ivanovo Museum of Art,
Ivanovo/BAL

Rape of the Daughter of Leucippus
Peter Paul Rubens
Alte Pinakothek, Munich/BAL

Panoramic View of Haarlem
Jacob Isaaksz van Ruisdael
Harold Samuel Collection,
Corporation of London/BAL

*River Landscape with Fishermen
at Work*
Salomon van Ruysdael
Christie's Images/Private
Collection/ BAL

*Study of rocks and ferns in a wood
at Crossmount, Perthshire*, 1843
(w/c on paper)
John Ruskin
Abbot Hall Art Gallery, Kendal,
Cumbria/ BAL

By the Tomb of the Prophet, c.1882
(oil on panel)
Albert Pinkham Ryder
Delaware Art Museum,
Wilmington, DE, USA/BAL
Visual Arts Library, London, UK.
Acquired through the bequest of
George I. Speer

*Interior of the Marienkirche in
Utrecht*, 1638 (oil on panel)
Pieter Jansz Saenredam
Hamburg Kunsthalle,
Hamburg/BAL

*The Norman Gate and Deputy
Governor's House*
(gouache over graphite on paper)
Paul Sandby
Yale Center for British Art,
Paul Mellon Collection/BAL

Repose
John Singer Sargent
National Gallery of Art,
Washington DC/BAL

Lamentation over the Dead Christ,
1524 (panel)
Andrea del Sarto
Palazzo Pitti, Florence/BAL

*The Mystic Marriage of St Francis
with Chastity, Poverty and
Obedience* (oil on panel)
Stefano di Giovanni Sassetta
Musée Condé, Chantilly/BAL

Orpheus Playing to the Animals
Roelandt Jacobsz Savery
Christie's Images, London/ BAL

Standing nude, facing front
(self portrait), 1910
Egon Schiele
Graphische Sammlung Albertina,
Vienna/BAL

YMCA Flag, Thank You, Ambleside,
1947 (mixed media)
Kurt Schwitters
Abbot Hall Art Gallery, Kendal,
Cumbria/BAL © DACS 2001

Paul (oil on linen, 102" x 126"), 1984
Sean Scully
Copyright © Sean Scully.
Transparency lent by Tate, London
2001.

Portrait of a Woman, 1512
(oil on canvas)
Sebastiano del Piombo (S. Luciani)
Galleria degli Uffizi, Florence/BAL

The Circus, 1891 (oil on canvas)
Georges Seurat
Musée d'Orsay, Paris/BAL

Holy Family with St Catherine
Luca Signorelli
Palazzo Pitti, Florence/BAL

Books and Apple, 1957 (silver)
David Smith
Fogg Art Museum, Harvard
University Art Museums, Harvard/
BAL. Gift of Lois Orswell.
© Estate of David Smith/VAGA,
New York/DACS, London 2001

The Bridge at Moret, 1893
(oil on canvas)
Alfred Sisley
Musée d'Orsay, Paris/BAL

Still Life with Yellow Fish, 1951
Matthew Arnold Bracy Smith
Guildhall Art Gallery,
Corporation of London/BAL

Beach Promenade
Joaquin Sorolla y Bastida
Museo Sorolla, Madrid/BAL

Roundel bearing a profile portrait of Alexander the Great (356-323 BC) surrounded by a garland of foliage, bas relief (terracotta with polychrome glaze), c.1480, modelled by **Andrea Verrochio** and enamelled by **Andrea della Robbia**
Kunsthistorisches Museum, Vienna/BAL

Birth of Christ (oil on panel)
Marten de Vos
Stiftsmuseum, Klosterneuburg/BAL

Fight between a lion and a tiger, 1797 **James Ward**
Fitzwilliam Museum, University of Cambridge/BAL

Jacqueline Kennedy No. 3, 1965 (screenprint)
Andy Warhol
Arts Council Collection, Hayward Gallery, London/BAL © The Andy Warhol Foundation for Visual Arts Inc/ARS, New York and DACS, London 2001

The Scale of Love, 1715–18 (oil on canvas)
Jean- Antoine Watteau
National Gallery, London/BAL

Nymphs finding the head of Orpheus
John William Waterhouse
Christie's Images, London/BAL

The Rain It Raineth Every Day, 1883
George Frederick Watts
Johannesburg Art Gallery, Johannesburg/BAL

Still Life (oil on canvas)
Jan Weenix
Leeds Museums and Galleries (City Art Gallery), Leeds/BAL

Willimantic Thread Factory, 1893
Julian Alden Weir
Brooklyn Museum of Art, New York/ BAL

Nocturne in Black and Gold, the Falling Rocket, c.1875 (oil on panel)
James Abbott McNeill Whistler
Gift of Dexter M. Ferry Jr./ The Detroit Institute of Arts/BAL

The letter of introduction, 1813 (panel)
Sir David Wilkie
National Gallery of Scotland, Edinburgh/BAL

Snowdon (oil on canvas)
Richard Wilson
Castle Museum and Art Gallery, Nottingham, UK/BAL
Lincoln
Peter de Wint
British Museum, London/BAL

Empress Eugénie surrounded by her Ladies in Waiting
Franz Xavier Winterhalter
Château de Compiègne, Oise/ Giraudon/BAL

The City of London from the Lloyd's Building (oil on canvas)
John Wonnacott
Private Collection/Agnew's, London/BAL

Twin Tub with Beaver, 1981 (sculpture)
Bill Woodrow
Leeds Museums and Galleries (City Art Gallery) U.K./BAL. Reproduced with permission.

The Duke of Rutland's 'Bonny Black', c.1720 (oil on canvas)
John Wootton
Yale Center for British Art, Paul Mellon Collection/BAL

An Experiment on a Bird in the Air Pump, 1768 (oil on canvas)
Joseph Wright of Derby
National Gallery, London/BAL

Landscape with Kermis (The Rustic Wedding)
Philips Wouwermans
Harold Samuel Collection, Corporation of London/BAL

Sea Boots, 1976 (tempera on panel)
Andrew Wyeth
Copyright © Andrew Wyeth
Founders Society Purchase/ Mr & Mrs James A. Beresford Fund/ The Detroit Institute of Arts/BAL

The Drummond Family, c.1769 (oil on canvas)
Johann Zoffany
Yale Center for British Art, Paul Mellon Collection/BAL

Girls from Dalarna Having a Bath, 1908 (oil on canvas)
Anders Leonard Zorn
National museum, Stockholm/BAL

Beato Serapio, 1628
Francisco de Zurbarán
Wadsworth Atheneum, Hartford, Connecticut/BAL

An Italianate River Landscape
Francesco Zuccarelli
Christie's Images, London/BAL

The Rape of Helen, 1770s
(oil on canvas)
Gavin Hamilton
Pushkin Museum, Moscow/BAL

The Crucifixion, c.1530 (oil on
panel)
Maerten van Heemskerck
Founders Society purchase and
Julius H. Haass Fund/The Detroit
Institute of Arts, Detroit/BAL

The Lamentation, c.1650
(oil on panel)
Jacob Jordaens
Hamburg Kunsthalle, Hamburg/ BAL

Neptune Creates the Horse
Jacob Jordaens
Palazzo Pitti, Florence/BAL

Garden of the Hesperides, c.1892
(oil on canvas)
Frederic Leighton
Trustees of the National Museums
& Galleries on Merseyside/ Lady
Lever Art Gallery, Port Sunlight,
Merseyside/BAL

*The Coronation of the Virgin
with Sts William of Aquitaine and
Augustine* (oil on canvas)
Giovanni Lanfranco
Louvre, Paris/BAL

*Death, one of the Four Riders
from the Apocalypse* (vellum),
from *Les Très Riches Heures du
Duc de Berry* (early 15th century)
Pol de Limbourg
Roger-Viollet, Paris/Musée Condé,
Chantilly/ BAL

The Vision of St Bernard, detail
of *The Virgin and Angels*, c.1485
(panel)
Filippino Lippi
Church of the Badia, Florence/BAL

Madonna and Child with Angels,
c.1455 (tempera on panel)
Fra Filippo Lippi
Galleria degli Uffizi, Florence/BAL

The Last Judgement (oil on wood)
Stephan Lochner
Wallraf Richartz Museum,
Cologne/ BAL

Samson and Delilah, c.1500
(glue size on linen)
Andrea Mantegna
National Gallery, London/BAL

Saint Sebastian
Andrea Mantegna
Kunsthistorisches Museum,
Vienna/Ali Meyer/BAL

Road to Calvary
Simone Martini
Louvre, Paris/BAL

The Adoration of the Shepherds,
c.1665
Bartolomé Esteban Murillo
Wallace Collection, London/BAL

Cupid Carving a Bow
Parmigianino (Francesco Mazzola)
Ali Meyer/Kunsthistorisches
Museum, Vienna/BAL

Charon Crossing the River Styx,
1515–24 (oil on panel)
Joachim Patenier (or Patinir)
Prado, Madrid/BAL

*The Triumphs of Love, Chastity and
Death*, c.1448 (tempera on panel)
Francesco di Stefano Pesellino
Isabella Stewart Gardner Museum,
Boston, Massachusetts/ BAL

*The Triumphs of Fame, Time and
Eternity*, c.1448 (tempera on panel)
Francesco di Stefano Pesellino
Isabella Stewart Gardner Museum,
Boston, Massachusetts/BAL

Apollo and Marsyas
Pietro Perugino
Giraudon/Louvre, Paris/BAL

Baptism of Christ (and two details)
1450s (tempera on panel)
Piero della Francesca
National Gallery, London/BAL

*Sacra Conversatione with Sts
Catherine, Sebastian and Holy
Family* (oil on panel)
Sebastiano del Piombo
Louvre, Paris/BAL

The Vision of St Eustace
(tempera on panel)
Antonio Pisanello
National Gallery, London/BAL

Arcadian Shepherds (oil on canvas)
Nicolas Poussin
Louvre, Paris/BAL

Christ in Glory with the Saints
Mattia Preti
Prado, Madrid/BAL

Bacchus and Ariadne
Sebastiano Ricci
Chiswick House, London/BAL

Salome, 1925
Charles Ricketts
Bradford Art Galleries and
Museums, West Yorkshire/BAL

Battle of the Amazons and Greeks
(detail), c.1617 (oil on panel)
Peter Paul Rubens
Alte Pinakothek, Munich/BAL

The Descent from the Cross,
Triptych (central panel)
Peter Paul Rubens
Onze Lieve Vrouwkerk, Antwerp
Cathedral, Antwerp/BAL

The Temptation of St Anthony
(engraving)
Martin Schongauer
Bibliothèque Nationale, Paris/ BAL

Devils, detail from *The Last
Judgement* (fresco)
Luca Signorelli
Duomo, Orvieto, Umbria/ BAL

*The Crucifixion with Sts Jerome,
Francis, Mary Magdalen, John the
Baptist and the blessed Giovanni
Colombini*, c.1480 (panel)
Luca Signorelli & **Pietro Perugino**
Galleria degli Uffizi, Florence/BAL

Isaac Blessing Jacob
**José (or Jusepe) de Ribera
(Lo Spagnoletto)**
Prado, Madrid/BAL

Perseus and Andromeda
Peter Paul Rubens
Hermitage, St Petersburg/BAL

The Three Graces, 1640
(oil on canvas)
Peter Paul Rubens
Prado, Madrid/BAL

Madonna in Glory with Four Saints
(panel)
Andrea del Sarto
Palazzo Pitti, Florence/BAL

Noli Me Tangere, from the
Altarpiece of the Dominicans,
1470–80
Martin Schongauer
Musée d'Unterlinden, Colmar/BAL

*Stations of the Cross, Christ's
Fall on the way to Calvary*
Giovanni Domenico Tiepolo
Prado, Madrid/BAL

Joseph and the Wife of Potiphar
Tintoretto (Jacopo Robusti)
Prado, Madrid/BAL

The Birth of St John the Baptist
Tintoretto (Jacopo Robusti)
Hermitage, St Petersburg/ BAL

The Presentation of the Virgin
(oil on canvas)
Tintoretto (Jacopo Robusti)
Francesco Turio Bohm/ Madonna
dell'Orto, Venice/BAL

Ecce Homo, 1543
Titian (Tiziano Vecellio)
Kunsthistorisches Museum,
Vienna/ BAL

Mercury, Herse and Aglauros,
c.1576–84
Paolo Caliari Veronese
Fitzwilliam Museum,
University of Cambridge/BAL

*Madonna and Child with Sts Peter,
Jerome and Mary Magdalene with
a Bishop,* 1500 (oil on panel)
Alvise Vivarini
Musée de Picardie, Amiens/BAL

The Birth of St Augustine,
c.1440–50 (tempera on panel)
Antonio Vivarini
Courtauld Gallery, London/BAL

Echo and Narcissus, 1903
John William Waterhouse
Trustees of the National Museums
& Galleries on Merseyside/Walker
Art Gallery, Liverpool, Merseyside/
BAL

The Entombment, c.1450
(oil on panel)
Rogier van der Weyden
Galleria degli Uffizi, Florence/BAL

Hell, detail from *The Last
Judgement,* c.1451 (oil on panel)
Rogier van der Weyden
Hôtel Dieu, Beaune/BAL

St Michael Weighing The Souls,
detail from *The Last Judgement,*
c. 1451 (oil on panel)
Rogier van der Weyden
Hôtel Dieu, Beaune, France/BAL

Section 3 (Glossary)

Portrait of a Gentleman
Pompeo Girolamo Batoni
Christie's Images, London, UK/BAL

View of the Pond at Charleston
Vanessa Bell
Sheffield Galleries and Museums
Trust, UK/BAL. Reproduced by kind
permission of the Estate.

Breton Women on a Wall, 1892
Émile Bernard
Josefowitz Collection, New York,
USA/BAL

*Fur Traders Descending the
Missouri* (oil on canvas)
George Caleb Bingham
Metropolitan Museum of Art,
New York, USA/BAL

An Astronomer, 1652 (oil on
canvas)
Ferdinand Bol
National Gallery, London, UK/BAL

*Corso Sant'Anastasia, Verona, with
the Palace of Prince Maffei,* 1826
Richard Parkes Bonington
Victoria & Albert Museum,
London, UK/BAL

*An Italianate landscape with
figures on a path*
Jan Both
Johnny van Haeften Gallery,
London, UK/BAL

*Bacchus and Erigone
(Érigone vaincue),* 1745
François Boucher
Wallace Collection, London,
UK/BAL

The Beach at Trouville
Eugène Boudin
Christie's Images, London, UK/BAL

The Round Table, 1929 (oil on
canvas) **Georges Braque**
Phillips Collection, Washington
DC, USA/BAL © ADAGP, Paris and
DACS, London 2001

The Last of England, 1852-5
(oil on panel)
Ford Madox Brown
Birmingham Museums and Art
Gallery/BAL

Marble Quarry, Isle of Iona
Sir David Young Cameron
Reproduced by kind permission.
Bradford Art Galleries and
Museums, West Yorkshire, UK/BAL

A Friendly Visit
William Merritt Chase
National Gallery of Art,
Washington DC, USA/BAL

Greta Bridge, Durham (w/c)
John Sell Cotman
British Museum, London, UK/BAL

*Liberty Leading the People, 28 July
1830* (oil on canvas)
Eugène Delacroix
Louvre, Paris, France/BAL

*The Vision of The Seven
Candlesticks* from the 'Apocalypse'
or '*The Revelations of St. John the
Divine*', pub. 1498 (woodcut)
Albrecht Dürer
Private Collection/BAL

*The Vision after the Sermon (Jacob
wrestling with the Angel)*, 1888
Paul Gauguin
National Gallery of Scotland,
Edinburgh, Scotland/BAL

Lenin's Vision Becomes Reality, 1934
(photomontage)
John Heartfield
Private Collection/BAL
© DACS 2001

Still Life with a Nautilus Cup, 1632
(panel)
Jan Davidsz de Heem
The Barber Institute of fine Arts,
University of Birmingham/BAL

*Snow at night: young women leave
a temple in heavy falling snow,
from the series '53 Stations of the
Tokaido' (yoko-e - horizontal
format, colour woodblock print)*
Ando (Utagawa) Hiroshige
Chester Beatty Library,
Dublin/ BAL

Sunbather, 1966
(acrylic on canvas), 72 x 72 inches,
David Hockney
Copyright © David Hockney.
Hans Neuendorf, Hamburg,
Germany/BAL

*Marriage à la Mode II – Shortly
after the Marriage,* before 1743
(oil on canvas)
William Hogarth
National Gallery, London, UK/BAL

The Ambassadors, 1533 (oil on
panel)
Hans Holbein (the younger)
National Gallery, London, UK/BAL

Snap the Whip, 1872 (oil on canvas)
Winslow Homer
Butler Institute of American Art,
Youngstown, OH, USA/BAL

*Supper with the Minstrel
and his Lute*
Gerrit van Honthorst
Galleria degli Uffizi, Florence,
Italy/ BAL

The Shadow of Death, 1870-3
William Holman Hunt
Manchester City Art Galleries,
UK/BAL

The Grande Odalisque, 1814
(oil on canvas)
Jean-Auguste-Dominique Ingres
Louvre, Paris, France/BAL

The Kiss, 1907-8
Gustav Klimt
Österreichische Galerie Belvedere,
Vienna, Austria/BAL

Untitled, 1979 (wood, canvas, rope
& smoke burns)
Jannis Kounellis
Private Collection/BAL

*The Cheat with the Ace of
Diamonds*, c.1635-40 (oil on canvas)
Georges de La Tour
Louvre, Paris, France/BAL

*John Brown Formed An
Organisation Among The Coloured
People of Adirondack Woods To
Resist The Capture of Any Fugitive
Slaves*, 1941 (gouache on white
wove paper)
Jacob Lawrence
The Detroit Institute of Arts, USA/
BAL Gift of Mr and Mrs Milton
Lowenthal

Landscape at Dusk
Claude Lorrain (Claude Gellée)
Hermitage, St. Petersburg,
Russia/ BAL

The Human Condition, 1933
René Magritte
Private Collection/BAL
© ADAGP, Paris and DACS,
London 2001

*Sistine Chapel Ceiling:
Creation of Adam*, 1510
(fresco) (post-restoration)
Michelangelo Buonarroti
Vatican Museums and Galleries,
Vatican City, Italy/BAL

Study for the Creation of Adam
(red chalk)
Michelangelo Buonarroti
British Museum, London, UK/BAL

*The Grand Canyon of the
Yellowstone*, 1872 (oil on canvas)
Thomas Moran
National Museum of American
Art, Smithsonian Institute,
USA/BAL. Lent by U.S. Dept. of the
Interior, National Park Service

Angel Traveller (w/c)
Gustave Moreau
Musée Gustave Moreau, Paris,
France/ BAL

Roman Capriccio (oil on canvas)
Giovanni Paolo Panini (or Pannini)
Ashmolean Museum, Oxford,
UK/ BAL

Still Life
Samuel John Peploe
The Potteries Museum and Art
Gallery, Stoke-on-Trent, UK/BAL

Sculptor at Rest
(etching) (b/w photo)
Pablo Picasso
Private Collection/BAL
© Succession Picasso/DACS 2001

Annunciation, 1501 (fresco)
Bernardino di Biagio Pinturicchio
Baglioni Chapel, Santa Maria
Maggiore, Spello, Italy/BAL

*Landscape at Varengeville, Grey
Weather*, 1899 (oil on canvas)
Camille Pissarro
Gift of Mr and Mrs Donald
D. Harrington. Phoenix Art
Museum, Arizona/ BAL

Snow Scene, 1917
Lucien Pissarro
Bristol City Museum and Art
Gallery, UK/BAL

*The Abduction of Deianeira
by the Centaur Nessus*, 1620-1
(oil on canvas)
Guido Reni

Louvre, Paris, France/BAL
*The Infant Hercules Strangling
the Serpents*, 1786-8
Sir Joshua Reynolds
Hermitage, St. Petersburg,
Russia/BAL

St. Andrew, c.1630-2 (oil on canvas)
**José (or Jusepe) de Ribera
(Lo Spagnoletto)**
Prado, Madrid, Spain/BAL

*Untitled, from the Boston Massacre
series of twelve*, 1970 (screenprint)
Larry Rivers
Wolverhampton Art Gallery,
West Midlands, UK/BAL
© Larry Rivers, courtesy,
Marlborough Gallery, New York.

*Self Portrait of Rousseau, from L'ile
Saint-Louis*, 1890 (oil on canvas)
Henri (Le Douanier) Rousseau
Narodni Galerie, Prague,
Czech Republic/BAL

Holm Oaks, Apremont (oil on
canvas)
Théodore Rousseau
Louvre, Paris, France/BAL

Exterior of Ducal Palace, Venice
(pen, ink and wash on paper)
John Ruskin
Ashmolean Museum, Oxford,
UK/BAL

Washerwomen, c.1891-92
(oil on canvas)
Paul Sérusier
Museum of fine Arts, Houston,
Texas, USA/BAL.
Gift of Audrey Jones Beck

Model from the Back, 1887
(oil on panel)
Georges Seurat
Musée d'Orsay, Paris, France/BAL

The Gleaners (conté crayon)
Georges Seurat
British Museum, London, UK/BAL

The Walk, 1890
Alfred Sisley
Musée d'Art et d'Histoire, Palais
Massena, Nice, France/BAL

McSorley's Bar, 1912 (oil on canvas)
John Sloan
The Detroit Institute of Arts, USA/
BAL Founders Society purchase,
General Membership Fund

Pantry Scene with a Page, c.1615-20
Frans Snyders
Wallace Collection, London,
UK/BAL

The Last Evening, 1873 (oil on
canvas)
James Tissot
Guildhall Art Gallery,
Corporation of London, UK/BAL

Wreck of a Transport Ship
Joseph Mallord William Turner
Museu Calouste Gulbenkian,
Lisbon, Portugal/BAL

Yarmouth Quay, 1823 (oil on
canvas) **George Vincent**
Norfolk Museums Service
(Norwich Castle Museum) UK/BAL

The Entombment, c.1450
(oil on panel)
Rogier van der Weyden
Galleria degli Uffizi, Florence,
Italy/BAL